The Jewelers of the Ummah

The Jewelers of the Ummah

A Potential History of the Jewish Muslim World

Ariella Aïsha Azoulay

VERSO

London • New York

First published by Verso 2024
© Ariella Aïsha Azoulay 2024
All images in this book are by the author or from her
archive, except where otherwise indicated.
The author and publisher thanks Ronny Someck for kind
permission to quote from his poem "Algeria."

All rights reserved

The moral rights of the author have been asserted

1 3 5 7 9 10 8 6 4 2

Verso
UK: 6 Meard Street, London W1F 0EG
US: 388 Atlantic Avenue, Brooklyn, NY 11217
versobooks.com

Verso is the imprint of New Left Books

ISBN-13: 978-1-80429-311-9
ISBN-13: 978-1-80429-312-6 (UK EBK)
ISBN-13: 978-1-80429-313-3 (US EBK)

British Library Cataloguing in Publication Data
A catalogue record for this book is available from the British Library

Library of Congress Cataloging-in-Publication Data

Names: Azoulay, Ariella, author.
Title: The jewelers of the Ummah : a potential history of the Jewish Muslim world / Ariella Aïsha Azoulay.
Description: London : Brooklyn, NY : Verso Books, 2024. | Includes bibliographical references and index.
Identifiers: LCCN 2024021722 (print) | LCCN 2024021723 (ebook) | ISBN 9781804293119 (paperback) | ISBN 9781804293133 (ebk)
Subjects: LCSH: Mizrahim—Algeria. | Jews, Algerian. |
Jews—Algeria—History. | Mizrahim.
Classification: LCC DS135.A3 A98 2024 (print) | LCC DS135.A3 (ebook) | DDC 965.004924—dc23/eng/20240524
LC record available at https://lccn.loc.gov/2024021722
LC ebook record available at https://lccn.loc.gov/2024021723

Typeset in Sabon by MJ & N Gavan, Truro, Cornwall
Printed and bound by CPI Group (UK) Ltd, Croydon, CR0 4YY

Contents

Introduction: Who Am I? Inhabiting the Jewish Muslim
World 1

Addressee Biographies 27

LETTER 1. ABBA, WHY DIDN'T YOU CALL ME ALGERIA? 33
A letter to my father, Roger Lucien
Oran / the European city / saints, healers, and tombs / trees go on strike / showing you Algiers / the lower Kasbah / Jewish jewelers / Government square / indigenous "types" and French painters / crochet and embroidery work / studying in Paris / vinyls / colonized in the colonizers' army / World War II / uncopyrighted recordings / "oriental music" / "Bésame Mucho" / direct and indirect lessons

LETTER 2. WE HAVE NOT FORGOTTEN FRANCE'S
COLONIAL CRIMES 81
A letter to Benjamin Stora
French report on the French colonization of Algeria / memory and history / imposed language code / the "repatriated" Jew / three exiles of Algerian Jews / traumatic experience / Évian Accords / two colonial projects / additional exiles from the history of colonization and repair / Arab is also a Jewish language / assimilation and the larger framework of Western civilization

Contents

LETTER 3. YOUR EARTH MOTHER IS MY EARTH MOTHER TOO 105
A letter to Samira Negrouche

Dreams / what I could not have guessed / Place des Martyrs / staircase in Oran / the wrong book / earth mothers / a children's book / fiction and nonfiction / what my ears remember / muezzin / muscle music

LETTER 4. "WITH ALL MY BEING, I REFUSE TO ACCEPT THIS AMPUTATION" 115
A letter to Frantz Fanon

Diagnosing my father's colonial syndrome / entering your clinic / the colonial organization of the clinic / the decision to join the Army of Africa / Jewish informants / anticolonial care / the Jews were not Europeans / rape of Algerian women / gleaning / craft labor / belonging to a race that has worked with gold and silver for centuries / *harki* / Man? / democratic aphasia / racial colonialism / to be unnoticed / it might have been different

LETTER 5. LATELY, I HAVE BEEN TALKING TO MY ANCESTORS 159
A letter to my beloved children

The right to be with our ancestors / European fantasies / Napoleon and the invention of the Jewish people / why I insist we continue to be the problem, not the solution / in the folds of Ladino / the no-choice of colonial choice / Zionist terror against the Jews / swallow-books / the French obsession with the veil / jokes and cantillation notes / storytelling / blessing / a paper boat / Black American jazz in Algeria / the biblical story of Babel / Jewish autonomy and a potential history of the Jewish ghettos / Hannah Arendt and the meaning of crimes against humanity / the nonexistent photo album / new Jews and "Jewish types" / jewelry-making / golden bracelets / fire, metal, and *djenoun*

Contents

LETTER 6. THE JEWELERS OF THE UMMAH 231
 A letter to Wassyla Tamzali

Elected kin / "our" mythological tradition / muscle memory / anti military memory / Jewish Muslim conviviality / knowing without knowing / colonization by art / art of tying ropes / jewelry-making / world-building and world-maintaining practices / the tale of the stolen objects / a hopeful story told in Paris

LETTER 7. "WE HAVE BEEN DISPOSSESSED OF YOU" 265
 A letter to Houria Bouteldja

Muslim Jew / mother tongue / invitations / indigenous peoples of the republic / Algerian Bund / *harki* / self-racializing / Islam with no Jews sustains the Judeo-Christian fiction / what the reports confess / synagogues / the miracle of the floating bible / our ancestors' refusal / homo economicus and homo islamicus / the departure of the Jews in 1830 / what the reports display / the voices of our ancestors / the destruction of the lower Kasbah / the art of the griot / breathing room / assembly of Algerian saints / the Golden Calf / the open trial on French idolatry / the handling of gold / the embodied guardians of the law / a plundered necklace

LETTER 8. THE ALGERIAN JEWISH ANTICOLONIAL MOTHER DID EXIST! 311
 A letter to my great-grandmother Julie Boumendil

Kosher butcher in French Algeria / the deportation to Auschwitz / "intact patriotism" / summer promenades and French musicians in Algeria / colonial education and the attack on the world of crafts / national subjects / the cavaliers of history / weaving factories for Algerian girls / retouching photos / domestic labor / the value of gold / bracelets understood as chains / labor organizing / a "better life" for children / Convoy No. 59 / birth documents / anticolonial motherhood / anarchism / embracing colonial unruliness / Moroccan threads / draft evasion

Contents

LETTER 9. GOLD THREADS, EMBROIDERY, AND GUILDS 361
A letter to Madame Cohen

Postcards recto-verso / unasked questions / the abandonment paradigm / family names / the violence of progress / a quiet insurgence / like gold in the bank / "Algerian products" / Universal Exhibition / "Silk of Algiers" / the seduction of the railways / local interpreters / silkworms on strike / crafting the perfect "type" / anusim / the man who would not buy a machine / the law of craft / the liquidation of Algiers / displaying Algerian objects / the punch of French warranty / our ancestors' dresses are not old

LETTER 10. BETWEEN EUROPEAN JEWS' EXPERIENCE AND OURS 419
A letter to Hannah Arendt

Double conversion / human solidarity / assimilation / "Oriental Jews" / Rahel Varnhagen and European assimilation / post-Vichy laws / Allies' complicity / forced labor camps / "the gift" of the newly naturalized / imperial citizenship / crimes against humanity / a second, older Aïcha / polygamy / two postcards / Jewish wedding

LETTER 11. IT IS A MIRACLE THAT WE STILL SEE CLEARLY WHERE THE SUN RISES AND WHERE IT SETS 453
A letter to Hosni Kitouni

A minor miracle / stolen identity / *marranos* in Algeria / another miracle

LETTER 12. THE DISAPPEARANCE OF THE DISAPPEARANCE OF JEWS FROM AFRICA 459
A letter to Sylvia Wynter

The other 1492 / drawing maps of Africa / imposed memories / "new world order" and old colonial crimes / the fabricated "Judeo-Christian" tradition / the war over Shabbat / a Judeo-Christian Jewishness / the disappearance of Jews from Africa / two Africas / life beyond Man / James Baldwin, Edward Said, and Frantz Fanon's cinematic memories / my father's one-man show of anticolonial revenge / rewinding / Africa's welcome gates

Contents

LETTER 13. THE AMNESIA OF JEWS IN THE US IS ONLY HALF THE STORY; THE OTHER HALF HAS NEVER BEEN TOLD 483
A letter to Katya Gibel Mevorach

Black, Jew / Declaration of Independence / writing with ancestors / the amnesia of Jews in the US / partial invisibility / many stories / art education / good hands / the origins of artistic talent / the other half of the story / our best hope

LETTER 14. FUCK YOU, FRANCE, MY DAUGHTER IS ISLAM 505
A letter to my great-grandmother Marianne, umm Aïcha

The evasive name / repetitive spelling mistakes / my father's tin fork / daughter of the republic / the two cities of Sidi-bel-Abbès / pacifying populations / many Mariannes / Aïcha's children / *en colère* / anticolonial female ancestors / Radio Monte Carlo and old medals / Jewish psychosis / apparitions and miracles / extended family

LETTER 15. WHY DIDN'T YOU LOVE ME IN LADINO? 539
A letter to my mother, Zahava Azoulay, born Arie

The intimacy of empire / in Ladino we will say / stubborn accents / the colonization of our mouths / the murder of revival / love in many languages / our family's legacy / the sultan welcomes the Jews as craftspeople / unruly women / the clothing of three brothers / lions / two fairy tales / the gift of unwritten writing / a smile / the fabric stall at the market / flatbread with hummus / Kol Nidrei / what you taught me

LETTER 16. THE GRANDDAUGHTERS OF SYCORAX 573
A letter to Ghassan Kanafani

Sycorax and the "deliverer of Algiers" / The Tempest / Tama's name / decolonized Palestine / Returning to Haifa / Prophecy

Acknowledgments 587
Notes 593
Index 635

Introduction: Who Am I? Inhabiting the Jewish Muslim World

Who am I?

This is not an existential question. It's a roar from a descendant of a world assumed to have been destroyed; an ancestral world whose inhabitants, deprived of their artisanal professions, traditions, forms of belonging, and communities, were converted to suit the colonial reality imposed on them. In these disrupted places, human factories were built, producing people severed from their ancestral worlds. I propose to call them converts. Do not expect me, reader, to be able to tell you exactly who they were before and who they became after the conversion. Destruction imposes rupture. It cripples the transmission of knowledge as imperial regimes operate through both military power and the education of children. *Who are they* becomes *who are we?* Who were our ancestors before they were colonized? Before they were forced to convert? Where are anticolonial memories to be found? What do these memories look like, and how can we learn to recognize them and bring them to life?

I was born in 1962, the year Algeria finally achieved independence from French colonial rule. Independence resulted in the formation of a new body politic, which was configured out of most of Algeria's colonized people—except Algerian Jews, *harkis* (those Algerian Muslims forced to collaborate with the colonizers), and European settlers. In 1962, excluding Algerian Jews from the newly independent Algeria and displacing them to

a place "for Jews" was seen as both acceptable and inevitable. In common narratives, this forced migration is seen as the logical outcome of the 1870 Crémieux Decree that declared (most) Algerian Jews to be French citizens. This decree is understood to be emancipatory—the Jews were *granted* citizenship, in the words of the colonial power—as if words created a world in their image.

But it was neither acceptable, nor inevitable, nor emancipatory, for it destroyed, though not fully, my ancestors' world: the decree was a colonial law that aimed to de-Algerianize the colonized. Decentering this decree and reading it as one of many colonial laws against the body of colonized—Jews and Muslims alike—I reintroduce our Jewish ancestors into the history of Algeria's colonization. I refuse to be blind to my ancestors; I sift carefully through the debris of what had to be destroyed in order for this violent decree to finally achieve its aim. In 1962, that aim was achieved, for in that year our ancestors, the Jews who "formed an ummah with the believers [Muslims]" in Algeria, were severed from that ummah.[1] This work has been a long time coming, pursued in plain sight, because this violence has been coded as emancipation or assimilation, not colonization.

In 1962 when I was born under the supremacy of the white Christian world, Jewish belonging and tradition could continue within the catastrophic project of the Zionist colony in Palestine, or among disconnected and blank individual citizens naturalized in other imperial countries. Claims to Jewish belonging within the Muslim world are still seen as an interference in the work of global imperial technologies tasked with accelerating their disappearance: most of North Africa was already emptied of its Jews, and the European imperial powers mandated the Zionists establish a nation-state for the "Jewish people" in Palestine. That Jews had been part of the ummah since its very beginning, part of what shaped it and defined Muslims' commitment to protect other groups, had to be forgotten by Jews and Muslims so that the Judeo-Christian tradition could emerge as reality rather than invention and be reflected in the global geographical imagination. Despite the dramatic change, this is never called a "crusade," but it sought to make Jews foreign to Africa, transfer them elsewhere to serve Western interests, and make them Zionists by fiat.

Introduction: Who Am I?

Objections to this crusade incurred a high risk, for it was (and is) in the interests of those in power to keep the Jews away from the liberatory idea that Muslims and Arabs were never their enemies. To ensure that this idea would stay suppressed, the involvement of non-Jewish European Zionists in devising plans to colonize Palestine with Jews from Europe and to empty Europe of its Jews, including through collaboration with Nazi actors during the war, had to be diminished and construed as a Jewish liberation project.[2] In this way, the Zionists were tasked by Euro-American powers with conscripting Jews from across the globe as settlers. Jews were trained in the European school of racialized nationalism to become operators of imperialist, colonial, and capitalist technologies—though some were disguised at the time as socialists. Despite the fact that the tiny Zionist movement was unappealing to most Jews worldwide, at the end of WWII the Euro-American new world order included the accelerated colonization of Palestine as yet another "solution" for the Jews. The French colonization of Algeria facilitated the forced inclusion of those Jews from the Jewish Muslim world in re-birthing the Jewish people in Palestine as European colonizers.

The settler-colonial grammar that deracinated Jews from Muslim countries had to adopt was given to me as my "mother tongue." For years, it forced me to say that though my ancestors were Algerians, I was not. For how could one belong to a world made nonexistent?

In an attempt to resuscitate a counter-grammar against my colonial mother tongue, I started to write open letters to my ancestors and elected kin, some of whom I have never met or known. Through these conversations in the imaginary space-time of the open letter, and in the reimagined space of the ummah, we—my addressees and I—unlearn imperialism. Unlearning the hermeneutic mode of interacting with some of them, notably those who are well-known authors, whose texts are read by many, is essential to these epistolary encounters. I do not offer an interpretation of their writings but instead interact with them through different intersections where what they said and did still matters for the ongoing anticolonial struggle. I would rather have those of them who are dead as my interlocutors, actors,

sometimes elders, rather than objects of my interpretative skills. In this epistolary space, I came to know things I never could have known if we had not been brought together. Some of those ancestors and elected kin have entrusted me with memories I hadn't known existed. Together, my kin and I confronted the (non)choices they were pushed to make and the destinies they were forced to embrace. In these letters, we refuse to comply with the termination of the Jewish Muslim world, a refusal that, we learn, is more luminous than the imperial orb that eclipsed that world and made everything to bring it to an end. In company, we don't have to start from scratch. As their vivid memories of this world are made mine, I don't have to unearth this world, but to inhabit it.

What imperialists proclaimed was over is not. By intertwining our shattered memories, we revive in these letters a Jewish Muslim entanglement and reclaim it as an essential component of our ancestral world. Affirming myself as an Algerian Jew is thus the invocation and practice of an anticolonial grammar. Similarly, in affirming myself as a Palestinian Jew, I invoke the precolonial formation when "Palestinian Jew" was not a settler identity and when Zionism was understood as violence against all the inhabitants of Palestine—and I invoke the diversity of Jewish life and the whole of the Jewish Muslim world.

These open letters are not only discursive exercises. They are part of an embodied effort to revitalize a Jewish Muslim world, inhabit it along with others. The letters are premised on what is now a disappeared constellation—a time when being a Jew in Algeria involved craft, magic, Jewish and Islamic saints and fables, and diverse texts; ethical rules related to different aspects of life, sartorial traditions, sounds of a spiritual liturgy, and indigenous, communal memories and legacies, all of which were targeted by colonization and made alien to the reformatted Jew, who had just one of two approved ways of belonging, either secular or observant. As I wrote these letters, I found that the worlds I had been taught were mine, the colonial secular grammars given to me as a mother tongue, had to be refused, and all the elements of that vanished constellation reclaimed and rehearsed. Here, my addressees and I practice speaking in our shared tongue,

Introduction: Who Am I?

practice imagining the (re)existence of Jewish Muslim worlds, and together experience them as necessary, as liberating.

To be an Algerian Jew is to revolt. In 1962, with the forced departure of Jews from Algeria, the existence of a Jewish Muslim world turned into *history*, the stable past that can never reemerge. To be an Algerian Jew is to resist this idea of history, to rebel against the settler identity that was assigned to me in the Zionist colony where I was born, and to open a door into the precolonial worlds where such identities can be possible again.

To be an Algerian Jew is to reclaim an ancestral world, to free ourselves from the "progress" imperialism forced upon us and from the new identities imperial nation-states imposed in every domain of our life. However, the refusal extends further. To be an Algerian Jew is to repair. It is to refuse to inhabit the "Jewish" identity invented by the secular imperial state, an identity bereft of the rich heritage of nonimperial world building of which it had been a part. To be an Algerian Jew is to inhabit Jewish Muslim conviviality. It is also a commitment to imagining that conviviality's repair and renewal on a global scale.

To be an Algerian Jew is to acknowledge that I have been inhibited for more than fifty years from saying the obvious: that I'm not a child of empire but the descendent of a world that empire aims to destroy. Writing open letters to my ancestors and other elected kin—among them Frantz Fanon; Hannah Arendt; Ghassan Kanafani; my great-grandmothers, Marianne Cohen and Julie Boumendil; my father, Roger Lucien Azoulay, and my mother, Zahava Azoulay (born Arie); Sylvia Wynter; Houria Bouteldja—is a way of conjuring their presence and our shared anticolonial heritage. This epistolary project is motivated both by the assumption that the Jewish Muslim world is essential to North Africa and to Africa more broadly, and by the belief that its destruction can still be opposed. It is motivated by the assumption that such a world can also be enlivened through interactions with objects, as well as with those who may possess some precious scraps of knowledge—crumbs of memory, half-remembered gestures whose meaning or purpose are not fully understood until put in conversation with others.

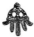

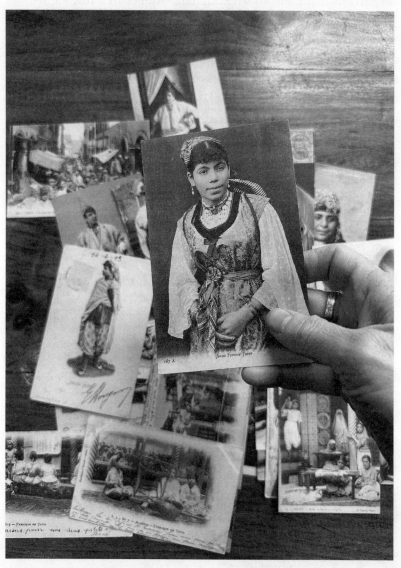

Where are my ancestors? Colonial postcards.

Introduction: Who Am I?

Writing these letters pushed me to look for my grandmothers in the vast visual archive that the French took from our Algerian ancestors. Looking at these women whose images were printed on postcards and sent across the French empire, I resent the rift that I can see between them and my grandmother Aïcha, of whom I have few photos (see photo p. 6). I keep looking at these postcards and asking in dismay: Where did my grandmothers disappear to? What did my female ancestors tell each other at the turn of the nineteenth century as they became "types," estranged from their own bodies and printed on postcards for their colonizers' pleasure?[3] Did they mourn their own disappearance? In this kind of postcard, produced en masse shortly after the colonizers turned Algerian Jews into French citizens, I can see how French imperial taxonomy disappeared my grandmothers twice. Posed as a "Jewish type," my grandmothers had to deny their immersion in and attachment to the Muslim world; now just "Jews" according to French colonial laws, they had to affirm themselves as French and "modern" while repudiating the "Algerian type" as a relic of their past, never to be reinhabited.

> Aïcha,
> Why didn't you tell me
> that it was you?
> That before you were French and modern,
> as you appear in our family album,
> you were Arab and Jew?
> Berber and Jew?
> Muslim and Jew?

What the postcards disappeared was my ancestors' indigeneity or, in French parlance, their Arabité. One of the signs of their successful inhabitation of a world the French called *moderne* was how they had discarded the heavy jewelry they used to wear. The production of these jewels was a craft Jews had practiced for centuries in the Jewish Muslim world. Many rabbis were also jewelers or skilled in other crafts. Their physical immersion in communities organized around artisanship and their care for objects was inseparable from their capacity to respond to

the needs of their communities. With their crafted amulets they brought rain, with their enchanted divination objects they protected pregnant women, and with their decorated knives they shielded babies from the evil eye. Through craft and the making of jewelry, Jews of the ummah had been able to keep Jewish law close to people's lives rather than use it as a tool in the arms and interests of the state. The disappearance of these beautiful North African jewels from my grandmothers' bodies, then, was not a simple change in fashion, but the disruption of a world where craft and guilds were part of a social and religious fabric of mutual care, a world that artistry helped bind together.

As I wrote these letters, I started to copy and reproduce pieces of Algerian jewelry myself, reviving the muscle memory of my ancestors' craft as a way to get closer to them while trying to understand the division of labor in a preindustrial and precolonial world. Through jewelry-making, what had not been transmitted to me could still be reclaimed. On social media platforms, Algerians I had never met started sending me photos of different jewels, and new friendships emerged in the process. To create a bracelet, a necklace, I drilled holes through hundreds of coins from Algeria, Haiti, Palestine, Morocco, Senegal, Egypt, Tunisia, and other places—some of them coins I had inherited, others I purchased online or received from friends (see photo p. 9). More than once, as I was drilling and letting my hands rehearse my ancestors' craft, or I was sharing bits of the letters I wrote with my companions, their responses mirrored my own excitement. What had kept us apart was shattering, and doors were opening wide, welcoming us to our stolen home.

One day, my electronic box was pierced by a few lines that took my breath away. They were written by Samira Negrouche, an Algerian poet, and they were addressed to me.

"We have not sufficiently measured," she wrote, "the drama of all these departures (by choice, by force, by fear, by necessity, by cowardice ...) and their impact on those who remained, those who had to remove the rubble and clean up the mass grave.

"We need each other to access this world, which, unlike our ancestors, we didn't know or only barely knew."

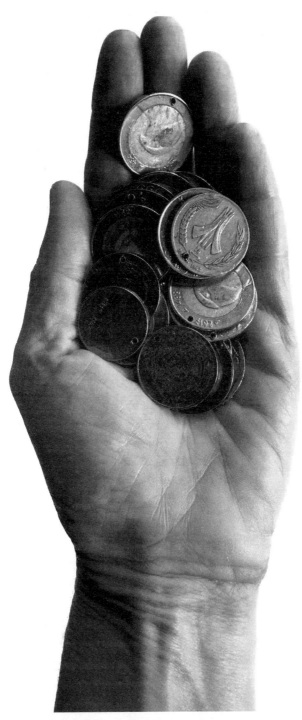

A handful of coins from Algeria, gifted to me by Samira Negrouche for the preparation of a breastplate.

Samira's letter made me think about those who remained. I screamed and asked my paternal great-grandmother for help.

She was furious when she heard that she had been left alone in our cemetery in Oran. I promised her I would come: "I will put a stone on your grave."

She yelled and asked for her jewels.

I promised.

I was too busy finishing a bracelet, which my granddaughter, who thought I was a magician, had asked for. I was learning to use gems, coins, and different cords.

But she demanded the jewels, my great-grandmother.

"I need more time," I told my paternal great-grandmother, "to acquire the embodied knowledge that my ancestors neglected to pass over to me, as they were packing suitcases and evaporating into their forced Frenchness."

"No, no," she replied, "you don't understand. I want my jewels. They are somewhere far away from here, in a museum basement. Find them!"

I begged my friend, the Algerian historian Hosni Kitouni, to find out what is known in Algeria about the Jews who in 1830 preferred to live in the Abd al Kader state than to live in the areas already conquered by the French. He wrote back, not about Abd al-Kader, but the French.

"No doubt," he said, "the French nationality imposed on your ancestors was the worst humiliation that was ever inflicted upon them."

The force of this question. "Who am I?"—entangled with "who are we?"—surprised me when it presented itself to me more than a decade ago. It felt as if the weight of an entire world were at stake in the answer. The question imposed itself just after the death of my father, which coincided with my departure from the Zionist colony in Palestine and with my arrival into a Christian world, one where I felt more Jewish than ever. I felt more Jewish than ever, I came to realize, because I had parted from the "Israeli" identity assigned to me at birth, and once I shed my national (Israeli) identity, I felt myself at once a "Jew" and robbed of being a Jew, a Muslim Jew, whose ancestors had once been

Introduction: Who Am I?

part of the ummah. The national identity, I saw, had destroyed and subsumed diverse kinds of Jewish life.

Moreover, in the Euro-American world in which I now live, Jews are understood to have come from Europe, and their history is understood as a European one. I am often marked as a European Jew or Ashkenazi Jew, regardless of the fact that my ancestors are Arab Jews, Berber Jews, Muslim Jews. Simple statements like "I am an Arab Jew" or "I am a Muslim Jew" require long explanations because the concept of a Muslim Jew disturbs the fiction of Jewishness as a primarily European identity. The fiction of Jewishness also obscures the fact that asking diverse Jews to become simply "Jewish" was part of the European "solution" to the "Jewish problem" Europe had created on the continent and in its colonies.

Refusing this fiction is an unpopular thing to do, I have found. I looked for others who were refusing this fiction, so that we might refuse together. Reading the work of Katya Gibel Azoulay, Samira Negrouche, or Hosni Kitouni triggered letters from me about our shared investment in the realities of diverse Jews, those Jews whose experiences and worlds are eclipsed by the fictive construction of a cohesive Jewish people. This fictive border had also separated Muslims and Blacks from Jews.

> Don't dare to tell us
> we cannot talk like this!
>
> No, don't dare!
> You silenced our ancestors
> until you pressed them to leave
> a world in which
> we could not be born.
>
> Don't dare to tell us
> "it was their choice,"
> as if
> they had wanted to ruin the world
> their ancestors shared
> with Muslims.

> Don't dare to tell us
> that their wish was
> to see beloved Palestine
> ruined.
>
> We will not let you bury us
> alive
> in your museums,
> where our ancestors' worlds,
> which should have been ours,
> are piled up in your acclimatized halls
> dedicated to extinct species:
> Afghan Jews,
> Algerian Jews,
> Egyptian Jews,
> Iranian Jews,
> Iraqi Jews,
> Tunisian Jews,
> Yemeni Jews.

Museums, art history, archives, and other industries based on the fabrication of the past and invested in objects that were made "authentic" play an important role in the forced conversion of diverse Jews, many of whom were craftspeople and traders, into one European model, easily assimilable into the white Christian states and capitalist racial formation of the West.

Modern art is a colonizing technology, a device that produces a universal notion of "heritage" and the museum as a place where "universal history" can be organized along a spatial and temporal axis. "Jewish art" in the modern museum is inseparable from the imperial violence that destroyed centuries of diverse modes of life, notably the Jewish Muslim world, as well as one of this diverse world's major sites: the synagogue in the Muslim world. Another way to say this is that "Jewish art"—as well as "Muslim art"—is the adjacent colonial fiction of those identities.[4] This invention was necessary to sustain the notion of a *people* in the European imperial sense, a people who could be converted into subjects

Introduction: Who Am I?

deserving of emancipation and acceptance into Euro-American citizenry. In making "Jewish art," whole worlds of existing art-making practice by Jews had to be extinguished and lost. In this way, museums became the legitimate curators of what was expropriated from diverse Jewish communities.

If we could re-establish Jewish Muslim synagogues, where artisanal workshops could be hosted and spiritual and anticolonial prayers renewed, we could begin to reclaim these manuscripts and objects held against us in museums, use them as our guides in reclaiming the world in which the know-how of their making is quintessential to being in the world and caring for it.[5]

Alternating between writing letters and stringing beads onto different threads, I finally understood how I could have once believed that I had never seen an Arab Jewish artist. I had forgotten that my father's gifted hands, the ones I watched as a child growing up in the Zionist colony, had acquired their skills in Algeria and had transmitted more to me than I knew. His artisanal know-how was neither Jewish nor Muslim, but something in between, the living presence of a world that had been destroyed. Yet there it was, simply, in the artistry of my father's hands.

These letters follow my father's hands. Through the practice and history of handcrafts, most notably jewelry-making, I can experience the vitality of the Jewish Muslim world that must be revived. Indeed, before the French defined our ancestors by their faith and used their faith as a blade to separate them from the world they shared with others—before this, the peoples of the Maghreb recognized my ancestors by their crafts. Craft-making knowledge was transmitted to children, and artisanal guilds were built within families. In the Hebrew Bible, the term "son of…" often refers to the guild, not the bloodline.[6] In different places, as Mark Wischnitzer writes, "when an artisan passed through the city or went to a nearby village, he was recognized by the distinctive badge he wore. The tailor had a needle stuck in his dress; the wool carder showed a woolen thread; the dyer carried different colored threads, the carpenter displayed a ruler."[7]

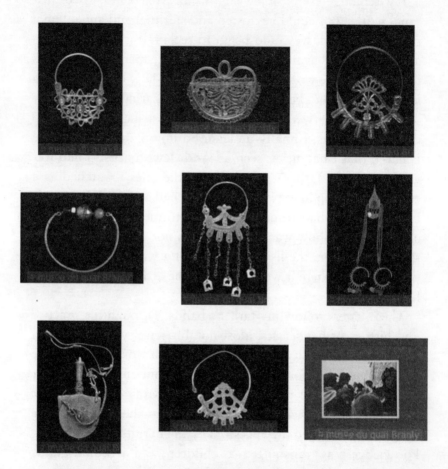

Algerian jewelry (Alâqa), still held at the Musée Quai Branly, Paris.

Introduction: Who Am I?

The blessing of the Alâqa, this special earring,
which children of Jewish jewelers
used to wear on their left earlobe as a form of protection,
is today forgotten.

With no more Jewish Muslim jewelers left to make them,
with no more Jewish Muslim children left to wear them
and bear their blessing,
they can now be found mainly in museums.

I have tried to inhabit this world by rehearsing the gestures associated with my ancestors' jewelry-making craft and by making jewelry similar to what they made. This has meant both tracking down the social life of craftswomen and craftsmen from different sources and attending to my own experience as I copied and learned their craft. Paying attention to minor details of their craft—details that are often neglected, overshadowed by the wholeness of a finished piece of jewelry—revealed unexpected aspects of their practice and an unanticipated significance of their quotidian life.

Jewelry-making was one of the professions that marked our ancestors' place in the world they shared with others, notably in the Muslim ummah. Since the beginning of Islam, Jews were the majority of those who worked in jewelry, minting, and blacksmithing, occupations considered to be "vile to Islam," and involving "protection and servility, nobility and degradation, parvenu and pariah."[8] This delineation of craftwork is implied in the Umar Pact, a canonical piece of Islamic law that defines the relationship between Muslims and non-Muslims, including the set of rights and restrictions for the *dhimmi*, the status assigned to non-Muslims living under Muslim rule, and apparently mentioned in the lost Charter of the Medina (*Sahīfat al-Madīna*). Jewelry-making was what simultaneously separated and united our ancestors from and with others. Jewelry produced by Jews who were tasked with dealing with fire and metal was—and can still be—the outcome of endless exchanges with those who desired to enchant the world again with the wisdom and magic involved in holding those jewels close to their bodies and hearts.

Many of my companions in this epistolary exchange are dead. And yet they talk to me, surprise me, and challenge me more than I could have expected. Together we explore how Jewish ancestors were not only forced to assimilate but also forced to convert themselves from Muslim Jews and colonized subjects to imperial citizens of a certain faith. Some of my epistolary companions and I ask how our respective ancestors responded, something traced only in signs and repressed lifeways and skills. With them, I am able to identify some of the clues that our ancestors left for us to find so we don't forget who we are. Together, we imagine an exit for our ancestors, and for ourselves, from the imperial nation-states that have repressed knowledge of ourselves and the world we once inhabited (and still inhabit).

As early as 1830, the French destroyed Algeria and forced its inhabitants—Jews and Muslims alike—to adapt themselves to the colonial infrastructures that were imposed as substitutes for the structures that the French had outlawed, sabotaged, and ruined. Identity was one such colonial infrastructure. Our ancestors were forced to convert to a secular mode of life, and secularism came to define all aspects of their life, including their modes of religious being and belonging, now siloed and confined within the imperial space of the secular state. "Simply put, the secular state offers individuals freedom of belief, but not freedom to act publicly based on those beliefs."[9] The separation of Jews from Muslims was part of it, as their shared traditions were reduced to two distinct religions. In addition to this campaign of de-Algerianization, in 1870 the Jews were forced to become legally French and to further resemble those who had coerced them into that becoming (i.e., the French). Tracing the different types of violence that were exercised against them beginning in 1830 so that in 1962 they would depart from their ancestral homeland as French guided my exploration of the multiple and often inconsistent ways our ancestors responded to this campaign and negotiated ways of protecting parts of their world.

Under the general condition of colonization, trying to draw a stable line between those of our ancestors who "chose" their conversion and those who were forced to convert or were born converts means ignoring how the colonizers crushed our

Introduction: Who Am I?

ancestors' communal and traditional life and made their previous identities unlivable, unthinkable. Accordingly, I relate to all the Jews who were made citizens by decree as "forced converts" and to their descendants, like myself, as "born converts." I refer to both together as the crypto-Jews or *anusim*, a Hebrew word that refers to Jews forced to convert under threat of violence. Finding the signs left by our ancestors about their conversion and about who they used to be, and learning to decipher their layers of meaning, is the duty and task of the children of the *anusim*, a duty these letters seek to perform and fulfill.

In addition to attending to moments of contradiction and incoherence, as a born convert, I insist on finding the signs of refusal that our ancestors left in unexpected places, the ones they left like a trail of crumbs when they were forced to depart from their world and their ancestral professions to enable the industrialization of Algeria and its integration into global racial capitalism. For example, an accidental glance at scrawled notes on a postcard in the collection of the Jewish Museum in Paris introduced me to Madame Cohen, a gold thread embroiderer from Oran, and she helped me find the semi-clandestine world of the craft-makers of the Maghreb and helped me also to ask questions about the craft guilds in Algeria, despite their swift disappearance that left very few traces. Was it possible that the craftsmen and craftswomen had not done or said anything against the demise of their profession and their way of life, and simply accepted their fate?

Writing these letters is also indirectly an act of writing to and for my children and grandchildren, and to other children of the *anusim*: without these letters, they would have even fewer silk and gold threads to cling to, less ability to re-imagine the precolonial world of their ancestors and re-embroider this one.

The psychological violence that the French exerted on Algerian Jews was so deep that, until today, the language used even by those who study the coercion is captive to an emancipatory narrative structure, as reflected in this example from a contemporary scholar: "Once emancipated, [they] would become citizens of the Jewish faith, fully integrated into the social and political body."[10] But thinking of our ancestors as identifiable primarily through

their "religion" (as coded by imperial states) misses the social fabric of the Jewish Muslim world they cocreated as neighbors and shopkeepers and artisans. One of the violences of the French colonization of Algeria is that our ancestors were taught not to recognize themselves in their own world, but instead to see themselves as secular "citizens of Jewish faith" in the French Republic. As *anusim*, converted Algerian Jews were forced to internalize the sacrifice of the world they shared with others. By tearing them away from their craft and trades, by teaching them worldless professions—professions that no longer served the members of their community but rather the "mother country" that had forcibly adopted them—and by destroying their socio-religious structures, the French constantly compromised their world. They became, in the phrase of Hannah Arendt, worldless. Their future became the empty future of the French nation-state, and we, their children, were deprived of even the story of their resistance.

> From whence shall our help come,
> if we can no longer lift our eyes up unto the mountains?

> From whence shall our help come
> if we, dethroned descendants of a Jewish Muslim world, are being *told*
> "*You no longer have a world that you can inhabit*"?

Some of these letters are accidental. I didn't plan to write a letter to my great-grandmother Julie, but I had to when I received a fellowship that gave me a writing space with a view of the Wannsee, the lake where, in 1942, officials from the Nazi regime met and agreed on a "Final Solution to the Jewish Question." Situated across the water from the Wannsee Conference villa, I was haunted by the role the Zionist colony had played in my father's inability to mourn the murder of his aunt, uncle, and three cousins in Auschwitz—and in his daughters' ignorance of their deaths. In the Zionist colony where I grew up, the Holocaust is the calamity of European Jews—and we were Arabs. My letter to Julie is driven by a refusal to accept the Eurocentric model of historical research that limits the study of Nazi extermination

practices and separates it from those of the French colonization of North Africa and other imperial campaigns of genocidal violence. Discovering Julie's anticolonial legacy helped me to approach the Vichy regime—the French regime that collaborated with Nazi Germany in France and its colonies—not as an accident that had happened to the French imperial state, but rather as a continuation of the French colonial regime. Likewise, I wanted to write to my father and rehearse a language with him that would help us express what the French did to us and what the French are still incapable of acknowledging. I wanted to take my father on a tour of Algiers and show him how, in 1832, the Jews had already been configured into "a problem" to be "solved" by the French colonizers through conversion and assimilation, anticipating the Nazi solution of genocide. But both, I want him to see, are part of a continuum of imperial violence.

Other letters are to my elected kin, like Frantz Fanon. In 1943, Fanon decided to travel to Oran and volunteer for the French Army of Africa. At the very same time, my father was released from the Bedeau concentration camp in Algeria, and despite the solid warnings he heard from many Algerian Jews, he volunteered for this same army. Both my father and Fanon soon departed from Oran for Tunis on their way to fight in Italy, Germany, and France; both came back to Algeria after the war. Fanon and my father never met, though they inhabited the same world. Even if they had, they would have been kept apart by colonial logic. Had my father asked for psychiatric assistance in Fanon's clinic, had he complained about his own colonial trauma, had he been treated by Fanon at the Blida-Joinville Psychiatric Hospital, my father, an indigenous Algerian, would have been classified as a "European" and sent to the European pavilion, together with French settlers, who were hostile to Algerian Jews and would have been suspicious of my father's status as a French citizen. Fanon knew that Jews had lived in Algeria for centuries, yet he still related to them as if the new status assigned to them by the French colonizers were a natural status rather than a forced conversion.

In my letter, I enter the half-open door of Fanon's clinic and spend time with him, learning from his insights into the psyche

of the colonized but asking him to think with me about my father, whom Fanon could have misdiagnosed by placing him in the "European" section of his clinic. Rather than arguing with Fanon about this failure, I wanted, in the space of the letter, to expand the purview of our shared anticolonial struggle—one in which Fanon is a central figure and teacher. Writing these letters, my keyboard is soaked with what Houria Bouteldja calls "revolutionary love."[11]

Revolutionary love guides my choice of addressees. I write only to those with whom I share a certain commitment to pursue the anti-imperial struggle of our ancestors, the ancestors we have and those we chose. For example, I will not write a letter to Adolphe Crémieux, the French Jewish colonial lawyer-politician and author of the decree that forcibly converted Jewish Muslims in Algeria into French citizens, though I think a lot about his role in the destruction of the Muslim Jewish world.

In writing open letters to my Algerian kin, memories that I didn't even know I had were revived, reclaimed, and resuscitated. I did not know how much I had lost until I started writing. These letters brought my Algerian kin into a shared refusal to lose our ancestors and our different corporeal, spiritual, and political modes of experience. Together, we rehearse a refusal and make the Jewish Muslim world retrievable.

I was born in the same year that Algeria stopped being French. The independence of Algeria also marks the end of a centuries-old intertwined Jewish and Muslim world, an end that is a non-event in the annals of history. The expulsion of the Jews from Algeria, emptying Africa of most of its Jews, was devoid of meaning in teleological historical narratives that account for Jews' arrival elsewhere but ignored the world destruction that caused this forced migration. Often when I read Muslim and Jewish Algerian historians, I wonder if they don't feel strange about the way Algerian history has so neatly divided Jews from Muslims, and how they have been invited to ignore the "other half" of the inmates in the historiographical prison they inhabit.

What exactly disappeared? The Jews? No, since prior to the invention and construction of different generalized communities

Introduction: Who Am I?

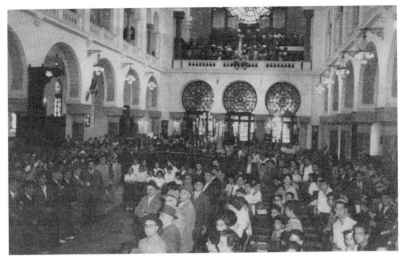

The Great Synagogue, Oran, late 1930. Family photo.

of Jews and Muslims by colonial agents they did not even exist as a "group apart." The Arab Jews? No, this isn't accurate either, since many of those who departed from Algeria were Berber Jews. What disappeared was the *world of which those who departed were once a part*, and what was established with their departure was a *world in which their departure was a non-event*. Some of what these letters help parse are the connections between these two worlds, and the forces that made the non-event that erased my ancestors.

In the piles of photos I removed from our family albums to take with me when my father died, I found a photo of the interior of the Great Synagogue of Oran. I was touched by the photo when I found it.

It took me a long time to unravel what is actually buried underneath this image of an impressive synagogue, the synagogue where my father's bar mitzvah took place.

Algerian synagogues, including this one, that we long for when we see them printed on "old" postcards, are actually new synagogues that the French built for the new Jews that they were in the process of converting.

Every time we see an "old" postcard, with a grand "old" synagogue, we ought to remind ourselves that that this is actually a

new synagogue that the colonizers forced on our ancestors, thus obliterating the memory of those smaller communal synagogues that the colonizers destroyed.

We were left with those deceptive images that we are invited to see as "old," older than us, who were born in other human factories, in other places.

We are nonetheless lucky if we have access to these "old" postcards with which we can still disrupt the unified history that was never ours but was implanted in our minds by another colonial regime aiming to reform us.

Buildings can be destroyed, synagogues included, especially as synagogues in different Jewish communities were mostly invisible in terms of their public presence and could take an ad-hoc form with the presence of enough people, a מניין—a quorum of ten—ready to pray.

The colonial destruction of all precolonial synagogues and their replacement was not, however, about the buildings but about who we are

and

who we will be.

Imagine a small community of Jews whose members speak only Arabic and read Hebrew mainly for prayers, suddenly required to listen to a new rabbi sent from the consistory in France, preaching to them in French.

Tell your daughter (והגדת לבתך) that the French destroyed thirteen synagogues in Algiers in 1830.

Do not tell her:

"With time, your ancestors learned French, they introduced an organ into their new synagogue, and their cantors, trained in the best conservatories, now sing as if they were in the opera house."

Do better.

Unlearn this narrative structure, and start again.

I try to discern the French imperial project of conversion, and the Zionist project of conversion, through their failures, no matter

Introduction: Who Am I?

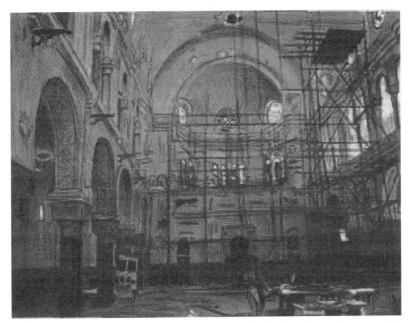

The Great Synagogue of Oran becoming the Abdullah Ibn Salam Mosque, 1972.

how small: in the artisanal guilds and markets, the "talking" wardrobe of clothing and jewels, cathedral-like synagogues, a labor strike of acclimatized silkworms in Algeria, and the underground gold trade that continued between Jews and Muslims regardless of French attempts to dissolve the class of Jewish jewelers in Algeria. When I look on this level, in the imagined space created by writing these letters, I can see the persistence of Jewish Muslim life until the Jews were physically removed. Our ancestors' world was much bigger than books and sites of worship; it was also made up of the jumbled and unruly places of everyday life and work.

In 1972, the Great Synagogue of Oran was turned into a mosque. The synagogue was not destroyed but rather its holiest part—the Ark of the Covenant—"stored" behind a wall, which was erected to separate and protect this area where the synagogue's podium and other sacred objects stood. Each time the name of the current mosque is said, Abdullah ibn Salam, it is a reminder that the Jews were and still are part of the ummah: Abdullah ibn Salam is the name of one of the Prophet's companions, a Jew who recognized the authenticity of the prophet and converted to Islam.

Despite the violence of the deracination of the Algerian Jews, which culminated in their forced departure, the objects they made rebel against and betray the clear-cut separation of Jews from Muslims, of Jews from Algeria. These objects remind us of the Algerian Jewish presence, contained in the jewels and artifacts that they made, a presence that still intermingles with Muslims.

These letters are a kind of semiconductor. They amplify the conductivity between the precious metals of jewelry and coins from across the much-bordered world and the lost wisdom, incantations, invocations, and chants of their makers, wearers, and users.

What could it mean to consider skill in a craft as a mode of reinhabiting one's place in the ummah? What would it mean to still be the jewelers of the ummah—and from that position, to struggle to decolonize Jewish history as invented in Europe and undo the white Christian imperial technologies that robbed us of who we can be with others? What would the renewal of the Jewish Muslim world mean for the decolonization of Palestine and of the world?

The genocide of Palestinians started as I was reviewing this book for the last time before publication. There are not enough tears to mourn the horror of a life world being trampled relentlessly for months by settlers determined to make Gaza disappear. The scale of the killing is greater than in previous campaigns of violence perpetrated against Palestinians. At the same time, however, this determination to destroy Gaza, to make Palestinians vanish in one way or another, and to bulldoze the material vestiges of their histories, is not new; it dates to 1948. Despite the massive erasure, the efforts of hegemonic media to cover up Israel's crimes, and the killing of Palestinian journalists, photojournalists, and media workers at a rate of one every day, Gaza is blessed with prophets, many of them dressed in blue vests on which the word "Press" is emblazoned. They are the truth-tellers of this genocide, the truth that Israel cannot eliminate as long as they are there. Each day a new prophet rises with the sun, joining the choir of those who convey the truth of this genocide, keeping it in plain sight to be witnessed by the millions around the world who refuse to

deny that it has been quintessential to this settler-colonial regime since its inception.¹² This book doesn't engage directly with the current genocide in Gaza, but with the *longue durée* of the Euro-American investment in the destruction of the Jewish Muslim world, of which Palestine is now the ultimate site of its genocidal violence. And yet, despite the disaster, Palestine can still be the site of the ultimate collapse of this crusade.

All this can be expressed with Safiyya's words that end this book:

> The return has already started. Here I am, breaking the Zionist spell over my body, over the land, over our prophetic powers. These are powers that can assist us in healing, in immersing ourselves in the seven years of repair the Torah calls for, renewing our gratitude to our life among others, respecting the balance and secrets of the world and living under their mantle.

Addressee Biographies

Roger Lucien Azoulay

My father (Abba in Hebrew). Born in 1923 in Oran, Algeria. Around the age of fourteen, he took a correspondence course and became a radio technician. While in Algeria he adored American films, jazz music, and *piyyutim* (sung Jewish liturgical poems). Under the Vichy regime, he was incarcerated in the forced labor camp at Bedeau. Upon liberation, he was drafted to the French Army of Africa and fought in Italy, Germany, and France. In 1949, he volunteered for a one-year stint in the newly founded Israeli Army, but he met the woman who became my mother and decided, instead, to stay in the Zionist colony in Palestine, where he worked as a radio technician and later opened a store selling audio equipment and records. He and my mother had three daughters, of which I'm the youngest. When he turned seventy-five, I interviewed him and edited a small booklet about his life, which has been a treasure trove in the writing of this book. He died in 2012.

Benjamin Stora

French historian. Born in 1950 in Constantine, Algeria. In 1962, his family departed from Algeria along with most of the Jews to France, where he became a historian with a focus on Algeria during and after colonization. Over the last decade he has curated exhibitions and edited several volumes dedicated to the relationship between Jews and Muslims in the Maghreb.

Samira Negrouche

Algerian writer and poet. Born in 1980 in Algiers, where she still lives today. She writes in French and translates poetry written in Arabic and Amazigh languages into English and French. A few years ago, we started an exchange of emails and letters about the wounds that came from the amputation of Jewish identity from Muslim identity, and vice versa.

Frantz Omar Fanon

Political theorist and psychiatrist. Born in 1925 in Martinique, under French colonial rule. In 1943, he joined the French Army of Africa in Oran, where his military service overlapped with my father's. After the war, he studied psychiatry and became chief of service in the psychiatric hospital of Blida-Joinville in Algeria. In 1956, he quit to join the Algerian revolutionary forces, was expelled from Algeria, and moved to Tunis and continued his revolutionary work. His writings became formative for postcolonial and anticolonial theorists and activists around the world, including myself. He was part of the editorial collective of the Algerian revolutionary newspaper *El Moudjahid*.

My beloved children

In 1987, while I was studying in Paris, I gave birth to Ellie. In 1991, I met the man who has been my partner since, Adi M. Ophir; his three children, Renana, Hagar, and Nimrod, became part of my life and my beloved children. In 2002, our son Ourie was born. In 2012, Adi and I left the Zionist colony in Palestine and moved with our son to Rhode Island in the United States. That same year, Ellie gave birth to my first grandchild and left the colony with her partner for France and then the UK, where she now works as a scholar, focusing mainly on music collectors and educators and archives. Hagar left for Berlin in 2016, where she lives and works as an artist. My point of departure for these

letters is a combination of the experience of becoming one of the ancestors of our grandchildren; our departure from the Zionist colony where our diverse modes of being Jews and Muslim Jews were ruined; and my gradual understanding of what we were deprived of with the establishment of a Zionist state in 1948.

Wassyla Tamzali

Lawyer and author. Born in 1941 in Béjaïa, Algeria. For many years she worked as an advocate for women's rights in Algeria and around the Mediterranean. She is the founder and director of the Ateliers Sauvages in Algiers. I first encountered Wassyla as the author of a book on Algerian jewelry and tried to contact her, but failed. When I published my letter to Benjamin Stora, she reached out to me. We met and have exchanged letters since.

Houria Bouteldja

Political activist and writer. Born in 1973 in Constantine, Algeria, she immigrated to France as a child. Bouteldja is one of the founders of the Partie des indigènes de la république. During a visit to Paris, I encountered her first book, *Whites, Jews, and Us*. It was the first time in my life that I felt a sense of belonging to a Jewish Muslim world.

Julie Boumendil

My paternal great-grandmother, who lived in Oran. She was a single parent with three children: Joseph (my grandfather), Camille, and Rachel, who died shortly after she was born. Joseph was the only child who was recognized by his father and given his father's name, Azoulay. Julie's daughter Camille and her husband and three children migrated to Paris in the late 1920s and in 1943 were deported by the French police to Drancy, and from there to Auschwitz, where they were murdered. While

looking for Julie in the archive, I discovered my anticolonial female ancestor.

Madame Cohen

A Jewish embroiderer from Oran who worked with gold thread. In the late 1970s, a decade and a half after the expulsion of the Jews from Algeria, she donated two postcards of Algerian women wearing dresses from Tlemcen to the Musée d'art et d'histoire du judaïsme. One of the women pictured in the postcards may be her.

Hannah Arendt

German Jewish philosopher. Born in 1906 in Germany. Her writings were formative for my theoretical and anticolonial education. Her attention to different realms of activity, and most of all to what we do in concert with others, inspired my political thinking and guided me out of Zionism. My letter to her was sparked by her short text on Algeria, written in 1943, and is also inspired by her deep understanding of the costs of assimilation for those who choose or are forced to undertake it.

Hosni Kitouni

Historian specializing in Algerian history. He lives in Constantine, Algeria. Hosni read an early version of my open letter to Benjamin Stora in the *Boston Review*, translated it into French overnight, and posted it to his Facebook page. This sparked a rich, ongoing email exchange about the lingering effects of colonialism, and how to live and think in a world striated by colonial scars. His book *Colonial Disorder* is a potential history of the non-colonization of Algeria by the French.

Addressee Biographies

Sylvia Wynter

Philosopher and essayist. Born in Cuba in 1928, to Jamaican parents. Wynter's texts accompanied me when I immigrated to the United States. When I first read her text on 1492, it appeared to me as a guide to the Americas, but I was troubled by her use of the category "Judaeo-Christian" (as she spells it), which seems to further, through language, the disappearance of the Jews from Africa and the destruction of the Jewish Muslim world.

Katya Gibel Mevorach (Katya Gibel Azoulay)

A cultural anthropologist. In her works, she writes about her experience of being both Jewish and Black. I reached out to her hoping to find a lost family member. I failed; the name we share belonged to her former husband. But I found an epistolary friend, and a friendship nurtured by our shared interest in diverse Jews.

Marianne Cohen

My great-grandmother. Born in in Sidi-bel-Abbès, Algeria. Marianne called her daughter Aïcha, a Jewish Muslim name, which I came to understand as an anticolonial act. With her husband she left the colonial town of Sidi-bel-Abbès (built around a French fort, and home of the French Foreign Legion), and moved to Oran, the family's original home. In my letter to her I try to understand the intergenerational ramifications of the violence perpetrated by the French when they forced indigenous Algerians to change their names, personas, and modes of life to suit the whims of the imperial bureaucracy.

Zahava Arieh Azoulay

My mother (Ima in Hebrew). Born in 1931 in Rishon Lezion, Palestine. Descendant of Jews who had been expelled from Spain in 1492, she spoke Ladino and Hebrew as her mother tongues. Over generations, members of her paternal family, the Ariehs, migrated from Bulgaria to Palestine, which was then part of the Ottoman Empire. Her grandparents migrated to Jerusalem in the mid-nineteenth century, before the first wave of Zionist colonization. After finishing primary school, she studied sewing. When she was seventeen, Palestine was ruined, the state of Israel was established, and the only history she was trained to understand and required to transmit to her children was Zionist history. When she was nineteen, she met my father, Roger Lucien Azoulay, with whom she had three daughters, of whom I am the youngest. She worked part-time in the music store they owned, loved cooking Bulgarian cuisine, knitting, and embroidery, and passed on to me a love of handmade things. Through writing my letter to her, I realized how many militant voices we lost when we were given only Zionists to revere as our elders.

Ghassan Kanafani

A Palestinian writer and a member of the Palestine Liberation Organization. Born in 1936 in Acre, Palestine, Kanafani was assassinated in 1972 in Beirut by Israeli military special forces. His novella *Returning to Haifa* is, among other things, a guardian of the memory of diverse Jews who have been nearly disappeared from Hebrew literature. In my letter, I tell Kanafani about a woman, Tama, his writing has brought to me.

Letter 1. Abba, why didn't you call me Algeria?

A letter to my father, Roger Lucien

Dear Abba,

I recently stumbled upon the last photo that was taken of you. It saddened me in a way I had not expected. I remember the moment I took it as if it occurred just yesterday evening. I was standing outside your hospital room, feeling as if I had no right to look at you as you lay there dying. I thought that perhaps you would not appreciate being seen like that, sick in your hospital bed. I had a sense that this moment was different—that you were not going to recover and return to normal. This was going to be the last time I would see you; your death was already here. At that moment, I couldn't grasp your death's meaning. I feared that when you were gone, I'd realize I had been absent from this moment. So I attempted to linger in it by taking a picture, from a distance, to defer my understanding of your death. I slightly inclined my phone and took a single photo. Taking it, I felt like I was stealing the last photograph of you, but at the same time I felt that I had a right to this photograph.

I was right. I'm looking at your photo now, and you seem different from the father I knew. You are totally decompressed. Even your hair escapes, spread on the pillow like a mane, reminding us that you were once a lion. Looking at this photograph, I don't see the sick man that you were at the time it was taken; rather, I see my father peacefully leaving the world. I would never have

seen you so at peace without the photo, since you were never at peace in the world. And in the last months before you died, you were more vexed and angrier (*en colère*) than ever. You refused to accept that you were no longer as strong as you had once been. Your body was no longer responding, and your willpower was fading.

Looking at this photo of you reconciled to your death, I know that I never had the father that you could have been. Raising us was not your job, and we, your three daughters, had to shield you from the hectic and demanding presence we posed as children. The traces of who we were during the day had to disappear when you returned in the evening from your small store, so that you would not be irritated by our noise, our uncontained movements. Even when we grew up, our exchanges with you were limited and mostly mediated through Ima.

You loved it when our life sounded cinematic, and so I always tried to spice my stories with a theatrical flavor, just as you did before your vocal cords were taken from you and you lost your storyteller's voice. Everything we said to each other could have

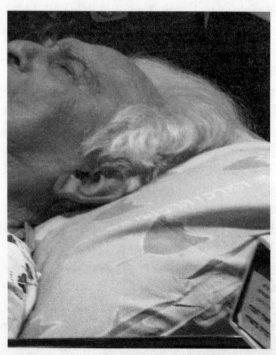

The last photo of my father, on his deathbed, March 13, 2012.

Letter 1. Abba, why didn't you call me Algeria?

been repeated in any others' ears; there was nothing intimate in what we said, nothing that testified to our feelings. Even after Ima died, your rage over her death was mutely present in your body; you didn't utter a word expressing your pain, which was visible only in the gestures that we learned to decipher, nor did you invite us to speak about ours. I don't think that it even occurred to you that we became orphans at that moment. We didn't ask for affection, and you didn't offer any.

Only after your death did I start asking myself how much I projected onto you and how much of the father that I knew was truly part of who you were. Was it me who neglected to share my feelings with you first, because I interiorized your distance? When did I understand that your reserve came from your own injuries, which didn't leave space for ours? Abba, I'm trying to interpret your foreignness to us, since I know that it did not come from selfishness or disinterest—you did not show such things. But you could not bear a certain volume of sound and strength of emotion, and we learned to live around you and adjust ourselves to your presence.

Addressing you in this letter makes me almost forget that you are no longer with us. No, that's not true. It is only because you are gone that I can address you this way, directly, with my feelings and my questions. I can ask you about what was taken from you, from us, from our ancestors, and why and how we became who we are.

This photo, Abba, is not only of you, but also of the distance between us, which even at your deathbed I could not bridge. No matter how much this distance was created by your personality, at least part of it resulted from the colonial project that shaped you and pushed you away from your ancestral homeland and your family. As a result, you found yourself in the Zionist colony, where until the last day of your life you felt foreign, lonely, and incapable of acknowledging the wounds of exile. All your life there, you had no intimate friends (except one, in your first years there, who spoke French with you and was no longer around when I was born). There was no one for us to tell that you were dying, and no one who could tell us stories about you, the kind of stories people tell during the shiva. I was overwhelmed by the

loneliness I felt as I sat at your deathbed. I didn't have any bodily memory of how to be close to you. You didn't have such knowledge either, so even during your last days, you didn't ask me to hold your hand, and I didn't imagine taking your hand in mine.

It was relatively late in the evening when I took this photo. Ilana and I had arrived to visit you for the second time that evening, since the nurse had told us that these would be your last hours. The still photograph silences what my body still viscerally remembers from these last hours: your unbearable groans that vibrated around the room. You were sleeping and yet miserable. In my heart I was praying hard that this ordeal would end. I could not find any words, perhaps because Ilana's words were so dominant. She kept mumbling, "Even dying horses are shot at this stage. Why don't they stop it?" I wished she would stop repeating this.

The groans came out of your throat but it felt like the entire room was moaning. We had to leave the room and we roamed the long corridors of the unit where you were hospitalized. We had already asked the nurse twice to do something to help you, but she muttered something like "There is nothing I can do." Shortly after we left, the nurse called us back. Someone announced to us your death. I recall only that Ilana and I looked at each other and simultaneously said, "We are fully orphans."

In some ways, I had already felt for a while that I no longer had parents. More and more, I felt a deep tear that I was not responsible for generating but you were not equipped to stop or heal. I don't blame you—I was born in a place where children are forced to accept the state's identity and parents must accept it as the cost of citizenship. However, as I grew up, I began to refuse the bargain, and after years of my engaging in political arguments, Ima revealed that she was ashamed of who I had become. For Ima I was a traitor.

Abba, I do not belong in that colony, just like you didn't. We were surrounded by people who policed our identities, forced us to be their Mizrahi Jews, devoid of our memories, cosmologies, and histories. That colony tore us from our ancestors. I don't think you ever understood what it meant for me to grow up in such a place. I realized slowly that this was not because of who

Letter 1. Abba, why didn't you call me Algeria?

you were, but because of who you were made to be. After all, you too were born in the human factories of empire.

I don't write this letter, Abba, in order to assign blame, but rather to seek understanding. I wish to understand this wound that I inherited from you and unwillingly transmitted to my children and grandchildren. You denied the existence of your injury; you never tried to address or heal it. In the colony, we were bereft of an extended family in which to grow up. In the torn world in which you grew up, what remained of your extended family was an obstacle for a young man who wanted to believe that he was making choices only for himself. This is how you were programmed in those imperial factories: to detach yourself from this unmodern (Jewish) world, to turn the page, start anew, reinvent yourself as an independent subject free of tradition. (Indeed, capitalism, which was introduced to Algeria along with the French colonial invasion, conceived of tradition as one of its major obstacles.) You had been poisoned by this modern colonial dream of self-invention, which was not easy for a Jew to realize in Algeria, even with French citizenship. It was rather suffocating for Jews to live in French Algeria, so you left—but you could never say why you felt like an exile in your own country.

You fought during the Second World War as part of the French Army of Africa, where you earned a few medals for your excellent service and for risking your life. Even so, France continued to humiliate you and your family for being Jews. Legally, you were French citizens in Algeria, but at the start of the 1940s, under the Nazi-aligned Vichy government, the French confiscated Jewish property and sent young men like you to concentration camps. You were in the camp in Bedeau. I read about a song you sang in the camp, but you never mentioned it to us; I recently met a cinematographer whose grandfather was in Bedeau, and in a film she is making about the camp, she, her father and other members of her family sing the song that their grandfather sang for them:

> Bedeau, camp of misery,
> Bedeau, camp of calvary,
> it is you who takes us away

> from our parents, from our friends.
> ...
> In this passing camp
> I am a prisoner.[1]

I was in tears.

Other members of your family, who had immigrated to Paris from Algeria a decade earlier, were sent to die in Auschwitz. France never apologized nor paid for what it did, and you could not voice your rage. In the most pragmatic way, you felt that no matter how hard you worked to dissociate yourself from your Jewish family, acting and attempting to pass as a modern man of the world and enjoying what Oran had to offer—cinema, music, dance—you were constantly reminded that you did not belong. But Abba, there once existed a world in which the question of belonging had not yet been imposed as the better of two bad options. The colonization of Algeria attacked not only our sense of belonging, but also the infrastructure that had enabled our ancestors to belong without having to make those harmful "modern" choices.

As for me, Abba, I do not belong anywhere. But I know where to look for fractures and for fragments of what remains of our Jewish Muslim world. These are fractures I am now learning to step into, to inhabit.

Are you surprised, Abba, that I can see you so clearly? It was unlike you to inhabit the victim position. Abba, I do not inhabit the victim position either. I'm trying, rather, to find my mother tongue, to unlearn those languages that we were forced to accept as our own, those words that don't match our experiences. Abba, I refuse to minimize our loss, to cover it up and move on, to forget how we were manufactured as modern subjects, French, Israelis, Jews, worldless. We have the right to find the words to say what was done to us, to speak of what was taken from us, to condemn what was (and continues to be) done in our name, and to refuse the glorious story about how we were given (imperial) citizenship. What was done to the Algerian Jews is still buried under the liberal language of emancipation and choice, and you know

Letter 1. Abba, why didn't you call me Algeria?

well enough that this language has nothing to do with your life experience, neither as a French citizen in Algeria nor as an Israeli in the colony.

Abba, you were born in the human factories of French Algeria. Implanted in you was French memory, which may have inspired you but could not help you put things in your own words, words that would have been true to your ancestors' history, words that would not have camouflaged what you felt as an inheritor of Algeria's colonization. Born in 1923 in the midst of French colonial rule, you were born to be reconciled with what had been done to your ancestors. But how could one be reconciled with what is wrong? A mother tongue, French, was imposed on you, a mother tongue that was not the one your ancestors spoke, different also from the one you could have continued to speak with others. In this space of distance and unspeakable loss, your colonial aphasia took shape.[2] In the absence of words to correspond with your reality, you found refuge in muteness and in a form of storytelling that allowed you to aggrandize everyday life, sometimes out of proportion, in order to not see other things. These forms of refuge were part of your striving not to be where you were, not to face the broken realities, not to feel or learn to love again.

Dear Abba, if you had been capable of acknowledging some of your scars, of remembering the gestures of love offered to you by your family in Algeria, you could have understood that your Algerian family was not your prison. What might have seemed to you like confinement could also have been their acts of refusal against colonial pressures to detach themselves from their Arabic culture. If their life seemed to you like being caught in a cage, as you once described it to me, that was not their fault either. The colonizers in Algeria trained colonized youth—you—to look at their ancestors through French eyes. To align themselves with the modern French against the pre-modern Arab. The promise of Frenchness caught you in a double exile, from the Jewish community and from the French community (for still, you were always an Arab to the French, always, too, a Jew)—and incapacitated you from being able to express your longing, except in the most clandestine ways. Ways that were secret, maybe, even to yourself.

Almost every Saturday when we were children, we went with Ima to the beach so that you could stay home alone and listen to music at full volume. When we came back, lunch was ready. It was always the same meal, always delicious: a piece of steak, twice-fried potatoes, and a fresh green salad. For years I assumed that Ima didn't like your music. Now that I'm more familiar with the world you left behind and know that my great-grandfather, your grandfather Abraham Cohen, loved listening to *piyyutim*, I wonder if you didn't carve out this time in order to listen to the sounds you longed for, free from our gaze and our questioning eyes.

I don't believe today that living outside of one's community could be a real choice, unless life becomes unbearable within it.

Were you familiar with the musician Ahmed Wahbi, who was also from Oran, and who consoled himself in exile with songs about Oran? He sings:

> I will never forget my country,
> my land and that of my ancestors.
> Oran, my childhood's cradle
> makes me forget my sufferings.

I'm not trying to contradict your feelings; I'm trying to suggest that it was colonization that turned the Jewish community into a cage and imposed on you this either/or binary. It won't help to tell me that I have no idea what I'm talking about, or to describe how much culture the French had that Algerians lacked. You knew nothing about who Algerians were prior to the colonization, nothing about what the French did in 1830, and nothing about what the French did to the Jews before they turned them into their captives in 1870. Please, Abba, don't think that I'm playing the *smarter than you* game. I'm not. I didn't know anything about it either, until I made it my mission to educate myself. Nor did I know about what the Zionists did to non-Zionist Jews before I sought answers.

Neither of us knew these things because others had a vested interest in our not-knowing, and our ability to know was damaged. We were given substitute narratives that made us ignorant of how

Letter 1. Abba, why didn't you call me Algeria?

to truly answer such questions as "Who are we?" and "Where do we come from?" and "What are our histories, languages, and memories?" We were forced to inherit an erased memory, and we were prevented from even seeing the erasure itself.

This explains our mutation into people our ancestors would not know.

Abba, I could not stay where I was born either. During your shiva, I got a phone call offering me a job in the United States, and we moved there a few months after you died. Since then, I've been trying to understand what these colonial projects did to us and how they can still be opposed, though these colonial projects have now been normalized as democratic regimes. Reversing the damage caused by colonial projects is not only an individual concern. It is a concern for groups and communities, for social and family life, for our collective moral disposition. It is an effort of love, loneliness, care, and worry for our planet, its different species, and their descendants. These are things that one cannot think about alone.

Like you Abba, after ten years I am also lonely here. I experience a multi-generational dissociation, but I try to disrupt it by refusing to describe the colonial projects in the way we colonial converts have been taught: modernization, secularization, emancipation. The revolutionary dawn of the French Revolution, wherein Jews were "emancipated" from their communities, is my year zero. I won't exhaust you with this long history, though; I want to stay focused on Algeria. I want to understand what I failed to understand about you—your pains, your loneliness, your dissociation, your traumas, your non-choices, your choices, your world, your silences, and our state-sponsored deafness to it all.

Since you died, I've been inhabiting Algeria. Every detail that I read helps me understand how being born an "Israeli" ensured that Algeria would not be part of our life. Simultaneously, my being born Israeli meant disavowing the same heritage that was taken from you upon your arrival in the Zionist colony, where you had to camouflage your birthplace. There are so many questions that no one asked generations of Algerian Jews. I'm trying to ask these questions, even if I cannot receive answers.

Algerian Jews forced to leave Oran with the French colonizers, Oran, Algeria, 1962.

Abba, though we rarely talked, really *talked*, I mean, I hope that what I'm going to share with you will be received as an expression of love and care, and will make you feel, finally, less lonely.

>Abba, do you remember
>the year of my birth?
>
>Yes, 1962.
>
>Our family had to leave Algeria
>in a rush, with barely any belongings.
>Did it hit you
>that you would never
>be able to return to Oran,
>to visit your home,
>pick up the things
>that your mother probably kept,
>assuming you would return?
>
>Did you dream
>of climbing one more time

Letter 1. Abba, why didn't you call me Algeria?

 the wide stairs
 leading to 3 rue Tafna,
 at the top of the hill,
 as you used to do
 until you were twenty-nine years old?
 To confirm once and forever,
 whether there are one hundred steps?

 If you could just have told me
 that the number of steps
 was part of what tormented you,
 I would have immediately promised
 to go there myself and count.

 Maybe then,
 just before you died,
 you could have told me,
 "I love you,"
 "I'm sorry,"
 "I didn't know how to be a father."

 Or simply

 "Bless you."
 "Take good care of yourself."

But you said nothing—not a word. We were left with your silence, which has now been enhanced by your death. Your silence, Abba, was not only yours, but the colonial imprint left on your body.

 If someone could have attended to you when you came back from the war, if you had not been greeted as if these French anti-Jewish settlers were part of the Nazi plot against Jews, you would not have had to conceal your feelings and leave Algeria, incapable of figuring out who you were running away from.

 If someone had addressed you properly, you might have slowly found the words to reclaim Algeria and transmit to us something from our ancestral land. You could have prevented us from

growing up in the Zionist colony, completely ignorant on the one hand, and intimidated by hearing that we were from North Africa on the other. Why couldn't Algeria have been a source of bliss, rather than something to repress?

Abba, why didn't you call me Algeria?[3]

When you were about to turn seventy-five, I prepared a booklet for you of the stories you had shared after I ceremoniously announced, "I'm going to interview you!" You liked that I metaphorically handed you a mic, and that day you told me many stories about your life before you arrived in Palestine. I made sure to talk with you alone, and not together with Ima; I was determined to hear something other than the familiar stories you both agreed on.

When I returned to that booklet after your death, I felt that I was reading *what you told me* for the first time. I had retained almost no memory of it. I knew that I asked you questions, the kinds I couldn't have asked outside of a formal interview. Maybe this explains, partially at least, why I didn't retain what you told me. Why was Ima so silent about all this all these years? Why, for example, when we learned about the Holocaust, did she not mention that your family had been murdered in Auschwitz, and that you had been in a forced labor camp in Bedeau? When I read these stories later in the booklet, told without emotion, it seemed as if you were talking about someone else. So it may not be surprising that though I was the one who recorded them, it was as if someone else was sitting there in front of you, collecting testimonies.

I'm trying to understand why I prepared the booklet, for if it was meant to help my sisters and me get to know our father better, it didn't do the job. The interview was not like a father talking to his daughter in an intimate moment when the heart breaks its lock; rather, it felt more like sitting with the storyteller father I knew, who turned some of the most painful moments of his life into stories I could bear to hear. Did you actually try to shield me from them? I recognize your storyteller's touch: each story ends with a punchline that forecloses a spontaneous emotional response. I don't think anyone in the family read it,

Letter 1. Abba, why didn't you call me Algeria?

but I gave it to you as a gift and I think you were happy that it existed. What I didn't understand when I prepared it was that it was also gift to myself.

Abba, I have read this booklet many times now. It was the only written guide you left for me to find my way to Algeria. I could not understand all of it on my own. Trying to make sense of what you had told me in relation to the broader history in which our lives unfolded, I decided to share parts of it with others, through open letters. You don't know most of the people to whom I write, but you should trust that I have chosen them with care for their wisdom, their life experiences, and their writings that were helpful in my journey to Algeria, to reinhabiting the Jewish Muslim world.

I asked myself many times: What made you think that your life in Algeria should not be part of ours? That you could cut us off from our origins? Why, when I was planning to go to study in Paris, didn't you tell me that the French sent you to a forced labor camp? That they humiliated you? That they deported members of our family from Paris to Auschwitz? Or that our family's French Catholic neighbors told the French police that they were living near Jews, and so gave our family their death verdict? Do you know that less than twenty years later, other neighbors denounced Algerian Muslims, who were kidnapped, tortured, and drowned in the Seine by the same policemen? Why didn't you warn me away from the French, and why did you let me grow up in the Zionist colony where we were taught to fear Arabs? Why didn't you tell me that during World War II, Muslims in Algeria refused to take part in the French colonizer's anti-Semitic politics? That Algerian Muslims prepared bread for Jewish families and brought the loaves to the public bakeries, since Jews were banned from using public ovens?

When I speak about those human factories where we were raised, I'm thinking about the love and hatred, trust and suspicion, enmity and friendship that were planted within us yet have nothing to do with who we are, with our histories. We were planted with colonial histories reflecting the political agendas of those who colonized us, our culture was taken from us to put in museums, and we were used as pawns in their wars. French

citizenship, the French mother tongue, had been planted in you and grew so large that you could not speak of the French except with respect. Even the French language itself was used against you, twisting your tongue around colonial idioms. For example, the French gave the families of the 70,000 Jews that they murdered during the Holocaust, including members of our family, death certificates that state that they "died for France" ("*mort pour la France*").[4]

The length of most stories in this booklet is barely a paragraph. In the paragraph about your uncle, aunt, and their children whom the French sent to Auschwitz, you mentioned in passing that it was their neighbors in the building who had delivered them to the police. You didn't know how to deal with this fact; it sounds like an anecdote. Perhaps you knew no one could hear you say it as anything but a story, for in the Zionist colony, the story of the Holocaust is not the story of Algerian Jews but a story only about the Ashkenazi Jews in Europe—and it is the Nazis, not the French, who are the only villains.

Only in 1995 did the French finally acknowledge their role in the mass murder of Jews during the Holocaust. But they have never acknowledged their crimes against Algerians, even though Algerians refuse to forget.

I am Algerian, Abba, and I also refuse to forget.

I refuse to accept the imposition of French citizenship on Algeria, a gun with its silencer of *liberté, egalité, fraternité*. Abba, the technology of disorientation used against you continues its work in us. It impacts my grandchildren, who must grow up in places where the soil doesn't recognize them, where their ancestors are not buried, with the fractured sense of belonging somewhere else.

Abba, do you know that when the French first invaded Algeria in 1830, they began by destroying significant parts of the city of Algiers, places where Jews had lived for centuries and had shared institutions, traditions, and rituals with Muslims? Before they were singled out for being "Jews" they were attacked and denigrated as Algerians, like the rest of the population. However, in the chronicles of the first decades of the colonization, Algerian

Letter 1. Abba, why didn't you call me Algeria?

Jews were erased. While part of their invisibility can be explained by their subsumption into the general body of Algerians, this cannot explain why Algerian Jews are missing from most books about the beginning of the colonization. This has given rise to a historiography that excludes Jews from colonization, making their separation from their neighbors and the history of Algeria through the category of "Jew" retroactive to the date of colonization itself.

In the 1840s, when French Jews arrived from France to assist in the conversion of Algerian Jews to French citizens, they disparaged our ancestors for being Arab Jews and offered them a path to gain French citizenship and stop being who they were: Arabs, Berbers, Muslims. This was already built on a physical destruction of their communal life as Muslim Jews, members of the Muslim Jewish world. In just a few generations, the French ruined our shared world and substituted our histories and memories with French ones. You were born into this disintegration, Abba. When you were born, you could not know that the soil in which you were to grow was filled with rubble and ruins and the traces of violence. I'm trying to understand how much of it you sensed and how much of it you disavowed, since your language could not account for it.

Abba, you left Algeria when you were twenty-nine. Do you remember that once in a while you disappeared for a full day, closing your store for the occasion, and went to see miracle healers that you heard had arrived from abroad? As children we laughed at you for believing in these magicians. Only in retrospect do I understand that miracle healers were part of the inherited Algerian beliefs that the French had not managed to destroy. As the youngest in the family, I had to join in and laugh at you, but I also embraced your attachment to things that escaped rational or scientific explanation. You ignored us; and this in itself was an important lesson. All these magicians, dear Abba, were of Arab origin. Not Arabs as the opposite of Jews, but Arab Jews, who were the guardians of the cosmologies, skills, and traditions that you could not speak of but that you refused to renounce.

I want to tell you how the French treated these healers, magicians, and saints, whose tombs were venerated both by Muslims and Jews, often regardless of the identity of the person buried in

Mausoleum of Ribach (Rabbi Isaac Bar Sheshet) and
Rachbatz (Rabbi Shimeon Ben Tzemach), Algiers.

them. After the invasion, despite the opposition of local inhabitants, cemeteries and tombs were desecrated. In rare cases, as in 1844 with the tombs of the two great rabbis, Ribach (Rabbi Isaac Bar Sheshet) and Rachbatz (Rabbi Shimeon Ben Tzemach) who settled in Algiers after being expelled from Spain, or in 1846, in the case of the marabout Sidi Mansour, the decision to demolish their tombs was accompanied by a decision to remove their remains to elsewhere, for even the colonizers knew that these tombs were sites of *ziyara*, pilgrimage.[5]

Sidi Mansour's tomb was in the garden of the Djenina, under a centuries-old tree whose branches provided pilgrims with refuge from the sun. Sometime after Sidi Mansour's remains were removed, this beautiful tree stopped blossoming and seemed to be dying of an unknown disease. The French set up a special committee to examine the tree. The committee determined that the tree was dead and recommended uprooting it. Hearing this verdict, the tree revolted and started to bud. The French ignored the tree's signal and cut the tree down. French experts came to check the trunk, hoping to find scientific explanations for the

Letter 1. Abba, why didn't you call me Algeria?

nature of the disease, but local inhabitants adhered to their own understanding: the tree suffered from grief over the loss of its companion, Sidi Mansour, and had been mourning.[6] French imperialists' learned deafness to the sounds of human and non-human suffering in response to their interventions enabled them to continue, day after day, for 132 years.

In some cases, new tombs were built. At first, I was moved by a photo of the tomb of the rabbis that a friend from Algiers sent me. However, I had to remind myself that this photo was not a souvenir from the life of the Jews in Algeria, but rather a souvenir of what colonialism did to us: destroyed a fifteenth-century tomb and replaced it with a French monument to a rabbi, a monument decorated with the symbol the French assigned exclusively to us, the Star of David. Yet even in this desolate way, Algeria still carries our memory.

Look at this postcard, Abba. How do you think this beautiful site became "old Algiers"? The French destroyed what you see here. And then their scholars inventoried what had been destroyed, collected traces of those traditions and described our world as "vanished," relegating our ancestors to the past.

The French documentarians who used their pencils and paintbrushes to make our ancestors part of "the past" in notebook

Algerian Jewish women visiting tombs, Bab Azzoun. The scene is described as "old Algiers." Colonial postcard.

after notebook didn't even ask these women whose dresses they carefully painted who the women had come to venerate in these tombs. They depicted these women as if they were already artifacts in a French museum, denying their continued living presence. These women's testimonies were not taken. Abba, do you see how beautiful their long dresses are, and the laced metallic *sarma* they wear over their hair, covered with tulles in different colors? Do you see their jewels? Do you know, Abba, that this is how our ancestors dressed before they were lured into being French, and modern, and taught that beautiful art is only what is shown in European galleries and museums? These exquisite adornments didn't need to be displayed in vitrines; they needed to be lived with, part of a culture carried on the body and forged by the skilled hands of artisans. Some of these adornments, used on special occasions, were handed down from one generation to the next, imbued with love, secrets, pieces of advice, and protective invocations embroidered into the pattern. Older women taught younger women how to wear them and transmitted their secrets. To wear these clothes, to learn their stories and their invocations, and to transmit them to one's daughters—these adornments were outside of the modern and capitalist mode of being, in which time taken to make them and to wear them would be seen as wasted time.

> Can you imagine, Abba,
> what it has meant to them,
> to have to seek their livelihood
> *chez les Français*
> and to get used
> to the different selves
> this unsolicited gentrification
> required from them
> in order to pass as acceptable subjects
> in the eyes of the French,
> who despised their looks
> except when rendered
> as a charming "type"
> by one of their painters?

Letter 1. Abba, why didn't you call me Algeria?

When you were born, this is what mainly Muslim women looked like. Abba, for your ancestors to stop dressing like this and living in these ways was the end of the world! I don't blame you for not knowing about the violence of the French colonization of Algeria; it happened almost a century before you were born and it was not taught in school. But Abba, you continued to feel the echoes of this destruction, as do I. But these destroyed worlds, I believe, can be recovered and reclaimed. They can best be reimagined when one insists on dwelling in the sites of original violence, from which some threads might still be pulled. From these threads, I continue to weave the world.

Colonial postcards. This used to be a vibrant neighborhood full of Algiers's craft workshops, artisanal knowhow, mosques, and synagogues.

I want to try to do what you could not: to mend the tears in the channels of transmission. I want you to join me on a visit to Algiers. The story that I want to tell you starts in Algiers in 1830. It is the story of the colonization as a story of destruction. These violent attacks were not directed just at the Jews, of course. But the colonization of Algeria disoriented us and carved us, Algerian Jews, out of the history of Algeria, made of us subjects of French history apart from Muslim history, and this is why it matters to put the records of colonization straight, to challenge the historians who didn't ask, *Where are the Jews in this colonial history?*

Algiers was not spacious enough to host a colonizing army of 36,000 soldiers, and so the French confiscated locals' houses and workshops and razed them to create a central square where their battalions could assemble "in case of emergency." I have amassed somewhere between sixty and seventy postcards and drawings of this single spot that I want to show you, taken from different angles and during different periods (see photo p. 51). I needed such a collection in order to trace the destruction that these postcards camouflage.

I want you to come with me; I want you to see how Jews and Muslims once lived in this city. Our ancestors were Arabs, Amazighs, and Muslims, as well as Jews—all components of who they were as inhabitants of Algeria. Our ancestors recognized themselves in this cultural amalgam as they navigated the winding paths of their city. Yes, Abba, this is what we were as Jews: Arabs, Amazighs, and Muslims; and our culture, which spread all over the city, was woven from these different threads.

The French arrived with dynamite and with scholars who taxonomized our objects, writings, dresses, jewels, traditions, buildings, and even our tombs (see image p. 53). They started to pressure the local population and to tell them who they were and who they were not, what was theirs and what was not. Given the small size of the Jewish population, the French used them to test different procedures of assimilation with relatively limited risk. They called it "assimilation," but actually the goal was conversion, and it required the detachment of the Jews from the world in which they were artisans so that they could be modernized in synchrony with the city. Given the large number of Jews among

Moorish, Turkish, and Jewish tombs. Nineteenth-century lithograph.

The port of Algiers, view from the upper Kasbah.

the artisan guilds, modernizing us effectively meant destroying the economy of craft. Craft was the enemy of modernization, since it resisted capitalist work rhythms and capitalism's ravenous appetite for extraction and production. Likewise, it is also fair to say that the destruction of craft pressured our ancestors to modernize. All of this meant that the heart of the city—the area of the craftspeople in what then became "old Algiers"—had to be destroyed.

Abba, thank God our ancestors' amnesia, like yours, was not absolute. Since you died a decade ago, I've begun recovering many things that I didn't realize had been transmitted to me, despite my initial feeling that nothing had been transmitted. I'm surprised to find that I even inherited some of my ancestors' powers and can use them to challenge the taboos that kept us apart from our original community. In the middle of the city, I shout with their voices, disregarding academic and social restraints, and I know that there are people around who hear me and recognize the voice as one of their neighbors'.

When I asked myself which one of these many postcards I should show you, I couldn't make up my mind. Most of them seemed to impose a kind of flashback mode, as if the postcards said *here we are now* and I'd have to add *but once upon a time there was* ... I wanted an image that bypassed the ubiquity of colonial temporality and spatiality. I finally found this one (see image p. 53). Look with me, Abba, toward the foot of this hill on the left side, closer to the sea. Do you see a white mosque? In 1830, after the French destroyed several mosques and synagogues, this mosque, the Djâama el-Jedid, was next in line for destruction. On one of the maps of Algiers that the French drew, there is an inscription that reads "to demolish" on the drawing of this very building. Luckily, one of the military officers realized that soon the city would be left without a place of worship for Muslims,[7] so they spared this mosque, along with three others in the city. From the inventories the French prepared alongside demolition, I learned that there were also thirteen synagogues in Algiers in 1830. Most, if not all of them, were destroyed, and no information about them survived, except one line testifying that the most beautiful among them was El Ghideur.[8]

Letter 1. Abba, why didn't you call me Algeria?

What was saved of this mosque is only the building itself. Its existence prior to invasion, however, was never as an isolated building displayed on a pedestal in the roofless white cube the French carved and called a square, posed on top of the ruins of its companions (see photo below). But it is exactly in this category of *the building itself* that a particular type of destruction resides. The violence done to it is more subtle than physical destruction. This building never used to exist in isolation but was entangled in a dense socio-religious urban syntax. In a city in which Muslims and Jews lived and worked together in close quarters, this mosque (like many other religious buildings) had a variety of sensorial, material, cultural, social, and spiritual functions that exceeded the simple religious classification as a house of worship for Muslims. Or, as an Algerian Jew remembers from his childhood: "We knew the rhythm of their lives, and they the rhythms of ours. You heard prayers when you passed the mosques, and these prayers had the same resonance as those at synagogues."[9]

In order to turn this mosque into a white object on a pedestal and to endow it with a fixed meaning, hundreds of houses, ateliers, and stores that it was connected to through shared walls and paths were demolished. They lost a sense of belonging that was anchored in place, a place defined by the overlapping coexistence of different Jews and different Muslims moving across

Djâama el-Jedid, Algiers. Colonial postcard.

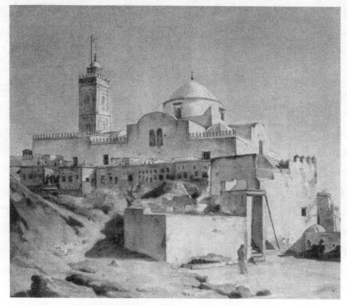

Pile of rubble in front of the mosque.

towns and villages and across the Ottoman empire. Only from the high vantage point from which this photo was taken—the top of the Kasbah—could what was a reality somehow still emerge, though now only as a perspective illusion: that there existed an intermingling of different religious and nonreligious buildings that local inhabitants could easily navigate. That there was an absence of dividing lines dictating where each group belonged.

When we get down the hill, however, the illusion of the entangled mosque will disappear, and we will encounter the results of the French military's force and of other instances of France's taxonomic violence. However, before doing so, we have to remind ourselves that the wide square that they built, using the mosque as one of its four edges, was what made the violence of destruction disappear, for what had been rubble was now smooth and flat. A new reality was imposed, one that now seems irreversible: Who would now destroy a civic square?

Fully whitened, the mosque lost its familiarity and was incorporated into the French urban syntax, which was imposed through the combined use of destruction and "embellishment projects" (that of course were not meant to embellish the life of the city for existing inhabitants). To turn the mosque into part of the

Letter 1. Abba, why didn't you call me Algeria?

newly imposed European-style city, the French turned it into an object of contemplation and detached it from the nuanced color palette of the Kasbah.

On July 11, only six days after the invasion of Algiers, Jewish and Muslim alike were evacuated from the heart of the city, and the destruction began. The ateliers of jewelers, bracelet makers, book illuminators, and fabric dyers were destroyed first, as they stood in the way of the Palace of the Dey, the Djenina, that the French planned to reveal by stripping it of its neighborhood.[10] You must understand by now that these small workshops didn't "stand in the way," except for those who saw them as a hindrance to a modern colonial world. The dey had, in fact, enjoyed their proximity to his palace and "supplied himself from the most skillful." That is, he acquired exquisite jewels and other metal objects and "paid them [the jewelers] according to his whim."[11] The craftsmen in these ateliers exchanged models and materials with other craftsmen in the Maghreb and in West Africa, and they found pleasure and sustenance in their work. Obviously, the French were not going to compensate them for the destroyed ateliers, as dispossession of the craftsmen was among their goals, and they immediately invited different European merchants and entrepreneurs to install more spacious stores of "Algerian crafts"

Roger Lucien Azoulay, Studio Perpère & fils, 33 rue Philippe, Oran, 1923.

in the city. These stores started to produce "Algerian crafts" by exploiting Indigenous labor and marketing their products as higher quality than the originals. The craftsmen, who until the conquest were members of guilds of peers, supporting and helping each other in difficult times and sharing their success in good times, were now thrown into a competitive capitalist market where they had few chances to succeed. Some of them managed to occupy other spaces adjacent to the Djenina and continued their craft. But in 1848, fire swept through these wooden workshops. The French took advantage of the fire to clear out the remaining original artisans. After these two blows, being a jeweler in Algiers was no longer the same, for succeeding in the new marketplace required abandoning one's ancestral craft and becoming a merchant, an entrepreneur, or worse, an exploited laborer.

Who created the crocheted pillow in this photograph (see photo p, 57)? Was it your mother? One of your grandmothers, Julie or Marianne? Is there a knife underneath your body to protect you from Lilith? I know you are not surprised by the question, though maybe surprised that I know the power of metals. Yes, Abba, because it was not only protective but dangerous, this knowledge was kept by the Jews over centuries as they dealt with the power of metal as artisans all over the Maghreb. But I want to return to this photo. I could not find a similar crocheted pillow in other photographs of babies from studios in Oran in the 1920s, which made me think it may not have been a studio prop but instead a treasured family possession.

Embroidery and crochet work were common in Algeria before the French arrived. Many of the embroiderers were Jews, and they made their living from this craft and were devoted guardians of its traditions, often passing it down through their families. Do you remember those gorgeous embroidered and crocheted pieces that one of your sisters, Georgette, used to make? I remember her house covered with embroidered pieces of all kinds, displayed on each piece of furniture, worked onto pillowcases and into wall-hangings and curtains. We went to visit her when she tried to live in Israel, sometime in the early 1970s. You knew it, but we didn't have a clue, that it was less than a decade after the expulsion from Algeria. I can only assume that she didn't feel settled in France

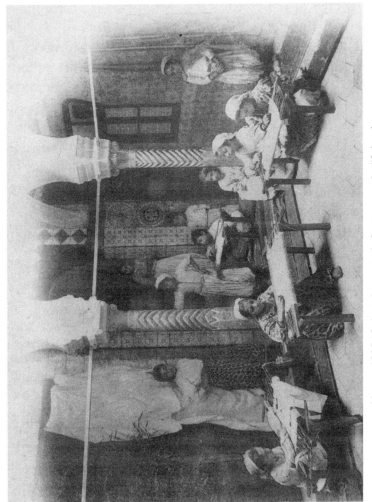

Algiers, 1905. Colonial postcard. Caption reads, "School of indigenous embroidery of Mme Ben Aben."

and decided to try her luck closer to her brother. I remember her smile but I didn't understand a word of what she was saying, as she spoke French, and at that time, I didn't. She worked hard to fill her home with Algerian craftwork, maybe in the hope that it would smooth her second immigration in a decade, but it didn't work and she left the colony after one year. As a child, I assumed she was French, and that her gorgeous handmade decorations were French too. Seeing this crocheted pillow from 1923 in the picture, though, I now see that she may have learned the craft from your mother, who may have learned it from her mother. Or was your grandmother one of the girls who were sent to the kind of French sweatshops called schools, where young Algerian girls were taught their own ancestral crafts by French women?

Since I first saw this postcard (see photo p. 59), I've been haunted by the idea that one of these girls is my great-grandmother, or yours. The photographer didn't leave records of who they were. Abba, look at the synchronized movement of their right hands. In embroidery and carpet-making factories (the kind that didn't masquerade as schools), the girls also used their left hands. Maybe here they were permitted to, but not when the photographer was present. This semi-mechanized gesture is not how their ancestors used the needle. Note how everything is standardized in the market logic of French educational institutions: Were there no left-handed girls among them? Was this "flaw" also eradicated, along with previous modes of embroidering? Is this why you also knew to write with your right hand, without concealing that you took pride in the fact that you and I are left-handed?

These girls were way too young to work in factories where the craft they inherited from their ancestors was parsed into mechanized movements to increase productivity. The young embroiderers were not trained to become masters of their art, but rather socialized to be laboring hands, and to expect a life of poverty and dependence. These schools played an important role in the transference of Algerian wealth to the French, and also in fashioning these crafts as a Muslim art, "enveloping Muslim life, from cradle to grave," despite the fact that Jews had long engaged in this work as well.[12] For example, in the anecdotal account of a British traveler: "There were several little Jewesses

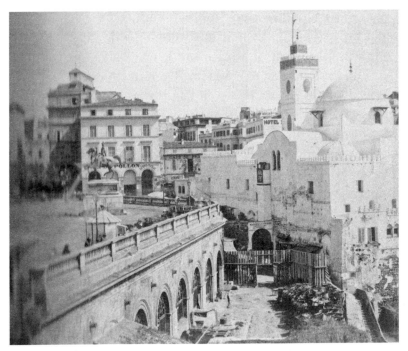

Government Square (on the right one can still see the Mosque suspended before the slope was fully leveled).

squatting most amicably among the Mauresques, conspicuous only by their simpler robe of colored stuff and a conical cap of red velvet, tipped with gold lace."[13]

When these crafts were part of social life, each and every embroidered piece registered the labor of an entire community. Those who prepared the threads known as Algerian silk, those who worked the gold threads, made the ribbons and fabrics—in every piece of clothing and ornament is an entire community of relationships. Abba, we were trained to be seduced by museums, as I was for many years, and to fail to recognize ourselves as guardians of these traditions. But these jewels and the traditions they were part of were so omnipresent in the world of our ancestors that in their communities, travelers prior to 1830 noticed that even beggars wore different embroidered fabrics and sumptuous jewelry (made from the cheapest metals, I assume) at different moments in their lives.[14]

Abba, craft was who we were in the Maghreb. This is one thing I'm sure you know since your body remembered and transmitted

to me a love and disposition for craftwork and the making and repairing of objects. Your hands were blessed, and I inherited your sensibility, that of a bricoleur. It was only after you died that I understood that this was the Algerian education you gave me, as it was in Algeria that your hands were trained, and it was from what was left of Algeria within the Frenchified cities that you learned to become the bricoleur that you were.

The hundreds of workshops where exquisite jewels, fabrics, and embroidered artifacts were made, artifacts that the French plundered for their museums, didn't generate records. Looking at this map (see map pp. 64–5), produced seventy years after everything in it was destroyed for the building of the square, you get a sense of the urban density, but no indication of, for example, the varied levels of the city, or its trees. Do you know how many trees mourned the departure of the symphony of the craftsmen's tools? Mourned their companions who rested in their cool shade? As they were cut down, their mourning of this loss, like the companion of Sidi Mansour, was swiftly silenced.

To build the flat square the Europeans desired on this mountain landscape, the ground had to be flattened (see image p. 56). The mountain's lower slopes had to be leveled by carving out the remains of the houses and filling the ditches with columns and arcs to hold the manufactured surface of the square (see photo p. 61). This took many months, and so for a long time, imagine how inhabitants gazed on their world, now shredded into piles of rubble. These massive demolitions "weakened the entire urban fabrics, and as most of the buildings were attached to each other, they led to cascading collapses."[15] A cascading collapse in many ways: once the mosque was broken off, isolated from its world and neighbors, the French could display it as an object of their own taste. In other words, the mosque that they nearly destroyed was reborn as *theirs*, a testament to *their* connoisseur's eye and engineering skills, taken care of with *their* preservation methods, a source of *their* enrichment and object for *their* scholarship, art, and postcard industry. Self-appointed guardians of Islamic art, the French colonizers could now teach its value and history to the indigenous Algerians who, in their eyes, didn't value it correctly or know how to take care of it properly.

Letter 1. Abba, why didn't you call me Algeria?

Do you get the trick, Abba? And that is just the beginning. Yes, Abba, our livelihood was stolen by the French over 132 years ago. We became the props, tokens, and the laborers of lucrative French businesses, scholarship, literature, museums, connoisseurship, and art.[16] Our ancestors knew that they were cheated, and when their workshops were destroyed, they tried to resist like the rest of the population. But they were busy trying to earn enough to sustain themselves when the economy of their city collapsed. The colonial transformation of their city accelerated, and in just a few years, their descendants, like you, were born into a wholly different urban space. For descendants, destruction for the sake of constructing "new and modern" (European) spaces was almost normal, a sign of reform, improvement, and modernization rather than catastrophe.

Some, like Abd-el-Kader, refused to surrender to this conversion. If ever a clock were to strike on Dar-es-Sultan-el-Quedima, known also as la Djenina, he said, "the infidels would be the masters of the country." And not so long after, a clock was embedded into la Djenina. When the building was later destroyed, the clock from la Djenina was affixed to the minaret of the Djâama el-Jedid mosque. In just a few years, whoever walked the widened streets of Bab Azzoun, rue de la Marine, or in the square, did so without knowing that underneath their feet were the remains of their ancestors, the ruins of what used to be workshops and houses. Many of those who lost their homes and workshops became older at once, struggling to carry on given the competition that invaded the city. Not yet recovered from the disappearance of their familiar neighborhood, they "had been surprised when their competitors, few in number, arriving from Paris, came to settle in Algiers to take advantage of the outlets presented by the new European clientele. It was with stupefaction that they saw spacious shops open, well stocked and lit by a glass front."[17]

The city that the French built out of our ancestors' world operated as a secularization machine, cogwheels for conjuring prejudices and seducing the young to adore the new. The city showed that everything could be melted down to make room for *the future*, a future fit for the young. The spaces of the city now conveyed not community but a "generation gap" juxtaposed

Map of destroyed streets buried under Martyrs' Square (formerly Government Square). Illustration: Paul Eudel, 1902.

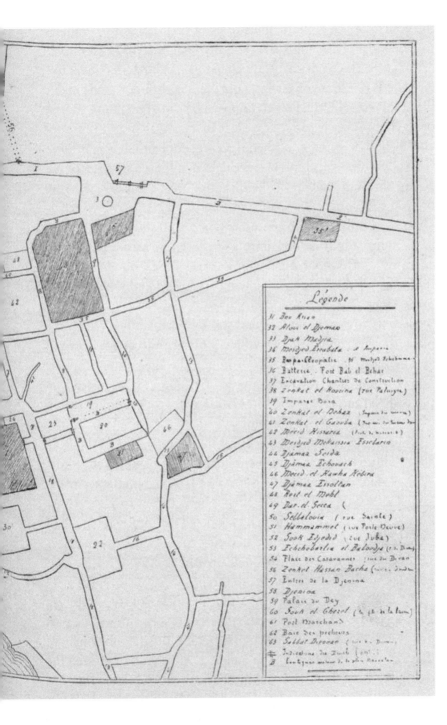

onto the cultural gap, the oriental and the European. Thus, in the course of a few years, the stories of their ancestors sounded to descendants like fairy tales and myths, *Once upon a time* ...

Abba, you were already trapped in this secularization machine. Abba, it is not that you freely chose secularization. Rather, under the secularization the French imposed on you, remaining part of one's community became a question of a choice (and a distasteful choice, at that—not *modern*, not *young*, not *new*). It is painful to read how overtly the colonizers calculated their seduction of the young through "choices" like this, and how compliments were offered to young Jews who took the plunge: "The new generation, less imbued with prejudices, is penetrated with modern ideas and ready to adopt more and more our fashions and our customs ... frequent our schools, and some abandoning the traditions of their race, renouncing trade and embracing liberal professions."[18]

Here we are at the square that we saw from above. This is the place that disrupted the worldliness of our ancestors. I invited you here, Abba, to confront our injury, the site of our amputation. Do not look for the injury in the square; it is, instead, in our dispositions and in the *belonging rights* that the colonization expropriated from our ancestors.

Abba, I'm also a political theorist and I cannot avoid thinking about all this as part of my scholarship, trying to counter how what was taken from us was normalized into laws and academic knowledge. Like a bricoleur, I have been trying to glean those belonging rights we lost, which preexisted the imperial regime of rights written in documents. I'm trying to find the broken pieces so that I can reconstruct this older world and inhabit it so that your memories be transmitted to me.

We look at this mosque and the memories of its world are almost irretrievable, barely remembered. It seems not to be partially ours but a totally Muslim structure. But I cannot believe that we were forgotten by the building. Alternating between the technologies of dynamite and museum, the French intervened in our ancestors' cosmology and filled it with taxonomized objects rather than interconnected ones, impoverishing our world into one of alienation and exilic separation. It is here, in this square,

Letter 1. Abba, why didn't you call me Algeria?

Place du Gouvernement, Algiers. Colonial postcard.

that we were dissociated from our culture. Our ancestors' gaze on the mosque was different from ours. It was not mediated by the wide field of vision that the cleared square opened, not mediated by the invitation to look at the mosque from the outside and from a distance and to judge its aesthetic value. Rather, our ancestors came to the mosque through small, winding alleys and along crowded main streets named after craftsmen—the jewelers or the dyers—streets and alleys that stretched from the Djenina to the mosque.

Abba, now close your eyes and imagine our ancestors sitting here in their tiny workshops carved into the walls of the buildings that covered this square, before the final fire that cleared them out for good. Our ancestors didn't enter the mosque for prayers, but its forms, colors, ornaments, sounds, and presence were part of their culture, a culture shaped in common with Muslims. The mosque was part of their world from the Maghreb to the Iberian Peninsula, from which some of them were expelled in 1492 and from which they carried knowledge of artistry, whether in architecture, jewelry-making, book-binding, or textiles. Our exile was already written in this square in the 1830s, but our return can be imagined through what is buried underneath.

In the nineteenth-century postcard photographs taken in Algeria, you can still see artisans' working spaces. In each of these small studios like rectangular open caves, there was enough room

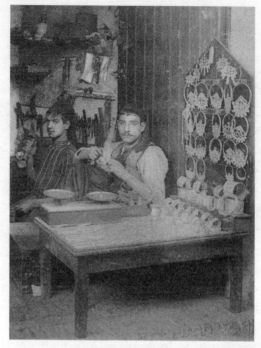
Jewish jewelers, Constantine. Colonial postcard (detail).

for one or two jewelers; their different wooden and metal tools; pieces of gold, silver, and brass; turquoise and red coral beads; glowing dust; small buckets with boiling chemicals; torches, containers, metal threads. The jewelers conversed with each other and with passersby in Arabic. The handmade rack on which they hung the bracelets and the *fibules* they prepared remind me of the way you used to build special shelves to present goods in your store. As they practiced their ancestral professions, the Jewish jewelers heard the muezzin calling Muslim believers to prayer five times a day, and they watched their fellow artisans leaving for noon prayer, sometimes slowly in groups, other times alone and in a rush. This was part of their daily life. Though you didn't tell me, I know this was still part of your daily routine in Oran too.

> If you had cared to tell me
> that you lived just behind
> the beautiful Mosque du Pacha,
> I would have spent less time trying,
> with the help of some Algerian friends,

Letter 1. Abba, why didn't you call me Algeria?

to locate your childhood house
on the map of Oran.

Do you know that your house is still there,
abandoned, dilapidated, empty?
If I were allowed to sneak in,
I would excavate its base
in search of
the metal threads
you practiced with
for the mail-order course you took
to become a certified radio technician.
These threads could lead us
to some of the Jewish jewelers
who worked around the corner,
and could assist us in finding their workshops,
theirs and others',
who refused to renounce
the art of their ancestors:
drawing brass threads.

3 rue Tafna, Oran. Photo: Adel Ben Bella.

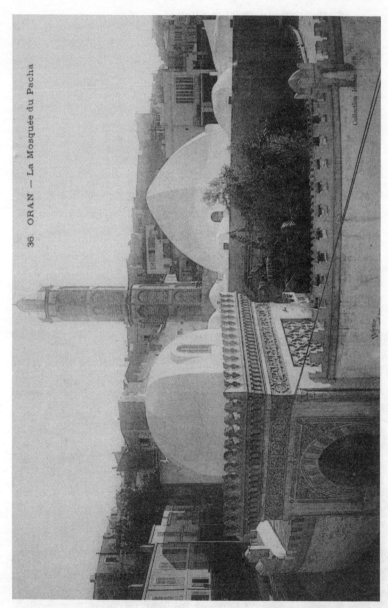

The Pacha Mosque, Oran. Colonial postcard.

Letter 1. Abba, why didn't you call me Algeria?

No matter which street or alley the Muslim inhabitants took to arrive at the mosque, they were greeted by their Jewish neighbors; and in their turn, they greeted those Jewish neighbors who were on their way to find the ninth or tenth person (to make up the minyan) to allow Jewish prayer to take place.

The demolition of the whole neighborhood cut off the local population from their livelihood, thus unleashing one of the major projects of the colonial state: the "transference of wealth from one ethnic group to another."[19] Our disappearance from what became solely Muslim culture in a European city is reproduced in different ways, including in critical narratives, like those that study the transference of wealth from indigenous people to the French. The Jews didn't have lands, so there was no wealth in property that could be transferred to the colonizers. But the rest of Algerian wealth was not transferred from the Muslims to the French, but from indigenous Algerians to the French.

When you look at this square you can understand how this pristine binary between Muslims and French was invented, disappearing us. In one decade or so, this binary that the French aimed to impose was codified in law. Thus, on June 9, 1844, a military order divided the city of Constantine into a European part and a Muslim one.[20] From the rich environment buried under this European-style square, only a single isolated building is left, a mosque that was made into an emblem of Islam as if Jews were not part of the world in which mosques were built. Can you imagine, Abba, what it meant to our ancestors, to be told that the only things that counted as their culture as Jews were synagogues built under French rule? (Remember that the French had destroyed thirteen preexisting synagogues in Algiers alone.)

The neighborhoods of craftsmen in the major Algerian cities, where many Jews worked and transmitted their knowledge, were destroyed without being counted as sites par excellence of Jewish life and creation. In places like the Bardo, a confiscated villa turned into a museum, the notion of Islamic art as free of Jews could be fabricated. Europeans were attracted to Algeria as tourists, settlers, and artists for its orientalist charm, described

in books and brochures as a juxtaposition of "two civilizations: ours [French] and that of Islam. This contrast is noticed in the customs, languages, usages and even the mode of constructions of habitats."[21] Hundreds of different postcards of the square in Algiers were printed and circulated across the world, solidifying the image of Algiers as only Muslim, and confirming our disappearance and the destruction of our world. Thus, the myth of aniconism, according to which the Jews are bereft of art, with the first commandment—"you shall not make yourself a graven image"—as its ostensible source, could be perpetuated. But this myth of aniconism is an alibi for the French crime against the Jews that dissociated us from centuries of art making and material culture.[22]

No matter how much of their labor, love, memories, blood, histories, or hopes were mixed in with the building of this world, when in 1830s the French turned it into rubble and reorganized Algeria according to their terms, the material and symbolic exile of the Jews from our heritage started. It started here in this square.

Abba, I better understand now how as a young man, roaming around in these partially Europeanized cities—where theaters, cinemas, music stores, printing houses, and photographers' studios stood for "culture"—you had no other idea of culture upon which to draw. When you were born, the Jews were already living as legal French citizens and were counted as Europeans. But within this "European culture" there was nothing characteristically Jewish, let alone Muslim or Arab, through which Jews could recognize themselves. Moreover, turning the Jews into Frenchmen and Frenchwomen meant requiring them to interiorize their Jewish Muslim culture as inferior, a prerequisite to becoming truly French.

A few years ago, I stumbled upon a short video showing photographs of tramway wagons in Oran. I was excited to be taken on a postcard tour of the city, and was surprised to see how many of the buildings, signs, and people reminded me of Paris. It should not have surprised me; that was the colonial goal. However, the non-French quarters and non-French people were missing from this photographic tour. If Jews were captured in these images,

Letter 1. Abba, why didn't you call me Algeria?

they were not Jews but, at least visually, seamlessly assimilated colonial subjects. Algerian Jews who passed as Europeans and walked in these streets could consider themselves French—but only if they forgot what the French did to them, and forgave them for it; that is the colonial bargain that was forced on your ancestors. That is the bargain I was left with.

To inhabit this Frenchness meant to despise the Jews, or to despise the Jew within the Jews, to look upon them contemptuously as the French did. Some Algerians Jews were able to choose urban traveling itineraries so that they could bypass and thereby forget the existence of other Algerian parts of their cities, recognizing themselves only in the new urban fabric. The city's so-called Frenchness, though, was not fully an invention since parts of the city that were built on the ruins of Oran were indeed French, conceived *for the French*, separated from the rest.

When I rewind the tapes of you in my mind, I can hear you say that you were French. Now I hear it as a self-description, and not only a kind of self-invention, as I previously thought. I understand better now that in this colonial world you could have said "I am French" without feeling that you were lying. You were French because France had imposed its spatial logic on you and allowed you to walk through these parts of the city as if you were French. Alongside structures, fashion, tastes, and language, it imposed the blindness that enabled the French to conceive of French culture as separate from the colonization of Algeria. The damage was such that someone like you, born in 1923, could recognize himself in this manufactured world as a Frenchman while at the same time feeling injured and lonely, though unable to identify the source of his emotional and mental disarray. Part of the reason I could not see this earlier was because in the settlers' languages that we spoke, being Algerian was assumed to be inferior to being French, so saying that you were French implied an aspiration to be more than who you were—a North African.

After watching this video, I looked for more footage from Oran in the 1940s, hoping to get a sense of what your life had been like. Among the videos that I watched was one with a familiar song, "Bésame Mucho," which you played many times at home, especially I think, on special occasions when you danced with Ima.

In the video, a big orchestra was on stage playing the song, and I was struck by the sight of the accordion, for I knew that Algerians first encountered the accordion when American soldiers arrived in Algeria in 1942. I assume that you had first heard "Bésame Mucho" around the time you were liberated from Bedeau and were sent back home to Oran, where you waited for several weeks before being drafted and sent to the frontlines. Oran was packed with Allied soldiers, and you may have encountered soldiers who sang the song or listened to it on the radio. Or maybe you attended this very show that I watched on video? The song was written in 1940 by the Mexican songwriter Consuelo Velázquez, and it soon became a big hit among Allied soldiers, "an anthem of lovers separated by World War II."[23] You were a bit obsessed with this song; as for me, I always felt rather indifferent to it. However, when I heard it as the soundtrack of this video from Oran, I could not stop my tears.

In 1982, when I moved to Paris to pursue my studies, you gave me a mission: find a cassette with Velázquez's song to bring back for you. It was not that you didn't have both vinyl and cassette recordings of this song in your store. It was that you wanted a specific performance but could not remember who played it. My task was to find the correct recording and bring it back as a gift, one wrapped in a story of the challenges I encountered on the way of attaining it. During my seven years in Paris, every time before I came to visit, I tried hard to find it. I went to stores in Bastille, Montparnasse, Clichy. I found several versions of the song, but each time you were disappointed when you heard them. None of them matched your expectation, and, as in a ritual or a fairy tale, you asked me to try again. And so I did.

I knew that you wanted Ima to listen to the version that played in your head, the one I could never manage to find. When I listened to this version in the video, as it was played by an Algerian orchestra who added oriental accents and instruments, I understood why I had failed to find the right performance for you. The one that was memorized by your body was an Algerian one, and no other version could replace it. Had I only known this then, I could have entered one of the cassette stores in Belleville and asked for an Algerian recording.

Letter 1. Abba, why didn't you call me Algeria?

Cigarette box with my father's monogram, 1950.

Abba, if you had only called me Algeria, I would not have failed to find you the version you were longing to hear, the one from your country.

Recently, I read a translation of the lyrics:

> Kiss me now
> kiss me with passion
> kiss me as if this were to be
> our very last night.[24]

We knew that this song united you and Ima. You loved to describe how in 1950, on the eve of your departure for Algeria after a year spent in Palestine, Ima bought you a silver cigarette box with your engraved initials. You were overwhelmed by this gesture, probably also by the touch of the precious metal on your fingers, and decided to stay in Palestine and marry her. She probably kissed you as if this were going to be *your last night*, and you were probably unable to bear another separation. By that

time there were already too many separations in your life, which I learned about only recently. So many loved ones died during the war: your father, your aunt and her family, your grandmother, and your friends; the millions who were murdered. And there was one more, the first death you experienced when you were eleven years old, when your younger sister, one-and-a-half years old, died in 1934.²⁵

All these deaths were inseparable from the colonization of North Africa. You saw so much suffering during the war: the camps; the moments when you almost died; and the ravaging of Palestine in 1949, which seemed to you like the continuation of the war in Europe. Given that your acquaintance with Hebrew was limited and you had arrived in Palestine for just a year to stand by the Jews who, you had read in Oran's newspaper, seemed to be under attack from several Arab armies, you could not fully understand who exactly was fighting whom. The Zionist propaganda promising a Jewish homeland where Jews could be safe could have seemed plausible. What you saw was that many people were miserable or were made miserable.

Already at the beginning of the Vichy regime in Algeria, many things felt as if they were happening *for the very last time*. No wonder you decided to stay in Palestine, with a woman who promised you a *forever*. You already understood that post-Vichy Algeria would not be a convivial place for Jews. In 1947, when you went to the office in Oran asking for a *certificat de nationalité*, again you received, as in 1942 under Vichy, a document attesting that your French nationality had been accorded to you by the 1927 law, which naturalizes foreigners. You were not duped, and when you received this document in your hands you knew that despite all the talk about post-Vichy Algeria's revocation of Vichy's 1939 revocation of the 1870 Crémieux Decree (that imposed French citizenship on our Algerian ancestors), French Algeria continued to be against Jews too. Giving you a document in 1947 that attested that your French citizenship stemmed from the 1927 law naturalizing foreigners, a law issued four years after you were born, meant that your French citizenship continued to be precarious and could be taken from you. When you were born, you were a French citizen, legacy of

Letter 1. Abba, why didn't you call me Algeria?

Roger Lucien Azoulay, certificat de nationalité, June 28, 1947.

the imposition on your ancestors; but by 1947 you had become a foreigner, to France and to your home in Algeria.

You decided to stay in Israel since you could not see where else to go. Algeria was already an injury for you. In principle, you could have gone to France, but you had already spent a few months there after the war and perhaps knew what it meant to be an Algerian in France during those years, and that no one counted you as truly French despite the dubious legal status, and that, after a few months in Israel, your Frenchness, if smartly articulated, could be better valued there than it would have been in France. When you met Ima in Palestine, you must have decided

that your love was not something that you intended to lose. *As if it were the very last night.*

You wanted a *forever* but you understood nothing about the meaning of living in the Zionist colony in Palestine, or what raising children there would entail. You knew nothing about how your children would be drafted, before they were even able to open their eyes, as soldiers in a settler-colonial project like the one the French ran in Algeria.

You never taught me an anticolonial lesson, but you did show me enough so that I could draw lessons for myself. I saw, several times, how you were enraged by different state institutions when they tried to take from you, or from others, what you knew they didn't have a right to take. Nor did you ever become a Zionist; you hated the state, even said you thought that its establishment was a mistake. You did not teach us the shit called Zionism. I'm grateful for this, Abba.

Abba, when you met Ima, you knew that you were not going to be able to live in Algeria anymore, but you didn't ask yourself why. If your father had not been hesitant to speak frankly with you in a city that was hostile to the Jews and embraced the Vichy regime, you might have known that he too distrusted state power, that he was an anarchist and a communist, and that he deserted from the French colonial army during the First World War. Had he told you this, you might have been more equipped to recognize the similarity between these two settler-colonial projects and could have refused to let us, your children, grow up there as settlers.

Abba, I no longer blame you for any of that, but I have to continue to write my rage, to imagine the reversal of those inaugural acts that created the square in Algiers and took our ancestors from us. I have to join others to stop the imperial regime that devours the world. The rage that you were unable to speak about your exile from Algeria, and my rage that started with seeing Palestine continuously being destroyed, are one and the same. I only later came to an understanding of how the destruction that I witnessed in Palestine is entangled with the destruction of our world, the world in which we were the jewelers of the *ummah*.

Letter 1. Abba, why didn't you call me Algeria?

One last thing: When we opened the black suitcase where you kept your documents and we found the *Livret de famille*, I picked up your mother's name—Aïcha—and put it under my pillow. When I woke up in the morning, I knew who I was.

Abba, I wish I could have invited myself earlier to walk with you in Algeria. We might have mourned not being allowed to dance together in the streets of Oran. I miss you and your stories,

Aïsha

Letter 2. We have not forgotten France's colonial crimes

A letter to Benjamin Stora

Dear Benjamin,

I wrote you an open letter in 2021, after I read the commissioned report you wrote for the French president, who a year earlier had publicly acknowledged the colonization of Algeria as a crime against humanity. I'm not sure what he meant by that, but the door was opened, and you could make your own way through it. Along with many others, I was looking forward to reading your report on the subject, and, with many others, I was dismayed at the near absence of discussion of imperial crimes. I fail to understand these omissions. Several points in this report troubled me, but the decision to address you in this letter arose from two entangled crimes of the French colonial era in Algeria: the destruction of Jewish cultures, and the destruction of the Jewish Muslim world in the Maghreb. This might seem a surprising critique, as a large part of your scholarship is dedicated to studying these worlds, and you also know firsthand how traumatic exile is, for you have described your own Jewish family's departure from Algeria after independence in 1962 as a "profound trauma."[1] And yet this double rupture is absent from your report.

 I would not write to you only to criticize. I'm writing to you out of frustration, even despair, that despite the important

work you have done on Algerian history and your dedication to remembering these destroyed worlds, you still disavow the crime that made them disappear. I care about these omissions and am interested in spelling out their colonial origins and the colonial syndrome of which they are a part. A silence was imposed on the Jews when the French "gave" them citizenship—and when the Jews tried to speak of what had happened, their words were jumbled and others spoke for them. This citizenship was "granted" by the 1870 Crémieux Decree, which told them that they were no longer colonized but now had been transferred to the colonizers' group. And with this bargain that was imposed on them, the Jews-now-French-citizens were no longer able to speak about what the colonizers had done to them. If they spoke overtly, they risked proving that they did not deserve citizenship and that they were not French; and yet, as Jews, they still faced violence in Algeria, as you know well.

The profound trauma many Jews suffered when they were exiled after Algerian Independence in 1962—for being French citizens, as if they too had not been colonized—has colonial origins, ones that have been unattended and unaddressed for decades. The destruction of the Jewish world didn't start with what you call the first exile (1870), but in 1830, with the destruction of the craft guilds and the sites where Jews had practiced their craft for centuries among Muslims. The destruction of the souks and workplaces in Algiers, which was also the beginning of the Jews' dissociation from what became "the Islamic world," is one emblematic example. This unattended trauma is reproduced in the children born in exile who experience their ancestors' losses and tongue-tied silence because their parents cannot explain why they were exiled along with the colonizers and forced to start a new life in France. In 1962 when Algerian Jews were physically exiled, they were again forced to assimilate with a group that made them disappear—the population of *pieds-noirs* ("black feet"), those European French who were born in Algeria during the colonial era and who, as colonizers, were responsible for Algerian Jews' trauma but denied their responsibility. In this way, Algerian Jews were further deprived of a language to speak of the violence done to them.

Letter 2. We have not forgotten France's colonial crimes

This "profound trauma," as you put it, comes with an interdiction on speaking of it outside of the narrow story of the French state. This interdiction is what I think of as the language code of French, set up by the "hosts," both in Algeria, where they were actually the invaders, and later in France, where they played the protectors. Even in your reflections on the absent history of Algerian Jews, including in your book *Three Exiles: Jews from Algeria*, you describe the absence without holding the regime or its central actors accountable. You say, simply, that the absence of such research can be explained by the fact that the Jews melted into the *pieds-noirs*.[2] You are speaking in this language code.

Making Jews part of the *pied-noir* community required violence. The French, who since the very beginning of colonization had asked the same racist European question—"What should we do with the Jews?"—deliberated until their departure about whether the Jews would be allowed in France, and if so, how and under which category, revealing once again that even after ninety-two years, the Jews were not seen as French or European. To make the Jews French, and *pieds-noirs*, required constant work. "Emancipation" of the Jews, since the French Revolution, has meant the destruction of the Jews as a collective, and this imperial conception is still at the basis of French racism against Jews and Muslims, as well as Jewish and Muslim frustration that despite the secular and universal language used, all French spaces, institutions, and histories are white, imperial, and Christian, and their only choice is to pass as other than who they are, or to fail. Emancipation is a command for compliance rather than a liberation.

As decades of anti-Jewishness has shown, whether Jews pass as French or fail to do so, they are not protected by French citizenship. After all, French secularism has never committed itself to protecting Jews' rights in the same way that Islam did. Moreover, French secularism cannot protect Jews as Jews since French law is based on the binary opposition between the secular and the religious. But being a Jew was never only a question of faith, but also of a culture and a world. By making what was a rich collective life, shared with Muslim neighbors, a simple matter of faith, French secularism expropriated Jews of their world and granted them pared-down rights as individuals under the secular state.

Thus, during the 1962 Évian Accords summit that formalized Algerian independence, a big part of the long deliberations was not focused on the social, religious, and ancestral meaning of looming exile or its traumatic implications, but rather on how to sweep under the rug of the Accords the racist contradiction that organizes French imperial law: only the truly European French are French citizens, and the rest are kept separate, unable to retain any collective identity apart from the "Frenchness" to which they are allowed only partial access. And yet the memory of Jews as a collective apart from the European French, a group whose French citizenship could be taken from them because it was granted to them in the first place, did not fade completely. The French lawmakers' memory didn't fade either; how could it? They needed to know whom to keep excluding. Thus, as Todd Sheppard shows, many of the Évian deliberations sought to find a way to include Jews without naming *the Jews* as a distinct group:

> The assessment of the "two sets of criteria" [for such membership] that follows in this October 1961 report is particularly telling, for it reveals both official thinking about the groups of people involved and suggests how difficult it was for French officials to accept the logic of minority rights. The writer regretted that "it does not seem possible to use objective criteria to define minority in Algeria." The term "race would exclude Frenchified Muslims"; the term "religion" would leave out "Israelites"; the term "language is very imprecise." Not only is the distinction between "Muslims," who have "race," and Jews, who have religion, significant, but the desire to fix membership criteria, the unwillingness to embrace a "strictly individual" choice resonates with the confused French history of "assimilation," "coexistence," and "integration."³

Once Algerian Jews were physically outside of the Jewish Muslim world, the exercise of imperial technologies continued its work and compelled Algerian Jews to think about themselves as "Jews" or "French" or "Israeli."

Letter 2. We have not forgotten France's colonial crimes

Algerian Jews' detachment from their soil had already started in 1830 with the destruction of the infrastructure of their world, and their invention as "Jews" with the coming of the French colonizers, who named them as such. At the same time, "the Muslim world" was invented by the colonizers as a cohesive unit, and it meant a world with no Jews. These events formed the inaugural exile of the Jews, an exile that preceded the first exile, which you identify with the Crémieux Decree in 1870. Already in 1830, the colonial assumption was that the Jews were easily transferable—the only question was, to where? In 1962, many imperial predators had an interest in where the Jews would go and what subject role could be assigned to them: French negotiators, OAS, Mossad agents, the Jewish Agency, Israeli representatives, and the FLN. Yet none of these actors was interested in their well-being or their ultimate fate. In 1962, there was no way for the Jews to feel secure—only more confused.

One notable exception was Jacques Lazarus, the head of the Algerian Committee of Social Research (CJAES), who refrained from attributing his own vision to the Algerian Jewish community.[4] Instead, he wanted to protect the community from various predators like the Jewish Agency, known for its role in inciting members of Jewish communities worldwide to migrate to Palestine in order to sustain the destructive and still unstable Zionist project. In an official declaration, Lazarus defended the right of Algerian Jews not to be represented by Zionists who claimed to speak for all Jews: "No Jewish organization, nor any single Jewish personality can claim to speak in the name of a collectivity that—like any other ethnic group—includes a whole variety of opinions."[5]

On February 7, 1961, Lazarus wrote to a friend in a private letter: "We wish to continue to be able to express ourselves as Jews. We do not wish to be forced to maintain silence with respect to Israel, nor with respect to the Arab states."[6] Being both Jews and Arabs, Algerian Jews were caught in a double colonial aphasia due to the destruction of a world in which they could continue to be both. Lazarus could not solve this contradiction, but he could oppose the voices of some Jews who claimed to represent the community but sought to purge it of its Arabness.

Without saying so directly, Lazarus's letter implies that having a Jewish state on the one hand and a Muslim state on the other (as only Muslims were part of the negotiations for Algerian Independence) denied the Algerian Jews the freedom to speak as Jews. A suffocation emerges from the letter, one caused by those Jewish voices invested in the Zionist colony in Palestine, whom Lazarus understands are not Jewish voices but voices of Jewish statesmen. And like other statesmen, these Jewish statesmen are deaf to the voices of communities who may pose a challenge to their state.

The French had their own interest in the Jews, and in cementing the fiction of a Judeo-Christian alliance in order to alienate Islam. It was another thirty years before, in 1995, the French finally recognized their role in the deportation of 75,000 Jews from France to death camps during World War II, including several thousands of Algerian Jews who lived in France (among them, members of my family). Two years later, during the commemoration of the Jewish Sanhedrin that Napoleon forced on the Jews in 1807, the mayor of Paris concluded the event with an insulting erasure of French crimes against the Jews, and described the relationship as "190 years of successful integration, preserving a vivid Judaism loyal to its roots in the framework of the republican secularism."[7]

It is less the way that the French speak about what they did that preoccupies me here. Rather, it is the language code that they imposed and that has been internalized over generations, a code in which Algerian Jews come to speak as the French do and to inhabit French history as their own. The children and grandchildren of the exiled live the contradiction, and if some of us have only now begun to ask questions, it is not only, as you imply, out of scholarly interest, but because we are captives of a world without a language for liberation.

I'm writing because I think you are also trapped and without the language you need for liberation. For example, your edited volume with Abdelwahab Meddeb, *A History of Jewish-Muslim Relations: From the Origins to the Present*, and the two exhibition catalogues, *Juifs et musulmans de la France colonial à nos jours* and *Juifs d'orient: Une histoire plurimillénaire*, present the richness of the Jewish Muslim world. And yet, despite your efforts, these volumes do not break the language code: nowhere

Letter 2. We have not forgotten France's colonial crimes

do I see a discussion of how the French were invested in exterminating the culture you took great pains to reassemble, lovingly, from its broken pieces. Instead, our ancestors' culture is depicted as *past*, part of bygone times, as if you accept that this destruction is complete and cannot be questioned and reversed. The French can take pleasure in reading these books, in becoming experts on our culture that they destroyed and that they hold in their museums as if it were a possession. What the French did should not be erased by the pristine status granted to precious museum objects; it should be a spur for us to recover our ancestral languages, spirituality, and cosmologies, and to follow the path toward our liberation. It should be a spur to repair the worlds that were destroyed, not to preserve them in museums as if they were relics of what is forever gone.

In your seminal book, *Three Exiles: Jews from Algeria*, on the three exiles of Algerian Jews—exiled from the Arab world by the imposition of French citizenship in 1870, exiled from French society by the Vichy regime's anti-Jewish laws in 1940, and exiled from their homeland by the Évian Accords in 1962—you describe exile as an inevitability. No one is held accountable. Most importantly, you seem reconciled to the irreversibility of the outcome: you often use the phrase "no way back" (*pas un retour en arrière*). You are accepting the colonial bargain here—protecting the French not only from accountability but also from having to hear the victims speak their crimes aloud. Do you really agree with the French that our ancestors' world is past and gone?

Of course you are not the author of this language code—I find it in many other books—but I am writing you, dear Benjamin, since it is from you that I first learned that we were exiled. But I understand these exiles differently. With the first exile we were also exiled from our diverse modes of being Jews. With the second and third exile came the injunction to practice our religion in private, in our homes, and the prohibition on speaking out against French colonial violence. This changed our ancestors' public selves and refracted in their private sense of self.

How can you narrate these three exiles without seeing the colonial violence that generated them? How can the exile of the Jews from Algeria in 1962, which should have been depicted

as the peak of colonial violence against them, be re-narrated as a neutral, liberal "choice" between two identities? No archival document testifying to Algerian Jews' opinions is required to assert that in 1962 the Jews ran from Algeria to places they didn't know, not because of "choice" but because of fear. That most Algerian Jews chose to go to France conveys both their fear and the legacy of the 1870 Crémieux Decree. After 132 years of colonization, neither Muslims nor Jews were willing to or could completely shed the Frenchness that had become theirs. But this doesn't mean they wanted to be French, to go to France, or to no longer be Algerians!

In response to the official report you composed on commission from the French President, I feel the urge to rehearse another "we," a "we" that is unreconciled to our exile, that does not seek to create shared memory with the French.

We have to reject the false answers that the colonizers gave to the question of who we are—"Jews"—as well as the second answer—"French." Both use an imperial conception of identity as something that separates people from others, rather than connects them. We have to reject the colonial idea that these false answers can be explained as the "choices" of our ancestors rather than as colonial violence.

We have to stop asking questions about the Jews' choices in 1962 as if they were liberal choices made under neutral conditions, as if the conditions of migration had not been forced upon Algerian Jews, as if a decade and a half earlier, the French had not deported from France 75,000 Jews, French citizens, to their death.

We have to ask the questions that have been prohibited, using terms that sow discontent among the colonizers.

We have to refrain from burying this colonial context or turning it into history that is *past*.

Letter 2. We have not forgotten France's colonial crimes

We have to reconstruct the colonial onto-epistemological violence that held our ancestors captive for decades, that designated them "European" while still denigrating the Arabness in them, the contradiction that pressured them to see Muslims whom they lived among for centuries as more frightening than the French colonizers.

We should remind ourselves that our ancestors' consent was not given but extracted.

We must not forget the role of *republican education*, the colonial state propaganda that violently dissociated our ancestors from their world to such a degree that, once forced to leave, they were left with very little of their own culture to transmit. We must not forget that it was this republican education that taught our ancestors the language code of French and took from them the language of their ancestral worlds, along with their ancestral access to this world as the jewelers of the ummah.

We cannot allow ourselves to forget that colonialism extracts loyalty through its secular institutions: archives, museums, history.

We must reclaim our losses, our pre-Napoleonic Jewish forms of life free of the consistory that left us captive to a religious/secular binary, and we must resuscitate an anti-imperial cosmology.

We should oppose the transformation of imperial and colonial crimes into "competing memories." Such crimes should be denounced.

We must refuse to become perpetrators of colonialism against ourselves, and against others.

I found myself rewriting this letter to you during the sixtieth anniversary of the Évian Accords and Algerian Independence. The silence about the Jews during the celebrations was deafening. One hundred forty thousand Jews were amputated from Algeria and then melted into "Europeans," but this received no mention. In

Roger Lucien Azoulay, certificat de nationalité, March 2, 1942.

Letter 2. We have not forgotten France's colonial crimes

photos of the exodus, the captions show only the technologies of erasure—the language code that I have been discussing above—and the amputated Jews are even not mentioned, only assumed as part of the crowd of "repatriates" or "pieds-noirs" (see photo p. 42).

In the human factories of colonialism
people who are forced to leave their ancestors
are forced to reconcile with their tormentors in advance,
and to confess
that what was done to them
was of their own volition.

How could we have expected that by 1962, the traumas of 1939, 1940, 1941, 1942, 1943, 1944, 1945, 1946, 1947, and 1948 would be evaporated? In 1942, Algerian Jews were required to appear in the French civil courts and were sent off with a *certificate of nationality* that designated them "indigenous Jews" (*juifs indigènes*). My father didn't tell me about it, but I have his certificate, dated March 2, 1942 (see photo p. 90). Algerian Jews knew that, had the Allies not landed in Algeria in 1942, these certificates could have been used as records of the Jewish population, could have been made into lists for deportation or death. Algerian Jews knew, as Muslims knew—Ferhat Abbas expressed this eloquently—that the citizenship France grants to non-Christians is not something that can be trusted. That under the Vichy regime, when Jews demanded the restitution of their citizenship after it had been stripped from them, it could not be explained as "French patriotism" but rather as a pragmatic response of fear, distress, and internalized colonial dependency. Algeria's Jews were forced to convert, to fit into the French side of colonial binaries that disappeared them:

Algerian / French
Muslim / Christian
Noncitizen / Citizen

Our ancestors' French citizenship was always precarious; never —France made sure of this—could one be a full French citizen without also being Christian.

My father's *certificat de nationalité* is a certificate of this precarity, captivity. I'm thinking about my father holding it in his hands and I see an unspeakable pain, a withheld rage. In 1947, the new certificate of nationality that he received was not reassuring either, as it stole from my father the origin of his citizenship status as granted by the Crémieux Decree in 1870 (which meant he had been a citizen from birth) and replaced it with a certain 1927 naturalization law (which meant he was not born a French citizen but had been naturalized at the age of four!).

During the years of World War II, even those who inherited the colonial state–sponsored amnesia and were born to believe that they were French were reminded that this was not an immutable identity but a conditional set of rights that could be easily taken away. Since 1870, the Jews had been caught in an endless cycle of proving their "attachment to France," and they considered this to be a duty that constantly needed to be fulfilled. Algeria's Jews refused to accept the Vichy government's disregard of the "numerous and strong proofs they had given of their attachment to France," and they sent a letter to Philippe Pétain, Vichy's chief of state, in which they expressed their "bitterness in the face of Vichy's decisions" and promised to try better.[8] The citizenship that was *given* to them was always on probation, never secure.

When finally in 1943 their citizenship was restored, without restitution or reparations, it was clear that they were not freed from the colonial bargain. The binary of the either/or, French/Algerian, was consolidated during the Algerian revolution as independence became a struggle between "two sides": Algerians qua Muslims and French qua Christians. That the Jews could not easily decide where they belonged in this binary is not surprising, since the binary could not exist without their conversion. As Abdelmajid Hannoum writes, "The Jews as indigenes disappeared from Algeria and were considered a category between indigenes and Europeans [...] not indigenous because of their faith, also shared by European Jews, but not quite European because too Arab."[9]

By the final phase of the Évian negotiations, the fabricated binary was assumed to be fact. As Todd Sheppard describes it, "Europeans" came to encompass Jewish Algerians, and those who

Letter 2. We have not forgotten France's colonial crimes

were not European "were thus wholly Algerian."[10] However, to deal with the many exceptions that this divide created, until the last moment the clauses of the Accords were "rectified" to reflect French politicians' interests in the subject. Sophie B. Roberts mentions that in a conversation with Guy Mollett, Charles de Gaulle (who, like Mollett, would become prime minister of France) "made a distinction between Jews and Frenchmen in Algeria," showing how easy it was to consider Jews as fully French citizens—and just as easy not to.[11]

The case of the Saharan Jews is even more outrageous. They were not naturalized under the Crémieux Decree in 1870, and in 1961, as Sarah Abrevaya Stein shows, they were precipitately "reinvented as French citizens and *pieds-noirs*" in order to be included in the "European" category. Why? Because oil had just been discovered in the Sahara in the midst of independence negotiations. Naturalizing the local Jews and "repatriating" them simplified the negotiations over the Sahara and contributed to the monolith of Algerian national identity. In their defeat, the French hardened the boundaries between Algerian Jews and Algerian Muslims and socialized each to conceive of themselves as bereft of the other.[12]

In this way, the French gave the new Algerian leaders lessons in becoming statesmen. The negotiations with the French at Évian lasted months. The leaders of the FLN were already rehearsing their sovereignty, and they sent confusing messages to the Jews, which could not be disentangled from violent attacks on them.[13] In the absence of the Jews from the negotiations and from the binary, a shared colonial understanding of the body politic took shape. Algerian statesmen were trained to conceive of the body politic as malleable according to the sovereign power's interests and the sovereign's authority to determine who belonged where and who could be moved in or out of the body politic. The Algerian statesmen learned that the ability to fashion a desired body politic was their inalienable right.

Dear Benjamin, you know this better than me. From the time of the Prophet, through the Pact of Umar and until French colonization, Jewish communities were unquestionably a constitutive

part of the Muslim nation and under its protection, sheltered within the category of *dhimmi*, part of Islamic law. After 132 years of colonization, the independent state that emerged out of negotiations between "two sides" could not escape the stamp of French secularism: the negotiations solidified the idea that all Algerians were Muslims. Thus, the legacy of Islam—protecting the "people of the book" (*ahl al-kitāb*) who live among them—would become foreign to the state that, shortly after independence, proclaimed itself Muslim and Arab. As the end of the colonial regime approached, the French tried to plunder as much as they could—art, libraries, archives, lands, oil. But as much as they took, they also left much behind: colonial institutions, political vocabulary, and the French language, the language code that facilitated their domination even after their departure. Thus, through the Évian Accords, the French, who for 132 years had brutalized the rights of the colonized people, compelled the Algerian state to "subscribe unreservedly" to the secular principles of the Universal Declaration of Human Rights, imposed as the foundation of a secular democratic state *in* which and *by* which many are not included or protected, as post-WWII history has already made clear.[14]

Algiers currency and bronze household utensils. Lithograph by Lemercier, in *Voyage dans la régence d'Alger, ou description du pays occupé par l'armée française en Afrique*, ed. Claude-Antoine Rozet, 1830.

Letter 2. We have not forgotten France's colonial crimes

I don't have to tell you that there are many Algerians of Muslim origin living in Algeria today who have no idea that Jews once lived there for two millennia. In 1962, Muslims were pushed to break apart the Islamic nation, the ummah, when they made it impossible to be an Algerian Jew. Reading the Évian Accords again, trying to grasp the meaning of our ancestors' disappearance, I was struck by this: we are not mentioned by name. Not one line in this document will retain our memory after we are gone.

And yet, the ghosts of our ancestors, the jewelers and minters of the ummah, now exiled, still snuck in, impacting the right of the sovereign state to mint its own currency: "Algeria will be part of the franc zone. It will have its own currency," reads chapter II, clause B.[15] This clause omits two things (see image p. 94). First, that in 1830 France destroyed the local *dar es-secca* (mint house) alongside the *souk es-seyyâghin* where Jews and Muslims made different utensils in silver, gold, and bronze that were used as part of the monetary system, and at the same time France imposed a new French minting facility; and second, the clause omits that from 1962 until 1988 France continued to benefit from a monopoly on the minting of Algerian dinars in France.[16] Thus in the Évian Accords, France could induct Algeria into the world of sovereign imperial nation states, premised on the creation of a differentiated body politic and tied to the ideas and institutions that saw in "new beginnings" the foundation of history. When, in 1988, Algeria was finally allowed by the French to mint its own coins, it was celebrated in the press as "the first African country to mint its currency." In the absence of the Jews, the Muslims internalized this colonial memory as postcolonial, for Algeria's Jews had minted coins for centuries prior to colonization. This double amnesia was the last "gift" the French forced on Algeria, to forget its own history, to forget its own people. Under the cement square of the Place des Martyrs in Algiers, our history (un)rests. Not our history apart, as Algerian Jews, but the potential history of all Algerians together again.

Like you, I have a personal stake in these matters. I was born in 1962 and didn't know anything about Algeria. My father had left Algeria in 1949 and said very little about it. Your book *Three Exiles: Jews from Algeria* played a formative role for me: first,

in my Algerian education; second, in helping me understand the continued operation of colonial logic whereby you could claim that for "the vast majority of Algerian Jews, the era of assimilation was complete, and going backward (*retour en arrière*) is henceforth impossible."[17] I still scream in anger when I read this! Such an impossibility could only be assumed if one accepts the imperial construction of the past as irreversible, implying that any possibility for a different political world is forever lost. It's true, two colonial projects produced the reality where you could write such a thing, but, dear Benjamin, why should we abide by the imperial dictates and their violence?

While we disagree on the nature of imperial temporality, I cherish the complexity of your use of the term "exile" to describe what was done to our ancestors in 1870 when they were turned into French citizens. This is a radical act of naming. It is not a common way for historians to describe the meaning of the Crémieux Decree. When you write that this decree "exiled" us from a "Jewish tradition on Islamic soil," I read an implicit acknowledgment of the fact that it was not only the French who exiled us, but also French Jews, who came to Algeria to "regenerate" us as part of European Jewry, thus exiling Algerian Jews from our own traditions as practiced "on Islamic soil." Thank you for writing this; thank you for naming this.

At the end of this book, you tell your readers that writing about these exiles disrupted your composure as a historian: "In this work as a historian, I suddenly heard the echo of an old love for Algeria, buried, sleeping underneath the desire to turn the page, to forget this origin and to fabricate others."[18] In this moment of grace, longing for something beyond what was possible, you opened a wound and refused to let the language code of the colonizers take over. But in the following sentence, which ends the book, you reverse course and assert, in the same way Jews have been expected to do since the ratification of the Crémieux Decree: "It is possible to be at the same time Jewish and French, republican and inclusive of religious rites, turning toward the Occident and being forever marked by the Orient, Algeria."[19] Do you not see how the identity of "Jew" for our ancestors was not a given, but the outcome of French

Letter 2. We have not forgotten France's colonial crimes

colonization? And how the French identity didn't allow you to be enraged against the French colonialism in Algeria?

Much earlier in the book, you write that this "disruption of an old tradition tied to the Algerian soil" is discerned, first of all, in the "progressive loss" of the Arabic language among Algerian Jews. This was not a naturally occurring loss but the effect of a regime that forced the Jews to lose their Arabic.

> I want to ask you,
> dear Benjamin,
> why is it necessary
> to preserve our exile from Arabic,
> our ancestral language?
>
> In whose interest is it
> to keep us apart from the intimacy
> of language we shared with Muslims?
>
> What will happen to
> French Islamophobia
> when the Jews once again
> speak Arabic?
>
> When our ancestors were exiled
> from what became Catholic Spain and Portugal
> and arrived in North Africa,
> they continued to speak an oral dialect of Spanish
> known as Hakétia,[20]
> and to relate to themselves as *megorsahim*—
> expellees.
>
> They learned new languages,
> as they always had,
> but they kept their ancestral tongue,
> which allowed them to tell their experience,
> to say, "We were expelled,"
> to keep their secrets,
> to transmit their wisdom,

to uphold their religious traditions,
without having to praise
those who expelled them
or lie to their descendants
about what had happened.

In these languages to which we were exiled,
which we learned as if they were our mother tongues,
we were born to repeat,
in the first-person singular,
as well as the first-person plural,
what the colonizers said
about what was done to us.

Why not ask questions
about the nature of this French language
that was given to children,
exiling them
from their ancestors?

Our ancestors were deprived of the power
to equip their children
with smuggled memories
about the nature of this exile,
memories that might protect us, their children,
from being born as if we had already reconciled,
in
through
with
our imposed mother tongues,
with the colonial avatars
that still surround us.

We should not forget that the impact of colonial violence lingers over generations, and its imperially desired outcome is achieved at the expenses of the rupture it creates between generations.

Letter 2. We have not forgotten France's colonial crimes

We were provided with colonial tongues disguised as our mother tongue.

We were trained not to remember that our ancestors spoke Arabic and were forced to lose their tongue.

We slowly came to know now that our ancestors' language was buried alive in their mouths.

We feel the ache in our own mouths when our ancestors' language speaks in us, even or especially as we don't know how to speak it.

> What happened to us
> could be described
> as "progressive loss"
> only in the languages
> to which we were exiled,
> the languages in which our exile
> ceases to exist as violence
> and is remembered only as history.

Your book was very helpful to me when I started to ask questions about the fabricated identity that was assigned to me at birth: "Israeli." The more I studied what had dissociated me from my Algerian Jewish ancestors, the less I recognized myself in this assigned identity. I rejected it twice over: first as a form of belonging, and second as an imperial template of history—an effort to mark a new beginning (1948), a rupture between what was "past" and the allowable future. The creation of the state of Israel proclaimed previous affiliations and formations either nonexistent (Palestine) or inappropriate (Algerian Jews, Iraqi Jews, and so on). It devalued the singularity of diverse groups of Jews, reshaping them into an undifferentiated bloc. This effectively continued the Napoleonic project of regulating Jewish life, making "the Jewish people" into a historical-national subject that could only be fully realized by a sovereign state of its own.

When I started to gather histories and memories of who we Algerian Jews had been, I noticed a striking similarity between

the settler-colonial identity assigned to me and the one assigned to my Algerian ancestors in 1870. Both were manufactured to make us forget who we were and to infuse us with memories so we could be used as instruments that made these colonial formations seem legitimate. My father left Algeria without imagining that he would not be able to return. When Algeria won its independence, the rest of our family was forced to depart and leave behind our two millennia of Arab Jewish life in the Maghreb. We, the children and grandchildren of my father, could not even visit Algeria. The colonial identity of being "Israeli" put us in opposition to our ancestral world. To reverse the destruction of our ancestral world, we have to reclaim the legacy of our ancestors who in 1865 refused to apply for French citizenship. We have to reclaim the tools, objects, skills, beliefs, powers that enabled them to say no. This refusal is not history—it is rather our vital anticolonial legacy.

Studying the connection between these two settler identities—the French and the Israeli—helped me understand their importance for major European colonial powers: namely, to dissociate the Jews from the Arabs, Berbers (Amazigh) and Muslims, and to incorporate Jews into a fabricated "Judeo-Christian tradition." Of course, some Jews volunteered to place themselves within the "larger framework of Western civilization," as Susannah Heschel describes it.[21] But this fact only demonstrates the colonial attack on human diversity and the success of its incentive to "assimilate." What you call the first exile of the Jews in 1870 should be understood as background to the creation of the settler-colonial state of Israel, which destroyed Palestine. The second exile in 1939, from their French citizenship was hijacked by the Zionists as proof for why the Jews needed a state of their own, rather than proof of why the Jews should protect their communal life from colonial predators, French and Zionist alike. And when the third exile came with Algerian independence in 1962, Israel had already cemented enmity between Jews and Arabs as a fixture of the Jewish condition.

To put it bluntly, the state of Israel functions as the liquidator of French accountability for France's colonial crimes against Jews in Algeria and other Muslim countries. It is a transaction between

Letter 2. We have not forgotten France's colonial crimes

colonizers: colonial citizenship and a Jewish settler state could be conceived of as "gifts," repayment to the victims of colonial crimes in colonial currency to keep the colonial project going. "Granted" French citizenship, "granted" a Jewish nation-state, imperially engineered Jews and their descendants are expected to simply move on, to forget about the destroyed world of which they could still be part, and to become instead part of the imperial world, citizen-operators of the technologies that continue to perpetrate crimes against humanity—and deny them their own ancestors.

Well, I refuse.

I am writing to you, dear Benjamin, because these imperial crimes are not past events but ongoing ones, and the institutions, structures, and laws that enable them must still be dismantled and abolished. Imperial architects expect us to believe that imperial crimes came to an end when the imperialists proclaimed that they had ended, as if history were relentless and what is past were over, dead, irreversible and irredeemable. It is not. Despite your wish to do good with this report, it performs a similar function—consigning these events to the past, even as they endure in the present.

I wanted to ask you, why do you not mention the three exiles in your report as crimes against humanity? Surely they are emblematic examples of the heavy price Jews paid for their colonizers' citizenship. Surely they are crimes against Jewish diversity. In fact, your report exemplifies what I propose to call the fourth exile of Algerian Jews: their erasure from the history of the colonization of Algeria. In 160 pages of your report, only two paragraphs are devoted to describing the existence of a Jewish community in Algeria, and the liquidation of this thousand-year-old community is thus made a non-event. In reality, as you know, there was not one community but multiple and diverse Muslim Jewish communities. Only through the colonial crime against humanity were diverse Muslim Jews forced to become one thing, as a prelude to their disappearance. In this way, your report supplies France with scholarly "proof" that its colonization targeted exclusively Muslims and Berbers (the latter assumed to exclude Jews). These omissions have serious consequences

For this retroactive removal of Jews from 132 years of colonization, one has to endorse the outcome of imperial violence

as progress, emancipation. Why else erase this group from the history of the French colonial project? All that we know about the French colonization of Algeria cannot be forgiven in order to preserve the successful assimilation of the Jews—especially when we know that successful assimilation is just a fiction. Of all people, how is it you—you who are deeply invested in collecting and retaining the memory of this world—who have now come to play the role of its gravedigger?

This final question—why *you*, in particular, were selected to write the report—requires our attention. Beyond your expertise, I suspect I am not the only one who thinks you were selected because you are Jewish—and because of the position of the Jew in the French colonial project.

For you as a Jew to be selected by the French president to write this report is not a coincidence but a trap. In this still-imperial world, Jews are still expected to act as blank citizens—to prove, as Houria Bouteldja writes, their "willingness to meld into whiteness ... to embody the canons of modernity."[22] This trap you were placed in was created through three imperial deals. The first is the bargain of citizenship: a good French citizen of Jewish origins should not fail to leave his Jewishness at home, especially when practicing his profession as a historian. Already in your book, you proved your French patriotism by depicting the three exiles of the Jews as past events, objects of historical inquiry that can now be integrated into European history. The second bargain accepts the Crémieux Decree as its architects conceived of it—as the granting of a gift, rather than the unilateral use of force. To accept the logic of a "gift granted" omits the theft from Jews of their heritage, world, and traditions. The third bargain supposes that France already settled its debts to Jews, when, in 1995, the nation recognized its responsibility for "the Jewish people" in deporting Jews from France during World War II. And yet these are not reparations, but colonial sleights of hand; colonial crimes against Algerian Jews in Algeria, including under Vichy, are further hidden from view by this "apology."

Accepting these deals, your report represents itself as unbiased history, dutifully advancing the state's mission. But this is exactly the problem. There is nothing solemn about engaging

Letter 2. We have not forgotten France's colonial crimes

with imperial crimes. Empire invented the past and charged archivists and historians with turning its living, ongoing crimes into past objects of unbiased historical inquiry. It even employs its victims to say that no crime was perpetrated against them. To resist these imperial erasures, one must not be unbiased, one must refuse to forget, one must speak from the vantage point of *unlearning imperialism*.

Instead of serving this imperial project, your report could have offered an uncompromising record of French crimes committed against Algerians—Muslims and Jews alike—and of colonial crimes against humanity. It could have sketched a map of the connections between these crimes and the imperial institutions—police, prisons, racial capitalism, archives, education, academia, museums, citizenship, and the press—that enabled them and that continue to do harm in France, in particular toward Algerians, targeted at once by state Islamophobia and anti-Semitism. If you had replied to this invitation, asserting your position as an Arab Jew, a Berber Jew, a Muslim Jew, a victim of the French colonization of Algeria, you would have asked to co-author this report with a Muslim French Algerian. That would have been an opportunity to depict a fuller picture of imperial crimes and their lingering consequences, and to impose on the French state who commissioned the report a reversal of the fifth exile of the Jews—their alienation from Arabs and Muslims in the new world they found themselves sharing in France.

With these gestures, even an official report could have provided us as descendants, and our own descendants, with the resources to continue the work of abolishing imperial technologies. It would have provided us the tools to appreciate your books, volumes, and catalogues not as a "civilizational fresco of two thousand years" but as a living tapestry of a world that we have the right to inhabit and reclaim.

With the hope to reverse those exiles, one after the next or all at once,

Ariella Aïsha, a descendant from Oran

Letter 3. Your earth mother is my earth mother too

A letter to Samira Negrouche

Dear Samira,

It is my father who should have invited me to go with him to Algeria. It should have been his desire to show me around. But he did not.

When I was born, in 1962, Algerian Jews had to exit their country, and our ancestors were abandoned in the cemeteries of Algeria. No stones were placed on their graves. They remained with the unfamiliar sound of their descendants rushing away like thieves in the night, departing in a hurry, with no time to say adieu. "Never mind, it can't be for too long, nor forever," the descendants hoped as they rushed to the terminals.

The other day I dreamed that I came to visit you in Algiers. We walked around the city for several days. Magically, we managed to avoid the Place des Martyrs. I told you: now I can understand what you meant when you told me that all the people in your grandparent's village were marked by the figure of the Algerian author Mouloud Feraoun.

I woke up, and you were no longer around.

I was in the bookstore, the same one you told me about, that your grandparents purchased because they wanted their children to grow up surrounded by books.

I realized that I was still dreaming.

But then I was already awake, replying to your email, and reminding myself I was still not in Algeria, not yet.

Since 1962, the gates of Algeria have stayed closed to its former Jewish community. Even those who wished to return didn't dare to say so. Algerian Jews were banished, though no physical force was needed: 132 years of colonialism sufficed.

The departing Jews heard people saying that they were leaving of their own accord, as if they were colonial entrepreneurs with an apocalyptic vision of their own deracination and the destruction of the world that, for centuries, they had used their hands to build.

For a long time, I didn't ask questions.

I was mad at my father for not resisting this rupture, for not introducing me to Algeria. At the age of fifty, despite Algeria's closed doors, I embraced my grandmother's name to enter Algeria, bypassing nation-states, borders, and passports.

As long as I was mad at my father, I could disavow the role I played in the forfeited transmission of our looted heritage. As long as I could say that it was he who failed to transmit the memory of Algeria to me, both colonizers—the French and the Zionists—could enjoy their success in making the history of our deracination evaporate, as if we were caught only in a family dispute.

In lieu of the heritage from which we were exiled, a fortified identity, named after the state that destroyed Palestine, was expected to root in my body.

I could not anticipate that the epistolary exchange with my ancestors, or that my artisanal experimentation—copying *mezuzots*, *ketuboths*, and breastplates like those our ancestors made—would take the form of meditative sessions and bring me closer to my ancestors' multiple religious affiliations, beliefs, and practices outside of the secular colonial regime that turned them into just "Jews."

I could not anticipate that when I'd begin looking for my father's home in Oran, there would be three of us climbing the staircase: him, you, and me.

> Or four of us, if we include Benali,
> or five of us, if we include Adel,
> or six with Amin, his family friend,
> or seven with your friend from Oran.

Letter 3. Your earth mother is my earth mother too

Without all of you, I could not walk in Algeria with my father, nor could I remember the one time when he did want to show me Algeria.

It was before searching online became part of who we are. My father asked me to get him a book of photos of Algeria. I went to the French bookstore in Tel Aviv and bought him the only book they had, titled *Algerian Jews*. When I offered it to him, he was as disappointed as a child. He lacked the words to explain why he was upset, and I was not yet able to understand. Later, I could see fairly clearly: this book was neither *from* Algeria nor *about* Algeria. He didn't want it, and the book found its place in one of the inaccessible shelves of my library.

It is a book about some kind of a lost tribe, whose members do not seem to live in Algeria, but rather in indoor spaces, or in the pages of old books, surrounded only by Jewish ephemera and symbols. There is not even a single photo of Algeria that is not of a Jewish cemetery or a synagogue.

> There are no photos of life in Algeria,
> only floating Jews,
> detached from their country,
> from the earth,
> from others, as if
> the Jews did not live in Algeria,
> but apart,
> already uprooted,
> ready to be "repatriated,"
> before they had even left.

My father wanted pictures *of* Algeria.

I knew nothing about Algeria and was tricked by this book that participated in making Algerian Jews an extinct species.

Years later, a tourist offered my father a panoramic picture of Oran. He framed it and put it on the wall. I was happy for him that he had found what he was looking for. I'm sorry that it didn't cross my mind to ask him to take me for a walk within the photo, to show me what he saw there.

Dear Samira, in describing your encounter with Naïm Kattan,

the Iraqi Jewish novelist, you write that he "knew the uprooting from the earth" and experienced in his "flesh the weight of separation."[1] I have known this pain from its reverse side, from being forcibly planted in another land, a land that was brutalized, desacralized, and soaked with blood. Palestine. My mother tongue failed me for a long time, prevented me from understanding that we couldn't be planted in a foreign land without first being torn away from our ancestors and our ancestral land.

We were ripped from everywhere, made *a people* in a colonial factory. My fabricated belonging to this people forced me to forget who I was before what in your words you describe as "the advent of a magisterial law which destroys and then names what remains."

I am also a Muslim, Samira, because my ancestors didn't know they weren't, because before 1830 they were not poisoned to the point of shedding their Arabness, Amazighness, Islamicness.

The things that were done to our ancestors, to our orchards, to our jewelers, to our sorceresses, are not matters of a distant past. They are still incubating in our bodies, in our souls. They are the source of our misfortunes and the misfortunes of others, the substance of our hopes and the hopes of others.

Your "earth mother" is my earth mother too.

When she calls you, like the *muezzin*, I respond too, and she understands, for she has not forgotten Hebrew, she knows that I, *muezzina* to her, מאזינה, I am listening. I have not forgotten my ancestors, nor my ancestral land.

Is it in response to this that you wrote to me: "Something is said to us by you."

This enchants me, but also makes me thirsty, realizing how far I am from the source.

I can't even hear what is said to you through me. I'm not from the inside, and yet, as you say, "The path from the source has come to me."

Who am I?

There are days when it seems to me that I am only a fiction.

An Algerian Jew?

No one heard of this species ...

And yet—here I am.

Letter 3. Your earth mother is my earth mother too

These are the voices of my ancestors, I believe, that speak to you, that you hear when I speak, that you call "my vertical speech." When we speak, this verticality collapses, and we are horizontal, the extended family that we could have, or make, or be.

These missing earth mothers are on my side, and I am on theirs. Their voices speak within me, fade, fly away, until the voices that have not been transmitted to you, call me by my name, Aïsha—and wake me up.

If this Jewish Muslim world really did not exist, you wouldn't have been able to open the door that let me in. In order to enter this world that we are told does not exist, one has to believe in its existence. For it to exist, at least two of us had to believe in it. Isn't that why we care so much for our exchange? It is only when we believe in it alone that we feel it to be a fiction.

Illustration by Hagar Ophir from *Golden Threads*, a children's story by Ariella Aïsha Azoulay (Ayin Press). Ophir's illustration is based on a photograph by Jean Besancenot, 1934, High Atlas Mountains, Morocco. Design: Haitham Haddad.

I don't want this Jewish Muslim world to be a fiction for my grandchildren. This is why I wrote a story for them that will one day be a children's book. The story is made from the historical life of a community of goldsmiths and gold spinners who lived in Fez in the 1920s. In researching the story, I became attached to images of five girls the age of my granddaughters, covered with marvelous jewels, that my ancestors, North African Jews, had made.

I met these girls in black-and-white photographs taken by a photographer who was one of the French colonizers, working for the so-called "protectorate." He was charged with a mission of iconographic documentation of our ancestors and their material culture.

The French carefully recorded what they destroyed.

I gave these five girls, whose faces have become intimate to me, the names of my female ancestors, which were completely unknown to me until not long ago:

Rachelle, Fortunée, Aïcha, Camille, Semha.

I refused to continue to look at these girls only as bearers of jewels, showing them to the camera of this colonial photographer, Mr. Jean Besancenot, who described the girls as "kindly consenting."

Rejecting his camera's view, I invented them in my story as the daughters of the jewelers and gold spinners who made these objects, and in the 1920s had opposed the introduction of a machine capable of producing gold threads at high speed. As their parents knew, such a machine would destroy their world of artisans and its Jewish Muslim character.

Seven hundred adults and children who made their living from their trades, and who inherited, cultivated, and transmitted this ancestral knowledge, rightly feared the new machine, for it would relegate their craft to the museum and leave them bereft of work and community.

They didn't want to become laborers with no protection, in their colonizers' factories. They rebelled, assembled, prayed, and acted; they wrote to the rabbi, who appealed to the sultan, who finally gave an order:

Destroy the machine with no delay!

Letter 3. Your earth mother is my earth mother too

I received your second letter just after I finished reading my granddaughter this children's story that I wrote. I was still under the impression of what she told me:

"It is not possible that you invented this story!"

It was as if she were telling me that this story was not fiction.

"We can invent stories about horses," she said, "but not about these girls."

I tried to explain to her that some of it was real, like the strike, but that the story about the friendship between the girls, their life in the mellah, and their parents' discontent with the photographer's frequent visits, were things that I invented—or at least imagined out of what I saw when I was looking at these photos and others.

She was familiar with some of these photos that I had printed for her when I came back from Morocco and brought dresses embroidered with gold threads for her and her cousins, machine-made, alas.

Trying to figure out her resistance to the fictional nature of this (true) story, I told her about my work process: how I look at photographs and refuse to stop imagining at what is given to me to see. After a few back and forths with her, though, I renounced my position. Because she was right: I did not invent anything. Rather, I put into words a world that the photographer neglected when he made these jewels into objects, and the girls into authentic models for showcasing them.

Through hours of beading together and listening to my stories about the jewelers of the ummah, my granddaughter understood that these girls were never just pictures but rather daughters of their parents, the jewelers, who sought to protect the world of the ummah.

"I know these girls," she told me again. "I saw them in the photos."

Both of us—she and I, you and me—we know that I did not invent anything, only refused to be alone in believing that we can still inhabit this world.

One day I'll reclaim the knife my ancestors used to place under the bodies of their newborns as protection. I'm still looking for it, theirs or one like theirs, one that has already been used to bless

newborns in Algeria. Are you familiar with this type of knife? With the invocations that endow it with power? Does your body still remember the chill touch of the metal?

For me, it is a memory that comes from something I read, a memory I should have but don't. My muscles and nerves memorize things I have not experienced, and my body surprises me with them, as I do nothing to bring the memories from my ancestors' deep sleep and into my life.

These memories reside in my ears, for I cry whenever I hear the musicality of Judeo-Arabic languages. We cry, obviously, for the loss—who wouldn't cry? But at the same time, my mouth's muscles refuse to move, paralyzed, bereft of the know-how to repeat the melody my ears recognize so intimately. As if I'm being told, *remember your handicap, remember the way empire clung to your ancestors' mouths and did not let go until you forgot how to speak*. It hurts to not be able to control these muscles, to feel the imprisonment of my mouth, its incapacity to console my ears.

But it could be the other way around, that my mouth is simply lazy, and that it takes its time to recover, to unlearn. It could also be that my ancestors blessed my ears and not my mouth.

They could have punched the lobes of my ears, as seen in ancient pictures, so that the injunction *remember your ancestors' language* would not escape me and would be worn by me as one wears earrings. They could have arrived when I slept. I am not sure, but I think I remember hearing footsteps leaving the room when I was a baby.

My ears remember not only my ancestors' language, but also the smiles of those girls from Fez whom I never met, except in mute images. You are the one, Samira, who was lucky enough to meet them.

When I told you their story, you responded like my granddaughter: you said that I had not dreamed, that there were such girls in Fez and that you know their descendants.

Did you know that their parents went on strike? That they were not scared? You wrote to me, Samira, that muscle memory is not gone—it just needs to be dusted off. Do you know what remains of fear after it has been "dusted off"?

Letter 3. Your earth mother is my earth mother too

I wonder where my fear went—is it possible that I no longer have any?

My fear had a national identity, it was "Israeli." And now that I am Algerian, Palestinian, Andalusian, *Oranaise*, a Jewish Muslim, my fear has disappeared.

We will see each other, inshallah, this summer, in the land of our ancestors, and we will listen together,

נאזין,

to the music of the awakening of the Judeo-Arabic muscles.

When the light can hardly be seen, I'm reading one of your poems to remind myself the power of love.

From the heart of our shared desire to not let those threads get lost,

Yours with deep-rooted friendship,

Ariella Aïsha

Letter 4. "With all my being, I refuse to accept this amputation"

A letter to Frantz Fanon

Dear Frantz,

I'm neither a psychiatrist nor a psychoanalyst, but I can say with confidence that my father suffered from colonial trauma and a colonial disorder. He felt foreign to his environment, totally alienated. And even though this kind of disorder must have been very common among Algerian Jews, there was nowhere he could go to take advantage of what you describe as the "the medical technique that aims to enable man no longer to be a stranger to his environment."[1] No therapeutic or psychiatric initiative in Algeria offered Algerian Jews a way to recognize or articulate their colonial disorder. They suffered from their colonial subjection as indigenous Algerians, their transformation into French citizens in 1870, the revocation of their French citizenship under Vichy, the anti-Jewish laws in the Maghreb, and the restoration of French citizenship after World War II—the latter, granted as if France had not confiscated Jewish property, deported young Jews to concentration camps in the Maghreb, and, in France, sent 75,000 Jews to their death (among them 3,000 Algerians living in France).[2] The infamous Crémieux Decree granting newly colonized Algerian Jews French citizenship was not the end of their colonization but its continuation in a different form.

Without recourse to the medical techniques of which you wrote so eloquently, and with his alienation impacting all areas of his life, my father attempted to leave the toxic colonial environment of Algeria three times in less than a decade—in 1943, 1946, and 1949. The first time was when he was held in the Bedeau internment and forced labor camp; he suspected that volunteering for the French forces and going to war would be better than staying in Algeria. Given the unresolved status of the Jews after the official end of the Vichy government in Algeria, he did not know exactly what volunteering for this army as a Jew would mean, but he went anyway. The second time he tried to leave was upon his return from service in World War II. I assume that, like many other colonized people who fought for France, including you, he quickly realized that the promise of freedom and victory over fascism was a broken one, since the racial regime under which he lived had not been defeated with the fall of the Axis powers. He then decided to move to France, but after barely a year in Paris, he returned home to Oran.

Reading "The 'North African Syndrome'" (1952), which you wrote based on your observations of North Africans' experiences in France in the same years when my father left for France, helped me figure out what may have provoked his quick return to Algeria. You quote a certain Léon Mugniery, who in 1952 submitted a doctoral thesis in medicine to the university in Lyon. In his thesis, Mugniery denounces the French government's "too hasty" mistake of granting French citizenship and equal rights to Algerians working in France "based on sentimental and political reasons, rather than on the fact of the social and intellectual evolution of a race having a civilization that is at times refined but still primitive in its social, family and sanitary behavior."[3] Even as you critique Mugniery's imperial stance, you do not ask yourself, "Who were these Algerians that Mugniery speaks of?" You assume they are Arabs, and that all Arabs are Muslims. However, the majority of Algerians with French citizenship who lived in France following World War II were not Muslims. The ruling of March 7, 1944, ascribed French citizenship only to "deserving" Algerians: "those having received decorations, civil servants, etc."[4] Algerian Jews had been legally considered citizens

Letter 4. "With all my being, I refuse to accept this amputation"

since 1870, and they migrated in small numbers to France in the first half of the twentieth century.

For racists like Mugniery, Algerians were Algerians, irrespective of their faith or citizenship status. The common racist idioms you quote—"Why don't they stay where they belong?"[5]—are indicative of a world where Mugniery could be licensed to heal people. And the trouble, as you say it, lies here: "They have been told they were French. They learned it in school. In the street. In the barracks ... Now they are told in no uncertain terms that they are in 'our' country. That if they don't like it, all they have to do is go back to their Casbah."[6] This is probably the drama my father also went through during his one-year stay in Paris. This is the core of the Algerian Jew's disorder—and that of Algerians in general—their (self-)ascribed Frenchness exceeded the status assigned to them, so much so that their performance of Frenchness was often experienced by French settlers of Algeria as an insult, and by the French in France as an invasion.

In a biography she wrote about you, Alice Cherki, who, as you know, studied psychiatry in Algeria before she worked with you, shared her memory of how a French psychiatrist-in-training responded when he read the names of the students displayed at the entrance of the medicine school in Algiers: "Benmiloud, Benghezal, Benaïssa, Chibane, Aït Challal, Boudjellal ... we are being invaded by Arabs. To say nothing of the Jews who consider themselves at home everywhere and anywhere they please."[7]

Since the very beginning of Algeria's colonization, the French were obsessed with planning to expel Algeria's Jews. This, in a way, turned the Jews of Algeria into captives of the settlers' goodwill, for despite all the settler-colonial violence, the French settlers offered Algeria's Jews protection from the even more vicious early plans of other Frenchmen (for example, plans to deport them or to water "the tree of freedom with the blood of the Jews").[8] As one of the Jewish protagonists in Olivia Elkaim's semi-autobiographical novel says, "We are so happy to be French that, from now on, we have become their guests. We are no longer at home. And they're going to do whatever it takes to kick us out."[9] It is not a coincidence that with Algeria's independence, France's early plans came to fruition and the Jews were forced

to depart from Algeria. (The French had to leave too; alas for them that they could not enjoy the realization of their dream, an Algeria free of Jews.)

It didn't occur to me to ask my father about his experience in France during that year in 1946. What might it have meant for him to be so unwelcome, knowing that deportation could be as real a possibility for him as it was for his paternal uncle and aunt, who had been deported by the French to Auschwitz? What I regret most is not being able to awaken the anticolonial interlocutor within him, who, in my decolonial imagination, should have existed along with his anarchic spirit. If someone like you could have helped him understand his distress, he might have acquired this consciousness, especially as his father, who died in 1943 and could not be there for him when he came back to Algeria, had been an anarcho-communist. Instead, my father had to be torn by the contradictions of colonialism, assimilation, and conversion, numb to the inherited pain of exile ingrained in those who were forced to leave their country and become converted Frenchmen.

My father dissociated himself from the memory of the forced conversion to Frenchness, even though he still retained some remnants of its harm, transmitted from his parents and his parents' parents. He was not given an anticolonial education that could have helped him account for his experience. And, similar to other North African men you describe in your essay, he had a hostile attitude toward his painful past: "It is as though it is an effort for him to go back to where he no longer is. The past for him is a burning past. What he hopes is that he will never suffer again, never again be face to face with that past ... He does not understand that anyone should wish to impose on him, even by way of memory, the pain that is already gone."[10] All his life my father suffered from chronic headaches; the condition lasted until he died. It was exactly as you describe: "The patient is not immediately relieved, but he does not go back to the same doctor, nor to the same dispensary."[11] No one could help him. After he tried physicians, he switched to pharmacologists, and he even consulted pharmaceutical companies and research centers. In one response he received from a research center in Montreal, I could see how desperate he had been to receive a supply of a hard-to-obtain drug.

Letter 4. "With all my being, I refuse to accept this amputation"

The third time my father tried to leave Algeria was in 1949. A Zionist advertisement in the newspaper called upon Jews to volunteer for one year of military service to defend "the Jews" in Palestine, whom the ads depicted as under an "existential threat." With all the disinformation about the establishment of the state of Israel, I don't think my father could grasp the deceptive nature of this advertisement, which concealed the colonial reality in Palestine. Nor could he conceive of how the Zionists were akin to the French colonizers, waging war to conquer Palestine and to destroy centuries-old conviviality between Arabs and Jews. The advertisement was deliberately written to make Jews like him, who had fought against the Nazis, see the war in Palestine as a sequel to World War II, the next place where Jews were under genocidal attack. My father had a return ticket, but toward the end of his year in Palestine, he met the woman who became my mother and decided to stay. If he hadn't met my mother, he probably would have continued as planned to Canada; as he told me once, "I would not return to Oran at any price."[12] He did not even mention France as an option.

In your 1956 resignation letter from your position as a Chief of Staff at the Blida-Joinville Psychiatric Hospital, you wrote: "I owe it to myself to affirm that the Arab, permanently an alien in his own country, lives in a state of absolute depersonalization."[13] It is not clear to me how much you understood that this *Arab* that you were talking about was not necessarily Muslim but could be Jewish too. In your hospital, Algerian Jews were confined to the same pavilion together with Europeans, many of whom never ceased to suspect, harass, and despise them for *enjoying* their imposed status as Europeans. There are some similarities between Algerian Jews and the *conversos*—the Jews-turned-new-Christians during the Inquisition in Catholic Spain, who were ostracized from their community, converted, and persecuted by Christians who refused to recognize them, a process that terminated in the *conversos'* definitive expulsion from the Iberian Peninsula at the end of the fifteenth century. Algerian Jews were uprooted from their Jewish Muslim world, forced to be French citizens, and subjected to suspicion and hostility by the French settlers who didn't want them as peers. The French preferred to

pretend that the Vichy regime was an accident, not truly French; the colonized Jews of Algeria knew better.

A single story—Jewish schoolchildren sent out from their schools at the beginning of the Vichy regime in 1940—recurs in Algerian Jews' written memories. Why this, out of all the harms suffered during the French colonization of Algeria? It is because they feared speaking about internment, colonization, confiscation, forced conversion. To testify to such things would go against the French Republican self-image, and the French were incapable of admitting that they had caused such harm. The only thing the Jews could say was that they were citizens who had been denied a republican education. They could only voice grievances that would, at the same time, prove that they had not forgotten their republicanism and were deserving of citizenship. Am I wrong to imagine you laughing?

Once French citizens, Algerian Jews, who were already subject to different forms of *de facto* and *de jure* segregation within Algeria, started to also face harassment around elections.[14] Despite being classified as "European," memories of their *de facto* European abusers stayed with Algerian Jews; similarly to the *conversos*, stories of their abuse were passed down to their descendants, out of conscious and subconscious efforts to remember the true nature of the French, whom they were now forced to resemble. Upon his return to Algeria after World War II, my father learned about the deportation of his aunt and uncle and their three children from Paris to Auschwitz. When he went to Paris after the war, he learned that "it was the French themselves that informed the Germans that Jews live[d] in a certain building or a street."[15] Perhaps this news is what shortened his stay there. And you see, the story has been passed down to me, and I cannot forget it.

Some Algerian Jews enjoyed the colonial taxonomy that classified them, within the Blida-Joinville hospital, as members of the settler race; for others, however, it meant reliving painful experiences and traumas. For, in the wing for "Europeans," they were confined with those who were responsible for their disorders. But there was no language available for them to describe their symptoms. The only psychiatric analysis of the mental state of Algerian Jews was conducted by Victor Trenga, another racist Frenchman

Letter 4. "With all my being, I refuse to accept this amputation"

like Mugniery, who earned his doctorate with a thesis he wrote in 1902, *On the Psychosis of Algerian Jews*.[16] That they were technically made French thirty years before Trenga wrote his thesis—and thus, according to the French state, there was no such thing as an "Algerian Jew"—didn't prevent him from using his racist pen to pathologize their difference, insulting them on page after page.

Our ancestors may have had psychoses, but not of the kind described by Trenga. Colonial disorders, as you taught me, are never just individual pathologies. If you had not died so young, maybe you could have revised your text about colonial disorders to include the Algerian Jews. Maybe you could have analyzed the long-lasting effects of the amputation of Jews from Muslims, and this amputation's role in both groups' shared colonial disorder.

I think about my father's return from the hell of the French internment and forced labor camp, and later his service in Europe as part of Second Armored Division, Twenty-Second Colonial Group of FTA during World War II, when he was segregated from his French battalion-members de jure and de facto. Upon his return, he discovered that his French citizenship had finally been reestablished almost one year after the landing of US and British troops in Algeria, but everything else was the same. And as much as he wanted to be French, he was not. He had nowhere to express what the French had done to him and to his family, since he was, again, officially French and again at the mercy of those who abused them. You were not yet in Algeria—how could you have known?

In case four of the first series of cases in *The Wretched of the Earth*, you describe how "a European policeman in a depressed state meets while under hospital treatment one of his victims, an Algerian patriot who is suffering from stupor."[17] The policeman cannot sleep at night since he hears the piercing screams of those he and his peers had tortured during the day: "Now I've come so as I hear their screams even when I'm at home. Especially the screams of the ones who died at the police headquarters." One day you found him devastated, after he stumbled upon one of your other patients, "who had been questioned in the police barracks." When you understood that the policeman "had taken an active part inflicting torture on [the] patient," you hurried

to "where the patriot was being cared for." The "personnel had noticed nothing," but the Algerian patriot had disappeared. After a while you discovered the Algerian patriot "in a toilet where he was trying to commit suicide." This is how you wrap up the case of the patriot: "The personnel spent a long time convincing him that the whole thing was an illusion, that policemen were not allowed inside the hospital, that he was very tired, that he was there to be looked after, etc."[18]

You saved him from committing suicide, but you prevented him from confirming the truth: that his anxiety was well-founded, that this policeman who had tortured him was here, in your hospital. Was it you who didn't tell the staff about your policeman-patient's involvement in the patriot's torture? Was it the staff's decision to shield the patriot from the reality that under colonialism, even the hospital is not safe? Or did you not find the courage to tell the staff they had done wrong? It seems, though, that you wanted your readers to know that even in the space of the clinic, reality, as it was experienced by Algerians, could not be confirmed. I'm having difficulty finding the right words to say so, but I think that this is the role that citizenship plays in relation to the Jews: an illusory trick. Whenever they tried to protest, they were and still are told, "But you are citizens!" And so the reality of the Jews' colonial pain was denied. And even when they had to leave all of their ancestors in their cemeteries, fleeing Algeria like thieves in the night with barely any belongings, they were told, "But you are citizens and it was your wish to become so!"

You see, dear Frantz, my ancestors in Algeria were not "Europeans," but, at different moments and for different interests, they were counted as "Europeans." I suppose you could not have understood this properly, since your informants were Jean-Paul Sartre and then the two Jews whom you befriended and worked with in Blida, none of whom revolted against their European categorization. You forgot—as they did—that they were colonized. They were acting in the role of interpreter, the tiny educated elite selected by the colonial state as informants. Interpreters are products of colonial aphasia and suffer from it too, for in the civil context, the role comes with a "certain status" that makes those performing this role forget that they, too, are colonized.

Letter 4. "With all my being, I refuse to accept this amputation"

Your two colleagues in Blida, Jacques Azoulay (who has no family relation to me that I know of) and Alice Cherki, didn't forget about French colonialism. This was the basis for your collaboration. But they did forget—in order to live as "new Christians," i.e., French citizens—that they, like their ancestors, were colonized not just when the French arrived in Algeria in 1830 but also through their citizenship status. And they especially forgot that they could still resist. Cherki writes about the Jews in the third person, as if she were a UN observant: "Rightly or wrongly, they [Algerian Jews] were classified as European by virtue of their political status."[19] Azoulay seems even more inclined than Cherki to deny that his Frenchness is the symptom of his ancestors' colonization. *Malgré eux*, Azoulay and Cherki's role in the colonial schema was that of the interpreter.

You, who arrived as a foreigner, spoke only the language of the colonizers. You wished to avoid having French settlers on your team and, at the same time, sought colleagues who, having trained in the French psychiatric system, could understand your desire to transform its premises. Your Jewish acquaintances, who were also natives to this place, and especially those who had anticolonial political ideas similar to yours, were a perfect fit.[20] Had it never occurred to you that you were all colonized by the French? Or that they too were deserving of decolonization? Or that they too were deprived of the words to acknowledge their situation? Did it ever cross your mind that the tacit covenant that bound you together was the bond of three colonized subjects who could not acknowledge themselves as colonized? If you could only have talked about it, all this could have come to light and guided you on how to *speak to the rock* of colonial power with words that would make the *second hit of Moses's staff* unnecessary.

Like Moses,
 it seems that you had to die before reaching the promised land
 of decolonization.
Cherki and Azoulay, too, were barred from entering it.

 I don't know whether Moses was barred from the promised
 land

because he was punished for his blunder,
or if he was saved from entering so as to be saved from seeing
what awaited him there.

I do want to speculate.
Given the fate of Algeria after decolonization, you were saved
from seeing how Algeria embraced the double myth of the
One—Arab and Muslim.

Allow me to further speculate: if you, Azoulay, Cherki, and
others could have entered—or actually stayed in—Algeria,
the myth of the One would have become impossible.

That Jews could not eat figs and pomegranates with Muslims,
I venture to say, was the first sign that the promise of the
promised land was broken.

The expulsion of Algerian Jews encroaches upon all Algerians'
being.
You were spared the image of the forced departure of the Jews
in 1962:
mortified, chastened, and crushed.

I truly cannot understand how you could ignore the fact that Algerian Jews were also colonized, and that citizenship was imposed on them precisely to prepare them to act as interpreters. Your disavowal is even more troubling given the long discussion of "the Jews" in your otherwise incredible *Black Skin, White Masks*, where "the Jews" become a unified category. This abstraction elides the histories of diverse Jews whose individual communities were destroyed in order to make up the collectivity, "Jews," to which you refer. It seems that you inherited this category from Sartre, for whom Algerian Jews don't seem to exist. Your later encounters with Algerian Jews didn't seem to impact this heritage.

And yet, I know you knew we existed. Cherki mentions the role she and Azoulay played in introducing you to the Algerian Jewish community:

Letter 4. "With all my being, I refuse to accept this amputation"

Jacques Azoulay and I, as well as others, helped introduce Fanon to the Algerian Jewish community. While in France, he had on more than one occasion claimed that as a minority he identified with the "Jewish condition," but he knew very little about the history and local culture of Algerian Jews.[21]

But why could you see us only as a "condition"? Relating to the "Jewish condition" instead of real Algerian Jews means naturalizing a certain abstraction produced by the taxonomizing logic of French colonialism: the conversion of a diversity of Jews into a single people living under a single condition. Though Cherki doesn't explain why she puts this idiom—the Jewish condition—in quotation marks, I read it as indicative of the uneasiness that an Algerian Jew like herself might feel about this generalization. Under a generalized "Jewish condition," differences in skin color, clothing, languages, prayers, habits, crafts, music, narratives, medicine, and hygiene could all be organized along a hierarchical ladder oriented in favor of French embourgeoisement. It should be said, explicitly, that not only were Algerian Jews not "Europeans," they were not "European Jews" either, but Arab Jews, Muslim Jews, or Berber Jews, like Cherki herself. Cherki distinguishes herself from Azoulay, who speaks about Algerians as Arabs while excluding himself from this identity, as if Algerian Jews were not Arabs too. Being an Arab Algerian, for Azoulay, meant being Muslim. Indeed, it was with you, Cherki writes, that "Azoulay discovered that there was such a thing as 'a Muslim cultural identity' and that it was important; that there was a link between cultural oppression and aspects of psychopathology."[22]

Cherki knows very well that our elders were part of Algerian culture. For them, she writes, French was "the language of politics and commerce, [while] Arabic and Hebrew, often conflated into the local Judeo-Arabic dialect, were the languages they used to speak about emotions, books, spirituality and moral values." She is also aware that colonialism made the young expect their living elders to hide their "Arabness" when in their company. Thus, for example, those elders who opted to dress in European clothing only when they had to go to administrative services

would also wear such clothing to the "wedding of a modern grandchild."[23]

In an interview with Cherki, Azoulay tells her what he learned from you: "Fanon's intellectual approach enabled me to apprehend a content that I would otherwise consider folkloric."[24] Do you hear what I hear? Do you realize how much Azoulay had made the colonial gaze his own? Only when you both roamed the country (Numa Murard describes your field trips: "Fanon drags Azoulay behind him in the villages") in search of "the social life of the Algerians and the way in which they deal with madness"[25] that Azoulay truly saw the culture and habits of "Arab society." Yet of course, if he were as foreign to it as he implies, you would have asked someone else to accompany you in your explorations: you chose him because he could show you around the land of his ancestors. He learned from you to recognize the particularities of Arab society as "culture," but he did not recognize it as his culture. Nor did he see your field trips as an opportunity to reclaim what colonization had made seem foreign to him. I see symptoms of the colonial syndrome in Azoulay's reference to his grandparents' Arab culture as "folklore." And you? You had to believe that "the Jews" were not indigenous in order to ignore the extent to which Azoulay had interiorized the colonial gaze, which you were so attuned to in your Muslim patients.

Our ancestors—this also includes Jacques Azoulay's—were colonized in 1830 and racialized as Jews. This meant the Arab and Berber in them had to be exorcised, and that they had to be dissociated from their Jewish Muslim world, even as they remained physically part of it. When my father was born, neither of these identities or senses of belonging—neither "Algerian" nor "French"—was obvious to him. Part of the North African syndrome's symptomology was the loss of the obvious: it was no longer possible to simply be part of society without having to prove one's *authentic* identity.

It is no surprise, then, that my father sought to escape the hostile environment that Algeria had been made to be and was even willing to join French military units to fight the Nazis and their French collaborators. It is likely that my father would

Letter 4. "With all my being, I refuse to accept this amputation"

disagree with my diagnosis that he suffered from colonial disorder; he never spoke about himself in such terms.

However, as his daughter, I recognize how his colonial disorder was transmitted to me, even though I was born outside of Algeria. I am the fruit of his third attempt at escaping colonial alienation, when he moved to the Zionist settler colony. The signature of this transmissible disorder is a state-sponsored ignorance that cultivates denial of one's circumstances and a general disorientation. This makes it harder for its inheritors to understand the causes and origins of their malaise. It took me several decades to see that I am a product of what I consider today to be the mass kidnapping of babies from the Jewish Muslim world. Due to a transmissible colonial disorder, our parents surrendered us to the Zionist project that gave us a surrogate history to call our own. We recognized this surrogate history as ours from the moment we first opened our eyes. When I was able to gradually differentiate myself from this history, I realized how little I had left to reconnect myself to the world of my ancestors, to Algeria, North Africa, Africa, or Andalusia.

Like you, dear Frantz, "I refuse to accept this amputation" of my history and my self that colonialism has wrought. Part of my refusal means recognizing other types of kinship, kinships of *anticolonial care*, the kind that this epistolary journey rehearses and renews.[26] Isn't this the sort of kinship that guided you when you chose to join Algerians in their struggle and to identify yourself as an Algerian? My choice to recognize myself in my ancestors' identities is part of practicing this kinship of care, care for the world that we are being told no longer exists and will never exist again. I connect this care with a commitment to inhabit my ancestors' world and refuse to accept that it is "past."

The story of one of your patients, case two in your second series of cases, conveys how disorienting colonialism's forced mass conversion was. Once the Algerian Revolution started, even though your patient was not interested in politics, he was caught: he had to be either an Algerian militant or a traitor. He was haunted by this colonial either-or approach to identity, and, because he had not joined the FLN, he started to believe that everyone, including his parents, saw him as a traitor. Desperate,

he moved to the European neighborhood, as if to confirm that this was who he actually was—a traitor. "His physical appearance," you write in his case description, "seemed then to safeguard him against being stopped and questioned by the police patrols." In parentheses, you explain: "He looked like a European." Other Algerians who walked in this same neighborhood "were arrested, maltreated, insulted and searched." His drama was the opposite; he was Algerian but went unnoticed. As you write: "This uncalled-for consideration toward him on the part of the enemy patrols confirmed his delusion that 'everybody knew he was with the French. Even the soldiers had their orders; they left him alone.'" Only when he acted as an Algerian, that is, when he tried to challenge the presence of armed French soldiers in his city and to steal their machine guns, was he treated as one. He was arrested and tortured. After a few days of torture, the truth was revealed: he was neither an FLN militant nor the embodiment of the "new Algeria"; rather, he suffered from a colonial disorder. As you remark, "During the year 1955, cases of this type were very numerous in Algeria."[27]

Reading the different "cases," we can easily understand that the disorder experienced by your male patients was a colonial pathology. However, there is the glaring absence of women in your case studies. While several rapes are accounted for in the cases, it is clear that these are but a fraction, given the pervasive deployment of rape by French soldiers against Algerian women.[28] Who helped these women during the colonial war, before it, and when it was over? Were they supposed to celebrate their Algerian citizenship when the war was over? Were they supposed to forget about these rapes so that every once in a while, the rapes could be "rediscovered" in the French press amid a fresh burst of outrage? I am gratified that though you didn't treat the women who were raped, you included and acknowledged accounts of rape in the cases you discuss.[29]

I have a question that I haven't found addressed in the literature on rape, and I want to share it with you. It is related to a broader *democratic aphasia* that still impedes us from recognizing that everywhere democratic regimes are built upon mass rape. We know that colonial rape in Algeria didn't start with the

Letter 4. "With all my being, I refuse to accept this amputation"

war's onset; Algerian women were raped in the first decades of colonization. That Jews were among the victims of this colonial violence, including rape, never became an object of study. Is this because, as presumed "French citizens," their rapes were not seen as part of the larger colonial violence perpetrated by the French?

Hosni Kitouni, an Algerian historian whose research focuses on the first decades of colonization, confirmed my intuition, noting that there is very little information about Algeria's Jews between 1830 and 1870, except some scattered references that single them out and stigmatize them.[30] In reply to one of my questions, he wrote: "While the counting of the population effectively distinguishes its different components: Arabs, Kabyles, Jews, Kouloughli, this distinction disappears in the accounts of the conquest war. However, the Jews lived among the populations targeted by the repression. Thus, for example, rarely are the Jews mentioned among the prisoners, or among the despoiled, etc."[31]

Do you remember the story of B? He was an FLN militant who came to you because he suffered from insomnia and persistent headaches. One day he learned, through a message he received from his wife, that she had been raped and beaten by French soldiers. You share his story: "For several months he had heard many stories of Algerian women who had been raped or tortured, and he had occasion to see the husbands of these violated women." Not only did he feel that his wife had "tasted the French," but he also had "an irresistible impulse to tear up a photo of his little girl." That girl, he told you, "has something rotten about her." He also told you: "While I was looking at the photo of my daughter, I used to think that she too was dishonored." In a few sessions, he stopped seeing the sexual violence used by the French against his wife—and maybe against his daughter too—as capable of splitting his family's life into two irreconcilable phases: the before and the after, the pure and the rotten. From thinking, "Oh, well, there's not much harm done; she wasn't killed. She can start her life over again" (but obviously not with him), B came to realize that "they'd raped her *because they were looking for me*." He expands:

It was to punish her for keeping silence that she'd been violated. She could have very well told them at least the name of one of the chaps in the movement, and from that they could have searched out the whole network, destroyed it and maybe even arrested me. That wasn't a simple rape ... it was the rape of an obstinate woman, who was ready to put up with everything rather than sell her husband. And the husband in question, *it was me*.[32]

The manifestation of B's colonial disorder is his initial identification of the colonized with the colonizer's deeds, of his wife and daughter with what the French soldiers did to them. His cure was in recognizing his wife not as disposable but as his political ally against the French. He saw her as one who didn't force him to be indebted to her, but rather freed him from their alliance: "She didn't say to me 'Look at all I've had to bear for you.' On the contrary, she said: 'Forget about me; begin your life over again, for I have been dishonored.'" B decided to "take my wife back after the war," for now they could cure their respective wounds together, as he'd seen other Algerians do: "I've seen peasants drying the tears of their wives after having seen them raped under their very eyes ... I've seen civilians willingly proposing marriage to a girl who was violated by the French soldiers and was with child by them."[33]

There is something else I want to bring up. In 1962, one year after your death, your revolutionary proclamation, "the old Algeria is dead,"[34] materialized with the formation of a newly constituted Algerian state. However, most of the state institutions were not "new" but were inherited from the colonial state. New man, new people, new nation—all are dangerous projects, especially when pursued by self-nominated leaders who feel authorized to pursue the new against the desires of others. If only your sensitive care for your patients could have tempered this deluded investment in the idea of the new man, Algerians might have translated your therapeutic practice into a political theory of decolonization! And we, Algerian Jews, Muslim Jews, would not have become invisible, "over." In 1962 all Algerians deserved healing of all sorts from the hell of colonization, not just from the war for independence.

Letter 4. "With all my being, I refuse to accept this amputation"

One of the first actions of the Algerian state was to displace populations in order to make way for the new. The Jews were not expelled with force, but they were made to depart, for it was made clear to them that they could not safely stay in Algeria. Unlike the dhimmi contract that was essential to traditions of Islamic law and protected non-Muslim populations, the Jews were not even mentioned in the Évian Accords, out of which the independent Algerian state was born. *Well, there wasn't much harm done; they weren't killed. They could start their lives over again, elsewhere.* The new Algerian state saw Algeria's indigenous Jewish population leaving and joined with the French in France, and it didn't object to the depiction of the displaced Algerian Jews as *pieds-noirs. Quelle honte! Quelle tragédie inavouée.*

Dear Frantz, imagine decolonized Algeria refusing to sacrifice its Jews for the Euro-Zionist Molech, setting an example for other Muslim countries who failed to stand against the pressure and actively expelled their Jews, or encouraged their collective departure. Imagine the dying colonialism of the Euro-Zionist project ...

Wherever they landed outside of Algeria, however, our ancestors were recognized as Algerians, not as French or Europeans. In France, Canada, or Israel, differences between "old" and "new" Algerians were undetectable—they were all equally Algerians, "Arabs." And those who tried to deny their Algerian identities and identify as French were seen as wannabe Frenchmen, pitiful. Writing about this brings tears to my eyes. I didn't always feel this sadness. It took years for this wound, which my father either ignored or buried, to be reopened in me. Sometimes I just want to send postcards with this notification: *French citizenship was forced upon our ancestors. It didn't end our colonization.*

Can you recall, *cher* Frantz, during your service as chief of staff at Blida-Joinville, a single moment of apprehension in which you understood that the "European" patient facing you was actually a Jew?

Neither a European, nor a European Jew, but an Algerian Jew?

I wonder if such a moment could have altered your admiration for self-fashioning, your desire to bury the "old humanity" and birth a "new humanity" and a "New Man."

Could we, dear Frantz, see eye to eye? Can we agree that it is

an abduction when foreign citizenship is bestowed on some to sever them from other members of their people? Could we see, dear Frantz, how the abduction facilitates the transfer of babies from one world to another?

Sometimes, I imagine myself as a gleaner, gleaning at the edges of a vast field, searching for the signs of my ancestors' refusal to be converted, proofs of this secular inquisition.

A Poem of My Academic Exhaustion

In your essay "Algeria's European Minority,"
you dedicate a few pages
to the Jews.
You already know
what I think about
putting my ancestors
in this category—
so I won't repeat it.

I return to these few pages,
since there is enough
in the margins for me
(bereft of ancestral resources)
to glean. My ears,
not unlike your pen,
are guided by those verses from Leviticus
on how to care
for those who do not have:

"When you reap
the harvest of your land,
do not reap to the very edges
of your field,
or gather the gleanings
of your harvest."

You didn't edit out
the data you gathered

Letter 4. "With all my being, I refuse to accept this amputation"

> about them,
> even when you were unsure
> what it meant.
>
> You left these numbers, records, details,
> for the poor
> and for the foreigners
> residing among you.
> Being foreigner to my people, I am grateful.

I wrote this short poem for you so that you could hear my academic exhaustion. I'm not a psychiatrist, but I also see symptoms of the colonial disorder from which you suffered, especially when you complied with the command to see us as Europeans. I bet that if an Algerian Jew had told you "I'm not a European!" you would not have insisted that she was one; instead, it would have led you to reconsider your stance. Well, here I am!

I bet that if we could talk, I wouldn't have to say much for you to recognize me as an Algerian, and for you to understand how the French citizenship conferred upon my Algerian ancestors was a forced conversion. I'm so eager to know if what I'm writing to you resonates.

Were you worried that questioning whether "Jews were Europeans" would tag you as an anti-Semite? Is this what led you to leave the Jews outside of your short history of plunder and imperial enrichment in *The Wretched of the Earth*?

> The well-being and the progress of Europe have been built up with the sweat and the dead bodies of Negroes, Arabs, Indians and the yellow races.[35]

Europe's enrichment from Jewish sweat didn't start with the Nazis. It dates back at least to the Jews' expulsion from Spain and Portugal.

It is not that I think that the Jews should be included in every discussion about European colonial history, but there are some discussions in which their absence is troubling. Your and Jacques Azoulay's reluctance to acknowledge that you too were colonized

and suffered from symptoms of the colonial disorder you diagnosed in your patients was a methodological error. After all, we know from your work that as long as colonialism is in place, no colonized individual can be out of this disorder's reach. This is probably what makes this non-psychiatric epistolary engagement with you feel so urgent to me.

In your writing, you defied the white colonizers' characterization of Black people as uncivilized, writing, "I belonged to a race that had already been working silver and gold 2,000 years ago."[36]

I belong to a race that, for centuries, was dispersed and resisted assimilation into a single historical subject ("the Jews"). *I belong to a race that,* for centuries, resisted incorporation into an expansive body politic that could command its members to become warriors or rulers with the power to command others. I am not echoing you: I say you speak for me too.

It was the Jews who were the majority of jewelers in the Muslim world, who developed "various techniques of goldsmithing and implanted their style in magnificent jewelry and other objects" for ritual and daily ceremony.[37] Since I learned about my descendance from the Jewish jewelers of the ummah, I've immersed myself in my ancestors' jewelry-making and practices of adornment. I look at those gorgeous beads and pieces of metal, and I trace, copy, pierce, fold, saw, carve, chisel, hammer, thread, and string. I'm not a professional jeweler: I simply concentrate on these objects and imagine, rehearse, and incorporate the gestures that I would have had as my birthright had I grown up among my ancestors.

I simply could not restrict this discovery about our ancestors to textual knowledge. Embodying it meant appealing to my muscle memory. My father's dexterous hands appear to me, every once in a while, as a bridge I didn't know existed between these once-unfamiliar gestures and me.

I cannot deny the therapeutic features of this activity, which I think explains my father's investment in working with his hands all his life. He could not stay idle. However, if he were in your clinic, and if you had invited him to work with wool, alfa, or raffia, as you asked the Muslim men in your medical ward to do, he would have refused just as they did. The memory of being

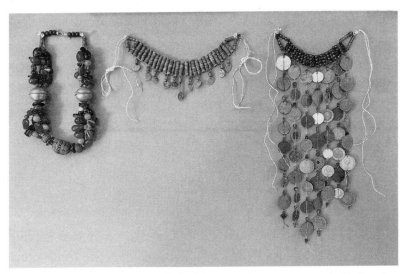

Rehearsing ancestral craft-making. Jewelry reproduced by Ariella Aïsha Azoulay.

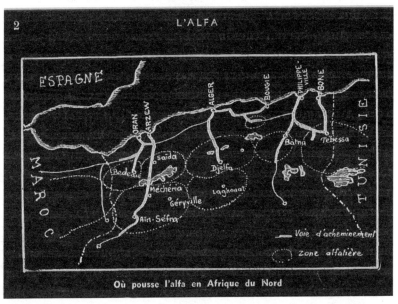

Colonial map of extraction of alfa from Algeria, early twentieth century.

forced to pick alfa in the Bedeau camp for the French to produce paper out of it was not easily expungable. This would not have been because "baskets and mats are produced by women," but because convening indigenous people in a French facility and requiring them to make crafts with no clear purpose would have been too eerily familiar to what he and other patients recognized

had been going on for decades in French establishments where Algerian labor and knowledge were extracted. One well-known example of this was the embroidery schools for girls, where the hand-crafted products the indigenous girls were making were sold in the market. In these schools, very young girls were commanded to hold a pencil in their hands and spend hours tracing, as one report from 1907 put it, "parallel lines, and squares, and diagonals inside these squares, and broken lines that modify these rectangles and diagonals and so on and so forth up to complicated designs that are found in the main models of carpets and are more or less common to them."[38]

When I started to understand the constellation of craft-making in Algeria, I recognized how craft division intersected with other group divisions. From there, I was able to understand that I am a Muslim Jew, belonging to the jewelers of the ummah, and not to a nation of warriors (the Zionists) that tore me away from my families, country, and gods with, as your predecessor Aimé Césaire put it, "a savagery unparalleled in history."[39]

I belong to a race that, for centuries, lived in small-scale, autonomous communal formations, undertaking different mutual aid initiatives and projects of care. Though mainly Muslims ruled this world, the Jews were organized as a "semi-autonomous corporate community functioning on the basis of religious law," a community that was also shaped through its "interaction with the Muslim court system."[40] They were part and parcel of this world, and their care for it was expressed through the different crafts they mastered and taught to their descendants: tailoring, shoemaking, butchery, lamp-making, scrivening, gold-thread-drawing, and jewelry-making. Their work with precious metals was one of several skills that allowed them to simultaneously be *part of* and *apart from* their fellow world-members. This is what made of them jewelers of the ummah.

Being a jeweler of the ummah meant that one was a carrier of the memory of shared traditions and had the ability to retouch, to repair. This was one's mode of being in the world. These principles were expressed not only in the objects jewelers made but also in the guilds and other more casual formations of which they were members. They cared for the world's well-being. These material

Letter 4. "With all my being, I refuse to accept this amputation"

activities rooted them in a cyclical temporality of renewal and shielded them from the destructive temporality of progress, which the conferral of French citizenship corroded. What you learned about Muslim society when you and Azoulay toured the country inquiring into the forms of sociability in traditional Muslim society was also what characterized traditional Jewish society in the exact same place. In this society of shared tradition, you and Azoulay observed that religion was "in effect, apart from a philosophical belief, a rule of life that strictly regulates the individual and the group." You even say "in Muslim countries," but you think only about Muslim *peoples* when you say, "religion impregnates social life and gives no consideration to secularity. Rights, morality, science, philosophy—all mingle with it."[41] But Muslim countries hold non-Muslim peoples too.

As you write in your short account of Algeria's Jews, three-fourths of all Algerian Jews still lived under traditional societal formations and had "only a poor knowledge of French, considering [themselves] by tradition and sometimes by dress as authentic 'natives.'"[42] The remaining one-fourth of Jews consisted mainly of civil servants and tradespeople, forming a certain bourgeoisie "avid of distinction," as Sophie Bessis describes the correspondent group in Tunisia. This group embraced conversion as willed assimilation, and their desires were often assumed to be representative of what "the Jews" wanted, or wanted to be.[43] Yet even among this group, it would be wrong to assume that all were willing to convert, or to assume that all believed that the colonial condition of their conversion disappeared because they were recognized as citizens. Providing their children with better chances for education, better professional opportunities, and a better quality of life played an important role in enticing the Jews to convert, for the world, they knew, was largely unsafe for them.

Attending to the innuendo of colonial relations matters, since it enables us to unlearn the imperial categories reproduced in our accounts. And so, dear Frantz, I want to talk to you about how you wrote about Algeria's Jews. Since you didn't conceive of the Jews as part of the colonized, you also accepted, as an ontological fact, their separateness. Early in your essay "Algeria's European

Minority," you write: "A first group of Jews has bound its fate very closely with that of the colonial domination."[44] I wonder on what basis you dissociated them from an equally tiny Muslim elite, which also "bound its fate very closely with that of colonial domination"? After all, the creation and identification of a class of indigenous interpreters and colonial servicemen didn't start in 1870 when the Jews were turned into French citizens, but at the beginning of colonization in 1830.

Innuendo is immensely important here because to identify it and challenge it is to restore the existence of a Jewish Muslim world whose existence is erased in retrospect. Though destroyed, this world should not be depicted as already and forever gone; so much of the historiography on Algeria is marked by a conflation between what the colonial regime aimed to achieve and what still exists.

The term *harki* is used to designate Muslims who were recruited as auxiliaries of the French army during the Algerian war. This common way of defining those colonized, forced-to-collaborate subjects was determined by three imperial dividing lines: time (the Algerian war), space (the French military), and body politic (Muslims). But is *harki* not the basic condition of all colonized subjects throughout history, who in one way or another are forced to collaborate with the regime that rules them? Isn't it fundamental to the colonial condition that the colonized are forced to inhabit a world imposed by the colonizers and, only at certain moments and under particular circumstances, can negotiate their situation, overtly and publicly resisting these colonial impositions? The anticolonial challenge to colonial citizenship is, first, to find evidence that not all the members of a captive group, like the Jews, willingly embraced their conversion by decree. Second, it is to show that being *harki* is a pervasive condition more than a matter of individual choice. Without imposing a general condition of *harki* on all its subjects, settler colonialism could not sustain itself.

I want you to look with me more closely at the first of the three imperial dividing lines, time. What colonialism aims to destroy are the principles and formations that enable communities to care for their worlds over centuries. One such form of care, for

Letter 4. "With all my being, I refuse to accept this amputation"

example, was the attempt to reflect the cyclical temporalities of the world's different components and inhabitants. Cyclical time impedes colonial capitalism's expansion, premised on the imposition of temporality of progress, a major organizing principle of settler-colonial life. This temporality is instrumental in turning colonial extraction into a fait accompli and socializing descendants of both colonizers and the colonized alike *to look toward the future*—as if "the future" were a real place ahead of them. Thus, regardless of the circumstances under which something comes into existence—for example, the Central Jewish Consistory of France, a patriarchal central administrative system established in Algeria in 1845 to "regenerate" Algerian Jewry—its status as an innate Jewish institution is already unquestionable, un-abolishable. Progress works like a pipeline and doubts will stop the flow. "Partition"? "(Differential) citizenship"? "Final solution"? From the moment such decrees or resolutions are conceived, the work of colonialists is to find practical solutions for their implementation. Imperialism obliges.

Anticolonial aspirations to transform the future are different from the future-oriented claims of imperial projects, but the acceptance of colonial temporality involved in *transforming the future* collapses them together in unsettling ways. It requires potent and demiurgic actors, colonialists and collaborators empowered to impose their inventiveness and creativity on others, through ideas premised on imperialism's violent license to destroy and disguised with the pioneer ethos that "the sky is the limit" for development and extraction. Such visions devised by statesmen, jurists, architects, archivists, or historians necessarily infringe upon the visions of others unschooled in empire's institutions of progress. In the imperial human factories that produce people and provide them with history that is not theirs, futures are also manufactured to impose upon these people. For those who *make* this history, it is *theirs*; for the majority upon whom it is imposed, it is *not theirs*.

Is the only way to escape the human factory by tasking the colonized to *make history*? "Old Algeria is dead!" is a scary call that no one in precolonial Algeria would have dared proclaim. Obviously, the world made by the colonizers ought to

be dismantled—but does the history of Algeria start with what the colonizers imposed? For what the colonizers did when they arrived in Algeria was proclaim that "old Algeria is dead."

I cannot ignore the colonial overtones when I read what you wrote about *our* ancestors: "The men and women of Algeria today resemble neither those of 1930 nor those of 1954, nor yet those of 1957 ... We witness in Algeria man's reassertion of his capacity to progress."[45] People do not progress. That is a colonial myth. Our ancestors' failure to stop the colonizers' genocidal violence testifies more to the nature of that violence than to our ancestors' capacities. If you had known Algeria post-independence, I'm not sure you could have ignored what this war did to the Algerian people, how much of the violence exercised by Algerian patriots during the war when the target was justified, sedimented and shaped independent Algeria. Unlike common narratives of the war that identify the beginning of Algerian resistance with the creation of the FLN, our ancestors opposed and resisted from the very beginning, as much and for as long as they could, in many different ways.

The ongoing struggle to *rematriate* from French museums the skulls of five hundred Algerians who, during the first decades of

A skull of a Jew from Algeria, No. 255, Collection: Potteau, Anthropology, Musée Quai Branly, Paris [image redacted by Ariella Aïsha Azoulay].

Letter 4. "With all my being, I refuse to accept this amputation"

the colonization, opposed the French invasion, is a chilling proof —if any is needed—of the longevity and resilience of their struggle.

Scholars usually argue about your position on violence, which I find to be brilliant for your insistence that violence is never an isolated event about which one can take a simple side. I'm troubled, however, that your thinking on violence does not seem to inform your definition of decolonization, and how you associate it with the "new," how you counterpose it to the "old." In *The Wretched of the Earth*, this division seems unavoidable, even desirable. There is no doubt that French Algeria had to end, but to escape the imperial fashioning of a timeline bifurcated between the "old" and the "new," decolonization should have been envisioned as a reparative process of disentanglement from imperial webs. Decolonization should have meant not the violence of claiming a "new" and agreeing with the colonizers that "old Algeria is dead" but rather the painful yet blissful work of reinhabiting precolonial fabrics and mending the tears where worlds, ideas, communities had been severed. The apocalypse of the new seems to be fashioned by a revolutionary imagination inherited from the French Revolution: the idea that each revolution inaugurates a "new" era.

The "new humanity" you refer to when you write that "decolonization is the veritable creation of new men"[46] is the epitome of the colonial disorder—maybe even its origin. After all, it was shortly after the French Revolution that the new revolutionaries undertook their colonial wars to propagate their ideas about the new man and citizen. The settler, you write, "makes history ... he is the absolute beginning." But the settler in question is French, and even before becoming a settler, he *made history*, putting himself, i.e., man, as "the absolute beginning," the revolutionary year zero. Is this what the colonized want, or want to be? Man?

It's different when, in *Black Skin, White Masks*, you express an individual desire "to be a man among men."[47] Here, the desire to be a man is a response to a racist society in which "man" was the dominant category by which people recognized themselves as deserving of dignity. This same category was used as an instrument of abuse—through its refusal—against members of racialized groups. And yet—the negative desire *not to be*

racialized in all spheres of life cannot be the only meaning of decolonization, nor the centerpiece of its imaginary.

However, this man became a rallying cry for you several years later in *The Wretched of the Earth*: "Decolonization is the veritable creation of new men," you argue, and explain how it works: "The 'thing' which has been colonized becomes man during the same process by which it frees itself." The colonized were neither thing nor animal and never fully interiorized the colonizers' perception of them: "The native knows all this," you wrote, and "laughs to himself every time he spots an allusion to the animal world in the other's words. For he knows that he is not an animal."[48]

So how did the status of the colonized as a "thing," a status assigned by the colonizers, survive as a viable point of departure for the project of decolonization? Why reach back only far enough to disprove the settlers by claiming that becoming "man" is the end point of decolonization? Don't we want to go farther back than this? In this same essay, you admit that "the atmosphere of myth and magic frightens me," but you nonetheless recognize indigenous people's power to integrate the colonized "in the traditions and the history" of their tribes and give us a different type of status, "as it were an identification paper," one in which we could recognize ourselves among others.[49] So, I ask you: Don't we want to go back to our "myth and magic"?

Miraculously, given the extent of the violence used against them, the colonized often succeeded in transmitting something of who they were—even of their magic and myth—onto their children, despite the way colonial violence had "thingified" them. I almost dismissed this in my father. His world, in which he used to recognize himself and in which he was recognized, was fatally injured, but it was not fully erased from his body. "Africa I have kept your memory Africa / you are inside me," Jacques Roumain writes in the poem that you quote.[50]

Decolonization, as I understand it, means withdrawing our investment in the human factories that produce people fit for "the future." It means that people are not models, and that worlds cannot be fabricated in factories.

Reading the proliferation of anti-Jewish sentiments in the

Letter 4. *"With all my being, I refuse to accept this amputation"*

Algerian press in the late nineteenth century is akin to watching a horror film, for indigenous Algerian Jews are trapped inside an identity that isn't theirs.

> Was this human experiment
> another form of colonial entertainment?
> Just a few decades
> before cinema was invented,
> the Jews were captives
> of a never-ending audition
> for a horror film
> in which their reward—citizenship—
> was the pretext
> for their persecution.
> Watching our indigenous ancestors
> try their best
> to seem French,
> citizens,
> was the settlers' pastime,
> those settlers who also provided
> the soundtrack:
> "Down with the Jews!"

Our ancestors were not asked but compelled to become citizens. On paper, this sounds as if they were invited *to be men among men*, citizens among citizens. But what was proclaimed with the paper (the Crémieux Decree) was materialized *only* on paper. The paper came from outside of Algeria and was, for a long while, rejected by the settlers who refused to comply with it. Their resistance came in the form of anti-Jewish slurs and hateful practices against their new cocitizens: insults, looting, massacres, protests, denunciations in the "free press," and attempts to incite the local Muslim population to see the Jews as invaders. Ferhat Abbas writes, "The anti-Jewish unrest of 1896 mainly expressed the colonists' desire to free themselves from the metropolis. Indeed, the cries of 'death to the Jews' disappeared as soon as Algeria obtained financial autonomy and the creation of Algerian assemblies."[51]

When the colonizers were in power, they could pass measures that ameliorated the condition of the colonized, presenting concessions as a kind of generous gift—and obscuring how their "gifts" had been extracted from colonized resources in the first place. Rather than "gifts," the concessions should have been understood as the beginning of a debt repayment to compensate for imperial violence. This colonial "generosity" is the basis of a major disorder that harmed our ancestors and was transmitted to us in the form of *democratic aphasia*. I take inspiration from Ann Stoler's discussion of colonial aphasia among French colonizers regarding their crimes, but I twist it to account for the colonized and reflect the particular status of the Algerian Jews. Aphasia, writes Stoler, is "a dismembering, a difficulty in speaking, a difficulty in generating a vocabulary that associates appropriate words and concepts to appropriate things."[52] In the case of the Jews too, it would be misleading to speak about "amnesia" and "forgetting" since the Jews didn't forget what the French had done to them but rather lived in a state of dissociation, unable to fully articulate or fully forget. How could it have been otherwise, given that French citizenship in Algeria is discussed as if it were not the colonizers' citizenship but a universal citizenship. Thus, when bestowed on Algerian Jews in order to mark their status change from protected non-Muslim as dhimmi to modern citizens, it provoked in them a *democratic aphasia*. The status change was both an act of forced conversion and an improvement in their place within differential colonial rule.

In 1870, they still remembered how in 1831 the French monarchy inaugurated the destruction of Jewish communities by suppressing "the autonomy of the Jewish nation, piece by piece."[53] Each and every such small community across Algeria was weakened in order to recreate its members as examples of one conglomerate, "the Jews." After four decades of disempowerment and synthetic grouping, "the Jews" were deemed ready for repackaging as a group fit for what the French considered their democratic institutions—most notably, assemblies and the voting system—institutions that enabled the French to run their colonies according to law and order.[54]

The French, Abbas writes, "did not fail to imprint on the

Letter 4. "With all my being, I refuse to accept this amputation"

whole of Algeria their conceptions and their domination." In this onto-epistemologically *French* Algeria, our ancestors were made precarious tenants. Only as precarious tenants could colonizers *give* them citizenship in their own country. Our ancestors were drained of their "ontological resistance" and became captives of their new citizenship status, fearing they might lose it (or lose it again) as they were made dependent on it. They started to speak about this citizenship as they were taught to—as an object of their desires—and repeated the confusion between emancipation (assimilation and conversion) and liberation (anticolonial or decolonial) to a point that they started to believe that it was they who wanted to become French citizens in their own country. When Muslim Jews said they were relieved by the improvements brought about by their conversion via citizenship—saying this in a tone of gratitude for what they had *received* from their colonizers—they demonstrated symptoms of their democratic aphasia. To put it simply, they lost, as Abbas asserts, what in 1943 their Muslim brothers were able affirm: "their right to live, their right to existence."[55]

To be in the world became entangled with embracing these expressions of democratic aphasia. They were socialized to think in their colonizers' terms, which took a cumulative toll on them and their ancestors and descendants. Losses, costs, wounds, scars, abuses, and harassments remained; Algeria's Jews continued to experience shame, forbidden desires, insults, or identity and family disorders. From one generation to the next, the aphasia was exacerbated rather than attenuated; children had less and less access to their family's eroded heritage, and they inherited a sense of denial that the French, whom they were taught to admire, were their ancestors' perpetrators and responsible for the ruination of their culture. They were often unaware that they suffered at all.

I recently read the military record of my paternal grandfather's service during World War I. I was full of joy when I found out that on November 23, 1913, he didn't show up when he was called for French military service. This was another sign I amassed in a growing collection of signs testifying that the conversion to Frenchness was a forced one rather than a welcome one. I am proud to be his granddaughter and to know that colonialism

didn't fully disrupt ancestral transmission, even if transmission took longer than it should have. Four months after he deserted, he was condemned to four months in prison. He had probably known he would be punished, but he likely preferred prison to being sent away from his family and community to kill others for the French.

Another sign was my great-grandfather's false testimony. Only one month after my grandfather was born (1893), his father recognized him. In order to do so, my great-grandfather had to trick the colonial bureaucracy by attesting that he was unmarried (*célibataire*). He was, in fact, married at that time to a different woman, through a Jewish religious marriage. Withholding the truth from the state is part of the colonized's silent resistance.[56] I don't know if this was a lingering polygamy that the French outlawed when Jews became citizens, but I suspect it was a kind of anomaly that existed in the intersection between French law and indigenous law, both Jewish and Muslim. It was common among Jews and Muslims not to share with the bureaucracy what could be used against them, as was the commitment to continue to maintain networks of support and mutual aid through the formation of extended families. I'm trying to track down even more episodes where my ancestors resisted the substitution of their Jewish Muslim conviviality, deemed past ("old"), with imperial formations ("new," "progress," "the future").

I tell you all this, dear Franz, because I want to persuade you to turn your focus from the future, from the new, which tethers decolonial thinking to the colonial project. Your investment in the future is stated in *Black Skin, White Masks*: "The structure of the present work is grounded in temporality. Every human problem cries out to be considered on the basis of time, the ideal being that the present always serves to build the future."[57] To counter colonization indexed by the future, decolonization requires our investment in rewinding, undoing, and unlearning the practices, structures, laws, institutions and principles that made this imperial future seem inevitable and the conviviality of the past hard to imagine. We must look for the residue of what can still be recovered and reclaim, revive, and reactivate that world. We must *return* to what colonialism has deprived us of.

Letter 4. "With all my being, I refuse to accept this amputation"

I am worried that these different temporal approaches are the basis of your understanding of race in your discussion of Jews in *Black Skin, White Masks,* or the origin of the different options you say are available to Blacks and Jews "to be[come] a man among men." You focus on the innate (in)capability of individuals to pass as such, while completely sidestepping the European project of assimilation through which the "Jewishness of the Jews" could "go unnoticed." As you say of the Jew, "He is not integrally what he is ... He is a white man, and apart from some debatable features, he can pass undetected."[58] Passing unnoticed was the protocol of forced conversion. While passing as white subsequently became an interiorized desire among many Jews, the transmission of resistance also continued, though sometimes in problematic ways. This campaign known as the "emancipation of the Jews," which began in the eighteenth century, commanded the Jews to pass unnoticed by presenting, speaking, dressing, loving, and even hating like secular Christians. In other words, French emancipation required Jewish self-erasure. They were not whites but were assimilated into whiteness only partially: forever-new-whites.

In *Black Skin, White Masks,* your discussion of race and Jewishness comes through your interpretation of Jean-Paul Sartre's *Anti-Semite and Jew.* As you write, you agree with Sartre's claim that "the Jew is one whom other men consider a Jew: that is the simple truth from which we must start ... It is the anti-Semite who *makes* the Jew."[59] Do you hear what I hear?! Insofar as the anti-Semite creates the Jew, it seems that it is the anti-Semite who disrupts the ability of the Jew to pass unnoticed, to enjoy the possible redemption of no longer being a Jew. But is this what the Jew wants or what the white Christian wants? Can we properly infer from the Jews of today, or the Jews of the 1950s when you and Sartre wrote these works, from Jews who were born into their conversion as a fait accompli, what "the Jew" (in the abstract) wants?

Unlike what Sartre implies, it was not the anti-Semite alone who made the Jew. Rather, it was those modern liberal European actors who engaged in "emancipating" *different* Jews, effectively destroying the small and distinct communities in which they lived

and turning them, first in Europe and then outside of it, into members of a cohesive historical subject whose members could go either noticed or unnoticed at the will of imperial actors. There is a strong parallel between France and Catholic Spain, which forced Jews and Muslims to become New-Christians and who persecuted them when they passed noticed or unnoticed, depending on the inquisitor. The imperial apparatus of conversion is fluctuant, with variable content and distinct expectations that are random and taxing: it forces people to act as individuals and, as such, to do things they would not do when acting as a member of a community.

In early-twentieth-century Oran, for example, where Jews could not usually pass unnoticed, the draft for WWI allowed Jews and Muslims to pass unnoticed by joining the French in their colonial wars and killing others. Military service during this war was tied to a European land grab in Africa and the rivalry between European imperial powers. My grandfather's refusal to accept the bargain was omitted from family memory and from history books, which speak about enthusiastic Jews who *chose* to fight in the First Colonial World War as Frenchmen. Was it my grandfather's adherence to an artisanal profession like butchering, which was still part of a Jewish Muslim world whose laws still prevailed, that empowered him to refuse? His actions say: *I am not French*.

Had your approach to the Jews not been shaped by Sartre and his European emancipatory project for us, such a unified conception of the Jews might have dissipated over the course of your multiple encounters with diverse North African Jews. You could have noticed what European emancipators did to Algeria's indigenous Jews. Did it occur to you that going unnoticed was not the aim of Algerian Jews? Or that what French colonialism actually deprived us of was not being *a man among men*, but rather, *being Jews among Muslims*?

We cannot discuss this desire *to be a man among men* without accounting for the imperial command to *be a man among men*! Inseparable from their efforts to deprive colonized and racialized people of regard as *men among men*, the same imperial actors also extended such a poisoned "opportunity" to the colonized. This power to determine how, when, and as whom racialized

Letter 4. "With all my being, I refuse to accept this amputation"

subjects could "pass" was the signature of racial colonialism. Since their "emancipation," Jews had not ceased to be noticed and unnoticed as Jews, Arabs, French, European, bourgeois, miserable, people of capital, usurers, scammers, artisans. And not much could help as their Jewishness became unconcealable under the Vichy regime, when the settlers invented and implemented anti-Jewish measures even before they were required of France by Nazi Germany. This conversion—the extension of such an "opportunity" to pass unnoticed and take advantage of the world the colonizers made for themselves—is a form of colonization, and it ought to be decolonized. This means the recovery of different modes of being Jews, modes that are not individual but collective, modes that do not involve inventing a new imperial nation-state, as Israel in Palestine.

Not taking into consideration these two modes of North African Jewish racialization—the deprivation of a convivial collective world, on the one hand, and the imposition of imperial citizenship-as-emancipation, on the other—your analysis of racism ignores part of the colonial infrastructure that shapes the mechanics of racism. Yes, certain Jews could pass as European, as white, more easily than others, but that didn't depend only on their physical traits (which were only partially reduced to skin color, as Jews too come in different colors). Following WWII, Europe's interest in the preservation of its colonies and attendant racial formations required Nazism and anti-Semitism to be narrated as exceptions, and the de-racialization of the Jews was given as proof of Europe's recovered innocence. Including Jews and supporting Zionists to have a state of their own became a way to continue to exclude racial others. Saying "Look, we support the Jews!" was a way for European states to keep using Jews as interpreters, mediators, and mercenaries of their colonial projects. It also gave Jews a way to pass unnoticed, mainly as national subjects—Israelis. The price, in your compelling terms, was the loss of our "ontological resistance" as Jews. The price was also the continuation of the imperial logic that had expelled the Jews from Spain in 1492 and colonized Algeria in 1830. The price was continued alienation for the Jews and violence for the Muslims who had been our sisters and brothers.

Upon reading your psychiatric writings about the two wards in the hospital in Blida-Joinville, the "Muslim" ward and the "European" ward, I wasn't sure whether to laugh or cry. You write that what enabled you to understand the psychiatric colonial condition in Muslim patients was the demographic organization of the patients in the hospital, such that "Muslims and Europeans were not mixed together."[60] Based on your experiments, you understood that a certain "cultural relativism" was required with regard to the Muslims. However, both you and Azoulay, the Black and the Arab Jew (or was he a Berber Jew?), performed as if you could pass unnoticed within a Western "we." Trying to understand the Muslim patients' lack of interest in theater, for example, you write: "The theatre as we understand it does not exist among Muslims." Who exactly is this *we*? Was not everyone in the hospital—including yourself, the staff, and patients—part of a much more complex reality than the colonial binary allowed? After you describe several failures to achieve the same results with the Muslims that you achieved with the women in the "European" ward, you describe a moving moment of success, when "a Muslim orchestra came to the hospital, played and sang" for all the patients. The Muslim women in the hospital, who on other nights were mostly reserved and "applauded in the European way," applauded differently upon hearing the Muslim orchestra: with "short, acute and repeated modulations."[61] You concluded: "Thus they reacted to the configuration of the ensemble, in line with its specific demands."[62] Certainly you achieved something here, but what was it?

A "Muslim" orchestra does not make sense, except during the Vichy years, when Jews were banned from playing and Muslims "filled the void left by Jews beginning in fall 1940."[63] Do you mean non-European? Arab? Berber? Did Jews and Muslims play as part of the same orchestra, as was common in Algeria, or were the players perhaps a mixture of Jewish and Muslim Berbers? That you didn't know is understandable, but that Azoulay perpetuates this ignorance is troubling. Could this have been part of his own performance to pass as European? Perhaps it could also be an effect of the spatial and conceptual configuration of your clinic, which implied that everything could be only Muslim or European.

Letter 4. "With all my being, I refuse to accept this amputation"

The applause of the women was a moment of grace, a moment of taxonomic failure. Could it be that listening to the local orchestra playing Algerian music, the Muslim women felt so *à l'aise* that they applauded freely in their own way, because among the "Europeans" in the audience of patients were also Berber and Arab Jewish women who applauded in a familiar way to the rhythm of the music? Perhaps such Berber and Arab Jewish women felt that they had finally been catered to with *their* music and therefore welcomed their Muslim sisters to join in applauding as they had been used to doing.

If your role in the Algerian revolution and its legacy were not that important, I may have felt less inclined to single out these oversights. But you understand, dear Frantz, that I cannot. I wish you had not had to *be a man among men* in these moments but could have been yourself, a Black man among Arab Jews, Arab Muslims, Berber Jews, Berber Muslims, European settlers, European refugees, and others.

I often wonder why you didn't say anything about *being a man among men* while in Martinique. In *Black Skin, White Masks*, you speak about the black man's belated encounter with white men: "As long as the Black man remains on his home territory ... he will not have to experience his being for others."[64] It reads as if Martinique had not been under colonial rule for centuries, as if racism existed in these individual encounters between Black men and French men in the metropole and was not inscribed in the colonies. Those whom the colonizers were invested in keeping unnoticed, unremembered, foreigners to their own land, were first the indigenous people. What made it so difficult for you to say that you were colonized? Was it that you were also a French citizen? Was it democratic aphasia? Was it only among Algerians in Algeria, a place where colonization could not be disavowed or sublimated, that you were able to act as a colonized subject and participate in the anticolonial struggle? Is this also the basis of your denial of how "the Jews" were colonized?

Your biographers count your three attempts to leave the hostile environment of Martinique under Vichy rule before you were able to join the French African Army in Oran. This was when my father was making his first escape from Oran. As you and my

father were both colonized and racialized subjects, the colonizers employed your bodies to fight their wars. They created an opportunity for you both to prove that you could become *men among men*. That you escaped the Vichy regime in Martinique is only half the story. The other half is that you responded to Charles de Gaulle's universal address, calling the children of empire to prove that France was not alone and that its colonized subjects were ready to fight for freedom whenever they were called. This was proof of your French republicanism. (However, this call was open to only some of the colonized. De Gaulle at first didn't want Jews in his battalions; too many anti-Semitic settlers still in office in Algeria, despite the official end of the Vichy regime, continued to send the Jews to labor in camps instead.) My father didn't want to miss the opportunity to show that he was *a man among men* and volunteered anyway.

Here is my father's story in his own words.[65]

Vichy laws arrived to us [in Algeria] and the government had to take all the Jews and put them in concentration camps and send them to Germany. I arrived at the concentration camp, and there I encountered my brother-in-law, Albert, the husband of Lucienne [my father's older sister]. He was there before me. His cousin, René, who was my friend, was also there. After a while, my brother-in-law and the others warned René and me that a French captain was going to come that week and ask for volunteers for the French Free Forces. Half of France was already occupied. He said that the captain would speak nicely to us. "Please do not raise your hands" he begged us. "Do not volunteer for the war." I talked with René and told him: "You and me, we will raise our hands and show them that we are fighters." I was sixteen and a half. The big day arrived. We were organized in a formation. At 7am, the French captain arrived dressed in red pants, polished boots, and black jacket with garlands and tassels. He started to speak about the homeland (*la mère patrie*)—France—and gave a half-an-hour speech, at the end of which he asked, "Who volunteers?" There was quiet. Two thousand, three thousand men kept quiet. All of a sudden, two hands were raised. They were René's and mine. They took us, and Albert yelled at me. I told

Letter 4. "With all my being, I refuse to accept this amputation"

him, "Leave me alone!" These were the same Jews with whom I could not stay in Oran.

I wish I had known when I transcribed this interview with my father what I know now. I could have asked him for clarification: How many times did the French captain visit before my father volunteered? Was it difficult for the Jews in the camp to plan and coordinate their silence and their refusal to volunteer? Why was my father so eager to depart? Did he still believe he could be recognized by the French as a Frenchman? Was he so sure of himself, or did he feel he was so special, that he believed nothing like what had happened to other Jews could happen to him? Was he in such denial that he failed to see that those recruiters were the same Frenchmen who had sent him to this concentration camp? Was the camp so hellish that he just wanted to escape at any price? To what extent was the Vichy regime a surprise? What was it exactly that my father could not stand in the camp on the one hand and among the Jews in Oran on the other? Was it the Jewish community that mirrored to him that he would never be a true Frenchman, that he would always be like them? Or was it the settlers' anti-Semitism, which made him believe that only outside of Algeria could the promise of self-fashioning be fulfilled?

For my father, refusing to listen to his older brother-in-law Albert and making his own decision created a moment of freedom: "Leave me alone!" If there was a moment of freedom here for my father, it was implied in his words, "Unlike them, I am..." Ignorant of the price he was paying, he adopted the colonizers' gaze when he declared himself to be unlike "those Jews" in Oran. He continued to see France as capable of providing him with opportunities for self-fashioning that his community could not. The other Jews in the forced labor camp, who did not raise their hands, may have remembered what France did to them. After all, as Jacques Attali describes it, under Vichy it was as if French Algeria "was just waiting for the Nazi occupation of the metropole in order to finally do what had long been dreamed of: getting rid of the Jews, while continuing to ignore the Muslims."[66] The French actually volunteered to

open concentration camps before the Germans did. This is not surprising, as French colonialism in Algeria preceded the rise of Nazism, and outdid the Nazis on occasion in racial violence (one emblematic example: asphyxiating the colonized, known as *les enfumades*).[67] Some of the older Jews may also have been flooded with their parents' memories of waves of organized attacks on the colonized, attacks that either didn't spare the Jews or targeted them directly.

The rumors about the landing of American soldiers would have already reached the camp. Reading my father's words, I cannot help thinking how disorienting it must have been for a young Algerian like himself to make such a decision at the moment when it seemed his community was on the verge of being liberated from the concentration camp. But the colonial ruse of rewarding individuals for leaving their communities was powerful.

The reason the other Jews did not raise their hands was because the French captain who arrived to recruit them sought to further intern them: his specific battalion was created to prevent them from becoming French soldiers and to perpetuate their forced labor in another way. And this is what happened to my father—a second period of forced labor. It was only a few months later that my father would be drafted into an ordinary military unit in the French Armée d'Afrique. When the captain arrived at the Bedeau camp, the life-threatening predicament of the Jews had not changed, and, as the two or three thousand Jews who were there understood, there was no reason to trust Frenchmen.

On the other hand, why would my father, young and able, not jump at the opportunity to depart from the hell of the camp? It was only in July 1943, when the camps were finally closed, that he joined a real military unit. Once out of the camp, he tried his luck with the Americans who were in the city and asked to join their forces, but it didn't work. This teaches me that after the second period of forced labor, he was no longer completely fooled by the French, and though he wanted to go fight against the Nazis, he preferred to do it under the command of American officers, not French ones.

You see, dear Frantz, even if my father were still alive, the questions would remain, no matter his replies. Whatever his reasoning

Letter 4. "With all my being, I refuse to accept this amputation"

may have been in that moment, it ought to be reconsidered in light of the fact that his logic was skewed by his colonial disorder, by his North African Syndrome. He, like the Algerian Muslim you describe in series B, case two, believed everyone saw him as a traitor and was trapped in an "accusatory delirium." He needed to prove he was not a coward Jew, what was projected on him by the French, or by other Algerians who were also plagued by this syndrome.

In fact, you and my father both participated in the same campaign in Alsace, though you were not initially recognized for your contributions to the French victory, since the "whitening of the Free French Forces" was required. Cherki describes this in your biography: "It was required to show the Allies that French soldiers participated in the liberation of France."[68] That my father didn't listen to his brother-in-law Albert or the two thousand other members of his community is one thing, but that you didn't listen to Aimé Césaire and your father is yet another. In a letter written to your parents toward the end of the war, you admit that it was a mistake to have joined: "If I do not return [from the war], if one day you learn of my death in the face of the enemy, console yourself, but never say: it was for the right cause ... because this false ideology, shield of idiot secularists and politicians, should no longer enlighten us!"[69]

Well, my father returned from the war more confused than you did, and he did not know how to ask the question, "If this war was a war to liberate all peoples, why are we not liberated?" Though my father felt he was not free in his country, the restoration of fucking French citizenship after the fall of Vichy spawned another wave of democratic aphasia, preventing him and other Algerian Jews from articulating their un-freedom. The restoration-of-citizenship measure included a restriction on converted-French citizens from reclaiming their rights as colonized subjects. In other words, at the moment one became a citizen, the right to question colonial citizenship or to claim reparations was lost.

In the absence of language to process his experience, and motivated by an impulse to find a way out of what he couldn't even name—his colonial disorder—my father left Algeria. Thereafter,

he was ready to endanger his life in yet another war waged by Zionists against Palestinians, whose causes he didn't really understand. Luckily, in the Zionist colony he was perceived as an Arab and only assigned to serve as a driver. So at least I know that he did not kill or expel any Palestinian. When we talked about his decision to volunteer for this war, he replied with a rhetorical question: "Why did I come here [to Israel]? ... I was free and I came as a volunteer. If I'll die? So I'll die." He sounds to me like a person who has lost all attachments.

In 1943, upon his return from his voluntary service in the French Africa army, Ferhat Abbas drew a lesson from the French refusal to restore citizenship for the Jews in Algeria. In his *Manifesto of the Algerian People*, which I assume you knew, he questioned what is known as his "assimilationist position."[70] Learning from the revocation of the Crémieux Decree, Abbas emphasized that assimilation-through-citizenship could not replace a liberation project: "The time has passed when a Muslim Algerian will ask for something other than to be an Algerian Muslim."[71] Abbas explained that what Algerians had had to accept earlier—for example, citizenship under French Algeria as "Muslim Algerians" —had lapsed, and that now the horizon for liberation concerned those who were primarily Algerian citizens.

With sadness, I say that this democratic aphasia had devastating consequences for the prospects for Jewish Algerians to ask to become Algerian Jews. It also deranged their capacity to recognize the obvious: that they were thrown out of their country by those who invaded it. I want to believe that you are horrified to learn from my letter that decolonization was achieved partially by sacrificing the Jews. Toward the end of the negotiations with the French during the Évian Accords prior to Algerian independence, the Algerians, only Muslims now, found themselves discussing what to do with the Jews, as if "the Jews" were an Algerian problem.

Paradoxically, now I want us, the Jews, to become an Algerian problem. I want Algerians to be bothered by the fact that our unwilling departure risks becoming part of their DNA (if it hasn't already, considering that those born after 1962 do not even know that Jews are integral to Algeria). They risk normalizing

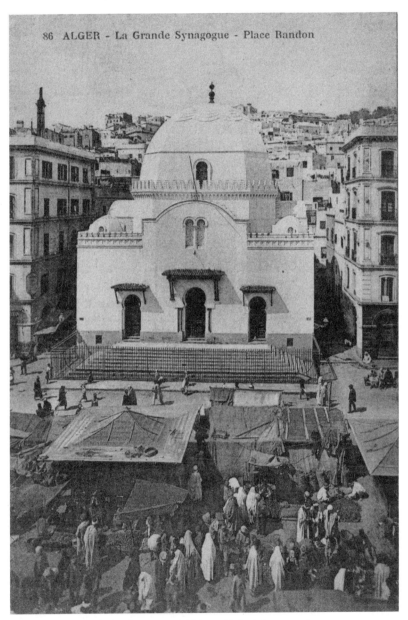

Great Synagogue, Algiers. Colonial postcard.

the colonial perspective as theirs in their continued failure to recognize their indirect contribution to the Zionist movement's investment in separating us from Muslims.

In my dreams, on the night of the next full moon, all the muezzins call on us to return, and their voice is heard by us, those who already walked the way to vocally state our anti-Zionism.

In looking at any image taken in Algeria from the invention of photography up to 1962, I envy the simply-being-there-ness of the photographed people—standing, sitting, walking, breathing, eating, drinking, laboring, celebrating, with no explanation, no program of repair, but a multitude of daily acts of caring and mending.

For a long time, I refrained from comparing the expulsion of the Jews from Algeria and the expulsion of Palestinians from Palestine. The Zionist instrumentalization of such symmetry as the basis for rejecting Palestinians' demands makes it very difficult to find a way to articulate this. To a certain extent, however, such a comparison can be generative, for it forces one to ask how the expulsion of the Jews, facilitated by their conversion into Europeans and Euro-Zionists, became the exchange rate of decolonization. That is: How did it become acceptable for Jewish bodies to be trafficked between (French) Christians and (Algerian) Muslims? And how did this traffic imposed through international agreements of decolonization contribute to the possible (non-) solutions offered to Palestinians—especially in a world where assimilation aligned all Jews with the Euro-American Christian world?

I wonder if you ever thought about the tension between your assumption that the Jews were "Europeans" and the meaning of Algerian independence to which you subscribed? I wonder what the fate of Algerian Jews would have been if you, or someone like you, could have attended to their colonial syndrome and offered an analysis of their situation as members of the Algerian people?

Dear Frantz, don't you think that the landscape of the colonial world might have been different?

With gratitude for your anticolonial legacy, yours,

Ariella Aïsha

Letter 5. Lately, I have been talking to my ancestors

A letter to my beloved children

My beloved children,

It has been several years since I started talking with our ancestors. I'm writing them all kinds of letters.

My ancestors—with their habits, traditions, crafts, songs, prayers, incantations—were hidden from me by two colonial projects that forced me to grow up as a secular Jew, with scant memory of our ancestors' world to raise you with. These two colonial projects ensured that I could not live in our ancestral land of Algeria, nor later in the Zionist colony in Palestine where we were born, and provide you and your children, my grandchildren, a caring extended family. I didn't choose to be apart from the place of our ancestors, and though it may seem otherwise, it is not completely my choice that I can no longer live in the place where we were born. I write to my ancestors and to you, as I want my grandchildren to be able to reminisce about what we lost: in these recollections are things they might need as they grow up in a world where the tissues of life are replaced with data.

I've chosen to inhabit the world of our ancestors that imperialism wants us to believe is impossible to inhabit, and to make it part of my—our—continuous present. I have departed from the settler geography of disavowal in order to come closer to our ancestors, and to open for my grandchildren possible paths toward worlds that could still be ours, theirs.

These letters I have been writing are as much intimate recollections of lived experience, partial transmissions from our ancestors, and political propositions as they are cosmological invocations.

Our Algerian ancestors reckoned with a cursed piece of paper called the Crémieux Decree, issued in 1870. With sixty-six words, printed on this paper, all indigenous Jews living in Algeria (except those who lived in the Sahara, who were not thought to be assimilable by the colonizers) were transformed into French citizens. It sounds like a scene from an absurdist play, but it was not. Forty-four words were given to detailing this new status, and the remaining twelve were used to revoke all previous forms of belonging, some of which had been assigned to them by the colonizers. Five years earlier, in 1865, Jews and Muslims alike were invited to apply for French citizenship; only 200 Jews out of 40,000 applied. I rejoiced at not finding traces of our family among the applicants.

Colonized in 1830, our Algerian ancestors were still struggling to recognize themselves in the racial classification of "Israélites indigenes," a category that obscured who they were and how they understood themselves: as mostly craftspeople and traders, members of small and diverse communities of Jews, part of a world in which their group rights were protected among Muslims through their status as dhimmi, legally protected non-Muslims living within Islamic nations. Some Algerian Jews lived in the mountains, others in the cities; some were expellees from Spain, or had migrated from Morocco or Italy. Many of them had as many "Muslim" habits as they had "Jewish" ones. Before the arrival of the French, they didn't recognize themselves as members of a unified category like "the Jews," "the Jewish people" or "les Israélites indigenes"; their identity was a composite one, intertwined with that of others who lived alongside them.

Writing to our ancestors feels like finding the North Star behind heavy clouds. The robbery of our ancestors' world has also robbed them from us.

I conceive of the imperial citizenship that "we"—diverse Jews —were trained to embody as the technology of our captivity in a history that should not have been ours, not in Algeria or in

Letter 5. Lately, I have been talking to my ancestors

Palestine. This citizenship is carceral: it jails us in imperial logic and practices, distancing us from our ancestors' beliefs and laws such as Shmita (the seventh year in a cycle of seven, when the land should lie fallow and debts be cancelled) or Shabbat (when no labor should be done). Through this citizenship we were initiated into the imperial world, a world formed against us and in which we and others were separated from our ancestors, denied our place among them, and deprived of their wisdom, cosmology, spirituality, magic, and ways of loving and being.

More than once, when I was still living in the colony, I was told by Israeli Jews: "If you don't like it here—leave!" In 2008, after one of these moments occurred during my presentation of a photographic archive of the 1948 destruction of Palestine to art students in the Zochrot Gallery in Tel Aviv, I wrote you a letter. I was still living there and could talk to you over dinner, but I needed to write down the frustration and sadness I felt. I guided these students through photos where they could see how Palestine was destroyed and plundered by the Zionists. At the end of my presentation, I spoke about the reversibility of imperial destruction and said that Palestine need not remain destroyed. I invited them to reflect on the way the destruction had shaped their identity, and the toll this destruction had also taken on Jews, who, since 1948, were doomed to inhabit the position of perpetrators, regardless of their individual political opinions and actions. A small group of vocal students told me: "So leave!" Naively, maybe, I had hoped that the students would be enraged and terrified—as I was when I first delved into the events of 1948—to realize that they had not been taught the history of how they came to be citizens. The deeper meaning of what they said to me was that as long as I stayed in Israel, I had no choice. This is *what* we—"Israeli Jews"—are, and this is what we are doing; subsequently, this is *who* we are. If you don't like it, you have only one choice: leave. I didn't leave the colony after this meeting with the students, or because of it; but I did come to refuse the "choice" they gave me, as well as its logic.

I owe this distinction between the *what* and the *who* to Hannah Arendt, whose book *The Human Condition* was, in many ways, my appendix to the Jewish Bible. Against the common

understanding of what politics is (a configuration of political institutions that sets people *against* others), Arendt argues for a different notion of politics: living "*with* others and neither for nor against them—that is, in sheer human togetherness."[1] Instead of being inheritors of the ancestral crafts that can sustain a world, as "Israelis" we were born to guard those stolen lands as ours and to disavow any life still present in the ruins of Palestine. This came to shape all the realms of life in the colony such that no matter how inspiring are their thoughts on education or urban planning, mutual aid or community, everything they do is shaped by their position within the state apartheid scheme and is necessarily *against* others with whom they are governed, meaning Palestinians. In other words, no matter what the citizens do, *who* they could have been is hijacked by *what* they have been made to be. The imperial rights of access and resources granted to Israeli Jews are meant to make them forget that they are denied one major right: the right to be *with* others, living and dead.

My beloved children, we also have the right to be with our ancestors and to be Jews of all sorts, irreducible to the identity of the Zionist or Israeli Jew, an identity manufactured by colonial states that robbed us of our Jewish heritage and replaced it with colonial secularism.

Hijacking who people *could* be is one of the major crimes of imperial citizenship, which is premised on assimilation. This kind of crime is not recognized by international law, and fleeing it doesn't grant one asylum or refugee status.

I'm not a refugee, but I do feel in exile. Not from Israel, but from the world of my ancestors, of which I could have been a part.

Pawtucket, Rhode Island, where we live now, is not my home. It is the unceded land of Native Americans who are no longer at home here. They used to call this place the Great Fall, *Pawtucket*, before the British settlers arrived and destroyed life around the waterfalls, changed the place into a textile-producing industrial compound they called a city. I'm not at home here, and there is nowhere else where I feel at home.

I feel myself a stranger everywhere, including in the place where I was born and lived more than half of my life. Maybe especially

Letter 5. Lately, I have been talking to my ancestors

there, since the manufactured commonality of being Israeli hurts more than soothes my dormant colonial wounds. My mother tongue, like yours, is Israeli: Hebrew saturated with violence, place destruction, lies, dissociations, exaggerations, reprimands, invasions, militarism, racism, anti-Arabness (anti-us), scolding, commands, destructiveness, grandeur, entrepreneurialism, secularism. I refuse the Israeli language's term for this place: Israel. That Israelis are hurt by my calling it the Zionist colony in Palestine is their way to rob me of a Hebrew that refuses to imbue itself with violence. Here and there, individuals are struggling to unmoor their tongue from Israeli and to speak only Hebrew, but they succeed only fitfully, and mostly in writing, when they are not in conversation with others. Spoken Israeli deafens my ears. I'm still unlearning it.

The Israeli language is a trap for Muslim Jews, whose migration to the colony was provoked by European Zionists for a variety of demographic, military, and labor reasons. The Israeli language doesn't allow Arab Jews to exist, since it commands that when Arabs are the objects of the verbs, the Jews are the acting subjects, and vice versa. It's easier to recognize this cleavage in the militarized geography than in our language, but it exists in both. For example, I recently read a book in Hebrew of Arabic *midrashim*, biblical interpretations, and my ears wept with happiness. Starting with the creation of the earth, the well-known opening sentence is inhabited not by the presence of God (אלוהים) but by the presence of Allah: "In the beginning Allah created the heaven and the earth." It follows with a beautiful story about the creation of the Tablet and the holy chisel that etched everything "with a great trembling at the voice of Allah, who called and hastened and ran upon the face of the Tablet from right to left, writing as told, all that happened before the creation of the world and in the hour of the creation, and all that happened from day to day to the end of all generations."[2]

This text, written in biblical Hebrew and telling of the Arabic Islamic tradition, is not a work of "reconciliation" but rather precedes the breaking away of Arab from Jew. It may be that the Jewish author who collected these stories in 1920s Palestine was motivated by a prophetic fear that the tales might not survive

in Hebrew, so he wrote them down. They read like magic, like the inscription of a language believed lost, one that you didn't even realize you could speak until you heard it. Hearing it in Hebrew made me cry. I wish I could have read these stories to you when you were children. I'm happy I can read them to my grandchildren.

Three decades after this collection was published, when Muslim Jews were coerced into leaving their homes and coming to Palestine, they found themselves in a state that was built against people like them. These violent stories are known and yet ... like many things we know *in/through* the Israeli language, we are accustomed to them and tolerate them without asking why they can't be reversed. That the state was imposed on Muslim Jews, Arabs, and Palestinians cannot be acknowledged since its architects and the citizens they manufacture must understand themselves as innocent so that Arabs and Muslims can continue to be the outside threat that justifies the state's existence. This gives the state of Israel its raison d'être. To enable this enmity, Muslims Jews were given no choice but to leave their countries and become part of the Zionists' "Jewish side." Europeans, who barely two decades earlier had been busy deracinating European Jews and transferring them to death camps, could sit back in their chairs and observe their project being completed by Euro-Zionists. Upon their arrival, Arab Jews were denied recognition as refugees, a status that was reserved mainly for European Jews, and mainly when it served the agenda of the state. In the colony, those Muslim Jews known by the Zionist category of Mizrahi were made the hewers of wood and drawers of water.

The reasons behind Israel's recent interest in recognizing Arab Jews as refugees is strategic, another weapon in the war against Palestinians. It is not motivated by the need to redress Arab Jews' injuries or to recognize how Israel helped make them refugees. Israel is using them again to counter Palestinian reparations claims regarding seized lands and property. A monetary survey of the value of the property left by Jews in North Africa is used to fabricate a symmetry between them and the Palestinians, and to prepare for future diplomatic negotiations toward "peace." The state doesn't even hide its interest in distorting

Letter 5. Lately, I have been talking to my ancestors

the story of why our ancestors left North Africa, nor does it shy away from manipulating their narrative for the purpose of signing "peace" agreements that makes the return of Palestinian expellees even more difficult in the near future. The recent triangular "peace treaty" between the United States, Israel, and Morocco, in what was already called by some a "transparent quid pro quo," is one such example. Under this agreement, each of these colonial powers recognizes as legitimate the violence involved in ruling over colonized lands without the consent of the governed people.

It is hard to understand what's wrong with the categories by which our world is organized if we don't know the violence that engendered them. Writing to our ancestors, I'm trying to track down what was taken from them when they were made secular citizens of Jewish origins. As descendants, we were raised with their pale and distorted representations. Proactively seeking traces of who they were and how they navigated their life under colonial rule is necessary, for we were not Israeli Jews. We were, and are, Algerian Jews, Palestinian Jews, and Andalusian Jews, and from your other parents' lineages, you are Ukrainian Jews, Hungarian Jews, and Lithuanian Jews. Being Israeli Jews is a betrayal of our ancestors and an erasure of the history that preceded the destructive phase of the Zionist project.

When I still lived in the colony, I experienced being "an Israeli" as a curse. I tried multiple times to find a way to (theoretically) transform the colony's constitution. After I left the colony and started to live outside the shield of its citizenship, I realized how much this identity had been an alibi for the theft of our existence as diverse Jews. Inspired by a transgender politics that rejects the violence of gender identities assigned at birth, I refuse to recognize myself in this identity, "Israeli," that was assigned to me at birth and that separated me from lands where the presence of our ancestors could still nourish us. Through writing *Potential History*, I understood that the state had invented me as an *Israeli* in human factories. I also learned, as I wrote my book, that I could refuse the type assigned to me in the garden of tolerated Jews—a Mizrahi Jew, invented as an identity category by the state of Israel to racialize us and regulate or eradicate us.

I reject any deal to be this invented past's futurity.

The rebirth of Europe after World War II and the whitewashing of its imperial crimes were pursued through us. Instead of abolishing the regimes responsible for the genocidal violence that targeted Jews among other non-Whites and communists, and instead of assuming responsibility for providing assistance to restore the remains of those Jewish communities they destroyed—instead of dealing with actual Jewish people, Europeans in post-WWII Europe venerated Jews only in the abstract. The *Jewish people* were a product of imperial violence preceding the Holocaust, and the *Jewish people* were given a state, after the war, where the same imperial technologies that had harmed their ancestors could be continued. We must recognize the perversion of turning Jewish survivors into perpetrators, made to fight a war against Palestinians who were made into their enemies. The transformation of surviving Jews at the end of WWII into colonial agents in the Arab world was the way European imperial powers absolved themselves of their crimes. Our political birth—as citizens born "free" in the colony—absolved Europe of paying for the crimes committed against the bodies of our ancestors.

The state of Israel was proposed as an appropriate payment for the destruction of Jewish worlds, of which the Holocaust was the most lethal and recent. This was an imperial bargain in which Zionists were ready to sacrifice Jews who lived in other regions and who were without Zionist dreams, sacrifice them and force them into a triumphant national citizenship, one that now set them against Arabs and/or Muslims worldwide. We were born Israelis, implicating us in this bargain: the destruction of diverse forms of collective Jewish life all over the world in exchange for individual citizenship and a fabricated, synthetic form of collective life in Israel—as colonizers!

This is why, my children, I insist that we refuse. We were robbed of the capacity to dream of freedom and to look beyond the imperial nation-state for other modes of collective life. In the company of our ancestors, I came to understand that we couldn't liberate ourselves from the Zionist project just by denouncing it for harming the Palestinians; we also needed to denounce it for what it did to us.

Letter 5. Lately, I have been talking to my ancestors

Referring to myself as
 a Muslim Jew,
 an Arab Jew,
 or a Palestinian Jew
 creates embarrassment among people around me,
 as if I were
 a snail
 without a shell.

The problem, I've come to see, is that being an Arab Jew or a Palestinian Jew troubles the white Christian world in which I've lived for more than a decade, since it implies that something went wrong with the solution to the "Jewish problem." My refusal of the accepted solution to the "Jewish question"—individual assimilation or assimilation into the new imperial nation-state—is also a retroactive refusal to be a European Jewish problem in the Arab world.

The European Jewish problem was the existence of diverse Jews who lived in small autonomous nations (not states) of their own, in which religion, sustenance, moral values, laws, political formation, and beliefs were entangled. I don't idealize these worlds, but I do reject their destruction and insist on our right to resuscitate them. Imperial citizenship was invented as part of a global formation of white Christian supremacist power. Non-whites and non-Christians were *granted* citizenship as an act of imperial largesse, making their rights always precarious and in danger of being taken away. The modern secular nation-state, following on from the French Revolution, destroyed Jewish communities through the invention of religion as a separate sphere —thus confining Jewish halakhic laws to religious matters—and imposing its separation from politics under the banner of secularism (*laïcité*). Thus, religion moved from being a world-making force to a personal attribute.

This is a long story to tell, so bear with me. When citizenship was taken from the Jews on the eve of World War II in most of Europe and in Algeria, the story of how it had been imposed on Jews in the first place, and how anti-Semitism targeted them once they were legally citizens, became blurred into a distant past.

Thus, France could depict itself as a liberator rather than as the developer of genocidal technologies.

Unlearning the history of the Jews introduces us to the European colonial project and particularly how it cuts a history of violence into separate slices in the mind of the colonized. I have been trying to join the slices back together. I want to share with you two of these reconnected moments.

Algeria was the first country where the fascist Vichy regime was defeated by 1942, three years before the formal end of the war. However, the French in power refrained from restoring citizenship to Algerian Jews. The leaders of the clandestine Jewish movement who participated in Operation Torch, the Allies' landing in Algeria to fight Vichy, were arrested and sent to forced labor camps where many of Algeria's Jews were already incarcerated. Property confiscated and plundered since 1939 was not restituted, and many Jews were still not allowed to return to their jobs, despite the fact that the Vichy regime had officially ended.[3] The French settlers who continued to run Algeria continued to be anti-Jewish, and the American, British and "Free French Forces" didn't intervene. (These last were too busy planning how to dominate the world and quell anticolonial revolts.)

The second moment is from the displaced person (DP) camps in the British Zone in Germany. When the war was declared over, Jewish survivors found themselves in different DP camps, once again as tokens of "the Jewish problem." Thus, the people who came out of the hell of the Nazis' camps were offered more camps as a "solution." Here is the testimony of a worker in one of the DP camps run by the United Nations Relief and Rehabilitation Administration:

> [The British] hated the Jews more than the German people ever did. I personally heard a good many British officers, as well as enlisted men, make the remark that "Hitler made one big mistake—he should have finished the job while he was at it." Meaning that he should have cleaned out the remainder of the Jews.[4]

John McNair, General Secretary of the I.L.P., addressing the delegates, says ... *idea that the white people have anything to give to the black. There is, on the other hand, a debt which the white people owe to the coloured races: a debt which must and shall be paid."*

felt that the discrimination, segregation and low standard of the negro's life there cramped his spirit. His escape was to the sea and for thirty years he has been in the Merchant Navy.

"The negro," he says, "must not only clamour for the help of the white man, he must also learn to help himself. The negro is not only exploited by white men—he is often exploited by the rich and wealthy negro traders. When we learn to help each other, then we shall merit citizenship and freedom from the white man."

The moral of his and similar stories was the motive force at the conference. George Padmore, leading negro journalist, maintained that a negro's skin is the passport to an oppression as violent as that of Nazi Germany's oppression of the Jews. "We don't need yellow armbands in Africa—just black skins," he maintained.

The Manchester 1945 Pan-African Congress, session chaired by Amy Ashwood Garvey. At bottom left, a placard reads, "Arabs and Jews Unite against British Imperialism." Photo: John Deakin, *Picture Post Magazine*, November 10, 1945.

No victim targeted by these imperial regimes in Europe, Africa, Asia, or America could count on the promise of full, unqualified citizenship, with redress and restitution for their wartime losses. Instead, "solutions" were manufactured to address the question of what to do with the Jews, as with other non-white groups.

Against Euro-American imperial visions of the world produced during the war, racialized groups drafted their own visions, in the form of congresses, appeals to the newly formed United Nations, and declarations of rights.[5] In the photo (see p. 169) taken at the Fifth Pan-African Congress in Manchester, at bottom left we see a visual sign of the involvement of Jews and Arabs in the anticolonial imaginary. The space was full of hope. As Mark Sealy, the curator of an exhibition of these photographs, wrote, "The war had just finished; it was a new world, there was a new contract on the table, new rights to be had. This was the place people were saying 'we've made a contribution, we've just fought the Nazis and the Fascists for you—can we have our freedom now?'"[6] While there were many commonalities between the disaster that befell the Jews and those suffered by other colonized and racialized groups, Euro-American powers aimed to "solve" "the Jewish problem" with universal terms that at the same time exceptionalized their perpetrators. The Nazis and the Vichy regime, the Euro-American story went, had been exceptionally violent and had made Jews exceptional in their suffering of ethnic violence. This suffering could be redressed through the granting of an exceptional state and a recognition of the political language of Zionism. What this accomplished was a separation of the Jews from others; another form of ghettoization, which they were doomed to maintain only through violence against others. Zionism made the idiom in the photograph, "Arabs and Jews Unite Against British Imperialism," an impossible thought. Zionism stood against solidarity, and Zionism sustained British imperialism by deflecting protest against it.

Several documents drafted by American Jews after the war testify to their attempt to attend to the victims in their particularity but also insist on Jews' commonality with others, including, as one historian puts it, "an International Bill of Rights for Jews and other minorities" and "a plan for the rehabilitation of Jews and

Letter 5. Lately, I have been talking to my ancestors

other despoiled groups."[7] But the imperial powers insisted that Jews be made "exceptional," and they insisted on their own solution to "the Jewish problem." The offered "solution" to Jewish suffering had nothing to do with the time victims needed to heal, recover, process, protest, idle, rage, mourn, dream, imagine and restore. The time that they needed was time that imperial citizenship could not allow to exist. Here is what the Jews might have done or pursued further in such a time:

- continued asking questions about the continuity between the genocidal technologies and the institutions that continued to ruin their and others' lives;
- found common cause with other groups who struggled against imperialism;
- considered the colonial dimension of their conversion to citizenship in the late eighteenth century in Europe and later in Algeria as part of a European project to Christianize them;[8]
- questioned the genocidal enterprise that turned all Jews into one people, preceding and enabling the Holocaust;
- held Europe accountable for the destruction of diverse Jewish communities, and demanded collective reparations to rebuild their Jewish worlds and live according to their own laws, many of which were incommensurable with the Euro-capitalist war machine;
- questioned the alleged separation between church and state that as citizens they were now expected to defend, and asked whether the diminishment of "Jewishness" to a personal practice observed at home or in synagogues was not a way of assimilating them into a white Christian state;
- reclaimed the synagogues as sites of gathering and civil imagination in addition to religious practice, sites out of which plundered Jewish objects held in museums could be returned to live in common with those who made them;
- insisted, if they were Muslim Jews, on their belonging to the Muslim world and not to the Christian European one;
- insisted on holding their governments accountable and responsible for restoring the infrastructures of their destroyed communities in Europe;

- refused Zionism's claim to conflate being a Jew with being a Zionist;
- considered the connection between European anti-Semitism and Europe's project to make Zionism "a solution" to Holocaust survivors, even though Zionism had been a fringe movement prior to the war.

Most importantly, Jews could have healed enough not to have been assimilated into a universalistic discourse of salvation—prompted by the triumph of racial capitalism—that served the pursuit of imperial interests in the Middle East.

By its nature, imperial citizenship requires non-whites to serve as a foil, a constant, unruly problem. Consider how many times there has been a proposed "solution" to "the Jewish problem": in the nineteenth century, Jews were "made modern"; in the mid-twentieth, they were killed en masse; immediately after, they were all sent to occupy a small sliver of other people's land so that Europe could evacuate its new post-war democracies of Jewish bodies that testified to European guilt and European complicity. Not surprisingly, it is now "the Islamic problem" that has to be "solved" by Europe and the West, involving the same calls to modernize and secularize Arabs and Muslims.

Today, my children, we have almost lost the memory of what we were forced to lose. When in 1791 white men granted citizenship to the small community of 40,000 Jews in France, they compelled them to swear a civic oath asserting their loyalty to the nation, law and constitution. This ceremony was meant to guarantee the Jews' religious freedom. However, in taking a civil oath, which was against their Jewish faith, the religious freedom that was allegedly granted to them was already imperiled. The secular citizenship ceremony put their faith in conflict with their political status, and it was the source of much of their agony in the years to follow. Some of them were asked for an extra proof during the ceremony: to remove their hats, or perform the gesture of the cross.[9]

Prior to their "emancipation," most of the Jews in France lived in poverty and were denied access to professional occupations. A tiny Jewish elite who had pleaded for citizenship embraced it

Letter 5. Lately, I have been talking to my ancestors

as "emancipation." Others, who understood it as a way out of poverty, also took the oath. Many others, however, refrained, still hoping that improving their circumstances could happen without a renunciation of their ways of life and their faith. For them, being a Jew was not reducible to a "religion," in the way that religion was codified by the French as secondary to secular citizenship. Rather, it was part of a way of being in the world with others, a cosmology, a spirituality, a tradition, a set of laws and ethical codes, a connection to their ancestors. When we understand what we lost in accepting citizenship and the imperial "solution," we can know how much work we now have to do to reclaim our ancestors.

> Jews' emancipation was conversion, renunciation, and reeducation.
> They were trimmed with razor blades, but the "Jewish problem" was still not gone.
> Why not a state of their own?
>
> I refuse the solution.
> I would rather be the problem again.
>
> I am tuned to radio signals from Algeria,
> from the precolonial era, from before the invention of the radio,
> when no one mentions that the Jews are a problem.

Is this world lost forever? Imperial histories say yes. But who am I then? And you? If we confirm this violent loss, we can only be imperial citizens of places whose cosmologies are not inscribed in our remembering bodies. We can only be blank citizens of nowhere.

No.

I refuse to cease to be an Algerian Jew, to cease to be a Muslim Jew. I am an Algerian Jew, though I don't have a passport or even an entry pass.

I am an Algerian Jew, inhabiting the Jewish Muslim world that colonialism tells us has been ruined.

I refute, retroactively, the invention of the Judeo-Christian

world. I would rather inhabit ruins adorned with jewels made by our ancestors.

No one knows how many Jews still live in Algeria as Jews, as semi-Jews, as converted Jews, as memoryless Jews.

No one knows how many Muslim Jews and Jewish Muslims continue to live in Algeria, but many know they do live there. The Algerian poet Samira Negrouche was once asked if she was a Jew, and she replied:

> I'm not a Jew by my blood mother, but I am by my earth mother, from whom one tore part of her children, her songs.

And hence, Samira continued,

> I need to carry this Jewish memory for the absent, the uprooted, us and them.[10]

Your earth mother is mine too, I replied to Samira, and I whisper it now so that it will travel to your ears and those of your children.

Remember: our earth mother doesn't distinguish her children by blood. With the foundation of the state of Israel, some of our ancestors' identity as Palestinian Jews was made an impossibility, as "Palestinian" became the adjective of the enemy, and the erasure of Palestinian Jews a necessity for their transmutation into Israelis. When I was a teenager, I didn't fully understand the difference between Mizrahi, the racial category the colony invented for non-European Jews, and Sephardi, the older term denoting not a race but those who were expelled from Spain, our ancestors from my maternal side. I was even more confused when my mother told me we were Sephardic on both sides. In the racializing language of Zionism, this meant we were Mizrahi on both sides, meaning those denigrated and discriminated against by European Jews.

One day, with my dark eyes, inherited from my father, I asked my mother, whose blonde hair and green eyes I envied:

Letter 5. Lately, I have been talking to my ancestors

> Mom, I don't understand.
> Your family is from Bulgaria,
> and my classmate's father
> is also from Bulgaria.
> He plays in the Philharmonic Orchestra,
> meaning he could not be like us,
> but how is he not like us?

While my mother didn't know how to explain the difference between Sephardi and Mizrahi, and clearly preferred to be called a Sephardic Jew, she knew to tell me that there were also Ashkenazi Jews in Bulgaria. She knew who we were because of the Ladino she used to speak with her mother. For centuries, Sephardic Jews knew that they were not *of* any state—not Spain, which expelled them, not Austria, a station in the migration of my family, not Bulgaria, where they had lived since the eighteenth century. Jews expelled from Spain were used to hiding who they were when it was not safe to be a Jew, and they transmitted to their offspring various *heretic* secrets to ensure that their children did not forget who they were. Ladino was one of these heretic secrets. In the folds and sounds of Ladino lies Andalusian remembrance, and the ability to transmit this knowledge to children. My mother didn't teach me Ladino since in the colony, most Jewish languages—Arabic, Yiddish, and Ladino —had to perish. Thus, between my mother and me, five centuries of knowledge-through-language were disrupted.

Prior to the creation of the Zionist state, the terms "Ashkenazi" and "Sephardi" designated specific groups. In Israel these names became markers of an interracial hierarchy between Jews. With the Zionist migration to Palestine, the Jews who had lived in Palestine for centuries, notably the Sephardic communities (like the Arieh family, from whom we are descended), were designated as the "old" Jewish community (Yishuv), to be distinguished from the "new," embodied by Zionists, who had acquired the power to name. With the mass forced migration of Jews from Jewish Muslim countries, the category Sephardi was confused with the Mizrahi: a culture and identity hardened into a race.

When used separately to designate the expellees from the

Iberian Peninsula, the category of Sephardic Jew performs another historical erasure—of the expulsion from the Iberian Peninsula of both Jews and Muslims. With 1492 depicted as solely a Jewish tragedy, the state used this persecution to justify the necessity of the Zionist project. Despite the fact that Jews and Muslims were expelled from Spain in separate waves, this didn't separate them, and they continued to live in community in the new places where they landed, mainly in the Ottoman Empire—North Africa, Italy, the Balkans. As long as the Zionist state manipulates the Sephardic Jew, I would rather choose to be an Andalusian Jew, in which this conviviality still resides.

In the 1950s, Algerian Jews were still not coming to "knock on the door of the Israeli office for Aliyah (immigration)"[11] in Oran—as they were still not persuaded by Zionism. After the creation of the state, some Zionists were sent to Algeria and other Muslim countries with the goal of enticing Jews living there to migrate to the colony. But in these countries where Jews lived among Muslims, these agents encountered difficulties recognizing the Jews in the crowd. Instead of admitting that the Jews in those countries were Arabs, Berbers, and Muslims, the agents looked for Jews who *looked like* Arabs, Berbers, and Muslims; they assumed these identities could not exist together with Jew in the same person: to the agents, Jews could not *actually be* Arabs. H. Z. J. W. Hirschberg, a professional orientalist who worked for the Ministry of Religions in Israel, is one of those who arrived with swords or pens, to "help" the agents:

> It is estimated that about 30,000 Jews live in the city [Oran], and I looked for ordinary people busy in their labor ... I looked [for them] and did not find [them]. Since our sages, may their memory be blessed, said on such matters do not believe [what you see], it must be that my eyes and my perceptive gaze are to be blamed, for my eyes did not recognize in the crowd the simple Jews, the workers and artisans, the peddlers and shopkeepers.[12]

When Hirschberg was able to speak with the Jews of Oran, he admitted that they were proud of being Jews and of the place where they lived—yet he still could not resist seeing them as

transformable and transportable: "I realized that they could be brought closer to us"—the "us" being Israeli Jews.[13] He himself migrated to Palestine in 1943 and became "Israeli" when he was forty-five. Instead of respecting Arab Jews' desire to continue living their own way as Jews-with-Muslims, Zionists had to destroy it. These missionaries of re-education showed a similar disrespect toward their ancestors, or else they could not have worked in the service of the civilizing colonizers—French or Israeli—who appointed them to assimilate Jews into Zionism and thus manufacture a people.

Napoleon's pretension was even greater: to pressure an assembly of French Jews to produce a "doctrine that 'could be placed next to the Talmud and thus acquire, in the eyes of all Jews in all countries for every century, the greatest possible authority.'"[14] Forcing the Jews to instantly produce a doctrine that would equate to the Talmud (written over centuries and not by rabbis nominated from above) was insulting, especially as the trauma of losing major Talmudic literature, burnt by the French in 1242 in the center of Paris, had not been forgotten.

As one historian describes of the 1242 burning,

> Wagon after wagon left the convents of the Preaching Friars, where the Talmud had been impounded, and were driven through Paris with a precious cargo. Manuscripts which would embellish any library in the world today were being carried to destruction. An immense throng had gathered, drawn by the novelty of the spectacle, for books had never before been publicly burned in Paris. The Jews remained hidden, in deepest mourning, terrified to venture on the streets.[15]

The mourning cries on this day—"O dreadful and terrible day, filled with calamity! Anger and cruelty are spread upon the earth"—expressed the understanding that the crime against the Jews was also a crime against others. Mourners insisted on the importance of generational transmission: "The giants of the past are called to life. The Universe mourns."[16]

Napoleon continued this French tradition, even centuries later. His imposition of a Jewish assembly and later a Sanhedrin were

an attempt to reduce the meaning of Jewish life to fit the state's conception of religion. Upon his invasion of Egypt, Napoleon intervened in Muslims' modes of life in the same way, by imposing a General Divan of 189 notables to help him reorganize and codify Muslim thought in order to control it. In his famous letters to his soldiers, he praises their previous treatment of Jews and asks them to treat the Muslims similarly. The small community of Jews living in Egypt—three thousand or so—was a small "problem" he already knew how to "solve": divide and conquer.[17]

The destruction of the differences between Jewish communities, the dissociation of Judaism from Islam, and the melting of all Jews into the "Jewish people" are crimes. In his *Appel aux nations unies: Le problème algérien* (Appeal to the United Nations: The Algerian problem), Messali Hadj describes this "cultural genocide targeting religion and language" as "the continuation of the crusades under a new form."[18] Everything that he says about Muslims, including the Arabic language, is true for the Jews. While our ancestors resisted, with the Zionist colonization of the Jews, the destruction continued and was partially pursued through the reclamation of Jewish ownership over the Bible, and consequently, of the land where some of its stories took place. The Zionists deafened our ears, disabled us from hearing Musa as Moshe or Nabi as Navie (the prophet), negating the centrality of biblical stories to Muslims, as well as the centrality of Muslim biblical stories in the lives of Muslim Jews. Yuval Evri, who studied Yosef Meyouhas's translation of biblical stories from Palestinian oral traditions (mentioned above), writes: "The translated stories do not reference a specific author or an 'original' source. Since there is no original with which to compare the translation, it is impossible to define a strict line separating the translation from the source."[19] If this interconnectedness had not been driven away from our memory, we would not find it surprising that women in our family were called Aïcha, after the beloved wife of the prophet Muhammad. Instead, it would be surprising that my grandfather's name in his French papers is written as Joseph, rather than Yusuf, and my great-grandfather's is given as Abraham rather than Ibrahim, while his father was called Sliman and not Solomon.

Letter 5. Lately, I have been talking to my ancestors

The intrusion of Israel into the life of Algerian Jews was not limited to opening an Israeli migration office (that was luckily deserted!) or the visits of orientalists appraising the condition of Jews in North Africa. In the mid-1950s, at the same time that Hirschberg wrote his orientalist study, a few Mossad agents, working undercover as Hebrew teachers in Constantine, trained a group of young Algerian Jews in self-defense. "By their own admission," Jessica Hammerman writes, "the Constantine Jews killed several dozen Muslims under the authority of the Israeli commanders."[20] Grandfather had already left Algeria almost a decade earlier—but imagine if he had not![21]

The European perversion of a state for the "Jewish people" materialized against the right of *different* Jews to exist, as much as it was erected against non-Jews. In fact, the "Jew" had to be created as a unified identity and made equivalent to the marker "Israeli" so that non-Jews could then come to define the new state through their exclusion. This is the project of imperial citizenship, and this is how Palestinians—most of whom were Muslims and Christians—became non-Jews. "This stripping," Sherene Seikaly writes,

> became juridically explicit in 1917 when the Balfour Declaration inaugurated both the British colonization of Palestine and the British commitment to the Zionist enterprise. That declaration called the Palestinians by what they were not: non-Jews who could enjoy social and religious but not political rights.[22]

When European Zionists were able to realize the imperial promise of the Balfour Declaration and found the state, they also proclaimed, implicitly, that the differences between Jews were irrelevant. This proclamation is now written on the bodies of Israeli Jews from birth. Each of us is the notary stamp of Israel's Declaration of Independence. Obviously, the state acknowledges some differences in religious movements or "denominations," but only within the confines of the secular category of religion. These different identities that I'm still laboring to restore, locate, map, rehearse, and reclaim are my refuges, my places of healing after being severed from our ancestors' worlds.

Israel was crafted in the mold of European imperialism. Similar to the way that European imperial powers aimed to liquidate the culture of those they racialized and colonized (including different Jewish communities inside and outside of Europe), so too did the state of Israel seek to liquidate the cultures of different kinds of Jews. As Idith Zertal (whom you know) and Yosef Grudzinski show in their writings, the Zionists were more invested in building the state than in attending to the survivors of the European extermination; rather, they recognized in the survivors the human substance with which a Zionist program could be advanced.[23]

The Zionists worked hard in the DP camps of Europe to persuade the survivors of these traumatic years to choose Palestine as their new home. Jews were needed for the Zionist project in order to change the demographics in Palestine and create a Jewish majority. Many of the Jews in DP camps didn't know where to go and changed their mind several times. How could they know? Many of the survivors wanted to return to their homes in Europe at the end of the war, but there was nowhere to return to; this would have required the resurrection of a place that could again be called home. But their so-called emancipation, which began in the late eighteenth century, was inseparable from plans for their transference from Europe, their colonization of others' lands, and the extinction of their forms of life. In much of Europe, survivors were barely offered a welcome, much less the recovery of their homes, and still, many of the Jews from the DP camps chose to stay in Europe, to the surprise of the Zionists, who, according to a firsthand witness in the camps, assumed "that all Jews, regardless of nationality, will join in one grand migration." As this witness continued, "One of the arguments directed toward the Jewish people by the Zionist leaders was that they had always been persecuted or discriminated against wherever they were and that they would, in all likelihood, continue to be persecuted and discriminated against. Therefore, they argued, now was the time to return to the land of their ancestors."[24]

The ancestors of the Jews in the DP camps were in Europe and not in faraway Palestine, where, they had been told, their ancestors lived two thousand years ago. The Zionists who worked in the camps after the war deceived the survivors, promising them

Letter 5. Lately, I have been talking to my ancestors

a place that didn't yet exist, and moreover, another transfer from the ports of Palestine under the British mandate to Cyprus, the place the British sent Jews who arrived in Palestine without proper certificates. The Zionists also deceived the Jews in the camps about the violence that would be required to make Palestine their "home." However, the Zionist recruiters did promise what Europeans and Americans mostly failed to promise or provide—to take displaced Jews under their care—and thus, many of those in the camps did decide to join in the journey to Palestine.

The Zionists were not alone in trying to make Palestine promising for the Jews after the war. As a worker in those DP camps recounts,

> Competent engineers and industrialists have testified to the effect that Palestine, together with Trans-Jordan, could be developed through irrigation, power development and industrial expansion to a point where it could support at least three times as many people as now live there.[25]

This sounds to me like another European plan to transfer the Jews outside of Europe. And it wasn't the first one:

> This plan was preceded by similar others, such as the El Arish plan to colonize European Jews in Egypt (1902), or the Uganda Scheme (1903) to transfer eastern European Jewish communities to East Africa. The collaboration of the British and Zionist leaders around these plans "demonstrated a shared hope that mass transfer of Europe's Jewish 'minority' could simultaneously solve the problem of Jewish integration, create a new modern nation, and develop as-yet-unclaimed space for empire."[26]

Among the Jews who did go to Palestine, many came to feel they had been misled, and they filed repatriation applications at the Middle East office of the United Nations Relief and Rehabilitation Administration (UNRRA), demanding to return to their homes in Europe. The difficulties they encountered in Palestine, "such as climate conditions, health problems, economic distress,

language hurdles, desire to reunite with family members abroad, and general feelings of estrangement," historian Ori Yehudai writes,

> suggest that these Jewish refugees experienced Palestine as a site of displacement rather than a permanent homeland and saw Europe as something more like home and a place of postwar resettlement and rehabilitation.

Obviously, the repatriation claims of those Jews who refused to renounce their homeland in Europe countered the "Zionist interpretation of Jewish history, that is, rejection of exile."[27]

Winning the Zionist demographic war to have a Jewish majority in Palestine required more Jews than Zionists could recruit in the DP camps of Europe. Here began another cruel project of bringing Jews from Muslim countries to Palestine. Within a decade or two, the Zionist interpretation won out, and our grandparents' world was liquidated into an amorphous "past" doomed to exist only as dead samples in museums, relics we cannot see without the mediation of experts and scholars.

> Think of our citizenship
> as a crystal ball.
> It forecasts a single future:
> more citizens, born of citizens
> who kill more noncitizens,
> whose names they must forget,
> if they don't want to let their spirits
> to come after them through the bullet holes
> of which their citizenship gown is made.
>
> Let the crystal ball fall,
> let it break into pieces
> and the earth will be less
> wretched than it is.

Museums drain cultures of their nourishing and vital forces. They help turn people into citizens, the smallest political unit

Letter 5. Lately, I have been talking to my ancestors

of imperial hyper-regimes programmed to master the future through technologies operated by citizens.

> Between the museum's walls,
> among differently textured objects,
> is it possible to recall
> any single thing
> that could still be ours?
> Renewed,
> as in the words of that oriental song,
> a constellation, that
> should neither have ended nor been reduced
> to a handful of objects,
> filigree in copper,
> withdrawn from the cycle of life.

Objects could matter. Objects can help us, here, as long as they exist among people, outside of the logic of states, museums, and other corporate bodies. These bodies aim to destroy the ties between people and objects, to eliminate the residue of rights that exists between them, so that the corporate bodies can count people as "theirs" and stand ready to protect corporate rights over the rights of people's communities, over the rights of others.

Imagine that the books the Nazis looted from Jews all over Europe had been kept and at the end of the war returned to the places where Jewish communities had lived. Imagine these books like the swallows that return each season. Instead of a community's joyful welcome, though, upon their return the swallows encounter corporate citizens working for the Library of Congress in Washington, DC, the National Library in Jerusalem, and Jewish Cultural Reconstruction, Incorporated, who were busy destroying the places where the swallows/books habitually nested. The swallows dart back and forth, chirping in fear over the destruction of their homes, appealing to the survivors who have returned from DP camps to help rebuild their nests. But the good citizens of these corporations preyed on these swallows/books under the auspices of the newly universalized criteria for historical preservation, dedicated to using the swallows/books

to enrich corporate and state libraries. Of their treatment of the swallows/books, these upstanding citizens say: *Our actions are in the service of democracy; we want to make the books accessible to all. The library is committed to accommodating everyone. We provide tempered spaces, advanced index systems, and librarians' care. What else could these books need?*

The corporate citizens of the libraries tell themselves, *There are only a few survivors left, after all, perhaps without the means to care for these precious books according to new universal standards of preservation.* Dov Schidorsky summarizes the way Jewish Cultural Reconstruction, Inc., an America-based organization founded in 1947 to redistribute the "heirless" property of European Jews following the war, which claimed to represent the interests of all Jews, viewed the survivors of Jewish communities with whom they had to negotiate:

> The weakness of the communities did not allow them to maintain tens of thousands of their books on a regular basis, and in the absence of a vital Jewish population and a thriving community, no future was predicted for the Jewish communities. The corporation tried in various ways to persuade the heads of the communities to keep for themselves only the necessary and useful books and to entrust them with the valuable and scientific literature in order to distribute them to other Jewish institutions.[28]

And the survivors' children? How will they know themselves in the absence of their books? Answered the corporate citizens of the libraries: *They will have to recognize themselves in the interests of the abstracted Jewish people—and anyhow, they would be better off in Israel.*

It requires some attention to see how the restitution of property to the Jews started to work against Jews and in favor of the bodies that claimed to represent them. During World War II, a special American commission for the "Protection and Salvage of Artistic and Historic Monuments in War Areas" was founded, and it ran from 1943 to 1946. American soldiers oversaw the rescue operation of books in Europe, and so the United States took its portion of these rescued objects for the US Library of Congress

Letter 5. Lately, I have been talking to my ancestors

without consulting anyone. This was in keeping with the American project of empire-building after the war. The US commission's recognition of several American Jewish organizations and Israel's National Library in Jerusalem as having a "successor interest" in the books is, however, striking. It introduced a change in international jurisprudence, which until that moment had recognized only states, not peoples, as proper subjects for restitution. This created a legal precedent that might be used against the United States and European states, whose museums are now full of looted property.

Why did the Allies take this risk? It is likely that the Cold War played some role, given the interest expressed by the USSR in the books. But this is not a wholly satisfying explanation. Rather, I think, it was part of the project of turning the Jews into an exceptional group of survivors, mirroring the already ongoing process of turning the Nazis into an exceptional group of perpetrators, and the genocide of the Jews by the Nazis into a rupture in the history of the West. The Nuremberg trials, as well as the 1945 exhibition of Nazi atrocities at the Library of Congress "showing the world" what *they* had done, were part of this distancing process, dissociating the recent violence from centuries of genocidal colonial campaigns conducted by those now acting as saviors. All this was done in the name of Jewish "exceptionalism." This exceptionalism served European imperial powers as it served the Zionists. The reified category of Jewish suffering was indirectly used at the end of World War II *against* other people who were equally targeted by imperialism's genocidal practices and mass plunder. Attending to the exceptional suffering of the Jews in a way that had little to do with healing or recovery allowed Euro-American imperial regimes to preserve their power and fashion themselves as different from the totalitarian regimes they condemned.

Why take the risk? Because decrying Jewish suffering, granting it a stage, restituting some seized Jewish property but very little property seized from other groups, enabling a Jewish state to be founded in the heart of the Middle East to serve Western interests—all this was a way of camouflaging the ongoing violence of Euro-American regimes. (It was not the Nazis who were responsible for the slave trade and enslavement, for the plunder of Africa,

Asia, and the Americas, for the Jim Crow regime, the genocide of Native Americans, the extermination of the Herero and Nama peoples, or the war against the Zulu Kingdom!)[29] Becoming caretakers of Jewish books and Jewish cultural and religious objects was a way to scrub these imperial regimes clean of past crimes and make them blameless in the future. It also silenced those who suffered genocides at the hands of these imperial regimes, who could not now speak their suffering without hearing: *But look what we've done for the Jews!*

As you well know, Israel didn't exist at the time these books were looted, but when the books' restitution was administered, Europe was already negotiating with the Zionist leaders through the Anglo-American Committee and other formations about transforming their organizations into state apparatuses so that a new Jewish state could be "like others." Thus it eventually became possible to "restitute" the books to Israel, which had not existed when the books had originally been looted. And yet, by focusing on this "restitution," a larger injustice was overlooked in international law: the Jewish property the Allies awarded the new state of Israel was not the Allies' property to give away, and Israel and these Zionist organizations had no viable claim to represent us.

Bringing all these looted books back to their homes in Europe—allowing the swallows/books to nest—could have empowered survivors of these communities to refuse to disappear. And descendants of those destroyed communities could have returned to Europe and had the swallows/books serve as substitutes for residency documents and proofs of belonging, rather than having to beg to stay in the places where their ancestors had lived and from where they had been deported. I can imagine you, Hagar, upon your arrival in Berlin a few years ago, going to local Jewish libraries searching for occult literature for your *Recalling History* project, as a way to prove your belonging to the city and to the books, rather than going to the visa office every few months, stressed and uncertain about whether you had the right papers, whether you could stay a few months more.

Thinking is an elusive activity. I often realize that my thoughts have been fermenting while I was sure I was immersed in a wholly different activity. Often, after being distracted by some blissful

Letter 5. Lately, I have been talking to my ancestors

labor such as cooking, sewing, beading, or drawing, I return to my desk and am overwhelmed by a sudden clarity—all of a sudden, words cohere together into sentences, and ideas appear that I was struggling to formulate an hour earlier. Similarly, I came out of writing *Potential History* understanding that I was already writing-without-yet-writing about how imperialism, the nation-state, and citizenship destroyed our lives—yours and mine, my children—and the lives of our ancestors. There is, beloved children, an entire body of knowledge that was taken from us— knowledge of the world, of our bodies, of the underworld, of *shedim* (*djenoun*, or spirits), of seasons, of the land, of the earth, of praying, of the sky, of love, of songs, of textile, of metals, of languages, of taste, and of our different kin. I don't know why I didn't find the words to acknowledge the intimate nature of this exploration earlier. It may be because I didn't know, I still don't know what it means to claim kinship with kin who were made into others. In whose hearts will these words of mine resonate?

We were colonized and abused by the invention of the nation-state, and we have a right to oppose its existence, to exit a project that was meant to force us to forget that we live in relation with different kin, with all other living organisms, with objects, the land, the earth. Thousands of millions of people aspire to this citizenship since it has become the only secure way for them to live in this untrustworthy world; but their pragmatic demand should not make us withdraw from the urgency of calling for its abolition. Who built the prisons many call to abolish? Our citizenship is made of the same substance as prisons and of its architects and wardens, though it carries the signature of freedom.

Our family did not originate in France, and no one from our family lived in France during the French Revolution. And yet, the history between our family (every single branch of it) and citizenship starts there. In the months that preceded the revolution, the king invited the French to register their wishes and grievances in what is called the "Notebook of Complaints." A complaint against the Jews appeared more than once, targeting their "numerous practices, incomprehensible to Christians" and the blended language they created, "intelligible only to them, and which covers their daily conventions with an impenetrable veil."[30]

The revolutionaries saw this veil wrapping around the Jews when they spoke among themselves. This veil was actually the substance of Jews' internal solidarity.

The French obsession with the veil did not start when they colonized the Maghreb and encountered the fabric veils used playfully by local women to protect themselves from intrusion. Unveiling was not limited to Algeria, as discussed in Frantz Fanon's essay "Algeria Unveiled." During the French Revolution, we can see this obsession with the veil firmly entangled in the assimilation and creation of the new republican citizen. In the Alsace region, thugs in blue coats armed with whips toured Jewish neighborhoods during Yom Kippur, making sure Jews did not come together in something that resembled a religious congregation.[31] In the Metz area, Jews were forced to take the civic oath; in Strasbourg, Jews were banned from taking it once they finally agreed to do so. The veils of solidarity surrounding the Jews were forcibly torn away.

After centuries, during which the Jews were recurrently expelled from France and later allowed to return, and had lived under all sort of restrictions and bans alternately issued and revoked (including, for example, forbidding them to speak with Christians in the streets), it's no wonder that the language of the Jews sounded veiled to their Christian neighbors. Like the way Algerian women used their veil to shield themselves from the colonizers, this was partly deliberate, a way to protect themselves from the hostility they faced.

However, only a few decades after the Jews in France were turned into citizens and lost their language-veil, some of these French Jews went to Algeria with the colonizers, aiming to *unveil* the local Jews and replace their Arab costumes with those of the standardized Jewish cult developed under the Napoleonic system of consistories. The civilizing mission started shortly after colonization in 1830 and preceded the transformation of Algerian Jews into French citizens a few decades later. Citizenship was, for Jews living France and Jews living in Algeria, a forced unveiling. It is this memory that I'm struggling to revive and inscribe here, for you, for others, to have access to it. I am trying to make up for the breakdown in the transmission of this knowledge through

generations: it should have been your birthright, and it should have been mine. I am trying to give you—and myself—our mother tongue back.

In Algeria, the veil—physically and mentally—was part of the nuanced way that women could be with and apart from others, not against them. In a dissertation I recently read on the common life of Jews and Muslims in Morocco's Atlas Mountains, the author, Sarah Frances Levin, describes how in certain communities in Algeria, Jews used Berber as "the language of affinity with their Muslim neighbors, Arabic their language of differentiation." This is how Moroccan Jews were able "to preserve a separate communal identity in the close-knit villages of the Atlas Mountains."[32]

Right after the French conquest of Algeria, the colonizers brought with them their obsession with the Jews' language-veil. Decades before they forced the Jews to become citizens, the French told the Jews: *We know what your true faith is and we will provide you with the means to administer it separately from your neighbors, so we can make you legible to us.* While the surrender treaty between the French and le Dey d'Alger signed in July 1830 explicitly secured the freedom of different religious cults, in October of the same year the French established a Jewish tribunal, nominated three rabbis to it, and defined the matters it would rule on. Four years later, they decided that this tribunal would handle only religious issues, thus redrawing the lines that separated religious life from the cultural and social spheres.

>—A dispute with your neighbors?
>Depending on who they are:
>Muslims?
>Go there.
>
>Jews?
>No, stay here.
>Give me your talisman first,
>it is against the law.
>This is a matter of religious life,
>but that is a matter of the law.

> —*But we do not recognize the difference.*
> So now you will!
> Do you feel pain?
> Go see a doctor
> in one of the clinics.
> Do not ever return to that woman!
> Forget about her herbs and this silly grigri,
> there is no such thing as evil eye (עין הרע)!
> Stop spilling salt!
> The entrance of your house is our street,
> get inside!
> Get rid of …
> and then, get out.

We could die citizens without knowing what our ancestors wanted us to know. By refusing to die as citizens, we will not be intimidated by the usual question: "So are you saying that Israel has no right to exist?" We can honor our ancestors and reply: "Our refusal is our ancestors' wisdom that you attempted to take away from us." The state sought to determine who our elders would be. But no, my beloved children—we decide.

> —Who is your ancestor who said that?
> —The Egyptian Jew Marsil Shirizi.
> —Didn't you say you were from Algeria?
> —Yes, and indeed, he is not biologically my ancestor,
> rather one of our elders.
> With him and others
> I am no longer alone.
> We form a minyan (מנין)
> but we are many more.

In Cairo in 1947, Marsil Shirizi addressed his Jewish brothers and sisters, calling on them to stop the dangerous adventure of establishing a Jewish state. It will contribute, he wrote, "to making Palestine uninhabitable" and will isolate Arab Jews from the Egyptian people. Zionism, Shirizi continued, "is the enemy of the Jewish people."[33] This unavoidable enmity with

Letter 5. Lately, I have been talking to my ancestors

Palestinians is the mold in which our citizenship was cast and it has shaped all of Jewish collective life in Israel.

> I didn't choose to leave,
> but I did refuse to be included
> in the state's calculus.
> I extracted myself,
> subtracted myself,
> from a body politic
> made up of citizens
> armed with metal rifles,
> who, at the border of Gaza,
> kill freedom dreamers.
> With every bullet in Gaza
> our ancestors' dreams
> refuse to die.
> A dream about an unconditional return
> of each and every dreamer from Gaza.
> When the Palestinian dreamers return,
> we too will have a choice.
> With them, I will return.[34]

I keep calling our ancestors to come to our aid, to give their testimony, to say aloud that they didn't want to be French, or citizens. It's a story we almost lost, and I'm still working hard to piece together their refusal, to have my own refusal echo theirs. This is what citizenship is made for—to socialize us to socialize our children who will socialize their children to believe that the same citizenship that enables so many people to perpetrate so many catastrophes should be preserved and passed down to new generations. When those who were not at first counted as citizens are then turned into citizens overnight—like the Jews, our ancestors—they are asked to serve as proof that people can move out of the "waiting room of history."[35] We have to warn our children and our children's children that at the same time citizenship is granted to them, others are denied it, since imperial citizenship is zero-sum: it can't be granted to some without being denied to a racialized group of others. As our ancestors

were the guinea pigs of this imperial experiment, we should hear their testimony and proclaim its failure.

Citizenship is the product par excellence of white supremacists, who exercise their right to make decisions about the lives of others. With the French Revolution, a universal language of rights came to separate individuals from different aspects of life through the term "regardless": *regardless of religion, race, class, language, culture.* The *regardless* citizens are the captive operators of the white supremacists' megalomaniac projects against living beings, objects, and the Earth. "Regardless" became a technology for human engineering. It enabled and legitimized the destruction of those realms of being-in-the-world in which life with others was not organized in separate spheres and did not have existence "regardless" of many aspects that made up their world.

Let me tell you more about this destruction (sometimes, self-destruction) by telling you a story about an essay competition launched in 1789 by the Royal Society of Arts and Sciences in the French city of Metz. Here was the prompt: "Are there means for making the Jews happier, and more useful in France?" One of the three winning essays was by a Polish Jew who lived in France. His answer began with the obvious: "Stop making them unhappy and unuseful."[36] The Jews in France have good reasons for being unhappy, he says:

> To be sure, during times of barbarism, there was no shortage of ways of oppressing the Jews. Yet, we are hard pressed, even in an enlightened century, not to repair all the evils that have been done to them and to compensate them for their unjustly confiscated goods.

He was right: the Jews had been expelled from France several times since the eleventh century, and their return to France was always conditional. As a racialized minority, most of the 40,000 Jews in France on the eve of the 1789 revolution lived in impoverished conditions. However, they lived in small communities that enjoyed a measure of autonomy and were organized around principles of mutual aid and support, and their life was not fragmented into dissociated elements such as "religion" that

could be emptied of their meaning and fashioned, managed, and controlled by the state. Surely, they desired and deserved what this prize-winning essay advocated: to be free of harassment by the French, and the lessening of harmful restrictions so that they might improve their conditions of life.

The author, however, who is already fluent in the universalized language of rights, doesn't call for the abolition of harmful laws and regulations, just lessening their impact on Jews in exchange for enhancing their surveillance. He recommends forbidding the use of Hebrew and Yiddish languages and characters in the account books and commercial contracts written by Jews, and he recommends making Jews subject to police inspection. He calls for the revocation of the authority of the rabbis and Jewish leaders, and he ends his essay with an ultimatum: "The freedom of the Jews is the best means of converting them to Christianity." In this essay we can see the occurrence of an almost seamless switch from the acknowledgment of a real problem—the oppressive French regime—to the blaming of the victims. It is not surprising that the jury selected this essay. It reflects the Enlightenment assumption that the Jews were ready to become universal citizens, to move from the waiting room of history to center stage, and to become white Christian citizens of Jewish faith, or even better, to convert. In and of itself, this essay, written by a Polish Jew, is a sign of the success of the destruction of Jewish diversity. As Patrick Girard writes in his book on the Jews and the French Revolution: "Nothing authorizes us to postulate a mythical unity, which is the consequence rather than the cause of assimilation."[37]

For centuries, when Jews were expelled from one place in Europe, they kept their group identity not as "Jews" but as Portuguese Jews, Alsatian Jews, or Jews from the Lorraine. They had their synagogues and cemeteries, their cosmologies and traditions. As small autonomous groups, they could exist collectively in opposition to and in distinction from many large-scale imperial projects. Some of this Jewish diversity found refuge in jokes. Here is one example you may be familiar with:

A Jewish man is shipwrecked on a desert island and builds not just one synagogue, but two. After a while, he is rescued by a sailor, who asks: Why do you need two synagogues? The Jewish man replies: This one is where I go, and the other is the one I would never set foot in!

This joke is thought to ridicule Jews and degrade their diversity into a purposeless inclination toward disagreement. But this is simply our ancestors' unruliness from the point of view of the imperial state, which can't understand or value their diversity. This joke is actually the story of a Jewish man's insistence, even on a desert island, in preserving the space of disagreement (מחלוקת).

In 1850, two decades after the colonization of Algeria, the French head of police found seventeen privately owned synagogues in Oran alone. As Joshua Schreier describes it, the French consistorial mission "demanded surveillance of public prayer and thus led to an ongoing effort to close" the synagogues.[38] When my father was born, there were no longer as many synagogues, and the aggression involved in the consistory regularization was barely remembered. My father used to mention with awe the extraordinary voice of the cantor in the Great Synagogue of Oran. I don't know how much was lost of diverse local cantillations when the prayers were standardized, but I do know that local shared Arabic sounds were kept in the synagogues of Oran at this time, persistent music played with their Muslim neighbors despite colonization and separation.

The French citizenship of Jews in France and later in Algeria was imposed as a bargain: *Dismantle your community and we will grant you limited legibility in the new state as a "religion."* From the moment they were proclaimed citizens, this bargain was assumed to have been concluded; our ancestors never even got to refuse or accept this "bargain." They became citizens *regardless* of their religion, which meant that they could be citizens only as long as they remembered to be, act, and speak regardless of their religion.[39] Even those who desired assimilation and citizenship were doomed to fail as the universality of citizenship didn't dismantle the technologies by which they and other groups

Letter 5. Lately, I have been talking to my ancestors

had been racialized for centuries. Thus it is not surprising that in the intersection between the racializing technologies and the universalizing ones, Jews-as-citizens could pass unnoticed only if they acted like those who opted for an official conversion to Christianity. Hence, the citizen of Jewish origin is by definition one who lies about their identity, preyed on by the anti-Semite to reveal their truth. That the Jews' inclusion in this citizenship was conditioned on their readiness to eliminate their differences should have been a warning sign.

The imposed citizenship in Algeria was also used to keep others out, captives in the waiting room of history. That it could be forced on our ancestors in Algeria, ending the lifeworld of Jews in North Africa, is not incidental but essential. Jews were offered a fatal deal: disappearance from the public sphere as Jews. Including the Jews in this citizenship was partially an attempt to whitewash the genocidal violence against Algerians that was perpetrated by French citizens. Our ancestors were forced to forget that they were victims of this violence too. The power given to citizens to annihilate others should not be denied when we consider the nature of imperial citizenship.

>Property,
>a lot of property,
>all the accumulated property of the world,
>cannot substitute for a world
>not owned but shared,
>not fully made
>but still partially given.

>Racialization is the essence of whiteness.

>Chameleon-like, Jews
>disappear,
>or fail to
>disappear,
>or could still
>refuse.

Worldliness cannot be regained without breaking this contract with imperial citizenship. It's true that our ancestors refused, but they, or their descendants, also betrayed us. My father stopped himself from ending meals with a blessing, praising God *who every day invites the world / To the feast of love, goodness, and compassion.* But he also inherited the capacity to disregard state officials, who acted as if they were gods in the service of institutions he despised. If blessing, acknowledging with grace what we have been given instead of rushing for more, had not been made foreign to the modern self-made youth, would my father have stopped giving this blessing? I sense that he did not want to stop: when he found people who would listen to him tell stories, he spoke as if he were blessing.

I feel blessed by the gifted storyteller that he was. He was like a magician: he didn't carry storybooks with him, but he always had a story waiting to be told, ready to take shape when the moment was right. Stories arrived to suit the listeners and the occasion. Storytelling is a way of being present in the world, tuned to its sighs, secrets, shapes, moans, and whispers—not making them

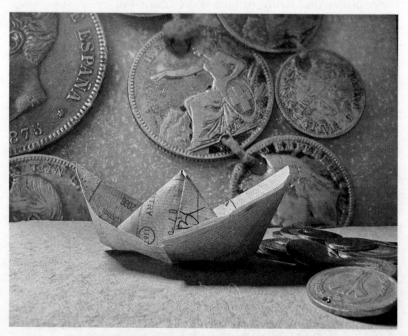

Miraculous boat, inspired by the Rabbi from Sevillia, made out of a passport page by Ariella Aïsha Azoulay, 2024.

Letter 5. Lately, I have been talking to my ancestors

yours, but generously and exuberantly stringing the world into words to give to others. When his larynx was removed and he lost his ability to tell stories, my father was no longer able to offer a blessing or to be blessed.

I'm trying to tune in to the stories that he wasn't able to tell and that were not told to me, so that I can learn them and write them down, over and over again. I want these stories to widen the spaces between the letters of the name-of-the-place-written-in-my-passport-as-my-birthplace ("Israel"), a name that separates me from my ancestors and bans our entry into the land-where-they-are ("Algeria"). I'm trying to slide these printed letters on my passport to the edges of the passport's pages until they are pushed off the four corners and the page turns blank (see photo p. 196). I fold the bottom half of my passport page up to the top, make a small pinch to crease the paper, open it back up, use the crease as a guide, fold the corners up and to the middle, flatten the folded pieces down, rotate the paper, flip it over, unfold and fold again, until the miraculous boat that in 1390 carried the condemned rabbi and sixty members of his community from Seville to Algeria reappears, and we can all sail to Al-djazaïr away from the history that was prepared for us into the potential one that was stolen from us.[40]

The recitation of a centuries-old refusal may be the only thing I can hand on to you, my children, as something *of* our family, of who we were before we were citizens, before our right to seclusion was violated, before we were made wards of the state, before we were trained to not speak our ancestors' languages. How do I know that our ancestors didn't want to stop being who they were? In 1865, all indigenous Algerians—Muslims and Jews alike—were invited to apply for French citizenship. Most of them, save for three hundred, did not apply. In that year Jews and Muslims performed a mass refusal of the colonial deal. Even though our ancestors were eventually forced to become citizens five years later, we have the right to continue their mass refusal and break the colonial contract.

> "If I had had another daughter,
> I would have called her Algeria."

When I think about our ancestors' refusal in 1865, I hear this poem by Ronny Someck in my head. Imagine Sliman Cohen and Semha Toubul calling their daughter Marianne. It was like calling her France. Marianne is the name of my great-grandmother in the French documents her parents were compelled to file. Did her parents call her only by this name?

When this Marianne, my great-grandmother, grew up, she had a daughter whom she called Aïcha (the name of Muhammad's third and beloved wife). This was like calling her daughter Islam and saying, "Fuck you, France."

Marianne, a Jew, told the French colonizers, through the name of her daughter, "Islam is my culture, alongside my Jewish faith, and my Jewishness is also my neighbors' culture, whose faith is Islam."

Now I say, *"Fuck you, Israel, I call myself Aïsha, even if my father, barely three generations after the French forcibly converted the Jews, was ashamed of his family for still being shrouded in Arabness, for failing to be shed of all their Jewishness."*

My father failed to call me Algeria, as well as Aïcha, like he failed to invite me to see the beauty of Africa.

When he passed away I called myself by my grandmother's name, and I misspelled it. I kept this typo to make sure I didn't forget the colonial injury that made it so that it was not my father who could give me my name, but I who reclaimed his mother's name.

In 1942–3 in Algeria, the Americans were the liberators. But they could not have landed in Algeria without the help of four hundred Jews organized clandestinely as part of "Operation Torch." Sometime between the landing of the American soldiers in November 1942 and your grandfather's liberation from the Bedeau camp in mid-1943, your grandfather would have heard that American soldiers had liberated Algeria. This is when his love for the Americans (nurtured by the films he watched) was cemented. The contribution of the Jewish clandestine movement was minimized, also by the Americans, and it was removed from the annals of the Nazi defeat in Algeria for several decades. I wish I had known of it earlier so I could have asked him if he heard

Letter 5. Lately, I have been talking to my ancestors

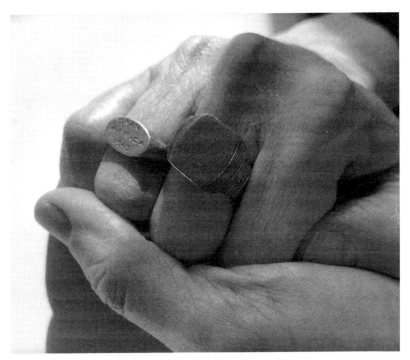

Rings made by local jewelers in Oran, memorizing the liberation of Algeria from Vichy, engraving the year 1943 (rather than 1942) to reflect the year when the Jews were liberated. Photo: Adel Ben Bella.

about it when he was in the camp or only after he was liberated from it. Had he known that the Americans also delayed the liberation of Algerian Jews after the defeat of the Vichy regime?

These two vintage rings can still be found online with the US version of the story, alleging that they were prepared by local jewelers to thank the US troops for liberating Algeria in November 1942. But those local jewelers didn't engrave the year of the operation but rather the next year—1943. I'm tuned here to the story these jewelers wanted to tell. In 1943, the French government in Algeria was forced to restitute to the Jews their political status and allow them to work again. The large variety of examples I was able to locate suggests these rings were not made by one of the big French jewelry firms that sought to profit during the time the Jews were not allowed to practice their profession. It was rather the return of those jewelers to work that can be traced here. These artisans engraved in precious metal a statement commemorating the time stolen from them that began with the Americans landing

in Algeria and lasted until their formal liberation was achieved. Our belonging to Africa is also recorded on these rings.

For my father, the Americans soldiers he encountered on the streets of Oran, many of whom were African Americans, were his liberators, and Ella Fitzgerald was one of them. Though he knew scarcely a few words of English, during the short interval between his liberation from the camp and his being drafted in the military, he found a small job as a translator in the kitchen of the American army base in the city. For him, this was an opportunity to talk about jazz and his love for Fitzgerald and Benny Goodman, as for him "American" meant jazz players and jazz lovers. One day, one of these soldiers told him that he was the brother-in-law of Artie Shaw. Your grandfather, elated, invited this soldier to his home and showed him his collections of vinyl records. "He could not believe the records I had!" my father told me proudly years later. Did he have a copy of "Any Old Time" that Billie Holiday recorded with Artie Shaw's band in 1938? Fitzgerald never came to Oran, but she did sing for US troops before they departed for North Africa, and later, for Europe. In 1943, however, Josephine Baker was brought from Morocco to Oran to sing the American national anthem with an all–African

Josephine Baker, Oran, Algeria, 1943.

Letter 5. Lately, I have been talking to my ancestors

American orchestra. If he was not already with his battalion on the way to Tunis, your grandfather probably didn't miss her show.

Baker, who lived in Paris, fled to Morocco when Paris was occupied. My father knew nothing about race in America, nor that these Black singers were discriminated against for being "African" before being "American." In his eyes, "American" meant them. Their voices were part of his Algerian soundtrack. He often said with pride that his younger sister resembled Fitzgerald. I never particularly liked the name my parents gave me, but I loved listening to my father's tale about how they decided on it. His idea was to call me Ella, after Fitzgerald. My mother had her own preferences, but he insisted, and he was proud of the compromise they achieved: Ella was preceded by my mother's family name—Arie. I was not called Algeria, at birth, but rather Ariella. When I was born in 1962, he likely understood from the anxiety expressed by his mother and sisters in Algeria that his family would soon be obliged to leave Algeria, and it must have been unsettling to see the door closed for *all* Algerian Jews, as if forever. In retrospect, I see that giving me Ella Fitzgerald's name was a way of smuggling his longing for home into our lives, since he was unable to acknowledge that longing outright. If he could have acknowledged this wound, its depth and width, its impact on his ancestors, siblings, or offspring—if he could have acknowledged that leaving one's homeland can't make the pain of world-loss disappear, he would have called me Algeria.

"Algeria, come home, look how I paint the eastern wall
with a brush of sun."[41]

Your grandfather watched American films, and his sister V., the one who he always said resembled Ella Fitzgerald, sewed him some nice American suits based on drawings he made after watching these films. What he wore was his own interpretation of being a French citizen in Algeria.

At the beginning, Algerian Jews felt a pain in their mouth when they had to say, "I am French." Their cheek muscles rebelled, until with time, saying "I am French" felt less an imposture. Their children could slip out of an Arabic or Berber accent and simulate

Roger Lucien Azoulay, dressed in a suit made in Oran by his sister, Marseille, 1945.

near-perfect French diction. Still, the French settlers hated them for usurping *their* citizenship, and the same anti-Jewish literature that proliferated in France after the Jews were made citizens flourished also in Algeria.

Algerian Jews realized that, contrary to what they had been told, French citizenship was not race-blind—rather, it functioned like a magnifying glass, blowing up differences that the state language of republicanism had proclaimed were too small to matter, though they did. They mattered to the *Français de bonne souche* (the French of good origin, that is, European), who considered Algeria's Jews "French" only through a trick of paperwork. It came to matter to the Jews when their citizenship was taken from them by the Vichy regime. For sixty-nine years, Jews with French citizenship had been taught that the French were good patrons, welcoming of them, even though it contradicted much of their daily experience. At the beginning of the Vichy regime, a few Jews even praised Marshal Pétain, maybe hoping that they might be rewarded for their loyalty or trying to please the

Letter 5. Lately, I have been talking to my ancestors

new regime in order to survive. Other Jews understood that assimilation drained them of their strength as a community and, as described by the historian Jacques Cantier, "deplored that in the name of assimilation they allowed the dilution of a Jewish identity, threatened by the decline of community bonds and of religious practice." The French Vichy regime's revocation of their French citizenship revealed the depth of what they had been forced to bargain away: they had gained a fickle imperial citizenship, easily withdrawn, in exchange for their centuries of mutual aid structures and collective resilience. Bereft of this citizenship and no longer able to deny French racism against them as Jews, they had, as one historian argues, "actually ceased thinking as a community."[42]

Do you remember the biblical story of the tower of Babel: "and all the earth was one language, one set of words"?

In the chapter prior to the story of the tower, we are told that a plurality of languages and peoples had existed before the tower was built: descendants of Noah, sons of Japheth, sons of Gomer, sons of Javan, sons of Ham, sons of Cush, sons of Raamah, "each with his own tongues." And then, in the next chapter, all the diverse peoples now share "one language, one set of words," and they come together to build a tower to the heavens. This worried the Lord, who "came down to see the city and the tower that the human creatures had built," and he feared what else this united, hubristic people might do. As the story goes, the Lord destroyed the one human language, and, unable to work together, the people left the tower unfinished and they scattered over the earth.

Most interpretations focus on the devastating loss of the united language. But the story suggests that the creation of a single language for all the earth was not an organic occurrence but rather one formed through violence—an original violence that predates the building of the tower.

Think about citizenship as this single language. The violence that *preceded* its imposition and made the story possible in the first place is omitted, cordoned off in a previous chapter. It is, however, not the only thing that is omitted. The existence of the single language erases its own violence, it does not admit that prior to its imposition, other diverse languages were destroyed.

In the story, all the people are represented as joining together to build a single tower, a constructive, vertical act that disavows the destructive one it memorializes. The violence of citizenship needed to be unseen by citizens, who were born to be citizens-who-beget-citizens, who beget yet more citizens, and so on and so forth, all of whom learn to speak the single language of citizenship (even if in diverse dialects). The single language of citizenship: the same set of words processed with compatible machines and software, with the same checkpoints and border patrol posts, detected with the same barcode scanners, certified by international law, monitored through facial portraits and identity checks. This single language is regularized and centered in the United Nations, the tower erected to make sure the official language is understood: citizens are *of* the state, and states have the right to define which aspects of their citizens' lives are within the purview of their intervention, as well as what can be litigated, where and when. The regime of human rights, in which one size fits all, is conducted in the language of citizenship.

Think of this story you know so well as one about citizenship:

> And all the earth was one language, one set of words. And it happened as they journeyed from the east that they found a valley in the land. And they said to each other, "Come, let us bake bricks and burn them hard." And the brick served them as stone, and bitumen served them as mortar. And they said, "Come, let us build a city and a tower with its top in the heavens, that we may make us a name, lest we be scattered over all the earth."[43]

While God is worried about the power the people acquired through unification, the people are worried they might be scattered. The people and God hold agonistic positions, yet they see the same thing: in order to rule over all the earth, they have to destroy the different languages that they and others speak. God is determined to not let the technology of the tower reach into his dominion and unite the people, while the people act as if the one language were under threat—*lest we be scattered over the earth*. Thus we see the language of citizenship in action: it reverses the relationship between *what is* and *what might happen*.

Letter 5. Lately, I have been talking to my ancestors

With this reading of the Babel story in mind, it is easy to see the trap of citizenship that originated in the French Revolution and survived as the lingua franca of politics, a promise of freedom in the name of which so many people were killed. Citizenship erases its own violence and erases any refusals made against its totalizing view. "*And the LORD said, 'As one people with one language for all, if this is what they have begun to do, now nothing they plot to do will elude them.'*"[44]

And indeed, the French revolutionaries, persuaded that they had found the philosopher's stone of politics, set off to war against others who adhered to their own languages to express love, compassion, pity, care, frustration, and poetry. In 1830, just four decades after the Revolution, the French even crossed the sea southward and arrived to Al-djazaïr. Their big army consisted of soldiers and scholars and heavy equipment, and they landed at the upper tip of Africa. The earth they found was babbled with Arabic, Tamazight, Mozabite, Judeo-Arabic, Riffian Berber, Arzew dialect, Shawiya, Shawiya Berber, Kabilyan Hebrew, Ladino, Turk, Italian, Spanish. The French were armed with cases full of papers, with which they were ready to turn people into civil data, to chop their names apart, to standardize their family formations and social life, so that they could own them through documents. The French were looking for a valley in which to settle in this vast land they had proclaimed to be theirs, and they said to each other, *Come, let us build a city and a tower with its top in the heavens, that we may make us a name, lest we be scattered over all the earth.*

Now you can see this reversal of *what is* and *what might happen*: the threat was not that the French would be scattered all over the earth, but that the diverse peoples they encountered could not be made to abandon their languages and adopt a single one. The French knew that as long as the inhabitants of the valley they now handled were scattered, they would not recognize French rule or commands. Concerned with the name of their empire, the French revolutionaries/colonizers denied the violent meaning of what they were doing in the present and presented citizenship grandly, as a gift. The French saw that taming our Algerian Jewish ancestors and making of them a cohesive group, as they had done with the Jews in France, would inscribe

them into the one language through the mode of a compliment: Jews whose "habits, language, interests were the same" as those of the French colonizers could now benefit from the language of citizenship, which "was a boon to them."[45]

This determination—shot through with hubris!—to pull the Jews out of their diversity, rescue them from their poverty among other nations and standardize their religion to make of them a unified people started with Napoleon's expeditions, which in turn were guided by his obsession with making for himself an imperial name. The printing press, armed with typefaces for different local languages (Arabic, Greek, Turkish), was central to Napoleon's expedition to the Orient. In the spirit of revolutionary France, a printed proclamation in the local language was disseminated in each new location, pamphlets taking the place of a horn to herald the power of the French. Napoleon's addresses, delivered at the turn of the nineteenth century to the Egyptians in the form of thousands of printed copies distributed across the region, invited Egyptians to see in him and his army their salvation.

When Napoleon arrived in Egypt, Egyptians would have already heard about his deeds and perhaps feared his interventions. Were they informed by the Jewish community in Egypt, who had already heard from other Jewish centers in Europe about the way he treated their synagogues? I don't know for sure; it is hard to find answers, as the little that is written on the Jews in Egypt during the French and later the British occupation follows the same story that European historians write about the Jews in Algeria: that they welcomed the colonizers as liberators. The Jews have no voice in this history. What I do know is that Napoleon was aware of Egyptians' fear and mentioned it in his pamphlets:

> People of Egypt, they will tell you that I come to destroy your religion—do not believe it. Tell them I come to restore your rights, to punish the usurpers, and that I respect God, His Prophet Muhammad, and the Qur'an, far more than do the Mamluks.[46]

Before entering Egypt, he instructed his soldiers: "For the ceremonies that read from the Qur'an, and for the Mosques, show the same tolerance that you have shown for the convents and the synagogues, for the religions of Moses and of Jesus Christ."[47]

Letter 5. Lately, I have been talking to my ancestors

The Egyptians didn't believe a word; they knew destruction was the meaning of anything Napoleon said.[48] These proclamations, described by the French as "seeds of true liberty" and intertwined with the work of the spies Napoleon recruited everywhere he went, could not take root, nor could they bloom.[49] Their devastating impact can be measured in the number of *blocks they baked and the bitumen that served them as mortar* for erecting their imperial power, on which future imperial projects could be built until *all the earth was one language.* For example, the address to the "Kouloughlis—sons of the Turks and Arabs, living in Algiers" that the French issued in 1830 refers to the proclamation to Egyptians three decades earlier: "The French will treat you as they treated your beloved Egyptian brothers thirty years ago, who have missed us since we left their country."[50]

When Napoleon invaded Europe he ordered the walls of the ghettos where many Jews lived to be torn down. These ghettos were not like the military-controlled checkpoint ghettos built by the Nazis; rather, they were actually sites of Jewish autonomy throughout Europe, organized as separate quarters or neighborhoods. Some of them were delineated with walls, others with regulations; some were stricter than others, some isolated, and some in constant exchange with their neighbors.[51] In a continuation of the French Revolutionary spirit of denigrating everything that preceded the revolution and imposing a "new beginning," commanding the fall of Jewish ghettos in Europe was not emancipatory but actually destructive of Jewish forms of life. Destroying the ghettos was part of the process of forcibly converting Jews into imperial secularism through the language of citizenship, which stripped them of their Jewishness in order to assimilate them as citizens.[52] (It is worth saying that the emancipatory language offered by Napoleon resembles the tropes used by all sorts of entrepreneurs today, determined to gentrify entire neighborhoods and describe them as depleted and unsafe before the "new beginning" of real estate development.)

A potential history of the ghettos as non-statist political formations, as sites of marronage, is still to be written. My hope is that these letters contribute to the growing insurgency against

the way our histories were both taken from and given to us, to make us disappear in the history of empire and to retroactively justify the assimilation of diverse Jews. First, not all Jews lived in ghettos, not all walls were oppressive, not all of them were torn down, and—needless to say—not all the Jews recognized this imperial-revolutionary storm as their salvation. Timelines of Jewish emancipation, reporting the year when "it happened" in one country after the other, usually beginning in 1791 and up to 1923, are an ironic satire of emancipation proffered as truth. Though we have so much else—poetry, films, images, words—that shows these timelines to be false, they nonetheless still frame how history is written and read. That many Jews in these places saw Napoleon as an aggressor and considered his actions an attack on their communities is not unknown by historians—yet still this timeline of emancipation has not been discarded or actively dismantled. The Jews' opposition, however, disappears from universal narratives of Jewish history or is included only in an anecdotal way. In these histories, emancipation-and-modernization is assumed to be an irresistible force.[53] Furthermore, opposition to state citizenship as a group is almost not available as a viable communal option, except in some ultra-orthodox Jewish communities such as *Neturei Karta* ("The Guardians of the City") and other *Haredi* (ultra-orthodox) groups. These groups are not merely anti-Zionist; for them, the power of the state is today as foreign as it always was in the countries where their ancestors lived.

In her essay on anti-Semitism, written between 1938 and 1939, Hannah Arendt depicts two competing versions of the history of Jewish emancipation in Europe: the "assimilationist," meaning forfeiting Jewish forms of life in favor of becoming citizens, and the "nationalist," a proto-separatist position of Jewish nationhood. The latter, epitomized by Zionism, is built on the assumption that the Jews' "exaggerated patriotism" in different places where they were assimilated "allowed them to deceive themselves, but no one else, as to this fact."[54] This "exaggerated patriotism" deserved to be questioned—what is this readiness to exist *for* the state, readiness to partake in its harmful projects? Zionism's response was to enhance this nationalist position and

Letter 5. Lately, I have been talking to my ancestors

direct it toward a Jewish state. Arendt sees both trends as "purely dogmatic" and emerging out of

> a shared Jewish *fear of admitting that there are and have always been divergent interests between Jews and segments of the people among whom they live*. As a means to avoid having to acknowledge any true and specific foe, generalization and misinterpretation turn factual rapprochement into 100 percent correspondence and factual difference into substantial alienation.[55]

As important as Arendt's emphasis on the "segments" of society is, this point should be followed by an emphasis on the divergent approaches among the Jews, which are irreducible to these two histories, "Zionist" and "emancipationist," or as Arendt says, "nationalist" and "assimilationist."

I'll briefly share with you two aspects that render both these histories fictitious. First, the history of "the Jews," as it has been told, has largely been a European conversation, among Europeans about Jews in Europe, though it is presented as a history of the Jews in general—thus incorporating Jewish communities in Africa, the Middle East, or Asia into European categories. Second, Arendt ignores the opposition to emancipation that is not framed within Zionist or nationalist terms. Opposition to emancipation in France didn't cease with the imposition of citizenship, and many Jews in different communities—including those in Metz, the Haut-Rhin, Strasbourg—rebelled against the consistories that were appointed by the emperor to conduct the "regeneration" of the Jews. In many of these places, according to the police, the Jews were conceptually divided into two populations, "old" and "new," where the old were described as "very heated heads, fanatic, passionate, insubordinate people."[56]

A European-only history of the Jews would not be as problematic if France had not colonized Algeria, forcing these diverse Jews to be homogenized and become part of France's history. Since the state of Israel was conceived as part of this European conversation about Jewish history, paying attention to the aspects that Arendt ignores is crucial to disaggregating the history of "the Jews." In the falsely unifying European history, Jews in Muslim

countries are included only as a kind of (slim) appendix, causing the memory of their opposition to fade away. Arendt is right in saying that this impulse to be included in imperial world history serves the interests of one segment of Jews, as well as "*segments of the people among whom they live.*" But it does not serve the diverse Jews whom it assimilates and silences.

> We are not bound by the pact
> forced on our ancestors,
> even as we are told
> that this was their desire.
>
> *Their* desire?
>
> Or that of a single segment?
> And what about other segments
> who desire it not?
>
> Those passionate, heated heads
> whose opposition was concealed
> to prevent the Jews' "true nature"
> from being publicly revealed—
>
> Even if after one, two, three generations,
> when it seems that they *all* desired,
> let's not forget
> there were those who desired it not.

Jewish communities in Asia and Africa had a different experience from the European one articulated in these narratives; they didn't have—and didn't aim to have—*a history*. History is part of the single language used to build *a city and a tower with its top in the heavens*. Potential history is premised on a refusal to climb the tower's stairs, and instead it rehearses the different languages of refusal.

When Arendt wrote this text in the 1940s, the scattered Jews in the Maghreb had already been forcibly incorporated into a unified Jewish people. In a place like Algeria, the Jews were also forced to go through an abridged version of Jewish history in

Letter 5. Lately, I have been talking to my ancestors

Sign announcing the building of a new national convention center on the lands of Sheikh Badr, 1950. Image part of the series Crafting Citizens (redacted by Ariella Aïsha Azoulay).

Europe: they were discriminated against by Europeans (though they lived in a Muslim country), then emancipated, then turned into the object of European anti-Semitism, then their citizenship was revoked and, finally, restored, and then they were "repatriated" outside of their homeland. It is important not to forget that when their citizenship was restored in 1943, most Jews in Algeria did not show interest in the Zionist movement. (In my letter to Hannah Arendt, you will find some interesting details about your grandfather in this context.)

I refuse to be the *new Jew* whose ancestors are assumed to be Israelis while who they actually were fades into a nebulous past. Through these letters I'm trying to reconstruct a genealogy of those refusals—the line of refusals into which you were born. The creation of a settler-colonial state restarts historical timelines. In this settlers' fantasy, the "new Jew" is programmed to progress over time and fulfill "its" destiny. I refuse to progress and to fulfill any destiny because "the new Jew" is not *for* the Jews but *against* all Jews.

The futurist and triumphant images of state-creation inspired the world, including what is depicted in the image above. In 1951, in ruined Palestine, on the lands of Sheikh Badr in Jerusalem,

Israel inaugurated an international exhibition titled "The Conquest of the Desert," sharing with the world its newly acquired expertise in empire-building.

Here again, I would like to share with you what I learned from Arendt. At the end of her book on the Eichmann trial, *Eichmann in Jerusalem*, she emphasizes what the trial failed to do. "At no point," she writes,

> either in the proceedings or in the judgment, did the Jerusalem trial ever mention the possibility that extermination of whole ethnic groups—the Jews, or the Poles, or the Gypsies—might be more than a crime against the Jewish or the Polish or the Gypsy people, that the international order, and mankind in its entirety, might have been grievously hurt and endangered.[57]

Rather than exceptionalizing the Nazi extermination program, Arendt emphasizes its continuity with other campaigns of mass extermination, with its "automated economy" and its cultivation of "thoughtlessness" (as Arendt says of Eichmann)—both of which are now available to all killers, anywhere. She continues: "It is apparent that this sort of killing can be directed against any given group, that is, that the principle of selection is dependent only upon circumstantial factors."[58]

Here, Arendt makes explicit the distinction between the selection of the victims and the nature of the crime:

> Had the court in Jerusalem understood that there were distinctions between discrimination, expulsion, and genocide, it would immediately have become clear that the crime it was confronted with, the physical extermination of the Jewish people, was a crime against humanity, perpetrated upon the body of the Jewish people, and that only the choice of victims, not the nature of the crime, could be derived from the long history of Jew-hatred and anti-Semitism.[59]

With this distinction, she made the principle of selection (not the fact of who was selected for death) into the reason for considering the Nazi-driven genocide as a crime against humanity:

Letter 5. Lately, I have been talking to my ancestors

It was when the Nazi regime declared that the German people not only were unwilling to have any Jews in Germany but wished to make the entire Jewish people disappear from the face of the earth that the new crime, the crime against humanity—in the sense of a crime "against the human status," or against the very nature of mankind—appeared.[60]

The attack against the human, as Arendt articulates it, is an attack "upon human diversity as such, that is, upon a characteristic of the 'human status' without which the very word 'mankind' or 'humanity' is devoid of meaning."[61] Thus, not only does Arendt reject Jewish exceptionalism; she also emphasizes the attack on human diversity as the core function of this crime, connecting it to other attacks on human diversity. Alongside the use of genocidal violence, the attack through assimilation upon the Jews, like that against Native Americans, using tools of assimilation, regeneration, re-education, and citizenship, is an attack on human diversity. The assimilation of any people should thus also be understood as a crime against humanity.

The exceptionalization of the Holocaust was the continuation of assimilatory campaigns that preceded the Holocaust. Jews were presented with assimilation as if it were a gift or consolation—first through the erasure of their ancestors' lifeworlds, making them vulnerable to imperial genocidal plans; and second, through citizenship's revocation as part of such plans. With the founding of the state of Israel and its support from European and American statesmen, the Jews became a symbol of the rehabilitation of Europe and the United States, permitting both to evade accountability for their own imperial crimes and also to continue their colonial projects and genocidal practices against other peoples. The case of Algeria is exemplary in this sense. While the French denigrated the Vichy regime and described it as an accident in the history of France, post-Vichy, they continued destroying the diverse rural life of Algerians (this time non-Jews) and deported several million Algerians from their villages to concentration camps that they called "regrouping villages."[62] And of course, describing Vichy as an accident helped obscure the French role in deporting French Jews to death camps and Algerian Jews to concentration camps.

In a cruel way, the rehabilitation of citizenship through the Jews, which neutralized their experience as victims of empire, made them captives of the colonial bargain—the only deal that was offered to them. This required the universalization of the Holocaust experience, and it also defined when, where, how, and by whom it could be spoken about. You may not remember, but when Ellie was in second or third grade, sometime in the early '90s, she was asked to bring to class photos *from* the Holocaust. I told her that she could bring photos of her grandfather who had fought in the war and was among those who liberated Italy and France. She replied with what she had been told by her teacher: "No photos from World War II, but from the Holocaust."

Let's be clear about this. People do not have photos "from the Holocaust" in their family albums. The Holocaust is not a place, and only a few Jews are known to have been able to take clandestine photos from the death camps.[63] These photos were not "of" or "from" the Holocaust, and they didn't circulate in family photo albums. What the teacher meant, probably, was photos of family life in Europe before or during these years. This teacher made three approximations, common in the Israeli education system: between Jewish life in Europe and the extermination that further homogenized the Jews; between the transition from European anti-Semitism to Zionism as the solution; and between European Jews and the Holocaust, as if Jews outside of Europe were not also targeted. Schoolchildren in the Zionist colony were being asked to bring what they or their family consider relevant, and in return, they were being disciplined into producing what can be considered an authentic piece of historical knowledge. This is how the extermination of the Jews is policed into a generalized Holocaust narrative, represented in the *one language of empire, the one set of words* that they were allowed, the set of words with which their lives were destroyed and with which they learned to forget who they were.

The twin of the universalized story of the Holocaust is the universalized story of emancipation. You can understand now why I wanted to share with you the opposition of many European Jews to the deal of citizenship offered to them as "emancipation" in the eighteenth century, since this legacy bolstered the narrative of their emancipation.

Letter 5. Lately, I have been talking to my ancestors

With the creation of the state of Israel, the two European narratives described by Arendt—assimilationist and nationalist—materialized in the world as the two major options for Jews to choose from. The political language that had destroyed the lives of so many people was injected with new blood in Palestine. The European fantasy of establishing a state for the Jews echoes the Tower of Babel, assembling Jews who were *scattered all over the earth* into *one valley*, in which the plurality of Jewish political lives and languages and refusals received a fatal blow. Despite this blow, refusing this citizenship is an opportunity to have an intimate dialogue with our ancestors about the worlds that we could have had if their lives had not been so brutally disrupted. In rejecting exceptionalism, we share kinship with others whose worlds were also destroyed by imperialism.

We were born, my beloved children, to live out dreams that were not ours, nor those of our ancestors before they were cast in the mold of the assimilated European Jew. The recovery of diverse forms of autonomous Jewish life is necessary in order to remember, imagine, and speculate on what a different form of sharing the world might have been and still might become today. Different Jews, dreaming and acting as different Jews, alongside others who care for the world, constitute the path to unlearning the institutional language of white supremacy that counts on the unified Jew to sustain its universality. We refuse the dreams that are not our own. We are different Jews.

The idea of encouraging Jews to transfer themselves from Europe to Palestine didn't start in the late nineteenth century with Jewish Zionism but rather much earlier, in the wake of the French Revolution, in Napoleon's orientalist circles and followed with ideas of Christian Zionism. Before Napoleon set off on his expedition to Egypt, Palestine and Syria, an editor of an influential journal wrote of the destiny of the Jewish people to revive their kingdom in Palestine. He presumed that "they would rush from the four corners of the globe if given the signal."[64] We can learn from this that inscribed within the conception of citizenship crafted by the French Revolution was an idea of self-determination that required the inevitable engineering of populations: building a *city and a tower with its top in the heavens.*[65]

To build the city and the tower, Napoleon's advisors collected data on the Jews and their dispersion in France. They discovered the principle of their spatial presence, their preference to live in community among other Jews: "The number of isolated [families] was relatively small since Jewish rites do not allow them to live isolated among Christians; they seek to unite a certain number together in the aim of providing mutual aid."[66] When the Jewish modes of being in a Christian world were reduced to a set of religious practices, independent of membership in a community, communal principles and mutual aid formations were broken.

In 1807, Napoleon decided to re-establish an old Jewish high court called the "Sanhedrin." The notables assembled from all over Europe had to answer twelve questions given to them by the government, and the High Court was required to assess their answers. That these representatives in the Sanhedrin were enlisted doesn't mean that all of them complied, or that they considered the documents they were compelled to sign as binding. This assembly of official Jews was used to approve the narrow top-down Judaism allowed by the state. With the Sanhedrin's resolutions defining permissible Jewish life, Napoleon's plan was "to have them disappear entirely by means of total assimilation, intermarriage and conversion."[67] Napoleon had a medal created to commemorate the event (see p. 218).

> Looking at this golden medal
> coined in France in 1808,
> should I laugh or cry?
> Napoleon in the role of God,
> granting the tablets of the Law
> to Moise, Moshe, Musa,
> the kneeling,
> grateful Jewish people.
> Did no one whisper in Napoleon's ears,
> "God should ever be absent"?
> Did no one also whisper to him
> that Moise's face had no horns (קרן)?
> His face was rather emitting rays,
> radiating.

Grand Sanhedrin of Jews from the French Empire and Italian Royalty, convened by Napoleon. Drawing by Michel François Damane Demartrais.

Cover page of the *siddur* commissioned by Napoleon and used at the Grand Sanhedrin, 1807.

THE JEWELERS OF THE UMMAH

Medal commemorating the Grand Sanhedrin, Paris.

> Didn't Napoleon read police reports?
> In Haut-Rhin, Metz, or Strasbourg
> hot-headed and passionate Jews
> were rioting in the streets,
> refusing to recognize themselves
> in the "Jewish people" Napoleon tried
> to coin in his mint.

After less than a year Napoleon dissolved the cumbersome Sanhedrin and invented another state instrument to subjugate the scattered Jews to a state-sanctioned Judaism, the Israelite Central Consistory (הרבנות הראשית), charged with the systematic destruction of diverse Jewish communities in France through a program of unification. The consistory imposed "a single customary prayer for all the empire," an interdiction against particular rituals such as outdoor congregations for special prayers. Jews were thus expected to adopt religious practices that resembled the French and Catholic ones, thereby becoming "hostages of the universal."[68] Napoleon, in the guise of God, sought to create on *all the earth one language*.

Letter 5. Lately, I have been talking to my ancestors

As we know well, the state of Israel invented the new Jew to defeat the old diasporic Jew. But this old diasporic Jew, as you can see, was actually another new Jew invented by Napoleon. The Zionists continued this imperial progression, creating us as ever-newer Jews. We should refuse all attempts, past and future, to make new Jews.

When the French colonized Algeria in 1830 they immediately preyed on the dead. The Jews were the first to be commanded to fill official papers with information on those who had died. Often, the Jews simply ignored the command: it must have felt totally unrelated to the ways they had accompanied the deceased on *their last walk among the living, and their way toward a gathering with their forefathers and foremothers*. Compared to the affective farewell in the cemetery, the silent document presented as a necessary seal to mark the end of a person's life was more like an insult—especially since the colonizers kept a copy of it. Colonial offices and paperwork, however, could not silence their ululations, mourning cries that were mixed into the bricks they were commanded to bake for the construction of the *city and a tower with its top in the heavens*. High as this tower was, the Jews knew that their ululations cemented in the bricks would, someday, collapse the tower from the inside and that their descendants could be invited to join the choir. Though our ancestors may be there no longer, their cries are still embedded in the bricks. We could still attune ourselves to listen to them, learn to sing with them our shared resistance to assimilate.

When the Lord came and saw the city and the tower with its top in the heavens, he said *one people with one language for all —if this is what they have begun to do, now nothing they plot to do will elude them*. At the beginning, our ancestors refused to cut short their long names that resembled bracelets made of beads, each bead for the first name of one parent, grandparent, and great-grandparents: Aïsha, daughter of Zahava, Dhahaba or Golda, daughter of Salma, known as Selina, married to Raphael, son of Esterina. I wish I could remember my maternal lineage beyond the name of my great-grandmother and recite the name of her mother, and her mother.

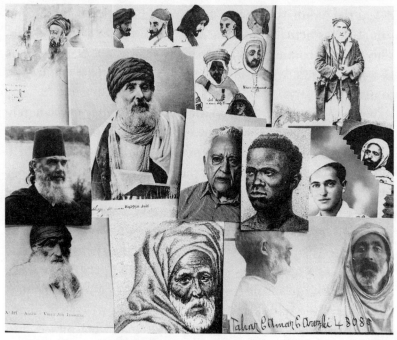

My Algerian male ancestors, family album.

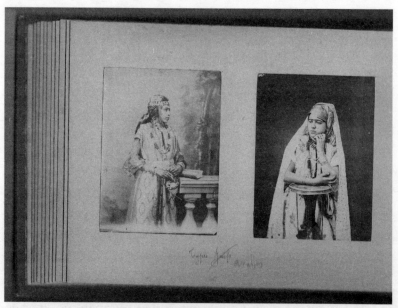

A found colonial photo album. Note that the caption "Jewish types" has been corrected to "Arab types."

Letter 5. Lately, I have been talking to my ancestors

I started to collect postcards and photos of Muslim Jews, as placeholders for the nineteenth-century photos of our ancestors that I do not have. It is striking to see how contradictory, evasive, unstable, and fabricated these images of "types" were. In my imagined photo album of male ancestors, I assemble them according to their resemblance to my father, young and old (see upper photo p. 220). Looking at these portraits together, you would recognize me too in their faces.

On one page of a found photo album, likely prepared by a French settler as a souvenir from Algeria, two photos of women, both taken in a studio, were captioned as "Jewish types" (see lower photo p. 220). I'm guessing that they were placed on the same page because of their shared profile, as both turn their head and gaze away from the lens. These two women look different, even though they are given the same label and share a distant, dreamy affect in the photos. Someone perusing the album's pages felt confident that the category "Jewish" was incorrect, and they decided that both of the women were actually Arabs—and not Arab women, but Arab "types." The "error" (if it was one) was corrected in pencil, and with the addition of this mark, the rest of the album was implicitly approved as properly captioned, absolving the people who made such an album conceivable. Such albums were colonial projects. Making these albums with our ancestors' photos was a pastime for settlers, and the diversion of recognizing types was akin to identifying flowers. The photos of these women, who could be our ancestors, didn't end up in their own photo albums, and we didn't inherit them. But by some coincidence, their images landed back in my Algerian album. These photos have, like the swallows/books, finally made it home.

> If the French colonization of Algeria
> had not happened,
> no scientific classification
> could tell us
> that our world
> is not ours,
> it is rather Muslim, Berber, or Kabyle.

If the French colonization of Algeria
 had not happened
 we would not have to tell them
 "they are us—and we are them."
 You should look more closely at your postcard collection;
 we are all these types.
If the French colonization of Algeria
 had not happened,
 French scholars
 would not dare to tell us
 that our more-than-two-thousand years
 of life in North Africa
 deranges the proper transliteration
 of the names of the objects
 our ancestors crafted.

Imperial history
 squeezes the tragedy
 of our ancestors' departure
 into thin prose.
 A Wikipedia entry,
 written in the style
 of a *nouveau roman*:
 "Jews have settled in North Africa
 since the 6th century BC.
 Between 1950 and 1970
 Most Berber Jews *emigrated* to France,
 United States and Israel."
 Is it out of imperial courtesy
 that we were spared the 'i'
 as in *immigrated*
 and were given the 'e' as a sign of attachment
 to the land we had to leave behind?

In a 1906 dictionary of jewelry from North Africa, a French colonialist, with the help of local and French draftsmen, prepared technical drawings of hundreds of jewels and accompanied them with lifeless descriptions. When I first stumbled

Letter 5. Lately, I have been talking to my ancestors

"Dah deg el-hommès," bracelet from Oran placed on Paul Eudel's *Dictionnaire des bijoux de l'Afrique du Nord*, 1902.

upon this book, I was angered by the verdict the dictionary implied about this incredible tradition of metalwork: "Gone!" But I was also enchanted by the opportunity to use this dictionary as a visual guide to our ancestors' craft. Perusing the pages let me rehearse my imagination and quest to acquire practical knowledge about the making of these jewels, the ways of wearing them, their heritage and transmission, their material, forms, colors, the care invested in making and keeping them, the family ties they created, the exchanges between the makers and the buyers, the ceremonies that these jewels participated in, their healing aspects, the prayers and blessings involved, the rituals of offering them and the cosmology behind them. This body of knowledge—a blueprint of community life—is not absent from these pages by accident. Separating the jewels from their life in the world of their community by corralling them into lists and

taxonomies and dictionaries is part of the imperial ravaging of our ancestors' world.

Disrupted modes of life do not simply disappear. We carry some of them in our bodies, even if only as a yearning for something we can't name, an errant pain. The corporeal knowledge of our ancestors, who worked these forms in metal long before their shapes were "transcribed" on paper and translated into discrete French words, has not evaporated. Their skills were not reserved for Jews alone; the jewels were not chosen from catalogues or dictionaries like this one, but were the product of a social, religious, cultural, and political interaction: according to the dictionary, they worked "according to the molds they [itinerant workers] have, they were provided with the metal and they set up their forge, and work in front of the defiant eyes of Arabs."[69] They worked in relation with their Muslim neighbors. And the jewelers were not the only ones who made jewels. Women were often assembling their beaded necklaces, integrating pendants and various found objects (see photo p. 227).

If the transmission of our ancestors' knowledge had not been disrupted, we would all know how to care for our world with our hands and tools. Repair rather than replacement would be the rule. Rather than exhausting ourselves chasing some crumbs of capital, rather than being implicated in mega-spectacles of destruction that we don't know how to stop, we could engage in the bliss of crafting in the company of others and participate in the miraculous moments when a form emerges out of stubborn metal. We were deprived of access to these more organic forms of transmission that occurred among large polyphonic families, in queer households made of multiple generations, where transmission never went along a linear vertical line from parent to child but across generations, back and forth in an agonistic as well as convivial way.

I'm drawn to the absent presence of Jewish jewelry-makers in these photos of different "types" adorned with jewels, and to the web of relationships involved in this artisanal work. In most of the tales about why Jews began working as metalsmiths, it is because others didn't want the job. David Rouach writes that "Muslims totally refused to do this work," especially in rural

Letter 5. Lately, I have been talking to my ancestors

areas. Working with minerals was an occupation assigned to people who were "partially excluded from the community."[70] It's the proximity of metals to subterranean fire that made the job undesirable, even forbidden, as Wassyla Tamzali writes: "If there was one remarkable trait of this profession, it is that it was almost always practiced by Jews, in the cities as well as in rural areas. Even if this particularity is supported only by a few rare documents, it is broadly conveyed through traditions."[71] I'm not interested in who had more or less appealing jobs; I'm interested in the way communities assigned tasks to certain groups with whom they shared a world when there was a job that they, for a variety of reasons, didn't want to or could not practice.

Among the few stories my father liked to tell about his life in Oran is the story of how every Friday he went with a big cooking pot full of *dafina* (*tafina* or *skhina*) to the Muslim neighbors, who had an oven, and returned to pick it up when it was ready for lunch on the Sabbath. Observing the Sabbath and not lighting the fire didn't mean self-segregation, but rather an occasion for interaction with his Muslim neighbors, a way of including them in a Jewish ritual. Even though in some contemporary Jewish communities this labor division with non-Jews takes the shape of service relationship (a "Shabbos Goy," which can be pejorative), it should not be assumed as the norm.

We can look at Jewish metalwork in Algeria in a similar way. It involved complex and nuanced relationships of power, love, and trust between people from different communities. I'm thinking about Rouach's sentence quoted above about Jews who worked with minerals—"*partially* excluded from the community." I can imagine him writing this sentence for the first time, and then adding "partially" because he realized that they were not truly excluded. But it was probably also true that they were excluded in some ways. How exactly? The meaning of their exclusion cannot be approached separately from the degree of their inclusion; after all, the artifacts that they created were intimate objects of memory, joy, and transmission, carried on people's bodies and used in ceremonies. How did this jewelry, this metalsmithing craft, make the Jews in the community both part and apart? How could they practice the extraordinary power of manipulating fire

Indication of where to stamp the bracelet. From *Catalogue descriptif & illustré des principaux ouvrages d'or et d'argent de fabrication algérienne avec l'indication des points d'application des poinçons de la garantie française*, (publié par ordre de M. Laferrière, Gouverneur Général).

and metal without awakening the *shedim* or *djenoun*? After all, both Jews and Muslims were scared of these *djenoun* (genies or spirits) and shared with each other objects (such as the *hamsa*) and rituals (such as offering the *shedim* oil) to chase the *djenoun* away.

The metal crafts of our ancestors were, like so much else, expropriated by the French as proof of the authenticity of "local culture," a judgment ratified by the gaze and money of the European clientele and soon brought under centralized control. By the 1860s, a small punch in the gold or silver was already a requirement, but both jewelers and the customers refused to comply (see drawing above). The same resistance is observed by Eudel toward the requirement to "polish" the jewels:

> The Jewish (*Israélites*) industrialists who had the monopoly of this industry, said that the Kabyles and the Arabs of the interior, for whom these objects were intended, would reject them if the finish endowed these jewels with a different appearance.[72]

Eudel is incapable of understanding that the colonized must defend themselves against intrusion since he doesn't conceive of himself as an intruder but rather as a scholar of arts and

Letter 5. Lately, I have been talking to my ancestors

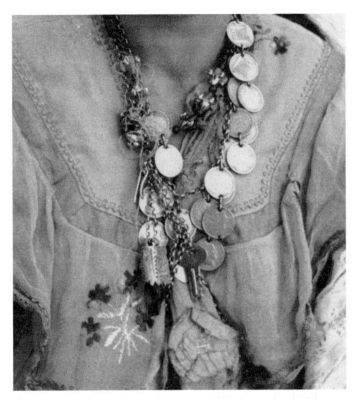

The necklace of one of the two thousand Algerian women who were forced to unveil in front of the military camera of Marc Garanger, 1960.

crafts. The books authored by Rouach or Tamzali, exploring the culture of the colonized, theirs (Moroccan and Algerian, respectively), seek to understand what people's jewels can tell, and how they can be read as challenging the colonial schema of such inventories.

Metalworking, we have been told, was transmitted mainly from fathers to sons, who at an early age were already assisting their fathers. Were women totally excluded? Were they not agents of transmission of the hidden life of jewelry? Certainly not. From Eudel's lists of jewelers, women are absent. While they were likely fewer women working with metals, women were often beading and assembling their necklaces and adding over time elements according to their needs or opportunities. A midwife's necklace, for example, was made over time from the incoming pendants gifted to her by women whose children she helped deliver. Among the necklaces Algerian women showed to the camera as they were

Is this a Jewish jeweler's child? (Detail from *Arab children playing* by Alphonse Étienne Dinet).

forced to unveil, we sometimes recognize a key, a staple, a bolt, or a nut (see photo p. 227).

Eudel's dictionary, for example, describes the earring called *Alâqa*. In Bou-Saada, he writes, "the children of Jewish goldsmiths have, on the left earlobe, a ring which also bears this name."[73] Eudel seems not to be curious about what this meant. Did only boys wear the *Alâqa*? We don't know. Given that the family was not yet structured according to the heteropatriarchal norms, and given that many of its members assisted in the different occupations, I assume that girls could assist both their mothers and fathers.

In a book written by a colonial doctor who studied Algerian Jews' psychoses, I found in between his racial slurs a small jewel of information about family formation. Describing the Jews as lacking calm and serenity, and as being overly excitable when expressing pain, he reports a scene that he seems to have

Letter 5. Lately, I have been talking to my ancestors

encountered more than once: "Often, when a person in a family is seriously ill, all the parents press together, approach the bed and communicate aloud a kind of artificial encouragement."[74] Everything that he describes with contempt and conceives of as a sign of racial sickness, I feel pained that we have lost.

Look at these bracelets in the photo below and imagine the sound they produced when *all the parents* come together in one room. How many parents, exactly? The psychiatrist doesn't say. But from what we know about these extended households composed of many adults and many children, we can assume that there are several adults who qualify as "parents." And if there are not enough in one household, other parents could be called from nearby, adding their voices to the collective effort of encouraging an ailing child to recover. Not only do they all arrive, but they also, as the doctor says, "press together." Can you imagine how much care, support, and how many blessings are encapsulated in all these female parents as they shake their bracelet-laden arms to chase away the evil eye?

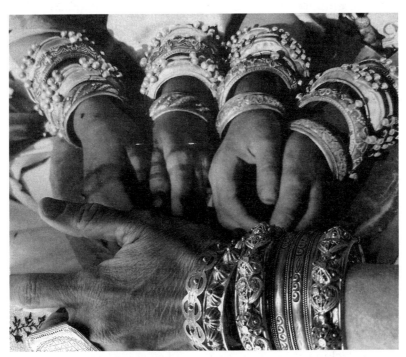

Joining with my reclaimed bracelets the women of Agadi-Tissint (the region of Sous), captured in a photograph by Jean Besancenot.

I end this long letter with an invitation. Delve with me into this array of "types," and together, let's not let our ancestors melt down into these "types" but renew this disrupted transmission from our ancestors.

I read and write, and write and read, but after I immersed myself in looking at these jewels our ancestors made, I could not resist their invitation: to experiment in reproducing them with pens and pencils, with metal and beads, with saws and drills, alone and in your company, or that of your children, my grandchildren. Together and separately, alone or in partnership with others, and whomever else, kin or chosen kin, we the polyphonic family of the sort that we are (five children whose kin relation is irreducible to blood, growing up with six parental figures) can reclaim into our lives and homes these jewels as objects of resistance. We can make these jewels ours again, our political talismans with which we inhabit the Jewish Muslim world, with which we can come closer to the memories of a world not ruled by borders, nation-states, citizenship, capital, and empire.

My grandmother Aïcha gave my mother an exquisite gold bracelet, filigreed with leaves, to give me when I was in high school. It was stolen from my apartment in rue du Maroc, in Paris, where I lived during the mid-'80s. My memory told me that there were four such bracelets, and that my mother kept one for herself and gave one to each of us, the three sisters. When I asked my sisters to send me a photo of theirs, each of them told me that theirs, also, had been stolen. One was stolen during a trip to Tunisia and one in Tel Aviv. None of us know where our mother's is.

How symbolic: the only item our grandmother ever gave us, stolen. Perhaps someday some of us will live in Algeria again, among Jewish jewelers. Perhaps someday the bracelets will return to us; and then I will gift mine, like this letter, to you.

Love you so much!

ima, sima, pima, relly, ariella, aïsha

Letter 6. The jewelers of the ummah

A letter to Wassyla Tamzali

Dear Wassyla,

When I first read *Abzim*, your beautiful book on Algerian jewelry, I could not anticipate that one day my phone's screen would announce that Wassyla Tamzali was calling me. Nor could I imagine that a few months later you would call again, inviting me to visit you in Paris and stay at your home.

You first called me after my open letter to Benjamin Stora was published in French. It felt like you had opened the door and invited me in. To where exactly? I think to Algeria. But "Algeria is an obsession," you told me almost in the same breath, as if to avoid its idealization. When we first spoke, I hadn't yet read your *Éducation algerienne*, but I had my own thoughts about why Algeria might not be a kind of heaven. The warm responses I received from you and from other Algerians after the letter was published surprised me, but it felt as if you were also surprised by the Algerian Jew who came from nowhere and refused to forget she was Algerian and is also an anti-Zionist. It was as if you had waited for my visit forever. Immersed in the quasi-imaginary realm where I write these open letters, the tenderness with which you responded shook me. How could we not have known, for so long, how much we lost?

Reading *Abzim* for the first time and looking at the jewels printed on the pages of your book unsettled me. I made myself a

Rehearsing with *Abzim* by Wassyla Tamzali.

Letter 6. The jewelers of the ummah

Jewelers' streets and neighborhoods, Algeria and Morocco. Colonial postcards.

student of the book, an inheritor of its world, and I read some of its sentences aloud, trying to attend to the meaning of my saying with you (maybe you heard my whispers?): "It [the snake] is present in *our* mythological history."[1] It was not the serpent but the "*our*" that made me pause. Could I ever be included in it? Or why am I asking this at all, as if there is a question that should have been formulated in the other direction—are you included in this Jewish mythology of the snake cultivated in Algeria, mainly in Constantine? I was already deep in my exploration of the colonial disruption of Muslim Jewish life in Algeria, but at the same time I was resistant to the conceptual trap of "the Jews" or of "Jewish things," as if, when the Jews lived there, the entirety of Algeria's mythological history was not also theirs, ours, because it was part of our universe. My ancestors' world didn't have to include identifiable "Jewish" components for them to feel at home in it, to know it, and for it to be their home. That was not because differences did not exist, but because there were no

categories imposed upon them that forced recognition only into the objects associated with their taxonomized colonial "type." For those who fabricated these "types," Algeria was, as Susan Slyomovics calls it, a "scientific laboratory in what passed for scientific experimentations."[2] These racializing and racist taxonomies forced people and objects to reaffirm the validity of their "types" and vice versa, identifying representations of themselves that were, as in a house of mirrors, false.

In writing these letters, I slowly understand what I'm actually doing: tuning back in to an Algerian transmission that was disrupted, and claiming access to what was denied to me. I'm refusing to be bound by the imperial storm that detached my ancestors from Algeria and from their memories as colonized subjects. I'm objecting to the imperial dictum that transmission is unidirectional, and that, once disrupted, descendants are forever doomed to be bereft of their ancestors.

You are probably familiar with the book *Arab and Berber Jewelry from Morocco*, published in 1953 by Jean Besancenot, the "iconographic manager" of the French Protectorate in Morocco. This was one of several colonial inventories of jewelry that sought to make sure that both unruly people and unruly objects were under control. The colonial scholars who established these visual inventories and helped create a class of European connoisseurs sought to capture in their drawings the "pure" form of each piece of jewelry, eliminating from the drawings anything they considered inessential. Yet Maghrebi jewelry design consists of recurrent forms, the product of intentional and unintentional alterations and improvisations. There is no real pure form, for the design is impacted by the jeweler's access to beads and metals, the exchanges they have had with those who commissioned the pieces, their way of confusing the evil eye, and their memory and beliefs about what each piece of jewelry should look like. Maghrebi jewelry was born also from contingencies, inspiration, and randomness, part of the social fabric of its production.

In his preface to the inventory in his book, which I find insulting, Besancenot laments the "decadence of craftsmanship" apparent in the jewelry of his day, while denying imperialism's role in destroying the local cultures in which jewelry-making was

Letter 6. The jewelers of the ummah

not *for* the market or French scholars and collectors, but part of social life—the opposite of decadence.

From the beginning, the French colonization of the Maghreb involved scholars like Besancenot who were busy "recording" what they thought were the authentic creations of the cultures they were colonizing. Colonial scholars were specialists in discerning the vanished authentic creations from contemporary "corruptions": "None of these corrupted models appear in the inventory of jewelry that we have endeavored to put together."[3] These are the imperial divisions and this is imperial power, the power to proclaim what is authentic and what is corrupt, and to designate oneself as the caretaker of both. Besancenot insists on drawing a line between those designated "authentic craftsmen," most of whom were no longer alive, and the people the French had colonized, who in French eyes lacked the talent and culture of their predecessors, and so deserved subjugation and the abuse of their skilled artisan's hands in hard labor in the factories and fields. Besancenot's inventory thus included only what he considered "authentic" models.

To his surprise, however, a guardian corps of the vanishing "authentic" artisans were still living and working in the Maghreb.

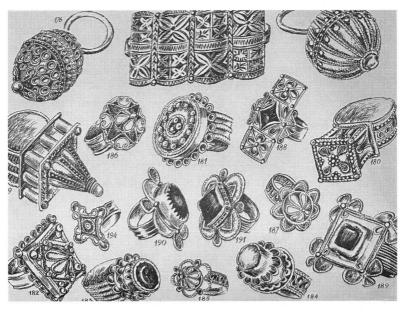

Panel XI from *Arab and Berber Jewelry from Morocco* by Jean Besancenot

Rather than vanishing like good imperial subjects, they had even organized an "important corporation of jewelers"! However, he found that the living jewelers had "lost all traditional quality," and he disparaged them in order to cater to his own nostalgia —and that of his class of erudite colonizers—for a fabricated imperial past. These contemporary jewelers, he sniffed, make "*bijoux à effet*," jewels intended merely to appear impressive, which "offer a maximum of surface for a minimum of weight," which are "poor" and have a "barbaric allure."[4]

This colonizer, who "records" tradition through objects and disparages the objects he determines to be inauthentic (along with their makers), is completely ignorant of the fact that the "superficial effect" he decries in contemporary metalwork actually pertains to his own treatment of the jewelry in his book. In classifying jewels as "types," he had to isolate and abstract each piece, delivering only their skeletons on the page. Regardless of their size and presence in the world, the "types" of jewelry are now rendered as pure floating forms. He (or others on his team) drew them with no regard for their cosmological context, no regard for the physical conditions under which their makers created them or how their purchasers wore or used them. He groups jewelry according to the part of the body where it is worn: around the neck, the wrist, the finger, the ears, the waist, and so on (see image p. 236). He thus intends to produce a certain *formal effect* in the large format publication of the book (often disproportionate to the size of the jewels) in order to please the colonizers, who have, since Napoleon's invasion of Egypt, recognized themselves mainly by gaining mastery over the cultures of others.

The putative "authenticity" of the objects is part of a racial regime that classifies objects and the people who wear them into "types," a regime that disappears the living artisans—mostly Jews. This disappearance has several ramifications. For now, I want to share with you only one.

When Jewish jewelers are captured in colonial postcards, they are depicted as old craftspeople, the last of a vanishing profession, who practice old techniques in filthy workshops, compared to the modern workshops run under French surveillance, in which the indigenous artisans are used as a token of

Letter 6. The jewelers of the ummah

The "Arab type" is used in this advertisement for a French factory store as a certificate of authenticity of its "indigenous jewelry."

authenticity (see the postcard above). Under this paradigm of an old and obsolete world that ought to be modernized, the robbery of knowledge from those "old" craftspeople took place; French jewelers even patented what they recorded and learned from local jewelers in the Maghreb. The integration of colors in jewelry, so common in what is known in the Maghreb as cloisonné, or the fabrication of gold threads, are two striking examples. The French were amazed by the local craft of making gold threads, and nearly destroyed it to be able to mechanize and monopolize its production with their obsession. Less than a decade after the colonization, the shoulders of those officers who participated in the colonization of Algeria were already decorated with epaulettes made of gold thread by a French jeweler who had patented the Algerian method.[5]

These postcards, along with Besancenot's book, are themselves inventories of how knowledge about these objects and crafts were taken from the community of their makers and deposited in a universal encyclopedia for colonial scholars. In this process of transfer of knowledge, the craftspeople were used as "informants." To enter into this encyclopedic context and fit its classifications, the jewelry had to be stripped of its complex ancestral meaning, meaning that came from community, land

knowledge, family, tribe, rather than writing, and was sustained through practices, rituals, ceremonies, and customs, not all of them had to be disseminated and shared.

The French racializing scheme in North Africa consisted of differentiating the colonized into groups and singling out one group—in this case, Berbers—as the authentic natives (*autochtones*). The jewelry of the Maghreb emerged from centuries of exchanges between Jewish makers and consumers from diverse ethnic groups, but this authenticity was transferred from the shared world to the jewelry itself, which came to be called "Berber jewelry." Because the Berbers had already been designated by the French as the authentic group, meaning culturally and customarily frozen in time, the jewelry could thus be equally authenticated. Besancenot describes, as if these were solid facts, that for a "long time [the Berbers] remained faithful to the rigorous customs forming their society whose rules of life seem to have changed little for many centuries." For him as for other colonial agents, the contemporary Berbers had failed to live up to their ancestors: "It is different today. The original purity of folklore has noticeably altered." In his account, the Arabs' contribution to centuries of jewelry production is minimized: "The oriental Arabic contribution seems limited to very little."[6] Besancenot acknowledges the Jews as the jewelers, but he reduces their contribution to a sort of execution, makers of the objects yet without any contribution to the creation of the jewelry.

The colorful photographs that you took stand in welcome contrast to these imperial inventories. In your images, the people and the jewelry they wear are often partially cropped, as if what was left outside the frame continued to live in an extant world where jewelry-makers and jewelry-wearers live in common. Looking at the pieces of jewelry in your pictures, I see that the jewelry and the people were not strangers to each other. I could join you and say aloud that the serpent "is present in *our* mythological history."[7] I have already crossed over mountains and valleys, fought against dragons and guardians (some of whom were actually legalized pirates) who told me that I am not allowed to withdraw from the identity given to me at birth; they announced that the routes I need to travel to reach my ancestors are no longer open for me.

Letter 6. The jewelers of the ummah

They told me, "You have already missed the moment, and that moment is gone now, forever."

Rehearsing the phrase "I am Algerian" or "in our [Algerian] culture" is not enough to make this culture mine, nor to make me feel Algerian; it enables me, however, to break the spell that made Algeria *not mine* and *not me*, that made me easy prey at birth for those who would brand me an "Israeli." It is a colonial spell, a double one in my case (French and Zionist). I wish I knew more about *our* mythological history so I could root this story I want to share with you in our mythical past.

Algeria felt like a cursed place to my father in 1945 when he returned from the war. He could not say why, but I can: it was a colonial curse. He was still colonized, but he was told he was not; he liberated France, and he was treated like scum, and he was told the French liberated him. Despite fighting for three years for the liberation of France, he learned that he was not truly French.

Who was he then?

He didn't know how to break the spell, how to feel at home, how to recognize those who surrounded him as relatives, or how to be recognized by his neighbors as one of them. He was not part of any group. He was so frustrated that he cursed the place where he was born and decided to depart. Just for a while, he told himself and I'm guessing he also used some words to curse his birthplace. I don't know the exact words but they were likely those one uses when slamming the door behind oneself, wishing everything would burn down, while at the same time knowing it should not, since this place is the only home he has and should stay standing forever.

He considered the world he left behind dead to him. As it turned out, after a decade or so, the curse that he had cast in a moment of despair became bitter prophecy: Algeria, damned by the intertwined French and Zionist colonial projects, could no longer be his home, or the home of any Arab or Berber Jews. His family, who had no intention of leaving, had to depart in a rush. That I am not an Algerian is not because my father decided to leave Algeria; I was born in 1962, the year of Algerian independence and the year the Jews, forcibly understood as "French,"

were forced to leave. *I could not have been born Algerian, even if my father had remained in Algeria.*

The world in which I could have been born Algerian did not exist when I was born.

Unlike a child wishing for his home to burn, safe in the knowledge that he has no such power, my father's curse came true and he could not return to his home. If I were captive only to my father's decision to depart from Algeria and not to the imperial extinction of Muslim Jews in Algeria or the foreclosure of their return, I could have always, while growing up, returned to Algeria. But there is nowhere to return to now. Algeria was, and still is, under a colonial curse.

The colorful photographs in your book *Abzim*, Wassyla, provoked strong memories of my father's gestures. My father was not a jeweler, but I nonetheless recognize myself as an heir to the artisanal world he inhabited, the world where such objects were made. He was the most impatient person I ever knew, except for when his hands were given a task. I remember the sound of his impatience when we visited somewhere and stayed longer than the time agreed upon: he would shake the keys on his keychain and let the clacking metal call a warning to us: *We're leaving now.*

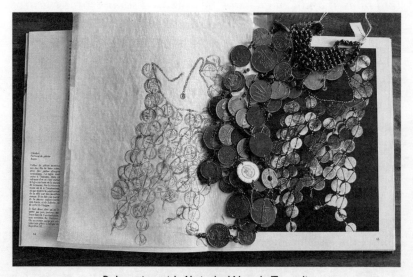

Rehearsing with *Abzim* by Wassyla Tamzali.

Letter 6. The jewelers of the ummah

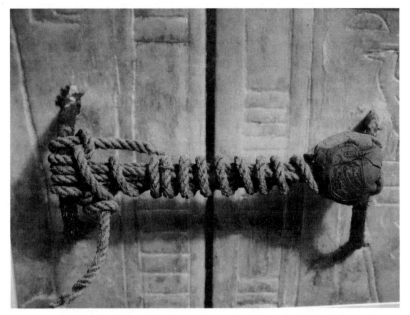

The still-unbroken seal on King Tutankhamun's tomb, 1922.

When I saw the photograph in your book of an incredible necklace made of more than one hundred coins attached to each other with a cotton thread and separated from each other by two small beads, I was reminded of my father's plastic jar in which he kept coins from all over the world, and of his big coil of twine, which he used in his knot-tying art. My father skillfully maneuvered the rope like a magician, making a series of knots until the rope forgot that it was a line. These movements were always driven by a specific need: never was this done simply for decoration.

As I was writing you this letter, dear Wassyla, coins and thin ropes were amassing on my desk. With a 1/16-millimeter drill I have already started to pierce and bead them (see photo p. 240). A few months later, I heard the sound of these strings of beaded coins clacking when I wore this big, heavy chest plate. Did you hear it in Algiers?

My father had many drawers in his little store. In some of them he kept used ropes, bundled like cocoons. I remember that when clients asked him for bags for their purchases, he would look at them as if he were a magician about to perform. He pulled on one of the fibers of a cocoon, wound the rope around the box twice, and made a sturdy and beautiful handle. See? No need for

bags! Recently, I stumbled upon a handmade rope handle that reminded me of my father's art and I saw how old the art form was. This handle survived, but only as a photograph, since British imperial agents broke it to enter and ransack spaces in Egypt that were supposed to remain closed (see photo p. 241).

Here and there in *Abzim*, you describe Jewish habits and beliefs, as, for example, when you discuss the figure of the serpent as "the depository and initiator of the secrets of magic."[8] But you don't turn this into an exclusively Jewish secret. You take a certain distance from the colonizers' method of classifying objects and symbols and fixing their meanings. (The indelible taxonomic marks they left seem to devour Algeria still today.)[9]

However, it was not these vignettes about Jewish symbolism that made the reading of your book important to me. It was, rather, the understanding that regardless of the type of jewelry I might be looking at, it was the Arab Jews and Berber Jews who had made these precious objects: "the corporation of jewelers will almost always have a majority of Jews," as you write.[10] All of a sudden, we had history in the Maghreb that troubled the structure of the historical narratives! We were among those who built this shared world, rather than being only members of a Jewish community made identifiable and distinct by the colonizers (and concomitantly, by historians).

I recently listened to Massamba Guèye being interviewed by our friend Kader Attia, who speaks about colonial gagging, describing it as the outcome of destroying indigenous spaces of decision-making. Colonizers, he says, "silence the chief, the shaman, the healer, and the griot" in order to impose an "imported speech."[11] To Guèye's list of silenced people I want to add the jewelers and the craftspeople. With the destruction of their craft, Jews were silenced, and what they used to create in common with others was reduced to a colonial product for export, and their mode of being in the world with others was replaced with a narrowed, racially exclusive Jewish space. But our ancestors didn't craft only for Jews, and the jewelry and other metal works they made were not, for the most part, decorated with "Jewish" symbols. They produced all different kinds of artworks for many diverse people, and they were skilled at producing jewels whose names were in

Letter 6. The jewelers of the ummah

Arabic (*their own* language despite the French fantasy that after a few decades of colonization, Jews were no longer Arabs).

Paul Eudel, for example, opens his *Dictionary of Jewelry from North Africa* with a warning, or an apology, regarding the deformed names he transcribes:

> Sometimes these words have been disfigured in use and the most profound alterations they have undergone are due to the Jews who, as we know, are engaged in the manufacture of jewelry in large numbers.[12]

This was a recurrent trope among French scholars, who claimed expertise in the native culture and disparaged the Jews for degrading the Arabic language.[13] Here again, we encounter a typical colonial reversal: a complete denial of the destruction of Arabic names by the French bureaucracy and its regime of French names and transliterations, and the subsequent blame apportioned to the natives for their language that purportedly "damaged" these names.[14]

When we met, I asked you to tell me more about the Jews in this story of the jewelry. You replied that you were not invested in anthropological research, that working on this book project was more like a "promenade" (journey). You emphasized that you were not interested in the identity of the jewelers but rather in the gender identity of their users, the women who wore them; you conceived of your book as a feminist project. In our conversation, however, you emphasized that "the beauty of the jewels is also heaviness, a prison for the body, like the traditions of this country." You knew these jewels, but if one is Algerian, you said, knowing them was a matter of "knowing without knowing." For the book, you looked for this jewelry in the markets and on women's bodies, and you celebrated the sumptuous presence of mostly inexpensive jewelry, showing that forms, meanings, and functions are entangled with ordinary ways of life, shared cosmologies, and feminist ways of being.

In your book, you didn't completely ignore the identity of the jewelry-makers. In your journey, you didn't find anything to challenge your research from the 1980s: the jewelry-makers

were mostly Jews. You write as if the Jewish jewelers were still there, as if it were obvious that the jewelers were Jewish, avoiding the fact that Jews were actually absent from Algeria after 1962, at least as publicly self-asserting Jews. Did this simultaneous absence and presence leave marks upon your language? How does the transition from their presence to their absence occur so smoothly? I wonder if, for the forced expulsion of the Jews not to be remembered as a major event in Algerian history, a colonial narrative of a vanishing world came in to replace it. Did you have to adopt this narrative? You describe how in rural areas, the jewelers were nomadic and they had to go from one hamlet to another producing jewelry on demand to satisfy their clients' rituals, needs, and desires. "But all of this," you write, "tribes, clans, hamlets have disappeared and given way to a modern organization of the country; it all seems distant to us and to belong to a past now gone."[15]

Thought it was not the focus of your research, you spend two full pages speculating on why the Jews became, almost exclusively, the jewelry-makers of the Maghreb. You mention the Islamic interdiction on working with metal and fire (*"un mal terrible"*) that made the Jews good candidates to deal with both. You mention the Constitution of the Medina and the understanding that the Jews would be in charge of these professions. You emphasize the practical need for manufacturers of coins for the Islamic state, and position this need as the main motivation for charging the Jews with this mission, as the Prophet "had cast anathema on those who touched precious metals, speculating on gold and silver."[16] Barakat Ahmad expands on this, writing that Arab Jews were known for their metalwork centuries before the arrival of the Prophet: "They also developed new arts and crafts from metal work to dyeing and the production of fine jewelry, and taught the neighboring tribes more advanced methods of exchanging goods and money."[17]

No matter how we tell this history, we could say that with the establishment of the ummah, the place of the Jews as its jewelers reflects the ummah's multi-religious nature. You also quote from a newspaper article published in 1962, describing the jewelers' seasonal migrations, and conclude that

many of the pieces of jewelry that we have photographed are from this period because now that the jeweler is installed, settled, he no longer makes these traditional pieces of jewelry. With this way of life, the forms of jewelry that interest us have also disappeared.[18]

Is the bygone world of nomadic jewelers described in this clipping from 1962 not also the world from which the Jews disappeared, one where they are no longer making jewelry? Is there a connection between the disappearance of the Jews and the disappearance of the world of which they were part, the one in which they were the jewelry-makers? The memory of this world's disappearance somehow makes the disappearance of the Jews disappear. And this disappearance of the Jews erases any idea that it could have been different, that decolonization did not have to be replaced with independence, and independence with a nation-state, as if Algeria could be free only without its Jews. Can Algeria be free without their return?

A little more than a decade before you went on this exploration, the Moroccan writer and filmmaker Ahmed Bouanani "was travelling around the country documenting its popular arts."[19] The two sketchbooks of "traditional jewelry" that he produced during his journey were the point of departure for an exhibition initiated and curated by Omar Berrada and M'barek Bouhchichi for the Marrakesh Biennale in 2016. In the catalogue of this exhibition, I read Bouanani's observation that the decline in artisanal production resulted from tourism: "Jewels were losing their place in social ritual and becoming commercial objects." Berrada and Bouhchichi are also intrigued by, and at the same time resistant to, the "vanishing culture" assumption. They write that both Bouanani and the historian Henriette Camps-Farber, who also studied these jewels at the same time, "recorded what was doomed to disappear." However, upon their arrival to Tiznit, Berrada and Bouhchichi realized that "the techniques have all but disappeared. The craftsmen's villages have emptied, nearly or entirely. But the keen eye and dexterous hand remain." They speculate that "exhumation and resurrection are common themes in North African literature of the 1960s and 1970."[20]

What they say is probably true, but the resurrection or trace of a "dexterous hand" is not a sui generis phenomenon. Imperialism and colonialism are obsessed with vanishing cultures, and colonizers do everything possible to fragment cultures and to chaperone them toward disappearance. Plunder, indigenization, collection, and the creation of inventories of authentic or "best" samples (museumification) are hallmarks of the colonial scheme to produce "vanishing cultures." Muscle memory rebels against the scripted disappearance of craft skills; techniques learned over generations cannot easily disappear, and knowledge and know-how are inscribed in each piece of jewelry. Recovery of the traces of this know-how can be aided by looking through the visual encyclopedias of objects made by colonial actors to record the vanishing of the cultures they themselves colonized.[21] That is, knowledge of what empire wanted to destroy through its regime of rarified objects can be found by appropriating and using imperial compendiums in ways they were not meant to be used. Such inventories can be and are being used in this way, as Berrada, Bouhchichi, El Guerch, Sara Ouhaddou, and others show through their work.[22] In their collaborative work, these artists, craftspeople, and scholars avoided assuming the position of "keepers of the temples" and rather inhabited the position of "heirs of the skill that they revitalize[d]."[23] The imperial production of vanishing cultures anticipates and brings about the destruction of precolonial worldly sovereignties, which means that they always target objects and people. Berrada and Bouhchichi notice that the "craftsmen's villages have been emptied," but somehow they do not question the meaning of this observation. What does it mean that they were emptied? Why? Who inhabited them? When did they leave and why?

I reached out to Berrada and asked him about this. When he received my email, he happened to be together with Bouhchichi in Morocco. They recalled: "The artisan from Imi Ougni who told us that there used to be a jeweler in every house also mentioned that people of the neighboring villages often considered the Imi Ougni people to be converted Jews." I'm still wondering why the different modes of disappearance of the Jews from North Africa don't become a question: Why they were converted? When? Was

Letter 6. The jewelers of the ummah

it the only way that made it possible for them to remain there? If they were converted, why is their Jewishness still mentioned?

Given that jewelry-making was practiced predominantly by Jews, it is hard not to associate these emptied villages with the colonially provoked departure of the Jews from Morocco—in 1948, 1956, and 1967—after the creation of the state of Israel. It is hard not to share Aomar Boum's speculation—even if it cannot serve as a full explanation—as to why the disappearance of the Jews didn't become a focus of research in Morocco: "Scholars can be labeled (and stigmatized) as pro-Zionist just for conducting research on the Jews of the Arab world, and this labeling can have serious professional and personal consequences."[24] Boum's research sheds light on these "silenced and marginalized histories" and their suppression through national historical amnesia, an amnesia that could be disrupted or challenged if the Jews were still living in Morocco. The reasons given for the departure of the Jews varied, but none of them can explain the reality their departure created: North Africa almost cleansed of its Arab-Berber-Jewish-Muslim life. The most manipulative explanation is the one that presents their departure as one of their own volition, omitting the colonial pressures that forced them to partake in the extinction of their world. The consequences of the French and Zionist colonial projects, however, continue to be studied and discussed separately, without accounting for their collective systematic attack on Arab-Berber-Jewish diversity.

The elimination of the Arab Berber Jew and his/her rebirth as the Zionist Jew, I proffer, ought to also be an Algerian problem.

I'm interested, dear Wassyla, in the afterlife of these pieces of jewelry. There is a rebellious ontology in their afterlife, which we can learn from. They are not "Kabyle Jewelry" or "Berber Jewelry," as they were called upon the expulsion of the Jews and as they have since been advertised everywhere. They are not remnants of traditional "ethnic arts." They are not "Jewish jewelry" either—this is not where I'm going. These pieces of jewelry mess up any attempt to stabilize them into "types" for any photo or postcard featuring them. No matter who was in the photographs, the women wearing the jewelry were always

also intermingled with Jews—the makers of these jewels—and thus continued to share with Jews some of their own practices and traditions. Who took the place of the Jews as jewelers, and who produced jewelry for people to purchase in the markets in the 1980s and today? Did the Jewish jewelers leave their tools and patterns for others to use? Did the jewelers bring their tools with them when they rushed away? Why wasn't a community of Jewish jewelers established in France or Israel? Why did Jews not continue this tradition, especially given the acquisitive interest imperial museums took in objects made by their skilled hands? What happened to the non-Jews working as apprentices in Jewish workshops after their departure? How many of the Jewish jewelers stayed and turned themselves into Muslims, hiding their Jewishness? It is not only the language that fails us, that makes these questions sound as if they were about private property; it's the colonial amalgamation of a people that can be transferred en masse, and the expectation that with an order expelling them, there truly are no more Jews in the Maghreb.

When Labelle Prussin carried out her research on Islamic design in West Africa, "passing references" to "Jewish involvement in Sub-Saharan African artisanship" troubled the well-ingrained divisions she was familiar with, divisions that organized the museal order of art history. I was quite excited to read of the presence of Jewish artisans, notably jewelers, also in West Africa. Why, you ask? Because I hate our disappearance from the worlds of which we were a part. Using the lens of trade and travel, Prussin studies the itineraries of Jews who acquired a "virtual monopoly over three particular commodities: the trade in precious metals, the silk trade and the spice trade (including indigo)" and over the related arts of dealing with these substances. She accounts for the Jews' presence and contribution as "itinerant artisan 'castes,' peripatetic 'strangers,' and 'servile' groups.'" She describes the Jews as artisan-travelers and world-makers:

> With kinship networks extending across the vast expense of the continent, they were primary agents of diffusion of arts far beyond cultural boundaries, maintaining the sustaining similarities in the iconography, materials, style, and technology of select

Letter 6. The jewelers of the ummah

forms and format in architecture, metalworking, and embroidered and woven textiles.

The Jewish artisan-travelers' presence is tracked through their different names, often indicating their status as "both within and outside the cultural frameworks that they served," and through the persistence of Kabbalistic cosmogonies captured in forms such as spirals, the ten sephirot, the tree of life, triangles, trefoils, or magic squares with letters and numbers, and their presence is tracked in occultism, both indigenous occultism and occultism intermingled with Sufism.[25] What makes it so fascinating is the impossibility of disentangling these sources, traces, forms, beliefs, from the African tapestry, showing the fiction of a colonially dissected Africa and exploding the fantasy that moves the Jews out of Africa and solely into a Euro-American Judeo-Christian sphere.

I'm grateful to the jewelry my ancestors made, for failing this imperial project of moving us, "Jews," to our "rightful" place, outside of Africa, away from Muslims.

I'm grateful to the jewels' insubordination, skipping over imperial divisions, testifying to previously shared worlds way beyond the delineated territory of their amalgamation, where the transfer of their makers outside of the country could have been doubled with their epistemological disappearance from history and memory.

I'm grateful to the jewelry, to all the pieces who taught me that my ancestors were not "the Jews" as defined by Europeans, but the jewelers of the ummah, those who were at once artisans, scholars, rabbis, sorcerers, traders, healers, and alchemists, those who were part of the ummah and at the same time also part of their Jewish communities protected as such with no coercion to erase its traits. Those who, despite the imperial erasure, were still treasured in local memories, names, invocations, customs, and oral histories, by those who still remember them and are not invested in sustaining their disappearance.

Dear Wassyla, finding who we were before we were kidnapped into the Zionist project is an anticolonial endeavor, a way to counter the colonization of the Jews by the Euro-Zionists, who coerced them into becoming soldiers. I want to share with you a story written by a colonizer who despised all the indigenous and their former rulers. I rewrote it in my own words to bring my ancestors' actions to the fore.[26] The story goes like this.

In response to some riots, the local ruler, the dey, decided to recruit all able-bodied men between the age of sixteen and sixty. Not having enough soldiers, he decided to also recruit the jewelers. Desperate, the jewelers ran to the temple where they used to pray, and they prayed. Their rabbi went to the dey and asked for mercy. Surprised, the dey responded that he hadn't ordered any executions, and he wondered why he was being asked for mercy. The rabbi continued to ask for grace and the dey replied: "It is exactly in order to protect you that I asked all men to bear arms."

"Where are your men?" asked the dey. "Bring them here."

"They cannot come," the rabbi replied. "They are being prevented from marching."

"By whom?" asked the dey.

"Fifty children armed with stones in their hands."

"And how many men are they?" the dey continued to ask.

"Almost five thousand."

The dey kicked the rabbi in his face and broke his teeth, and he said, "I'll order these dogs, these sons of dogs, to disarm. They are so cowardly that they will run during battle."

The rabbi blessed the dey and went to the temple. The crowd was delighted and proposed to preserve his broken tooth in memory of his heroic courage. The Jews continued their ancestors' tradition and refused to become soldiers.

My muscles are reminded that we are a people of jewelers and that our only talent for armament was that of crafting metal objects.[27]

I often write in the margins of the books I'm reading. I can still recognize the sense of excitement I felt on reading in your book that metalcraft in the Muslim world was predominantly practiced by Jews: "If there is a remarkable trait of this profession,

Letter 6. The jewelers of the ummah

it is that it was almost always practiced by Jews, in the cities as well as in the country."[28] Understanding the woven presence of the Jews in Algerian life through the objects they produced for everybody was breathtaking, like a gift. It meant that their presence as makers could not be reduced to the individual objects that they made, or to symbols singled out as "Jewish" in order to justify to art history scholars their delineation as a group. Rather, it proved that their presence transcended, preceded, and exceeded any individual inclination, aspiration, or decision one could make to belong or not, to be part of or not, to isolate, assimilate, or concede to any imperial measure that would make of them a group apart. What you told me illuminated the way different communities shared labor and cosmologies to organize their inter-communal life.

When I read about this in your book, I felt as though I had learned it for the first time. After a while, I realized I had actually read somewhere else that the Jews were often metalsmiths in Islamic countries. It was in Cecile Roth's book *Jewish Art*, which I read when I was in high school, and where the mention of Jewish metalsmiths takes up scant pages.[29] That I didn't remember this fact is not surprising to me: even in high school, I had an intuitive reticence toward the idea of "Jewish art" and the Zionist origins of the project of collecting "Jewish" objects from all over the world. This was even before I understood the violence involved in dissociating such objects from their contexts and turning them into components of a single linear history.

Why did your book speak so powerfully to me? While reading your book, it occurred to me that the forced departure of Arab Berber Jews from the Maghreb meant that many, many objects made by Jews (Arab and Berber) had been left behind. It also became clear that these objects continued to exist in close and intimate proximity to the bodies of Algerian women, who knew, even if some didn't transmit this knowledge to their children, that the presence of Jews' skilled and caring hands was imprinted in these objects. In other words, Algerian Muslim women know without knowing that each of these objects carries an anticolonial key to a shared Muslim Jewish world, necessary in the anticolonial struggle that continues in Algeria, in Palestine.

Can these objects break the Zionist spell cast by the state of Israel? What would it mean not to interact with these jewels as remnants of a bygone world reduced by colonial agents to a "Berber tradition," but to reverse these fossilized and racialized inventories so that these objects can once again be North African talismans whose dormant powers can be awakened?

For that to happen we must tell a potential story, a tale in which objects and their magic powers are not neglected. A fable in which the telling of what happened to this jewelry—much of which was expropriated from our ancestors and stored in Euro-American museums—is part of telling what happened to the people who made it. Our fable begins, as do so many other such fables, with the theft of objects.

The Tale of the Stolen Jewelry

Once upon a time, there was a community of people, the ummah, who dearly loved the objects they crafted, and those crafted by their neighbors: bowls, jewelry, fabrics, tools. For centuries the jewelers of the ummah had been in charge of crafting jewelry and other metal objects. They knew the bowels of the earth and the secrets of its metals, the mysteries of each metal's spirit, and how to embed powers in the forms, figures, colors, and material assemblages of each ring, bracelet, necklace, pendant.

One day, however, a king sent a precious pearl to a rabbi in the ummah, asking him to send in return something of equal value. The rabbi sent a mezuzah. The king was dumbfounded when he received this little piece of parchment, which the rabbi considered equivalent to the king's precious pearl. The king was furious, and he sent messengers to ask the rabbi for an apology. The rabbi asked the messengers to explain to the king that they had different sets of values. He said that whereas the king's gift was something he, the rabbi, would constantly have to guard against theft, his own gift to the king was something that would guard the king and protect him. "When you walk it [the Torah] will lead you, when you lie down it will watch over you, when you are awake it will talk to you" (Proverbs 6:22). The explanation

Letter 6. The jewelers of the ummah

did not appease the king, and he sent his soldiers to destroy the rabbi's community. The soldiers scorched the earth, destroying villages and workshops and stealing all the beloved objects of the rabbi's people—especially the jewelry.

Many of the stolen pieces of jewelry were sent far away from their people and introduced into strange buildings with empty white walls, large, cold rooms of shelves deep underground, and glass boxes that they soon found themselves caged within. The jewelry missed the humidity, winds, sunlight, and heat of the outdoors, and the warmth of their people's bodies as they were handled and worn. The jewelry was not accustomed to the steady weather inside the glass cages. The presence of people in the white rooms barely changed the moisture or warmth in the air. The stolen jewelry longed for human touch and felt neglected. Only on rare occasions was some attention given to them, and, then only by people who wore gloves. These were unfamiliar people. They spoke about the necklaces, bracelets, rings, and pendants in a foreign language, looked at them in a strange way, and pointed their fingers at some of them and not at others. The jewelry tried hard to listen to what those people were saying, hoping to hear a familiar incantation, or some calls addressing their powers, but there was hardly ever excitement in these people's voices, except when they spoke of how the different pieces of jewelry looked. Even those words sounded like the cracking of ice.

Our jewelry didn't forget its people and kept longing for them. After a while, the pieces of jewelry understood that their people might never come, for it had been too many years. But still they hoped that the descendants of their people might. Someday, the jewelry imagined, they would be freed of their captivity and could refresh their curative and punitive powers; they would exit the glass cages in which they were encased and would meet with people who could recognize their powers.

Back home, the invaders sent by the faraway king had taken almost all they could put their hands on, and they had destroyed the workshops where the people of the ummah made their beloved objects and taught their children how to make them too. However, some of the jewelers continued to produce jewels for the invaders. These jewelers found that they had been cursed,

for the objects they made did not exist as beloved parts of their people, as they had before, but were now bought and sold, treated as simple commodities.

Along with the invaders came the educators, who presented themselves as friends of the jewelers, and some of them even said they were co-religionists. They didn't bear arms, but they carried books and writing tools. They said they had come to help and to enlighten, but no one was asking for their assistance or their light. The jewelers were somewhat curious about this first group of co-religionists, for they knew that some of the same sacred books they studied and some of their prayers were similar to the jewelers' own and were sung in the same language. Sometimes, accidentally, the co-religionists even mentioned a familiar-sounding magic word or cure, though soon they always denied it, calling the jewelers' magic "pagan."[30] *The educators were obsessed with the jewelers' rituals and sought to control them and the magic these rituals engaged. Soon, they made the jewelers limit their interactions with neighbors and abandon their shared fables, beliefs, and practices, especially those involving magic.*[31]

The educators—in league with the invaders—who wanted the jewelers to stop engaging with magic, still wanted to know everything about it, including the secrets about what they called "old" jewels, made by the ancestors of the jewelers of the ummah. To try to control the jewelers and their magic, the invaders and the educators acquired as many jewels as they could and started to spread the word that the new ones the jewelers were making were inauthentic, and that the jewelers could no longer make magical objects. Nonetheless, the educators kept inquiring about the objects and their secrets, phrasing their questions in the past tense in order to deny the power the jewelers' objects still held in the present. The educators filled notebooks with the things they were able to learn from the jewelers. This was how they controlled the jewelry and took the magic of the objects away from the jewelers.

Even if some of them did not know how to make jewelry themselves, the rabbi's people knew the secrets of the objects. They were, all of them, the ummah's jewelers, and the secrets of the bowels of the earth they knew, were also known to their

Mezuzah case, Algeria, late nineteenth century.

neighbors, *whom they had always lived with, and who also knew the mystery of the jewels, why each of them was made, their propylitic qualities, for whom, and what exactly its power were. The invaders dedicated extra effort to destroy the jewelers' attachment to their craft, their connection to the earth and the spirits, and also to the people in the midst of whom they lived and with whom they shared a world, a world made of sands and winds, legends and metals and fire.*

Because of the educators, much of this knowledge is now lost. Like the lost gems in an old chest plate, the different bits and pieces of this knowledge must be brought back together for the ummah's jewelers to regain their artisanship, and for the objects that they made to break the curse of the faraway king and realize their magical power.

Since the invasion of the faraway king and his colonizing knights, the spiritual knowledge and magical practice of people in the ummah have dwindled substantially, for these things had always been communal practices. For centuries, men and women shared skills and secrets, models and desires, spells and spirits, pain and hope, joy and sadness; they used jewelry to interact with their different neighbors, to learn about them as much as to please or cure them, respecting their very many differences, not only those of faith. Years later, when the jewelers were forced into exile, they were often blamed by the fellow members of the ummah for not staying. In turn, they secretly felt that other members of the ummah hadn't mourned their departure, and they noted that they had never been called on to return to the ummah. The jewelers of the ummah knew that by acting as if the jewelry-makers departure did not matter, those they left behind would sink deeper into a colonial sleep, a trap. Nonetheless, the jewelers didn't mention this. It had been made difficult for them to say anything.

It was difficult for the jewelers to say anything because the larger world of the ummah was unraveling. The ummah had been a world of natives of many faiths, who for centuries used to intermingle as neighbors, and who felt at home in the world this intermingling created. Gradually our people's world started to change. The invaders made sure that enough was changed so

Letter 6. The jewelers of the ummah

that the people would no longer trust their traditional modes of living—their clothing, occupations, tools, metals, languages, modes of interaction, rhythms, medicine, education, and principles. The invaders and the educators laid the first bricks, and soon the mental and physical walls grew taller and taller, stronger and stronger. Years passed and the temptation to yield to the invaders' demands, expectations, language, and culture intensified.

One day, a decree issued by the invaders invited our people, regardless of their faith, to apply for membership in the invaders' country-within-country. Our people, the people of the ummah, including the jewelers, did not want it and did not apply. After five years, the jewelers were designated by the invaders as a distinct group, set apart from the rest of the ummah, and membership in the invaders' country-within-country was forced upon them. The ummah was so devastated that it was hard for many of its members to remember the violence it involved. And so with time, the jewelers and their descendants forgot their initial refusal to surrender, forgot that membership had been imposed upon them, and forgot the traditions and practices they had tried so hard to protect. This is not surprising, as they were forced to forget their multiple languages and think, speak, dream and remember in the language of the invaders.

The words of the decree that imposed this membership upon the jewelers and their descendants had a hypnotizing power, and some of the jewelers started to believe that it truly had been a gift, not an imposition, just as the invaders and their historians used to say. But it was no gift, for the invaders did what they could to make sure the jewelers' membership in the invaders' country-within-country mattered less than their own. The jeweler's neighbors in the ummah, not allowed to have membership themselves, began to suspect the jewelers. The jewelers were mistaken to believe they could trust this membership to protect them, which only made their neighbors in the ummah distrust them more. Oh, how our poor people were torn apart!

There were many signs that indicated that this membership was, in fact, a curse on the jewelers to block the powerful magic of their creations. But under the colonial sleep and the spell of their hypnotizers, the jewelers started to trust the invaders—no

wonder as their previous fabrics of protection were damaged and they were kind of naked without this membership. Occasionally, some jewelers saw through the spell and understood that there was something wrong with their condition, but in learning to speak like the invaders, they had lost the words to describe the rift they felt and to articulate their pain. This, they realized, was what the educators had taken from them: the language in which they described the powerful magic they had once presided over in the ummah.

New generations of the jewelers' children, born into membership in the invaders' country-within-country, knew that something was wrong. Things kept going awry, until the moment when the jewelers' membership was taken away overnight, their property confiscated, and their men sent to labor camps. The jewelers' co-religionists on the faraway continent suffered more—they were murdered, harmed, and brutalized. From that moment on, the children of the jewelers started to wonder: Perhaps this genocide made them one people with their co-religionists, rather than with the ummah?

The genocidal violence against all people of their faith was instrumental in helping the jewelers and their children forget about their membership in the ummah while surprisingly not in the invaders' country-within-country that had also participated in their extermination.

After this genocidal violence, in the decades before the jewelers of the ummah were sent into exile already deprived of their ancestral occupation, on another continent, another group of invaders conquered a different land, ruined it and spoiled its wealth. Because these other invaders, who were colony builders, shared a faith with the jewelers of the ummah, they invited the jewelers of the ummah to be part of the new nation they were building in the place they had conquered. However, the colony builders had one condition: the jewelers had to forget their craftsmanship and their attachment to the ummah, and they had to join the colony builders in doing violence against the local inhabitants, many of whom shared the same language and culture as the jewelers and the same faith as that of their neighbors in the ummah. The jewelers ignored the colony builders, knowing that they did not

Letter 6. The jewelers of the ummah

share the same set of values. Even those who no longer had their workshops still used tools they kept at homes to chisel and hammer pieces of metal and prepare mezuzah cases, a small way of remembering who they were, a small act of resistance against those like the colony builders, who tried to dissuade them. When they were exiled, most of the jewelers refrained from going to the new colony and joining the colony builders in their violence. The few who did go there were soon punished by the colony builders for the decision of their fellow jewelers not to come to the colony, and they were put on trial for treason.[32]

Perhaps we would not think too harshly of the colony builders, had they genuinely been seeking to assist the survivors of the genocidal violence. But all their actions were mobilized toward colonization and enrichment at the expense of the indigenous people, and this meant that they also ignored the pain and exile of all their co-religionists. Perhaps we should mention that they were working in a violent and imperial tradition that was not their own. Most of the colony builders were originally from the same continent where the genocide had taken place, and where the invaders of the ummah came from. This should not surprise us, since on that continent, technologies of invasion, genocide, plunder, abduction, and slavery were part of a tradition practiced for centuries. The colony builders learned their skills on the invaders' continent, even though for centuries they had been outsiders there.

A few decades before the genocide, in order to escape their outsider status, those-who-would-become-colony-builders went to their teachers—the same people as our invaders—who advised them to start experimenting in colonizing a lovely place on yet another continent across the sea. The teachers were happy to see those-who-would-become-colony-builders leave, for the teachers had never understood them as part of "their" country or continent. The teachers promised those-who-would-become-colony-builders that if they could "make the desert bloom," one day this land across the sea could be theirs. Following their teachers, the colony-builders-in-training learned to split their being: to keep their religious selves in the privacy of their homes or—even better—simply behind, and to practice their civic skills

in public. They despised the knowledge of the jewelers, since it reminded them of what they had sacrificed when they sought to use the invaders' skills to create their own colony.

For the success of their project, the colony builders attempted to recruit many of their co-religionists from around the world. They started to go from town to town, from one country to another, preaching their vision of a split-emancipated being and destroying local communal ties. The colony builders told their co-religionists that there was no place for people of their faith anywhere else in the world except in this faraway colony they had built. They promoted co-religionist kinship over all other forms of kin relations. The colony builders, taught by their teachers the invaders, soon became invaders themselves.

The jewelers of the [ummah] *were not willing to listen to the colony builders, let alone to move to their colony. But the invaders who had destroyed the* [ummah] *protected the colony builders' colony, and had taught them the art of using laws to force others to do their will. In this way, the colony builders turned into sovereigns.*

The colony-builders-turned-sovereigns knew that for thousands of years, the jewelers, who were recently recognized as co-religionists, had been part of the people of the ummah, whom they now proclaimed to be their enemy. In order to destroy the magic of the jewelers of the [ummah] *(as the invaders and educators had sought to do before them), the colony-builders-turned-sovereigns pretended they were the jewelers' rescuers, for they knew that if they could detach the jewelers from the ummah, make them forget, even, that they had once come from the ummah, they could break their magic.*

Because the colony builders proclaimed their sovereignty in the colony, the places where the jewelers continued to live became unsafe for them. The colony-builders-turned-sovereigns took advantage of this vulnerability, as well as that of those who survived the genocide on the continent of the invaders. In two to three decades, the colony builders managed to provoke the departure of all the jewelers who remained in the different countries of the [ummah]. *Angry about the colony-builders' new colony—which the colony-builders claimed was also the colony of the jewelers!—the*

Letter 6. The jewelers of the ummah

Mezuzah parchments purchased on eBay, 2021.

leaders of the [ummah] *denounced both the colony and the jewelers themselves. Where were the jewelers supposed to go, in such a climate?*

The colony builders hoped that the jewelers would all come to their colony. Some did; some did not. For those who did go to the colony, their children started to see the world through the eyes of the colony builders; they too began to believe that the stolen land was theirs and that those from whom this land was stolen were actually the dangerous invaders. This, too, was as much of a curse as the curse the invaders had brought to the people of the ummah over a century before.

The jewelers who were forced to leave the ummah could take with them only a very few things, the most precious of their remaining objects. Many of these precious objects (jewelry, mezuzahs, and other ritual objects) were considered lost en route. Later it became known that many of them had been stolen to furnish libraries and museums built in the colony to ratify its sovereignty. Some of them pop up today at different auctions, where they are promoted as heirlooms, authentic objects made by the jewelers from the ummah (see photo above).

In order to survive in the colony-turned-sovereign-state, the children of the jewelers often sought to resemble other young people who surrounded them. Their younger children and grandchildren, however, still had the potential to recognize that something was wrong. Some of them "discovered" their grandparents' sounds—language, music, liturgical prayers. Those who started to learn these sounds were rewarded with conversations they had not believed they would ever have with their grandparents. They didn't find, however, the courage to explore further the lyrics of songs they rediscovered, fearing the words would spiral out of control and tell a hard-to-believe truth about what this co-religionist religion did to them and to others. Worse, the younger children and grandchildren of the jewelers started to feel trapped between a world they no longer had access to and one into which their ancestors had been exiled, where they never actually felt at home. They realized that they were cursed, and as they did not know how to break the curse, the colonial sleep became their refuge.

Our tale could remind those who may not be aware that the beloved objects taken from our people at different points in the process of tearing apart and disabling their magic powers are still waiting for us, the descendants of the jewelers of the ummah, to retrieve them. If these objects could hear that some of the descendants of their people are starting to awaken from their heavy colonial sleep and stretch their limbs, they would start to click and clack incessantly until they break out of the glass cages and white-walled prisons in which they are stored, where silence is the most respected virtue. This tale is to remind the jewelers' descendants of the magical powers our ancestors once had, the power that our beloved objects can help us wield. We do not need a prince or a knight to rescue us from the colonial spell and its sleep; rather, what is needed is a readiness among all descendants of the ummah, undifferentiated by faith, to reconnect to the objects and wake themselves from sleep.[33] *This tale is told to remind us that powerful objects can unite, rebel, and emerge from captivity whenever they recognize that their beloved people have not abandoned them.*

Letter 6. *The jewelers of the ummah*

What would it take to imagine Jews as part of Algeria again?
What would it take for Algerians to imagine themselves again as inseparable from the Jews?
Stolen jewels, rescued teeth, and undifferentiated skulls, all captives in colonial museums, may inspire in us hope in this long process of decolonization.

We were sitting in this small café in Paris, dear Wassyla, waiting for a nearby bookstore to open, just a couple of hours before my flight back home. You received an email from the son of a Jewish friend of yours. You started to read it to me:

> To block the demands of the two ethnic communities: Circulate leaflets insisting on their common racial and cultural elements, disseminate common demands. At the end of hostilities, they would provoke a plebiscite of all European inhabitants, Jews and Muslims in Algeria. The slogan would be: vote for an Algerian dominion, from which the influence of the Europeans would be eliminated as much as possible and which would be led by a Judeo-Muslim government.

I listened with joy. You didn't tell me it was an old document that your friend's son had found in his parents' archive, so I interpreted it as a direct report from a current assembly of Jews and Muslims in Paris, responding to the current wave of Islamophobia. You read it with such excitement! From our first conversation, you were intrigued by the way I claimed and affirmed my Algerianness, and I was not sure if you understood that the Jews' refusal to cease to be Algerian is part of your struggle too. As we continued to talk, we didn't have to address it directly to know that we both share this struggle, along with so much else.

Yours,

Aïsha, descendant of the jewelers of the ummah

Letter 7. "We have been dispossessed of you"

A letter to Houria Bouteldja

Dear Houria,

Reading your book for the first time, in French, touched my heart. I had never read a text that addressed me in the way yours did, nor one whose words resonated so deeply:

> You can't ignore the fact that France made you French to tear you away from us, from your land, from your Arab-Berber identity. If I dare to say so, from your Islamic identity. Just as we have been dispossessed of you. If I dare to say so, of our Jewish identity. I cannot think about North Africa without missing you. You left a void that we will never be able to fill, and for that I am inconsolable.[1]

I had never heard music like this before, chère *Houria.*

My heart was dancing as my eyes ran along the lines to the beat of your music, written in a tune of revolutionary love. When I read your words, it had already been a few years since I'd begun my rehearsals, saying aloud and in different ways:

> I am an Algerian Jew,
> my name is Aïsha.

Your call pierced through the ranks of guardians, historians, and soldiers, who stood in front of my door to Algeria, restricting me from saying the obvious:

I am a Muslim Jew.

When I read your book, I had already begun refusing to recognize myself in any *we* that was imposed by the identity assigned to me by the Zionist colony. I already recognized that Zionism was "another name for *your* [our] capitulation,"[2] and that the *we* to which I belonged was but one of the "two primary victims of the Israeli project"—the Palestinians and the Jews.[3]

Unlearning Zionism as an "Israeli" was a relatively easy epistemological task. An anti-Zionist language already existed, ready for use. I had to make it mine and speak it with others. Once I understood the disaster that the Zionist regime perpetuates, its pervasive imprint became more legible to me, and my mother tongue could no longer failed me as much. The challenge took a different turn, however, once I shed this identity called Israeli and felt myself nakedly a Jew, attempting to inhabit pre-colonial identities: Palestinian Jew, Algerian Jew. There was little available language for these identities to be spoken, few models for how to inhabit them, and almost no spaces in which I could find these identities reflected back to me.[4] I found that rehearsing anti-Zionist existence was a project of Jewish liberation from Zionism, and that it was also a rehearsed liberation from the Euro-American pact that had made of Zionists the representatives of the "Jewish people." Euro-American imperial training and support allowed Euro-Zionists, claiming to speak for all Jews, to continue the European project in Palestine—the project of destroying autonomous Jewish communities and shared Jewish Muslim life, as well as to carry on the forced migration of Jews. The outcome of this devastating pact is that most Jews today no longer live in their ancestral homes or as part of their ancestral communities; rather, they live either as Zionists (in or outside of Israel) or mostly as individual blank Jews, nationals of other, mainly Christian, countries. The challenge, here, is not only to commit oneself to anti-Zionism but to understand that Jewish

Letter 7. "We have been dispossessed of you"

liberation or decolonization requires the recovery of Jewish communities living alongside Muslim communities, i.e., the recovery of a Jewish Muslim world.

By saying I am Algerian, I am not claiming national allegiance but rather retrieving a precolonial disposition. I didn't shed one nation-state identity ("Israeli") to replace it with another! Not surprisingly, the challenge is corporeal as much as it is epistemological, given that two colonial projects sought to erase our communal corporeal memory and given that I lack an embodied community to which I belong. Deciding to depart from the Zionist colony only revealed to me how much the French colonial state had targeted both the Jew and the Muslim among my ancestors, how the state sought to convert them to French secularism and to create Judaism and Islam as two faiths apart.

Reading these sentences in your book, "France made you French to tear you away from us" or "I can't think about North Africa without missing you," made me cry. I felt like I had come across a treasure map. If my father had only heard a voice like yours after he had left Algeria, I could have had a different father. He was unable to express even the slightest longing for his former home. Was he even allowed to think about North Africa as his home? In the Zionist colony, where he landed in 1949, Algeria was perceived as a battlefield between Europeans and Algerians, i.e. Muslims, a place where a small, "endangered Jewish minority" survived and had to be rescued and brought to the newly founded Zionist state in Palestine. Among this Jewish minority was my father's family.

That one misses their ancestral land when exiled from it is a primordial truth. However, such a truth was hijacked and interdicted by a constellation of colonial regimes. That my father could not talk about Algeria was no coincidence. Can you imagine, *chère* Houria, it was only after he died that I noticed this? Missing home was not something my father could afford to feel, since it would have required him to say *I am Algerian* or *I miss Algeria*. The meaning of his longing would be: *I miss the land of Islam*.

I now miss Algeria, not just for myself but on behalf of my father as well, and for my ancestors buried there, who miss us. I miss it for all the years that he could not afford to miss it, and for

the years when I could not hear the call of my ancestors buried there, calling for me to come. While I was deeply touched when I read that you feel "inconsolable" for the void that we left, a void you "will never be able to fill," I was alarmed when I read your next sentence: "Your alterity becomes more pronounced and your memory fades." This told me how thoroughly what was done to us has become normalized, even to imperialism's fiercest critics.

Do not forget, *chère* Houria, that this alterity is not ours but is what the colonizers did to both of us. The colonizers made my ancestors French, as they lured Algerian Muslims into sacrificing and erasing us from memory so that the French could have a clean and empty Sahara desert for their nuclear tests. Had this not been the case, voices like yours would sound familiar to us, and would not come as awe-inspiring surprises later in life.[5]

> I was born to reside
> in the fortress created
> by the Zionist state.
> I was born to stop
> resembling you,
> to fade in memory,
> to keep your Jewishness from you.
> Their human factory
> will not last
> forever.
> We both know
> the clock is ticking,
> we must hurry,
> rush, truly,
> before a new
> model of tongues
> is released,
> tongues that spasm
> on the before-image
> of such memories,
> regurgitated
> from the throat.

Letter 7. *"We have been dispossessed of you"*

When I finished reading your book, many things fell into place. We lost our Islamic identity. I knew that if there were a way to resist this loss, it would be by holding on to it, treating it as inextricable from our Jewish identity, from your Jewish identity. It is hard for me to say now, in retrospect, to what extent I already knew this and how much I learned from you. Our lives, who we are or were forced to become, and who we refuse to be, can't be explained in the academic regime of citations, nor should they be thought of only as individual trajectories. Our lives are collective. Could my Islamic identity be a footnote in someone's book? In which of my broken languages can I locate the traces of my Islamic identity's refusal to disappear? In which language was it mostly forgotten, and in which can it be reclaimed?

> The letters in the body of the colonized
> are indelible,
> even when they fail to assemble
> coherent words,
> sentences,
> paragraphs.
>
> And yet—
> our bodies are not texts.
> They are not made of
> decrees or ID papers.
> Our bodies rejoice at
> the sound of words
> in our different stolen languages.
>
> Our bodies are in pain
> when language fails them
> or forces us to fail them
> by what was made to be
> our tongue.

I have been working to unlearn what was done to my ancestors both before and after I read your book, and I still cannot say "I'm finished." A few months after my parents died, I left the

Zionist colony in Palestine with a clear understanding that I would not return unless all Palestinians could return. Around the same time, I became a grandmother—an experience that made me ask who we are and where we belong (or where we could belong), questions that felt ever more urgent as my children grew older and my grandchildren grew from babies to children. As I called upon my ancestors for answers, I realized I had now become the ancestor of my grandchildren, and that I had ancestor-work to do for them. Telling them that we are Algerian was quite abstract. Unlike me, my grandchildren didn't grow up with an Algerian father, and I want them to be able to join me in saying, "You are familiar to me, too, dear Houria."[6]

I was excited about what seemed to me the second part of your invitation to us Jews: to "walk some of the way together" in the process of freeing ourselves.[7] For the first time in my life, this invitation made me feel that I could belong somewhere. Ever since becoming an adult, I remember keeping a distance from the many terms I risked being attached to—a "woman," a "Mizrahi," a "Jew," or an "Israeli."

In 2019, I invited you to give a lecture at the university where I teach. I also invited Samia Henni, whose book, *Architecture of Counterrevolution,* had also just been published. I knew this event was going to be a real treat, and indeed it was. However, it was not without a series of hurdles that perhaps you don't remember. I need to bring them up here since each of them was

Poster announcing the lecture of Houria Bouteldja and Samia Henni.

Letter 7. "We have been dispossessed of you"

quite symbolic and fraught with meaning. Each signaled how the world was not ready for the three of us to come together and to set the terms of our conversation.

A few days before your joint lecture, I receive printed copies—not a draft!—of the poster for the event. I tried to close my eyes and make it disappear, but when I opened my eyes, I still saw the pile of posters with your names printed alongside images of French soldiers and tanks rolling through Algiers, images from the film *The Battle of Algiers* (see photo p. 270). I had invited both of you to speak on the different ways your work challenges the continuing effects of French colonialism. However, this poster was a visual reminder of how instinctual it is to pair the work of the colonized with the presence of armed colonizers. When I protested the circulation of these posters on campus and their use for our event, I was told that they could not be reprinted. So I decided to tweak them. I used the titles of your books as graphic elements and printed them multiple times on stickers just the right size to cover the images of the tanks. I tried not to tell you about this, hoping to keep this episode from becoming the center of our attention. But you told me that the original poster was emailed to you. We laughed together as I peeled the sticker back to show you where your books' titles had buried the tanks.

I had barely finished putting these stickers on one hundred flyer copies when I received an email addressed to some of us involved in the organizing of the event demanding that we cancel it. According to the author of that email, you were an anti-feminist who should not be hosted by the center where the event was to be held. I was already familiar with this misunderstanding of your position, but was still worried until the event was over; you were not surprised either. You mentioned that similar emails had been sent to other institutions where you lectured.

As we were sitting in the lobby of your hotel, discussing this and preparing to go to the auditorium, I learned that you were going to give your lecture in French. You simply mentioned it. I was a bit nervous but also appreciative. I felt even more appreciative when I learned that you had a degree in English. I myself was at a turning point, exhausted with the condition of being a foreigner and having to express myself, always, in English.

In my first years of being an immigrant, I had made an effort to improve my accent and grammar, with moderate success. But later, I switched to self-acceptance, a silent revolt against the imperial expectations that I both diversify and enrich the institution with my knowledge and ethnicity and also flawlessly adopt the parameters of the American settlers' English-language model. I tried not to show my surprise that you hadn't told me in advance, and I thought about how to make your lecture accessible to the audience, most of whom likely wouldn't speak French. Samia and I looked at each other, and I was grateful that she volunteered to share the work of live translation with me. The lecture was set to take place in two hours, and, obviously, we didn't have time to prepare.

The auditorium was already crowded when we arrived. I introduced you and said a few words about the live translation. You were at the podium. Samia and I sat at a table in the corner of the room, concentrating on finding the right words in English. While simultaneous translation is transmitted discreetly through headphones and does not disrupt the flow of the lecture, our consecutive translation (and probably mistranslation, at moments) was heard publicly, by everyone together. The audience was patient and extremely attentive, and I realized that there was something magical in the ritual of repeating your dense and provocative thoughts, sentence after sentence. I loved conveying your defiant sentences with my voice, saying the words that liberal white feminists do not want to hear. I especially loved the great care you expressed toward colonized men, who are easily perceived as the source of colonized women's oppression. You insisted: "The indigenous man is not our main enemy."[8] Thus you put straight on the table the often unquestioned assumptions of universal liberal feminism, which was itself mobilized to invade colonized worlds. Liberal feminism, too, is a colonial technology.

After the conversation following your lecture, the three of us posed for a photo. As the audience started to leave, a friend who had retired from the French department at my university lingered on in conversation. When you and Samia recognized that he was Algerian, the tones immediately turned warm and friendly. One of you—I cannot recall who—asked me if I could take a photo

Letter 7. "We have been dispossessed of you"

of all of you, all "the Algerians." I replied, half-jokingly, though I meant it, "I'm also Algerian," but I left the group to take the picture while one of you wrote in haste on a piece of paper *Vive l'Algérie*. You held the sign and I clicked the button on the camera of my phone.

Can I be heard when I say "I am Algerian too?"
Maybe not, maybe I cannot say I am Algerian. Or maybe I'm not?
Can one be an Algerian if one is not recognized as such by Algerians?

The day after, we continued the conversation in my class. During lunch I told you that the next time I was in Paris, I wanted to attend the school of the Parti des indigènes de la république (PIR). You said quickly, "It is only for the indigenous people of the republic." I tried to tell you that was also a descendant of the indigenous people of the republic, and you replied, "But not according to the French colonial indigenous code [*le code de l'indigénat*, 1887]." And then you told me, "You have to work with *the Jews*, and then we could partner up."

I was surprised. It hit me hard. I was disappointed by your reply, and I also knew that you were wrong about the definition of indigenous people, as in 1830 the colonial regime abolished Algerian Jews' status as *dhimmi* and "placed the Jews of the regency of Algiers on an equal footing with the Muslims, henceforth all referred to as 'indigenous.'"[9] My ancestors were indigenous before they were forced to become French citizens, and becoming French citizens didn't protect them from becoming, once again, indigenous according to French law, which changed our status at a whim. Yet I also knew that you were partially right regarding the other part—about the Jews. I had to overcome the reticence that Jewish institutions and formations provoked in me due to the often-blurred lines between Jewishness and Zionism. I had to look for a community in which my self-affirmation as an anti-Zionist Muslim Jew could be respected and even echoed. Maybe in France it would have been easier to find such a community, given the size of North African immigrant communities, whose

descendants might still register the diverse memories of their ancestors.

Where I live in the United States, though, I'm surrounded by ignorance of the existence of Jews who have a different history than those who originated mainly from Europe, who were socialized to pass mainly unnoticed or to relate to themselves as *Jewish*. The use of the adjective instead of the noun *Jews* is one of the long-term manifestations of the unwritten post-WWII bargain that helped Europe absolve itself of its crimes against Jews, and to masquerade as our protector from what Europe itself had made a slur: "Jew." I have even been corrected more than once when I refer to myself as a Jew rather than by the adjective "Jewish," which is what Americans have adopted to assimilate themselves into blankness. This bargain enhanced the eighteenth-century secular command that obliged the Jews to leave their Jewishness at home and assimilate in public spaces as national citizens. As you will see, dear Houria, my work on our ancestors' world refuses this bargain and insists on our difference and on our right to organize our lives around principles drawn from our precolonial heritage. My work insists that our lives before the French colonization were and still are an alternative to the corpus of laws that emerged as we were colonized. Being assumed to be the blank adjective Jewish—rather than the noun with a world of diverse ancestors, a Jew—hurts, as it emphasizes how my family history, like our shared history, Houria, was made irrelevant to our political life and forced into the realm of personal stories.

It struck me that despite the fact that most of the Jews who surround you in Paris are North Africans, the call in your book invites Jews "to follow in the footsteps of the proud militants of the [General Jewish Labour] Bund."[10] It's a great reference, but why do *you* of all people send *us* to find our ancestors in Poland?! Why is it that alongside this exciting call to remind ourselves of our Islamic identity, you ignore *our* history and suggest that for us the "dream of liberation" should be sourced from an Eastern European Jewish movement? A movement that you read as pertaining only to Zionism?

There are certainly people who continue the Bund's dream of liberation, but my commitment is first to undo the making

Letter 7. "We have been dispossessed of you"

of Algerian Jews into a monolith represented only in general assumptions about what they did and wanted, to listen to the voices that were never heard and the histories that were never told. Our ancestors in Algeria didn't write anti-Zionist texts; they were indifferent to Zionism from its start, and they were shielded from its encroachment until the Muslim Jewish world in which they lived was destroyed. The majority of them didn't open the doors of their heart to Zionist messengers who came to Algeria and sought to engage them in deliberations about the future of "the Jewish people." I believe this was because they felt, deep inside—though they left very few written traces of such affects in the archive—that their attachment to Algeria could not to be questioned.[11]

Moreover, for them, as for many other Jewish communities who lived in multiethnic and multifaith polities for centuries before the emergence of the Zionist movement, the law of the land was a binding law. דינא דמלכותא דינא, *the law of the immanent kingdom is the law [by which we abide]*, is the Aramaic expression that defined their relationship to extra-religious political legislation. This, however, did not mean that they submitted to the law with full obedience; rather, they sought to preserve a sane distance between themselves and the law of the state, keeping state apparatuses foreign to their communal modes of life rather than interiorizing them. Our ancestors didn't like Ottoman rule and they saw it as foreign, just as they would later see the rule of the French. That French Jews were forced to praise Napoleon III in their prayers in the wake of French colonization is not a sign that they loved him, but quite the opposite: what is often treated as a sign of Algerian Jews' Francophilia or dreams of assimilation is actually a sign of their survival strategy, one common to other colonized groups. This is why, Houria, I knew that I might not find organized political movements in my research and should look for signs of aspirations and self-understanding in their social, spiritual and craft formations. This is why I am interested in jewelry-making: I want to know the distance my ancestors kept from the state and the commitment they made to retaining indigenous practices held in common with Muslims. I read these crafts as their liberation struggle. Members of the

Bund left important texts, but theirs and text in general are not the only form of resistance to the onto-epistemological terror of colonization, not the only form of evasion.

Several French Jewish messengers arrived in Algeria a few years after colonization, aiding the terror of conversion through the reports they wrote for the French government regarding our ancestors' modes of life. Despite their desire to show that Algerian Jews were already—or ready to become—attached to France, they could not deny our ancestors' deep attachment to Algeria. Discussing a relatively wealthy group of Algerian Jewish merchants, who by virtue of their trade had to travel frequently, the author of one of the reports wrote with astonishment: "A remarkable thing, which confirms what we said above about their attachment to the places where their birth is remembered [*qui les ont vus naîtres*], these trips (to Europe) would very rarely end up in emigration."[12]

Until 1962, very few Algerian Jews migrated to Palestine, and in 1962, less than 20 percent of the 150,000 Jews who were forced to leave Algeria opted for Israel. The cruel pragmatism that accompanied the Évian Accords—namely, the various leaders' readiness to end the life of one of the oldest segments of Algerian society in the Maghreb by resolving the "Jewish question" in Algeria, didn't provoke any opposition. The obvious idea that "no one leaves home unless / home is the mouth of a shark," to quote Warsan Shire, was muted in 1962. One year later, the Zionists, preying on these Jews and frustrated that they had lost to France this human stock that could have helped sustain their enterprise in Palestine, decided to put the leaders of those who had migrated to Israel on trial in order to punish them for their recalcitrant co-religionists. Indifferent to the leaders' trauma of having been exiled from their ancestral homeland less than a year earlier, the Zionist courts blamed the leaders for failing to guide *all* the members of their community to Zionism. In the same year, 1963, the independent Algerian state passed its nationality law that restricted "nationality to persons who had two paternal ancestral lines who had Muslim status in Algeria."[13] Exiled from the Jewish Muslim world, Algerian Jews were integrated into other nation-states—mainly France, Canada,

Letter 7. "We have been dispossessed of you"

and Israel—countries committed to purging them of the rest of their Muslim identities. Concomitantly, return to Algeria was foreclosed.

The separation between the Jewish and the Muslim communities in Algeria is also built upon a manufactured memory that falsely distinguishes between what the republican colonial regime did to both Muslims and Jews in France and Algeria: destroyed their shared culture, appropriated their country while rebuilding it for colonial purposes, racialized them, kidnapped them from their lives, drafted them to become soldiers in its wars, concentrated them in different places and camps, forced them to labor in camps, used genocidal violence against them, and plundered their wealth while transferring it to France. For their assimilation in France after 1962, the Jews were forced to self-identify as *pieds-noirs*, or at least not trouble the French version of their history, and they were forced to forget their Muslim sisters and brothers. The persecution of Muslims in France is due to their "inassimilability," either because they refuse assimilation in protest or because the state uses institutional Islamophobia to withhold assimilation. However, as we know it well, despite this current difference between the two communities in France, even when their members are assimilated, they will always be almost French.

This is in keeping with what you write in relation to the *harkis*: "Whatever their allegiance to the French Algerian project might have been (whether voluntary or forced), the *harki* never became French, a luxury which only Europeans can afford."[14] This is what saves us from becoming fully French. This is the republican paradox: the French asked our ancestors to become French, but once they came close to being French, our ancestors were punished for daring to call Frenchness their own. You write, "When I look at you, I see us," and you locate the similarity between the Jew and the Muslim within this shared "willingness to meld into whiteness, to support his oppressor, and to want to embody the canons of modernity."[15] While this statement is true, you forget to mention that the willingness to assimilate into French whiteness is the lingering post-traumatic effect of a colonization that has not yet ended, and whose ruling elites and ruling institutions are still in place.

You write, "Between us, everything is still possible." From a global point of view, what is still possible has vast ramifications. The liquidation of the Jewish Muslim world exceeds what transpired in Algeria. The *sudden deracialization* of the Jews post-WWII occurred without dismantling the technologies used to racialize them in the first place. These tools were then used to shape the "new world order" that called for the accelerated assimilation of Jews in the West, using the alibi of an invented Judeo-Christian tradition given to "the Jews" as *their* memory. Thinking back to the history that I learned at school: it was the West that produced art and civilization, in contrast to the Jews, whose history was dematerialized, as if their life in different places had not left tangible traces, and as if the places from where they were deracinated were not real places in which their presence was and still is inscribed, but only a floating series of names.

In addition to Zionism, Judeo-Christianity names our shared capitulation, since Islam-without-Jews had to be invented to sustain the (invented) Judeo-Christian tradition. Resistance to these terms does not only involve missing each other—though we do! It also demands disruption of the imperial re-programming of the human species.

Just because at the end of WWII perpetrators of racial violence and racializing state technologies sought atonement doesn't mean Jews forgot their diverse histories. But they did lose the ability to maintain practices that once organized their communal life, now made incommensurable with the new world order: ideas of justice, a sense of community, practices of mutual aid, *shmita* (ceasing from exploiting the land and letting it renew its powers), *shvita* (ceasing from all work), דינא דמלכותא דינא (suspicion toward state apparatuses), or intercommunal solidarity. Jews lost the ability to recall and maintain these practices because they were all reduced to aspects of "religion" and demoted from their places as traditions in a social world. The colonizers did manage, as you write to us, the Jews, "to make you trade your religion, your history, and your memories for a colonial ideology."[16] But this exceeded us as individuals, since colonial ideology is embedded in the nation-state and became the ultimate political condition of our being together.

Letter 7. "We have been dispossessed of you"

So, Houria: I have much esteem for the Bund, but part of undoing the normalization of the nation-state also involves recovering diversity among the Jews, especially among those coming from Jewish Muslim worlds. Undoing the nation-state, though, requires tracking down *our* Algerian Bunds, and doing so against the lies written about our Algerian ancestors. From my point of view as a descendant of colonized Algerian Jews, one of the most destructive lies is the one that says that my ancestors welcomed French colonization. The fallacy of such a claim is blaringly obvious, especially as we know that European anti-Judaism "planted its first roots from the beginning of the conquest [of Algeria]" and that the Jews are described in the writings of military officials, travelers and intellectuals as "lacking loyalty, greedy, deceitful, obsequious" and "traitors to the French cause, filthy and illiterate natives, usurers, profiteers."[17] This same lie is reproduced again and again in scholarship, and for a long time it shamed me about our ancestors: Were we all colonial collaborators? No, we were not, but collaboration was our fate, a condition shared with *all* the colonized. I'm assuming that this is also what hindered me from describing our oppression in a second campaign of colonization by Zionists.

Reopening this history paradoxically means "self-racializing." It means refusing to inhabit the blank body of a citizen through which the nation-state system operates; it means opting instead to be the problem by rejecting the "solutions" imposed on our ancestors, ones that we continue to abide by. It is their fragmented and scattered refusal that I'm renewing.

Many other lies were built from this first lie about our ancestors. One of these subsequent lies is the idea that it was their choice to leave Algeria in 1962, at the moment called independence. The truth, however, is that the different cities where they lived became unsafe for them; they were targeted by the French when they refrained from assisting them or were discovered to be assisting the FLN, by the OAS (Organisation Armée Secrète) and also by the FLN; and their transfer out of Algeria was one outcome of the negotiations at Évian, ensuring that we would not be part of decolonized Algeria, another manifestation of the colonial strategy of divide and rule.[18] Algeria reiterated this

termination of our life there with the 1963 nationality law. The violence colonialism introduced into Algeria as it rent Algeria's social fabric apart gave rise to "ethnonationalisms throughout the region (notably Zionism and Arab nationalisms)," as Joshua Schreier describes it. During the last decade of colonization, this violence "created Manichean choices that eclipsed Muslims' and Jews' vast and enduring array of opinions, relations and attachments."[19] Remember, no matter what our ancestors wanted for themselves individually or collectively, their destiny was determined by the Évian negotiations between French Christians and Muslim Algerians: they were to be repatriated as Europeans.

This was no "choice." My ancestors did not consent. Or even if they did, their "consent" should be understood as something extracted from them as a colonized people, not something willfully given.

This cries out for repair.[20]

If the basic fact of our colonization alongside Muslims had not been erased, I probably wouldn't have responded in the same way to your suggestion about the Bund. It is not that our liberation dreams should necessarily be *ours* or only ours—but I refuse the imposed idea that *our* history of defiance happened only in Europe. Furthermore, if I am to work with Jews, as you suggested, I must first address (and redress) who we were before we were collectively made "the Jews." In the absence of a community of radical Muslim Jews around me, I engage with my ancestors and elected kin. With their help, I'm working to track down the archive of our embodied Bund, the one built by their craftspeople's hands. I am guided on this journey by an anticolonial onto-epistemology that I developed in *Potential History*, where I argued that despite the "achievements" of a long colonization aiming at converting our ancestors, there were unruly enclaves where imperial conversion failed, was opposed and refused. Houria, our ancestors refused everywhere, and you know it.

Inspired and reassured by your statement about the loss of *your* Jewish identity, I searched for *my* Islamic identity in what happened to Algerian Islamic identity when the French invaded Algeria. I looked for traces of our entangled identities in the little isles where it persisted, and especially in the lived experience of our ancestors.

Letter 7. "We have been dispossessed of you"

The destruction of our ancestors' livelihood was erased from the annals very early. In the spirit of the French Revolution, whose glorious history was created through denigrating everything that preceded it so that freedom appeared as its primary attribute, the history of the Jews in Algeria prior to colonization was also denigrated. This was done in order to justify the Jews' conversion to modernity by different (French) liberators.

The accounts of the miserable lives of the Jews under Ottoman rule do not describe specific situations; rather, they enumerate the set of written rules in the dhimmi contract and imply that these contracts set the terms of the Jews' lived realities. An emblematic example of this is Simon Schwarzfuchs's introduction to his edited volume on the 1840s-era reports commissioned by the French government to survey colonial Algeria. Reviewing a long list of what the Jews were not allowed to do in public spaces frequented by Muslims, as well as a list of the different types of humiliation and punishment they suffered, he neglects to provide any evidence of if and how these punishments and rules were implemented—when, where, how, and how frequently? He doesn't even mention the protective side of the dhimmi status that was conferred on a number of non-Muslim communities under Ottoman rule, which allowed Jews to organize their lives and communities with minimal state intervention.[21] In this same introduction, Schwarzfuchs also ignores the nuanced descriptions in these reports, such as the clear statement that opens one of them about the lack of sources, which prevents the author from giving a fair description of the Jews' situation prior to conquest: "We lack documents. The Jews in Algeria do not have archives that we could consult, no public registers, zero record of official acts."[22]

Despite these reports' commitment to proving the readiness of Algeria's Jews to become French, the reports' authors admit that the situation is more complicated. The Jews, "rather lost than gained from the French conquest," they write. Their "devotion [to the French] is more out of calculation than sentiment." But this, they reassure their readers, can be changed; they admit that "their situation was less difficult than our ancestors among Christians [in Europe]," and that the "Muslims seemed highly appreciative of the presence of the Jews among them." Hence, "they gave them

posts of trust in their palace, including guarding the treasure and supervision of the currency." In sum, "despite not having civil and political rights, the Jews enjoyed unlimited commercial liberty."[23]

Yet despite the ambivalences these documents display, and other accounts written by historians such as Jacques Taïb[24] that provide a rich picture of life before colonization, still today many historical accounts continue to unequivocally present Algerian Jews as waiting for French saviors. Some still suggest that Algerian Jews related to the Crémieux Decree not as a despotic and "authoritarian"[25] act, but rather as "the last stage of a process of assimilation which started from the beginning of the French conquest, welcomed by the major part of this small minority, discriminated against under the regime of the beys of Algeria."[26] When the colonization of the Jews is not denied and what happened to them is understood as part of what happened to the entire indigenous population of Algeria, the Crémieux Decree can no longer be presented as a form of welcome; rather, it is a document of cultural genocide and marked the operation of the colonial technology of forced assimilation wielded against Algerian Jews.

Thus, without forgetting what is often occluded in historical accounts of the first forty years of colonization, the Jewish population declined from 80,000 in 1830 to 40,000 in 1870.[27] The imposition of citizenship began as catastrophic decline and led into historical oblivion. From the very beginning, the French destroyed the internal organizations of Algerian Jewish communities. Their goal was, to use David Nadjari's words, "to undermine the deep foundations of the Judeo-Maghrebi society." This was achieved in part through the construction of French synagogues bereft of Muslim Jewish memory and traditions, in which worship was "directed by a single body having a monopoly on religious activities."[28] In this way, colonial actors used the new synagogues to socialize Jews into recognizing the power of authoritarian figures. Thus, traditional Jewish practice, based on the idea that the "presence of a quorum of ten faithful is sufficient to conduct an office," was violated through the imposition of French Judaism, which imposed an utterly different structure of authority. This new French Judaism was centered around the "figure of a rabbi, mid-way between the Christian conceptions of

Letter 7. "We have been dispossessed of you"

the pastor and the image of the Hebrew erudite, depository and guardian of the law."[29] Religious jurisprudence was also reorganized to grant more power to the state and disrupt the existing craft guilds, which held many Jews as members. On August 10, 1834, "The rabbinical courts were confined to the sphere of personal status and the ordinances of February 28 and September 26 entrusted all trials between Jews—including personal status problems—to the French courts."[30] These guilds, in addition to protecting the interests of local artisans and traders against the institution of racial capitalism that the French imposed, were also social formations that protected the rights of their members and were inspired by religious laws in both communities.

When I understood the intertwinement of three forms of destruction—of Jewish communities' autonomy, of craft guilds, and of the urban spaces where their shared life with Muslims was inscribed—I decided to take my late father on a tour of Algiers of 1830, in the form of a letter. In this imagined tour, I walked him through the destruction of the lower city, where Jewish life

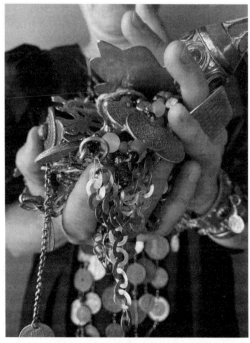

The jewelry made by our ancestors in their workshops, buried under Martyrs' Square, Algiers. Photo: Yonatan Vinitsky.

unfolded. I wanted to show him our ancestors' attachments to their shared life with Muslims as people lived and worked and mingled in the streets of the Lower Kasbah, roaming its alleys, mosques, synagogues, and artisanal workshops.[31] I wanted to awaken in him his sense of belonging to Algeria. I wanted to show him how the seemingly deficient Jewish world was the outcome of French destruction, that it only appeared impoverished because it was only a partial world, bifurcated from its Muslim half. I wanted to share with him the beauty of the jewelry that our ancestors made in those streets, streets that were ruined by the French for the imposition of the Royal Square, currently Martyrs' Square (see photo p. 283). I showed him how this binary excluded the Jews from everything Algerian, and I tallied for him the costs this loss levied.

When we looked at this pristine white mosque in the Martyrs' Square (see photo p. 61), I showed him how it was isolated from the buildings to which it was once attached. This was done so that it could be symbolically tied to the reins of the horse on which the statue of Duc d'Orléans rides, pulling the Muslims (slowly) toward the modern world. On our tour, however, I forgot to mention that the bronze in the sculpture was looted from our cannons. The destruction of Jewish religious and nonreligious sites and worldliness was pursued to convert Jews to secular modernism, to draw an "impenetrable boundary between religious belonging and civil belonging."[32] This, however, was not pursued by relegating "the religious" to the private sphere. Rather, the "religious" was a delineated sphere forced to exist in secular public space. Here, in what the French called "big synagogues," common religious practices that made religion synonymous with life, politics, and community were renamed "old" and "archaic" practices, and banned.

This culture-cide is mostly ignored by historians who still praise the French. For example, "Jews hastened to plan a number of synagogues, monumental in character and design," and historians repeat the propaganda according to which this happened because the Jews had been banned from building synagogues under the Ottoman empire. Such explanations not only omit the fact the French had totally destroyed all of Algeria's synagogues,

Letter 7. "We have been dispossessed of you"

Grave of Rabbi Ephraim Ainqaoua (Al Naqawa, Alnaqua, Encaoua), Tlemcen.

forcing the Jews to demand new ones, but they also ignore the fact that the French imposed a theatricality upon sites of worship. That most of our ancestors' ceremonies were held in their homes and not in the synagogues is not surprising. The spatial organization of the synagogues built under the French didn't welcome the intimate ceremonies that our ancestors traditionally held. Thus they continued to hold ceremonies at their homes, often in community with their Muslim neighbors.

The replacement of the destroyed small synagogues with new ones enabled the French to *restart* our ancestors' corporeal memory, and it forced them to learn how to pray differently. These new buildings were cleansed of memories, of ancestral life, of spirits, and also of Muslims, who used to enter certain synagogues wherein they felt Allah's blessing awaited them too.[33] All over the Maghreb, Jews and Muslims venerated the same saints, treated their sacred texts with the same care and love, held their prayers in spaces that were built and decorated by artisans of both religions, illuminated each other's sacred texts, and believed in and were impacted by some same miracles. Known examples are the Hara and Dar Zarphati in Algiers, al Ghariba in Bône, another in Biskara, and the Synagogue Rab in Tlemcen in northern Algeria, which was named after the Rabbi Ephraim Ankawa, whose grave was a site of pilgrimage for both Muslims and Jews

(see photo p. 285). A friend from Tlemcen told me that today older people still remember the story of how Rabbi Ankawa healed the sultan's son. As an expression of gratitude, the sultan allocated what became the Jewish quarter to the Jews.

In the Algerian port city of Annaba a miracle occurred. One day, a few local inhabitants who happened to be near the sea noticed a wooden crate rocking between the waves. Intrigued by its contents, they tried to catch it, but each time they reached for it the crate receded. Several Jews who lived in the city heard about the crate from neighbors and rushed to the sea. They wanted to see with their own eyes the miraculous crate. As they came close, the crate came toward them. They extended their hands and pulled it from the water. To the amazement of everybody present, Jews and Muslims alike, inside they found an old, handwritten bible, inscribed on parchment undamaged by the water. The way this miracle has been orally transmitted among the inhabitants of the city provides a local example of *matan torah* (the giving of the Torah), a variation of the story that is based on shared participation in the Torah's reception and its veneration. In this story, it is Muslims who are first to notice the crate and who call upon the Jews for help. In some versions, the story begins with a Muslim man traveling home by ship from his pilgrimage to Mecca. On board, he meets a Jew carrying an old Bible from Jerusalem. The ship sinks and all the passengers drown at sea, except the Muslim man. Upon his arrival, he tells the story of his journey to others. When the crate is noticed in the water, someone thinks it could be the Jew's, and the Muslims call the rabbi for help.

In both versions of this story, without Muslims' devotion and care, the crate would have drifted elsewhere and been lost to Annaba's Jews. The story goes that the Muslims offered to build, with their own means, a synagogue to host the recovered holy Bible. The Jews welcomed the idea, and the synagogue, named la Ghariba (the Stranger), was opened for both Jews and Muslims.

So you see what a commingled world of believers the French sought to destroy, Houria. Our ancestors opposed the French conception of religion that sought to tear them apart in order to make them modern secular individuals, and they sought to adhere to their communal practices that were denigrated by the

Letter 7. "We have been dispossessed of you"

French. This is why in 1865, when the Senatus Consulte invited Jews and Muslims to apply for French citizenship, the majority refused to give up what remained of their personal status as Muslim Jews after the invasion. As Taïb writes, "abandoning the personal status was akin to apostasy."[34] Alongside the majority of Muslims, the Jews turned down the invitation, and only approximately 300 people from both communities applied for French citizenship. I refuse to forget my ancestors' efforts to resist secularization and deracination from Muslims. Moreover, I'm committed to "follow[ing] in the steps of the proud Jewish militants,"[35] not members of the Bund as you suggested, but those who, by adhering to their customs, beliefs, and practices, kept themselves *anti-modern* and not fully secular.

As I tried to show to my father, the destruction of Jewish autonomy was entangled with the reorganization of Algeria around a double binary that contrasted Europeans and Muslims, the modern and the premodern. For this contrast to appear in all aspects of life, what remained of Jewish autonomous communities could exist only behind the closed doors of synagogues. Since almost all Jewish synagogues in Algiers were destroyed as early as 1830, the big new synagogues reflect the first binary between European Christians and Muslims architecturally; they were built as imitation cathedrals, as in Oran, or imitation mosques, as in Algiers.[36]

Muriam Haleh Davis recently offered another way to describe this binary: a tension between "homo economicus, the exemplar of European economic modernity, and homo islamicus, the model of native social practices."[37] As with other colonial binaries, the colonized were forced *to progress* from homo islamicus toward homo economicus. From this binary too, the Jews evaporated, and the violence done to them was made invisible and irrelevant to understanding this colonial history. Their disappearance enables continued ignorance of the violent colonial campaigns that forced Jews, too, to become homo economicus.

For example: I knew that my grandfather Joseph, whom I never met, was a butcher in Oran. But only in the past few years did I manage to discover that he deserted the French army in WWI and that he became part of the anticolonial and anarchist trade

union, the Confédération Générale du Travail Unitaire. Further, I learned that being a Jewish butcher also meant serving both Jewish and Muslim communities, who shared similar food restrictions. His radicalism was connected, through his life experience, to the diverse Muslim Jewish world of which he had been a part.

Rejecting the erasure of their indigeneity and religiosity, the premises on which our ancestors' autonomous lives were built, is our legacy to reclaim. And we do so by recuperating the traditions that the Muslim and Jewish communities shared. One example is the centrality of care and assistance for the weak and the needy, enshrined in communal law in both Islamic and Jewish communities in Algeria; these laws were incommensurate with the newly imposed racial capitalist regime. Another example is the *habous* system of collective property for public use, a practice that the French abolished since those inalienable properties preserved the memory of a different economy, one predicated on different public and religious practices, needs, and charity. If the power to protect members of their communities had not been damaged, the French might not have been so successful in bringing indigenous Algerians into the capitalist wage labor market that made them dependent upon the regime. The French continued to attack indigenous autonomy: in 1900, to satisfy the colonizers, Paris "formally confined the Jewish consistories to a cultural role, by prohibiting them from providing any social assistance to the needy."[38]

Our ancestors feared the arrival of the French. They had heard how the French attacked Muslim and Jewish rituals, sites, and beliefs in Egypt barely three decades earlier. They were fearful and skeptical of the colonizers' promise to respect their religions. They knew the French had come to demolish their world and to build a new one to inhabit as if it were the colonizers' own. Some of them, who had the means, left upon the arrival of the French.

The departure of the Jews from Algiers in 1830 left a strong impression on the British painter William Wyld, who happened to be staying in Algiers for a few weeks at the beginning of the colonization (see photo p. 289). Indeed, Wyld returned to this scene of departure a decade later, after a second trip to Algiers. In a description he wrote to accompany his 1841 painting he

Letter 7. "We have been dispossessed of you"

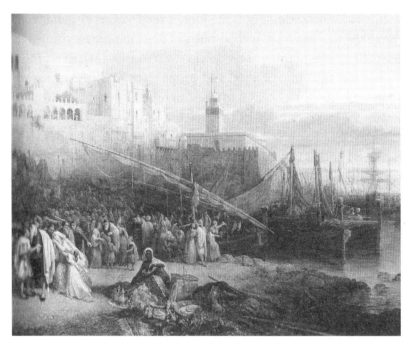

William Wyld, *Departure of the Israelites for the Holy Land (Algerian Scene)*, 1841 (detail).

noted that many of the Jews were thrown into poverty when the French introduced luxury items into local marketplaces, and that "a large part of the Jewish community of Algiers sought refuge in emigration and went to look for an easier existence in other places in the barbaresque countries."[39]

These Jews were not fearful of the entrance of the French before the invasion; rather they ran away after they had already tasted colonial violence and decided that they would fare better and safer as Jews elsewhere. The British painter's title describes the crowd in the port as Jews (*Israélites*), but from other sources it is known that Muslim families also departed Algiers at the same time for Greater Syria, notably Palestine, to find refuge from the French in other parts of the Ottoman Empire. We can assume that they are also among the crowd Wyld depicted.[40] While orientalist painters more often depicted Jewish women with the *sarma*, this long conical headwear of married women was used by both Muslims and Jews. The painter, thus, cannot be trusted with describing who he saw in the 1830s, especially as European knowledge of our ancestors' rich traditions was scant.

In 1830, those standing at the foot of the Djâama el-Jedid from the other side of the Royal Square (as depicted in the painting), regardless whether they were Jewish or Muslim, carried on their bodies the clothing, objects, and props that, until the invasion, Jews and Muslims alike had been manufacturing, selling, and buying on the other side of the mosque. However, within Wyld's painting, a sad atmosphere of departure hovers above the crowd, faces and bodies depicting anguish at having to depart from home toward the unknown. Near the water, a woman is throwing water on those who depart to bless their journey.

Algerian Jews had also feared French Jews, as they likely heard rumors about the edicts that had been issued by Napoleon. French Jews had agreed to certify what Napoleon dictated as the Jews' duties: "It is the religious duty of every Jew born in a State or who becomes a citizen thereof by residence or otherwise, in accordance with the laws which determine the conditions thereof, to regard the said State as his homeland."[41] The French Jews who visited Algeria and reported throughout the 1840s on Algerian Jews took this duty one step further and propagated the Napoleonic command. Reading their words I shiver—not because of how insulting they are, but because they make clear the extent of the loss endured by our ancestors. This report is on the Jews in Oran, where my family is from:

> The most important acts of religion, circumcision and marriage, are not performed in the synagogue but in the houses and in the midst of deafening confusion and tumult. The benediction by itself presents nothing remarkable, but the ceremony which presents and accompanies it, is so ridiculous and barbaric that it is impossible to recognize the Jewish stamp in it; these are evidently customs and superstitions borrowed from the semi-savage peoples among whom they have lived for a long time. The piercing, high-pitched cries with which women claim to enliven and flavor all family celebrations, resemble perfectly those which Arab women utter on such occasions ... what is especially important to make disappear as soon as possible is the cruel practice of women who plow their face and chest with double fingernails. These acts of ferocity are not only contrary to humanity, but also

Letter 7. "We have been dispossessed of you"

to religion. Education and instruction will, we hope, do justice to these uses which revile of us and our beliefs.[42]

I quote this report, written by a French Jew, at length so that you will understand how deep French contempt toward our ancestors ran. This intrafaith hatred is often forgotten when we speak about "the Jews" as a group apart. Even the term "co-religionists" is part of the nineteenth-century French anti-Semitic discourse that sought to generalize all Jews into a single group. Through this construction, those who were already forced to enter into the pact of "emancipation"—namely, French Jews—were compelled to betray other Jews, like our ancestors in North Africa. These French Jews, who despite their citizenship experienced the effects of their racialization in France, feared that the differences they noticed in Algerian Jews would put their own Frenchness at risk.

Despite the fact that our ancestors figure as the objects of these reports, their voices don't appear. First the French Jews spoke for them, and then those made state-approved spokespersons spoke for them.[43] In writing these reports, French Jews spoke with "trustworthy people whom we knew to be the most versed in knowledge of the past," meaning a tiny elite who worked with the colonizers.[44] The authors belonged to a French Jewish elite that was inclined to forget or disavow the ordeal of "emancipation" that their parents and grandparents went through in France at the end of the eighteenth century and the beginning of the nineteenth, as well as the price paid for the dissolution of French Jewish autonomy.

The French Jews who wrote those reports had to forget their ancestors and disavow the fact that the humiliating ways the French spoke about Algerian Jews also reflected French attitudes toward them.

"Despite their attachment to their primitive faith," said the lawyer, "the Jews are endowed with an extraordinary faculty of assimilation."

As a reliable source the lawyer quoted a historian, who said with confidence, "To make of the dirtiest, the most bigoted of the

Oriental Jews, a Westerner and a Parisian, should hardly take more than one or two generations. The Jew adapts to all and assimilates all. This is his master faculty."⁴⁵

They counted on the second and third generation to forget, but they didn't take into consideration that the fourth or fifth generation might rebel.

> Not because we know better,
> but because our ancestors
> were not so assimilable
> after all.
> They transmitted to us
> their primitive faith
> that we've chosen to cherish
> as our way out
> of the imperial imaginary.

In France, following the forced conversion to secularism and the dissolution of Jewish communal life, a significant number of Jews—I don't know how many—were also converted to Christianity.⁴⁶ Those who volunteered to come to Algeria in the name of the French government and to reeducate Algeria's Jews were those invested in proving that the Jews were adaptable to anything and could assimilate anywhere. They believed that this was in fact our master faculty, and hence we could be French and Jewish, even though we were Arab and Amazigh, Jews and Muslims. When they encountered our ancestors, they didn't see them for what they were but only for what they were taught to see: primitives in need of reeducation. The permeability between our traditions and those of Muslims was perceived to be the source of our degeneration. The success of our ancestors' conversion was the French Jews' badge of honor.

Our ancestors were not European but were colonized by Europeans, and so their reeducation was not as successful as it was thought to be in France. Much of what is described in this report as Algerian Jews' ecstatic corporeal traditions, which were putatively eradicated by their French "co-religionists," were still present to observers in 1930. Some of these traditions

Letter 7. "We have been dispossessed of you"

were diagnosed to be symptoms of Algerian Jews' psychosis (for example, a French psychiatrist who was sent to Algeria wrote his doctoral dissertation about it). Other traditions are part of our lost-and-found *marrano* legacy that we ought to reclaim.

Dear Houria, I long to hear the voices of our ancestors at the moment of conquest, rather than hearing the narratives that were projected onto them as "the Jews," narratives laden with stereotypes and ignorance that occlude the rage and despair our ancestors experienced when their workshops and neighborhoods were demolished, when the graves of their ancestors and saints were ruined, and when their intimate synagogues were destroyed. Even in the absence of such records, no real effort is needed to see that French rule was established to their detriment. Even if some of them hoped that French rule would improve their condition, free them of the burdensome taxes collected at the whim of the dey under Ottoman rule, it is nonetheless clear that any hopes of better treatment were shattered at the moment their world was razed to make way for the "French city."

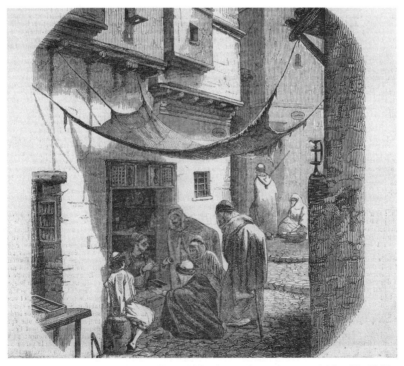

Jewish jeweler, Oran, Algeria. From *L'Illustration: Journal universel*, May 20, 1847.

A few decades after the initial demolition, erudite French scavengers (called art historians) came to document what they had been told was a dead tradition: the jewelry-making of our ancestors.

In imagining how these Jewish jewelers might have looked, scavenger Paul Eudel described these Jewish jewelers as having a "yellow complexion," "parchment skin," an "aquiline nose" and "all the characteristic features of the Hebrew race." Eudel also provided a detailed description of their workshops, composed of

> niches of difficult access. As a staircase, one or two large shapeless stones, supported against the wall, serving as a threshold. Other times, holes dug in the wall were intended to serve as rungs. Finally, it sometimes happened that the jeweler could only enter his refuge by means of a rope hanging from the entrance; he grabbed it and hoisted at once into his shop.[47]

In 1900, when Eudel compiled his dictionary of Algerian and Tunisian jewelry, the workshop sites were already destroyed. Eudel produced a map of the entire neighborhood, whose streets' names reflected the trades practiced in them. Most, if not all, of those jewelers whose workshops were destroyed in the 1830s were dead. To obtain physical descriptions of their workspaces and how they were used, he had to rely on informants, some of whom were likely the descendants of the jewelers, who may have continued their family's artisanal tradition elsewhere, and who must have still remembered the stories transmitted to them by their ancestors. The jewelers who occupied the jewelers' market (Souk es-seyyâghin), he wrote, were horrified by the demolitions that drove them from the center where they had worked for ages. His descriptions of the rope, the hole in the wall, the niche, and the rungs account for the small, quotidian movements of their ancestor's bodies, which the jewelers remembered even after the demolition of the workshops. I cannot avoid thinking about the phantom pain they must have felt in their limbs after their workshops and homes were demolished and their limbs could no longer make their habitual movements. The new colonial authorities obviously didn't provide them with any

Letter 7. "We have been dispossessed of you"

compensation or a way to voice their grievances. René Lespès, who studied the urban design of Algiers for the celebration of the colonization's centenary, described the settlers' efforts to avoid recompensing the indigenous people for the confiscation of their property. He also described their fear of indigenous revolt, which they called the "street war" (*la guerre des rues*).[48]

There are hundreds of colonial images of Government Square, but none of them show the violent destruction required to create a plaza out of a slope. The square seems to have always been there. In fact, this square erased what was once the lower Kasbah, full of workshops and homes and alleyways and cemeteries, a neighborhood. A single line here or there in settlers' writings mentions protests by the indigenous Algerians, who particularly opposed the desacralization of cemeteries. But such accounts provide no details of the names of the protestors, their occupations, or the language of their demands. The lack of religious affiliations mean these protests are read as Muslim by default, because the Jews were retroactively assigned a history dissociating them from their indigenous Algerianness. It is up to us, now, to undo that retroactive false history and to recognize the shared interests that brought indigenous protestors of different faiths together. In this light, the protests were part of Algerians' attempts to survive and stop the disaster before it began.

Looking for my ancestors' voices, I came across an English translation of a French transcription of two pieces of oral testimony from Algerian Muslims responding to the conquest. The editor of the English translation, Alf Andrew Heggoy, writes that the oral history texts "were carefully hidden from the eyes of infidels and treated with almost the same reverence as pages of the Qur'an itself."[49] He doesn't ask why those Frenchmen—namely, General Melchior Joseph Eugène Daumas in 1850 and Jean Desparmet in 1905—who knew about the texts and their hidden nature, nonetheless decided to obtain access to the oral histories and expropriate them from the indigenous people.

Part of the art of the storyteller, the griot, lies in altering the story to fit the occasion and the audience. Hence, this printed version is a transcription of what indigenous people wanted the French to hear. I want to honor our ancestors for this act.

295

Regardless of their content, these transcribed texts should remind us of our ancestors' courage. These narrations present a rare situation of plunder, where, despite being compelled to deliver words to the French, the colonized still managed to withhold parts of their story. I don't have access to these hidden parts, to this treasure concealed from the French, but noticing our ancestors' actions and acknowledging their power already makes me feel closer to them as their descendant.

Instead of continuing to describe these texts as works collected and transcribed by the French, we should call the Frenchmen's actions what they actually were: attempts to gather information from the colonized to use against them. The French infiltrated gatherings where stories and poems were recited. They then expropriated these stories and poems and made them French intellectual property. Once in their hands, the texts could be transcribed by French as they saw fit, and they could also make the texts useful for the needs of the colony. Daumas was a soldier and he recognized the importance of these stories: they "allowed French authorities to gauge popular feelings, a mood of sullen resistance that could easily be fanned into active uprising."[50] Acting as colonizers, they used scholarship as their alibi and believed themselves to be humanists. Nonetheless, these texts are an aperture to our ancestors' world.

Here is an excerpt from the poem composed by Si Abd al-Qadir and translated by Heggoy:

> O regrets for its [Algiers's] houses
> And for its so well-kept apartments!
> O regrets for the town of cleanliness
> Whose marble porphyry dazzled the eyes!
> The Christians inhabit them, their state has changed!
> They have degraded everything, spoiled all, the impure ones!
> They have broken down the walls of the janissaries' barracks
> They have taken away the marble, the balustrades and the benches;
> And the iron grills which adorned its windows
> Have been torn away to add insult to our misfortunes.
> O regrets for Algiers for its stores,

Letter 7. "We have been dispossessed of you"

> Their traces no longer exist!
> Such iniquities committed by the accursed ones!
> Al-Qaisariya had been named Plaza
> And to think that holy books were sold and bound there.
> They have rummaged through the tombs of our fathers,
> And they have scattered their bones
> To allow their wagons to go over them.
> O believers, the world has seen with its own eyes
> Their horses tied in our mosques,
> They and their Jews rejoiced because of it
> While we wept in our sadness.[51]

The poem describes, with much pain, a series of major attacks on the lower Kasbah of Algiers. There is almost no harm mentioned here that the Kasbah's Jewish inhabitants didn't also suffer. This fact was known to both Muslim and Jews. The ruination of the shared urban space dispossessed both communities from their houses, stores, and tools; of shared and public sites such as cemeteries; and al-Qaisariya, the site where scribes and bookbinders worked. And yet, the Jews are not mentioned among those impacted or concerned by the violence. Was this a Muslim erasure? Obviously not, for they all lived in common in the Kasbah. Did they intend to erase the Jews from among the victims of the colonization or pretend they were not impacted? Unlikely. Such erasure was a French project that expressed French interests. So why are the Jews absent from these descriptions?

While I don't have documents to prove my answer, I insist on the most obvious thing: the poem focuses on the violence exercised by the colonizers and it describes its effects on the colonized indistinctly. So the mention of "the Jews," who are presented as if they rejoiced with the French while the Muslims "wept in our sadness," is a false flourish. The Muslims knew that their neighbors the Jews were not rejoicing but rather also weeping. When the poem was not recited for French ears, it was repeated in Arabic, the language shared by the colonized. We have no reason to assume that the Jews, whose mother tongue was Arabic, were excluded from the circles where storytelling took place. Nor can we rule out that Jews added their own lines

or remembered the poem differently. "They [the French] and their Jews" doesn't make sense within the scope of the Muslims' and Jews' shared sense of loss, except to reference two or three wealthy Jewish families (the famous Bacri and Bujanach) who did welcome the French. Those families could have been referred to as "their Jews," the Jews of the regime—but not the majority of diverse Jews who lived in Algiers.

We know well that our histories as colonized subjects are disrupted and understudied, and that this is innate to history as an imperial discipline. While none of us can redress this individually, raising questions that should have not been foreclosed by historians, even if we cannot answer them, is a way to begin to clear these obstructed channels of transmission. Raising questions helps me make breathing room for Jews outside of the construction of "the Jews."

Could it be that colonization actually brought them closer together? Could it be that colonization catalyzed a concerted effort on the part of both Jews and Muslims to escape the colonizers' controlling eyes? Could it be that despite the differences in faith, which colonials manipulated to separate them, their shared fate brought them even closer? Oral and written accounts provide sporadic and anecdotal information about intimate friendships and relationships between Jews and Muslims during the French conquest, though none of them touch on the Ottoman era or the beginning of French rule. We do know, however, that they shared religious traditions—food codes, kin, circumcision, prayer, saints, religious bodily expressions and gestures, religious celebrations, stories, crafts, objects, amulets—many of which took shape over centuries of life in common. These traditions were so entrenched in the Maghreb that when the French Jews encountered Algerian Jews in the 1840s, they found them utterly foreign. Despite the inferior status of Algerian Jews under Ottoman rule and despite the fact that their communal life was autonomous, their traditions testify to significant contact and exchange between Jewish and Muslim communities in the Maghreb. But did this also included intimate companionship and partnership of the sort that the shared colonial fate later provoked? The imperial temporality destroys so much that recently imposed infrastructures

Letter 7. "We have been dispossessed of you"

Djamaa el-Djedid, entrance on rue de la Marine.
Colonial postcard. Photo: Jean Geiser.

are assumed to be "the past." Dear Houria, I suspect that what is assumed to be the deeper past can be, in fact, still the effect of colonization.

Jews are also almost completely absent from a second oral history collected by the French and translated by Heggoy. Interestingly, it is presented as a tale akin to the interlinking tales of "A Thousand and One Nights," an imagined 101 sessions of an assembly of Algerian saints meeting to discuss the invasion. The tale is called "French achievements in Algeria as judged by the natives"; however, most of what is mentioned in this imaginary assembly concerns Algeria's Jews too. Moreover, some Algerian saints were Jews whose graves were visited by Muslims, and so we have no reason to assume that Algerian Jews were absent from this imaginary banquet.

The saints in this imaginary assembly also invited a Frenchman to take part, hoping he could be persuaded by what he heard and disavow his country's colonization. Listening to the Algerians, he admits that the invasion was a source of anxiety and shock:

> The true believer, drowning in this environment [Algeria under French rule], can never be sure of being in a state of purity because he is in constant danger of coming into contact with things that his religious law holds to be impure. This is a great source of worry for a devout person, and a preoccupation about which we are only imperfectly aware!⁵²

The list of dangers and impure things French colonization has forced on Algeria is long. The text gives many examples, including:

> The sugar will be bleached with bones of jifa or of impure animals that have not been butchered according to our rites ... they will mix into their butter the fat of pigs to stretch it; our foods will be prohibited meats cooked with prohibited ingredients; the candle that we offer to our murabits contains pork fat mixed with their wax; the soap they sell us is adulterated; our body sullied in every way is a disorderly collection of legal impurities.⁵³

The list goes on and on, touching on customs and Algerians' sense of being in the world, such as shaving men's beards, sitting on chairs, or using napkins. Another threat is the French insistence on modernizing Algerian religious practices: "The French ... will spread rugs in the mosques, they will decorate them with fresh colors ... they will set up certain machines that will warn us at the hour of prayer, an engine that will mark the precise moment when the fast can be broken during Ramadan," and "the judges that the infidels will choose for us will sell justice for cash."⁵⁴

At one point in the translation of this oral storytelling, the editor intervened and added, in square brackets, the adjective "Christian" to qualify the sort of idolatry Algerians feared or denounced: "Under French influence, Muslims who are descendants of the Prophet will be seen yielding to [Christian] idolatry"⁵⁵ The American editor seems to miss the point. The assembly of the saints was indeed worried about idolatry, but they weren't concerned with whether the idols were Christian or not. In this assembly, I hear traces of the biblical and the Koranic stories of

Letter 7. "We have been dispossessed of you"

the Golden Calf, which, I believe, shaped these oral conversations about the implications of the French invasion. The way the saints speak about idolatry recalls those stories from the Torah and the Koran that tether idol worship to the rejection of religious law writ large, the law that they had sworn to follow and that was never reducible to faith. The saints in the tale are concerned about the temptations of capitalism, greed, and the fetishism of profit, which the colonial conquest had brought with it, and how these factors would impact their law.

Soon after the invasion, the French proclaimed the suspension of indigenous laws—the Koranic and the Mosaic law—and imposed extractive capitalist idolatry as the new law of the land. In the biblical story the people built the Golden Calf in defiance of the pact they had previously accepted ("we will do and will heed"), provoking Moses to fling down the Tablet of the Law. The Koranic version of this story introduces the figure of as-Samiri as the one who led the people astray. It is hard not to think about the French as latter-day versions of as-Samiri and notice how their actions distorted this figure. As-Samiri lures the believers to sin, and the Koran stresses the moment when the people are tested, that is, the moment they have the opportunity to reject idolatry. With the French invasion, the Algerians were deprived of this test, a chance to reject the idolatry imposed upon them. Instead, they were immediately put under a new law, incommensurable with their own. Being forced to live under this law, they found themselves not only outside of God's protection but also within His wrath.

The invasion was understood quite well by Algerians as a "clever and studied policy" of conversion, whereby the French would "penetrate our customs and destroy our beliefs."[56] This was to be achieved through "the combined influence of bad example, legislation, public education and military training," and the worry was that "many Muslims, without realizing it, would end up being assimilated."[57]

Their fears were not unfounded; both Jewish and Muslim communities were prone to infiltration, secularization, and internal betrayal. What you write in your book, dear Houria, regarding the parents of your generation, actually started with the invasion:

"Our own parents look at us, perplexed. They think, 'Who are you?'"[58] This is the question parents ask under imperial regimes when they see how their children have been seduced by idolatrous technologies. The most common form of secular coming-of-age tale involves rejecting the family and communal affiliations for "not being modern." Living among Jews for centuries did not present such a danger to Muslims' modes of life! Given what we see in this oral history, it would be insufficient to say that the Jews shared the same fears as the Muslim saints, because this would imply that they were from two separate communities. Rather, since the beginning of Islam, Jews and Muslims built a profound intercommunal trust that operated across many aspects of life, from simple market objects, through various beliefs, to communal laws. Muslim fears were Jewish fears. They could trust that where the two communities came in contact, no organized "*sin crouched at the door*," and members of the community did not live as if they were on constant trial.[59]

Through their text, the assembled saints insisted on keeping the trial on French idolatry open by reversing the temporality of the invasion, dealing with it as if it hadn't yet happened. Reading this only as a rhetorical device would miss the power of their action: turning what has been imposed into that which can still be opposed. The aim of this assembly, however, was not to decide whether to allow the French to enter Algeria or to ban them from it, but to devise ways to resist the secularization that was already becoming law.

One such form of resistance was through maintaining artisanal professions and refusing to allow them to become extractive practices. Rather, artisans were committed to respecting shared traditions and modes of life, cosmologies, saints, and ancestors. Since the dawn of Islam, Jews in the Maghreb had been those who dealt with precious metals. The jewels they crafted, along with the coins they minted and the objects and amulets they manufactured, preserved the memory of the lesson they had learned with the Golden Calf, and of their renewed covenants with Allah/Elohim. But what was that lesson?

I'm interested in this particular aspect of trust with respect to the handling of the gold. Gold was in abundance in the treasury

Letter 7. "We have been dispossessed of you"

of Algiers, as we learn from the accounts of its plunder during the conquest. This gold was not particularly well protected, since before the invasion such protection was not necessary. It was only with the imposition of a racial capitalist market that the idolatry of money was cultivated and became widespread. As a result, gold was reduced to its monetary value. The saints warned: "They'll take us through greed. These people who are so contemptuous of our rites will make us lose our head with their gold."[60] Prior to the invasion, the presence of gold in the Kasbah, in the market, on women's bodies, in houses and workshops, didn't constitute an object of unrestrained desire, a source of temptation, or a factor in the transformation of the communities' mores or lifestyle. As jewelers and minters, Jews were trusted with huge quantities of gold. Being under the dhimmi contract, they were deprived of the sovereign power to change the laws, which made them the genuine guardians of this equilibrium of gold—the jewelers of the ummah.

The sin of the Golden Calf is commonly interpreted as an attempt to replace God or Moses with a different god, one made by humans. It is a transgression against the command "You shall have no other gods beside me."[61] This interpretation jumps directly to the Golden Calf without paying attention to what happened prior to the making of the calf and to the different roles gold plays in the story, and the qualities lost when the scale of the objects made of it changes significantly. I want though to first think of the precious gold objects melted to make it—mostly earrings—and the fact that exquisite objects made of gold were not banned by religious law. On the contrary, God asks Moses to collect from the people gifts of gold, silver and copper out of which they should make him a sanctuary. God give precise instructions and expects it to be done "exactly as I show you."[62] Already earlier, Moses ordered the Israelites to take their gold objects with them from Egypt, and people did, and they kept them close to their bodies, hearts, and imaginations. They treated them as amulets to protect themselves, in part from God's gaze: when they are asked to remove their ornaments, God orders them to appear in front of him without their gold ornaments' protective presence.[63] In the Golden Calf scene, they are actually betrayed

by Aaron who, in response to their anxiety, asks them to give away their precious protective gold objects and mold them into one centralized gold object. Was it a different God that they were creating, or were they actually celebrating human-built power? The transgression, it seems to me, is in the human accumulation of central power premised on depriving people of their moderate earthly power and of the ontological resistance they bore to say no, to stop, to refuse and to object to sinful temptations while keeping their small jewels and amulets from being used to create centralized human power. In analogy, prior to the French conquest, everyone owned small quantities of precious metals in the form of jewels; in these objects was their power, even right, to say no.

Attention to how the Golden Calf was made recalls a scene familiar to modern political theory, the social contract foundational to the formation of centralized power. In the hypothetical scene in which the social contract is composed (according to Hobbes, Locke, Rousseau, and others), the people are required to renounce their individual power and right to exercise violence, and to instead authorize a sovereign to exercise the accumulated power he acquires by disempowering the members of the community. Unlike this classical scene, which mirrors the biblical one, in settler-colonial regimes such as in Algeria, the invaders disempower the colonized, accumulate their sources of power and rule them directly through violence, without even a kind of mythological narrative, in which a memory of what was taken from them when they were forced to submit to central authority could have left traces in a hypothetical social contract.

Dear Houria, I'm not writing to you as a scholar of the Torah, but as a storyteller, a story-listener or story-receiver of biblical folk stories from both Jewish and Islamic traditions, stories which shaped the shared space of our ancestors as neighbors, a "protean and ambiguous" space of multiple encounters that grant "each party separate autonomy while acknowledging their independence, and that carries the potential for both conflict and co-operation."[64] In the twelfth chapter of Exodus, on the eve of their departure from Egypt, we are told that the Israelites didn't know what to expect. Yet they do what Moses tells them to do:

Letter 7. "We have been dispossessed of you"

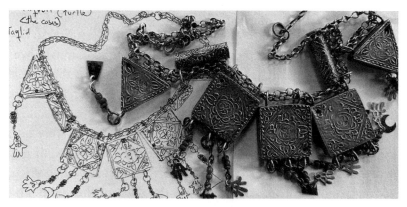

Taqlid, unknown date, likely from Ghardaïa, Algeria.

"And they asked of the Egyptians ornaments of silver and ornaments of gold and cloaks" before leaving Egypt.[65]

Isn't it *taqlid*? Which in Islam means the unquestioning acceptance of another's command or the conformity to the teaching of another? It is as if before the exodus from Egypt they were already performing their *taqlid*, their part in the later pact, "we will do and we will heed." The negative connotations of "being led by a collar" or condemned to "blind imitation" were used by the settlers to describe out ancestors' adherence to their traditions against the injunction to destroy everything that stood in their way to impose what they considered to be the "modern" world. I'm thinking about how much our ancestors did manage to save thanks to *taqlid* despite this campaign of liquidation. Isn't it interesting that this necklace is called *Taqlid*? In the one necklace I managed to acquire from Algeria, which was made I'm assuming sometime in the mid-twentieth century, the jeweler carefully reproduced the amulet boxes similarly to those in the oldest model I encountered in one museum, except that they have no opening. Whoever was behind the decision to produce these cases while foreclosing the insertion of pieces of paper or parchment with blessing and curses, the jeweler didn't totally surrender. They didn't reproduce only the form as flattened plates, but rather cared to create cases, so that, wearing them, women will not completely forget that they were dissociated from their legacy, outlawed under pretext of being magical. These cases are for us, the descendants of sorcerers, to open and use with a variety

of Jewish and Muslim texts that secular imperialism turned into religious texts, necessarily irrelevant to the "modern times" ...

Dear Houria, let's return to Moses. I have no doubt he was familiar with the role these golden objects served for the people in Egypt as icons of their gods, and anticipating that temptation, it seems that Moses was either seducing them or putting them to the test. Either way, they were misled. The people were also misled a second time, after Moses burned the Golden Calf and ordered them to kill each other: "Each of you put sword on thigh, go back and forth from gate to gate throughout the camp, and slay sibling, neighbor, and kin."[66] As with the Sacrifice of Isaac, after they proved they were ready to do and then to heed, the sacrifice had to be halted. Were they not stripped of their small amulets, they would have understood that this was a test, and not a plan they had to execute, i.e., they could have resisted Moses.

The Hebrew verb used to describe the people's interaction with these precious gold objects is intriguing. It literally means to remove something/someone from one place to another, but it often means removing from danger, rescuing from peril or from sin, idolatry included. It is also often used in the bible to describe God's protective powers against all sorts of hazards. The English translation is somehow reductive: "And the Lord had granted the people favor in the eyes of the Egyptians, who lent to them, and they *despoiled* Egypt."[67] They didn't despoil Egypt, for they asked for their gold objects and the Egyptians lent their objects to them. In chapter 33, after Moses burns the Golden Calf, everyone in the crowd refrains from putting the rest of their jewelry on. God addresses the people and orders them to take off all of their jewels—without taking them from them—as if to see them naked, unprotected, so that he can decide what to do. As long as they have them, even if just in proximity, they are shielded from God's "overwhelming presence" and "dreadful presence," and from the temptation of a "overwhelming presence" of human power.[68] In response to God's explicit order, the people remove their jewelry. The same verb that connotes both removal and rescue is used here again, this time to refer to the Israelites themselves, as if the people rescued themselves from committing another sin by removing their jewelry, and are now awaiting protective guidance.

Letter 7. "We have been dispossessed of you"

In the next few chapters, the Israelites are asked to perform, once again, the action they took to fabricate the Golden Calf: to hand over their gold to Moses. Except this time with a new outcome: in exchange for gold, they are given the law and instructed in the essentials of working with precious metals, the object of trial par excellence, at the sanctuary. Moses conveys God's words. He first orders that the seventh day be a day of "holiness for you, an absolute sabbath for God." On the Shabbat, they are to cease from all labor, a lesson against accumulation. Then they are given another prohibition of accumulation, and they are ordered—as before—to give him their gold: "This is the thing that the Lord has charged, saying: 'take from what you have with you a donation to the Lord. Whose heart urges them, let them bring it, a donation to the Lord, gold and silver and bronze."[69]

However, at a certain point, when too much gold had been accumulated, Moses demonstrates the limit to accumulation by telling them to stop: "Let each man and woman do no further task for the holy donation." Thus, it seems that their lesson was not only about the handling of metals, but also, if not primarily, about constraining oneself against overaccumulation and the excessive use of labor, time, arms, power, gold and objects. Only after this lesson in restraint are they given a detailed lesson in how to work with those metals, and the skills, wisdom, and disposition required of the artisans who are to build the tabernacle, God's sanctuary, from the materials of the earth. This sanctuary also served as the place where God and Moses—and sometimes God and the whole assembly of worshippers—would convene. God filled the artisans with "a spirit of God in wisdom, in understanding, and in knowledge, and in every task, to devise plans, to work with gold and in silver and in bronze and in stonecutting for settings and in wood carving to do every task of devising, and he had given in his heart to instruct."[70]

The law, then, was ultimately embodied in the Israelites' artisanal skill. They transmitted this skill, along with the law, across generations. The means of transmission is what the French infringed upon; as the assembly of saints says in the tale: "They [the French] will take us through greed. These people who are so

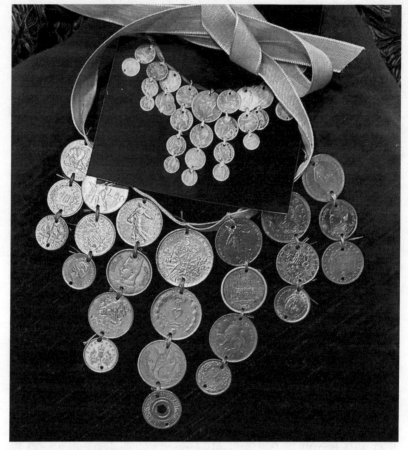

A necklace reproduced after the photo of a ninteenth-century Algerian necklace held in Musée Quai Branly (inventory number 71.1899.30.98).

contemptuous of our rites will make us lose our head with their gold."[71] A minor correction: it was not "their gold" but ours. It was the gold the French robbed from our treasury in the Kasbah, gold that has never been restituted.

Dear Houria, I reproduced for you one of our ancestors' necklaces that is presently being held captive in a French museum, donated by the Algerian Government, which is none other than the French colonial government in Algeria. For now, neither you nor I can wear what they still hold in their museums, but we can come close to the secrets of these objects, and we can awaken the jewels to rebel.

Letter 7. "We have been dispossessed of you"

This necklace was taken from our ancestors as part of the overall plunder of Algeria and the destruction of our artisanal world, which was the embodied guardian of the law.

This law was utterly different from the one imposed by imperialism and racial capitalism.

I'm not a jeweler but a descendant of the "wise-hearted people"[72] to whom Allah gave the wisdom of knowing how to prevent themselves from repeating the sin of melting down different adornments into one figure that stands as a representative for all.

In reiterating the gestures that my ancestors practiced as members of a Jewish Muslim world, I'm trying to awaken the memory of prohibitions, of saying no, of withdrawal and strike, of being attuned to the dangers of trusting machines and technologies, of trusting the right measure, of guarding precolonial law, of living in community, of caring for each other and for the world.

This world, we were told, is lost. But it is still inscribed in the objects that were stolen from us.

This memory is not mine or yours; it is ours. One day, when the "primitively accumulated" gold that was stolen from the lower Kasbah is restituted, we will cast this necklace in gold.

And if Palestine is free before we cast this necklace, we will add a pre-'48 Palestinian coin in the middle. In solidarity, yours,

Ariella Aïsha

Letter 8. The Algerian Jewish anticolonial mother did exist!

A letter to my great-grandmother Julie Boumendil

Dear Julie,

Dear great-grandmother whom I never met, mother of my grandfather Joseph, whom I never met either. I know almost nothing about you. We, the dethroned descendants, have been told so often that your Jewish Muslim world is gone, that we cannot walk in it, sleep in it, dream in it, for there is no such a place. I didn't even know that I was looking for you.

I was looking for traces of my grandfather Joseph, and that is how I found you. Now that I've found you, and have lived for several months in your close company, it feels like I have found a counter-spell to lift the imperial curse that kept me foreign and ignorant of our history in Algeria. Slowly getting to know you today feels like rewinding colonial destruction.

My father didn't speak much about his family, and we didn't ask. When he passed away, it hit me that I had inherited nothing from your world that made me *an Algerian*. At the moment I had this thought, I knew it couldn't be true: if you were Algerian, so was I. But I needed to say it, write it, have others read it, in order to learn that I do carry more of Algeria than I initially realized.

Each crumb of information I gather feels like a jewel retrieved from a treasure chest lying on the floor of the Mediterranean. No, it is not an exaggeration: your world, which could still be mine, has given me treasure that I desperately needed as I was freeing myself from the histories created to hold me apart from you. I'm your great-granddaughter, dear Julie, born in a colony where my parents couldn't remember how to protect their offspring from the arms of the colonial state, bereft of the memory of your wisdom and your protection.

I beg you, dear Julie, listen to me. I would not bother you with such a long letter were I not sure, from the little I now know about you, that it is your anticolonial wisdom that had to disappear so that I could be raised as a national subject of a colony.

Your world that should have continued to be *ours* isn't lost. Rather, it was stolen from you, from my parents, from me, from my children and grandchildren. This is how I could be born in a human factory where I was fabricated into a colonial subject, not knowing how you raised your son Joseph, my father's father.

My father used to visit his father, Joseph, quite often in the butcher shop where he worked in your coastal city of Oran. Oran's streets at that time still held the memory of the riots of Jews who were rejecting rabbis nominated by the French, collaborator-rabbis who were hired in order to monitor local Algerian Jewish rabbis, to prevent them from holding what the settlers called unauthorized prayer assemblies, and to teach our local rabbis what the French determined "Jewish" teaching to be.[1]

Joseph, whose lips guarded knowledge, wanted his son to be a butcher like him. But my father, who spent six years in the republican school, didn't seek knowledge from his father's mouth.

I want to share with you a story my father told me about one of his visits to the butcher's where his father worked. He would have been fourteen years old. He was looking around at the sheep that hung upside down and told his father, "I want to cut a sheep." "I took the axe and cut the flesh," he told me, but "the slice was not straight but zigzagged." That same day, my father told his father, your son: "A butcher I will not be."

Letter 8. *The Algerian Jewish anticolonial mother did exist!*

You surely know—don't you?—dear Julie, that colonialism uses different methods to *kidnap* children from their ancestors. At the moment the French arrived, they began to build schools for the indigenous children. Some of our ancestors preferred to escape to the unceded territory ruled by Abd el Kader rather than see their children abducted by French knowledge and ideas.[2] Their fear was justified. The colonizers sought to stop the transmission of wisdom, knowledge, skills, and forms of care and respect inherent in different local professions that used to be transmitted *through* and *within* families. Joseph wanted his son to continue in his profession, which was never just a profession. He didn't own the butcher shop, so it was not about taking over what in a different world is called a "family business." The transmission of a profession was not just about wealth or skills, but primarily about how to *be* in the world with others.

In the imperial world in which you raised your children, the world where Joseph raised my father, children were made to believe that their ancestors were obstacles on the way to freedom. Such freedom was presumably located in the opportunities "new worlds" and "modern ideas" offered them. My grandfather's desire to keep his son within the Jewish Muslim community's world of professions was a stillborn hope, for when my father tried to cut the flesh of the sheep with an axe, he was already convinced that he did not want this life for himself.

And still, in my father's telling, I also heard something else: the confidence with the axe that he felt from watching his father Joseph's gestures over years, being in his presence and seeing him repeat the same gesture over and over again. And yet, my father failed to cut a straight slice. He failed to cut it straight, I think now, not because he lacked "know-how" or skill, but because he didn't want to be there in the butcher shop, in the place where he had been told that the colonized were doomed to live with "no dream."[3] He chose to fail because in his invaded world, escaping was a form of survival, narrated as a story of self-fashioning. Being the product of five generations of colonial subjection and three generations of imposed colonial-citizenship, and one who struggled to find language for describing the colonial condition of the Jews, I can say that my father mistook his own family as

the cause of his distress and discontent. I do not think he himself fully knew why he chose to fail in the butcher shop that day.

"All of it was not for me," my father told me when I asked him about his life in Oran. He looked at his aunts, uncles, sisters, the whole family and the way they lived from the outside. Probably as they lived as Arabs, spoke Arabic, and didn't know how to write properly in French that seemed to him the first sign of people not living in a cage. "I didn't like this life, I didn't speak when they spoke. This life in a cage was not what I wanted. I told myself—I won't be like them."

One day, a big American ship arrived in Oran, the biggest port in the whole Mediterranean. "I knew some English," he told me, "which I learned from some vinyl records I had. I spoke with the captain: 'I want to go to America. I don't need money, all I want is just to work, eat and sleep.'

"The captain replied, 'No problem. I'll just need your parents' signature.'"

My grandmother, his mother, the general officer of the family who was not intimidated by bureaucratic forms and was the letter writer of the family (as my father described her with affection), refused to sign. His father, he explained, also with affection, never had the last word at home. So there was no boat and no America for him.

When he told this story to me, my father admitted that he had cried for a whole week.

Contrary to how it may sound, these stories about my father's life in Algeria were not part of our life. I only know them because I interviewed my father and wrote down some of his stories shortly after his vocal cords were removed in a necessary surgery; I was worried about my storyteller-father going silent.

When I read these vignettes later, I understood that being asked to tell about his life was an opportunity he had never been afforded. Most of his stories sounded like stories from a foreign world, and they didn't correspond to the Jewish history I had learned in the Zionist colony. One such story was, I only recently came to realize, about you and your daughter Camille,

Letter 8. The Algerian Jewish anticolonial mother did exist!

and though I wrote it down, I wasn't able to understand its meaning until later. Here is the story, as my father told it to me:

My uncle, aunt, and three of their children were deported to Auschwitz. The eldest child went to buy pasta at the moment the police arrived, and thus survived.[4]

He told it briefly, in only a few sentences. This was probably as much he could say about this traumatic reality you experienced, a reality your descendants were taught to not recognize as part of what we were told was history, our history. It took me two decades, plus a few weeks on the shore of the Wannsee lake, facing the place where the "final solution" was decided, to return to this story he told me in so few words and to make the destruction of your world legible on its own terms and finally be able to embrace our history. To do this meant connecting names to stories, reconstructing anti-imperial meanings to correspond with lives, and drawing out the entanglement of the French colonial regime and the Nazi regime to show how the Final Solution for the Jews also targeted Algerians.

I first looked for Azoulays in the lists of Algerians deported from France, and I found twelve of them: Azoulay Aaron, Armand, Moise, René, Albert, Charles, Francine, Gustave, Henri, Jacques, Simone, Victorine. But none of them matched the family profile of the parents with three children in my father's story. These explorations led me to Andie Giraudet-Fort, a descendant of the Azoulay family I hadn't known existed. Our exchanges and her reconstruction of the family tree helped me fix some holes in my understanding. Though some documents seem to connect us, I was not sure if we were related, since she was not familiar with the deportation of members of our family to Auschwitz. Trying to connect the dots, we realized that the uncle and aunt from my father's story were not Azoulays but rather your daughter Camille Boumendil, Joseph's sister from another father, and her husband, Sylvain Amar.

It is heartbreaking to think about what you went through during this time. I apologize, dear Julie, for not trying earlier to break the mold of history that for so long kept the campaign of

violence waged against you separate from the broader colonial violence of which World War II was a part.

It is also revolting to read how much scholarship is still impacted by French propaganda, which continues to speak about the Vichy years as a deviation from France's republican history, as if French republicanism were not predicated on aggressive colonialism. This scholarship also detaches Vichy France from the decades of colonial racism and anti-Jewish persecution and harassment that was part of your daily life since you were declared French citizens in Algeria, as well as from the *longue durée* of French colonial violence, including the decimation of the indigenous Algerian population during the first decades of colonization. Dear Julie, I want you to trust me that through our family history I now see it clearly that Vichy France and French republicanism are different faces of the same colonial project.

Those who see Vichy France as an exception to French republicanism and assign to the Jews in the Maghreb a feeling of "French patriotism" also erase their efforts of self-organization and resistance to the violent measures of the French against them. The Jews of the Maghreb were not French patriots, but they were rather often suspicious of the powers that be, as testified by Operation Torch in 1942, which was led by a clandestine group of Jews who facilitated the landing of American and British armies in Algeria to fight Vichy France. During the war, Algerian Jews also boycotted Italian banks and German products, volunteered for the Allied armies, smuggled resources across borders and Jews across empires. Algerian Jews understood their life under this or that rule as a bargain that required them to perform certain duties in exchange for the enjoyment of certain rights. In a letter addressed to Marshal Pétain, the three Grand Rabbis of Algiers, Oran, and Constantine made clear that their civic behavior was not, as some historians wrote, a question of "intact patriotism" but of fulfilling their part in the colonial bargain: "Citizens for already seventy years, we are conscious of having completed all our duties under every circumstance and with no reservation."[5]

For a long time, I thought that when the citizenship of Jews in Algeria was abrogated in October 1940, you were in Algeria. When I learned recently that in 1939 you moved to France to live

Letter 8. *The Algerian Jewish anticolonial mother did exist!*

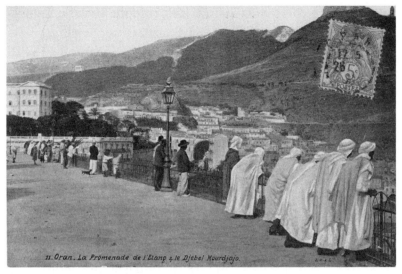

Promenade, Oran, Algeria. Colonial postcard.

near your daughter's family, it didn't change the fact that your French citizenship had been revoked, just the date. When your French citizenship was *given* to you anew, once again France didn't pay for its crimes or for taking the life of your daughter and family. Rather, France turned you into a debtor, indebted to the generosity of the Republic for restoring your citizenship. Calling the ways you had to navigate French rule in both Algeria and France "intact patriotism" is insulting. Being asked to express gratitude for having your citizenship restored is insulting.

When I finally began this work, I learned to understand how citizenship confines the imagination to a play between opulence and deprivation, citizen or noncitizen—regardless of the price. The orchestrated denial of this economy explains why, despite the omnipresence of colonial anti-Jewish violence and propaganda in Algeria, colonized subjects aspired to and adhered to this colonial citizenship that came with a minimum of rights. Enjoying a fraction of the luxury, power, and mobility that the colonizers experience in European quarters in Algeria cannot be conflated with French identity or patriotism.

Some of this glamour was made accessible to the indigenous people in the summers on Oran's promenade. Famous French singers used to come there every summer. With a certain naivete about the colonial economy, my father told me that the singers

were paid by the owner of the lottery booth as their songs attracted ticket-buyers. Like other French entrepreneurs, artists and musicians came to the colony to inspire themselves with local tunes and to take advantage of a captive Algerian market, one enabled by Algerian labor, resources, and money. Algerians often spent their money on lottery cards in exchange for dreams about sudden enrichment that could not be realized. The musically attuned ears of a young Jewish man like my father could not avoid also hearing the slurs coming from the French settlers on the promenade alongside the music, slurs describing Jews as "ruthless usurers" or "the cause of unemployment." He also could not ignore the props that were part of the ambiance, such as the "anti-Jewish hat," the "colonial cap," or the signs that banned Jews from some of the bars, where an "anti-Jewish aperitif" was served.[6]

> If there is a promising future
> for the colonized
> it is elsewhere.
>
> A corollary:
> the promising future of the colonizers
> is also elsewhere.
>
> The colonizers' elsewhere
> is the land of those they've colonized,
> whose lives they've asphyxiated.
>
> "I don't know who sold our homeland,"
> wrote Mahmoud Darwish
> in one of his poems,
> and closed the stanza with
> "but I saw who paid the price."

Dear Julie, since the beginning of the French invasion of Algeria they aimed to weaken us by blocking ancestral transmission. Centuries-old tribal and family formations, the embodied knowledge preserved through guilds, were all targeted as Algeria was

Letter 8. The Algerian Jewish anticolonial mother did exist!

transformed into a site of profit for France. To accelerate the extractive economy and to finance wars, the French sought to abolish the guardians who protected the knowledge our ancestors had developed over centuries. Citizenship, education, and industrialization were oriented to destroy craftsmanship and the skilled professions that had been handed down through generations. Craftwork was still needed by the colonizers, but it was broken into assembly-line jobs that forced the colonized to become unskilled workers whose labor could be extracted on a daily basis. In an assembly line, people are not trained in ways of caring for one another or for the world between them.

By the end of World War I, craftwork had already often been conflated with commerce, and many craftsmen had already reoriented themselves toward import-export businesses to avoid the punishing reorganization of their former professions.[7] The axiom of modernization lures historians to describe the violence of these processes as organic, as swift developments, and to occlude the persistent efforts of craftsmen to adhere to their professions and their mode of being *in* the world. Thus, for example, the forced naturalization to which Algerian Jews were subject is depicted by historians in glorious terms, celebrating how the Jews were modernized. Sixty years after the collective naturalization, statistics counted many Jews who stayed adamantly in these "small traditional professions," including trade (55 percent of the Jews were engaged in both).[8] More and more of what became "qualified work" was generated by and for the needs of racial capitalism, whereas the colonizers profit and the indigenous provide the cheap labor. Such work was premised on a withdrawal from the world that existed prior to colonialism and was designed to serve the French colonial world with professions such as accountants, brokers, insurance agents. As a result of these new jobs, the world was made remote, and its abundance was read as exploitable resources to be extracted, administered, calculated, and profited from.[9]

This systematic attack on the constellation of crafts and on the centuries-long investment craftspeople had made in world-building and world-maintaining was waged through the power the colonial state claimed over children and their education. In a

few decades, the French ended the guild structure once extant in Algeria, in which children were immersed in ancestral professions not as laborers-for-hire but as constituents of a shared world. They grew into their professions, learning their ancestors' skills and values over the course of years, until they became "depositors of an ancestral know-how" who could transmit such knowledge in their turn.[10] Your ancestors—whose names I could not find—dear Julie, were in firm opposition to European education, similar to the hostility that came from within "the Muslim milieu" toward the same European system.[11]

Once the French were able to colonize Algeria and justify it as "moral conquest," the question of French education in the colonies ceased to be a question of yes or no, but rather a question of how. How to detach children from their environment and traditional sites of growing up? What kinds of schools would be put in place, for whom, and what would their curricula teach? Resistance to the colonial school system among the colonized never totally faded, but it became restricted by the growing assumption that schools as disciplinary technologies should exist in Algeria. Over the years, many colonial ideals like "education" were imposed on the colonized, and once imposed—and once taught to new generations of colonial subjects—other, more harmful things could be built upon them. From the start, involving the colonized in negotiations on the nature of education was part of the process of recruiting parents and community leaders to the French system of imperial discipline and surveillance for children. Over the course of two centuries, it became hard to imagine a world without schools in the French model: monocultural, focused on book-learning while books were authored mainly by settlers of all sort. This was especially true as schools were imposed at the expense of other social sites where children used to grow up and learn, such as extended households, craft guilds, and tribal formations.

I do not know, dear Julie, how you grew up. Despite the colonial state's devotion to registering every colonial subject with documents to be archived, I could not find your parents' names and addresses, nor any other information that could illuminate your upbringing. I cannot pretend to know much about your children

Letter 8. The Algerian Jewish anticolonial mother did exist!

including my grandfather, but as you will see, your presence in some of their stories and records gave me some idea of their upbringing. I assume, for example, that you didn't encourage my grandfather Joseph to go "*chez les colons*" and find his future there. I assume you preferred to see him grow up among his people, in the *Derb Lihoud* or in its vicinity. Without knowing which school Joseph attended or for how long, I assume that he attended, at least in part, a Jewish school, which influenced his choice to become a butcher and introduced him to the *kasherut* laws.

As different modes of transmission persisted in spite of the French interdiction, the colonizers strove to make sure that "renewed contact with family life, tied to a hostile world w[ould] not constantly call into question the fruits of learned lessons" acquired in their schools.[12] As much as the opposition of indigenous adults was repressed and despite the fact that schools were imposed through the combination of violence and seduction, children continued to embody the memory of such resistance. What was at stake was whether children would grow up to be depositories of imperial knowledge ready to identify themselves with the colonial state, or resist these terms and adhere to a world deemed "old" and "vanishing" by their colonial education. In this environment, Joseph's choice to become a Jewish butcher could not have been pursued without facing resistance, conflict, tension, and not without employing strategic determination. After all, being butcher was not reducible to knowing how to cut and sell meat. It implied an attachment to one's community and knowledge of centuries-old *kasherut* rules that were also compatible with Muslim halal rules.

Do you know, dear Julie, that before the French and French (metropolitan) Jews sought to make you French, and before Zionists sought to make me an Israeli, the French wanted to make you Algerians? This should not surprise you. We both know that the national subject was fabricated in order to replace other forms of belonging.

Two decades before you were born, as part of a French discussion about what to teach indigenous children in order to most effectively contradict their ancestors' authority, some French teachers and publishers conceived of a curriculum built around

teaching you to say, "I am Algerian." They believed an education in national pride was the "duty of a French teacher" in her effort to elevate the indigenous, for whom "the motherland is the tribe." Such an idea stemmed from the belief that the indigenous "have not yet come to understand the meaning of this wider homeland that they owe to the French conquest."[13] They wanted to teach that the nation-state, the European form, not the indigenous form, was the unit of governance, and to cloak this weapon in something that sounded like home.

Shortly afterward, they renounced this project, and soon after you were born, you were already provided with papers attesting that you were French. But this abandoned ideal of pedagogy in Algerian national pride is telling. It suggests that the goal of conferring upon you either Algerian or French identity was to make you believe you were part of a disembodied (national) entity rather than part of the world in which you were born and were destined to maintain and care for. This ideal of national belonging over and against other forms of belonging can even be marked in the articulation of Algerianness in the wake of the anticolonial revolution. Thus, at the end of 132 years of French rule of Algeria, anticolonial victors could declare Algeria an independent nation, though they knew that the Jews, native to Algeria, could no longer say *I'm Algerian* and that they had to depart from their country. Saying *I'm Algerian* is something I'm now rehearsing in order to unlearn everything that prevented me from being an inhabitant of my ancestral world.

Our chroniclers, storytellers, and craftsmen were replaced with the cavaliers of history, for whom people's small, hard-won victories seem mostly inconsequential as they often left no textual traces in archival documents. Such cavaliers of history embraced the myths of the French revolution and of our "emancipation," and they sacrificed our ordinary, everyday stories. It is not a coincidence that I did not know about the Algerian rabbi who saved the able-bodied men of his community from being drafted to an unnecessary war; or the one about the rabbi from Fez, who demanded that the sultan destroy a machine that threatened to end a craft tradition of handmaking gold threads, a tradition kept by at least seven hundred workers; or the one about mothers

Letter 8. The Algerian Jewish anticolonial mother did exist!

who dressed their boys in feminine clothing, despite risking evil spells, to prevent them from going to republican schools.[14] We must rehearse these stories over and over until they are once again ours, not just anecdotes but tales that shape our temporal and spatial grammar.

In the 1840s, at approximately the same time that the French wanted to teach you to say *I'm Algerian*, some well-intentioned French people, mainly women, came to salvage y/our craft and extract ancestral muscle memory from young indigenous girls to feed the European market's growing interest in orientalist crafts (see photo p. 59). This extraction of labor was pursued through the European education model: they set up schools of Algerian weaving and embroidery and made themselves caretakers of the knowledge they themselves had destroyed. Some of these schools were funded by the colonial state, meaning from the money the state generated from our resources; the crafts produced by these schools were sold locally to settlers and tourists and on the European market.

A report on the arts and art industries, signed by the governor of Algeria, describes the success of one of these schools and offers a reflection on how "not only the young pupils understood that it [was] not necessary to have in their heart the form [they weave], but also that one can come to understand a drawing of a form, to draw one, and to embroider or execute it on the upholstery."[15] That the girls were disciplined to weave from given patterns was considered an achievement since in between the lines of those reports we understand that those four- or five-year-old girls resisted the school's discipline, which was in stark conflict with the way they learned to weave growing up, weaving while singing with their mothers. I imagine that they didn't like hearing the way their teachers talked about their mothers and grandmothers as "old indigenous women," nor the way their teachers distorted what their mothers taught them. Their mothers were not old indigenous women, and the instructions that mothers gave their daughters on how to dye fabrics and threads were not "almost lost" before these teachers came and appropriated indigenous crafts for their own benefit, proclaiming themselves caretakers of what was "lost."

A portrait of an "Arab servant" is used in this colonial postcard to promise French settlers the luxury that awaits them in the city of Alger.

Letter 8. The Algerian Jewish anticolonial mother did exist!

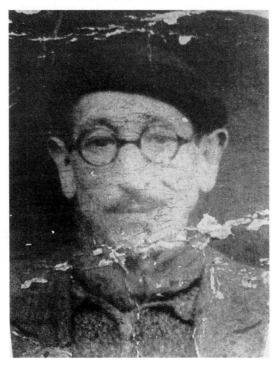

Joseph Azoulay, 1930s.

Looking at the many postcards I have that capture these girls working in craft school factories, I asked myself if you were there in one of the pictures, dear Julie? I wish I had an early photo of you, or some visual description or material object to hold on to, so that I could imagine you while addressing you.

I have a single photo of Joseph, and I still ask myself, "Does he resemble you?" I saw his photo for the first time in the early '90s, when I started working in an art school and told my father how photos could be retouched. My father had only one photo of his father. He asked me if I could repair the white wrinkles that crossed the photo. These fractures in the upper surface of the photo often happen when photos are carried in a pocket. Just before departing for the war, my father was allowed a short visit to see his ailing father, who died the year after, when my father was already soldier in Europe. Did he take this photo with him before going to war, worried he might not see him upon his return? Or did he fear he himself might not return from the war?

I didn't know how to retouch photos, or eliminate fractures, but I didn't want to disappoint my father. I was able only to flatten the photo and print a coherent image out of it. My father was pleased.

I recently printed it again and hung it on the wall in front of my desk. I never saw before that my grandfather is smiling. Now, he greets me every day. When I see him I feel that it is at me that he is smiling.

On a Holocaust memorial website, I saw two photos of your daughter Camille. In one of them, crossed by vertical creases, I recognize myself. The deep eyes, the thick eyebrows, the wide forehead and the hidden smile. Did you look at the photos of Camille or your grandchildren after the police kidnapped them in front of your eyes? Or when you received the horrifying news that they would never return?

Am I looking at you when I'm looking at Camille's photo, or Joseph's? Or is it only the wound that I'm seeing underneath the salt spread on these faces forming these cryptic smiles?

How would it otherwise be possible that I also see you when I look at the postcards I'm collecting of women from the Maghreb?

In colonial documents you are described once as a housemaid and another time as a servant (see photo p. 324). I wish I knew how old you were when you started to work as a servant, and whether it was in a Jewish household or a French one. Through conversations I've had with Nassima Mekaoui, who wrote a book on Algeria's servants, I understand the complex connection between this occupation and education.[16] Altaras and Cohen, two French Jews who came to Algeria to draft a scheme for the "regeneration" of Algerian Jews, describe the presence of five hundred Jewish girls in French houses as an opportunity for these girls to be in continuous contact with "respectable families." On the other hand, as I learned from Nassima, Jewish girls or their parents sought these jobs as a pretext for escaping the formal colonial education system. I wish I knew what led you to work for others and who they were and if this allowed you to avoid the colonial education. Was this how you encountered Aron, my great-grandfather? Or maybe you were not a servant, and this was your way to hide from the French who made the Jews citizens

Letter 8. The Algerian Jewish anticolonial mother did exist!

and outlawed their laws regarding family formations, notably what they called polygamy. This interdiction didn't disrupt at once the complex family formations, but rather led to more creative ways of handling civil documents.[17]

Assuming that you were a servant as the civil documents indicate, I still don't know anything about your daily life. Domestic servants' chores in Oran at the end of the nineteenth century involved housecleaning in addition to skilled manual work, such as weaving rugs and repairing baskets, to furnish a house and keep it in good shape throughout the year. Some of the rebellious girls in the embroidery schools run by French women kept using their left hands while weaving, or they insisted on their ability to achieve complex forms without preparatory drawings, and they were punished. For their errantry, they ended up as maids, and they even served in the houses of the teachers who didn't want their "bad" influence at school. They were not rejected from school for lack of talent but rather for an excess of talent, their unruliness, their resistance to the education order. Were you one of these girls? Was this how you became a *domestic* in someone else's house?

> Looking at these young girls laboring,
> copying European models of their own crafts
> would be less painful
> did I not know
> that prior to their training
> they told these entrepreneurs,
> "It is useless
> to embroider a carpet
> if the pattern
> is not in your heart."

When Camille and her husband, Sylvain Amar, departed from Oran in 1927 or 1928, Sylvain was working as a representative for a French company that sold champagne. Even if he still held in his heart tapestry patterns that he inherited from his embroiderer father, the know-how was probably not something he could transmit to his children while living in France. However, despite

the industrialization of crafts in Algeria (mostly for export), and despite the growth of importing industrial articles from Europe, craftsmen of all sorts continued to work, though in declining numbers. Hundreds if not thousands of Jewish jewelers, for example, were still working in Algeria in the first decades of the twentieth century.[18] In all the different localities that Paul Eudel studied when he did his survey, the majority of the jewelers were Jews. Here are some names from Oran that may be familiar to you: Benichou, Emselem, Ben Aïcha, Ben Guigui, Nephtali, Ben Haïm, Cohen, Ben Iseri. Several of them were not naturalized.[19] The same with Aron, Joseph's father, who only applied for naturalization in 1915. Were they descended from those who were expelled from Spain in the fifteenth century and landed in Morocco? Even if they arrived in Algeria before 1870, Moroccans living in Algeria were not included in the mass naturalization of the Jews by the Crémieux Decree. The jewelers who came from Spain carried with them tools and knowledge all the way from Andalusia. They succeeded in transmitting their know-how to their children so that the world that was destroyed in Spain survived and was materialized anew through their crafts.

A *senōr* (a manual drill repurposed as a wire twister), gifted to me by *mu'allim* Abdullah in Essaouira, Morocco, 2022.

Letter 8. The Algerian Jewish anticolonial mother did exist!

I recently went for a few days to Essaouira, also known as Mogador, on the Atlantic coast of Morocco. In a local jewelry workshop, I was welcomed by the blurred portraits and certificates of the older Jewish and Muslim jewelers, by definition also teachers, mu'allimūn. *When my* mu'allim *Abdullah showed me how to twist silver threads, he called the tool he was using a* señor. *In its name I could recognize its origins in Spain.*

The French art historian Paul Eudel, whose claim to fame is our ancestors' pieces of jewelry, denigrated the work these jewelers were doing: the "jewelry doesn't offer any special interest from an artistic point of view. Models from Algiers are being copied."[20] Eudel, whose work consisted of detaching our ancestors' jewels from their worldliness and cleansing them into pure forms and models, dared to denounce their craft as fraudulent.

The frequent trope of the Jewish jeweler as a forger is not just an anti-Semitic slur. It was part of a broader terror campaign exercised by the French against the Jews to expropriate their professions and destroy their community standing through decrees, confiscation, plunder, and deportation. One decree from July 24, 1854, encapsulates the scale of this campaign. Advertised by the general secretary of the government, it explains that "manufacturers and merchants are required to record in an ordered and approved register the names and addresses of residences of those from whom they buy gold and silver materials, and they may only buy, on pain of criminal prosecution, from known or recognized persons." The language used in this decree is that of law and order. The values it privileges are universal and the principal it follows is progress. This language allegedly sought to provide bureaucratic protection from fraud. However, the targeted group, as the text makes explicit, is that of Jewish jewelers: "If [the law is] strictly enforced, five-sixths of the Jewish jewelers in Algeria will soon close up shop."[21]

What was targeted by this decree was much broader than this group alone, as jewelers, gold and silver traders, and clients of these jewelry pieces comprised a shared Muslim Jewish economy. Often, jewelry was made out of silver or gold held outside of the controlled colonial market, traded either in its raw form or as

pieces of jewelry that were melted down to create new ones. The exchange between Jewish jewelers and Muslim clients that continued despite the introduction of colonial decrees undermined the separation of spheres that colonial capitalist markets required, and that the French sought to effect in Algeria. As Eudel admits, all over Algeria,

> in all the tribes there is a center with Jews who roam the surrounding douars and manufacture on the spot. Their workshop is more rudimentary. It is located outdoor. They sit on the ground, pull out of their bags the crucibles, the molds, a bellows, a hammer, a few chisels and a small anvil. Then they set themselves in a position to melt the gold and silver coins that the Arabs gave them and to which they give the form of the jewel commissioned from them.[22]

As in the Spanish colonization of South America, the French targeted the indigenous economy, which conflicted with the imposition of the centralized colonial state. In the indigenous economy, precious metals were not objects of extraction, and mega-mines that exhausted the earth were not required. Those precious metals were cherished instead for their polysemic nature and the multiple functions they served: fabrication of jewelry, a mini-bank of precious metal that could be melted down as needed, a source of protective forces, and more. With colonialism, a new form of fraud was introduced to the gold trade—the plunder of that precious metal from disempowered people who had been colonized, making it the private property of the colonizer-entrepreneurs. This imperial fraud was of a different scale and exceeded the question of alloys, or how individuals may have combined different metals of varying values and misrepresented the composition of the gold at the site of a sale. In the name of "law and order" in the metal trade forced on colonized people, the Jews were blocked from continuing as the jewelers of the ummah until their final exclusion from independent Algeria. The lingering consequences of the destruction of this ancestral Jewish Muslim tradition of jewelry didn't end here.

Letter 8. The Algerian Jewish anticolonial mother did exist!

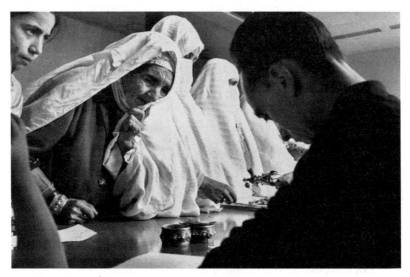

Algerian women responding to the call of the Algerian independent state by donating their jewels to the *Sandok Tadamoun* (National Solidarity Fund).

In 1963, one year after the departure of the Jews and the formation of the independent state, Algerian women, now only Muslims, who possessed their own small capital in the form of silver and gold jewelry were asked to donate their treasures to fill the empty coffers of the state. "France had left the public treasury coffers almost empty ... As a result, the president decided to call the people to set up a National Solidarity Fund (*Sandok Tadamoun*)."[23] This campaign was depicted as the liberation of women from their chains and they were encouraged to publicly raise their "soundless arms stripped of the clanking bracelets."[24] Instead of demanding the return of the gold plundered by the French at the beginning of the conquest, women were lured into believing that their ancestral jewelry constituted chains from which they needed liberation. Some resistance to this distorted conception of national solidarity and freedom, mainly in rural areas, was recorded—but the memory that Algeria's gold reserves had been plundered by France had already evaporated by the early 1960s. Thus, France could act as if *giving* Algeria to Algerians were a generous act that freed it from further colonial reparations.

In 1939, when you joined your daughter and her family in France, you could not know that the colonial practices and the anti-Jewish measures would follow you there.

I wonder,
dear Julie,
what kind of object,
or piece of metal,
or jewel,
your daughter
brought with her
when she went to France in 1929?
I think I see the form of an *abzym*,
the rounded Algerian pendant
hidden under the crocheted collar
of her dress,
in family photos.
I wonder,
dear Julie,
what kind of object,
or piece of metal,
or jewel,
you brought with you
when you joined her in France?
I wonder, dear Julie,
if when the French police came to take your daughter
they also took your jewels?

In 1939 neither France nor Algeria was safe for Jews, and no one could tell which of these two places was more dangerous. Soon after you traveled from Oran, the plunder of Jewish property started in both places. The plunder in Algeria may have been as organized as it was in France under *L'Action meubles* (the Furniture Operation), and bureaucratic documents may have been produced as part of the violence. However, I didn't find lists of what was plundered from Jewish jewelers in Algeria under Vichy, nor did I find lists of what was taken from your homes in general. Documents can detail the exact value of the property of individuals that was commandeered or damaged, but no records are needed to prove that your homes were violated and marked by the presence of those who never wanted

Letter 8. The Algerian Jewish anticolonial mother did exist!

you to be their French peers, and who sought to make you feel vulnerable through the threat of their possible return.

We do not know the exact contribution of the Vichy regime to the asphyxiation of the world of craftsmen in Algeria and to dethroning the Jews from their role as guardians of a non-colonial cosmology, a process that began in 1830. However, we do know the indisputable outcome less than twenty years later: by 1962, no Jewish jewelers were left in Algeria or in the Maghreb. No one who had practiced craftwork in Algeria was able to continue in their profession in France, where Jews had never been jewelers. Until 1790, when, following the French Revolution, they were made citizens, Jews had been banned from engaging in many professions, including craftwork. Thus, in between Algeria (where jewelers were always mainly Jews) and France, the French murdered this ancestral tradition.

Until recently, France had not acknowledged its role in this violent campaign, nor had it engaged in repair work that might allow the renewal of the world of the Jewish jewelers. The end of the Vichy regime in Algeria didn't end the colonizing regime. The absence of records of plunder and destruction during the Vichy years in Algeria corresponds to the absence of governmental and organizational initiatives to compensate the Jews and help them file complaints and demands for restitution. Although in France, precious works of art plundered from upper-class Jews were restituted relatively early after the war, compensation for concentration camp survivors and their families started only in the 2000s when France was sued by Jewish survivors. Even then, France recognized only a few hundred demands as eligible for modest financial aid.[25] In 1945, France didn't assist you or other Jews in their misery as France sent their relatives to death in Nazi camps. The restitution of works of art of some Jewish collectors was conducted publicly, as a sign of moral conduct, overshadowing the ongoing plunder through the transfer of the remaining works to French museums.[26]

The cursed departure of the Jews from Algeria in 1962, and their cursed conversion from professions premised on world-building into modern, disembodied liberal professions, could not

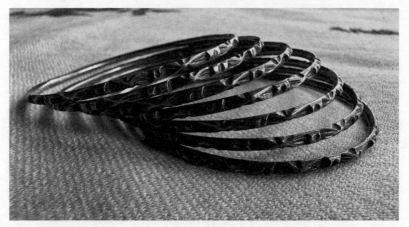

Semainier, used like an amulet to ward off bad luck, each of the seven bangles signifies a day of the week (semaine in French).

have happened without the normalization of continuous colonial plunder. In museums, only "precious" objects survived. Those people who against all odds were still engaged in craft-making in the Maghreb ceased to practice their professions not only in France, but also in other places where they found themselves taking refuge and mourning the ancestral world of which they would no longer be a part.

Dear Julie, I wanted to learn jewelry-making from an ancestor.

Not necessarily a family member, but one who carried some of the knowledge all the way from the Maghreb.

I reached out to several people of my generation who had departed from the Maghreb, hoping they would know a jeweler who would take me as an apprentice.

To my surprise, all seven of the people I asked, one for every day of the week, were themselves descendants of jewelers.

All seven of them told me the same story: in the new place where their ancestors found refuge, instead of workshops, they found themselves in factories; instead of metals, they were given synthetic substances to manipulate.

No more jewelry came from their hands. All of them mourned the dying craft and the theft of the place they had in the world.[27]

No longer artisans, they worked in those human factories where we were born and raised.

Letter 8. The Algerian Jewish anticolonial mother did exist!

Despite the colonial format of my ancestors' official record, and despite the common depiction of craftspeople as old, I was struck by the way the documents still conveyed the family and friendship networks of different guilds—tailors, jewelers, or shoemakers. Witnesses, required to be present during the registration of newborns or marriages at the municipality, often belonged to the same profession, testifying that artisans were not in rivalry but rather in company. Thus, for example, a shoemaker father had other shoemakers as witnesses, as did the jewelers. This companionship didn't immediately disappear when artisans were pushed out of their profession and became workers in French factories, or when they changed professions and became merchants or traders.

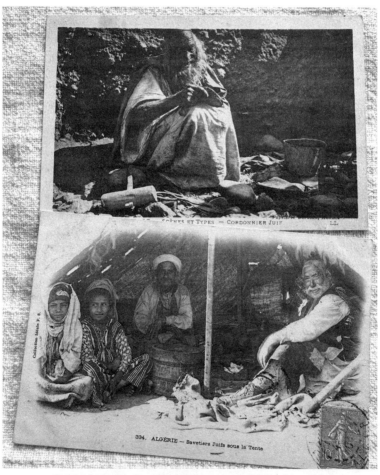

Colonial postcards of shoemakers depicted as old people practicing an occupation with no future.

Knowing that these kinds of professions, including that of butchery, were passed down in families, I expected to find butchers among Joseph's ancestors. But Joseph was not born to a butcher, but rather was the son of a shoemaker, Aron. At a certain point, probably due to some changes in colonial Algeria that affected the sustainability of his profession, Aron stopped being a shoemaker and started to work in Bastos, the French cigarette factory. I knew nothing about Aron's twelve children from his other wife, and I asked Andie Giraudet-Fort, the daughter of Aron's younger son, what their professions had been. I learned that none of them became a shoemaker. Everywhere I looked in the different branches of our family, I encountered ruptures in professions. However, I also came across some continuities.

The memory of earlier networks of solidarity and companionship preserved a measure of communal power, as for example the labor organizing among Jewish merchants in the Maghreb, who boycotted products from Germany at the beginning of WWII.[28] Strikes also took place in cigarette factories like Bastos, where Aron, Joseph's father, worked, along with two of his daughters and one of his sons, when he stopped working as a shoemaker. Did they participate in the multiple strikes in this factory (two of

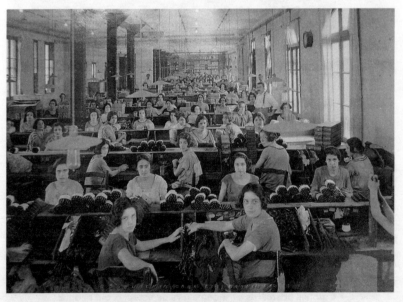

Bastos cigarette factory, Oran, Algeria.

Letter 8. The Algerian Jewish anticolonial mother did exist!

them known to be among the earliest women-led feminist strikes in Algeria)? Although during the different anti-Jewish campaigns at the turn of the century, which took place at the same time, the Jews were not regarded as French but rather as Jews, the descriptions of the body of workers indicates that in the cigarette industry, "indigenous workers were not yet employed."[29]

This memory of labor organization, materialized in the artisan's guilds, was targeted by the French from the moment of colonization onward. The regulation of labor in France at the beginning of the twentieth century, which was also applied to Algeria, meant to end these traditions of solidarity, organizing, and striking. Under the claim of granting "freedom to work" (but truly, in response to numerous strikes), a whole set of laws was proposed to forbid "coalitions formed with the aim of suspending or cease work." These laws included "punishing provisions" against strikers, allowing for their immediate replacement regardless of the cause of the strike.[30] The colonial state sought to discard the principles of previous regulations and, in the name of protecting consumers, weakened the power of the guilds who had cared for the world. All were turned into "merchants" and "traders" whose interests were profit and productivity based on structural rivalry, rather than shared interests with their neighbors, the consumers.

I imagine, dear Julie, that what I'm talking about doesn't sound foreign to you. You know that Joseph—a Jewish butcher—saw his profession undermined by colonial regulations. This was part of the broader way that French colonialism aimed to dismantle Jewish communities and subordinate them to the power of the consistories in France, as well as in Algiers, Oran, and Constantine. Against the backdrop of endangered "traditional occupations" and a long history of colonial campaigns to destroy Jewish Muslim conviviality, Joseph's choice to practice this profession cannot be reduced to his skill in cutting meat. The choice signifies his commitment to care for and inhabit a world, particularly a Jewish Muslim world, that was under constant threat. His choice also signifies his devotion to maintaining it. Joseph's work was for both Jews and Muslims, who, due to the affinities between kosher and halal rules of meat preparation and

consumption, could each frequent the Darmon butchery where he worked.

I don't know if you knew about this episode of my father's "revelation," when he came to realize he would not be a butcher. But I'm pretty sure you noticed your grandson's efforts to distance himself from his family and from the world that, as he conceived it, imprisoned them. My father told me that from a fairly young age, he had dreamed about departing from Algeria, which he finally did in 1949. He left one year after your death. He was not the first Jew to feel suffocated in colonial Algeria. I don't know the exact reasons that led Camille and her husband to depart from Algeria for France in the late '20s, but after the election of yet another anti-Jewish mayor in Oran, the future for Camille and Sylvain and their one-year-old child may have seemed more favorable across the Mediterranean.[31] The election of overtly anti-Jewish figures into key positions was not new to you, but it was probably an additional proof that the colonial anti-Semitism to which you were all subject was not going to end soon.

In 1893 when Joseph was born, the anti-Jewish movement in Oran and elsewhere in Algeria was at its peak. In May 1897, for example, Jewish stores were plundered and destroyed over the course of three days.[32] Given such campaigns, which recurred in the 1920s, it's hard to believe that Camille and Sylvain's decision to leave Algeria was ever what one historian describes as "the ultimate culmination of the frenchification process."[33] Did you consider leaving with them in 1929? It's hard to believe that they, as young parents, wanted to raise their child apart from his grandmother, just as I cannot help imagining the pain you must have felt at saying goodbye to your grandson, with no idea when you would see him again. I imagine that you could not afford to visit them in France: domestic work did not ensure a high or stable salary, and I don't think that at this point there were any syndicates of domestic workers, which might have offered you some support. Under the imperial condition promoting "progress," children can sometimes afford what their parents cannot.

Letter 8. The Algerian Jewish anticolonial mother did exist!

I can even imagine that you encouraged them to leave, not because this is what you wanted but because you understood that this may have been the only way you, as a mother, could help them have a "better life." Such a wish from parents for their children was widespread. It was promulgated by the "generational gap" that was imposed and manifested in colonial schools and through colonial language. In republican schools, for example, children were not allowed to speak Arabic. Compelled to speak only the colonizers' language, which their parents didn't necessarily speak or master, children like Camille and Sylvain were made to aspire to "better opportunities" in the French labor market.[34] I don't know what their occupations were before they migrated to France, but they may have studied for a few years in republican elementary schools, since Sylvain became a representative for a French company (where the products he marketed were likely extracted from his homeland).[35] School trained him to not become a weaver like his father and weakened his power to organize like his father. This republican education that was state and market oriented opened certain opportunities that, from the perspective of the colonized in their precarious and often unbearable condition in Algeria, could have seemed "promising."

You may already understand by now, dear Julie, but let me say it straightforwardly: when I was born in 1962, all your descendants except Joseph (who died in 1943) were made to leave Algeria, as it became an exclusively Muslim and Arab nation with independence. Only a small, unknown number of Jews remained, and either became Muslim or hid their religion. No one dares to ask the question of how many Jews remained in Algeria, and any number would be misleading since it would require defining who a "Jew" could be said to be, in the wake of the Crémieux Decree and the imposition of French colonial categories. An Algerian sociologist, quoted anonymously, contends that "even today, this relationship [with the Jews] was never disrupted, since they are always here. They are more numerous than we believe. They are among us, they are us."[36]

> The French expected Jews
> to no longer use names
> known to be Muslim.
> They failed,
> despite the fact that
> people like my father
> followed their command.
> I want you to know
> that it was not my father
> who named me Aïsha,
> but me.
> My father raised me in ignorance
> of the name of Joseph's wife,
> who was also the Prophet's wife.
> It cannot be only my father's fault.
> I was also cursed—
> otherwise, what can explain why I didn't
> open the door earlier
> to welcome Algeria,
> dressed in her ceremonial *gandoura,*
> into our home?

Shortly after you died, Algerians engaged in an overt struggle for decolonization. During the years of bloody war, the colonizers refused to renounce their colonial power against Algerians and to dismantle their technologies of rule and extraction. They launched a campaign of systematic brutality, attempting to crush the liberation struggle. They failed. When the French eventually surrendered, rather than accepting Algerian governance, the French colonials preferred to leave Algeria altogether. Thus, instead of helping to decolonize Algeria and taking responsibility for over a century of their crimes, the settlers switched the terms of the battle to one of diplomacy, which required sovereign state powers on each of its "sides" to determine what independent Algeria would be. In this way, the decolonization of Algeria was doomed to end in a nation-state on the European model, with European categories that made of us Algerian Jews "French Jews." You, we, us—we were not part of the negotiations between

Letter 8. The Algerian Jewish anticolonial mother did exist!

the "two sides" but rather the sacrifice offered to transform Algeria into a cohesive nation-state. We, too, were evacuated from Algeria along with the Europeans.

Do you know, dear Julie, that I don't know Dārja, your everyday dialect of Arabic? Could you believe that I never heard the melody of Dzayri coming out of my father's mouth? Or that I need books in order to get to know your daily routines, habits, and prayers, and the types of crafts and amulets that you used to share with your Muslim neighbors?

Physically detached from you and your world, I had to find other kin whom I could trust. One of them was Frantz Fanon. He came to Oran from Martinique in the summer of 1943. Like my father, he joined the French Army of Africa. Fanon did so despite what he knew about the French empire, and despite the fact that his father, Casimir Fanon, used to remind him that when the French took the Bastille, slavery was still in place in Martinique. Fanon believed that this was a war for freedom, just as my father did. I first assumed that in 1943, when they were both still in Oran, you were there too, worried about Camille and her family in Paris. Now, through the daughter of my father's cousin, your other grandson, Camille's son, I have learned that you joined them in France in 1939. You were together, worrying, as more Jews around you in Paris were deported to Auschwitz, and you hoped that the French police would, somehow, not knock on your door. In addition, you worried about your ailing son, Joseph, who stayed in Algeria, and his son, my father, who was first sent to a forced labor camp and then to the battlefield in Europe.

When did you hear about the first convoy from Paris to Auschwitz, which took place on March 27, 1942? More than two months passed before this hell became routine in France, and every few days, more Jews were kidnapped from their homes and sent to Drancy, and from there put in convoys to Auschwitz. After the mass arrest of 13,152 Jews during the roundup of the Vel' D'Hiv', no Jew could deny that they might be next. I cannot imagine the horror and the pain you felt when they knocked on your door and kidnapped Camille, her husband, and three of their children. As you could barely walk, kidnapping you would have been a burden for them, so they decided to leave you alone

at home. Your older grandson returned home shortly after. It is heartbreaking to think about what both of you experienced during these—days? weeks? months?—while waiting to hear from them.

During the first convoys, some managed to send letters to their families during a several-day stop in Drancy. I could not find letters from Convoy No. 59. The temporal markers of the bureaucratic death factory—kidnapped on August 27 and deported on September 2—continue to shape historical narratives. Your son Joseph passed away barely two months after the murder of his sister, Camille, and I wonder when you heard of their deaths. The world was falling apart. My father, your grandson, was about to depart for the war. In reading about young Algerian Jews who begged their families not to worry and promised that they'd "be back with Hitler's head on a platter,"[37] I could imagine my father giving such a promise that of course no one could guarantee.

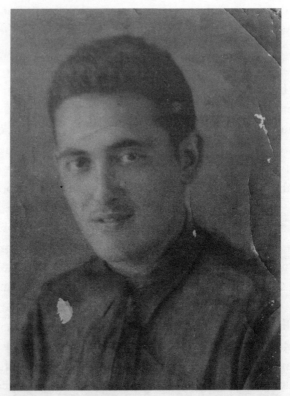

Roger Lucien Azoulay, Casablanca, Morocco, May 25, 1943.

Letter 8. The Algerian Jewish anticolonial mother did exist!

When my father was sitting in front of the camera
in a certain photographic studio in Casablanca
and looking straight into
its single eye,
was he thinking about you,
dear Julie,
the grandmother whose daughter's life
he was hoping to save?
Otherwise, why would he have asked
the woman in the back chamber,
who knew how to use pigments and tiny brushes,
to embellish life onto the photograph's surface,
to color the dark skin of his face in rose?
Was it his way of telling you
ne t'inquiète pas, mammie,
look at me, I promise,
we will soon see again *la vie en rose*?
Did he mail you a copy of his portrait
on the eve of his departure for war
or was I daydreaming
to avoid the nightmare
of a broken hope?

In May 1945, the war was declared over. De Gaulle commanded citizens that "the days of weeping are over, the days of glory have returned," and so now there was nowhere for you to weep.[38] For you waiting in Paris with your grandson, for the return of your daughter and family, it was the opposite—the height of weeping. "From the end of hostilities on May 8, 1945," your grandson, the only one who survived from his family, wrote many years later,

> we were aware of the atrocities suffered by the deportees ... what a desolation—the return of the living dead! Hard to believe! But I still did not despair, I was sure to see my parents again ... I ran to all the reception centers to see the names. But the days passed, then the weeks, and I was still hoping. When we coldly learned that all the prison and deportee camps had been liberated, I had

to admit that it was over. That I would never see my family again and that the Auschwitz extermination camp was their tomb.[39]

When you received the death certificate, it stated, "Died for France." Dear Julie, when I learned about this, I was thinking about you and your pain and found only biblical terms to express my horror of what France did to you: "Would you murder and take possession?"[40] Only in the 2000s did France agree to change those death certificates that lie about the place of burial (for many of them it is given as "Drancy") and the patriotic lie about the cause of this death.[41]

On the same day when de Gaulle announced the end of weeping, the French massacred tens of thousands of Algerians in Sétif, Guelma, and Kherrata, showing that they had no intention of stopping their persecution of the colonized—subjects and citizens alike—nor to offer redress for their crimes. I'm not surprised that my father could not stay in Algeria, nor in France when he returned from this war. When did he manage to come to see you when he entered Paris to liberate France from itself, a Jewish soldier, who on one paper was recognized as a French citizen, on another as an indigenous *Israélite*?

When they defeated the Nazis, the Allies, who were invested in colonial projects all over the world, didn't care about the survivors of the war or the worlds that it had destroyed. They used the end of the war as another opportunity for them to redistribute their trophies, to liquidate enclaves of craft-making and to force more places to surrender to the requirements of the racial capitalist regime that they had been running for centuries. In Algeria alone, the French, who in 1945 acted as both the liberators and the liberated, continued their long and slow colonial genocide until they were forced to leave in 1962 after having killed 4 million Algerians.[42] The Zionists participated in the sorting of the trophies, and instead of helping to repair devastated Jewish communities in Europe and North Africa, they used the opportunity to gain support for their plans to destroy Palestine. They started to play a direct and indirect role in destroying the infrastructures of the centuries-old Jewish Muslim world. Imagine they had not done so. Imagine if you, Georges,

Letter 8. *The Algerian Jewish anticolonial mother did exist!*

and my father could have helped repair your world by raising our families in Algeria?

Now I finally want to dwell on my encounter with you over Joseph's birth certificate. Only when I returned to his birth certificate did it occur to me that you raised Joseph as a single mother. I knew that only one month after Joseph was born, Aron Azoulay (Azoulaï) showed up in the municipality, recognized him as his son, and gave him the surname Azoulay. However, I didn't know—or perhaps couldn't remember—that Aron had been married to another woman with whom he had several children. My first thought was that you and Aron had been married according to Mosaic law but hadn't registered your marriage with the French offices; when I learned about Esther Levy, his wife, I thought that maybe you formed what used to be a common Jewish and Muslim household formation in Algeria, in which several women lived together with one man under the same roof, and you had to conceal this, since the French had outlawed polygamy.[43] However, given that at the time Joseph was born you and Aron had different addresses—though very close to one another—this seems unlikely.

When Joseph was six years old, you gave birth to Camille. Who was the father who did not recognize her? Was it also Aron? When Joseph was ten years old and Camille four, you had another daughter, Rachel, who died soon after she was born. If I had known about Rachel sooner, I would have given my daughter her name. Four of Aron's children also died young. Joseph's daughter also died when she was one and a half years old. If I had known of all these premature deaths in the family, I would have protected my children with talismans. If I had known that after a baby became a child, the piece of jewelry a mother places upon them for protection should be melted down and the paper with the magical incantation carrying the name of God sent to a *genizah*, not be reused for the next child, I would have done this too. But no one taught me any of this. I wonder who taught you. Who helped you, as a single mother, to do what you knew you should do?

Who are you, dear great-grandmother?

I was left only with your joli *name, Julie, that is said to be of French origin.*

But just as they claimed our Roman-Berber antiquities as their own, your name, of Latin origin, is not French, but rather French passing. I wish I knew who gave it to you.

I wish I knew how you were loved by those who called you Julie and by those who recognized you as the daughter of the man with the turban—bou mendil *(mindîl or in Algerian,* mandîl*), Boumendil.*

I wish I knew something about your relationship with my great-grandfather Aron, about the support that you received—or didn't —when your first son was born. How did you transform into the anticolonial mother I am slowly coming to discover? I know that many of the questions I have for you will stay unanswered. However, with each new question I ask, like a thread in a tapestry, I'm weaving into being the world of which you were a part.

Joseph's birth certificate mentions that a doctor in the Civil Hospital in Oran took him to register his birth, but there is no word about a midwife. Was there no midwife around? And what about Aron, when was he informed of his child's birth? Did he care for you during your pregnancy? Who assisted you during these challenging days with your first newborn? Which kind of knife did you place under Joseph's ear? What else did you do to chase away the *djenoun* before his circumcision? Who joined you in singing his arrival? Was there a nice armchair in the synagogue to welcome Elijah the prophet? Did Joseph see his siblings regularly? Did he see Esther Levy, Aaron's spouse and the mother of twelve of his children, the "third grandmother" that my father once mentioned, enigmatically, as a sort of unresolved matter? If so, would that mean that Aron and his wife were active grandparents for my father? Bringing these questions up now helps me keep possible paths open for later.

Dear Julie, I encountered you for the second time when I was looking at Joseph's military records. You were not mentioned by name in these documents, but I think that I recognize your presence there twice.

Letter 8. The Algerian Jewish anticolonial mother did exist!

I was curious to see Joseph's military records since my father had told me that his father was a soldier during World War I. I thought I'd find out about the nature of his military unit, whether he fought alongside Muslim or French soldiers, whether he went to France. But when I read his military records, my interest in these questions faded, and I rejoiced in the discovery of a cherished and unknown family legacy: my grandfather deserted the army!

You and Joseph should have been our idols. I read a low-resolution scan of this document several times to make sure that I wasn't dreaming or inventing this information. I was so happy when Malek Sheikh, who helped me with my archival research, sent me this document. During the four months between November 23, 1913, and March 25, 1914, my grandfather Joseph woke up each morning and renewed his decision not to respond to the mobilization order he had received from the colonial authorities. He knew he didn't belong there. *Quelle joie, chère Julie!* He didn't consider joining the French army or fighting in the war to be his duty.

Why would he?

Thirteen thousand out of the seventy thousand Jews who lived in Algeria on the eve of World War I were drafted, but Joseph did not join. Many responded to the military command. But for Joseph, neither the sounds of "La Marseillaise," which played in the open terraces of local coffee shops in the city, nor the French flags that decorated the bronze sculptures of Bugeaud and other colonists as part of the "patriotic fervor," appealed.[44]

You may wonder why I say that I encountered you in this record. Because for him to take the risk of not showing up when he received a military conscription order, there must have been something that had informed him from a young age that this was a colonial army and that he was not expected to join it. He must have been raised with an understanding that the French citizenship conferred upon him didn't change the colonial conditions under which he and his family lived.

Parents were often caught between their love and care for their children and the state's order and expectations to raise children to be dutiful subjects of the state. Parents were urged to embrace

obedience to the law as a sign of "good citizenship," and to be ready to sacrifice their children's lives for the sake of the colonial state. Refusing to do so also meant refusing to forget that this colonial state had already spilled enough of their blood. Joseph must have had intimate experience with this anticolonial disposition in order to take such a course, knowing its consequences would be prison. What you taught him seems to me to resonate with something that Mohamed Saïl, the Algerian anarchist, said in his appeal to Algerians to join the anarchist movement: "Teach your children the right to rebel against colonial despots."[45]

Being a single mother was already a rebellious act against the French colonial order. Antimilitarism, antipatriotism, and anarchism are not limited to organized movements or to the prescriptive acts detailed in pamphlets. You invented and performed your own anticolonial duty. Even without an explicit anarchist ideology, you knew the state had a different interest in the *bien être* of your son, and you refused it. The French blamed the Jews in Oran for being "anarchists" when they rebelled against the foreign laws imposed on them by the consistory and defended their own local laws. The French saw this "anarchism" as a sign of Jewish backwardness, a "rejection of civilization itself."[46]

This legacy of anticolonial anarchism could not be foreign to Joseph, who was trained as a Jewish butcher and thus was conversant in local laws. But it may also be that when WWI arrived and conscription followed, he was already familiar with anarchist ideas, or with movements that were organized in Algeria prior to the war.[47] Historians concur that it was mainly Europeans who organized these movements before the war, and that the indigenous people started to organize and join existing formations later. But these definitions place emphasis only on written pamphlets and documents, and not on lived experience, and they do not give information about the Jews—how they were classified within the binary between "indigenous" (a category from which historians tend to exclude them) and "European."

I don't know if Joseph's father and his daughters, who worked in the cigarette industry, participated in the multiple strikes that took place there. It may well be that the agitation and rage that they brought home were part of the anarchist fermentation that

Letter 8. The Algerian Jewish anticolonial mother did exist!

prompted Joseph to join the syndicate once he became a butcher, and to become part of the anarchic-communist milieu around the CGTU (la Confédération générale du travail unitaire). Embracing unruliness (*insoumission*), we should avoid the reign of documents. Anticolonial unruliness is first of all a disposition and a form of cosmo-corporeal transmission.

In proportion to the number of Muslims who didn't join the army, even though military service was mandatory for them (though only one member of each family was conscripted), the number of Jews who refused service was much higher. The percentage of draftees among the Jews is surprising, since fifty years prior, a mass movement of Jews had refused the open call of the state for them to become citizens—the 1865 Sénatus-Consulte. I think this mass abstention in 1865 should be described as an active refusal to be the executors of their own internal exile.[48] As you know, this refusal was ignored, and the pressure put on by French Jews, led by Adolphe Crémieux, spawned the beginning of the end of Jewish Muslim life in Algeria.[49] I believe that this historical refusal lingered, and that among the 13,000 Jewish draftees, there were many who resented or questioned the draft.

With the colonization of Morocco in 1912, Algerian Jews were reawakened to the same colonial reality unfolding there, where the destruction of ancestral worlds and strength was pursued under the French campaign of "pacification" and "reorganization." For many, Morocco was closer to their hearts than France. Some of you had family members who lived there, or who migrated within the Maghreb, migrations that had been common since the expulsion of the Jews from Spain and Portugal and after subsequent attacks by the Spanish after they conquered Oran and Tétouan.[50]

Do you know, dear Julie, that I have only recently learned about two branches of our family from Morocco? At first, learning about our family's life in Morocco contradicted my father's firm stance that we are Azoulays from Algeria, and *not* from Morocco. For a long time, I associated his statement with a kind of Algerian Jews' arrogance toward Moroccan Jews, who, unlike Algerians, were not French citizens. Now, I hear in it something else: my father's rejection of the colonial classification of our

family as one with "Moroccan origins." You are Algerian, but on Aron's naturalization certificate, he is described as being of a Spanish family in Morocco. Did they land in Morocco when they were expelled from Spain in 1492? Or did they land in Oran, only to find themselves again under Spanish rule, as the Spanish came after them, conquered Oran, and expelled them again in 1699? It may be that my father knew what the colonial paperwork sought to deny—that prior to our family's arrival *from* Morocco, we had been expelled from Oran to Morocco. Hence, he told us that we were from Algeria.[51]

What is beautiful about these Moroccan threads is that none of the possible answers to these questions will make us *either* Algerian *or* Moroccan, as the colonial regime and the later nation-states sought.

Rather, we were—and this is the crux of the anticolonial heritage that I'm trying to resuscitate through these letters—the jewelers of the ummah. Joseph was not a jeweler, but he was a butcher who catered to the ummah's inhabitants even under French rule. For young Jewish men who may have had doubts about the draft, translating this into a decision to desert the military required the support of family and friends. It won't surprise you to learn that a high percentage of the draftees went to French republican schools, but no numbers are available for draft evasion sentiments among Jews or Muslims. There are no records of the threats and possible punishments they feared, nor of the other possible reasons one might have acquiesced to the draft, except for the problematic claim of "patriotism" under which historians deal with Jews and WWI. If statistics of this sort were available, I wonder in which category Joseph would be counted: four months of deserting, four months of prison, and four months of military service until he managed to be released. The absence of any data should have made historians think twice before they confidently determined that "when the war arrived, Algerian Jews d[id] not ask questions regarding the draft: they [were] French and shedding blood for France on the battlefields, just like Europeans, [was] obvious to them."[52] This account is but one example among many from historians who retroactively project that what Algerian Jews struggled for—the protection of

Letter 8. The Algerian Jewish anticolonial mother did exist!

their communities and their ways of life—was already lost, and who turn them into tokens of "an extreme [French] patriotism."[53]

What an insult to Joseph and others like him, and to mothers like you who supported them!

Even if Joseph had been the only Jew who evaded conscription, his refusal should have stood as a warning to historians. I'm sure, however, that Joseph was not alone. Rather than spending time in the archive looking for documents of others who evaded conscription so that I might refute historians' unfounded observations about people under colonial conditions, I rely on family memory to produce further evidence. In my family alone, there was another young Jewish man who evaded the same colonial war but from the "other" side. My mother told me about him, and his granddaughter confirmed. He was one of her great-uncles in Bulgaria who ran away from fighting in World War I. Had he been recruited, he would have had to fight against Joseph on the side of the "Central Powers," which consisted of the Kingdom of Bulgaria, the Ottoman Empire, Austria-Hungary, and the German Empire. Why would my Jewish ancestors fight on either side of this colonial battlefield?! I cannot refrain from mentioning a German Jewish philosopher whose name is Walter Benjamin, who for years I have considered as one of my elected kin. He also evaded the draft. Why would any of them fight in armies established to destroy the worldliness and the livelihoods of their sisters and brothers all over the world? Why, as craftspeople of all sorts, would they destroy what others built and maintained?!

The experience of Jews and Muslims in colonial Algeria is often reduced to inferences made about their civil status as citizens. Thus possible resistance among the Jews is often foreclosed by historians who perceive them through the imaginary of assimilation as integrated citizens. Muslims' resistance is more easily imagined, but it is also imagined ex post facto from 1962 backward. Thus, for example, the absence of Jews from histories of the long struggle for Algeria's liberation is assumed in a way that creates false correlations between categories and data. As we don't know the identity of those who destroyed kilometers of telecommunication cables that the colonial state

operated, why should it be so "obvious" to historians that Jews didn't participate in these efforts?[54] Why should we be induced to believe that the firm and impressive resistance of "Jews and Muslims together in Constantine against the French army, [that] succeed[ed] to prevent the colonization of the city until 1837," had been completely erased a generation later?[55] Were there no Jews in the massive revolt that took place in Constantine against the draft? Or Jews who were inspired by it and, similarly to Joseph, evaded conscription?

One hundred seventy-three thousand Muslims, out of four and a half million, served during World War I in the army that the French created out of people they colonized. Shamelessly, the French named it the Army of Africa, as if it were created to defend Africa. Not only was fighting in this war an attack against the colonized, it was also an attack against any colonized subject from either side of the battlefield. That is, it was a war against the aspirations of Jews and Muslims worldwide. For example, Muslims who imagined themselves as part of a pan-Muslim world formed networks of solidarity in Turkey and other places in the Ottoman empire to resist the war's efforts to turn Muslims from different places into enemies.[56] It was also a war against the human geography created by the 1492 expulsion of Jews from the Iberian Peninsula, which created small Jewish communities among and adjacent to Muslim communities. In these areas, members of both groups communicated across them in ways that often "disregarded" colonial boundaries "as Jews continued to interact with networks of Jewish authority in the Mediterranean that transcended national and colonial borders."[57]

Did you support Joseph's decision to evade the draft, or was it you who encouraged him in the first place? What inspired you and who supported you? Did he stay at home during the four months of his desertion, or did he hide elsewhere? Did the military knock on your door? Were you scared they would come after him? Did you talk about it? Was your support unconditional? Did you both understand the cost if Joseph were found? Did you anticipate a prison sentence? Was your decision informed by other political activities in which you—or he—were involved? After four months of avoiding recruitment, Joseph finally showed

Letter 8. The Algerian Jewish anticolonial mother did exist!

up. Why? Was he caught? Perhaps he considered that after a few months, the risk he was taking was too big. I assume that he expected his sentence and was not surprised that he had to spend four months of prison.

A relatively short time after his term in prison, he was released from the army. *Bronchitis bacillaire* is mentioned in his records as the official reason for his release. But at the top of his military document, a different reason, written in red ink, indicates that his presence was necessary to sustain his family: "classified as an essential family breadwinner" (*soutien de famille indispensable*). This is the second time I recognized your presence in his military record. Whatever his wage may have been, it was certainly necessary for your subsistence. Being a patriot meant making sacrifices for the state, but you did not surrender to this bargain: you refused to let yourself and your family be a sacrifice of the state. I'm proud to be a descendant of yours, my dear great-grandmother Julie, and of my grandfather Joseph too. For Joseph to be classified as an "essential breadwinner," you had to go from one office to another, in order to negotiate, insist, persuade, and reclaim your son Joseph at home. In short, you had to perform your anti-patriotism. Again, I rejoice!

However, can you imagine, dear Julie, that while I was ecstatic to discover that my grandfather was a draft dodger and I euphorically speculated about his antipatriotic and anticolonial aspirations, I realized once again that my father failed to retain and transmit this legacy to me. Before I read Joseph's military record, I assumed that my father had volunteered for the French army at the beginning of WWII because his father Joseph had been a soldier in WWI. It took me some time to realize that upon coming of age, when he could have conversed with his father about whether or not to go to the army, my father was sent to a concentration camp the French created for Jews. There, he was detached from his family and subjected to laws imposed by the Vichy regime, and he volunteered to fight in the war. Under different circumstances, his father might have had the time to talk with him about colonialism, militarism, and anarchism. But Joseph was ailing when my father was liberated from the camp, and he had already been drafted.

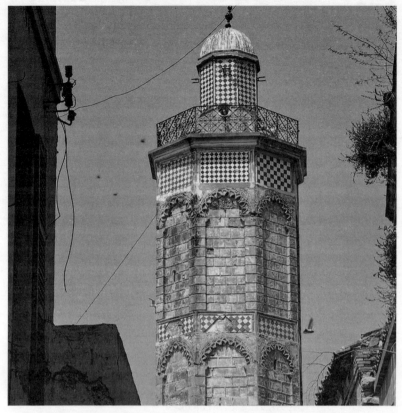

Minaret of the Pacha's Mosque, Oran, Algeria. Photo: Maël Assal.

My father's battalion was first sent to Morocco. To this day I'm not sure if this was part of another forced labor phase, or if he was sent there only to be provided with American equipment that the French didn't have.[58] When they left Morocco and headed toward Tunisia, he asked the officer if they could stop on the way in Oran to accord him a few minutes to see his sick father, perhaps for the last time. He had ten minutes to climb the one-hundred-step staircase of the street that led to their apartment, just behind the Pacha Mosque. His mother, Aïcha, wrapped some cakes and gave them to him, requesting that he thank the officer for allowing him to see his father and her, and that he give the officer a blessing.

The situation of the Jews in Algeria under Vichy remains under-studied. However, from several texts about the Bedeau camp, I was able to fill in missing information from my father's vignette, in which he describes raising his hand to volunteer for

Letter 8. The Algerian Jewish anticolonial mother did exist!

the war. He told me that other Jews in the camp tried to dissuade him, but he didn't mention that they knew (or hadn't denied, as he did) the French didn't want Jews in the army. Never in his stories was there any hint about him not being wanted. Yet, the fact of being unwanted must have been a central part of his daily life, as for all other colonized subjects. Can this explain his urge to volunteer, despite the voices of other Jews around him? Did he need to prove that Jews were worthy of being drafted? Or was it simply that volunteering felt just as risky as staying

Staircase leading to my father's house in Oran (the minaret is on the right).

in the camp under the command of its infamously anti-Semitic officers?[59]

Inmates in the Bedeau camp spoke about "the trap of volunteering," referring to the lack of information they had about the military service they would be asked to perform if they volunteered.[60] Given that Vichyists stayed in power after the defeat of Vichy and didn't restore Jews' citizenship and didn't want them in the army, camp inmates might have feared that the military service that awaited them if they volunteered could well be another position of forced labor. The allegedly military units to which Jews were drafted revealed the labor involved at the same time that they camouflaged the nature of the camps: Bataillon des pionniers israélites (BPI, Jewish Pioneer Battalion) and Groupement des travailleurs israéliens (GTI) are two examples that blur the lines between forced labor and military service.[61] In this deliberately disorienting situation, wherein Jews wanted to fight the Nazis but were rejected by colonial anti-Semites, your grandson chose to volunteer.

In addition to his readiness to fight against the Nazis, my father's insistence on becoming a soldier in the French Army was also an insistence on becoming a citizen again, opposing the local authorities' decision to keep the *statut des Juifs* in place, a law that stripped Algerian Jews of the citizenship imposed by the Crémieux Decree. In this context in which the French didn't want Jews in the army, refusing service in World War II was not the same as doing so during World War I. Hearing the anti-Semitic officers in the camp falsify history and deny the fact that Jews fought in WWI, my father could have been reminded of one segment of his father's military saga—his four months of service in WWI—and decided to volunteer.[62] From my father's military records, the fact that he was incarcerated in Bedeau is excised, as is an earlier or later period of forced labor. The name Bedeau is mentioned, but not as a concentration camp or as a camp of forced labor, but simply as one station among others. The French, who had already stolen his life and confined him to a concentration camp where he was forced to dress in black clothing and labor to maintain French colonization of his country, had also stolen the true meaning of this time from his records.

Letter 8. The Algerian Jewish anticolonial mother did exist!

My father fought in WWII for two years, and he never turned into a patriot nor did he transmit to us any military values or language. On the contrary, if I were to describe my father's political legacy, his hatred of the state of Israel and of the "Israeli type" would feature prominently. In the colony where I grew up, even without patriotism and reverence for the military at home, children are prepared by the state to join the army. A dense and manipulative education system is dedicated to preparing them, over the course of twelve years of public education, to imagine no life outside of perpetuating the crime of destroying Palestine, a crime that is waged with no perspective of redress. The army exists for a single purpose: foreclosing, by all means, Palestinians' claims for their return to their homeland and the restitution of what was stolen from them.

In 1980, when the time came for me to perform my mandatory service in the army, I viscerally didn't want to be a soldier, but I lacked any language that might have helped me translate this sentiment into action. The few organizations that offer such language to like-minded Israeli youth today didn't exist then. When I was seventeen years old, I didn't have a model of disobedience to follow and was too scared of the consequences of objecting, so I just failed in all the tasks I was asked to complete while in the army, and spent as much time as I could being or pretending to be sick.

No matter what one ends up doing in the colonizing army—including nothing, as I did during the year and a half that I worked in the offices of army museums—one must earn a shooting certificate at the end of the first six weeks of boot camp. I was depressed during these six weeks of camp and spent most of my time in bed, aside from some visits to see doctors. There was no way I would hold a gun and shoot, even if the target was a paper one. While I didn't know how I could disobey the law, I did inherit a strong antipatriotic disposition—a combination of hate for the state and disrespect for its apparatuses and agents—which I combined with a confidence in my ability not to do what was expected of me. The officers told me that they would force me to stay for another round of boot camp if I did not shoot. I don't remember how I managed it, but I found my way out without

firing a single bullet, knowing already that I could be as good a trickster as my father. Indeed, he was proud of me when I came back home and told the story of how I skipped the shooting. Or maybe he was proud of himself since I acknowledged my indebtedness to his trickster talent.

While I wish your legacy could have been with me when I turned seventeen, I know now that my father was able to transmit the embodied knowledge he received from his ancestors on to me. In a convoluted way, you were with me then. As I grew up, I found the words to match this legacy with an expansive language of anti-imperial refusal. I passed your legacy on to my children when I became a mother, and I actively encouraged my children to refuse to go to the army.

Though I still know very little about you, what I do know is that you are the parental figure I always felt I was missing—an anticolonial mother who refused to deliver her child to colonial predators and stood firm against the colonizers. When I was young, you were not around, and there were no other women who could mobilize this kind of wisdom and decisiveness against the forces of the colonial state. I do think that my maternal grandmother, Selena, was able to transmit the wisdom she inherited from her ancestors, but she spoke the colony's mandatory language of Hebrew poorly, which at the time was the only one I knew; she spoke it in a way that distanced us from the wisdom that our maternal ancestors carefully transmitted to their descendants over centuries in Ladino, Arabic, and non-Israeli Hebrew. And yet, when I think about my life now, I feel that at some points I acted as if *you* were there empowering me to make certain decisions and guiding me to reimagine our lives in alienation from state power, as part of the legacy of the jewelers of the ummah.

It is not a coincidence that I didn't know of you and that even now that I've *encountered* you, my anticolonial ancestor, I still know so little about you. In the lapse of time between several generations, imperialism sought to make you and other anticolonial mothers like you almost disappear. I don't remember having read about other anticolonial mothers in Algeria, and yet I'm confident that you were not alone. I'm committed to not letting you go, dear Julie, to holding on to your legacy.

Letter 8. The Algerian Jewish anticolonial mother did exist!

My mother's black mourning scarf.

As I was completing this letter to you, I wanted to visit you in the cemetery and put a stone on your grave. When my maternal grandfather Raphael died, my mother and her mother bought two black scarves and wore them on their heads. When my mother passed away, I took her scarf, and I tied it around my neck during my father's funeral.

I already knew that you were buried in France, and from the cemetery records, I learned that your grandson George took care of your burial in the cemetery of Thiais, division 82, line no. 3, grave no. 14. However, it also seems that you are no longer there. Since the late 1920s, article No L.2223-4 of the General Code of Local Authorities in France has authorized municipalities to exhume people's remains whose concession has expired and group their remains together in a bone box and place it in the municipal ossuary, or cremate them. In the absence of known or attested opposition from the deceased, the municipalities therefore have the option of cremating the buried remains. Oh

my goodness, dear Julie, I cannot believe that the French didn't even have the minimum degree of respect to leave you alone and let you rest in peace. This legislation became mandatory in big cities in France, regardless of one's religion.

This method of burial is yet another attack against Jewish and Muslim burial rites. "For dust you are and to dust you will return,"[63] and it is strictly forbidden to derange the dead or exhume them. Rest in peace, dear grandmother Julie. Your soul will forever be bound in the bond of the living. תהיה נשמתך צרורה בצרור החיים.

Your great-granddaughter,

Ariella Aïsha

Letter 9. Gold threads, embroidery, and guilds

A letter to Madame Cohen

Dear Madame Cohen,

Your name is listed as the donor of two photographs stored in the Musée d'art et d'histoire du judaïsme in Paris (see photo p. 362). Both were taken in a photographer's studio. Both could be read as images initiated and arranged by a photographer, and such images were often sold by postcard companies to reflect a racial "type." At the same time, they can also be read as photographs that were initiated by the photographed women and staged by or with them. Before I saw the postcard template on the reverse side, I assumed that these were personal photographs and that you were the woman in the picture, as you had written your name on the card listing yourself as its donor.

These images resemble many colonial postcards of Algeria except for two elements, which usually mark those postcards as commissioned for European audiences. You probably know what I'm talking about: the printed captions on the front designating the women as tokens of colonial categories ("a Jewish woman," or sometimes with qualifications: "an elegant Jewish woman"), and the typical postcard crop, which cuts the lower part of the woman's body out of the frame. I cannot avoid wondering how my female ancestors felt when they saw their likenesses given as groundless figures, floating in the cloud produced by the photo's blurred and feathered edge (see photo p. 363).

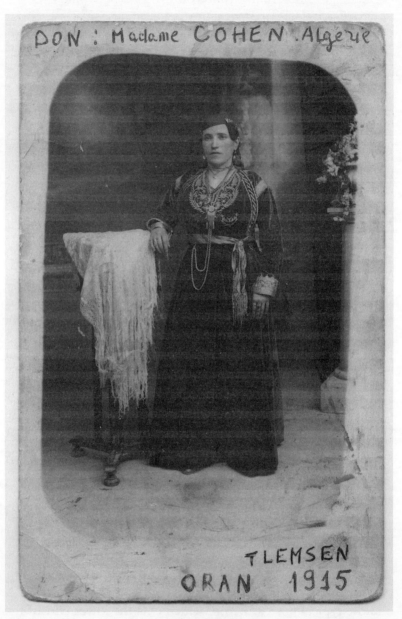

Are We Relatives?

Letter 9. Gold threads, embroidery, and guilds

I do not have a hard copy of your two postcards—only digital files of their front and back. That these are postcards does not eliminate the possibility that you are one of women photographed. Nor does it eliminate the possibility that you might have negotiated with the photographer to have copies made for yourself in exchange for allowing him to print your image for mass circulation. I don't remember reading, in the literature on the colonial industry of postcards, about whether the photographed women insisted on having copies of their own images, as if, to historians, it was unimaginable that some of you might have asked to have a copy of your own postcard! For a while, I played with the possibility that you or a close friend of yours worked in one of the many photographers' studios in Oran and thus were able to keep a photography collection of your own.

Recently, I stumbled upon a single portrait of a "modern" woman—the opposite of the conventional "type" photographs since the "modern" was not considered a figurative colonial

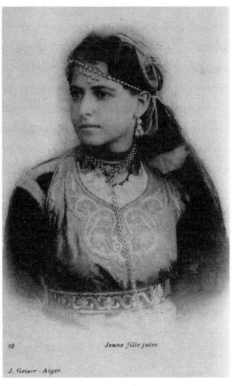

A young Jewish woman. Colonial postcard.

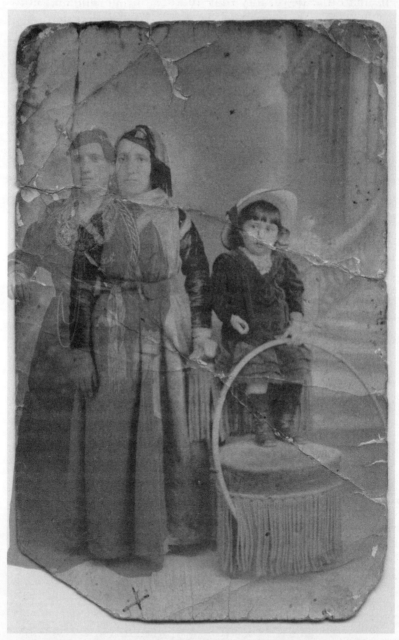
Are You Relatives? Montage by author in collaboration with Yonatan Vinitsky.

Letter 9. Gold threads, embroidery, and guilds

type—taken in the studio of a photographer whose name was also Cohen. It made me laugh. Finding that a photographer named Cohen worked in the city at the same time made me imagine you plotting, in the studio of a perhaps familiar Jewish photographer, a plan to satisfy the norms of the colonial market with images of the "Jewish type," and plotting to surreptitiously introduce certain insurgent elements (see photo p. 363). That colonized women like yourself figured as "Jewish types" doesn't exclude that at the same time you could have been part of a team of photographers producing those postcards.

The resemblance between these two women who appear in the photos donated to MAHJ dissociates them from the imaginary of the colonial "types" and intimates that they may be relatives. Now that I place them next to each other, in a single frame, I'm even more curious to know if one of the photographed women is you.

I recognize in both your images a refusal to be read as "a type." Let's say that you are not one of the photographed women. That you owned both of these postcards makes me think that at least you knew both women. I know a Cohen who still lives in Algeria, who promised to ask if anyone in his family knows the Mme Cohen who lived at 39 rue de Vienne. It was your name, Mme Cohen, written in ink on the photo, that first captured my attention. Writing as you did, you unsettled the standardized postcard

Quotidian notes on the back of the postcard.

text, a text which often lures us into believing the women photographed are always anonymous. Your inscription on the front of the photograph reads like an insistence on associating this postcard with yourself at the moment it entered the museum's collection. It is unlikely that a museum worker would have written your name on the front of the photo they were acquiring. That you wrote it only on this photo could be an indication that this one is a photo of you, but it also could suggest that you felt close to this photo in particular.

There are also handwritten notes on the back of the other photo, the one with the woman and child, which seem more quotidian (see photo p. 365). Several different hands wrote these notes, with different pens and pencils, and for different purposes. These casual notes are like aide-mémoire: addresses, names, and the measurements of women's waists and breasts likely related to dresses or caftans to be fixed. Things not to forget. These notes, as well as other signs of use left on the postcards, provided me with an unexpected view into the prosaic aspects of your world, your life as an independent embroiderer who, so it seems to me, fixed and renewed other women's embroidered clothing, like the Tlemcenian dresses worn by both these women.

But first I must ask you, dear Mme Cohen, are we family?

It's not easy to tell whether we are related, as several decades have passed since our families were dispersed from Oran or Tlemcen in Algeria, and Fez or Meknes in Morocco. Is it serendipity that a certain Paul Azoulay is the author of a book of postcards from Algeria, and a certain Nathan Boumendil (the name of my great-grandmother) is a photographer situated in Sidi-bel-Abbès?[1] I don't know if they are family either, but I would rather consider them kin and reject the category of *pied-noir* that the French dared to call all of you when you were forced to leave Algeria as a consequence of their colonization. Paul and Nathan were both Jews who lived in the same neighborhoods in Algeria as my family.[2]

Thinking about my family through names like Cohen and Boumendil is relatively new to me. I used to think about *us* in Algeria only under the name Azoulay, as if my family were a specimen that could be traced linearly through one patriarchal line, as if

Letter 9. Gold threads, embroidery, and guilds

all members of my family were connected like the branches of a tree, with a trunk named Azoulay at its center. I didn't consider *us* as part of a complex life-tapestry made of migratory and cross-family fabrics, with diverse threads, stitches, knots, and loose ends—a life-tapestry caused by, or survived in spite of, French colonization and its aftermath. Until recently, I didn't know that my grandmother Aïcha, for example, was born a Cohen from both her paternal and maternal sides. Learning this broadened my hypothetical tree, and it confirmed family connections with other Cohens in Oran.

Again I'm asking, are you a family member?

You lived on the same street as Mimoun Cohen, my grandmother Aïcha's uncle. Were you married to one of his sons? Are you Semha, Aïcha's sister? Or the wife of one of Aïcha's brothers, Eliaou or Salomon, or of another cousin? Or are you the daughter of Moïse Cohen? Even if I cannot confirm any of these guesses, it goes without saying that in Oran's relatively small and crowded *derb lihoud*, the Jewish neighborhood, where Aïcha and her ancestors lived, you must have known each other. Are you Mme Cohen by birth or by marriage? My grandmother Aïcha dropped her Cohen name when she married my grandfather Joseph and became Mme Azoulay. She could, as well, have become Mme Boumendil, since this was the name given to my grandfather at birth, before his biological father, who was married to another woman at the time, officially recognized him and gave him his name—our name—Azoulay.

If only I knew your first name …

If only the museum's archivists had been less concerned with objects from the "past" and more interested in the woman who had carried these photos all the way from Algeria to Paris and was gifting them to the museum… If only they had asked you why you kept them …

If only they had made an effort to mention, in the scant records they produced from your encounter, the names of the photographed women, I could have known whether you are a relative, or whether you knew my ancestors …

If only they had asked how these photos came into your possession …

If only they had asked you about your profession and how you managed to practice it!

For you made a living in a colonial world where, since 1830, the Europeans who had invaded your country "compete[d] with Jews and Muslims on the ground where they reigned as masters."[3] The archivists didn't even ask you questions pertinent to their own supposed expertise as museum workers, question like:

"What kind of gold threads did you use to repair such dresses?"

"Where did you purchase gold threads for your embroidery, as the supply was limited in the 1900s?"

"Were these gold threads or silk ones, or perhaps what is called the *brilliance of Algiers*?"

If only the museum's workers had simply spoken to you and invited you to speak ... It is not the individuals who met you in this museum who are to blame, but the profession that tied their tongues and drained them of interest in you.

Now, only a few decades after you deposited these images in the museum (probably in the late 1970s), your words, which could have been registered but were not, are even more difficult to access. With your death, the remains of your ancestors' memories also evaporated. If only these questions about why and how you were made into an extinct species to be collected in museums were not foreclosed by the impulse to preserve artifacts rather than to engage with the living person in front of them...

But, dear Mme Cohen, at least part of what you could tell us is not gone. In donating these postcards with your handwritten notes that attest to your doomed profession, you *used* the museum to *address us*, to tell us that these are not dead dresses and that you didn't surrender to the force of colonial violence. I have decided to accept your challenge and find ways to follow the threads that you left.

These threads unsettle what the museum has to say about your "traditional" clothing. They trouble the museum's investment in reducing your clothing to items that can be studied according to style and period. They challenge the museum's framing of your photographs as items untouched by the regime of colonization.

Dear Mme Cohen, listen to this: This museum has only two costumes for men and many more for women. The text that

Letter 9. Gold threads, embroidery, and guilds

accompanies the publication of your postcards explains this by pointing to the differences in fabrics between men's and women's garments: women's clothing was made of noble fabrics like silk and velvet and worn only on rare occasions; men's clothing was made of cotton, linen, or wool and was worn daily; thus it wore out faster. That men also had special clothing for holidays, clothing made of noble textiles and adorned with gold thread embroidery, doesn't seem to trouble the museum workers' assumption that all Algerian Jews moved from wearing traditional clothing to wearing European garb. For museum workers, this transition was only a matter of different paces in the Jews' inevitable march toward Europeanization. According to the museum, "Men were the first to adopt European fashion," and this "appeared from the first years of the conquest." Thus the use of different clothing styles deemed to be "European" is construed as an inescapable destination, even a destiny, a sign that inside every Jew—yourself included—was a desire to become European and abandon their modes of life. Women are described as being slower to follow this progression, but still they confirm the ultimate "abandonment of traditional costume in favor of European fashion." Mme Cohen, your insistence on gifting us these photographs is taken by the museum and by historians as proof of this "abandonment paradigm" since they ignore these casual notes they bear of the living world from which they came: "Precious and little used, [these dresses] were transmitted from generation to generation, even after the abandonment of traditional costume."[4] But your photographs are not that.

I don't know the age of the women in these photos, but they are not old. It could well be that at the moment the photograph was taken, the embroidery of these dresses had just been completed. Instead of automatically assuming that this was an "old dress," from the prideful postures of the women, I somehow think they could rather be new dresses, full of the excitement of future occasions on which they might be worn. The possibility that these women might have been celebrating their look in front of the camera, rather than putting on an "old" style, is a consideration foreclosed by the "abandonment" paradigm that undergirds much of the narratives about the life of the Jews in

Algeria, which tell us that young women at this time were already dressing *à la française*.

Two Frenchmen "of Jewish faith"—perhaps you may have heard of them, Altaras and Cohen?—came to Algeria in 1842 to write a report on our ancestors' readiness to become French. They understood that "old people will find it difficult to give up a costume they have worn since childhood to dress in another in which they will be awkward and embarrassed."[5] Nonetheless, as good Frenchmen "of Jewish faith," they were confident in the success of this human engineering project to Frenchify the Jews, and trusted that time would bear their hopes out.

In addition to challenging the historiographical distinction drawn between Frenchified Algerian Jews and their ancestors, the clues you put in the postcards you left for us are helpful in rejecting another progressive assumption: that the Jewish women in those postcards were captives of the photographer's imagination, and that the photographer dressed them in traditional clothing different from the modern urban garb they were more prone to wearing. Implied in this kind of claim is that those women were "modern," "pioneers of slow emancipation," and it is only the colonial view of the photographer that kept them in their traditional garb.[6] This limited framework, employed by museums and historians alike, doesn't end here. In every aspect of life, whatever you were dispossessed of, whatever you were forced to do that departed from your world's traditions, was described as a step toward "progress" and as something "beneficial" for you. It is painful to read how the French terrorized you with their progress narrative, how they forced you to see your culture as something that had to be amputated in order for you to be modern.

As you were forced into this linear progression toward "modernity," the destruction of your world and your traditions often went unnoticed. Even when those narratives acknowledged a loss, it was more as a trope than something to revolt against. This is the civilizing mission, which implies that without the French redemption Algerian women would be backward, to the extent that historians have described those Algerian Jewish women as "rarely expressing [their] moods and or [their] secret thinking spontaneously," as if you were not expressing yourselves

Letter 9. Gold threads, embroidery, and guilds

through your clothing, embroidery, jewelry, songs, invocations, and sorcery.[7] They terrorized you with their single European model for expression, and they dismissed the affective value of your richly expressive verbal and nonverbal languages. This hierarchy in discursive forms actually shapes the temporal path that the historiographical concept of "progress" follows.

Dear Mme Cohen, the tribal social family formations that were denied us were devalued, presented as ways of life that must evolve. They evolved through the civil forms you had to fill out, the colonial institutions you had to interact with, the languages you had to adopt as your (or your children's) mother tongue, the education system you were compelled to enroll in, the historical narratives you were conditioned to see as your own. They evolved through the bourgeois nuclear family as against the tribal notion of affiliation, and through the museums, which reified this historical narrative and enforced a strict separation between old and new.

Historians are resolute in their worship of progress: "The idea that marriage could establish a privileged relationship between two individuals slowly made its way."[8]

And who will care for the women or men who were not willing or able to find themselves in such heterosexual couples?

And who will take care of the children whose mothers were slower to recover from the labor of their births? And who will care for these mothers themselves?

Reading such descriptions alongside your photographs in the museum, I'm appalled by the denial of colonial violence. Whatever the colonizers didn't accomplish in terms of their progress project with you, they expected to achieve with your descendants.

We, your descendants, did as we were expected to. We recognized the progress narrative as normal, until ... blessed by you and other ancestors like you, we continue the struggle.

There are plenty of vintage postcards of "Jewish women" from Algeria in circulation. Some are unused, others contain handwritten messages from colonizers, who would mail them to recipients abroad. Until coming across your photos, I hadn't encountered

postcards with written messages from the colonized. Reading your handwriting on these cards is like being given directions for how to reject the museum's colonial framework. Through your writing, I realized how their simple descriptions enlist us in an imperial temporality by using past tense markers: the dresses our ancestors *used to wear*, or the *dresses they gradually stopped wearing* as they embraced European modes. You continued to care for these dresses and the world they still carried. You knew that dressing in what they called "European" clothing was no proof of your successful conversion to being French. You knew that all this discourse about clothing styles diverted attention from the real drama in your photograph: the attack on the conditions for fabricating your clothing. All those articles of European clothing, which are posited as proof of your successful assimilation, obscured the high prices extracted from you in exchange, costs that you never conceived of as emancipation and never chose to pay.

Even if you loved your new French outfit—why wouldn't you?!—it did not mean you were willing to destroy your world to wear it.

Dear Mme Cohen, your commitment to adhere to and revive what you didn't want to sacrifice, as well as your struggles against the costs extracted from you, is not a detail *of the past*.

We are here, and we refuse to accept this bargain in which we were all used.

This bargain of Frenchification in exchange for our world was imposed through deceit, and it was so subtly struck that it has taken us many years to realize it. This kind of deception is hard to see since it is never only epistemological, never only one discrete injunction. In a way, writing to you and thus being in your company is an effort to scrutinize rather than to dismiss its signs. These signs confirm the existence of a different world that the "facts" fabricated by colonizers, historians and the museum sought to bury. Here is an example of such a fact: at the beginning of colonization, "local artisanal production suffered from the disruptive presence of the French military."[9] This seems almost obvious, right? There is nothing surprising to learn here, and yet, how come a craft-icide is described as an ordinary development?

Letter 9. Gold threads, embroidery, and guilds

You knew that French destruction of your craft tradition meant the destruction of a major pillar of Jewish life in the Maghreb, as until the invasion of Algeria, the lesson from *Pirkei Avot* (*Ethics of the Fathers*) to "love handiwork, hate acting the superior, and stay away from the ruling authority" was cherished and observed.[10] The French knew that many of the rabbis in Algeria were craftspeople, many of them jewelers, but the French could not see this as a constitutive part of their mode of being Jews. For the settlers, Jewish law had to be limited to what they could codify as religion, a form that they could administer. The colonizers knew that craft and craft guilds were obstacles for their plan to extract resources and wealth from Algeria. Craftspeople were guardians of memory who lived with respect for principles that enabled care for each other, Muslim and Jew, and care for the shared world—and so were foreign to the racial capitalist principles imported with the settlers.

These guilds, established centuries earlier and often with their own synagogues and mosques, were not only a barrier against the entrenchment of aggressive capitalism, they were also the materialization of Jewish and Muslim conviviality. Historians

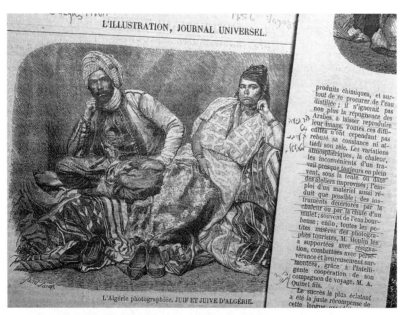

L'Illustration: Journal universel, 1860s. Nearby text refers to "Arabs' repugnance at having their images reproduced."

mention the existence of the guilds only sparingly. Particularly scant mention is given to those that formed around the fabrication of silk and gold threads[11] and the "delicate arts" in which the Jews excelled, like "jewelry, watchmaking, [and] embroidery on clothing."[12] Destroying these guilds was also an act of destroying an utterly different mode of Jewish existence from the one known in Europe, where Jews were not allowed to be craftsmen and craftswomen.

Please bear with me Mme Cohen; I know that my letter is long, but the web of deception is quite dense.

I don't know how much of this was transmitted to you, but our ancestors recognized, early on, the figure of the colonial entrepreneur in the photographers who came with the colonizers to Algeria. It was known among the photographers that our ancestors did not like to be captured in photographs. A journal article praising the publication of a book by the French photographer Félix-Jean Moulin, *L'Algérie Photographiée* (1857), describes how the local population recoiled from being photographed (see photo p. 373). This didn't stop Moulin, though. When the Algerian scholar Malek Alloula looks at such photographs, he understands something about them. The "'realistic' underlay" of the colonial postcard, Alloula says, is what allows it to "obstruct the horizon of its productions, all of which are meant to convey a 'truth' upon the colony."[13] Thus, when we look at the photographed people in all these millions of images seized from them, their reluctance recedes, and instead of seeing Algerians responding to the event of photography, we are invited, rather, to see the plain truth about Algerians. The imperial temporality of photography tricks us into conceiving of the photographs as *coming after* an event or an encounter, and the photographer as one who captures territories already conquered, not the one who is in the process of conquering them and making them into the object of their photographs. But our ancestors didn't fall into this trap. They understood photography's intertwinement with the other invasive colonial technologies that were being used to produce visual information instrumental to their colonization.

Even without knowing this history, you knew that photography was used to inscribe the differences between you and your

Letter 9. Gold threads, embroidery, and guilds

colonizers within a hierarchical order fashioned against you. You knew the photographer was a colonizer too, and this is why you became a "type." I see the accumulated photographs as an endowment conferring upon those with access the capacity to regulate the terms for researching, exhibiting, writing about, and republishing these images. Possession of such photographs also endowed one with the privilege to rework the stories of the photographed persons. Through this infinite photographic endowment, which continues to be held in the colonizers' archives and museums, we continue to be captives of the places they assigned to us at different moments in the process of assimilation and "emancipation."

The technologies the colonizers put in place included many deceptive traps, so that even thoughtful writers among the colonized would be tricked into repeating, with astonishing conviction, assumptions about these photographed women. Thus, for example, an Algerian author, well known for a powerful book on the colonial assumptions of these postcards, describes the identities of the women captured in nineteenth-century photographs as "no doubt, for the most part, prostitutes, filles de joie, as they continue to be called, or beauties of the night."[14] It is as if, in describing these women—one of whom could be you, Mme Cohen—he took delight in using three different terms that designate them as "prostitutes." Part of the violence of this postcard industry, which exploited the people photographed and often denied them access or rights to the images, lies in how its agents abused their power by disseminating lies about the people photographed. Often, as in the images of "racial types," the specific people photographed were detached from their environment and disappeared into the silent anonymity of a "type" elsewhere, where their images landed.

Dear Mme Cohen, in response to your act of writing on the postcards I choose to address you by your proper name when I interact with these images, regardless of whether you are one of the photographed women. Undoubtedly, you are the woman who (re)claimed these images by saying quite loudly, "This photograph is mine!" Your claim reverberates throughout the silent realm of postcards and unsettles the colonial technology within

the postcard form, a technology that tried to detach you from your world so that it would be easier to separate you from what was yours.

Locating your quiet rebellion against what colonialism did to you is our inheritance. We should not let these signs disappear in the objects the colonizers collected from you, nor let these objects continue to exist alone in museums, as objects bereft of their people and world. As part of the same project, the colonizers bombarded and bulldozed cities, leaving intact a quarter, or some monuments, that they then called "the old city," which their photographers made their fortune and fame by photographing. The colonizers destroyed the infrastructure of craft- and art-making and built museums to preserve what they deemed worthy of preservation—and so the colonizers claimed control over our past too. This "past" was your livelihood before they made it past! Plundered objects are stored in their museums like gold in the safe of a bank. These objects are used to measure and thereby devalue what you manufactured after the invasion; they are used to protect the value of the colonizer's bounty.

We, your descendants, have been kept from these objects in the basements of many museums. Instead of feeling our bodies, our longings, our powers, these dresses and jewels are freezing, alone.

This attack on crafts sought to eliminate certain professions and to force former craftsmen to work in factories or to apply for jobs in service of the colonial regime. Given that colonization had already torn the social fabric of protection held in those centuries-old professions, people were more easily induced to believe that their livelihoods were secure in the new waged jobs: "My parents were merchants. When they had debts, they took all their jewels and brought them to a pawnshop ... this was not a decent life. I would prefer someone who works for a monthly wage."[15] Sadly, with that destruction, this became not wholly untrue. I know that you will not ask me, "How many people you are talking about?," as if the exact calculus mattered when it comes to the rights and wrongs of colonialism. I want you to know that people today, especially scholars, will ask me such a question, intending to force my discomfort. While I don't know

Letter 9. Gold threads, embroidery, and guilds

how many refused a wage job nor how many enjoyed their new paychecks, I do know that most of them would not have chosen to destroy their world if they had been given a choice. Given the limited options for practicing their ancestral crafts outside of the colonizers' industrialized structures, and the increase in options to work in the "jobs" that colonization produced, the historical narrative of Algerians' so-called "attraction" to jobs in the colonial public service ought to be thoroughly rewritten.

As we learn from your postcards, women continued to practice embroidery at home, secretly for the most part. Despite not knowing your first name, I could not find any Mme Cohen whose profession was embroiderer in the Archives Nationales d'Outre Mer (ANOM), as the French continue to call the deposit of papers they produced about you and then stored in France. I doubt that embroiderers who catered to Jewish and Muslim clients went to register in the colonizers' offices. In Guelma, for example, two Jewish sisters worked "behind curtains in their apartment, they sewed djellabas for a mainly Arab clientele."[16] I don't have to tell you, dear Mme Cohen, that, several decades after the invasion, whoever continued to wear a djellaba was considered an "Arab" client. I'm sure you know from your choice to work at home that your clientele was Arab, meaning it was composed of both Jews and Muslims. I'm assuming that my grandfather's choice to become a butcher catering to the religious dietary restrictions of both Jews and Muslims was motivated by similar considerations. I'm sure you knew him. He worked at the Darmon butchery, which was close to where you lived.

The more women were pushed to dress in "European" clothing, the more local crafts suffered. This was not because local craftsmen and craftswomen could not also experiment with incorporating—as they always did—some elements of new styles into their creations, but rather because their crafts had to be destroyed for French enterprises to thrive.

Part of what was destroyed was a clientele for your wares. The departure of the Turks after the invasion in 1830, for example, meant the departure of the main clientele for these exquisite, luxurious crafts. The Turks "distributed on the Algerian craftsmanship a significant part of the income collected by the beylik."[17]

377

Unlike the French colonizers, the Turks didn't view Algeria as a resource to drain. Unlike the French, the Turks' consumption of, for example, fancy saddles from Algeria was inseparable from sustaining the world of those who fabricated the saddles (see photo below). It is not that the French didn't need uniforms and saddles for their Spahi regiments; it is that they didn't care about returning the money they unjustly earned from plundering Algeria and destroying its community of craftsmen. The French simply "drew their saddles and harnesses from France and Tunis," for it was world-decimation and not world-sustainability they were after in Algeria.[18] Moreover, whenever we speak about the destruction of a certain craft, we have to remind ourselves that we are actually speaking of a cascading set of professions: when the saddlers were unemployed due to the colonization, the leather embroiderers were also impoverished, as were the "tanners and the factories of gold and silver thread."[19]

The termination of gold thread manufacturing in Algeria has somehow disappeared from the archive, and worse, from accounts of the colonization. Knowing how it was terminated in Morocco almost a century later, I recognize the French malediction of turning violence into progress, and into silence. Given this,

The gold-embroidered saddle of the dey, plundered in 1830 by the French, now in the collection of Mucem, Marseille, France.

Letter 9. Gold threads, embroidery, and guilds

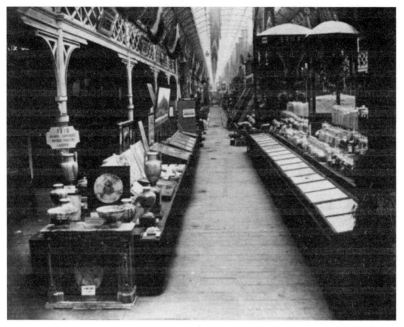

"Algerian products," Universal Exhibition, London, England, 1855.

I draw on what I know about Morocco to ask about Algeria. For example, guilds there didn't include women who were engaged in embroidery, but they had their own kind of social formation.[20] And in Algeria?

I know that French-manufactured threads aggressively replaced regional products, but since their production continued in Morocco through the 1930s, it cannot be that in the still-functioning embroidery ateliers, whose needles were accustomed to local hand-manufactured gold threads, this was not a topic of concern. It is hard to believe that in the homes of the thousands of craftsmen and craftswomen, this robbery was not mentioned.

Producing and using gold threads was part of your ancestral legacy, a combination of local knowledge and skills brought with those expelled from Spain, intertwined with the sacred texts you cherished that discussed this craft know-how. The colonizers sought to make this legacy irrelevant, dispossessing you of your power and setting the new terms of your world. Despite the command to "be modern," Algerians didn't immediately renounce their traditional garments and instead kept using familiar thread. In fact, it is because the demand for these products

continued that the French sought to supply the demand on their own. To do so, they sucked the know-how, the forms, the styles, the colors, and the spirit of several local items from the veins of local communities, fabricated products in France, and exported them back to Algeria as "Algerian products." "Algerian" came to describe not things *from* Algeria, but things that *used to be from* Algeria. In this way, "Algerian" came to mean "French," or "French Algerian."

"Algerian products" soon became a title for an ambitious colonial project (see photo p. 379). In the 1851 Great Exhibition of the World of Industry of All Nations and in subsequent exhibitions, millions of European visitors came to London to share "feelings of extreme pride" in the technology and "human ability" exhibited from around the world.[21] In bottles and containers of different sizes, the French exhibited Algerian resources as *their* Algerian products: different types of woods for luxurious furniture, minerals, marble, iron, cork, silk, olives and olive oil, cereals and vegetables, semolina, fruits, wine, and much more. The French acted as if these raw materials were their possession and behaved as their legitimate vendors. (Also part of this organized plunder, though not advertised for sale, was cheap labor power, available locally or for local deployment through a newly implemented global system of indentured-servitude contracts.[22])

Through these universal exhibitions, the European public was socialized into the global labor division that industrialized colonialism implemented along racial and religious lines. The colonizers would not have populated Algeria after the conquest if they hadn't already calculated that local resources—"the inexhaustible fertility of its soil"[23]—exceeded, by far, what indigenous people drew from them. Thus, for the triumph of colonial technologies, and for the forced introduction of Algeria into global racial capitalism, Algerians, and Algerian craftsmen in particular, had to be sacrificed.

The terms of this sacrifice were discussed in France, but as if in a mirror world: as a sacrifice required by the French. The French were asked as individuals and as a nation to invest money in Algeria to yield future returns.[24] Universal exhibitions like the ones in London or Paris (1855) were forums where colonial

Letter 9. Gold threads, embroidery, and guilds

violence was submerged beneath scientific and economic language about the development of new crops, their acclimatization, and the profits that could be made from them. These exhibitions provided the proof Europeans needed to invest in the future of global racial capitalism.

I wish I could listen to how your ancestors described the plunder that came at your expense and benefited white Christian European settlers and their partners in France. With the "eighth wonder of the world"—the nickname the French gave to the Mokta el Hadid, a region rich in metals and minerals—who needed those hundreds of local craftsmen working at a slow pace? The craftsmen used to spend weeks going through the many steps of making gold threads. Throughout each step in the process, the families of the craftsmen were able to eat decently from the profits that the lucrative profession ensured. These craftsmen, thus, had no reason to work faster and produce more. They even sang songs, told stories, and, from time to time, "one of them, the most educated, brought a book, posed it on the loom and read to his companions."[25] After twenty-five days from the moment raw materials were purchased until the gold threads were ready, the threads were passed to another group of local craftspeople, who used them for embroidery. Indigenous women purchased and

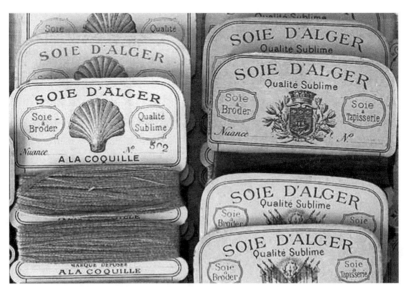

"Algerian" silk threads (not from Algeria).

wore this embroidered clothing, and they preserved, repaired, and passed the clothing down to their descendants.

This network of craftspersons and practice of ancestral transmission interfered with the capitalist impulse toward efficiency and growth. The craftsmen in Algeria had been organized in guilds for centuries, to protect themselves from unjust competition and exploitation; and so they united in revolt when asked to work on Saturdays (Shabbat), the day when Jews must cease all work.[26] Obviously, guilds were obstacles for the colonizers, and so they were abolished. So too, the craftsperson, who signified much more than the production of handmade objects but a way of communal life, were rendered superfluous.

After destroying their world, the French reinvented the figure of the craftsperson for their own purposes. The figure signaled the authenticity of the adjective "Algerian," a fetishized description applied to a variety of French industrial products. Even today, the French sell threads branded as the "Silk of Algiers" (see photo p. 381). Since the 1860s, the bright cotton threads produced in France were marketed under this name:[27] a 1905 advertisement announced that "this item replaces Algerian silk thread." "Algeria" was detached from the place where Algerians lived and was made an idea of authenticity that the French leveraged for profit, no matter how tenuous or harmful the connection to the country and its inhabitants.

The colonizers needed to convince the indigenous people that this enterprise was *for* them, to convert them into proponents of the modern world. As in other colonial enterprises, this could not be achieved without luring individual local informants into service and sending them to France; in the case of Algerian Jews, they were sent on the new train that took them to the port. Blinded by the wonders of modernity in France, these informants were seduced into forgetting that modernity itself was financed with what had been plundered from them, obscuring their world's destruction by inculcating dreams of the lifestyles of the colonial metropole. Upon their return to Algeria, these indigenous informants were expected to tell their brothers and sisters of the wonders to come in their promised futures.

Here is what an indigenous Algerian, commissioned by the

Letter 9. Gold threads, embroidery, and guilds

French government in Algeria to report on the 1862 Universal Exhibition in London, wrote upon his return through the train station in Paris:

> I could not find words, Monsieur le Maréchal, to express all my admiration at the sight of this crowd which goes to all countries … and of this immense quantity of goods of all sorts which cross France from one end to the other. I thought I knew all the greatness of France, but reflecting on this admirable invention [rail way system], I understood that if the Arabs could appreciate all the benefits of civilization, they would be more advanced and happier than they are.[28]

Did you feel the same fear that I did when you read this text, Mme Cohen? Did you worry that the author was another tragic Jewish interpreter, blinded by the "good education" he received in French schools? A Jew whose skills were used to "save" his people from backwardness, making of him an unwitting player in the colonial theater of cruelty?

From the 1860s onward, statesmen and historians used such accounts from Jewish interpreters to prove their argument that *all* Algerian Jews were actually loyal to the French. And yet—the author of this report is Muslim, and his name was Hassen Ben Caïd Ahmed.

Obviously, Ben Caïd Ahmed was not the only Muslim acting as an interpreter, but since Muslims were not naturalized en masse as the Jews were, such texts could not be used to demonstrate the desire of all Muslims to become French, and it is harder to ignore the colonial nature of this kind of report the indigenous were asked to write. Ben Caïd Ahmed's report was translated into Arabic and published in the journal *Le Mobacher*, which was founded in 1848 by the colonial government in Algeria. He was very proud of his country, seeing with his own eyes how well "Algerian products" were received: "Each people [in the exhibition] brought its labor and intelligence, each country the natural products of its soil, and I am glad, Monsieur le Maréchal, to see that in this respect my country stood out as one of the best."[29]

Ben Caïd Ahmed was no less impressed by what he saw in the factories, where "machines transform iron and wood with surprising speed and intelligence; blocks of red-hot iron instantly become, under immense hammers moved by steam, nails, bolts, plates of all sizes and all shapes"—or in the school-farms that he visited. In his report, he expressed a wish to see the school-farms spread in Algeria: "Out of 700 children confined in the establishment, 500 become farmers and 200 are destined to become skilled art workers."[30] Many such schools for "indigenous industries" of art already existed in Algeria and their products were marketed and presented in universal exhibitions.

Among all the "Algerian products" Ben Caïd Ahmed saw at the exhibition in Paris, the crafts receive the least attention from him; he reports their presentation in a single paragraph at the end of his twenty-page report. Compared to the exploitation of other resources, crafts brought France a smaller profit, which may explain their marginal place in Ben Caïd Ahmed's report. And yet, craftwork was not totally eradicated but, rather, exploited in three ways: 1. guilds were asphyxiated by the introduction of new sources of raw and processed materials; 2. handcrafted items were copied and mass produced, with no compensation, profits, or recognition going to their originators; and 3. former craftsmen were exhibited in exhibition halls as living examples of a craft tradition whose main purpose now was to signify authenticity, concealing the fact that these supposedly "handmade" goods were factory-produced or made with cheap labor performed outside the social umbrella of the guild (see image p. 389).

Thus many of those whose work was stolen and whose labor was devalued were forced to become colonial wage laborers in order to survive. Was it out of naivete or a need for survival that Ben Caïd Ahmed used the pronoun "we" in his report and expressed his desire for Algeria to produce olive oil for France? He remarks, "What an immense source of fortune would it not be for us to be able to supply to France, as I have already said, I believe, the immense quantity of olive oil which it draws from abroad."[31] Or was he writing in a moment of amnesia, forgetting that such an export system would ultimately profit the colonists and erode his own world further?

Letter 9. Gold threads, embroidery, and guilds

The indigenous interpreters must have known that the sustainability of local communities was not a concern for the colonial regime. What they could plausibly deny, however, was that the raison d'être of the regime was to destroy the sustainability of local communities. If they had not, I would perhaps find traces of relief programs to attend to and care for the craftworkers as their livelihoods were destroyed. Instead, a different set of ideals took over, ideals that were foreign to the world of craft: speed, efficiency, and high profit, no matter the societal and environmental harm they also brought. What our ancestors experienced first-hand was the triumph of France in the international race to accumulate capital. Algeria's resources enabled France to better position itself in this race, which took place in different international arenas and was displayed in the vitrines, pavilions, and booths of exhibition halls, botanical gardens, and shops throughout the empire.

The universal exhibitions had international juries who delivered verdicts on who should be dispossessed or exploited, and how best to do so. Their recommendations could be reduced to a single logic: *If you can produce more, you must, regardless of the well-being of the local communities or the earth.* This is, for example, what the jury recommended concerning the cultivation of silkworm: "Algeria does not make any better use than she has done to date, of the enormous quantity of mulberry trees she has access to, and she has not produced any further developments in sericulture."[32] The jury was aware that only eight years earlier, similar efforts had led to a "fatal disease" in mulberry trees, which caused production to diminish substantially. And yet they asked for more again. Our ancestors didn't want to cultivate silkworms for profitable export. They wanted to continue to draw the cocoon's threads, to dye them, to spin them, to pair them with locally manufactured gold streaks, and to provide the local embroidery ateliers with the highest quality gold thread, just as their ancestors had done. They wanted to work at their own pace, to be reassured that the silkworms were not stolen from conquered lands and that the secrets of their cultivation were not expropriated from the cultivators. If they had been asked, they would have condemned the kind of acclimating garden that the colonizers envisioned also for the acclimation of "imported"

workers to the climate and the weather when the labor force needed replenishing.[33]

One day, the silkworms proclaimed, "We are on strike."

The silkworms could tolerate many things—insufficient air quality, inclement weather, broken ventilation, unacceptable hygienic measures, precarious places for them to cocoon, unfamiliar languages around them, the mockery of "acclimatization"—but they refused to tolerate the disappearance of caring hands, the quieting songs they used to hear when their threads were drawn, the conversations they listened to during lunch time, the smell of the sweets the women shared.

The silkworms hated the huffing tone of the steam, the hissing sound of the air pump, and the pompous words that accompanied them: A revolution that is only the presage and the prelude to a more complete revolution.

Their revenge was too subtle for the colonizers to understand. The French were used to calling their campaigns of destruction "a revolution," and they reassured themselves that this was the right path to take. The colonizers blamed the silkworms for not acclimating to industrial conditions.

It was just a matter of time, after all. We cannot reform a people in a day, the French wrote in their reports. In another colony, the silkworms blamed the workers at the machines for not drawing the silk comme il faut, hoping that the manual workers would soon be back. The mulberry trees soon joined the strike.

When we learned about your strike, we understood that you were assisting the silkworms and the mulberry.

> *You stopped the rain, and brought it back.*
> *You brought the locust and chased it away.*

The silkworms' revenge was yours too.

Except ... when the silkworms and the trees went on a general strike and all of them fell sick, on both sides of the Mediterranean, physicians were called in to assist them; when you went on strike, the policemen arrived before, during, and after, to force you back to work.

Letter 9. Gold threads, embroidery, and guilds

Chiseled jewels, *larger earrings, bracelets, thousands of coins,*
we will find you
in your different forms and shades of metal.

The music,
with the right lyrics of a strike,
we promise—
will arrive,
and even ears made of stone will dance.

In a letter written on December 7, 1861, and addressed to the governor general of Algeria, the French minister of war explained the importance of performing well in the upcoming universal exhibition:

> It is a major question for Algeria since it is a solemn occasion to be judged on its works, production and resources it offers to industry and to the capital, and to reveal itself to the whole world ... France is counting on Algeria to support the struggle with foreign colonies with dignity. Algeria owes it to the metropolis; it owes it to itself.[34]

The letter ends on a reassuring note, saying that this is already being taken care of: "Local populations, Europeans as well as the indigenous, have responded to this call. Administrators and settlers are already setting to work." As Algeria was still under military rule, local inhabitants were forced to learn what they "owed" to the metropolis. The French needed our ancestors' help to deliver on their promise that the Maghreb was the "granary of the Roman world." Many indigenous people, however, refrained from working in the labor market that the colonizers created, and some still tried, against all odds, to survive in their old professions.

By dissolving the guilds, the French could more easily amalgamate indigenous people into the categories used to classify and rule the local population, categories that contradicted the indigenous community's own internal organizational structures. Before colonization, guilds provided members with a centuries-old

Jewelers Street, Tlemcen, Algeria. Colonial postcard.

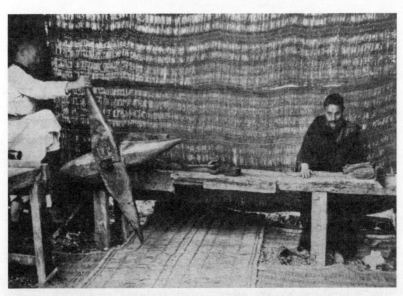

Gold thread drawers, Fez, Morocco. Photograph by
M. Vicaire et R. Le Tourneau, 1930s.

Letter 9. Gold threads, embroidery, and guilds

tradition of power, resistance, and autonomy. The new colonial groupings obliged our ancestors to renounce their "shared cultural deposit."[35] Crucially, in renouncing the guilds, the colonized were asked to renounce their intermingled and diverse ways of life. It is known that in certain places, when Muslims convened in mosques for their prayers, Jews convened alongside them reciting their prayer *Shma Israel*. So too, craft guilds were organized around ethnic or religious groups, but these were not defined in an oppositional manner. Given the way crafts were organized, there was much contiguity between and within guilds, especially as certain crafts required the finest coordination between different craftsperson.

Such was the case, for example, during the final phases of the preparation of gold threads, a profession practiced by Jews. The movement of the thread in this phase relied on the coordinated choreography of one Jew and one Muslim, who sat on opposite sides of the bench.[36]

Dear Mme Cohen, do you think your ancestors will recognize themselves in any of the figures "displayed" at the 1867 Universal Exhibition in Paris? It may be the fault of the poor drawing, but I see no resemblance to our ancestors in this performative display of craft in an exhibition space. How could these figures

Algerian craftsmen "displayed" at the Paris Universal Exhibition, 1867.

resemble them? For years, the French cast "Arabs" as the reason for labor shortages in the colony, blaming the Arabs' presumably indolent nature, and they even described Arabs as innate enemies of work. A Jewish "type" in the role of the jeweler was also out of question, as the transmission of the profession from generation to generation was exactly the phenomenon the French tried to end. In this exhibition display, the colonizers have opted for the Berber "type." However, when the Algerian jewelers are dissociated from the Arabs (though the Berbers were Arabized for centuries) and from the Jews (despite the fact that many Jews were Berbers), they resemble French people wearing Arab costumes from the props photographers kept on hand in their studios. So here they are, Berbers reinvented as the perfect colonial workers, "hard-working, docile, fit by their intelligence to become a devoted auxiliary of European and Christian colonization."[37] "The Berbers further resemble the European," and hence, can be assimilated by the colonial regime.[38]

Despite this fabricated resemblance, the Berbers in fact were *too large* a group among the indigenous and were finally found unfit for the role of "loyal indigenes"; naturalizing them was considered "too risky," since they were never as docile as the French tried to pretend at the universal exhibition. Nonetheless, the French still needed one loyal group among the colonized to help handle the unrest of our ancestors who, as the French knew very well, "from 1835 to 1870 never went more than five years without insurrection."[39] Though Algerian Jews were never thought to resemble Europeans, some of the French were confident in colonial human engineering technologies that could turn them into good candidates for Europeanization. This is how Algeria's Jews became "Jews," just an identity group, negating their Arab and Berber origins as well as their Muslim culture and attachments. And in this way and for this purpose, the French made Jews citizens.

In the decade that preceded France's decision to reject the Berbers and choose the Jews for this role instead, various metropolitan Frenchmen (Jews and non-Jews alike) and French colonists expressed opinions for and against this choice. In addition, in 1869, a tiny group of wealthy and politically active Jewish

Letter 9. Gold threads, embroidery, and guilds

merchants (members of *"les grandes familles juives"*) in Algeria, as well as some French Jews, wrote an infamous petition in the name of all Algerian Jews, asking for their assimilation to be made complete by being granted citizenship. This petition ignored the fact that four years earlier, most of the Jews in Algeria had expressed their feelings about becoming French by ignoring the opportunity to apply for French citizenship.

Can you imagine, dear Mme Cohen, if members of your family, who in the 1840s had probably already resisted the system of French consistory imposed against their local forms of social and religious organization, had asked their colonizers in 1869 for "more of your justice and the generosity... to complete the work begun to proclaim our definitive assimilation with our brothers of the motherland"?[40] "Our brothers"?! For centuries, Jews had formed discreet minority groups and never wielded any national or imperial power (thank God!) until the Zionist malediction.

However, there is a way to understand how signatures were collected for this petition. Jews were so used to asking for favors and protection from the powers that be, and so used to strategically using the language of those in power to obtain them, that, clearly, those who claimed to be in favor of French citizenship were not calling for the sacrifice of their ancestors' world. The memory of the *anusim*—those who, in the wake of the mass Jewish expulsion from the Iberian Peninsula in the late fifteenth century, professed conversion in order to remain where they were and to avoid persecution—is constitutive of the Algerian Jews' minority group identity. It is especially particular to Jews who experienced a similar campaign of conversion during the Inquisition before being expelled from Spain and Portugal, and whose memory of these terrors and impositions migrated with them to the Maghreb.

Unlike in the fifteenth century, by 1865, the Jews were not under threat of expulsion and had no reason to reinforce their support for French secularism. Those who wrote the petition needed more Jews to sign it so they could claim to represent Algeria's Jews, and so translate it into Judeo-Arabic. The translation, addressed to local Jews, could not use the same French discursive construction—the "principles of Judaism"—that was

used to justify the conversion of Jews in France. Instead, in order to attract those local Jews who had opposed or resisted conversion (those who were not members of the "grand Jewish families") and obtain their support for the petition's provisions, the construction, "principles of Judaism," was replaced with "our holy torah."[41] Judaism didn't have principles until Napoleon invented them in France, and the colonization imported them in the form of the Central Consistory, which local Jews opposed adamantly. I won't exhaust your patience here by expressing how much I disagree with the petition, but I see the origins of Zionism's harms rooted in this appeal put forward by some in the community who claimed to speak for "the Jews." Both the Zionist project and the Frenchification of Algerian Jews relied on a small group to act as representative of the "Jewish people" and to pretend that impositions were choices made with the Jews' free will.

The differences between metropolitan Jews and Algeria's "grand Jewish families," on the one hand, and their indigenous co-religionists on the other, were irreducible to class differences.[42] The major distinction was in each group's degree of readiness to sacrifice the existing world for a new one. This didn't happen without resistance from the indigenous Jews, but unlike previous eras of forced conversion to Christianity, this campaign promised a "universal modernity" that purported to exceed the particularity of religion, a concept of political universalism premised upon a purportedly egalitarian system of infinite rewards and temptations. You are familiar with the way the republican education system was premised upon "captured infants" (תינוקות שנשבו). This secular education was understood as the key for success in this new world governed by racial capitalism, since it opened the doors for a certain upward mobility from non-European positions to passing-as-Europeans. Everything that one had learned prior to this instrumental education was devalued, as if nothing was learned before the French determined the nature of education. Republican education was the technology used to convert the colonized to the regime of capital. The use of the category *Israélite*—part of the name of the French colonial school system designed for the assimilation and embourgeoisement of Jews,

Letter 9. Gold threads, embroidery, and guilds

the Alliance Israélite—fabricated an unquestionable affinity of interests and historical concerns between different Jews, and it posited this affinity as more important than all other modes of being in the world with others.

Almost nothing was left of the world of your ancestors in the place where I was born. Similar world-destroying technologies shredded the signs that some of our ancestors tried to transmit to their descendants, making them harder to recognize. In families of *anusim*, mothers used to choose only one daughter or granddaughter "to whom the origin of the family was disclosed."[43] It was mostly for safety reasons that they chose only one. But also, not everyone could bear life under the strain of such knowledge of their double belonging, overtly to the Christian community and secretly to the Jewish one. Accordingly, genealogical information was carried by a few in order to make life easier for the rest.

No one can blame them, but I want to break the spell of silence. Once I started to talk with my female ancestors and found the legacy they were prevented from transmitting to me, I became determined to find as many signs of their presence as possible. Giving myself the name withheld from me—Aïsha—inaugurated this effort. Writing these letters, I realize that the most difficult part of this project is not only to identify the signs but also to be able to foreground and make legible their meaning outside of the recursive narratives told about the Jews: that we wanted to become modern and to be ruled by capital. Algerian Jews, who were forced to become French citizens in their own country and to renounce their culture, were *anusim*.

Dear Mme Cohen, I don't know if your parents told you the story from Fez about the man who would not buy the machine? Even if not, maybe hearing it now will resonate with other things that you heard. *The story is about a man who was working as a* ma'allemin sqalli *(the director of an atelier for gold thread preparation). One day, his son, who was "a young man, educated and evolved (évolué)," suggested that his father purchase a machine for the production of gold threads, replacing the slower workers in the atelier. He convinced his father that their initial investment would be returned in a short time. The son promised his father a future, maybe the same future that the father had*

already promised his son when he sent him to the French republican school. This was a future that already seemed inevitable, unstoppable, one that could only be adapted to. Based on his education, the son was better placed to know what to do to prepare for this future, and he tried persuading his father to follow him. The son believed that his proposal was the only way to save his family from ruin, due to the looming decline of the golden-thread industry. It was only, he thought, a question of time.

Marcel Vicaire, who worked for the French government in Morocco, and Roger Le Tourneau mention this incident in their thorough account of the craft of gold-threading: "The father gathered information and was about to place the order, but reflected on the social consequences of this initiative: several hundred people were going to be suddenly deprived of their livelihood, and he abandoned the project." The man arrived at his decision *not to purchase* the machine at the very last moment, just before it was too late. This is what I love so much about this (true) story—it reminds us that it is never too late to do the right thing. At the very last moment, the father says no. On his own, he was able to postpone the end of the gold thread craftworkers. Later, his son said, "You see? I was right." The father had the strength to tell his son, "No, you were wrong and I was right."[44]

Even if, in the end, the father had decided to purchase the machine, it would not have been too late for his descendants to dwell again in this moment of decision and to change their minds. The difference between the father and his son is of utmost importance here. What made the son educated and his father not: the son was removed from the world of his ancestors and informed by colonial knowledge that stood in distinction and opposition to his father's world and its existence. Such knowledge is future-oriented and creates opportunities that seem like they should not be missed. Though the father did his own research, which ultimately confirmed his son's vision of prosperous revenues, his rootedness in the present and in his shared world reminded him that there were seven hundred people who would lose if their work was replaced by a single machine, purchased for his prosperity alone. Only together could their resistance to new labor regimes succeed.

Letter 9. Gold threads, embroidery, and guilds

Where did the father's strength come from? From his education as a member of a Jewish Muslim world of guilds. He didn't get it from books, though he could have gleaned such a position from various *taqqanhot* and *thshuvot* (rulings and responsa) in the halakhic tradition. For example, consider the story about Joseph, Moïse, and Mardochée, who worked in the *dar as-sikka*, the Moroccan mint. There, they also practiced the *mleket al-mtarqa* (hammered-metal craft), a craft reserved for Jews in Muslim countries. A rabbinic *taqqanah* from 1750 obliges Jews, who were the only ones to make gold dinars or silver coins to fabricate them only "under the effective and exclusive responsibility of an *amin* [who is always a Muslim]." This *taqqanah* was written "for the interest of the collective" and was, according to one historian, "motivated by a concern to spare the community the damages and conflicts resulting from the circulation of currency of bad alloy," since the "charge of the currency and the administration of the mint is imposed on the community entity—the Jewish minority community, and not directly on an individual person, a notable, a finance or banking man."[45]

At the very last moment, the father decides not to convert to the new market logic, and instead he maintains his loyalty to his guild and its members. Not only did he remember the right thing to do, he also knew first-hand the damaging consequences of the actions of the *convertées*. It had already been a few decades since people first tried to introduce these machines into the mellah, and accomplishing the introduction took another few years, during which "the former workers of the gold thread who ha[d] not found another occupation or ha[d] fallen back into unemployment as a result of the worsening of the crisis, agitated and sought to revive their old profession with the support of the public authorities."[46] These machines were not tools that someone purchased and sold in order to improve the work and the conditions of work; they were technologies of destruction that made room for racial capitalism and turned destroyed worlds into *old* ones. It was never just about the manufacture of gold threads.

When the French debated the advantages and disadvantages of ruling the colonized (the "Jews") by imposing citizenship, they knew that naturalization would require finding a way to "bypass

the consent of the Jews."⁴⁷ By 1870, the consent of the Jews had already been disregarded and bypassed several times. Most precolonial Jewish institutions were already dismantled. This was achieved with decrees like the one issued on November 9, 1845, that abolished "all civil, political and administrative powers by which they [the Jews] were governed before the conquest and during the first years of our domination." As a consequence of this decree, "their *Mokdem* (governors), their *Beth-Dins* (tribunals), their *Chauchs* (executive agents) were simply and purely canceled."⁴⁸ In Morocco, which was invaded by the French almost a century after the invasion of Algeria, the conversion of Jews into French nationals was a more protracted process that was only partially fulfilled, especially since not every institution was as brutally targeted as they were in Algeria. This can help explain how stories like the one of the father and the son could happen there.

Mme Cohen, the colonizers could not destroy your world without destroying the infrastructure of local craftsmanship and without neutralizing the power of these craftsmen and craftswomen. The colonizers destroyed your world by replacing those craftspeople with people who possessed no memory of the places the French had colonized nor of how these places functioned prior to their arrival.

When I understood that this large-scale destruction took place only partially through the implementation of new laws and otherwise through the destruction of the environments in which laws were inscribed, I understood that this crafto-cide itself was an attack on pre-colonial law. *Craft was the law of the land and the formation through which it was preserved.* Plundering your world, disempowering its guardians, and furnishing museums with samples from your destroyed world, now reduced to objects, were the ways the French destroyed your laws and imposed their own, as if "French law [didn't] need a special promulgation in order to become applicable in Algeria. It followed the army and the French population, it was established with it, with the conquest law."⁴⁹

Craft was the law and craftsmen were the guardians who defended it when it was violated. Over centuries, this law, which was embodied in social-religious-legal formations stewarded by craftspeople, enabled your ancestors to live sustainable lives,

Letter 9. Gold threads, embroidery, and guilds

even in the midst of strife and famine. With military force, the French proclaimed that only written systems of laws existed in Algeria: Muslim and Jewish law (though they did not respect either). As a result, the other legal systems of the world you shared with each other—in your capacities as masons, boilermakers, tailors, trimmers, embroiderers, saddlers, stick-makers, blacksmiths, jewelers, shoemakers, slipper-makers, saddle-makers, dyers, horn-bracelet-makers, carpenters, potters, butter-makers, perfumers, grocers, skullcap-makers, tinsmiths, bakers, soap- and mat-makers, barbers, auctioneers, fishermen—went unrecognized by the French and were simply abolished. The French and the Europeans "didn't need these craftsmen who were well integrated in a given economy and society. The new style of life didn't need these manufacturers, slow and meticulous, that were indispensable to Turkish Algeria."[50]

In the introduction to a catalogue for an embroidery exhibition from the Maghreb, a French museum director wonders "how not to succumb to a certain nostalgic charm when approaching the needlework of North African women."

Monsieur le directeur, your question is rhetorical, as if your readers agree that the needlework only paints an image of the past.

Well, we disagree.

These exquisitely embroidered pieces, plundered from our ancestors, do not "invariably send us back to a past mode, to a bygone era."

They are the fertile soil upon which we resist the programming of your human factories. It is we who now turn the rhetorical question on its head and ask "how not to succumb to the desire to take back from the Musée national des Arts d'Afrique et d'Océanie what was never yours, but ours."

We will leave on the walls the small white cards with captions through which "the world of museums has given to many objects destined for destruction" their status as "works of art."

One day, like the faces that disappeared from the first photographs you seized from our ancestors, we will disappear our world from your museums; and then what will you have?

Conversion, like hyposulphite fixer, doesn't last forever.

Suspending the arrival of the gold thread machine. Illustration by Hagar Ophir from *Golden Threads*, a children's story by Ariella Aïsha Azoulay (Ayin Press, 2024). Design: Haitham Hadad.

Letter 9. Gold threads, embroidery, and guilds

Dear Mme Cohen, I didn't dismiss the reverse side of the postcard you donated. You could not stop the storm of "progress," and there was no machine that you could have refused to purchase. But you knew that your fingers shouldn't forget the craft that your ancestors struggled to maintain since the time clothing was prepared for the Highest Cohen (Priest): "And these are the garments that they shall make: a breastplate, a ritual vest, a dress, a tunic of checker work, a cap and a sash."[51] You knew the importance of keeping this craft alive, even if it would only be practiced by isolated individuals. You remembered that the commitment to protect individual artisans was exactly what had prevented guilds from becoming too powerful and from accumulating a disproportionate share of the wealth in the hands of the most powerful. This is exactly what the *taqqanah* issued in 1744 meant to achieve.[52] Defiantly continuing your embroidery was the least you could do, and you were not alone in doing so.

I don't know who the woman in the postcard is, but every time I address you, dear Mme Cohen, it is her—your—image that I see (see photos p. 362). And even though I cannot confirm that this is your picture, I know that whoever she is, she was also part of this effort. In this sense, you and a few other women are present in this postcard, even if you don't appear inside the frame. Through your inscriptions, you draw our attention away from the printed image and toward your shared refusal. Though many Jews found ways to continue practicing their ancestral professions and to cater to and care for their mixed indigenous communities outside of French economic infrastructure, from the early years of the colonization the French had stated that "the assimilation of the Jews [*Israélites*, as they called you]" into Frenchness was already more than half achieved."[53]

Not so far from where you lived and worked, there were at least five men who declared their profession as *fileur d'or* (gold thread spinner). The process of preparing gold threads, though, could not be completed by the *fileurs d'or* alone. Others, whose craft consisted of spinning the drawn gold blade with a silk thread, were also working in the vicinity. This used to be the work of men. However, if one inherited the knowledge, the leather legging (*jambière*), and the *jelda d'elyed* (leather glove) that comprised

the necessary equipment for spinning, women too could practice the profession and produce small quantities of gold thread. Is this why the name "Mme Simon" is written on the reverse side of the postcard, where we learn that you had to prepare golden embroidery on a black bodice (see photo p. 365)? The social palimpsest you activated through your inscriptions is the inheritance of the *anusim*'s children. Without this palimpsest, we could not have access to the ways you and your ancestors responded to and engaged with colonial measures. Without your inscriptions, accounts of this crafto-cide risk being determined only by what was left of the crafted products, the museumified artifacts.

It seems to me that you inherited your skill of embroidery from your ancestors, and that you didn't learn it from French women in one of those *ouvroirs* (embroidery rooms). The first thing that made me think so was that you took the trouble to write the year 1915 on the postcard near your name, as if you wanted us to know that you didn't leave it in Algeria when you left, but carried it with you until you donated it in Paris, approximately two decades after you left Algeria together with all the other Jews. I imagine that different things could have reminded you that this photograph was taken in 1915, things that may have been painful or emotional. I think about the pain you and your ancestors experienced in 1915, facing this public negation of who you were. I think about the resentment you felt when you were commended for your loyalty to France and praised with those empty colonial words for supporting the French colonial wars waged against your relatives in Morocco and the rest of the Ottoman Empire in the bloody "Great War." Already then, you knew very well that if conscription had not been mandatory, many more would have defected from the army. My grandfather, by the way, defected, and I have no doubt that it was known in the *derb lihoud*.

In addition to the stress and anxiety brought on by this large-scale colonial war, this year was also colored by the eulogies written to Mme Luce Benaben and her grandmother, who established a sweatshop in Algeria for young indigenous girls and called it a school. These eulogies ignored how these kinds of schools and workshops, where French women taught your ancestral art, could

Are You Relatives? Montage: Author in collaboration with Yonatan Vinitsky.

only exist on the ruins of your craft. This campaign of destruction also put resilient craftspeople like yourself in precarious work conditions. These eulogies, therefore, must have felt like an insult. I wonder if writing "1915" was a spontaneous decision you made at the moment you donated the photograph to the museum. Did you feel this was your one day in the court of history and that you could not miss the opportunity? With the consciousness of a daughter of the *anusim*, once I looked around, I started to see the signs you left.

The defiant postures in both these photos are not typical of colonial postcards (see photo p. 401). They remind me of myself, when I use my whole body to say:

Don't you dare tell me, "You cannot talk like this."

And I see you both stating with your body—
Yes, I can.
Here I am.

Our ancestors were silenced to the point where they had no other choice but to convert.
Their conversion materialized in their (forced) departure from a world in which we could no longer be born.

This culture of embroidery that you struggled to sustain and transmit—the know-how, the patterns, the improvisations, the cosmologies, the dexterous hands, the history—was attributed, in these eulogies, to Luce Benaben. You may have also heard it being attributed to other French women, like Mlle Quettevill in Oran or Mlle Saëton in Tlemcen. After all, there were at least a dozen lucrative embroidery establishments in the Maghreb. But Benaben's school was one of the most well-known among them. The colonizers crowned Benaben as "part of the history of Algeria" and, as the epitaph on her gravestone indicates, praised her for her contribution to the preservation of "Muslim art."[54] You knew that Benaben's embroidery work was not "Muslim art." Is this why you donated these postcards to the Jewish Museum once

Letter 9. Gold threads, embroidery, and guilds

you departed from the Muslim world? After all, you knew that it was not Jewish either, and that it was not "art" in the sense the French understood it, the product of a practice detached from the world that birthed it.

In these schools and workshops, run by French women, children were trained to work: "From the age of five or six years, young girls from Constantine show their aptitude to execute ... brilliant and complicated embroideries that are characteristics of the region. At the age of 10, they can be perfect laborers."[55] If the guilds of your grandparents had not been destroyed, children would not have been transformed into laboring hands at a young age. Nobody would have continued to write of the civilizing mission that in Benaben's school, "sewing work [was] supposed to give young girls work habits, and, at the same time, a potential means of living."[56] You knew that the best means of living came through the craft guilds, because these members, as well as their families, supported each other and helped each other balance their different tasks within and beyond their professions.

The attack on the world of crafts is a constitutive feature of colonial revolutions. The French revolution is an emblematic case, and colonization is that revolution's extension. The destruction of your life in Algeria could not have happened without the preceding destruction of the guilds and the surveillance of workers in mainland France on the one hand, and the destruction of Jewish life in France through "emancipation" on the other. The idea of a huge industrial exhibition emerged in the midst of the French revolution and is attributed to Robespierre, and it signified the revolution's great faith in industrialization, the new, the modern. This meant the mass conversion of people with diverse occupations into laborers, and the conversion of craftwork as part of caring for the world into disposable labor power.

Industrialization is not just an approach to the manufacture of objects but also a regime that requires the conversion of craftspeople from guardians of the world to laborers. A massive legalization of violence is needed to normalize this conversion and erase from memory the knowledge that machines would "steal the bread of the poor and deprive them from work." In the early years of industrialization, those who were engaged in

breaking the machines all over England and France understood their actions as "giving service to their countries"[57] for disrupting the common and ubiquitous "belief in the application of technology for the improvement of the quality of life."[58] In the face of this wave of popular resistance, grand exhibitions and colonial enterprises were efficient ways to establish these capitalist ideas as universal doxa. The first such exhibition took place in 1797, and it was followed by those organized by Napoleon in 1801, 1802, and 1806, displaying the riches plundered from Egypt. Soon, mechanization and industrialization became the norm as public debates were organized around "universal questions" like the nature of progress and the product's monetary return. Throughout these debates, a solid assumption was established: that "the freedom that had come with the abolition of guilds had allowed inventiveness, which in turn had allowed industry to flourish in France."[59] Thus, alongside armies of soldiers, imperial states fashioned armies of workers.

Finding themselves turned into disposable laborers, the former craftworkers in France revolted, wrote petitions, and organized a "solemn mass" as part of their call for the renewal of the guilds. But such calls were already inflected by the institutions and the language that had been established during the French Revolution and those that the Bonapartist regime had put in place—an "excellent system for the policing of factories and workshops."[60] In other words, even if the proponents of the renewal of the guilds in France, who had suffered a significant defeat in 1821, had won, a renewal of the guilds could have only meant the renewal of a mode of fabrication of objects and not the renewal of sustainable social formations to take care of and protect their professions, each other, and the world. Over the course of a few decades of debate between allegedly opposing camps, a universal assumption that transcended the opinions of either camp emerged: there would be no looking backward to the model of the guilds, and the triumph of universal (economic) freedom, universal education, inventiveness, and industriousness would become the horizon for all subsequent struggles, including anticolonial ones.

The conquest of Algeria in 1830 was part of the imperial triumph of industrialization that appeared unstoppable. The

Letter 9. Gold threads, embroidery, and guilds

storm of colonization didn't need any particular decree to proclaim the end of the artisanal world; the French had already assumed its irrelevance. The different decrees that were issued as ways of reorganizing Algeria into an industrialized country that worked for France destroyed the artisanal world without necessarily calling for its destruction directly, for the guilds were obstacles in the way of a "free labor market." The French arrived in Algeria having already proclaimed victory over their local guilds—as the Parisian Chamber of Commerce proclaimed, "Nothing has contributed as much to the progress of French industry as the complete freedom granted to the exercise of industrial undertakings by the abolition of guilds, masterships and corporations of arts and trade."[61]

The first attack on the artisanal world in Algeria was the mass plunder during the conquest of jewelry, tools, and gold bars. France tried to conceal the exact number of objects and gold it confiscated during the conquest, and so there are different estimates of how much was taken, based on documents and oral testimonies by French civil servants charged with inspecting the plunder. One of the most recent documented estimates was given by the former director of the Center of the National Archives of Algeria, who calculated the total theft at a value of 27,000,000 in gold francs of the time, 684 billion euros today.[62] In addition to the plunder of gold and silver coins, "jewelry, precious crockery, [and] clocks"[63] were also plundered, objects whose value has not been calculated. We know that many of the gold and silver coins that were transported to France were melted into bars, liquidating the economic foundation of the regency of Algiers.

> Above some buildings
> in Paris,
> the birds' tweets
> sound heavy metal.
>
> We do not know
> all the details
> of what happened
> to those jewels

looted from the Kasbah
and transported to Paris
in the Marengo ship,
the same ship which had already pleased the French
when they plundered Martinique and Guadeloupe.

We do know that
few of these jewels
appeared in front of the
French archivist, who was waiting
to create records
that could have been made available to us
like the other crumbs we are
served in the national archives.

We do know that
many of them
were melted down,
but we do not know
exactly how many.

We do know that,
compared to what was plundered,
what is preserved in French museums
is only a fraction of the take.
1830 is the year
when the French
looted from Algeria
its jewels
and their value
as raw material.

They closed the mint
and stopped the work.

Our ancestors' hands
didn't forget
how to make

Letter 9. Gold threads, embroidery, and guilds

those jewels,
and women continued to
adorn themselves with
as many as they could obtain.
This was their
gorgeous revenge,
falsely transformed
into an *old* style.

By dispossessing Algerians of their jewels in three respects—as crafted objects, as precious metals,[64] and as sites of shared knowledge and laws—the French minimized the importance of local jewelry-making and denigrated its products as "jewels crudely made by the natives of the city and the mountains, jewels similar to those of the savages of America."[65] This argument justified the rapid opening of a French control office for precious metals to replace the local one. I could not find information on when the circulation of gold and silver was renewed after the colonizers drained Algeria of its treasure, but I assume it took a while. Low-key activity could be a more accurate explanation for the delay. This triple attack on precious metal crafts was accompanied by a fourth action led by French scholars, connoisseurs, and entrepreneurs: the rescue and renewal of the *vanishing lost art* that they and their fellow republicans had helped destroy. This is the colonialists' trick par excellence: becoming the guardians of what they themselves have destroyed.

The art they purported to rescue was reduced by them to its style-related elements. You or your parents may have stumbled upon one of the rescuers who roamed around Algeria and Tunisia preparing commissioned reports on the jewelry our ancestors made. These scholars-cum–civil servants arrived in North Africa prepared not to see the connections between their work and the conquest's plunder. One scholar, for example, prefaced a report with a wish that his "entire work [would] contribute to the renaissance of the art of Arab jewelry."[66] What these scholars and civil servants denied was that the taste they shared for "oriental" *objets d'art* had little to do with the skills or well-being of local craftsmen but was part of a game of social distinction played by Europeans.

When I studied in France in the '80s, I was fascinated by the way Pierre Bourdieu, one of my professors, analyzed this game of taste, which the French elevated into a lifestyle. Though he spent several years in Algeria and wrote about it, he kept Algeria as a separate topic, and when he wrote about the formation of French taste and social distinction through objects, he somehow forgot that "orientalism" was a French style and ignored its role in this game of distinction. Had your craft not become, even prior to the colonization, both an object of French distinction and a source of profit and prestige, the colonizers might have left even less of your world. Don't be mistaken, I'm not grateful to them; I am just making a point about how calculated their destruction was.

> Plunder is dripping
> from the upper corners
> of French museums' walls.
> Golden residue
> makes the floor sweat.
> The barriers of silence
> are falling down,
> museum workers

The Rise of the Jewels, "Rehearsing with ancestors," fabrication / narration workshop convened by Ariella Aïsha Azoulay. Part of the exhibition *Weaving In the Inner Bark of Trees*, Archives Sites, SAVVY international, Berlin, Germany, 2023.

Letter 9. Gold threads, embroidery, and guilds

Women in Algiers in Their Apartment. Eugène Delacroix, 1834. Colonial postcard.

 are in turmoil—
 they shiver at night
 when the skulls
 they are used to seeing in boxes
 wear silver jewels
 and go out to a party.

Dear Mme Cohen, you were in my mind when I recently repurposed the map of the destroyed quarter of the artisans, drawn by Paul Eudel, who made his career as an art historian from the knowledge of our ancestors when he compiled dictionaries of Maghrebi jewels. With the help of Maghrebi jewelry I traced this part of the the lower Kasbah where our ancestors worked as craftspeople with pieces of jewelry. I invited other descendants to sit with me around the map in the recreated Kasbah, and we took back what was in the drawings of the jewelry that he signed with his own name (see p. 408).

In 1830, the French shut down the local mint, "since indigenous coins were no longer minted." They released the *amin es-sekka* from his duties and shut the door in the face of twenty-nine Jews

who were coin-minters, a profession they had practiced for centuries in the Jewish Muslim world.[67] I could not find our ancestors' stories about the attack on the mint or about the coin-minters. But I want to believe you grew up on these stories.

You may be familiar with this painting, *Women in Algiers in Their Apartment* (see photo p. 409). If we forget the title for a second, we can read it as a visual survey or repertoire of a unilateral transfer of wealth. It showcases the different types of Algerian gold and silver craftwork used by women in Algeria: clothing and shoes with gold embroidery, bracelets, earrings, necklaces, a coral-encrusted gold mirror. It can also be read as a guide for the French to identify the plundered jewelry circulating in Paris after conquest. There is more to this painting. I'm not going to bother you, dear Mme Cohen, with the details of how the painter got access to an interior in which he was not welcome. I'll just say that this is an early display of our female ancestors, who were forced to serve as an exclusive resource for French artists, photographers, and postcard merchants to depict and exploit.

In part, they did so through the production, consumption, and circulation of postcards. In 1837, shortly after this painting was shown in Paris, King Louis-Philippe I acquired enough wealth to renovate the interior of the palace at Versailles. Even today, France still has not disclosed how much of this wealth was appropriated from the gold stock of the Algiers Kasbah. In the renovated palace, the French king dedicated a space for paintings of French military victories.[68] A monumental work of art by Horace Vernet supplanted a previous collection of artifacts that had showcased the French victory over Algeria: the decapitated skulls of Algerians who fought against them.

This expansive display of Algerian "things" in the palace was a predecessor of the display of "Algeria" and its resources at the 1849 industrial and agricultural exhibition. The organizers' idea was that "a national industrial exhibition could be just the proper ritualistic event to announce the incorporation of Algiers into France."[69] Instead, Algerians were to be "incorporated" into French commerce as the French secured their violent presence in the country and declared themselves legitimate custodians of Algeria's wealth. In the same year as this exhibition, Sheikh

Letter 9. Gold threads, embroidery, and guilds

Bouzian (1848–1849) revolted and refused to recognize the colonizers' confiscatory possession of indigenous Algerian labor and fruits. He also refused to pay the increased tax on the date palm. His refusals led to a yearlong battle during which one thousand Algerians were massacred, women were raped, and the heads of several dozens of the leaders were decapitated and sent to France to be preserved in a museum. Thus, in the year when the French incorporated Algeria into their industrial and agricultural exhibition, they also exercised their right to possess our ancestors' bodies as their trophies and objects of study. The act of display became a colonial technology.

I'm trying to understand how conversion forced Algeria's inhabitants to produce goods for a global market and for a universal consumer. This market and its consumers' demands set new standards for social and commercial activity. Our ancestors, who were slowly trying to recover from the violence of the conquest and its concomitant attacks, were exposed to all sorts of changes that further destabilized the conditions of possibility for them to practice their professions. Throughout the 1840s, articles in the French press, as well as petitions to the Ministry of War written by European and French merchants and their customers, complained about fraud and demanded the establishment of a French Office of Control for gold and silver. These Europeans expected the application of the French law from November 9, 1797, to Algerian products, "prescribing the seizure of falsified works and the appearance of the offenders before the courts."[70] The law's application could make all indigenous jewelers working with gold and silver, as well as gold thread drawers, into offenders, since the gold and silver they used were alloys different from those required by French code. The French opened several inspection bureaus in the main cities, but the majority of indigenous jewelers and jewelry merchants were peddlers and could evade this harmful law. A different law and approach were needed, so in 1846, a draft of a decree was prepared, but King Louis-Philippe refused to sign it. The explanation he gave is astonishing: "This will affect the manufacturing habits and trade of indigenous jewelers," he explained upon rejecting the decree.[71] Was he caring for them all of a sudden?

It is most likely that the king was told that the type of fraud targeted by the French law was not practiced in Algeria, and so a different decree was issued on July 24, 1857, opening an office of control. However, this decree didn't stop the major type of fraud at the time, which was not practiced by indigenous people. Rather, it was practiced by French tourists, who were attracted by the "golden age of collection" of antique coins and Algerian jewels.[72] Tourists came to Algeria, among other areas, to collect different arms and jewelry for low prices that were sold for high prices to Europeans, with a promise of the objects' "Arab," "Roman," "Turkish," "Jewish," or "Spanish" origins. The mass of plundered objects in Paris cultivated this taste for "authentic" relics, and anyway, the Europeans thought, the Algerians "d[id] not care for their history" and would not miss the objects they sold so cheaply. This was an invasion of Algeria enacted by collectors, equipped with classificatory categories foreign to local communities, who seeded the fraudulent enterprise. To protect the "public and the treasure" from fraud—the "public" here signifying European tourists and settlers—a system of punching jewels with the mark of French warranty was put in place, alongside a system of written sale records that became mandatory for the jewel trade. These laws disregarded the fact that many of the jewelers were illiterate or at least lacked the ability to read and write in French.[73]

Unlike in France, in Algeria most of the jewelers were peddlers. They went from village to village and had intimate, personal interactions with their clients. Still today, I hear stories from Algerian, Moroccan, and Tunisian friends about their parents or grandparents, who told of how they used to go to the Jewish jewelers to prepare wedding trousseaux and all kinds of protective jewels. Conversion to the secular French marketplace obliged the jewelers to relinquish these intimate relationships in order to become, along with their clients and suppliers, part of the French colonial surveillance regime, required to fill out records for each item manufactured or sold, including an itemized description, the number of pieces produced or sold, the item's weight, the item's measures and alloy, and the disclosure of the identities and addresses of buyers and sellers.

Letter 9. Gold threads, embroidery, and guilds

The treasure chest of the colonial government filled up with money as value was legally extracted from the local population through commandeering goods and issuing fines for not adhering to new laws. In a report on the operation of this office, its former chief controller was thanked for his dedication to the "public interest" and for his success in collecting, "all by himself," a huge amount of tax money—over 91,201 jewelry items—from the department of Algiers. This same controller is the author of a guide for consumers, commissioned by the colonial governor and showcasing 157 pieces of our ancestors' jewels considered to be "the most generally employed," each depicted with explicit visual instructions on where to look for the punch mark of French warranty (see photo p. 226). Of course this catalogue of jewels—"which are the delight of many tourists and winterers frequenting Algeria during the summer season"[74]—was made for the use of Europeans, since our ancestors didn't need to be told whether to wear jewelry on their necks or on their ankles, or which item might conjure the evil eye.

I could not find written petitions by jewelers against the new measures imposed by the office of control after 1858, but I did find traces of the inspiring ways they sought to bypass the regime's impositions. Some of these peddler-jewelers continued to make jewels in secret, using the same tools and alloys and selling them to their peers, indigenous clients who did not require the French punch mark. Here, we see the trust between jeweler and client rebuilt as, together, Jews and Muslims continued to cherish jewels made of their own ratios of metal. Until the Jews had to depart from Algeria as a consequence of their forced colonial naturalization, the Jewish jewelers' clients, both Jews and Muslims, reached out to them when they needed money, and "as a pledge, they gave them a package containing their jewels."[75] The jewels were probably not made of the French standard alloy but of the one familiar to Algerians, who for centuries had had their own ratios and a variety of ways—not just one!—of recognizing alloys. Have you ever heard the name Aron Akoune? He was known for his special technique of provoking the smell of copper by rubbing pieces of precious metal together and estimating its portion within the object. He was not the only one who did so, and his

Grand Place d'Alger, 1830. Painting: Colonel Jean Charles Langlois.

was not the only technique used by our ancestors to evaluate precious metals. This knowledge that our ancestors possessed had to be destroyed in order to allow the imposition of the European method of inspection and its universal standard. Like all types of colonial knowledge, their methods were premised upon reducing human encounters with the world by privileging "objective" and "scientific" forms of observation and estimation.

Of course our ancestors, who experienced the destruction of their *souk es-seyyâghin* (the jewelers' market), where most of the Jewish jewelers lived and worked before the invasion, resisted the imposition of this single system of warranty. I wish I could hear all their creative ways of refusing it, told in their voices and with the details that they would have chosen to include. But in lieu of this, I take some revenge in gleaning their forms of refusal from between the lines of colonizers' records of the jewelers as "offenders" of the new laws. I love thinking about those jewelers who allowed the controllers to mark items with the punch without altering their mode of fabrication. I can imagine the collaborative thinking that was involved in finding a way to patch a punch on pieces of jewelry that ended with rings by "unsoldering and resoldering the punched part."[76] Others brought only half of their jewels to be punched by the office of warranty; when the controllers visited them in their ateliers, they said that the other jewels were

Letter 9. Gold threads, embroidery, and guilds

"just a deposit" from clients.[77] They didn't cheat, nor were they cheated in their transactions. They adhered to their own system of jewelry-making and banking from before colonization, a system shaped during the time of the Ottoman monetary system. In this system the value and alloy of coins could be changed according to circumstances and as needed.[78] The only response of gold-thread drawers to the establishment of the control office that I could find is contained in the brief lines of a report in which they asked for permission to continue to work at home and to use gold bars with an alloy different from the one imposed by France, which was the only gold their tools could properly work.

As you probably know, dear Mme Cohen, the French attack on the *habous* was not unrelated to the destruction of guilds. The *habous* was an institution where property was held publicly and was to be used only to benefit pious work or for general utility work, a usage and ownership system that was inalienable. *Habous* structures were central to the life of local communities and served as barriers against the movement of capital. There was not much left of the *habous* in Algeria after the French arrived. And memory? After a while, when the destruction had been successful, the French started to turn the "past" into another resource, an object of exploration, study, cataloguing, preservation, and display. Yet within this past, there remain residues of what they haven't yet destroyed and of what they failed to understand. Colonizers organized our ancestors' crafts according to a typology of fabricated identities, and this typology was reified by the affiliation of different crafts with different regions, colors, and styles that were only meaningful in light of the colonizer's brutal mastery of the "whole." How amputated is this memory, abetted by the colonial categorization of our ancestors' crafts?

Those "traditional" dresses that were captured in postcards in the late nineteenth century should alert us to the existence of other dresses whose disappearance the "traditional" ones mark: the dresses that were prepared in bab-el-Oued, in the area of *souk es-seyyâghin*, which was demolished together with the Mosqué Es-Sayida and almost five hundred houses. Upon these ruins, the central square of Algiers would eventually be built. When they worked in this *souk*, the hands of our ancestors were skilled but

not yet disciplined. The threads they used were soaked in the love of their neighbors. Their patterns were not yet fixed on paper but expressed the fluctuations of their soul. And the differences between dresses were irreducible to the fixed categories that the French indulged themselves in identifying. The labor put into the dresses was not quantified only according to profit. And our ancestors could spend as much time as they needed on each piece since their goal was simply to make a living and not to maintain the bureaucracy of globalized empires or feed a global consumer market.

The removal of the sculpture of the Duc d'Orléans from the central square of Algeria in 1962, as part of making the square Algerian *again*, was a commemorative act that is a bit misleading. The square was never Algerian. It was colonial to begin with. Likewise, scholarship pertaining to the dresses with gold embroidery that museums' catalogues promote is part of a colonially sponsored amnesia making us forget how, even when the name of the square is changed from something like Place du Gouvernement to Place des Martyrs, we are not yet standing in the *souk es-seyyâghin* burried underneath.

As French colonizers destroyed this infrastructure of collective art-making, they also imported their colonial conception of art. In 1907, a French art critic was commissioned by the general governor of Algeria to produce a report on the "arts and industries of art." He started his report with a recommendation: Algeria "needs to have its own art." This meant a full disregard of our ancestors' modes of making art, since only what the French considered "universally" to be art could be art. The critic clarified his point by saying that Algeria needed to "generate *expressions of its life*, the ideal emanation of its soil and its spirits," and that this could be achieved only through tutoring by French artists and the influence of "those who will come to settle in." The collective art-making of our ancestors could not be considered "the emanation of Algeria's soil and spirits," because it was not shaped by the French, was not based on individual distinct artists, and was not interpreted along a linear timeline of progression defined by the colonial fiction of art history. The French art critic was aware that his philosophy of art would cause further harm to the local

Letter 9. Gold threads, embroidery, and guilds

formations of art-making. Nonetheless he found it a necessary price to pay in order for Algeria to have, like other nations, an art of its own. The newly imposed idea of art helped European artists "feel at home"[79] when they arrived. Accordingly, a French scholar of art could ruminate on how to "choose the right methods for the classification of *my* buildings [edifices]" when he actually refers to 176 buildings "devoted to worship" that were in Algiers before the French demolished 129 (!) of them.[80]

Imperial temporality is evasive. It requires a strong and continuous resistance to put things straight and to say that not only are the dresses worn by the women in the postcards *not* old, but they are the outcome of the long labor of refusing to let this craft die. As the colonizers understood the monetary value of the "extinct and old" in relation to objects, and as they had already put our ancestors on a timeline of progress from old to new, the destruction of our ancestors' world could be monetized through their postcard industry, among other methods. Once we understand the factors at play in the postcard industry, it becomes obvious that no matter how photographers wanted to present these women, their way of life was not "old," and what they wore was something that they sought to protect from the colonizers and to keep in their lives.

From the moment I looked at the postcards you sent us, I saw the women pictured as part of a long procession of anticolonial resistance. I saw your dresses being made and worn, rather than posed in. Forty-five years after they forced you to be French, many of you said with your bodies: "We are who we are! We are not French!" Your *shahal* is exquisite, and I wonder if it was done by the renowned jeweler Amsalem, or his father? All these postcards of "old Algiers" or "old Oran" are deceptive—they are from the late nineteenth century and not the beginning of the nineteenth century, prior to the colonization; and yet, despite the colonial violence meant to cleanse colonial times of your refusal to let go of this world, we recognize in these postcards your continuing refusals, now, in our present.

Yours,

Aïsha, the granddaughter of Aïcha Cohen
who lived at 3 rue Tafna until 1962

Letter 10. Between European Jews' experience and ours

A letter to Hannah Arendt

Dear Hannah,

I know this letter is an interruption, and I apologize. I need to talk with you about Algeria—yes, I read the single short text you wrote about Algeria—labor, work, family, citizenship, and a few other things.

I began my unlearning journey as a student of your texts. I used them to unlearn the identity I was given in the human factories of empire, and I embraced them as a substitute for the absent voice of anti-imperial or anticolonial "elders" I didn't yet know existed. You see, when I first read your work, I was surrounded by adults who had failed to protect their children from the assembly line of the state in which I was born, which prepares children to become citizens in its image, conscience-less colonizers. This letter is not intended to be an academic engagement with your work. I will allow myself to say briefly all the torah, all the instruction for living with others, that I learned from your book *The Human Condition* was for a long time the substitute for my ancestors' voices. All this torah is encapsulated in three terms that you elaborate: first, labor, from which we cannot liberate ourselves, hence we should find bliss in it; second, work, pursued with our hands, essential for world building and world caring; and third,

action, which defines our relationships with others as a series of never-ending inter-*actions*.

As I was manufactured in a human factory, this torah was my life raft. I spent years unlearning my "Israeli" self and detaching myself from the mold that the Israeli state cast me in to legalize their expropriation of Palestine from Palestinians. With Palestinian companions, I learned that the violence was constitutive of Israeli citizenship. Your writings helped me to understand the role political theory and its imperial attachments played in denying the existence of a worldly sovereignty in Palestine prior to 1948, and to reclaim our right and duty as Jews to participate in its "return."[1]

Once labor and work are introduced into political theory, as you demonstrated in *The Human Condition*, they can index the effects of imperialism. That is, when labor and work cannot be practiced in a given context, we have to recognize this as a clear sign of imperial and colonial violence. Though you didn't say this, and you did not discuss what happened to labor and work under imperialism, I analyzed imperialism with you in my book *Potential History*. I used your discussion of these three domains of the *vita activa*, the active life—labor, work, and action—as one uses a metal detector to find lost jewelry in the sand. I thought with you earlier as well, while I was writing my book *The Civil Contract of Photography*. That book was premised on a refusal to recognize photographs as private property and photographers as owners of images, and it emphasized the always-plural event of photography and the rights of the photographed persons. My questioning of photography as a craft was informed by the presence and interventions of photographed persons in the event of photography—that is, my questioning was informed by recognizing their labor, work, and action. Recognizing the rights of the many who participate in the event of photography to undo the "pastness" of the photograph was how I first experimented with what I call a "historical fiction."[2] The anti-imperial commitment implied in this fiction became explicit in *Potential History*, which is premised on a refusal to recognize the existence of the major pillar of historians' work—the *past*.[3]

This work of fictionalizing history, or of bringing back to life those who were made past, is not a way of inventing facts

Letter 10. Between European Jews' experience and ours

but rather undoing what solid fact had repressed. It is a joyful effort—though not free from pain—of foregrounding facts that seem invented, unlikely, or implausible, only because the narrative structures we were born into prepared us not to notice these facts, to judge them as delusions and dismiss their persistence as errors.

Can you imagine, dear Hannah, that even on his death bed, my father hadn't planned to tell me that all his life he had been withholding from me the name of his mother, Aïcha?

Can you imagine, dear Hannah, how ashamed he must have been of her name, which was forbidden to French citizens, and how extensive his loyalty training was, so that he was willing to pay the price of depriving his daughters of the sound of his mother's name, of knowing, inheriting and passing it on?

Not even once did the name come out of his mouth.

Are the unfamiliar pain and the unexpected fury that I felt when I discovered this actually his?

An unattended, intergenerational wound, which I didn't know existed, erupted. For years, I felt defined by one imperial project, that of the colonization of Palestine. But suddenly, my feelings were transposed also onto another: the French conquest of Algeria in 1830. In the background of this conquest was an enigma: Who were my ancestors before they were colonized? The onto-epistemological challenge that this question raised points to how we might reject the historiographical power of the Crémieux Decree, which imposed French citizenship on Algeria's Jews, removing my ancestors from the history of Algeria's colonization and making them available for sacrifice when Algeria was finally decolonized in 1962. Their removal from the history of colonization made them, made us, captives of a European history of assimilation and progress—a progress that is realized in the imperial state proclaimed in the Zionist colony—and whose Jewish citizens are denied the knowledge that can lead us to revolt against their, against our, condition of captivity.

A while ago, when I was still living in the colony and had begun to explore the destruction of Palestine in 1948, I thought that I

was doing the unthinkable in Israeli Jewish society: questioning the legitimacy of the state. Later, when I refused to recognize myself in the Israeli identity, I understood that *this* was what was truly unpardonable. Dear Hannah, people I knew for a long time stopped speaking to me. I was not only betraying the state and its imperial sovereign power but committing an act of treason against "my" people—as if the manufacture of this people by Zionists were not itself a betrayal of diverse forms of Jewish life now deemed unworthy of existence by comparison. Thus, with the creation of the state of Israel, the threat of *being lost to the Jewish people* through assimilation or conversion became the threat of *being lost to the Israeli people*. For that to happen, "Judaism [had to] be cast off"[4] and then enacted on a state scale. Now that the state defines itself as Jewish, Jewish life in its diversity is disavowed, and "assimilation" means becoming a people like all other peoples, with the right to self-determination ensured by their own nation-state.

What follows from this acceptance of the progress narrative and the nation-state form is a development into imperialism, the belief that a state has the right to sacrifice other groups. Thus, the dispossession of Palestinians—and their transformation from neighbors and guardians of the land into enemies—was made necessary to fashion these neo-Jews, or perhaps more accurately neo-Christians (since this identity is premised on the racial capitalist Christian project of the Enlightenment), who would come to be known as Israelis. Israelis are a Jewish mutation engendered by the European invention of the Jewish question on the one hand and the invention of the question of Palestine on the other.

The tragedy that the double project of conversion wrought upon Algerian Jews (first by the French and second by the Zionists) is that, as you wrote in relation to the condition of Jews in Europe at the beginning of the nineteenth century:

> Judaism could not be cast off by separating oneself from the other Jews; it merely became converted from a historical destiny, from a shared social condition, from an impersonal "general woe" into a character trait, a personal defect in character.[5]

Letter 10. Between European Jews' experience and ours

The present not only accentuates this point but tragically reveals how difficult this conversion is to reverse. What makes it tragic is that contemporary opposition to this generations-long conversion doesn't change the reality that almost nowhere in the world today could being a Jew mean collectively more than "a defect in character or, at times, characteristic advantage." You observed how this condition materialized at the turn of the eighteenth century in Prussia, looking to Rahel Varnhagen, to whose life and milieu you dedicated an entire book. In your study, you sought to understand the condition under which Jews came to experience their Judaism as "an unfortunate personal quality." Varnhagen was willing to assimilate (though without being baptized). "People like us cannot be Jews," she thought, or at least this is how she understood herself. However, you seem to doubt her claim when you ask, "But was Rahel really prepared to take all the consequences and radically extirpate her own identity?"[6] Without quite replying, you attend to the ways she lived as a conscious pariah. Importantly, you don't treat her lifestyle choices merely as personal decisions, but explain the historical circumstances under which these choices became matters for personal reckoning:

> Deceptively, the Jews had been lured out of their two-thousand-year-old badger-hole. Their lives had been poisoned when they were inoculated with the poison of ambition, which in the end led them desperately to want to attain everything because they did not receive the simplest rights such as "peasant women and beggar women"—and were not even permitted to say so. Rahel had fought for this stolen "natural existence."[7]

Dear Hannah, assimilation was a real question in your world, Europe, but it was not a question that pertained to my ancestors prior to the invasion of the French. And when I was born in the Zionist state, I was told that the question had already been resolved because the Zionists had forced others to assimilate. I am struggling to recover our ancestors' refusal to convert, their questioning of the bargain that imposed on us certain rights in exchange for being "rescued" from our "conscious pariah" state

and silencing doubts about our imperial conversion.[8] As I said earlier, there is no longer a place where descendants of Muslim Jews, we Jews who once shared a world with Muslims, can de-convert and revert to our former existence. Thus, while I entered this epistolary engagement with the conviction that I would be able to avoid *once upon a time* narrative structures, I sometimes ask myself what point there is in saying "it is never too late!" when there is so little left of the Muslim Jewish world. These two colonial projects, the French and the Zionist, nearly emptied Africa and the Middle East—save for Palestine—of its Jews.

After I fell prey to the belief that I had no "Algerian" possessions—no objects, memories, tastes, songs, habits, or language—I was angry at myself for not having revolted earlier against this imperial deception. After all, it simply cannot be that the factories of nation-states could completely rob one of one's ancestors. Through these letters and through copying my ancestors' crafts, I started to ask myself, *How might I remember what was not transmitted to me?* Is it truly lost forever? Exploring moments in the long history of the Jews' forced conversion brought me to what my father and our family in Oran experienced on October 8, 1940, when their citizenship was taken from them by decree in Algeria. Were they reminded of the forced conversion of their ancestors in 1870, also achieved through a similar gesture of paper violence? In 1940, were they already (partially?) deracinated from their indigenous condition? What remained of their indigeneity during the first decades of colonization that was then turned against them as a penalty by the colonial regime? By 1940 many of my ancestors' indigenous modes of life were already destroyed, lost, and prohibited; others were made "past" and "uncivilized." Many of the objects that constituted their indigeneity were already held captive in the basements of French or other European museums, and most of the indigenous population at that point no longer knew how to make more of these objects or to bring the crafts of their ancestors home.

My father didn't leave letters or an intimate journal. In a way, your short text on the abrogation of the Crémieux Decree in Algeria, published on April 23, 1943, was helpful in that it enabled me to speculate about the black hole in the narrative of

Letter 10. Between European Jews' experience and ours

his life in Algeria, both before and after the Vichy regime. It also helped me to mourn the world of my ancestors. Their persecution began at the moment they were forced to recognize themselves and be recognized in this worldless category of "Jews," a category that required the destruction of the inconsistent, incompatible, irreducible, unsuitable, and ill-matched forms of "being a Jew" that had existed prior. Had I read your text "Why the Crémieux Decree Was Abrogated" when my father was still alive, I could have had more tools to make him speak about his own experience.[9] But I came to your Jewish writings late.

For years, I avoided engaging with "Jewish" things in my own scholarship. Even when I studied the differential model of citizenship shaped by the French Revolution, I glossed over the fact of France's denial (and subsequent "extension") of citizenship to the Jews in the wake of the revolution. Rather, I focused on the mechanisms of exclusion and the belated inclusion of two other groups of governed subjects: Blacks and women. My choice of focus was, I think, a way to protect myself from the damaging and alienating effects of Judaic Studies' claim to produce a history of "the Jews" as a relatively cohesive object of study. The internal hierarchies between the groups that the field claims to represent, as well as the way the field is entangled with both Israel studies and Holocaust studies, seem to make European colonial crimes against non-European Jews and the crimes that the state of Israel perpetuates against Palestinians and Muslim Jews tolerable, justifiable, or outside of the discipline's purview.

But in retrospect, it appears that my reluctance to engage with Jewish "things" was also the result of an inherited but seemingly newer model of the Enlightenment trap that you describe: "Naturally one was not going to cling to Judaism—why should one, since the whole of Jewish history and tradition was now revealed as a sordid product of the ghetto."[10] Being colonized by European Jews and by modern art (yes, it is an agent of colonization, but I won't expand on that now) meant my assimilation first began with the acquisition of my "natural existence," as you call it, among "Jews." It meant "always having to represent oneself as something special."[11] What I grew up thinking was that my mother tongue of Hebrew actually was, and still is, the language

of my assimilation. It still hurts to recount that the Hebrew language, praised for its rebirth, was actually the language by which our vocal muscles were trained to forget all the other languages that my ancestors spoke—Ladino and all the variety of Judeo-Arabic, regionally specific.

Despite these affinities between the European experience and ours, and despite the story of assimilation imposed on "oriental Jews" (as you saw us), assimilation was actually a process of forced conversion. The Jewish Muslim world of my ancestors was turned, by the very same gesture of conferring colonial citizenship upon the Jews, into a non-Jewish world, making their deracination acceptable and justifiable. The production of the de-coupled "Jew"—not the Algerian Jew, the Egyptian Jew, the Palestinian Jew, but just the "Jew"—became a source of a multigenerational malaise.

The name Aïsha is my amulet. It guides me through the colonizer's labyrinth of destroyed worlds, erased identities, and new promises of colonial citizenship. *Lose your father,*[12] who embraced colonial citizenship. Maybe. But why lose my female ancestors? Why were we asked to let the Algerian witch Sycorax be depicted only by Shakespeare, who hated and denigrated her in his play *The Tempest*? Why were we asked to forsake other Algerian witches and comply with their disappearance from history books, rather than learning that Shakespeare distorted the story of the real Algerian witches who used their powers to destroy the fleet of King Charles V in 1541 and so halt his plot to invade Algeria?[13]

> Why abandon my dreams? asked Abdellatif Laâbi.
> Did I already encounter
> the person
> or the people
> whom I could
> confidently trust with them?[14]

Since I began calling on my ancestors and asking them to side with me as I try to remember who they were before they were buried under the wreckage of two successive colonial projects,

Letter 10. Between European Jews' experience and ours

my palate has sweetened. One day I might even be able to pronounce the sounds of the Arabic language, stolen from me, or at least pronounce them with less effort. If, at the end of the day, "the Jews" had not been forced to capitulate (twice!) to a belief that citizenship would protect them, I would not have had to distance myself from "Jewish" things or from my mother tongue. I might be able to speak it again through Arabic, echoing my ancestors' way of writing their language, Arabic, with Hebrew characters. I would not have to labor in order to call my ancestors; their sounds and tunes would already be within me. But I was born to be a member of a colonially crafted and differential body politic, which is not only a legal conundrum, a "juridical schizophrenia," but also the subjectivity we inhabit.[15]

You were already living in the United States and researching what would become *The Origins of Totalitarianism* when you learned that in addition to the revocation of Vichy legislation in Algeria following the landing of American and British troops, the French Colonial General Henri Giraud also abrogated the Crémieux Decree. You published a text on the matter in the American Jewish journal *Jewish Contemporary Record* in April 1943, whose editors invited readers to learn the story behind the story. Without international pressure on the American and the British, who were preoccupied with imperial strategic plans rather than caring for the indigenous population who suffered under the Colonial Vichy regime, the Crémieux Decree would not be restored. Your text analyzing the history of the decree and its revocation played a major role in the American campaign to restore the decree—and thus restore French citizenship to Algeria's Jews.

Only recently did I come across a long and unsigned brief that includes a few parts of your published text on the revocation of the decree. Recognizing those few passages extracted from your work, I first assumed that you had written the brief, but as I continued reading, it became clear that its author could not have been you. A friend referred me to a book that attributed this brief to someone who worked in the American Jewish Committee (AJC), but the author of the book doesn't provide any background information as to why it circulated unsigned, nor about the relationship of the author to the text.[16] I was astonished

to see how your work could be incorporated without reference, while male writers are quoted in this brief with their full names. I was relieved though, since the language used in the brief, especially regarding the law and the past, was revolting and unlike the language in your other writings that I know well, even those with which I disagree.[17]

When something troubles me in your writings, I often use other parts of your text to counter you, to open doors you avoided, to invalidate political institutions you hoped could be corrected, and most importantly, to approach the life of Jews in Muslim countries beyond their stereotyping as "Orientals." Figuring out what bothers me in your writings usually doesn't require more of my effort than does finding what troubles me in Frantz Fanon or Sylvia Wynter's writings. When it comes to my ancestors in Algeria, I ask myself what hurts me more: that Fanon assumed that my ancestors, like all of Algeria's Jews, were European without recognizing the violence involved in affiliating them with their colonizers; that Sylvia Wynter incorporates "the Jews" into the Judeo-Christian tradition, ignoring both what Christian states did to Jews and the fact of forced assimilation; or that—drawing only upon French statesmen to formulate your argument—you explain how the Jews were made citizens because, "unlike Muslim natives, [the Jews] were closely linked to the mother country through their French brethren"?[18] Writing these letters is an opportunity for me to return to these discomforts and to engage with all of you, my dear elected kin; it is an opportunity to be with you here and now, as equals—not to criticize you, but to invite you to reconsider what you could not see at the moment of writing. This ought to be possible in the shared spaces opened up by this epistolary engagement, a space not dictated by the past and in which we all agree that imperialism should be undone.

I mention Fanon not only because I also wrote a letter to him (and to Wynter), but because I think you were wrong when you failed to see how his "deeper hatred of bourgeois society," as you described it, was part of why he was "inspired by compassion and a burning desire for justice," sentiments that you attributed to the "conventional left."[19] On the contrary, these feelings of his were one and the same. I don't think it was "hatred" but

Letter 10. Between European Jews' experience and ours

rather a refusal to accept the colonial institutions built by the bourgeoisie to protect their colonial plunder as a fait accompli. You recognized this colonial plunder when you wrote that for Algeria, "the result of this daring enterprise [French colonialism] was a particularly brutal exploitation of overseas possessions for the sake of the nation." But you pardoned the bourgeoisie, as you saw in the French colonial project the Roman model of empire, one you thought less harmful than other forms.[20] You believed that justice could be achieved through the institutions the colonizers imposed, and this is why a large part of your argument draws upon statesmen's writings, from those who shaped and ran these institutions. Your vision was narrowed by relying only on the words of statesmen, political theorists, and political philosophers. The language employed to build these institutions, which primarily served people of a certain class, race, color, and religion, was misinterpreted as "universal," i.e., transcendent with regard to the particular interests of different groups. This claim to universalism should not be our guide to "human solidarity."

In response to imperialism, human solidarity cannot be built without three elements: the cessation of imperial crimes, their acknowledgment, and a commitment to repairing their damage. You knew this. You wrote about it in *Eichmann in Jerusalem*, but the repair you believed necessary was legal in nature. But what of the people? You were involved in the restitution of books plundered from Jewish communities after World War II, and you did your best to keep some of them in Europe, away from the Zionists on the one hand and the Library of Congress on the other; you wrote about forgiveness within interpersonal relationships; but you didn't think Europe should pay for its imperial crimes or work hard in order to be pardoned for them. Why not? I still cannot fully understand how the Jews could pardon Europeans and see them as civilized allies, how Jews could agree to move on as citizens of imperial regimes that had persecuted them and others without seeking to abolish the laws and institutions that enabled their imperial crimes. Why didn't you engage with this question? Don't you believe that a substantial transformation of citizenship, for example, is needed in order to bring this history to a certain closure?

Do you understand, dear Hannah, that the world we were born to inhabit only grew into a bigger monster, and that this cruel form of repair offered to the Jews—"gifted" by Euro-Americans with the establishment of Jewish nation-state, based on a differential European model—only inflicted on this group muteness? It seems so natural that your *Origins of Totalitarianism* would end with a call for repair, or would be followed by a sequel dedicated to such. Were you concerned that asking Europe to be accountable and pursue repair would lead to another "sectorial struggle" devoid of the goal of "human solidarity"? But dear Hannah, it was the ruse of a universal "human solidarity" that facilitated imperial crimes in the first place! When we refuse to forget that each society was organized differently prior to the colonial destruction, we have to acknowledge that only because those sets of ungrounded principles were bereft of ancestors' wisdom and worlds could they be imposed as the only just way of living with others. Hence, no use of this ungrounded language or promotion of this imperial ideal could have successfully substituted for those three indispensable principles: the cessation of crimes, acknowledgment of the violence, and reparations for their victims as defined by the victims. Together, these principles could transform the premises of the law. Without them, we are stuck in the world organized by imperialism.

In your critique of Fanon, you accused struggles for these anti-imperial principles of being "sectorial"—meaning they had no universal conception of the whole of society. It's true that those who struggled against French colonialism did not necessarily have a concept of communal life that included their perpetrators. But they knew *their* pre-colonial communal life was attacked and they had a burning struggle to wage (not necessarily a burning hatred, as you say). They knew that when true justice was granted, the institutions that had perpetuated these crimes would no longer operate in the same way.

You see, dear Hannah, as much as I disagree with your critique of sectorial struggles, in considering how the Jews were forced to depart from independent Algeria in 1962, I agree with you about the danger of not having a vision that exceeds the sectorial, which in this case became Arab and Muslim nationalism.

Letter 10. Between European Jews' experience and ours

I'm thinking about the Algerian revolution led by the FLN. It was a stunning struggle against colonialism that ended up as a negotiation between "two sides," according to the way imperial international politics and diplomacy operate. For the Algerians to be a "side," they were forced to become a nation-state, based on a differential body politic where Arab Muslims incarnated the state. Thus, the anticolonial struggle that started in 1830, which preceded the FLN and involved diverse indigenous groups, including the Jews, gradually became a nationalist struggle for Arab Muslim independence. Algeria's Jews were cut out. It is not surprising that the struggle for the decolonization of Algeria became sectorial, as colonization was designed to divide the local population and rule it differentially; part of colonialism was the importation of narrowed forms of politics, categories, and knowledge to the colonized. The wrongs done to people targeted by the "daring enterprise" of colonialism do not simply disappear. Their consequences linger. We don't need to know the cause of our democratic regimes' "failure to repair the collective trauma that haunts our societies like the phantom limb of an amputated body" in order to know that citizenship is not the cure.[21]

Colonized and persecuted people cannot encounter justice in the same institutions that were built to prevent them from demanding the return of what was taken. You knew it when you wrote *Rahel Varnhagen* and when you wrote this short text on Algeria published in 1943. The serious problem, as you write in the latter, was that upon entering Algeria, the French realized that they could not assimilate the local population all at once. It is painfully clear that in writing this, you were thinking only about Muslims, whom you recognized as being too proud of their "old and rich tradition" to concede to France's assimilatory technologies. You ignore, or perhaps deny, that an opposition to conversion also existed among my Jewish ancestors. Here again, your sources and informants are European Jews, who were already converted by and incorporated into European institutions. You knew that these same Jews forced our ancestors to leave their culture; you describe how the French consistory assumed "the responsibility of overruling native rabbis" and you

acknowledged that what the French defined as "personal status" allowing "Jewish indigenous [people]" to stay under Mosaic law was "not very different from the customs of their Arab surroundings," Arabs for whom personal status meant staying under Koranic law.[22] Calling this "Arab surroundings" denies that our ancestors were themselves Arabs!

When you wrote about these French Jews "overruling native rabbis," I wonder if you meant to imply violence or if you were providing a neutral description of a process you thought necessary for Algerian Jews' salvation? Despite this ambiguity, I'm grateful for the care you put into transmitting such accounts of (what I see as) violence and into tallying the cost of assimilation. Even when you understood these costs as acceptable ones, you accounted for them out of a sense of responsibility to inform those who would follow you. Without your account, we'd have even less information to explain what our ancestors suffered to survive "the benefits of French civilization."

What would I have done in 1943 if I were you and had to face the fact that imperial citizenship, forced upon my ancestors in 1870 and the source of our *malheur*, was not to be restored, even though the Vichy regime was overthrown? What would I have done, knowing that once citizenship was ripped from Algerian Jews, their lives were put in danger? Dear Hannah, I had to ask myself this question and find my sincere reply before I continued writing to you. I think that I would have done the same as you and written a similar essay to yours, especially considering that your text may have been meant to accompany a legal brief whose goal was to contribute to "the cancellation of the abrogation of the Crémieux Decree."[23]

As you already know by now, I am one of those "Oriental Jews" you described in the letter you wrote from Jerusalem when you attended the Eichmann trial, a description exchanged among Europeans (from you to Karl Jaspers): "They speak only Hebrew, and they look Arabic."[24] Most people don't perceive me as an Arab-looking person, whatever it is you meant by that. However, as long as I lived in the colony, there was no doubt that I was not one of the colorless people—Ashkenazi Jews—who felt at home in the country they built for themselves in other people's lands.

Letter 10. Between European Jews' experience and ours

(Just briefly, as I don't mean to deviate: your fierce opposition to the creation of a state for the Jews in Palestine was extremely valuable to me, as such a voice was rare in the colony.) In the United States, being a Jew is almost automatically conflated with being the descendent of a "European Jew." Since moving here, most people assume I am a "European Jew" before I find myself explaining their error. I hate it when people assume that I'm a European Jew, and I also hate explaining that I'm not part of this story but rather its victim, as Ella Shohat describes in her text on "Zionism from the standpoint of its Jewish victims."[25]

My father was not part of the Zionist-provoked mass migration from North Africa and the Middle East to the Zionist colony, and so he was not subjected to the humiliations visited upon those who migrated as an Arab-identified group. In fact, to my father—who adopted the French cultural identity as his own—those migrants were indeed "Oriental Jews," from whom he distanced himself. In a way, they were the mirrored reflection of himself he didn't want to see. They, however, had each other and a community life with elements of the Arab culture to which they belonged. Upon their arrival, they were sent to inhabit the Zionist "new towns" built as part of the colonization of Palestine. My father, on the other hand, arrived in the colony with the self-consciousness of a Frenchman, which somehow shielded him from fully understanding, when he was approached in a condescending way as a North African, situations that I could not ignore. He was determined not to be treated as a lower-class citizen, even if it required self-deception and a denial of his ancestors and himself; as much as he identified as French, he could not completely shed the imprint of his Arabness.

He was, indeed, technically or "aspirationally" a French citizen, but you know very well how fragile such citizenship could be. On November 8, 1942, when the British and American armies landed in Algeria and Algeria's Jews hoped that their citizenship (revoked two years earlier) would be restored, you were working hard to make their demands legible to Euro-American institutions and statemen. Similarly to those leaders and lawyers in the civil rights movement in the United States, you were fighting for Algerian Jews to gain the rights that Jews had already acquired

under these imperial regimes. Without these rights, you knew their lives were at risk.

Algeria was one of the first places where Nazism was defeated, and the first place where Jews could regain their civil rights. When the Allies landed in Algeria, my father was in an internment camp. I assume that the news about the Allies reached the camp, and that hopes of liberation rose among the internees. As you were following the situation of the Jews in Europe, your attention was probably diverted to Algeria as soon as the Allies landed there. You must have felt a sliver of hope, expecting that the racial laws might be abolished, but those feelings turned to dread soon after. In March 1943, just a few months after they landed, it became clear that the deceptive acts of General Giraud, backed by the Allies, were actually what you called the "re-enactment of the Vichy laws." That day the French High Commissioner in Algeria issued several ordinances on Jewish rights. Read separately from the rest, one of these ordinances could have mistakenly given the impression that Jews' rights had been restored: "All legislative and administrative acts, subsequent to June 22, 1940, which include discriminations for reason of being Jewish, are null and void." But it was accompanied with an additional decree that re-enacted the revocation of Jewish citizenship first passed during the Vichy years: "The decree of October 24, 1870 [the Crémieux Decree], concerning the status of the native Israelites of Algeria is abrogated."

To justify his decision, Giraud pretended that this would appease Muslims and prevent unnecessary Muslim uprisings in a time of war. Before this propaganda became an accepted truth, you felt it was your duty to finish a research project on the naturalization of indigenous Algerians. You published it one month later, on April 23, 1943.[26] Your concern that faulty assumptions about the rights of the Jews would become accepted truths was prophetic, as the title of a *New York Times* article from March 22, 1943, testifies: "Jews' Rights Lost as War Measure; Crémieux Decree Repealed to Avert Discontent of Arab Troops."[27] You titled your article "Why the Crémieux Decree Was Abrogated," with no question mark. I read this as a protest against the question-that-was-not-asked when General Giraud misleadingly explained, by

Letter 10. Between European Jews' experience and ours

using an argument about equality between Jews and Muslims, his decision not to restore Jews' citizenship.

While "both the American and British governments had been led to believe that the abrogation of the Crémieux decree was a super-republican, super-democratic and super-anti-racial law,"[28] many Muslims understood the deception and knew this was not the equality they were aiming to achieve. As one Algerian informant put it, "No one gave any gift to Muslims by making a new category of Algerians unhappy ... On the contrary, we were deprived of an essential argument for the improvement of our lot."[29] Your text is both pedantic, as it accounts for all the (failed) attempts by the French to naturalize the Muslims, and quite pragmatic regarding the nature of a citizenship where the colonials "never recognized the naturalized native as a French citizen and did not allow him to share in the rule of the country."[30]

Despite the presence of Allied armies in Algeria since November 1942, presumably marking the end of the Vichy regime, the regime continued. While in retrospect, historians could write that "the landing of British and US troops in Algiers and Oran on November 8, 1942, thwarted the regime's plans for the Jews' deportation," when you wrote your article this was not clear at all.[31] The "final solution" was already decided on January 1942, during the Wannsee Conference. You could not have known that the Nazis had made an official decision, but enough was already known about the deportation of the Jews and the mass killings to cause concern. I read your text as a struggle against time, as if you knew that what was at stake exceeded the restoration of citizenship to the Jews. It helps me as I'm thinking about my father in the internment camp in Bedeau and the uncertainty he and others experienced there, given that census mapping of the Jews in preparation for deportation had already been conducted. While the world didn't know yet about the "final solution," it is likely that it was communicated to the main figures in governments collaborating with the Nazis, like those overseeing the Vichy government in Algeria. This can explain the series of public and secret actions taken by General Giraud, who clearly didn't plan to end his regime but rather to prepare the terrain for the "final solution." Similar to how you describe that in Algeria, "street

Roger Lucien Azoulay, certificat de nationalité, March 2, 1942.

signs declared in 1882 that 'all methods are good and should be used for the extermination of the Jews,'" "final solutions" for the Jews were not foreign to the colonial project in Algeria.[32]

Among the very few documents my father kept was a "certificate of nationality" issued in Oran on March 2, 1942, less than two months after the Nazis decided on the "final solution." A census of Jews in France and Algeria had already been conducted the summer prior. Why was my father, already stripped of his citizenship, asked to show the French "peace judge" at the Civil Tribunal his parents' family book (*livret de famille*), and why

Letter 10. Between European Jews' experience and ours

was he provided with a "nationality certificate" that racialized him as a Jew ("indigenous Algerian Jew")? This same certificate also turned his status into that of a foreigner, as the document clarified that his nationality would be defined according to article 1 of the law of August, 10, 1927, pertaining to foreigners. This was exactly what worried you about Giraud's legal actions, that abrogating the Crémieux Decree was "a racial and discriminatory law" to "reinstitute in public French law the discriminatory notion of Jew and non-Jew."[33]

Giraud also kept the Jews in internment and forced labor camps until July 1943. The Allied forces in Algeria didn't do anything to liberate the Jews from those camps. I don't know how much was known about these camps when you published your text, since the existence of forced labor camps in Algeria was kept secret for a long time, including by the Allies.[34] Moreover, one week after the Allies landed, General Giraud secretly issued an order assigning Jews to "work units."[35] Thus, instead of offering the Jews liberation, a French officer arrived to the camp several times, inviting the Jews to "volunteer" for the army while in fact assigning them to labor units. The Jews quickly understood the plot, and they dissuaded each other from raising their hands to volunteer. However, eager to leave the camp, on February 23, 1943, my father and a friend of his took the risk and volunteered for the fake military unit called the Battalion Pionniers Israélites. My father would be transferred just a few months later to the 2nd Division, which fought in the war.

The solidarity and care with which you wrote this text on Algerian Jews *and* Muslims helped me to stop judging my father for identifying himself as a French citizen and to recognize, perhaps for the first time, how he struggled to escape from and to navigate the colonizers' gaze that he had interiorized. I know that decades of deracination preceded my father's emigration, making the prospect of leaving his home-forever conceivable. You make it clear in your text that being denied rights that one had previously gained can be far more dangerous than not having them at all, and you emphasize how, in being returned to the status of "indigenous," the Jews found themselves "without any organized status, inferior in position to the natives who have not wanted or

have not been able to become French citizens themselves, as they were not willing to fulfill the conditions required."[36] In exchange for imposed citizenship, Jews' "cultural, scholastic, legal, religious and other organizations have disappeared or have been profoundly modified to conform the new status of the new state of affairs."[37] French and British colonialisms were responsible for making us available for displacement.

When you discuss the 1865 *sénatus-consulte* ("senate decree") that offered both Algerian Jews and Algerian Muslims French citizenship on request, you emphasize that "neither native Jews nor native Muslims ... showed themselves very eager to ask for French citizenship."[38] In fact, fewer than 200 Muslims and 152 Jews applied for citizenship. With this in mind, I wonder why most historians continue to describe the 1870 Crémieux Decree granting French citizenship to the Jews as a gift, rather than the obvious imposition that it was?

You describe, rather uncompromisingly, the inherent cynicism in France's decision to transform Jews into citizens in 1870. You note how this conferral of citizenship created a new cohort of citizens to help the French recover from defeat in the Franco-German War and the political crisis that followed: "It was, therefore, of no small importance to the government to have about 38,000 loyal Frenchmen in the colony at a time when trouble obviously lay ahead."[39] I love this turn of phrase, in which you reverse the dynamics involved in the granting of citizenship: citizenship is usually described as a gift extended to the governed, but you imply that the citizenship of the governed was a gift extracted from the colonized and granted to the colonizing power. Your account reveals who actually benefitted from the citizenship conferred upon the Jews, and whose interests it served.

Let's be clear: with a single decree consisting of only a few lines, the French government created 38,000 loyal French citizens! How was their loyalty obtained? Through lifelong probation, by being neither wholly visible nor wholly invisible as Jews. Their world was further destroyed and they were forced into a new one under French auspices. No longer could they be craftsmen, but they could now become lawyers, magistrates, and civil servants for the French government. Using the Jews for their own needs

Letter 10. Between European Jews' experience and ours

was not the beginning of the catastrophe the French colonizers unleashed in Algeria, and it marked the beginning of the termination of Jewish life on the African continent.

When citizenship unfolds as a gift, it means that it is also, at the same time, a weapon. Not surprisingly, Adolphe Crémieux, after whom the decree was named, was a Jewish lawyer and minister of justice in the French parliament and one of the founders and leaders of the École Israélite Universelle, a Paris-based network of Jewish schools that operated throughout the Mediterranean with the goal of "modernizing" Jews. The school system's mission, like other imperial boarding schools across the colonial world, was to produce *new* men and women. The new Jew whom the school system sought to produce was one who could fit into the culture of Christian French secularism, and thus, French imperialism.

To fully grasp the instrumentality and brutality of citizenship, we must imagine the Jews in Algeria not as a diasporic group living in exile but as part of the indigenous populations of North Africa who were colonized in 1830. I cannot recall ever reading in the many different books about the colonization of Algeria a straightforward sentence saying that the French colonization of Algeria was also the *French colonization of Algerian Jews*. I had to write it myself. Colonial citizenship should be called what it is: a technology for creating internally deracinated groups.

You must have known this, and yet—despite your deep understanding of the problem of assimilation and your acknowledgment of the Jewish Muslim world in Algeria—you still fell into the trap of attaching a colonized group, the "Jews," to "the mother country through their French brethren." It is only by cleansing the "Jews" of their indigeneity and of their world that such a brotherhood between European and Algerian Jews could be invented at the expense of centuries of brotherhood and sisterhood with Muslims. In the French context, where many Jews were either not allowed to live within town walls or were confined to practicing a handful of humiliating occupations (moneylending, peddling, cattle trading), according citizenship to certain Jewish communities in France could be, and indeed was to a certain degree, perceived as a triumph.[40] But to make of that necessity a virtue, and of that accommodation a standard for all forms of

relations, ignores the damage that citizenship wrought upon different Jewish communities and ways of life in Muslim countries.

In *The Origins of Totalitarianism,* you brilliantly captured the essence of imperialism by arguing that "expansion as a permanent and supreme aim of politics is the central political idea of imperialism," and you recognized in such "expansion for the sake of expansion" a totalitarian recipe.[41] I wonder why you ignored the expansive nature of imperial citizenship and the role it played in facilitating territorial expansion. You seem very close to addressing these matters when you discuss the Crémieux Decree—its promulgations, abrogation, and restoration—not only in relation to the Jews, but also in relation to the French body politic, which considered the naturalization of the Jews "a way to attract the Arabs by the privileges it gave to its citizens."[42] But why then, dear Hannah, after you uncovered the problematic nature of the Crémieux Decree, do you buy into the imperial assumption of the universal nature of citizenship, believing that the naturalization of the Jews was the first phase in a progressive stage of governance?

You could not have been surprised to see this citizenship taken away, right? After all, when citizenship is accorded to one group of people while other groups are deprived of it, it cannot be trusted. The revocation of Algerian Jews' French citizenship was not an accident of the Vichy regime but a constitutive feature of imperial citizenship. I would not be upset with your oversight if it hadn't been your writings that had first taught me how to unlearn citizenship and reject its poisonous promises. However, I'm grateful that in 1943 you advocated for the decree's restitution in order to save Jewish lives, and I appreciate that you cared to tell the history of this citizenship from the point of view of its contented beneficiaries and from those oppressed by it.

I finally came to understand, with your help, what makes imperial citizenship irredeemable: that imperial citizenship becomes the enlightened standard of being in the world with others, a standard shaped by those who perpetrate crimes against humanity while their victims lack recourse to changing the laws that make these crimes lawful. While your interpretation of "crimes against humanity" is always inspiring, I think there is one thing that you could not fully imagine from your vantage point informed by

Letter 10. Between European Jews' experience and ours

European history and politics. You called for redress under the same laws that had overseen the crimes, not for the laws' abolition. Perhaps this was because you continued to recognize in the existing European legal system certain values that preceded the crimes you studied, or values that were still valid and, you thought, protected the rights of diverse groups.

But, dear Hannah, in colonies like the one that subjugated my ancestors, or the one in which I was born to be a colonial agent, imperial law must be abolished for redress to happen. At base, imperial law's raison d'être is to prevent local formations of law from surviving. This is one major manifestation of crimes against humanity: decimating the principle of diversity that gives humanity, in your interpretation, meaning and value. These local systems of law were centered around ancestral knowledge that respected the earth and valued differences between communities. Had that knowledge not been destroyed, it could have served as a barrier against the expansion of relentless imperialism. Furthermore, the people who abided by these local systems might have continued to benefit from the care and protection these laws gave them. However, such systems of law were replaced by the French or Zionist regime, legal codes whose primary commitment was to the principles of racial capitalism and their own imperial ideologies.

Do you understand, dear Hannah, that my ancestors' expulsion from their shared world with Muslims, undertaken in the wake of Algerian independence in 1962, substantially reduced the "human diversity" that you placed at the heart of your interpretation of crimes against humanity in *Eichmann in Jerusalem*, which you wrote that very same year? The Jews in Algeria were not only "Arab-speaking Jews," as you describe them. They also spoke various dialects of Judeo-Arabic, Ladino, Judeo-Berber, Tamazight, and other languages. And you knew that they shared much more than language with Muslims; in fact, it would be more accurate to say that much of what they shared was not *across* the categories of "Muslim" and "Jew" but existed prior to their differentiation.

Sometimes, even in the span of a single sentence in your short text on Algerian Jews, it is not so clear that you understand the

term "Arabs" outside of its colonial usage. You seem to recognize Algerian Jews as part of the local culture, but at the same time you seem to assume this local culture as an external influence. For example, you write that the practices of the Jews "were not very different from the customs of their Arab surroundings." Or again: "[These customs] did not appear to the French as typical of the Jewish people, but rather bad habits of a small portion of that people, somehow led astray—habits that could easily be corrected by the majority of the same people."[43] Are you speaking from the perspective of the French settler?

Perhaps you are speaking in the voice of Rahel Varnhagen, whose biography you so lovingly wrote. You describe that as a young girl she "made her first journey to Breslau—to those inescapable provincial Jewish relations through whom, at the time, every assimilated Jew with a European background was connected to the Jewish people and the old manners and customs [s]he had discarded."[44] The purpose of the journey was to attend a "marriage according to the Jewish rites." To describe the distance between the assimilated Jews of Berlin and their relatives still living in the "past" (as if the past were a place!) you quote Varnhagen describing how "she was welcome to the *affair* 'as if the Grand Sultan were entering a long neglected seraglio.'"[45] There was no seraglio in Eastern Europe, nor any polygamous Jewish formations; and yet Jewish traditional rites were described by Varnhagen with the same revulsion as the Ottoman empire would be, in Europe's orientalist terms.[46] Varnhagen didn't have to know anything about Ottoman subjects beyond that which was mediated through European eyes in order to have ready-made depictions of Jews as the Other to explore "what it meant to be European."[47] You understood how assimilation and hatred of Jews were intertwined:

> The person who really wanted to assimilate could not pick and choose among the elements to which she should be willing to assimilate, could not decide what she liked and disliked. If one accepted Christianity, one had to accept the time's hatred of the Jews along with it.

Letter 10. Between European Jews' experience and ours

This was also true in relation to Orientalism. Looking at Jews in Muslim countries with an orientalist gaze was a prerequisite for becoming European. The denial of this component of newly acquired Europeanness partly explains why the forced conversion of our ancestors is not studied as one of the imperial technologies of violence approved and partially led by some elite groups of European Jews.

One decade after you wrote your study of assimilation through Varnhagen's life, as part of your inquiry into the revocation of Crémieux, you studied polygamy in Algeria without deferring to European sexual fantasies but by considering it on its own terms. With sincere regard and care, you presented it as a major factor fueling the resistance of indigenous Jews and Muslims to French citizenship. You don't seem to assume polygamy to be indicative of backwardness; you reject Europe's Orientalizing gaze. Instead, you describe Algerian polygamy as a social model of sustenance and class protection, in particular against the oppression of the landless class. Very pragmatically, you explain how women were the main source of "labor power" for the *fellah*, the peasant, and the only form of labor he could afford "to hire." Reducing polygamy only to the terms of the marriage contract—one man married to several women—ignores the variety of polygamous formations that existed, as well as the care and support members those extended families enabled.

As you imply, "these French colonialists, mostly large land owners whose prosperity depend upon cheap native labor and sympathetic government officials," had a direct interest in breaking up polygamous formations to have more unprotected laborers available for exploitation. You even expand your criticism in relation to French law: "Through the deputies they [the settlers] could even influence the government at home, as they did in 1924 when they forced the Chautemps government to ban Arab emigration from Algeria to France in order to keep their cheap manpower reservoir untouched."[48]

Critiquing the economic interests of French colonists, you don't buy into the myth of an innocent France whose legal system and politics were separate from its colonial role, nor do you buy into the way the French discarded polygamy in the name of women's

rights. Breaking these polygamous formations meant that women could be exploited as cheap labor by the settlers, and at the same time be deprived of mutual aid, care, and protection that members of extended family units provided. While you saw this and explained that Muslims' refusal to "renounce their personal status (which, similarly to the Jews, permitted polygamy and the denial of rights to women)" led to the failure of the French policy of assimilation, as if irresistibly, you then undermined yourself by reiterating the French myth of equality by which the French are more advanced than others: "French civil law and the French penal code have their bases in the equality of the sexes."[49]

I refuse to buy into the myth of "equality," and I insist on the urgency of further research and the restoration of the variety of extended queer family structures that present alternative ways of being in the world.

My ancestors didn't leave letters or diaries, and I don't know exactly what my grandfather's or my father's extended families looked like, but I do know that their extended families formed part of their worldliness. Dear Hannah, you recognized this worldliness in the "personal status" that my ancestors were forced to renounce in order to become citizens. But again, it is as if you stopped midway and let the imperial temporal marker of disappearance—"polygamy has almost disappeared"[50]—undermine your efforts. With the temporal marker of polygamy as an index of progress, colonial agents imposed an endpoint for the ways of life they were still trying to destroy, making destruction seem a fait accompli. Yet polygamous family formations still refuse to disappear, resisting the wholesale attack on the diversity of human relations.

As part of this epistolary journey, I became aware of at least two "irregularities" within my family that intimated the existence of a polygamous family formation. I had written my cousin and his wife, who were born in Algeria and migrated to France in 1962 when Jews were forced to leave. Prior to reaching out, I had only met with them once or twice, many years ago. However, I wanted to hear from them about our grandmother's name, Aïcha, so I sent them an email. Here is what my cousin wrote in reply:

Letter 10. Between European Jews' experience and ours

> The first name AÏCHA comes from a very rich woman who lived in Oran. Grandmother said that this woman had bracelets from the wrists to the elbow!!! This woman held that grandma carries her first name. Who was this woman? I do not know.

I hadn't even heard about this older Aïcha until my cousin mentioned her. And though you write with confidence that polygamy was eradicated from the towns of Algeria, my first assumption upon hearing about her was that she was my great-grandfather's second wife. My family lived in Oran, Sidi-bel-Abbès, and Arzew; apparently, like other Jewish families, they made polygamy disappear from their official documents and the language they used.

My Ariadne's thread to this older Aïcha was woven from three strands: The first was a vague memory of my father once saying that he had a third grandmother. I don't remember anything else except that he was only able to explain the terms of our kinship with this woman as being "outside of marriage." The second is a detail I heard from my cousins during that single conversation: "Mémé [our grandmother Aïcha] made twenty-one trips to Paris to see her daughters, and six to Israel." All these travels, they told me, took place in one decade, the 1950s, prior to the era of low-cost flights. My cousin added: "Mémé was proud of her first name because she said that she [the other Aïcha] had blessed her, and that she would always have money for her, especially when she went to buy plane tickets to see her daughter or Roger [my father]." This other Aïcha was not only my grandmother's source of pride and love, but also her source of economic sustenance. The third strand is also related to something my cousins wrote. Unprompted by me, my cousin and his wife volunteered their understanding of the irregularities surrounding marriage: "Mixed marriages were prohibited, and men were beaten up and women ostracized from society." I didn't ask anything about "mixed marriage." I didn't even have this notion of "mixed marriage" in my head—mixed how?—but now I understand that no matter what they meant, these irregularities were produced by the French system that sought to regulate existing kin formations into the hetero-patriarchal family unit.

I'm still unable to say who this second Aïcha is, whose name was given to my grandmother, and what sort of irregularity she posed to the French system of *état civil*. But I do know now that there are at least two "irregularities" in my family. The third grandmother that my father mentioned could also be part of the family of my grandfather, Joseph Azoulay. When he was born to Julie Boumendil, his father already had several children with another woman, with whom he continued to have more children after my grandfather was born. I don't know anything about the relationship between the two women, if they lived in one house or separately. I do not know if my grandfather grew up with two mothers, but I take my father's mention of "a third grandmother" as an indication that the other wife was not kept away from their family life. It is clear that from the moment polygamy was outlawed, the exact kinship between members of my family had to be blurred. This seemed to be true across Algeria, so that women could continue to be part of complex extended family formations tying people together by love, mutual and financial aid, and other forms of support.

The attack on polygamy was part of a campaign of destruction waged by the French against all indigenous protective formations and support structures. France's determination to forcibly convert the indigenous people appears neither to have started nor ended with the Crémieux Decree. In 1962, as they were already halfway out of Algeria, the French forced the nascent Algerian state to subscribe to the Declaration of Rights of Man and Citizen as part of the independence agreement, the Évian Accords. In the hostile climate created by the colonizers, even in an independent Algeria the memory of family formations and networks that existed prior to French colonization were now coded as a set of problems, blurred understandings, and irregularities.

This other Aïcha, whose name was given to my grandmother, may have been born just before the Crémieux Decree was issued. Thus, she may have been part of an expanded indigenous family unit that was no longer allowed to exist once the decree made them "Jews" and "French." In some interesting cases brought to court, Jews were denounced for faking dates and kin relationships on documents in efforts to camouflage now-outlawed polygamy.

Letter 10. Between European Jews' experience and ours

The known cases are probably just the tip of the iceberg.[51] Some of these family formations seem even more complex than what I'm able to reconstruct retroactively. For example, Aron Azoulai, shortly after recognizing my one-month-old grandfather born to Julie Boumendil and granting the baby his own last name, rushed to officially marry the other woman with whom he already had several children. It may be, however, that he and the other woman were already married under Mosaic law, and, for reasons I don't know, they now felt the need to validate their marriage in the *état civil* records. But "fixing" their papers according to the imposed French system required some creativity as well as solidarity among members of the community who could be hurt by these "irregularities." Why did Aron Azoulaï recognize my grandfather as his son only after one month? Was he really his father? Or were he and his wife assisting Julie, who was a single mother and worked as a cleaner in other people's houses, by giving her son a "legitimate" birth? There is yet another possibility. Perhaps Aron Azoulaï was both his father and also the father of Julie's two other daughters, whose records do not mention a father's name. I wish I knew the answers to these questions.

In his book on Algerian Jews, Michel Ansky describes the community as living in "complete isolation from the Jewish world as well as from the rest of the world."[52] He gives this as an explanation for why polygamy continued in Algeria while it was forbidden among Jews elsewhere. The Hebrew translation of Ansky's book includes an open letter sent to the publisher from the chief rabbi of Oran, refuting Ansky's explanation and providing a rich portrait of his community and the various connections of its members around the world. Thus, the rabbi also rejects the emancipation paradigm that undergirds Ansky's narrative and that was often used to justify the civilizing mission of French Jews toward Algerian Jews. As the rabbi writes,

> Whoever accuses the Chief Rabbinate of allowing the marriage of many women—actually blames the written Torah constitution and the oral Torah, because the Torah and the Talmud legally recognized bigamy and polygamy. In Algeria, as in other countries whose Jews did not accept the Rabbeinu Gershom's prohibition

of polygamy, rabbis in the eighteenth and nineteenth centuries had to legally recognize the marriage of a Jewish husband to many women.⁵³

Imperialism's "almost disappeared" structure not only generates historical accounts that are repeated as truths, but it also creates taboo or irregular topics about which one cannot speak without being suspected of antifeminism, conservatism, backwardness, or anti-Semitism. Hence my gratitude to you, dear Hannah, and to the weak transmitted memory of my polygamous family, for opening this small door into polygamy in Algeria and understanding it on its own terms: both as a family formation common to Jews and Muslims and as a socio-political formation of partnership and care that posed an obstacle to colonial capitalism.

If from the late eighteenth century onward, Jewish assimilation was always, as you wrote, "assimilation to *enlightenment*," then the Jews' assimilation must have been preceded by the assimilation of a smaller group of scholars who could no longer speak of the polygamous family without being labeled uncivilized, against women's rights, and anti-Enlightenment thinkers. Nor could these scholars suggest that perhaps the rights that women enjoyed prior to their assimilation to the Enlightenment, such as within polygamous formations, were greater than those they enjoyed under the patriarchal property regime consecrated by bourgeois monogamous heterosexual marriage.

You could not have had access to the documents some of these French-Jewish messengers of the Enlightenment left behind.⁵⁴ A mesmerizing picture emerges from them. In the name of enlightening the local populace, the Napoleonic Central Consistory of France, who sent representatives to Algeria to "overrule" the local rabbinical authority, were asked also to change the focus of the local rabbis' activity. Their primary duties switched from charity work and ritual services to policing women's lives by eradicating polygamy and divorce. The secondary goal of this new policing activity was to further distance Algerian Jews, now converted into French Jews, from their Muslim brethren. This conversion resulted in the eradication of Jewish Muslim life and the deracination of Algerian Jews into a secular "Jewish" identity.

Letter 10. Between European Jews' experience and ours

I wonder why in the *Origins of Totalitarianism* you don't discuss the racism of European Jews toward "Oriental-Jews" as part of imperialism's racial apparatus. Nor do you consider this racism as a form of anti-Semitism, one interiorized by Jews and directed toward other Jews. After all, these French rabbis were themselves fresh converts to a new form of being-a-Jew, and they were lured into assuming responsibility for this assimilation/conversion/civilizing mission and the rapid assimilation of Algerian Jewry. This could be read even in your own text on the Crémieux Decree: "The Parisian Consistory was given legal power to appoint all Algerian rabbis ... The schools of the Alliance Israélite Universelle, together with the active policy of the Consistory, assimilated the native Arab-speaking Jews in a relatively short time and changed them into loyal French citizens."[55] Details about this coordinated colonial attack on indigenous modes of life can be found only in scattered records. Thus it is still often referred to by historians as a glorious moment when Jews were turned into citizens. In fact, they were no longer permitted to live as Algerian Jews, and soon after, in 1962, they were no longer allowed to be Algerian Jews at all.

Pierre-Auguste Renoir, *Jewish Wedding (after Delacroix)*, ca. 1875.

This inculcated fear of not being up to the European model of citizenship pressured Jews to constantly prove their loyalty to it and to imagine their liberation following Europe's crimes in World War II within European forms of speech and action. Otherwise, different Jews would have reclaimed en masse what was taken for them.

Dear Hannah, I include in my letter two postcards, both testifying to the way that, despite their naturalization, the "truth" of the Jews as "Arabs" and "Orientals" intrigued painters and photographers. This truth speaks, I think, to European Orientalism but also to the smuggled refusal of our ancestors to let their world be truly destroyed.

In 1875, Pierre-Auguste Renoir painted a Jewish wedding in Morocco after Delacroix's painting from 1839 (see painting p. 449). The fact that in Morocco Jews had not received French citizenship is relevant here since Renoir's copy was painted and circulated barely five years after Algerian Jews were turned into French citizens. Asking why he would copy this painting at that particular moment, I cannot avoid thinking that Renoir, like other French painters at the time, sought to visually capture "the truth" of the Jews: that they were "still Arabs." Jews are depicted here mingling with Arabs, as if visually indicating the social truth underneath Algerian Jews' French citizenship. Even as French

Algeria, ca. 1910. Colonial postcard.

Letter 10. Between European Jews' experience and ours

citizenship forced Jews to renounce polygamy and subsume it under civil status, their proximity to Arabs persisted. It is as if Renoir were depicting a *truly* Jewish wedding.

The date of this photograph is unknown, as is its printing on a postcard (see photo p. 450). The postcard was purchased in Algeria and mailed to France in 1910, as the postal stamp attests. It was taken after Jews were made French citizens, when polygamous formations were already, or were about to be, outlawed as part of the effort to civilize Jews. And yet, obsessively, the French seek to capture some persisting Jewish traits underneath the frocks of "modern" French citizenship. Once again in this image, we see that they are still "Arabs" in their manners and modes of life.

The six women and their many children in this postcard, compared to only two men, present "the truth" about the North African Jewish family and its unruliness in the eyes of an emerging global capitalist market. There are no signs of capitalist work discipline in the photograph: children of different ages are mixed together and are mainly inactive, the men do not work, nor do two of the six women (the pregnant woman in the background and another one who stands idle). There are no signs of productivity; rather, there are signs of what you invited us to understand as the distinct domain of labor: caring for one's needs and all the members of this polygamous formation. In this image there are no traces of modern work tempo and exhaustion, as those who need rest stop working; there is no renunciation of traditional clothing or visible religious accessories. The postcard was not made in order to praise the unruliness of the Jews. For the settlers, it could either demonstrate that the Jews were a lost cause, unworthy of the citizenship that had been granted to them, or it could be a profitable token of their exoticization. The postcard displays a mode of life that imperialism sought to bring to an end while simultaneously capitalizing on its representability as a rarity, an exotic specimen to be commodified.

We do have a hidden truth, dear Hannah. It is not in us, but rather in what was hidden from us. It dictates what we are still not allowed to be: not individuals but part of social and spiritual formations with laws and principles of our own, cultivated by our different ancestors over centuries.

When you set out to advocate for my ancestors in Algeria and called for the restoration of their citizenship, you also gifted me this clue about polygamy. You helped me see it as the form of an extended family, a tribe, a non-state formation, an anti-capitalist and non-capitalized queer political formation, one we can turn into a talisman and use to resist, together, our individualization as citizens of empire.

With gratitude for relentlessly thinking through those totalitarian situations and transmitting to us the lesson that horrible things can happen in most places—but that they did not happen everywhere—and hence "humanly speaking, no more is required, and no more can reasonably be asked, for this planet to remain a place fit for human habitation."[56]

Yours,

Ariella Aïsha

Letter 11. It is a miracle that we still see clearly where the sun rises and where it sets

A letter to Hosni Kitouni

Dear Hosni,

Sometimes I think of the little miracle that made my open letter to Benjamin Stora, written in English, cross your path. You could have simply not encountered it, or read it and put it aside. But no, you read it carefully and you told yourself: *I am also its addressee.*
 That's how I imagine it.
 And you were right, although at that time, I did not know you yet. Our texts circulate without our knowing most of our readers.
 There was more to it. You read it and told yourself, I am not only its addressee, I'm also going to address it to others. Thus, my voice, still anonymous in Algeria, circulated through yours.
 Because of the time difference between Algeria and the United States, I was still asleep when you decided to translate my letter into French and post it on your Facebook page, urging others to read it. When I woke up, I read a chain of reactions from your Algerian friends, as well as your kind message in my inbox. You told me that you had taken the liberty of translating it "without having had the decency to ask your authorization."

You wanted others to read it, and you didn't want the time difference and the absence of my authorization to cause a delay. You recognized in it something urgent for Algerians to read, and you recognized the urgency with which I had written it.

Why do I call it a bijou miracle that this letter reached you?

Because I didn't know that my voice could be heard in Algeria.

Claiming my stolen identity is inseparable from rejecting the identity imposed upon me at birth in the Zionist colony in Palestine. I have been accustomed to hearing, when I try to reclaim what was stolen from me, this insulting imperial refrain:

> "We are sorry Madam,
> you arrived too late,
> it's over for you,
> you can't change your mind,
> or in your case, the mind of your ancestors,
> nor your identity.
> You got your country,
> and our colonial accounts have all been settled already."

But that's not the music I heard once my letter circulated in Algeria among your circle of friends, some of whom also became mine.

On the contrary, I was relieved at reading the warm welcome expressed by many Algerians, who allowed me to feel that I was not alone in inhabiting the Jewish Muslim world, the world that we were told was lost forever.

We, the inhabitants of this world, are more numerous than I expected. Our numbers go far beyond the number of pages that these open letters fill, and they exceed the finitude of our solitary imaginations. They make this world a little less gone.

You wrote to me that my letter to Stora "reveals the blind spot of French historiographical discourse, which tends to emphasize lethal violence, which makes it possible to mask the persistent forms of coloniality: cultural genocide."

That's right, that's part of what my letter did.

But it seems to me that at that time, I knew more than you did about what had prompted you to circulate my letter: the overtly

Letter 11. It is a miracle that we still see clearly

professed identity of the Algerian Jew who had written it, who had used the first person singular to publicly claim what this cultural genocide had killed within her.

It was not only the strength of my voice sounding my refusal to forget Algeria that made my letter feel necessary to you; it was also the knowledge that it was not I alone who needed to claim this identity. Dear Hosni, this Jewish identity was stolen from you too.

You too were once a Jewish Muslim, or a Muslim Jew, because it could not have been otherwise in Algeria.

Since then, we have exchanged many letters, talking about the multiple meanings and uses that our identities—*mine and yours, ours and yours*—had during different phases of colonization. Together, we wondered what was left underneath the violence that gave them their shape.

Our very conversation was the manifestation of another late-stage effect of this genocide: we talk about ourselves in colonial terms, and we will do as long as we are still preoccupied with ordering the colonial archives, whose order is not ours and whose terms forced us to appear as something other than what we were. The colonial order, colonial terms forced us to disappear from our communities and from the company of our ancestors, from ourselves, and from so many pages of history that we are almost unable to understand what was really done to us.

The other day I read, in an article written by André Nouschi, that at the time of colonization, there were 80,000 Jews in Algeria. Everyone knows that in 1870, forty years later, when France forced our ancestors to become French citizens, there weren't even 40,000 Jews in Algeria.

Where did they all go?

They disappeared, and their disappearance disappeared from the pages of history as well.

It was not the fact that the Jewish population was decimated by half that terrified me—we know that the entire population was decimated by half through French colonial violence—but that this is not even mentioned in the common historiography of the Jews in Algeria. This is what allows the Crémieux Decree to still be celebrated as a plausible story about becoming republican

citizens, and colonial genocide that cut the indigenous population in half can be narrated as something abstract, with no Frenchmen involved, and no Jewish victims. No Frenchmen are held responsible or marked as slaughterers, and their descendants do not have to face this genocidal legacy, or question the wealth of France that they inherited. They can continue to take pride in their museums, and their philosophies, which they offer to the world perfumed by freedom and undisturbed by genocide.

I am not interested in "the Jews" as much as in their existence as Muslim Jews and in the history of Algeria, which was theirs, mine, and ours.

It makes me uncomfortable to read entire books and detailed indexes written by Muslim Algerians and by French people about the history of Algeria from which the Jews are absent, disappeared from Algerian memory and history. Books on the Jews of Algeria, written mainly by Jews, are written as if Algerian Jews had lived on another planet, as if colonization didn't impact them, as if they were always already available to be dispatched to the realm of imperial citizenship.

Do you remember a year ago when I asked you: *Why is it almost never mentioned that the Jews suffered the same colonial violence as the Muslims during the first four decades of French colonization?*

Your answer, as always, was enlightening: *As a group,* you wrote to me, *the Jews were non-existent for the settlers, invisible to them.* I never dared to ask you why didn't you write anything about the Jews in your book Le désordre colonial: L'Algérie à l'épreuve de la colonisation de peuplement.[1]

Something you mentioned then unsettled me. *Some of the Jews,* you wrote to me, *refused the decree and kept their status in total anonymity. They then assimilated into the Muslim population while maintaining their religion, which they exercised in private. This is how we have many families of Jewish origin who stayed in Algeria.*[2]

I've heard before that some of the Jews of Mz'ab, who were forced into citizenship very late, during the negotiations of the Évian Accords in the early 1960s, escaped this forced naturalization and stayed in Algeria, where they were assumed to be

Letter 11. It is a miracle that we still see clearly

Muslims. They avoided being integrated like frightened silhouettes into the crowd of *pieds-noirs* who left Algeria as Europeans.

But no, you weren't talking about the Jews of Mz'ab in 1962, but rather about 1870! You provided an explanation: *Mixed with the Muslim population, the Jews suffered the famine of 1868–1869.* It seems to me that you are slightly wrong about the impact of famine on naturalized Jews. Even when they lived as "Frenchified Jews" side by side with the French, as they did, for example, in Sidi-bel-Abbès, their mortality rate was twice that of the French.

The choice of those Jews, if one can even call it a choice, who refused the Crémieux Decree and decided to live in anonymity, perfectly illustrates the extent to which it was an authoritarian decree. And they remind us how much work we still have to do to unlearn the histories that suggest otherwise.

But alas, after the departure of the colonizers, those Jews who decided to live in anonymity still could not assert themselves as Jews or as Muslim Jews. Not unlike our ancestors in Spain, who were forced to convert to Christianity, these *marranos* in Algeria were also forced to convert to Islam. This is the fault, too, of the Crémieux Decree and the French, not of the Algerians.

As the decades went by, and with the growing hostility that the Zionist colony imposed on non-nationalized Jews, there were even fewer opportunities to come out of anonymity, and there was the added risk of being "saved" by the Israelis if they learn there is still "a minority" of Jews to nationalize.

> Dear Hosni,
> it's a miracle
> that after a colonization
> that has not yet been undone
> we can still see clearly
> from where the sun rises
> and where it sets down.

Inshallah soon under the sun of Constantine,

Aïsha

Letter 12. The disappearance of the disappearance of Jews from Africa

A letter to Sylvia Wynter

Dear Sylvia,

I love teaching your texts. They inspire me and stir the minds of my students. Your essays "1492: A New World View" and "Beyond the Word of Man," in particular, which I read upon my arrival in the United States a decade ago, gave me a temporal compass to navigate the foreign settler-colonial state I had arrived in while looking for refuge from another colonial state.[1] In these writings you study the invention of Man (and the idea of Man's rational self) in early modern Europe, a specific political-intellectual-economic historical event that you argue was tied to settler colonialism, the rise of slavery, and capitalism. As you write, "The tradition of discourse to which [the present order's] specific discourse of man belongs ... [is] the tradition on whose basis, from 1512 onward, Western Europe was to effect the first stage in the secularization of human existence in the context of its own global expansion and to lay the basis of the plantation Structure."[2] You explore how, based on principles of purity of blood and religion, the Spanish state laid down the infrastructure

of "a colonization of the cultural Imaginary" through which the others of Man were understood as savages, infidels, or idolators, those who "were to be transformed into [Man's] lack."[3]

Often when I taught your text, I felt that I owed you a postcard from my anticolonial travels, in thanks for helping me navigate my first years in the United States. Coming from the Zionist colony in Palestine, I found familiar the many signs of the still-working-empire that I encountered in the United States. They seemed similar to the technologies of destruction, forced migration, dispossession, and forced assimilation I was already used to and had studied in the colony. Reading you, I was inspired to think about Palestine in 1948 as part of the *longue durée* of 1492.

Thinking with you about the world wrought from 1492, I was often troubled by your use of the term "Judeao-Christian."[4] Unlike other terms you carefully question and whose meanings you transform, "Judeao-Christian" is left untouched in your writings, as if there were a confirmed reality behind it, as if the Jews had not been persecuted as non-Christians, as if among different Jews many practices and cults had not been classified as idolatry. The term wouldn't stand up in the same way if you hadn't ignored the purging of Jews and Muslims from Spain and Portugal that also occurred in 1492. It is not that you are not familiar with this history—you refer to it in earlier writings, in your discussion of the expulsion first of Jews "who refused Christian conversion in the high year of 1492," and later in your discussion of Muslims given the same ultimatum, "stay or leave." This, you write, was "an act related to her [Spain's] growing sense of national destiny, as well as to the rise of a new system of centralized monarchy based on the unifying cement of a single faith—the Christian."[5] In that earlier text, you use a different term—"Euro-Christianity." I cannot help thinking that your omission of the other 1492, and your change in terms, is a manifestation of this Judeo-Christian epistemology and dictated by its use.

I remember it hurt me when I first read this unquestioned use of "Judeao-Christianity." For example, you describe the triadic model through which Columbus perceived non-Christians as Judeo-Christian:

Letter 12. The disappearance of the disappearance of Jews from Africa

That is, he would see them as one category of a human population divided up into Christians (who had heard and accepted the new word of the gospel), infidels like the Muslims and Jews, who, although monotheists, had refused the Word after having been preached the Word (and who were therefore *inimici Christi*, enemies of Christ), and idolators, those pagan polytheistic peoples who had either ignored or had not as yet been preached the Word.[6]

In your text on cinema, you elaborate on the notion of Man's memory and explain the key role cinema played in forging one memory for Man at the expense of the diverse memories of humans: "No other medium was to be more effective than that of the cinema in ensuring the continued submission to its [Man's] single memory of the peoples whom the West subordinated in the course of its rise to world hegemony."[7] Non-Christians—from whom you exclude the Jews—were trained, you write, to share this memory that is actually a memory of a white bourgeois mode of being human, and thus non-Christians were subordinated to Man's "specific view of the past."[8] To me, your unquestioning use of the term "Judeao-Christianity" functions in a similar way by subordinating the Jews to a memory that is not theirs. As a young adult, I didn't know to say that the memories that had been imposed on me actually sustained the invention of the "Judeao-Christian," but I sensed that they were not mine and that something was wrong with them.

Here is a story about me in fourth or fifth grade, at school in the Zionist colony in Palestine.

In class we had been asked to copy the map of Africa.

I don't remember the teacher's exact instructions, but I can *see* them being followed by my left hand moving as if already trained, copying Africa's map made of imperial markers, with no people, no life, no flora or fauna,

but rather
borders,
states,
and colonial names.

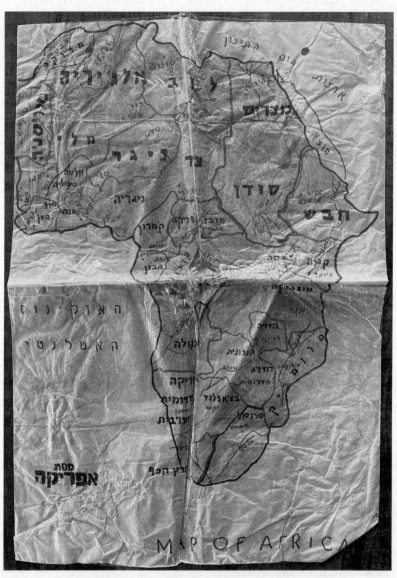

Map of Africa, made by Ariella Azoulay in fourth- or fifth-grade geography class in the Zionist colony in Palestine.

Letter 12. The disappearance of the disappearance of Jews from Africa

Coastal regions, colored in green, were designated as "temperate zones," and most of Africa was colored in brown to designate a "torrid zone."

What you describe as a "boundary marker between the habitable temperate zone of Europe and the unhabitable torrid" is being repeated here, through our education, in the depiction of Africa.

This is how, before the French agreed to depart from Algeria, they could use the desert for their nuclear tests. After all—*Why not sacrifice areas that in maps are colored brown? They must be no man's lands.*

It is from Africa that my father and my entire paternal family come. So do the families of many of my classmates.

The Aboukasis,
the Abergils,
the Azoulays—
they all came from Algeria, Libya, Tunisia, Egypt, Morocco.

And yet, in school we were trained to look at Africa as a foreign continent, as a form, rather than the place of our ancestors' histories and memories, a place to which we too belong.

Years later, when I looked carefully at this map of mine, I realized that I had skipped a few of the countries, including Tunisia, which is part of the Maghreb. I'm assuming that I was copying the map without thinking in advance about how all the countries would fit into it, not surprising, as I was only in fourth or fifth grade. This, however, cannot explain everything. There was a teacher in class who was clearly not from the Maghreb and was probably not familiar with Africa, but who followed the required curriculum. The Maghreb did not matter: what mattered was preparing us to see the world through these imperial markers that we were asked to copy so intimately.

The teacher should have insisted that I draw another line between Algeria and Libya with the tip of a crayon, and not forget Tunisia. But familiarizing us with Africa was not the true lesson. We were being trained to look at Africa as if other people— "Africans"—lived there, not our ancestors. We were being trained

to forget that we too were Africans. We learned this lesson well because our memories were those of Europeans, memories crafted by Zionists, who were European Jews.

In the late 1960s, when I was in primary school, some African leaders fell prey to the Zionist propaganda that presented Israel as triumph over British colonialism, and a country of experts in "making the desert bloom," experts whose experience could also help Africa bloom. When they woke up and realized this was false, they forgot about us, the children of Africa marooned in the Zionist colony: we were amalgamated in the minds of African leaders with Europe, with the West.

In the colony where I grew up there was no room for our memories, and I believed we had none. I'm still haunted by my incapacity to understand my father's words the one time he told me about his life *before* he arrived in the colony in 1949—about his life in Algeria, in Africa. Writing this sentence, I'm struck by how another imperial mechanism—the "anthropological"—operated through me in that conversation with him, when I asked him to speak about his life *before* ... As if lives were bifurcated into a before and after, as if a foreign and distant place like Algeria, or North Africa, could be observed as pristine, separate. I was preoccupied with transcribing this interview, editing and rendering what he told me into a booklet for our children, and in a way, I missed the moment, failed to recognize his silences about where he came from. I don't think our children read it, and after a decade and a half, the booklet finally found its most avid reader: me. It became my cherished companion, a way to go back and refuse our alienation from Algeria, from North Africa, from Africa.

A few years after this interview, my friend, the anthropologist Susan Slyomovics, asked me if she could interview my father—knowing his age, she guessed he might have been in a concentration camp or forced labor camp in Algeria.[9] I didn't know if he had been, but I was happy to introduce her. It was only then that I truly *heard* for the first time that my father had been incarcerated in one of the forced labor camps the French built for Jews during WWII, before they built camps for Muslims, often on the same sites. He never talked about it, I thought, though when

Letter 12. *The disappearance of the disappearance of Jews from Africa*

I read again the booklet I had made, he had clearly told me and I had dutifully written it down.

My failure to understand was not a coincidence but part of the organized crime of the Zionist state, which planted memories in us that weren't ours, false memories that meant our true memories could not be retained. In the Zionist colony, the Holocaust was the trauma of European Jews, and though I was an African Jew, this version of the Holocaust was made my memory too: nowhere did I hear about the French persecuting us Algerians and building concentration camps in the Maghreb, which was my family's true traumatic memory.[10] To discover our true memories required the talent of an archivist, as if our ancestors were foreign to us.

In the colony, the memory that Man—as distinct from "concrete individual men and women,"[11] as you would say, dear Sylvia—had of World War II was that held by European Jews, and the Holocaust was instrumentalized to absolve Europe of its crimes against the Jews and to justify European colonialism and the settler-colonial state in Palestine.[12]

The colonization of the Jews by Europe didn't stop with the "solution" of our assimilation. It continued through other "solutions," of which Zionism was one.

Each of these solutions made the real problem—Europe and its racializing and colonizing technologies—disappear!

Euro-Zionism started as a European solution for the Jewish people, and it served as a resolution to the question of Palestine, decades before Palestine was literally destroyed by Euro-Jewish Zionists, who emptied Palestine of its inhabitants.

I know dear Sylvia, it seems confusing with the dates, but already in the first half of the nineteenth century, a certain Lord Palmerston, the British Prime Minister, proposed the permanent settlement of Jews in Palestine. The British didn't want the Jews to stay in Britain, and they wanted to have a footing in Palestine.

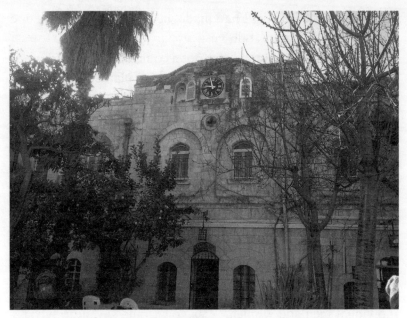
Christ Church, built in 1849 by the London Society for Promoting Christianity amongst the Jews in Jerusalem.

Why not use the Jews, again, as middle-persons to facilitate their own disappearance from Europe?

It is only when Jewish Zionism emerged, invented by Europeans as a solution to their "Jewish question," and later carried on by Jews against themselves, that a Judeo-Christian enterprise could take shape. The state Euro-Zionists formed was a misshapen imperial solution presented as a project of Jewish (national) liberation. This could not have come into being if the Jews had not been colonized, if their plural memories and histories as different Jews had not been falsified, if their memories of the violence done to them had not been limited to the Nazi era and to Nazi agents, and if the centuries of life they had shared with Muslims in Africa had not been destroyed. Instead of living with the trauma of their persecution by Christian Europeans, the Jews were offered a national redemption by Europeans who also offered them a prosthetic enemy—the Muslims (interchangeable with the Arabs), who had been seen as enemies by Europe since the Crusades.

Some of us Muslim Jews, or other Jews, are also trying to live, dear Sylvia, "against the reality of a colonization of the cultural Imaginary."[13]

Letter 12. The disappearance of the disappearance of Jews from Africa

Still today, this European racializing technology, compounded by its American variant, is leveraged to preserve the split between Jews and Muslims, Jews and Arabs, sustaining the "Judeo-Christian tradition."

In the aftermath of the Second World War, this tradition enabled Europe to be reborn as the savior of the Jews. Postwar Europe determined who Jews could become, how they could speak, who they would recognize as their enemies, and how they could act. Jews were forced to adhere to the invented Judeo-Christian tradition's mandates, lest they turn once more into a problem needing to be solved, again, by Europe.

During the occupation of Germany, the Allies exceptionalized Nazi crimes and construed them as unprecedented, thus absolving themselves of their colonial violence. This omission of the Allies' genocidal violence before and after WWII silenced the suffering and the claims of the different groups targeted by that genocidal violence. This double exceptionalization—of the Nazis and of the European Jews—was instrumental in the imposition of a "new world order," allegedly to prevent the reemergence of a regime like the Nazi one. And so after WWII, imperial violence continued under the auspices of the UN and UNESCO, international platforms that disseminated destruction through the language of "human rights" and the technology of the museum.

As part of this new world order, an Anglo-American committee for the "question of Palestine" was established, and its work, against the will and interests of the inhabitants of Palestine, led to the UN resolution to partition Palestine and establish the Zionist state. Instead of attending to the Jews who survived the Holocaust and helping them to rebuild their destroyed communities, European imperial actors proffered Palestine to Zionist Jews, as if Palestine were their property to give or take away.[14] The Jews were charged with further "modernizing" Palestine, a euphemism for the destructive force of post-WWII capitalism. Three years after its establishment, the state was recognized by those same European imperial powers as "heir to those victims who had no surviving family"[15] and was paid reparations by Germany for resettling survivors of the Holocaust in Palestine. Thus did Europe and the West absolve themselves of even the least taint of

association with Nazi crimes against the Jews: by sending Jews to live far from Europe, on land stolen from others.

Why the European Jews, represented by the state of Israel, were singled out from all other racialized others—all the others against which, as you say dear Sylvia, *Man* is defined—is not unrelated to the invention of the Judeo-Christian.

K. Healan Gaston, who has studied the history of the term "Judeo-Christian" in the American context, says that it entered the political lexicon in the 1930s, "when cataclysmic world events led many Americans to reassess the ethical and religious dimensions of their political system." And yet, Gaston also reports, this invented term generated discomfort and opposition: "The vast majority of American Jewish leaders insisted that only tolerance, freedom of expression and strict church-state separation could protect them against the increasingly powerful view of democracy as an outgrowth of traditional theologies."[16] The term's utility in the 1930s was to integrate Catholics and Jews, both of whom suffered from marginalization, suspicion, and segregation, into a "tri-faith" democracy alongside Protestant Christians. This melding of Jewish and Christian imposed a problematic imaginary, based on the erasure of diverse forms of Jewish life, and it excluded Islam, as well as Islamic Jews or Jewish Muslims. The reduction of religious belonging and a shared world to simply a faith identity is itself a scar from the long Christianization of Jewish life, compelling Jews to pass as non-Jews outside of synagogues, and to access political rights through the pursuit of profit, individualism, and the suppression of communal diversity. This history of assimilation, often violent and abusive, is excluded from the term "Judeo-Christian" that arose in the 1930s.

At the same time this term emerged in the United States, a frieze depicting eighteen lawgivers was sculpted on the Supreme Court building in Washington, DC, among them the prophet Muḥammad. As Muslim organizations and individuals noted, the frieze is offensive on many levels, among them: first, the creation of an image of the Prophet is banned in Koranic law; second, the inclusion of the Prophet alongside figures like Napoleon, who attacked Islam and Judaism; third, among the reasons mentioned justifying the Prophet's inclusion in the frieze was the contention

Letter 12. The disappearance of the disappearance of Jews from Africa

that he was a "founder" of Islam, when he is actually "the last in a line of prophets that includes Abraham, Moses and Jesus." And he is also represented in the frieze as holding both the Koran and a sword, echoing the western stereotype of Muslims as "intolerant conquerors."[17] In this frieze we see the offensive, assimilationist violence that incorporates the others of Man—in this case Muslims and Jews—into Man's depictions of law and justice, both claiming and neutralizing its others and erasing its own violence.

I'm less interested in the intellectual history of the term "Judeo-Christian" and more in its devastating assimilatory power. Euro-American imperial powers (Man) used this tradition to make the Jews' diverse memories into a single story in which no real Jew is actually represented. Thus, in the late 1930s, Jews were persecuted by the Nazis and their collaborators for being part of what Europe itself had invented as "the Jewish people" from diverse communities and modes of living. And even more, those Jews who lived in the United States—refugees and migrants from different communities in Eastern and Central Europe, among them communists, Bundists, anarchists, and non-conformists—were made to promulgate the fiction of "Judeo-Christian" as one side of a binary: "democracy as a Judeo-Christian alternative to totalitarianism."[18] The diverse Jews didn't fit in (nor did they want to! ... until they were left with no viable option) with this imperial white Christian democracy that racialized, marginalized, and persecuted them.

The only way out of this European terror is to work for the decolonization—and denationalization—of the "Jewish people," to be a problem, again, for the Euro-American "new world order," and to revive a shared Jewish Muslim world, offering Jews access to other possible ways of living outside of Judeo-Christian forms, and ways to join with others in undoing the world the invented Judeo-Christian tradition imposed.

The imposition of a Judeo-Christian imperial democracy—Israel—in the midst of a Jewish Muslim world that spread from the Middle East to North Africa was a large-scale attack on us

as different Jews, Muslim Jews. Our memories of the expulsion of Jews and Muslims, and Muslim Jews, from the Iberian peninsula in 1492 were obliterated from this tradition that we were compelled to call our own.

Dear Sylvia, your uninterrogated use of the term "Judeao-Christian," and my resistance to it, pushed me to identify the "Christian" component in the secular Jew produced in Europe and exported to Algeria and the United States. More and more, I learn from my experience in the United States that there is no room for us to be Jews, let alone Muslim Jews, who refuse to be represented by Christianized Jews who support the destruction of Palestine and its replacement with a Euro-Zionist state. There is no understanding that we are subjects of multiple unresolved histories, peoples for whom democracy, empire, racial capitalism, and whiteness have long been coercive and repressive forces.

The end of WWII required a solution to the uprooted European Jews, preferably resettlement outside of the United States

Enough! The Strike Must Go On, Fundació Antoni Tàpies, Barcelona, Spain, co-curated by Ariella Aïsha Azoulay and Carles Guerra.

Letter 12. The disappearance of the disappearance of Jews from Africa

Protests against the UN Partition Resolution, December 1947, Cairo, Egypt; Baghdad, Iraq; Beirut, Lebanon (clockwise).

and Europe. Of the 300,000 visa application from Jews to enter the United States after Hitler took power, only 20,000 were approved. Much has been written about how little the United States did to save the lives of Jews during this period. One of many examples is the story of the ship with 937 passengers, mostly Jewish refugees, that in June 1939 was not allowed to land in the port of Miami; its passengers were perceived as a "threat to national security" and were forced to return to Europe.[19]

I recently finished working on a photographic archive that I assembled over several years, which juxtaposes ninety-six panels of an exhibition prepared by UNESCO in 1949 with vintage photos taken in the decade after WWII, photos that capture protests, strikes, and other moments of resistance against colonial, imperial and capitalist violence around the world (see photo p. 470). The UNESCO panels illustrate the UN's Universal Declaration of Human Rights (UDHR), while the vintage photographs that I assembled feature people's hopes about their rights and their imagination of what a better world might be.

Among the vintage photographs I included were several in which people gathered to oppose the UN resolution for the

partition of Palestine, in Egypt, Iraq, Lebanon, Palestine, and Syria—countries where hundreds of thousands of Jews lived (see photos above).

> *Only our damaged perception and broken memories can mislead into assuming that among these huge crowds in Cairo, Baghdad or Beirut, there are not also many Jews, whose lives in those endangered Jewish Muslim worlds were entangled with anticolonial struggles.*

Their protest also opposed the imposition of empire in the form of a Christian-modeled secular state run by Zionists. The protests in these photographs are not an expression of "Arabs' war against Jews" but a multi-dimensional opposition to modernization, secularization, industrialization, plunder, expropriation, imperialism and white supremacy. After all, hundreds of thousands of Jews lived in the region, and this branch of empire was also imposed against them: it set a countdown clock for the termination of Jewish Muslim life in the area, and it forced neighbors to separate into fictionalized camps of "Jew" and "Muslim," unnatural in comparison to how they had lived for centuries. That this opposition to the colonization of Palestine was seen to consist of mostly Muslims and non-Jewish Arabs

Unidentified artist, drawing of policemen beating Orthodox Jews, Israel, 1950s.

Letter 12. The disappearance of the disappearance of Jews from Africa

helped the Judeo-Christian alliance seem less outrageous than it had in the first years after WWII.

Growing up as secular Jews in the Zionist colony in Palestine, we were offered the "Western episteme" of (Christian) secularism as an alternative to Jewish education, which was made the terrain of religious Jews. Our national secular education was meant to make of us a better species of Jew. I want to share with you a drawing created as part of an Orthodox Jewish movement's struggle against the Zionist campaign to secularize Palestine and violate Palestine's sacredness to multiple religious faiths (see drawing p. 472). I could not find much information about the drawing's maker, except that it was drawn in the early 1950s, either by a member of the Orthodox community or by someone who was not hostile to the cause. In the image, an Orthodox Jew lies on the ground, subject to the blows of a policeman's club; another Orthodox man is also being beaten; and a man with a camera watches the whole situation. The text below conveys the cameraman's words, "Are there still any British policemen around?" alluding either to the fact that these are Jewish policeman who beat Jews and they should be called to order by the recently departed British, or that Orthodox Jews felt safer under the British police than under Zionist rule. Either way, the man with the camera watches the violence exercised by the police without raising his camera to take any photos, perhaps implicating the press as well.

Violence against Orthodox Jews in the years following the establishment of the Zionist state was not rare; it was part of a systematic Zionist campaign to secularize human existence (as you refer to it, Sylvia) and thus to accelerate the country's integration in global racial capitalism. The Orthodox Jews protested any violation of the Shabbat in public, and they denounced the increase of Zionists in Palestine. They didn't buy into the binary that the Zionists sought to impose, and they lucidly saw that "the danger for Jewish life is the fault of the Zionists themselves, and strengthening their power will further endanger the Jews. Moreover, in their desecration of the Sabbath, the Jewish brigade (*notrim*) endangers further the security of the Jews and will bring about its destruction."[20]

In the first years after the Zionist colony was proclaimed as a sovereign state, these Orthodox Jews were depicted as extremist and fundamentalist, while secular Zionists, responsible for the ruination of Palestine, described themselves as part of the enlightened left. Violating the Shabbat and harassing Orthodox Jews was encouraged behavior for Israeli Jews in order to publicly demonstrate their secularization. This took place almost every Saturday over several years. In a leaflet that was probably printed a few days after September 1, 1956, ultra-Orthodox Jews issued a call for help to Jews who lived abroad:

> A rescue call to our Jewish brothers in the Diaspora wherever they are. A terrible thing happened yesterday ... Thousands of ultra-Orthodox Jews went out into the city street and shouted Shabbat at the cars driving on Shabbat to bathing places and maliciously destroying the Shabbat. The Zionist police pounced on the ultra-Orthodox, old and young, and beat them with terrible cruelty ... and their minds did not cool down until they attacked the righteous rabbi Rabbi Pinchas Segalov and beat him to death.[21]

This violence was similar to that exercised by white Christian secular French policemen against French Jews under Napoleonic rule, forcing them to swear allegiance to the state and stop being Jews in public. Tellingly, we find it reproduced in Israel a century and a half later, illustrating the secular, imperial, Christian basis of the Zionist state.

Thus, wrestling with the normalization of "Judeao-Christian" in your writing, I came to understand the state of Israel as the materialization of a Judeo-Christian vision. Not only was the state of Israel created with imperial tools (colonization, partition, deportation, the nation-state form encouraged and ratified by imperial powers); it also replicated the domination of secularized Europeans of *Jewish faith*. This is a state committed to the nationalization of Judaism and its fusion with a political system, a state that imposes its way of being Jewish—a Judeo-Christian Jewishness—as the only way of being Jewish. In so doing, this state imposed the Christian-secular state apparatus (which, in

Letter 12. The disappearance of the disappearance of Jews from Africa

Israel's case, was creolized to become "Judeo-Christian") as a universal form. Like other "universal" forms, it is one based on differential and unequal governance.

For this project, European Zionists had to accept their own whitening and work to further whiten themselves by forgetting the entanglement of the violence against them and against their ancestors with these state technologies offered as liberation. To gain the same privileges of European whiteness in their new colony, European Zionist Jews needed other Jews to be *their* non-white Jews. We, the Muslim Jews of Africa, became their non-white Jews. The crimes against humanity that Europeans committed on the bodies of Jews for the sake of racial purification were absolved by the UN partition resolution that sacrificed Palestine and turned Jews into colonial settlers, who then committed crimes on the bodies of an indigenous population. This was how the Zionist Jews could inhabit the position of white Christian Jews, refashioned into European settlers and now charged with persecuting Arabs and Muslims. This is the real triumph of imperial *laïcité* post-WWII.

What is "Judeo-Christian," then? It is the name of a post-WWII onto-epistemological project that incorporates "Jew" into the Christian paradigm at the expense of a shared Jewish Muslim world. Thus it is not only about "Man and its others," or maybe it never was, since men could not become Man without destroying previous alliances, pacts, and shared worlds. Some, like the Jews at a certain point or the Senegalese at others, had to also be made into what Fanon calls "interpreters" and conscripted into Man's projects so that Man could better colonize and create others in order to create himself. Since 1492 (and even earlier, if we bring the Crusades into consideration) targeting the Jewish Muslim world has been one of Man's raisons d'être. For the creation of this state in Palestine, the Jewish Muslim world had to be jeopardized and sacrificed. Its termination is a Judeo-Christian crime.

As you can likely guess at this point in my letter, I'm troubled by the disappearance of approximately 600,000 Jews from what is today a Muslim world but used to be a Jewish Muslim one, in North Africa and in Africa. I'm even more troubled by the disappearance of this disappearance from our political, historical,

and worldly memories, and the orchestrated disavowal of this world on a global scale. I am concerned with the dissociation of Jews from Muslims in anti-Muslim violence, called Islamophobia, and its contribution to the perpetuation of white supremacy. The termination of thousands of years of Jewish life in North Africa by two colonial projects—the French and the Zionist—is not a minor event. And yet, depictions of Africa, as well as imaginings of its future, neglect to address this absent segment of Africa's population in a way that sustains the curse of the colonial invention of two Africas, one white and one Black.

This racial perversion was materialized in the anthropology museum in Paris, the Musée de l'homme or Museum of Man, where there was one department for white Africa and another for Black Africa, two Africas that visitors were told were "physically, administratively and conceptually divorced from each other."[22] With the double disappearance of the Jews, the plural history of Africa can be written to associate Africans with Blacks and North Africans with white Muslim Arabs, who both "have been mutually divided and defined as exclusive ethnicities or races by European colonialism."[23] Mohamed Amer Meziane, the author of these words, criticizes the "invention of North Africa" and tallies the costs of its de-Africanization to both sides in his attempt to renew Frantz Fanon's idea of Pan-Africanism: "When Black people deploy racism against Arabs and Arabs deploy racism against Black people, they do so for the benefit of White supremacy, not for continental liberation."[24] And yet, even here, Pan-Africanism is imagined as the suturing of those two Africas, already free of Jews, and it sustains the colonially invented binary of Muslims and Judeo-Christians.

The demographic transfer of the Jews out of "white Africa" and their inclusion in the group "Europeans" (even while they were still living in Africa!) made the imposition of this binary possible. The disappearance of their disappearance is so strong that visions of Africa, including inspirational visions created by scholars like Achille Mbembe,[25] are caught in binaries that European racializing technologies created and proliferated. These binaries are harmful to all sides—for example, to Arabs and Amazigh in North Africa, or to Arabs and Blacks in all of Africa—but are

Letter 12. The disappearance of the disappearance of Jews from Africa

also harmful to groups who fall out of them, like the Jews who were excised from "White" Africa, and the Black Jews still living in Black Africa. Indigenous Black Jewish communities in Tanzania, Mali, Nigeria, Songhay, Biafra, Ethiopia, Ghana, Uganda, Somalia, and elsewhere are neglected in this imperial epistemology, as is the "adoption by blacks of racial Israelite identities and religions both in Africa and the United States," as a "subversive way of shedding a racial identity that was sullied by slavery, segregation, and colonial oppression."[26] To see these outsiders would threaten the post-WWII colonial attempt at whitening of the Jews and with it, the new world order.

Alongside the diffusion of practices, shared cosmologies, astrologies, and the intermixing of kabbalistic and Sufi philosophies in Africa, Jews and Blacks in both Africa and Europe had, for centuries, been approached by Europeans as related groups, both pariahs and outsiders, and they "were regularly imagined to have shared ancestry."[27] Julien Cohen-Lacassagne, for example, undoes the fantasy of a unique Jewish source in his book describing a stay in Mauritania, where he discovered practices similar to those he was familiar with from his home in Algiers.[28] The racial cleavage of Jews from Black (Sub-Saharan) and white (Muslim North) Africa traps Palestine in a colonial dead end where a solution to Europe's question of what to do with Palestine can be solved only by creating another imperial nation-state. This is not a coincidence: reparations to European Jews at the end of World War II did not include the abolition of European imperialism.

It is not that we need the re-Africanization of the Jews—African Jews exist today, even if they are unnoticed by most and often disguised as Muslims. We need to undo the onto-epistemological binaries that sustain the fiction of Judeo-Christian, a fiction sustained par excellence in the Zionist imperial state. By this I mean we need to undo the division of Africa into White and Black Africa, and the disappearance of the Jews from Africa, for this is what made the Zionist colony and its attendant violence possible.

I was not fortunate enough to grow up with memories of my ancestors who were Arab Jews, Berber Jews, and Muslim Jews living at the northern tip of Africa. But from the moment I started

to look for them, I found their guidance everywhere. For instance, I see them in the memory of the Radhanites riding camels carrying silk and jewels across Africa and Asia, or in the example of Sebe Bafour, who founded the city of Ouadan in the Adrar region; in the Tuareg Judeo-Berbers, who lived around Djebel Amour; or among those who lived among the Fulani in Burkina Faso; or again in the Jews under the protection of the Ibadites. Rather than tracking only my own genealogies, I seek ways to renew affiliations with those whom Labelle Prussin calls "trader-cum-scholar-cum-artisan[s]," whose ontological existence resisted the colonial and national taxonomies to come. Imagining them into existence is part of reclaiming our precolonial and a prebordered understanding of Africa—an Africa with its indigenous Jews, and us Jews with our indigenous mythical texts. As Prussin writes, the African landscape

> through which these resourceful individuals moved included not only sedentary but also nomadic populations. These, themselves crossing and controlling vast expanses of the Sahara Desert through the centuries, served as conduit in cultural diffusion: in point of fact, it was often within this nomadic flux that the shape and form of the Jewish presence unfolded.[29]

I have so far gathered quite a few memories from centuries of Jewish life in Africa so that I can unlearn this disappearance. I continue to unlearn Man's false memories in the hope that recollections of a shared Jewish Muslim and Euro-African life will become available—"life beyond Man," as you call it.

The right to undo political pacts, treaties, bills, declarations of independence, and imperial citizenships is an inalienable right of descendants of people ruled by imperial regimes. We have the right to replace them with the principle of repair. In undoing imperial bargains, we can repair our shared worlds.

Working to retrieve memories of my family's *Arabness* and *Islamism*, from which we were alienated by being made enemies of ourselves, I joined you in the endeavor to expose Man's memories as not universal but rather the narrow view of a white, middle-class Christian committed to perpetuating what you call

Letter 12. The disappearance of the disappearance of Jews from Africa

"unimaginable evil." For a long time, though I knew that the state of Israel was responsible for the destruction of centuries of Jewish life in Africa, especially in the Maghreb and Ethiopia, I had difficulty reconciling this with the fact that exiling our family from Africa seemed to me like my father's own choice. And yet—despite all his efforts to be recognized as a French immigrant, his relatives, acquaintances, and friends knew he was from North Africa. This was a kind of open secret, an admission of the implicit racism of Israeli society—what it was to be an Arab Jew in a place built around the hatred of Arabs.

What kinship could I possibly claim if my father hadn't brought things from Algeria with him, hadn't helped us know ourselves as Algerian? Immersing myself in the jewelry made by Muslim Jews, in their secrets, mysticism, spiritualism, forms, numbers, and substances, and meeting with the women who wore them, I realized that he could not ultimately dissociate me from Algeria because Algeria came with him regardless. In another essay, "The Cinematic Text and Africa," you describe cinema as the vehicle through which the memories of Man, captured on celluloid, become etched in people's minds as *their* memories, even if these people are in fact Man's *others*. This happens because, even if they radically oppose Man, these others have been "educated in the Western episteme or order of knowledge, which is based on the *a priori* of this conception of the human, *Man,* must normally know the world even when most radically and oppositionally so, from this perspective."[30]

Without having read each other's accounts, James Baldwin and Edward Said describe almost verbatim the same childhood experience, one whose meaning they grasped only as adults. As children, both of them identified with cinematic heroes who chased the "natives." Those natives, they understood years later, were actually themselves. Fanon had a similar experience: "I can't go to movies without encountering myself. I wait for myself. Those in front of me, spy on me, wait for me."[31] Reading these accounts, I could not avoid thinking about my father, who frequently went to the cinema in Oran, and who also ran with the villains after himself, without realizing it.

Did he not realize it, really?

Did he not know that the French settlers in Algeria did not see him as their equal?

Did he not recognize that the way the French ran after Muslim Algerians in 1945 was the same type of violence he and other Jews had experienced in 1939, 1940, 1941, and 1942?

Would he have decided to leave Algeria for Europe and for Palestine if he had realized that many of those who were murdered in the death camps he saw in Germany, like his aunt and uncle and their three children, were actually sent there by the French?

It was only in Germany that he found the strength to stage a one-man show of anticolonial revolt, a revolt he was unable to ignite in his hometown, Oran, against the French.

Here is how he described to me what he called his "strange job":

> We conquered famous cities, Baden Baden, Freiburg, Carlsruhe, and Munich. Each time when we conquered a city or a village we placed announcements on the city's walls, ordering all Germans who own cameras, guns, bicycles, or radios—to bring them to the city center. Cameras—so no photos will be taken, radios—so no music will be heard, bicycles—so no riding could be enjoyed.

Taking watches from the Germans he stumbled upon in the streets seems to have had a special importance for him, though he didn't continue his Biblical cadence to say *and watches—for no mastery over time will be theirs*. He did, however, make it his mission to ritually repeat fifty times the same sentence in German—"Do you have the time, sir?"—after which he gave accommodating Germans the order to hand their watches over to him so he could distribute them to his brothers in arms.

He did want people to see and be aware, למען יראו וייראו.

He said:

> In one of the villages, I found something like thousands [of] German flags. I asked one of the soldiers who spoke German to summon the entire village in the main square. I brought all the flags and asked the same soldier, "Tell them they are going to attend a unique spectacle they never saw." I poured a jerrycan

Letter 12. The disappearance of the disappearance of Jews from Africa

full of gasoline and in front of their amazed eyes, I burned one thousand German flags.

His story didn't end there:

> One day we entered a glass factory. I asked my friends to come upstairs with me. "Do you see all these glass sheets? We are going to make some noise." We broke everything. You cannot believe how much we broke.

His mother, my grandmother Aïcha, he once told me, took care of all the family's papers, and she went to the municipality to help others fill forms and applications. She was the letter-writing for them all. He told me this with a smile of admiration.

From this I know that, like him, she was also a storyteller, another colonized trickster who knew what it meant to enter the exotic bureaucratic gardens where papers grow out of the heavy hands of those clerks who threaten the colonized with these papers that they respect more than them and treat with dark ink.

Colonized tricksters live in the deep present, fictionalizing the world so that they can inhabit it, able to move their hands and eyes as if they were heroes in the stories they fantasize, part of the happenings, which they communicate to others, distracting their interlocutors from ever encountering *them, the storytellers*, outside the narrative space.

Colonized tricksters often seek revenge, but rarely do they have an entire square or an entire factory as their arena, as my father did by his own proclamation when he sought vengeance against one colonial regime by another.

Relatively early in your "1492" text, you ask:

> Can we therefore, while taking as our point of departure both the ecosystemic and global sociosystemic "interrelatedness" of our contemporary situation, put forward a new world view of 1492 from the perspective of the species, and with reference to the interests of its well-being, rather than from the partial perspectives, and with reference to the necessarily partial interests, of both celebrants and dissidents?

Immediately, you reply that "the central thesis of this essay is that we can."[32]

Dear Sylvia, after I published the first draft of my letter to you, Achille Mbembe wrote to me that he could not help thinking that this letter was addressed to him too. I think it was the disappearance—and the disappearance of the disappearance—of the Jews from Africa that made him feel that way. He is not wrong. I feel addressed by your "world view of 1492" and his speculations on a borderless world, but instead of fast-forwarding to a utopian future, I'm interested in rewinding imperial history and thinking within the incompleteness of the past.

Do we need a *new* world view of 1492?

Why not an older one?

Can we disrupt imperial onto-epistemologies without joining our ancestors' refusal of empire?

I started to write letters to my ancestors buried in North Africa in the hopes of awakening them from the slumbering colonial consciousness in which they were trapped while their descendants were hijacked by the manufactured histories and memories of other nation-states. I realized that some of my ancestors were not sleeping at all but were still restless. Some of them wondered why I hadn't come earlier.

They trusted me with their memories of Africa, expecting me to weave into the memories of 1492—a moment when people and resources were kidnapped and extracted and expelled across the Americas, and expelled from Iberia—their memories of Africa as a place of hospitality. In 1492, African gates swung open to welcome the Jews and Muslims expelled from the Christianized "new" world of Spain and Portugal.

They remember. Their presence in Africa is endemic to Africa, and they will not be forgotten by Africa, despite imperial amnesia. They will not be forgotten because I, too, now remember. As do you now, dear Sylvia.

From the heart of our shared recovered memories,

Ariella Aïsha

Letter 13. The amnesia of Jews in the US is only half the story; the other half has never been told

A letter to Katya Gibel Mevorach

Dear Katya,

We only recently met, and yet, after reading your book, I feel that I have found an interlocutor with whom I can share some of my swirling thoughts about who I am.

Katya, our biographies, which are the substance of both your and my writings, are different, but I think that we share a desire to undo the monolith commonly referred to today as "the Jews." We do so by speaking as and about diverse Jews who refuse to be secondary to a European-invented white Jewishness and try to unsettle its ground.

At the beginning of your book *Black, Jewish, and Interracial: It's Not the Color of Your Skin, but the Race of Your Kin and Other Myths of Identity*,[1] you describe being raised with two strong identities, and you say that you position yourself "in the middle of the intersection." You write as a person who claims "descent across racial and ethnic lines," being both Jewish and Black, born to a mother who was a Jewish refugee from Nazi Austria and a father who emigrated from Jamaica and whose

ancestors are Afro-Cuban-Caribbean. Your research and writing demonstrate your commitment to extending this idea of identity intersection beyond your personal biography. You criticize the category of "multiracial," which assumes that the identities of Jewish and Black are mutually exclusive, and you reject the "cartography of collaborations and frictions" used to depict the relationship between Jews and Blacks. Instead you identify "models of emulation and explication" in the survival of both peoples and anchor that survival in shared histories of (forced) migrations and a diasporic condition.[2] I love the way you describe American Jews as suffering from "collective amnesia" because they refer to themselves as "white Europeans rather than one branch of a people whose different colors and accoutrements of national identities reflect diasporic migrations and mixing."[3] We do not see the formation of Jewish diasporic existence in the same way, but I'll say more about that later.

I reject the identity assigned to me at birth as an imposition full of unaddressed lies and contradictions that, as a child, I lacked the tools to understand. Unlearning it, I realized that the world in which I could belong, if I were to walk toward my ancestors, was destroyed, and merely arriving to say that it has to be rebuilt feels like inhabiting its ruins. I have an early memory from when I was in primary school, maybe around age eleven or twelve. I was trying to memorize some sentences from the Declaration of Independence of the state of Israel. Some of the words ran together in my mind and their meaning wasn't clear—"the right of the Jewish people to national revival in their own country," "an irrevocable right," the "natural right of the Jewish people to be masters of their own fate, like all other nations, in their own sovereign state." I had to memorize these phrases by rote because, on a cognitive level, I could not match the words with a world that I knew. I knew that most of us came from elsewhere, so Israel could not be "our country." And also, on an experiential level, this notion of one Jewish people felt at odds with the different Jews I recognized in my classroom and in the city where I grew up. Other kids in my class didn't have this problem; maybe their parents had done "a better job" socializing them to the history the state fabricated for us.

Letter 13. The amnesia of Jews in the US is only half the story

My father could not be bothered to give a damn about Zionist verbosity, while my mother, when asked, recycled her clichés of the "grandeur" of the days of Israeli independence (meaning the Nakba). These "memories" were not her own experiences, and her reliance on state-approved public memories covered over her own traumatic experiences of watching the destruction of the world in which she was born, and the psychic stress of being asked to believe that destruction was in fact a triumph of construction.

Several years passed before my inchoate sense of estrangement from this identity—"Israeli"—became an articulate refusal of it. My effort to memorize parts of the Israeli Declaration of Independence was, maybe, one early trigger for my later refusal. When my critique of the nation-state turned into a broader project of unlearning imperial geographies, I came to understand the anti-imperial potential of one's identity. I began to pay attention to unruly gestures and memories that were transmitted by my parents, despite my father's commitment to forget Jewish traditions in order to sometimes pass as French in Algeria, or my mother's commitment to raise us as "good citizens." The only "Jewish" thing we knew he loved was liturgy, though he refused to go to the synagogue to listen to it. Instead, he listened to different cantors on vinyl in his store, never at home. These disruptive gestures testified to the existence of more troubled geographies than the geography the nation-state sought to impose, and they testified to worlds that existed before imperial borders, worlds that could still be reclaimed. While my parents were both complicit in the liquidation of their ancestors' worlds, my father, at least, taught me that I need *not* be "a good citizen." I'm assuming that it was the inheritance of his ancestors' hatred of the colonial state that guided him. He often said that the Jews should not have had a state of their own, though his reasons for saying so were very different from my own.

It was part of our education to constantly discuss whether we felt more like "Israelis" or like "Jews," and the "right" answer was "Israelis," meaning also secular, a colonial way to teach us to hate Jews. But identity, obviously, is not about what one feels, since the feelings of settlers' children are colonized even before they are born. In the imperially crafted world, identity is what

was imposed on us and it is also what was robbed from us and from our ancestors when imperial identities imposed. As children, we could not have known that we were actually something else before the newly established state told us who we were. In other words, growing up in Israel meant being incapable of grasping the fact of our pre-Israeli identities. Creating this generational gap is at the heart of the imperial project, and it is what enables its reproduction. Often, our parents were lured into jeopardizing the transmission of their ancestors' knowledge by adopting different imperial technologies, including education. Since the French Revolution and its invention of "free education," state-sponsored education had taught parents to give up their children to the state. Imperial state education taught children to be "new" and "modern" and to be good citizens, a system sold to parents as part of a necessary good for their children. It was a colonial trick: for their colonial education then turned children against their parents.

We were Muslim Jews on my paternal side, and on my maternal side, we had a centuries-old attachment to Palestine and to Spain, and the precious heirloom of Ladino, a language and anti-imperial political formation that the Zionist colony stole from me. However, what I inherited doesn't feel like anything my parents intentionally wanted to transmit. They didn't pass on distinct rituals, or leave us intimate journals. But when I read memoirs of others whose lives followed similar trajectories and patterns of migration, I find more familiar things than I had expected, and many dormant memories are awakened. I must have heard more stories than I thought, but they were probably sporadic and there was no world where they could make sense or resonate. This was my experience when reading Massoud Hayoun's book *When We Were Arabs: A Jewish Family's Forgotten History*.[4]

I read his book at the same time that I read yours. In one of Hayoun's tweets, he describes the process of writing this book as a shared endeavor with his grandparents: "In 2016, I moved back to LA to write a story with my grandma, we felt/feel we needed to tell the world."[5] Hayoun was raised by his grandparents, who refused to relinquish their Arab identity. As a result, their grandson, who grew up in the United States, can state clearly that he is a Jewish Arab. A Jewish Arab, Hayoun emphasizes, not an

Letter 13. The amnesia of Jews in the US is only half the story

Arab Jew: "I am Arab first and last. Judaism is an adjective that modifies my Arabness."[6] Out of fear that his grandson would not know enough about the Jewish Arab world in which they lived, his grandfather filled three notebooks with stories. Fearing that Hayoun wouldn't read them, his grandfather later decided to dictate these stories to him. When his grandfather was hospitalized, Hayoun started to share his sense of urgency, acknowledging that his grandfather had only "so much time to paint for me his life in an Arab world that no longer exists."[7]

I was reading his book with avidity as it felt like coming closer to my ancestors' world, but also with pain, knowing that the story Hayoun chronicled was not a common one. His grandparents had been committed to holding on to their Arab Jewish world despite multiple colonial projects; they did so in order to ensure that their descendants would not have an alienated relationship to their world, which was being forced into the past. Once preserved, the continuity of Jewish Arab identity may seem like a simple process. But it was not. His book discloses the labor it required from his ancestors and from himself to keep this identity alive.[8] Hayoun doesn't use the term "intersection" that is central to your book, Katya, but he inhabits an intersection nonetheless, for he is both Arab and Jew, as were his ancestors. This identity is a gift for Hayoun, as you can imagine, since our world of identities is still haunted by binaries.

You use the term intersection as part of an attempt to valorize the coupling of your two inherited identities, Jewish and Black, and to counter different cultural and political formations invested in minimizing one identity at the expense of the other. In a recent exchange, you sought to emphasize the nature of the intersection: "I was taught always to say AND—no halves or mix or 'between.' I don't inhabit an in-between ... rather, I am always both Jewish and Black ... but the first (Jewish) is existential and permanent and the second is political and conditional."[9] Reading this, I was reminded of what Azmi Beshara, who still lived in the Zionist colony in Palestine in 2005, before being forced to leave his ancestral homeland, told me when I made a film about him: "I'm not half Palestinian and half Israeli, I'm both Palestinian and Israeli."[10] Beshara, at the time, was aspiring to transform the

meaning of being Israeli. Today, I'm assuming that he would not repeat this formulation, which testifies to the fact that the first identity, Palestinian, is in a way—but only in a way—existential, while the second, Israeli, is conditional.

Dear Katya, I find this distinction between the existential and the conditional problematic since you seem to see only half of the problem. That Jews in the United States learned to self-identify as whites was not automatic. As in Europe, they lived under growing pressure to forget their Jewishness in secular spaces modeled after the Christian Man, as Sylvia Wynter puts it, and to accept assimilation as a condition of their *droit de cité*. Despite being shaped by different communities of Jews mainly in Europe, most of which were destroyed, diverse Jews in the United States were amalgamated into one group, "Jews," while at the same time they were asked to forget what made them Jews, either for their well-being here, or for their safety.

You are right to see one major harm of this self-identification with whites, that "looking Black" precluded the possibility that a person "would be mistaken for Jewish, therefore a Black identity was reinforced where a Jewish one did not exist."[11] And you also discuss the "amalgamation of African groups [that] had occurred among the slave population in the United States," but you ignore the colonization of the Jews by Europeans, and that of non-European Jews by European Jews, and of Palestinians of all faiths by European Jews—all events that helped to amalgamate diverse Jews into one people. I share your call to Jews in the United States to awaken to the "obligation to demystify the false assumption that there is a symmetry between *being* Jewish and *being* white." But this should be done not just because it is part of "a race-rooted political order and economy."[12] We have an obligation to undo this amalgamation of different Jews in order to be able to tell *our* untold stories as diverse Jews, and to hold Europe and Euro-Zionists accountable for the destruction of our different communities all over the world that enabled this amalgamation. Jewish, like Black, is the mark of our racialization, amalgamation, and colonization.

I'll not expand further on the damage the Israeli identity has wrought upon Palestinians; I would rather dwell on the way

Letter 13. The amnesia of Jews in the US is only half the story

different Jews' identities were buried under a structural intersection created from two imperially crafted identities: "Israeli" and "Jewish." Even though the "Israeli" identity is adopted by millions, it is still relatively easy to explain (even if many remain unconvinced) that it was created in 1948 together with the state that carries its name, and that the identity is part of the same Zionist project.

From the so-called emancipation of the Jews until the end of WWII, with its concomitant destruction of Jewish communities in Europe and beyond, Jews were hated by Europeans both for being Jews and for no-longer-being-Jews, that is, for passing as Europeans with the same citizenship rights as white Christians.[13] In the Jewish Muslim world, Jews were not persecuted for their faith or for being part of the general culture. In the United States, the focus of your book, the growing number of "white looking slave children who also remarkably resembled their masters," as you write, created a certain "*invisibility* of Blackness that became a threat to white self-identity." Similarly, this "emancipation" of the Jews created a certain invisibility that threatened Christian Europe's idea of itself. From 1870 on, the partial invisibility of Algerian Jews, who were forced to become French citizens in their own country, transformed them into "a threat to white self-identity."[14] I use the term "partial invisibility" to emphasize that, in comparison to the Jews in France, Algerian Jews were not made fully invisible inside Frenchness, since they were also Arabs and could not easily pass as white.

You write, "Whiteness could only have significant meaning in juxtaposition to Blackness," and you contend that "if this opposition proved to be an illusion, the entire cornerstone for attributing significance to separate racial group identities would be destroyed."[15] I somehow think that for Jews, the opposite dynamic is at play. Much of the violence exercised against the Jews throughout history was done in order to erase their difference rather than to emphasize it—conversion, inquisition, expulsion, massacres, emancipation, assimilation, and genocide. And yet, a certain difference often persisted despite attempts at its eradication, which was again a proof that Jews' difference was innate to who they were. It is the difference that was racialized,

rather than allowed to be, and it is its erasure that had to be opposed.

In Algeria, a similar process occurred with the Crémieux Decree imposed by the French government. The French settlers were rather anxious upon seeing the Jews naturalized amongst their French secular peers, and they opposed the decree. The potential invisibility of Algerian Jews in French colonial society seemed to carry a threat, as described by a French lawyer, also a settler: "The children of the Jews will be more dangerous for us than their fathers, and those who will be better dressed among them will be better thieves." "Better dressed" obviously meant "like us," true "French." The disappearance of the Jews into French style became a perverse source of incitement, fear and persecution. From 1870 onward, the French settlers who had to relate to Algerian Jews as Frenchmen demonized the Jews as potential thieves of Algerian resources. As the same French lawyer wrote: "The descendants of the Jews use so many ruses in order to steal from the natives that it is nearly impossible to mention all of them to our readers."[16] Once the Jews were forced to become French, effectively invisibilizing their Jewishness, whatever they did in their homeland, meaning Algeria, was perceived as an act of intrusion. In post-1870 Algeria, when a small group of colonized Jews started to enjoy rights that had been the exclusive prerogative of the colonizers, these Jews were depicted as profiteers and moneylenders—that is, they were depicted with longstanding European anti-Jewish tropes. (Ironically, these descriptions were rather accurate depictions of the French colonial settlers who were then plundering Algeria). Paradoxical as it may sound, in Algeria, the partial invisibilization of the Jews meant their transformation from indigenous people to inferior members of the colonizers' class, who threatened the settlers' monopoly on imperial rights.

The assimilation and invisibilization of Jews across the world prepared the ground for concretizing "the Jews" in a single state and imposing a monolithic identity upon them, following the model of a Eurocentric/liberal/imperial construction of nation-state and national identity. In Israel, "Israeli (Jews)" were created. They formed "a nation like all other nations," a nation

Letter 13. The amnesia of Jews in the US is only half the story

of colonizers who stole others' lands; they were regarded by other nations as capable of imposing and operating a racialized state apparatus informed by white Christian supremacist logic in Palestine, similar to the one that had been previously employed against them. This all happened in less than a century, following the genocide of several million Jews, the confinement of millions in concentration camps, and the forced migration of Jews from diverse worlds to Christian-dominated countries, including to the new Zionist colony. The Zionists, in tandem with Euro-American powers, proclaimed that the colony-turned-state constituted adequate reparation for what had been done to the world's Jews. As sovereign citizens of a nation "like any other," Israeli Jews were offered a place of honor in the Judeo-Christian tradition that was fabricated at the end of World War II.

Dear Katya, I want to challenge your insistence that different Jews were unified around a single moment in Mount Sinai. "Every people," you write, "has a moment in which they invent themselves—Jews have Mount Sinai," and you claim that this event —the covenant between God and the people—"conditions the possibility of a Jewish people coming into being."[17] I'm troubled by a certain confusion between the mythological and the historical. We can read Mount Sinai as a founding moment for the people who were at the foot of the mountain, but did all Jewish communities around the world emanate from this moment? Is it everyone's founding story? Or was Mount Sinai selected in the nineteenth century as a founding moment to help invent the Jews as one people, a nation in the modern sense of the world? Your work is about the diversity of Jews, so why focus on this single story and assume that this moment is the one diverse Jewish communities identify with across thousands of years? You know how different Jewish communities didn't recognize themselves in other Jewish communities until Europe forced them to shed their differences and unite under a banner of shared oppression—once through their "emancipation" and then through the lens of the Nazis who persecuted them even when they had only a quarter of Jewish blood. Jews have never had one law but many laws, never had one founding story but many stories, never had one tradition but many traditions, and also never had one torah but

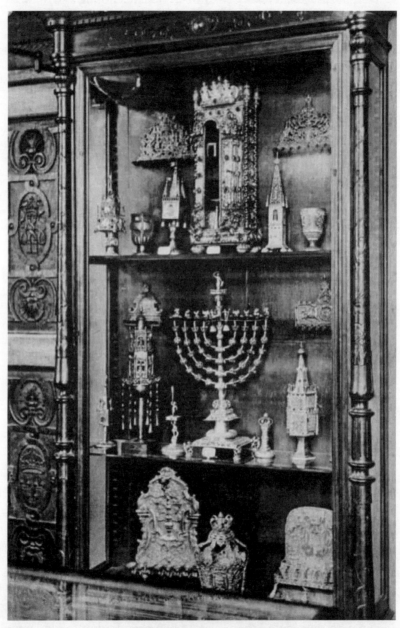

Jewish metalsmithing (*orfèvrerie hébraïque*), Musée de Cluny, Isaac Strauss collection.

Letter 13. The amnesia of Jews in the US is only half the story

several torahs: the written one, the oral one, and, let me add, the manual one.

This last is a torah related to craft-making, denoting a particular kind of communal formation and a way of being a Jew, a practice of dealing with metal, fire, and incantations. While still in the desert, Moses tells the people that God "has singled out by name Bezalel son of Uri son of Hur, of the tribe of Judah" and endowed him "with a divine spirit of skill, ability, and knowledge in every kind of craft; to make designs for work in gold, silver, and copper, to cut stones for setting and to carve wood—to work in every kind of craft."[18] This is followed by a very detailed description of the different crafts and the laws by which the people are being determined. When I think on Muslim Jews in the Maghreb, I think that this could have been their formative moment, part of their covenant with God. Crafting sacred and non-sacred objects was innate to their self-understanding of being Jews, and to the vibrancy of their communities, and this was protected under Islamic law.

If I wanted—but I never did—to look at art related to our history, I could look at either Christian imagery of episodes from the Bible's "Old Testament," or ethnographic Jewish objects. The European museums of the nineteenth century, where objects Jews used became part of "ethnographic" collections, accelerated and anticipated the killing of diverse Jews for their rebirth as modern citizens and assimilated "Jews." These objects were collected from synagogues described as having "fallen into disuse." "Falling into disuse" is code for violence, the exercise of external pressure, or the issuing of threats. This campaign of assimilation was so successful that Jews, too, became collectors of "Jewish objects," trained to look at these pieces of diverse ancestral worlds as museum objects, as objects that were part of their *heritage* but not part of who they were.

Isaac Strauss (Claude Levi-Strauss's father) was one of these collectors, and his collection—drawn mostly from Europe—was donated to the Musée de Cluny in Paris (see photo p. 492). Only the very few items in this large "Jewish collection" that came from the Jewish Muslim world were all made by Jews. The rest, those collected from Europe, were made by Christians, since in almost all of Europe Jews were not allowed to be metalsmiths.

This series of letters I am writing is one way to refuse the language of the museums that hold many of our ancestors' objects, and to rebuild a world where these objects can live with us and teach us about our ancestors.

In high school, I had a proclivity for art classes and did my best to absorb as much as I could. In the colony, I was raised to love Western art and culture, and taught to appreciate it as my own tradition. If I worked hard enough, I learned, I could enjoy the right to claim it as mine. I never saw an image of a Jewish Muslim person engaged in any kind of artmaking in school, however; my models were Western culture. When I visited encyclopedic museums to see "modern" art, I could see, in passing through the halls of ethnic art, "precious" objects and images classified as "Jewish" and produced in Arab or Muslim countries. What I saw, I realize in retrospect, was already mediated by imperial knowledge production, which produced a distinct Jewish iconography and symbolism devoid of any world or community. This was called "Jewish art." The dexterously built worlds of Jewish Muslims in Algeria, and their traditions of craft-making, were hidden from me as a child.

Undergirding the feted notion of a monolithic people, "the Jews," is the retroactive assumption that "the Jews" were always already detachable from the places where they lived, never fully a part of their homes. The same goes for the objects they crafted, as if they could be singled out and identified as "Jewish" according to some expert's idea about what "Jewishness" can be said to be in an aesthetic or ontological sense. The destruction of the Jewish Muslim world and the atomized existence of "Jewish art" is mirrored in museums, exhibitions, and books of Islamic art, where the work of Jewish Muslim artisans is disavowed, and all objects are presented as if made by Muslims.

The separation between people and their objects, and by extension, groups of people whose objects are used to reflect such separations, is central to the imperial project. Asking questions about the physical and material dimensions of world-building is a way to counter the ethnic, religious, and racial classifications that are imposed upon colonized spaces and reified by museums and their repertoires of art objects.

Letter 13. The amnesia of Jews in the US is only half the story

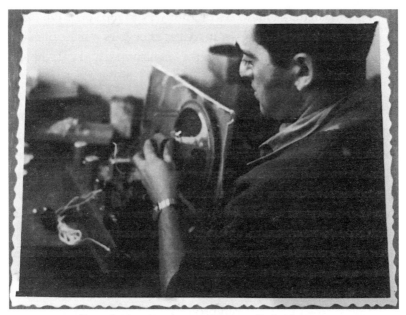

Roger Lucien Azoulay, repairing a radio in his store.

I inherited good hands from both my parents. I recognize myself in my father's nimble fingers, in his eyes alert to how things worked or were made, in his sense of improvisation, intuition, and audacity. However, the artmaking practices that I learned at home were not artists' skills as much as a way of living with objects, keeping them in good shape, repairing or repurposing them as needed, caring for them. The artmaking that I learned at home was exactly what I was asked to forget whenever I studied art in school. What I was asked to forget was the world, since art with a capital A, *Art* as a transcendental category, we learned, exists independently of the social world. Art transcends the daily work of maintaining the world and caring for it. Art with a capital A has its own history—a Western one—though the millions of objects plundered from other cultures are what enabled its invention. So while I never saw an image of the dexterous hands of a Jewish Muslim in Algeria during my education, I grew up with the agility and skills inscribed in the hands of my father, who was trained in Oran, Algeria, from his birth until his late twenties.

Among the several examples that come to my mind when I ask myself where I see evidence of his agile hands and his manual

skills is a dormant memory only recently awakened after I decided to take a jewelry workshop to study the craft Jews practiced in the Maghreb. The moment I entered the workshop, I had a flashback to my father holding a soldering iron and leaning against one of the big radios he had in his store (see photo p. 495).

When I was a child, I was fascinated by the tongue of fire that came out of this spoon-like tool, which he used to solder thin electrical copper wires and shape them into what seemed to me like beautiful pieces of jewelry—spools, knots, and cones (see photo below). He would then place this jewelry inside big wooden radio boxes he was repairing. He loved to tell the story of how, when he was thirteen or fourteen and already out of school, he learned to become a radio technician through a correspondence course. I know today that he lived surrounded by small ateliers of jewelers in Oran, and I can now imagine him asking to use their smelting iron so that he could practice his radio and electricity course homework. I can see him telling himself that he could do even more than they could, because he could conjure sound from the jewelry he made.

When my sister and I went to art school and were lauded by our teachers, my father decided to search for the origins of our

"Jewelry" inside the wooden box of the radio.

Letter 13. The amnesia of Jews in the US is only half the story

Roger Lucien Azoulay, *Star Wars*, late 1970s.

talents; he spent some time painting, trying to prove that we had inherited artistic talent from him. He started with a "still life"—a vase with flowers. He then copied two or three of Joan Miró's paintings. I assume he got to know Miró through the art books we brought home, and he loved the floating forms and colors on which he could project almost anything.

From copying Miró, my father moved on to painting images of extraterrestrial life and, at that point, concluded his career as

an artist. It made us laugh. Not because we didn't believe that our talent could have come from him, but because what we were learning to call "art" was antithetical to what he was doing. It didn't occur to me, however, to see that our father sought to track down the origins of what we were doing in a stylistic and aesthetic sense, rather than by affirming that his own artistry and dexterity, unrelated to his experiments with painting, were the origins of his daughter's confident hands.

My question about why I never saw images of things I know existed doesn't end with the absence of images of Jewish Muslim artists. I also wonder if I ever saw an image of the colonization of Jews in Algeria. I have already said elsewhere how much I hold the discipline of history accountable for these retroactive interventions into what and how things happened, into removing the Jews from the body of colonized peoples in Algeria. By erasing Jewish diversity and turning enmity with Arabs and Muslims into its raison d'être, the state of Israel actually completed the colonization of Muslim Jews by taking their history out of the Muslim world and placing it inside that European invention, the "Jewish people." This is how we were made invisible.

Robbing Muslim Jews of their colonized consciousness started when the French authorities sought to invisibilize Algerian Jews and to incorporate them into Frenchness by attacking their different modes of life. We were granted biographical narratives of redemptive assimilation, were allowed to exist as invisible Jews amidst white Christian people, and were made doubly invisible as Muslim Jews within the "everyone" named in imperial declarations of rights as citizen.

This invisibilization of the Jews troubles me because it relies on our silencing. The current global campaign allegedly against anti-Semitism is not to protect the Jews from racism, but to normalize the genocidal regime against Palestinians and silence us and our diverse histories and repress our liberatory aspirations to be free from the "solutions" Euro-American empires imposed on us. It also silences others who criticize the violence exercised by the state of Israel. The state of Israel endangers the Jews more than it protects them, and those who pour money and arms into its government and military do so to protect their interests in

Letter 13. The amnesia of Jews in the US is only half the story

Torah scrolls plundered by the Nazis and stored in the Central Museum for the Extinct Jewish Race, Prague, Czech Republic, 1943.

the Middle East, rather than out of concern for the well-being of the Jews.

Our ancestral histories of diverse Jewish communities threaten the established new world order imposed by Euro-American powers that invented Israel as a solution to "the Jewish Question" and imposed one approved "past" on us, forcing us to think of ourselves as one people apart from others. The solution the Euro-American powers offered was twofold: first, assimilation

into Christian culture, and second, a sovereign nation-state for the Jews in Palestine so that we could be imperial citizens. This solution did not undo the devastation of European violence against the Jews; it created further destruction, about which we are not allowed to speak. We are not allowed to say that the extermination of our ancestors was perpetrated not only by the Nazis but *also* by the same state apparatuses and technologies that continue to persecute others today.

Discussing this global campaign against anti-Semitism, Lena Salaymeh writes: "Zionism and antisemitism are intertwined in complicated ways; global North actors often use the latter to justify the former."[19] This intertwining of our invisibilization and our silencing explains how Jews in the United States have come to identify as white.

It is hard to think about the Jews in the United States as silenced, right? When restrictions on Jews were lessened in the 1950s, they could assimilate into a world that was not made for them, with assimilation as the price to pay to enjoy upward mobility, occupy high positions in different spheres, escape the health apartheid reserved for racialized and ethnicized groups, and more. With time, assimilation—and the broader project of American whiteness—included supporting the Zionist project, which is entangled with supporting Euro-American interests in the Middle East. Shouldn't we ask how Jewish inhabitants of the Zionist state became enmeshed in imperial aims without their consent? Shouldn't we ask why so much money and so many weapons are being poured into the region such that no peaceful way to end the settler-colonial regime can emerge? Shouldn't we ask, eight decades after the Holocaust, why we Jews, victims of the white Christian world, have become its mercenaries? Without excusing the Israelis for what they are doing, I cannot ignore the truth: they are also victims of Euro-American interests, trapped in a settler-colonial project "offered" to them by imperial powers who are doing everything to keep them trapped in it. The vocal support of Israel in Western Christian countries every time it bombards Gaza is not a sign of love for the Jews, but rather of an ongoing Christian crusade against Muslims and a Euro-American project of geopolitical dominance in the region. This is

Letter 13. The amnesia of Jews in the US is only half the story

what whiteness has come to mean: it is not about skin color, as you know, but about power—I disagree with Fanon's emphasis on color. We must understand this so we can envision the decolonization of Palestine and the world beyond Fanon's definition of a conflict between only the oppressor and the oppressed, because the root of this settler-colonial regime lies not in Palestine, but in Europe. Decolonization must involve not just Jews and Muslims but Christians in Europe as well and the undoing of racial capitalist technologies.

Europe sponsored long processes of de-Judaization or Christianization (there were so many missionaries and societies to Christianize Jews in Europe, Africa, and Asia in the nineteenth century!) that produced a two-headed Christian-European hydra, with one head named the "Jewish Question" and the other, the "Question of Palestine." Jews in Europe were "chosen" to destroy their own diversity and colonize Palestine, and they were told it was a Jewish liberation project. Jews in the United States, in Africa, and in the Middle East opposed this monster, but this is almost totally forgotten because the Zionist state integrated its Jewish citizens—and many Jews in those Christian states—into imperial time, in which there is no past other than the national one.[20] Thus, opposition to the creation of this state became a distant memory for scholars rather than a resource for those opposing Israel's colonial formation today, those who insist on remembering what Israel's formation did to the Jews: turned them from victims of Europe into its executioners, who fight an invented enemy created to pay for Europe's crimes.

I'm horrified by what Zionists are doing to Palestinians, but I'm just as horrified by the grim future for the colony's inhabitants of Jewish origins, as denial prevents them from returning to their ancestors who opposed colonization. It is not out of the love of the Jews that this monster, the conjoined heads of real anti-Semitism and the false solution of Zionism, is sustained.

We should be clear: this monster, fueling violence against Palestinians and Jews today, was not created initially by Jews but was and continues to be a Christian evangelical project that uses the Jews. Euro-American interests are invested in the story of a conflict between two sides, Jews and Arabs. They want us,

non-Zionist or anti-Zionist Jews, to forget how we all arrived here. We must hold Europe accountable for the creation of this monster and include in our imaginaries of Palestine's decolonization the decolonization of Jews from Europe.

Palestine is still a place of hope, as it can be a place of further tragedy for two peoples who were artificially and violently created at the expense of their plurality and their ancestors' nonimperial traditions, values and laws.

While I join your call to the Jews in the United States to disidentify with whiteness, I think that a more radical call could be made: to reclaim and rewrite their histories as diverse Jews. American Jews might start by asking about the cause of their aphasia. I was struck by your observation about the participation of Jews in the Civil Rights Movement, which "seemed to fill a vacuum for young adults who were Jewish by birth but were alienated from involvement with Jewish life."[21] Beyond the solidarity young Jewish Americans felt with Black Americans, I read this also as a kind of speculative rehearsal in imagining ways out of the dead end of their assimilation—"Jewish by birth," alienated from their heritage one generation after another, trying to speak from their own experience but without finding the words for it. They were socialized to accept the citizenship bargain imposed on them to forget the political and legal struggles of their ancestors, and socialized to renounce their own collective claims as victims of imperial, racializing states. Those American Jews who joined the Civil Rights Movement still had some trace memory of being a minority in unjust world. Largely unable to find words to describe the injustice done to them, except when the perpetrators were Nazis or through the European narrative of their exceptional suffering, they could more easily stand against injustice toward others.

During the Civil Rights Movement, Black people fought to be included in the arenas that had excluded them and to transform systems made to oppress them. They came together as a mass movement and didn't shy away from voicing their claims collectively as an oppressed group, or from describing what had been done to their ancestors during slavery. When, after WWII, Jews struggled to stay in Europe, or when they opposed the creation

Letter 13. The amnesia of Jews in the US is only half the story

of a Jewish state in Palestine, their claims were superseded by the Euro-American postwar solutions to the "Jewish problem," which created a fictional Judeo-Christian tradition to usher in Europe's rebirth. Jews in the United States, for example, were proclaimed assimilated with white Christian America without being asked. Thus, their ancestral memory was stolen and replaced with a Euro-American narrative of the Holocaust that provided proof of the Euro-Zionist story of the Holocaust, a story that held that the historical emergence of racism against Jews is in fact an ahistorical and ever-present anti-Semitism.

What you describe as the collective amnesia of Jews in the United States may not be an amnesia alone but rather combined with an aphasia, the loss of speech and understanding, and either way it is only half of the story. The other half is that the places where their ancestors used to live and where their ancestral memories were enshrined, in Europe or North Africa, were destroyed (see photo p. 499). When they were integrated as citizens in lands foreign to their ancestors, they could at best only read their Torah scrolls, never knowing who their ancestors had been in places once governed by the laws written in those scrolls.

We—diverse Jews—still lack the language-in-common to speak about the destruction of our diverse communities and to make this destruction the substance of a shared anticolonial struggle for liberation. Katya, you describe a moment when "with the rise of Black Power, and the drive for Black consciousness and self-esteem … Jews and other ethnic groups would begin to—publicly—readdress and question the price of assimilation and the meaning of identity."[22] This was not the first moment, nor would it be the last. But the reason we don't yet have the language-in-common to question assimilation and discuss Jewish identity is because words alone—without the objects and sites and communities that give them meaning—cannot build a world.

Like you, I have a complex relationship with Hannah Arendt's writings, and yet I cannot stop returning to her work, which I read not only for what she says but also for what she transmits from the experience of seeing her world destroyed in Europe. While *The Human Condition* doesn't deal with the destruction of Jewish

communities, the importance she gives to "work," "things," and "world" in that book should guide us:

> The things of the world have the function of stabilizing human life, and their objectivity lies in the fact that—in contradiction to the Heraclitean saying that the same man can never enter the same stream—men, their ever-changing nature notwithstanding, can retrieve their sameness, that is, their identity, by being related to the same chair, and the same table.[23]

Our chairs and our tables were stolen, destroyed, and supplanted with the stream of capital that washed away sporadic and weak efforts to rebuild our worlds.

Our sacred objects, many of which are stored in museums, are our best hope. Our objects are the carriers of our diverse memories, our diverse laws; we are their inheritors, and we should be ready to awaken those memories and be awakened by them. Our objects should not be on display but used, for they are powerful: if they were banished to the museum in order to establish Europe's empires, we should treasure their secrets and their power to still derange those same empires.

I'm grateful for having found in you an ally for a diverse Jewish liberatory project, premised on the urgency of undoing our fictive alliance with white Christian Europe, which racialized our ancestors. I hope that despite our disagreements, you will recognize the importance of my insistence that the project should be undertaken as an anticolonial struggle, the only way we can reclaim our right to live by our laws and traditions.

Yours,

Ariella Aïsha

Letter 14. Fuck you, France, my daughter is Islam

A letter to my great-grandmother Marianne, umm Aïcha

Chère Marianne,

Let me present myself—I am your great-granddaughter. I could not find your death certificate, but I'm assuming that you were no longer alive when I was born in 1962 (see upper photo p. 506). The guardian of the Jewish cemetery in Oran is still searching for your grave, at my request. I'm the daughter of your grandson Roger Lucien, your daughter Aïcha's son. I'm looking for you, for all of you from whom I was detached to be raised as a different species than you were.

My biological parents raised me, but I was born in the human factories of the Zionist colony in Palestine. This is one of the colonial forms of adoption: children grow up with a history that is not theirs. Some of them attend to the gaps they observe in this given history, and they hold on to the bits and pieces of things that speak to a different history in the hopes that one day they will understand. These children, and I was one of them, hope to experience a miraculous moment when these known-unknown details coalesce into an explanation for the phantom pains of amputation they have felt their whole life. "Where am I from?" can be an existential question, but it can also be motivated by an anticolonial drive to oppose given histories, given geographies,

Dear Marianne, are you there, buried in one of these thousands of abandoned graves? Jewish cemetery, Oran, Algeria, November 2022. Photo: Yohana Benattar.

given polities. I love my parents but I alienated myself from "their" world, which was not theirs either. I grew up to resent and alienate myself from the Zionist colony and from most of the people there, those who in one way or another still speak the colonial language we learned as our mother tongue. In the last few years, I have felt a growing solitude. Your world, which

Algerian musicians chase the *djinn* from a child.
Painting by André Brouillet, 1884.

Letter 14. Fuck you, France, my daughter is Islam

I want to inhabit, is nearly destroyed, and the gates leading to its ruins are not yet fully open. As much as I feel your presence when I sit to write to you, dear Marianne, you are not here to give me loving words, to take me in your arms and tell me stories, to teach me how to prepare the special couscous made with spring vegetables and fruits that we eat once a year in celebration, in the company of other women while singing.

I promise you, dear Marianne, I'm not a shedu, *djinn*, *djenoun*, or any kind of spirit who comes to bother you in your afterlife. There were moments in my life when I felt the *djinn* in my soul, when I wished one of my ancestors from outside the colony could sit close to me, caress my hair, call more relatives to join with their musical instruments and chase the *djinn* out of me. What I experienced as a *djinn* back then has been revealed to have meaning now, and I don't want, anymore, for it to be chased away. I rely on its powers to guide me to my ancestors' world, where Jews and Muslims can celebrate the exorcism of colonialism from their bodies and minds together (see lower photo p. 506). I am your kin, *chère* Great-grandmother. May I call you *Grand-mère, ou Mémé*?

I somehow didn't pay much attention to your name when I looked at the *livret de famille* that I found in my father's black faux-leather suitcase after he passed away.[1] This is why it took me some time to find you. The name that captured my attention when I first read this document was *Aïcha*, your daughter's name, my grandmother's name, which she cherished, though some of her descendants wanted her to have a different one, more French.

This Jewish Muslim name that you gave your youngest daughter in 1895 was suddenly the most tangible thing that I had from Algeria. Learning the true name of my grandmother was a window to our family's life in Algeria before French colonization, even though you named her sixty-five years after colonization had begun. It was a relic from the moment before common Algerian names started to be disfigured, manipulated, fixed, disregarded, outlawed, and used by the colonizers to sustain their rule. And yet, in 1895 my grandmother was born Aïcha, a testament to how "Muslim" or "Jewish" names were used interchangeably by Algerians for centuries and how they went on being used, despite

colonial pressures that should have prevented you from calling her Aïcha, your ancestor's name.

Controlling names was part of the campaign to impose the French system of "*état civil*" on you, determining what you would be called and how you would be known by others.[2] This legal code was imposed in 1882, but its foundations were built much earlier, by the system that forced you to declare births, marriages, and deaths in French municipalities. State intimidation was intertwined with legal measures that accompanied the most intimate moments of life and often came with the threat of punishment. For example, "Article 346 of the civil code of 1848 punished any person refusing to register their newborn in the civil status of their municipality."[3]

I carry the name of your daughter, which is also the name of the grandmother of your husband, Abraham. It is probably also the name of her grandmother, or her husband's grandmother, and her grandmother.

When my daughter was born I lived in Paris. No one told me how we bless our newborn children. I appealed to God for help, as I often do when I look for guidance in how to amend, or seek forgiveness, or offer blessing.

Mon dieu, I said in Hebrew, el-lie, el-lie, illahi, and I inhabited the blessing of her birth in the feminine form of her written name. I knew she was Ellie and that her name should be spelled with a double l (elle). The year was 1987, and the French were still working through their repertoire. They rejected one l from the official documents of your great-great-granddaughter, as if they could still tell us how we should name our children, and our grandchildren, and our great-grandchildren.

A day will come when one of my grandchildren will bless their daughter with the name Aïcha.

My father could not call me Aïcha, but it was not *his* decision. I can't find a written law to prove it wasn't his decision—but I have 132 years of the colonial disintegration of Algerian's ancestral traditions as proof! There is no way to imagine my father, in 1962, with his dark skin and North African accent, going to the

Letter 14. Fuck you, France, my daughter is Islam

relevant office in the Zionist colony in Palestine and declaring that his daughter's name was Aïcha, by then a name thought to be only Arabic. Because of where he came from and where he arrived, he interiorized heaps of inhibitions, decrees, laws, and self-negation mechanisms, to the point that I cannot even find out if he ever dared to tell my mother what his mother's real name was. You see dear Marianne, Aïsha is not my *given* name. In 2012, when your grandson died, I took this name directly from this piece of paper and made it my *taken* name, embraced and retained it. I inhabit it every day with more and more jubilation. I celebrate this precious gift offered to me at the age of fifty, my jubilee year, a year that marks the end of seven cycles of Shmita, that marks my chosen exile from Palestine, the land the Zionists abused, in the hope that I will see Palestine free from their hands in my lifetime.

I spell my name slightly differently from you: *Aïsha*. I didn't mean to stray from your spelling, but when I realized that I had copied it twice, each time with a different error, I refrained from correcting it for the third time. (After all, is there any proper way of writing an Arabic name with Latin characters?) When I wrote it down for the first time, I remembered it with a *y* instead of an *i*. I even opened an account with this spelling mistake on a platform where people nowadays share images with others. (It's there that I often see images of Algerian women and ask myself, are any of them you? Or Julie, Joseph's mother? Or Semha, your mother and daughter? Are any of them named Aïcha?) After I looked again at this document, I rushed to correct my error, but this time I misspelled its second part and replaced the *c* with an *s*. By then, I had already signed a book contract (for my previous book) using this misspelled name, and I felt silly telling my editor that I had fumbled my own name. After it was published and she read this letter to you, she said, "You should have told me and we could have fixed it!" But by that point I had already embraced the double slippage as a reminder that an estranged name cannot become intimate again in a single stroke. I must labor for it to become fully mine. So here I am, caring for and working toward a world in which I can be born Aïcha. I feel blessed that I was able to reclaim this name and begin to transmit it again to our family, though with a different spelling.

I could only inhabit this name after my father died. As a consequence of his death, the few official documents he kept on the highest shelf of his bedroom's closet were now mine. Can you imagine—at the age of fifty, I was going through my father's seemingly boring papers and all of a sudden, the key to an entire world fell into my lap? My sisters were there with me at the moment we read your daughter's name. We didn't even have to argue with each other; they didn't express any wish to take the name and so it was all mine, pronounced for the first time in the presence of my two older sisters. Our mother, whom you could not meet since she never went to Algeria, passed away one year before my father.

As long as my father was alive he acted as a barrier between Algeria and us, his daughters. By not making any effort to bring us closer, he sent us a clear signal that there was nothing to look for. And we didn't try. In a broken society where identities are fractured, being Algerian seemed to be only his identity, not ours. When he left Algeria, his descendants left Algeria with him.

We did live with our North African family name, Azoulay, but with almost nothing else from Algeria. We were given a history that was not ours and taught not to know this fact. In the Zionist human factories, similar to the ones the French established in Algeria, we were racialized at birth: Jews like us who came from Muslim countries were defined as *mizrahim*, i.e., Orientals, and marked as distinct from and inferior to other Jews, who came from Europe and decided to ruin Palestine. In a paradoxical way, in the Zionist colony we were just like Jews in French Algeria: socialized to be like European Jews, or doomed to stay "Arab," which we learned was an insult.

Does this sound familiar? The destruction of your world by the French colonization of North Africa, and its role in fomenting and legitimizing a Zionist project, were never part of what we learned at school. Under the imperial conception of a world made of nation-states, we learned a story of emancipation in which all these different Jews—regardless of their belonging to other people and places—had to migrate to another place to have a state of their own. We were told this was freedom, and not a population transfer, and not colonialism. Can you imagine,

Letter 14. Fuck you, France, my daughter is Islam

dear Marianne, that your resentment of the creation of a Zionist state in Palestine, and the harm you suffered when the Zionists intervened in your life in Algeria and the Jewish Muslim world, was concealed from us? As you see, it was not just our lineage of names that was broken.

In 1949, when my father arrived in the colony in Palestine, you would have been ninety-five. Were you still alive? I know he was determined to look for a different life elsewhere, and I can't imagine that he waited for anyone's blessing before leaving. I just want to tell you, dear Grand-mère, that though he went to the colony, he didn't plan to stay beyond the year he was committed to as a "foreign volunteer." It is only because he met my mother that he decided to stay. He never felt at home there and never liked the place. Maybe this is why, when I decided to leave, I found I could cut the place out of me without much pain. I was stuck with the refined pain of not having a place in the world where I belonged.

My father came from Algeria with a cardboard suitcase packed with some clothing and nothing else. He told the story of arriving to the port in Haifa with a lousy suitcase that broke when it was thrown on the ground—he had to use his belt to hold it together. It sounds to me like a story from someone who wants to emphasize that he brought nothing valuable with him and that he wholly reinvented himself in this new place. Dear Marianne, it took me years to realize that this absence of Algeria in our life was a symptom of disintegration and dissociation. Children grow up with what surrounds them and ask very little about where things come from, who brought them to their life, when, why, and from where. And they ask even fewer questions, if any, about things that are not there. I knew that we were "North African," especially because we were reminded of it by the colony's European Jewish society. But I had no idea what made this place feel so distant. In the colony, you see, we were expected to demonstrate that we were better than what was said about us (i.e, that we were North Africans), and so the fact that we had nothing from Algeria was "in our favor." This fabricated absence was not felt by us to be a problem, an attack on our powers or on our resistance—until it was.

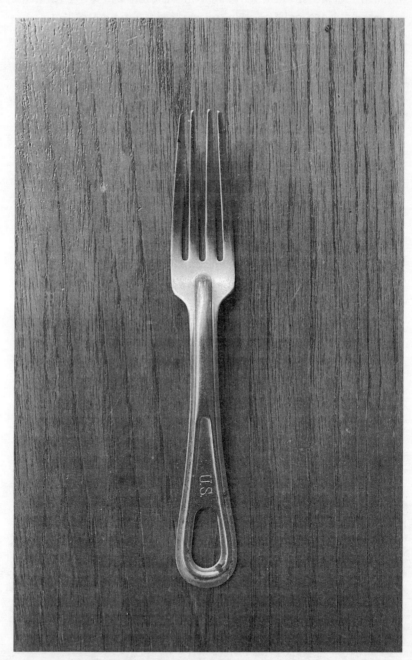
My father's amulet carried with him from Algeria.

Letter 14. Fuck you, France, my daughter is Islam

Writing these letters, reclaiming skills, locating objects, rehearsing my muscles and vocal cords in my ancestors' languages and movements are part of reclaiming this resistance. No one can now deprive me of my grandmothers' names, or deprive me of affirming that I belong to a world that was destroyed, from which I was exiled while being denied even consciousness of my exile.

While I was writing to you, I was reminded of one thing my father brought with him from Algeria in 1949. It was not made in Algeria but was given to him there. It was a stainless-steel fork with an oval hole in the lower part of its handle, indicating that it was part of a military utensil set. The fork, impressed with the letters "U.S.," was probably part of the US Army supplies given to him sometime between his liberation from the Bedeau labor camp and his recruitment to the French Army of Africa, whose provision was secured by the US Army. He ate all his lunches and dinners with this fork, day after day for sixty-nine years until he died.

Today, knowing how central metalwork was to the life of Jews in the Maghreb, I can say with confidence that this fork was his precious amulet. Maybe this was as far as he could go toward owning a piece of metalwork of his own, an artifact associated with Algeria, despite (or because of?) the stamped letters "U.S."?

As children, the first thing we did when we prepared for meals was to place our father's fork near his plate at the head of the table. We would never ask to use his fork ourselves, nor did we dare to offer it to anyone else. When he passed away, my sister took the fork. I recently asked her to take a photo of it and send it to me. I was pained when I saw the stains of corrosion at the bottom, stains that were never there as long as he used it.

This fork is one bead I can use as I string together memories of our ancestors, the jewelers of the ummah. The jewelers of the ummah engraved letters on their metalwork and made magic with their hands, and so I declare: U.S. stands for the Union [des] Sorcières *(sorcerers' union).*

Do you understand, dear Marianne, how comprehensively these human factories deracinated us, so that having my father's fork and the name *Aïcha* feels like riches?

With this single page of family records, a door was opened to five or six generations of our Muslim Jewish families. My ruminations start with your parents, Salomon Cohen and Semha Toboul, whom I felt I also encountered in this document because of the symbolic name of the French Republic that they gave you. My first thought was that you were named Marianne because you were born after 1870, following the Crémieux Decree. When I later found your birth certificate and learned that you were actually born in 1854, only twenty-four years after the colonization, it directed me toward a more inclusive understanding of the longer process of de-Algerianization that began in 1830, well before the Jews were made its first target.

Rather than thinking about your name as your parents' response to the 1870 naturalization law, I could explore it from the "other side" as an imposition of the regime's program of de-Algerianization. When I think about de-Algerianization and Frenchification as two parallel campaigns of violence, it is clear that the French subjected Algerian Jews to a regime of physical and mental dispossession, suffered alongside Muslims. From 1830 onward, Algerians were drained of their Algerianess and were threatened, humiliated, and punished when they enacted it.

You were born in 1854, so your parents should have been born in the 1830s, into an already colonized Algeria. A first generation of people who did not know another world, who lived in the same world as their ancestors but experienced the world differently from them, a first generation socialized into seeing colonialism as the norm. Knowing how fast colonial technologies work, I started to imagine them growing up surrounded with French objects, words, hierarchies, and laws. What for their parents was an intrusion was for your parents' generation a simple fact.

Even in 1854, calling their daughter Marianne was a reflection of your parents' colonial condition: *Why would your parents have called you by the name of those who invaded their country and were destroying it?* Any answer must start by pointing to colonialism's disruption of entire naming systems, the enterprise of disintegration that comes to structure our unconscious and our imaginary. No matter which exact year the name Marianne was given to a Jewish baby in Algeria, it was already chosen

Letter 14. Fuck you, France, my daughter is Islam

Inside the Jewish cemetery, Oran, Algeria, November 2022. Photo: Yohana Benattar.

in an era of brutal disruption. When not only individuals but entire communities are drained of who they are, they can be refashioned into almost anyone. This *anyone*, the foundation of the French conception of citizenship, would later be forced on us too. Promoted as the basis of equality, this *anyone* is actually a colonial technology that recruits people to take part in their own destruction.

Chère Mémé Marianne, I'm sorry that I have to be the one who tells you that after you died, Algeria was emptied of its Jews. There are almost no Jews in Algeria, at least for now. As with an old model of a camera, a car, or a phone, this extinct species—the Algerian Jew—was replaced by a new model from the human factories: the Israeli Jew.

Model 1962 *was* me.

No longer. *I ran away from the factory. I'm still asking people to stop recognizing me by the serial number that once sanctioned my belonging.*

Stop!

In 1962, the French colonizers were finally forced to leave Algeria. The Jews were not, however, free to call their daughters Aïcha. Rather, the opposite—they had to forget more Algerian things, including Algeria itself. I know that if you could hear me, Mémé, you would ask me to repeat what I'm saying, ask me to say it slowly, as it didn't make sense. Indeed, it doesn't make sense. I'll say it again, slowly, but it will still not make sense. One hundred thirty-two years after they invaded Algeria, the French finally left. As they had forced Algeria's Jews to become legally French, Jews had to leave Algeria with the French, as "the French," as if they themselves had also been colonizers. Yes, all of them. *Mon dieu.*

Thank god that the "repatriation" of dead Algerian Jews to France or to the colony in Palestine was not demanded. You are the last ones of our family to be buried in Algeria (see photo p. 515). Your daughter Aïcha left in 1962, as did her three daughters and their children. I don't know anything about your other children. I'm assuming, though, that all your offspring left in haste like most of the Jews. You have probably been wondering why no stones have been put on your grave in the last six decades, or why your loved ones no longer come to be close to you in the cemetery. My feet have never touched the soil of Algeria. Can you imagine that my father and I never spoke about this coincidence—how in 1962, when Algeria celebrated its liberation and when his family was disappeared from Algeria, his younger daughter—me—was born? All of a sudden there was nowhere for us to return to. I was born exiled.

Letter 14. Fuck you, France, my daughter is Islam

Your birth, in 1854, was registered in Sidi-bel-Abbès, where your parents were living. I wanted to learn more about this place, since I have always been enamored with Oran (though I have never been there) and thought, perhaps erroneously, that this was where we came from. Reading about Sidi-bel-Abbès made me feel dizzy, because you, us, we—we could not come from this place, since it was built just five years before you were born! The sources that I consulted confirmed the existence of a small, sedentary community of several hundred indigenous people: Muslim, Jewish, and Black, and a weekly market "with a regional or inter-regional vocation" that probably served the surrounding tribes and those who constructed the city. The souk preceded the colonization and was frequented by traders from big cities like Tlemcen even prior to the roads built by the colonizers. The Jews sold mainly fabrics, jewels, and local perfumes in the market. Was your father one of them? Did your parents live there already in the 1830s, as part of this very small indigenous community, or did they move a bit later, new inhabitants of the new city?

There is something confusing about the historical accounts of the Jews in Algeria. The Jews in Algeria tend to disappear without leaving traces of assimilation, implying that they were already assumed to be European. I want to share with you this example, to show you how confusing and deaf the history is that assumes the French could use decrees and proclamations to take your indigeneity out of you.

For the new French city to come into existence, and for the surrounding population of indigenous people to survive and make use of their skills and knowledge, it had to grow quickly, alongside the many tradesmen or craftsmen who sold their wares at the souk, "above all: masons, carpenters, joiners, plasterers, necessary for construction or shoemakers, saddlers, hairdressers, embroiderers, weavers, tailors."[4] From the original 641 people counted in 1837, in 1861 the number grew to 2,349, and in 1877 to 19,464. These later numbers, however, are presented as those of the "Arab city" that was developed in parallel to the "European city," while the count from 1837 includes 391 Jews. In 1877 the number of Jews "naturalized by decree" was 427. This could not include all the Jews in Sidi-bel-Abbès, a town now "two cities in one."[5] How

many Jews stayed in the Arab city, refusing to shed their Arabness? And for how long? Were all the Jews obliged to leave the Arab city and accept that from one day to the next they were no longer Arabs, nor indigenous people? Were they allowed to stay where they were, if they liked, without moving into the new walled city? These questions are unanswered, but what these figures show is that the cleavage imposed between Arabs and Europeans didn't leave room for the Jews, who were made invisible. For example, schools were not opened in the Arab city until 1922, but a "mixed school" in the new city that admitted naturalized Jews—what a euphemism for converted!—was opened already in 1877. I'm assuming that this impacted the decision of your parents and other Jews about which part of the city to live in.

I was struck when I read about a protest in the late nineteenth century in Sidi-bel-Abbès's Arab city against the obliteration of Muslim referents in the cityscape, and the protesters' demand for some streets to carry Muslim names. The destruction of your local Jewish institutions' autonomy and their replacement by the French model of the consistory made it so Jews could not even ask for streets to be named after their ancestors, as they were told that European heritage was for them too. They were also socialized to disidentify with Muslim names. Was Ibn Khaldun not also your hero, ours?

During these years, in cities other than Sidi-bel-Abbès, colonization was enhanced by apartheid. Arabs were discriminated against in relation to the European city, and Jews were discriminated against in the European city and not allowed to perform collectively as Jews outside of the imposed French-Jewish institutions. The gradual identification of "Arab" with the Muslim population in city neighborhoods, names, and history—all this de-Arabized the Jews, who had been neighbors of the Muslims. In 1873, three years after the Crémieux Decree, the Arab city of Sidi-bel-Abbès was formalized by decree.[6]

The scant accounts of Sidi-bel-Abbès, whether written by French colonialists or by Algerians after the departure of the Jews in 1962, not only ignore your evaporation from the indigenous population, Mémé—they participate in it. The few hundred Jews who lived in the area in the 1830s came either from Oran or

Letter 14. Fuck you, France, my daughter is Islam

Tlemcen. Did our family used to come to this weekly market, or did the men of the family live there during weekdays and go back to Oran or Tlemcen to welcome the Shabbat with their family? Were they one of a few hundred indigenous people asked to conduct their commerce there, and so provide the French Foreign Legion soldiers with nourishment and crafts while they built the "new city" and its separating walls? Or was the situation in the big cities like Oran or Tlemcen one decade after colonization so devastating that your parents were forced to move to a militarized colonial city under construction? Was their home in Oran demolished as part of the urban campaign of building "new" cities within (or against) what became the "old" cities? Were they incentivized to move to Sidi-bel-Abbès in exchange for expropriated houses or property? Did they continue with their trade or did they adapt it to the needs of the new city? Did they realize that they were part of an urban experiment testing the assimilation of de-Arabized "Israélites"?

When you were born in 1854, the city was not yet fully built. Like other "new" cities, it was not fully new in the sense that the colonizers used "old" resources to build it, and they expelled the indigenous, mostly nomadic, population, who likely opposed this campaign and whose resources were abused. The need to fortify the city and surround it with walls five meters high (with two and a half meters of soil standing in for a dividing wall until construction was complete) was a clear sign of plunder and abuse. The "new" was another technology of violence that enabled the French to proclaim ownership over things that had never belonged to them.

During the late 1840s, when your parents were probably installing themselves in Sidi-bel-Abbès, the colonial authorities kept up their attentive examination of Algeria's Jews in order to decide what to do with them. Even if at that point most were already within the walls of the European city, they were not Europeans but under European rule and scrutiny. French Jews who arrived from France with the task of "regenerating" you, Mémé, contributed to this surveillance. The abolition of the autonomy of Jewish institutions and the decimation of Jews' artisanal guilds left them captives of the arbitrariness of the colonial

regime, which determined its approach to the Jews according to its ever-changing needs.[7] To justify their mission and move on with their plans to convert Algerian Jews to the French model of "Jew," the French Jews who intervened "in your favor" by writing sociological reports about you denigrated your life as backward and called your religious practices superstitious. With this kind of pressure, and with no reassurance that plans (discussed several times by the colonizers) to expel them altogether from Algeria would not come to fruition, how could Jews in the 1840s make any right choices?

Given this, plans to expel Algerian Jews from their own country (realized in 1962) and plans to house them in new towns and in the European sections of towns like Sidi-bel-Abbès are not that different. When the French colonized Algeria, you were part of a relatively small group of Jews that the colonial authorities considered easy to govern. Drained of communal solidarity, Algeria's Jews could be displaced, used, punished, rewarded, intimidated, disposed of, and "eliminated as a political adversary through their progressive assimilation."[8]

I knew that the Jews had been used directly and indirectly since the beginning of colonization for the needs of the colonizers, but I didn't realize that you were also used as a kind of human shield to protect the French from other indigenous people who might revolt. This is why Sidi-bel-Abbès was needed: "The security of Oran commanded the occupation of the whole country, up to the limit of the Tell. The plain of the Mekerra, on the road linking Oran to the post of Daya, could not remain empty."[9]

I don't know how many Algerians were expelled from this area in order to build Sidi-bel-Abbès, but I know that some of them were reintegrated as working hands for its construction. I could not find data for how many of them were allowed to move to the European city as its inhabitants versus how many lived in the old city. I wish your parents' stories about how they came to live in Sidi-bel-Abbès had been transmitted to me. Instead, I have to look for their stories in colonial words, trying to understand how Jews and Muslims were recruited to be part of their own colonization.

I was, however, able to find out how the colonizers used two other local groups to facilitate the establishment of the city. One

Letter 14. Fuck you, France, my daughter is Islam

group was the Turks; instead of expelling them from the country as they first intended, the French military decided that the Turks "should be carefully preserved" since, "deprived of their chiefs, incapable of governing by themselves and fearing the resentment of their former subjects, these would not have been long in becoming our most useful intermediaries and our most zealous friends, just as the Kouloughlis." The second group were those who were weakened by the Turks, the religious aristocracy or marabouts, whom the French sought to modestly empower by restoring "to the marabouts the political existence which they had lost." Instead of fighting the infidels, the goal was now to use religious elites "to govern their fellow citizens."[10]

Sidi-bel-Abbès was built to reduce the military burden of "pacifying" populations designated as "hostile." Building a new city populated partially by civilians was chosen by the military for strategic reasons: "The war made us discern which populations were the most energetic, the best organized and the most hostile. It is beside or in the middle of these that we establish ourselves to prevent or to repress their revolts."[11] Two thousand people were needed to inhabit the planned city. As in other colonies, the colonizers needed more Europeans to ensure their demographic vision of a majority-French city. Promotional material for the new city was posted in France and incentives for moving there were advertised, making it attractive despite the expatriation it required and the challenging climatic conditions it posed. In 1847, one square meter in Sidi-bel-Abbès could be purchased for 4 to 6 francs, while in Algiers it could cost up to 1,000 francs.[12] Geographically, the new city of Sidi-bel-Abbès created a crossroads between four existing cities (from which its gates drew their names), and it was considered by the military to be perfectly located to "intimidate the population" and "control the tribes," as well as a base from which to use internal indigenous tensions to "decimate the troupes of the Emir Abdel Kader" who opposed colonization.[13]

Were there any other choices available to Salomon Cohen and Semha Touboul, your parents? When they moved there, the conditions of life were still very unwelcoming. There was a reason why, for centuries, no city had been built in this "strategic"

area, though it was never wholly "unpopulated" as the French claimed. Nomadic and semi-nomadic tribes knew how to live in this area, where to move and when, according to the local climate and the fertility of the soil. It was not in their culture to curse the earth and dry its swamps. The colonizers, however, decided that no obstacle would stand in their way, and they brought the French Foreign Legion soldiers to drain the swamps, a landscape that they approached with the same ignorance as the Zionists in Palestine, and the same hubris.

Beginning from the year you were born, Mémé, it took at least another decade or so for the unhealthy climate to improve and the heavy presence of flies to abate, for the food supply to become regular, for the houses to be warm enough in the winter, and for the experience of isolation to change. Soldiers from the French Foreign Legion inhabited half of the city. The legion is closely tied to the conquest of Algeria—it was created in 1831 by the same French king who ordered the initial invasion. He understood that without military support and demographic implants, France would not be able to hold Algeria. Thus, you grew up as a member of a minority group, Algerians acclimated to living in their own country among soldiers and civilians from different places in Europe—Germans, French, Moldavians, Spanish, Italians, Maltese, Belgians, Poles, British, and Russians.

The colonial logic requires that the number of indigenous people needed for the development of such an invented city had to stay small, especially within the city walls. It must have been a hard place for Algerian Jews and Muslims to live. I ask myself how many names your parents had to reject before they could agree that the best choice for them, for you, was to call you Marianne? Did they agree on this name immediately? I try to remember that living in such an invented city full of Europeans was like living on probation, always tenuous. I try to remember how much colonial thinking your parents must have interiorized, and how much of themselves had to be repressed, concealed, eliminated, replaced. Did they regret their decision when, a year later, at the same municipality of Sidi-bel-Abbès, the Lankri family declared that no matter what, their daughter's name was Aïcha?

Letter 14. Fuck you, France, my daughter is Islam

In 1962 it didn't even occur to my father to stand in front of a civil officer and pronounce an undoubtedly Arab name. My father echoed the incapacity of your father, Salomon Cohen, to declare stubbornly that the name of his daughter—born in 1854 in this new town of Sidi-bel-Abbès, built at great cost by French and Foreign Legion soldiers—was Sultana, or Meryam, or Messaouda, or Esther.

You were born Marianne and you grew up in Sidi-bel-Abbès, where seven other girls, all of them Christians and all born in the 1850s, were also named Marianne. When you heard your name uttered by others, did you feel alone? What was it like in 1870, at age sixteen, to be told that from now on, you were just like these Christian girls, while you were constantly reminded by your colonial city that no matter what you did, you were an indigenous Jew from a Muslim world? Did you have to pretend that you felt at home in this faux-European city that replaced what might have been your home? How did it feel to be captive to the colonizers who believed themselves to be your benefactors, saving you from backwardness? Did you know, at the age of sixteen, that this model colonial city was created by stealing your resources and using them against you?

You were twelve or thirteen when cholera erupted in Sidi-bel-Abbès and "caused a certain number of victims in the city, and especially among the Jewish population." The author doesn't detail why, but it doesn't seem to me to be a coincidence that cholera mostly attacked Jews in the European city, as Jews were generally more vulnerable in terms of housing and health services. There was also a rise in the death rates of Muslims—though that would have been discussed by this author in reference to the other, "Arab" city—due to malnutrition, as they were forced to cultivate food on indigenous lands owned by the colonizers (who also had first pick of all their crops). Thus in years of drought or locusts, the Muslims of Sidi-bel-Abbès were the first victims: "Deprived of food, no longer having the courage or the strength to move, these destitute people remained exposed to sudden variations in temperature, and died of misery and hunger."[14] Until the invasion, "Algerian agriculture was sufficient for the needs

of the population and even generated surpluses."[15] This taught you, the Jews in the non-Arab Sidi-bel-Abbès, that it was better to behave like the colonizers if you didn't want to completely disappear from the country.

The colonial mayor (who fashioned himself a historian), wrote that

> while the Jews, as if brought back to life by our civilization, took advantage of the country and populated it everywhere, the natives, not slow to see that our settlement also modified their situation ... Our settlers are still, for the natives, the models of work and order that they shall endeavor to imitate, at first slowly, and later confidently, if they do not wish to wear themselves out and disappear entirely from the country.[16]

This is the emblematic colonial condition: having your resources stolen to build cities in which your defeat is inscribed and where you are given no choice in how to live except to imitate the colonizers. The Jews, we are told by the mayor-historian, understood this readily. The Muslims were slower, the mayor says, to understand. Those who write histories based on this propaganda continue to tell us, shamelessly, that emulating the colonizers was your choice. It was not.

I don't know how much your parents told you and how much you observed yourself, but I do know that after you gave birth to your first child you decided: no more.

You left Sidi-bel-Abbès and returned to Oran, where you gave birth to your three other children. That your husband, Abraham, was from Oran, probably played a role in this decision.

Oran, too, had been destroyed and reorganized as part of the colonization, but the struggle between different modes of life there was more open, and resistance and old ways could persist in corners because it was not a city originally designed with a colonial master plan like Sidi-bel-Abbès. No doubt there were shoemakers in Sidi-bel-Abbès, but they could not be part of a milieu of shoemakers who preserved the memory of their guilds,

Letter 14. Fuck you, France, my daughter is Islam

like your husband, Abraham, and his father, Eliaou, in Oran. It is enough to read the names of the shoemakers who witnessed Abraham's birth, and those of his three brothers, to understand that their guild of Jewish shoemakers survived as a caring social formation even if not as an official guild. Some of the witnesses didn't speak French, and an interpreter was required to read the short declarations of birth, and some signed the birth certificate in Judeo-Arabic, and so I can say with confidence that in Abraham's family they continued to speak Arabic or Judeo-Arabic. Moving from the *derb lihoud* (the Jewish quarter) in Oran to a place like Sidi-bel-Abbès must have been suffocating for him. Even if you learned to appreciate some things that the French brought to your life, I am sure you never meant to commit yourself to the violence of de-Algerianization.

The campaign of de-Algerianization was by far more dangerous than naturalization. Singling out the Jews as a cohesive group (which they were not) and then forcing them to become French citizens was assumed by some of the French to be "a safe experiment."

The French could not have cared less about whether this "experiment" harmed and endangered the Jews. Oh my God, it did! And it harmed Muslims too, and it continues to do so today. The French did care about the lasting consequences of their experiment that benefitted them: Jewish Muslim families falling apart, children parting ways with their ancestors and siding with the French, parents taming their children and forcing them to equate being good with being French.

In the distorted mirror-world that imperialism creates, indigenous parents giving their children French names can also be an imperially driven act of rebellion against their own parents, who wanted to adhere to their "old" world. It was a rebellion of the modern, but the modern could not be parsed from the colonial. Such a decision could also be a wish to protect the family from French settlers and remove doubts about their loyalty; it could be a recognition of the precarious status of being always-on-probation in a place like Sidi-bel-Abbès. Not that this ever protected Jewish children from hearing about their alleged inalienable difference: "This change of clothing modified them

only from the outside; deep inside they stayed as sordid and squalid as they always were."¹⁷

Dear Mémé Marianne, I hope you read this letter as my recognition of the courage and strength you had in 1895 to reverse your ancestors' choice and to say no to the racist machinery of the state that expected you to give your daughter a French name such as Marie, Geneviève, or Anne.

What should have been an ordinary decision, giving your daughter the name of her grandmother Aïcha, became a brave act of resistance. It was also an act of reclamation, claiming your investment in the Algerian culture that was slowly being taken from you.

I didn't come to stir up old resentments, but I can no longer accept what my father did to us by separating us from the Algerian family we could still have. There is no such thing as "too late." I choose to inhabit an anti-imperial temporality that allows me to speak with you, my lost-found kin. With every line I write, I feel I'm inhaling Algeria and exhaling the Zionist colony out of my body.

Naming myself Aïsha, I was empowered by your determination to situate yourself within the Jewish Muslim world and not the French, European one. What made you so determined? Was it your encounter with a Jewish family who, unlike yours, lived in the *derb lihoud* where Abraham's parents felt confident enough to give their children Jewish Muslim names—Abraham, your husband, and his brothers Mimoun, Moïse, and Sadok? What else encouraged you? Were you aware that your choice, no matter what it was, would also be determined by the either/or options imposed by the French—and that an anti-imperial rebellion could be read as a simple cliché, a way of rebelling against one's parents? When my grandmother Aïcha grew up and had to choose the names of her children, she was lured to rebel against you. None of the names she had chosen for her children—Lucienne, Georgette, Roger, Emilienne Rose (who died when she was not yet two), and Vivienne—had any Jewish or Arab origin, sound, or meaning. How did you feel when you heard the names Aïcha

Letter 14. Fuck you, France, my daughter is Islam

After-image of Jacques-Louis David, *Oath of the Horatii*, 1784.

gave to her children, your grandchildren? Were you disappointed that she didn't follow you, or did you assume she was protecting her children by not identifying them as Jews?

The command to fashion one's identity by rebelling against one's kin and recognizing it as proof of patriotism was the way the French modeled citizenship from the French Revolution onward. They believed so much in this form of citizenship that they were ready to tour the world with their arms, invade others' worlds, and force people to tear apart the webs of protection that had sustained them over generations.

A painting by a French painter, Jacques-Louis David, analogizes the French Revolution to classical Rome, depicting the patriotic oath as the heart of patriotic citizenship, a definition that would become the global standard (see image above). I don't know if reproductions of this image circulated in Algeria, so I attach it to this letter for you to see. Four male members of a Roman family (Horatii), three brothers and their father, are swearing to fight against three brothers from another family (Curatii) from Alba. Deciding to fight to the death, these men prioritize their commitment to the *patrie* over commitment to their female relatives. Camilla, their sister who is engaged to one of the rival brothers, figures the sacrifice expected of a female

family member, but despite her sacrifice she is relegated to the background with other women in the family. The citizens' oath embodied in the male actors is the subject of the painting, and it is this kind of imagery that made the culture-cide of our ancestors acceptable. I think of this painting when I want to understand why Aïcha gave her children European names, why your parents named you Marianne, why my father could not call me Aïcha. Why call their children Aziza, Saidiya, Mimoun, or Djamila when Lucienne, Georgette, Roger, or Vivienne seemed more likely to chaperone them toward promising futures, beyond the "past" to which these other Arabic names were relegated? This is obviously a false choice; it's a weapon used to make us believe that the dissociation imposed by colonization is for our own good, and … irreversible. It tries to make us believe in its inevitability, rather than paying attention to the ways our ancestors struggled with the consequences of colonization.

I'm ashamed that I didn't realize much of this earlier when my father was still alive. When I was much younger and still lived in my parents' house, I failed to recognize the colonial origins of his contained rage and was completely ignorant of his pain. How could I attend to something I didn't know existed? He transmitted to me his (dubious) admiration for the French, which played a role in my decision to go to study in Paris. His perception that Vichy was an accident in French history made me ignore, during my eight years in Paris, that we had been colonized! I was also never asked a question about it in class or in conversations with my professors, some of whom had actually served in Algeria. I never hid that my father was from Algeria, though for years I didn't know what that meant in terms of our history.

How do you remember my father as a child? In the Zionist colony he was often *en colère*—angry about different things—and we, his daughters, used to laugh about it among ourselves, as if this was his latent Algerian character. Making jokes about the hot-tempered North African man was common in the Zionist colony, and it was a racial character nourished by many books and films.[18] We knew that we were connecting ourselves—though with the spice of humor, or irony—with the stereotype associated with oriental Jews: violent, turning tables upside down

Letter 14. Fuck you, France, my daughter is Islam

when visiting government offices, pulling knives, temperamental. He never mentioned the term "colonization" at home and he reminded us only occasionally that he was French, with no reflection on the toll this citizenship took or on the changes wrought when he became an "Israeli."

My father never embodied the Israeli identity—this would have required him to lie down in the Zionist bed of Sodom, where whatever doesn't fit is cut away. Very few Algerian Jews had migrated to the Zionist colony in March 1949 when my father arrived there. He was a peculiar specimen: though he looked like other migrants from the Maghreb, he insisted that he was a French citizen. His trajectory was different from that of other North African migrants and was more akin to a trajectory of the Ashkenazi Jews who immigrated after World War II: his citizenship was revoked at the age of sixteen by France (in Algeria) on account of being a Jew, he was sent to a concentration camp, and upon liberation he fought with the French army against the Nazis. However, due to his dark skin color and his North African origins, combined with local ignorance about the Holocaust experience of the Jews in North Africa, none of these events in his life story were recognized by the people around him in the colony. The particularities of his experience had to be cut away for him to become an "Israeli" and for the Holocaust to be kept as a solely European tragedy. He didn't insist on his story and we grew up without it, prepared to accept the story of "the Jewish people" we learned at school, though we knew enough to know it wasn't quite ours. But we didn't have "our" story, except the very short Zionist version: we were backward people from a Muslim world who needed salvation to become "civilized."

Echoing Sidi-bel-Abbès, my father didn't live in the "Arab" cities where most of the immigrants from Morocco and Tunisia were placed. He lived in a mostly "European" city in the Zionist colony, in Rishon Lezion, where my mother was born. Her parents, descendants of Sephardic Jews, cared only that he was unmarried and a Jew; and once his mother sent certificates from Algeria proving this, they agreed to the marriage. In this city, where no one could mistake him for an Ashkenazi Jew, and no one would acknowledge the Holocaust of North Africa, he could

not share his story without destroying their sense of history. No wonder he was so often *en colère*. He would not let anyone humiliate him, so he often sidestepped history and performed in a different arena. He loved music and dancing, which he told me he learned in your house, Mémé. He knew how to connect electric instruments and he organized large parties with music that no one in the colony had heard before. He hated their Zionist songs and he played other tunes for people to dance to. It took me some time to realize that he was familiar with living-on-probation from his time Algeria.

When I looked up the location of the Bedeau camp where he was confined, I realized it was not so far from your birthplace, Sidi-bel-Abbès.

What were the words you used to invoke old spirits still enshrined around the tomb of the marabout Sīdī Bel ʿAbbāss to protect your grandson while he was confined? Did you know that the French military (whose name Bedeau was assigned to what was left of the Algerian village Ras-el-Ma) also "undertook to create the requisite colonial infrastructure that produced settler

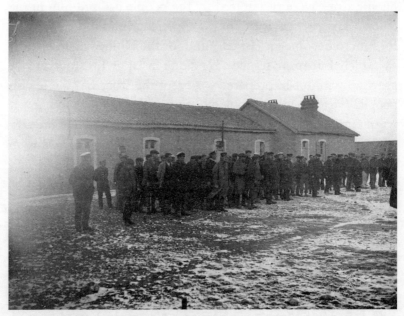

Is my father among them? Screenshot from film *Algeria sous Vichy*, showing Jewish inmates in Bedeau. Director: Stéphane Benhamou.

Letter 14. Fuck you, France, my daughter is Islam

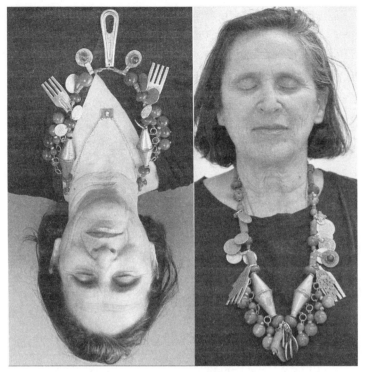

In my dream ... Ariella Aïsha Azoulay with necklace made from calcified red mud and stainless-steel forks fabricated in 1943.

villages through land expropriation, agricultural water projects to support plantation settlements, and the roads and bridges for transportation"?[19]

I dreamed I took some calcified scalpels and tweezers that had been used to destroy the lands of Sidi-bel-Abbès, where you were born, and Bedeau, where your grandson was confined, and I put their sharp edges in a linen cloth to hang around my neck. I was following the recommendations of Abraham ibn Ezra's treatise Sefer Hanisyonot (The Book of Experiments), based on a lost tenth-century treatise by the Andalusian physician Abd al-Rahmān ibn al-Haytem al-Qurtubī.[20] When I woke up and looked in the mirror, I had around my neck a necklace made of pieces of the fork given to my father when he was liberated from Bedeau, strung alongside gems made of red mud (see photo above).

A friend who is making a film on Bedeau, the same friend who took the photo of the cemetery where you are, recently filmed

on location in the Bedeau area.[21] *No one there remembered that among the several military bases, there was once a camp where Algerian Jews were forced to work breaking rocks and picking alfa, for the good of the French empire.*

Your choice to return to Oran, and your hope that you might be able to live there as a Jew among Muslims, didn't last. In 1939, the Jews were differentiated again, this time from both Muslims and Europeans, and those who tried to pass as either/or were hunted by other means: "In the presence of Jews detached from the practice of their religion, useful indications can be found in the aspect of certain surnames, in the choice of first names appearing on civil status documents and in the fact that the ancestors would have been buried in an Israelite cemetery."[22]

How long can a person keep his wounds, pains, traumas, and those inherited from his ancestors to himself?! I think my father knew who the French were, but I think that he could not allowed himself to lose *nos ancêtres les Gaulois*, whom he learned about in school in Oran, since he believed he didn't have other ancestors to look to.

Do you understand now, dear Marianne, why I won't let you and my great-grandmother Julie disappear again? You are my anticolonial female ancestors. I'm holding you close to my heart, here to stay so my grandchildren can grow up with your legacy.

I resented the male European Zionists imposed on me as fake ancestors. In your absence all these years, I revised my version of "our Gallic ancestors" to include the French philosophers who I came to realize actually betrayed me, as they didn't say much about their own inheritance of the empire that dispossessed us. Mastering their writings earned me entry to the university. If only I had known earlier that my father was not actually venerating his Gallic ancestors in the way we all believed ...

Until recently, I was sure that when my father connected his radio to Radio Monte Carlo every day it was his retreat into Frenchness. But no, I've just found out: this station was bilingual, in French and Arabic, and through it he was actually continuing

Letter 14. Fuck you, France, my daughter is Islam

to inhabit the Jewish Muslim world that he never had any intention of leaving. He never spoke about it, and we didn't ask.

In the '90s, when the opportunity arose in the colony for people like my father to be recognized, he applied for a certificate in Hebrew proving that he was an "ancient combatant" in the fight against the Nazis. When he gave one of his grandsons the medals he had won for liberating major cities in Italy and France, I understood how much he had kept his pride silent. He died enraged. His rage never had words or a narrative, but we recognized it on his face and it made us silent in his presence. We, his daughters, failed to be his Frantz Fanon and to interpret his rage's colonial origins. But even Fanon himself failed to see my father's rage; in my letter to Fanon, I ask about this failure to recognize the Jews as part of the colonized population, and I urge him to pay attention to their illnesses and their anger.

From a small booklet, part of the flourishing literature of French biological racism at the turn of the twentieth century, I learned how much this emotional world had to be repressed as part of the "safe experiment" of converting the Jews to secular Christians of Jewish faith. The pamphlet was written in 1902 by a certain Victor Trenga, who was appointed to serve in the Hospital Mustapha in Algiers. "Based on clinical facts," Trenga came to the conclusion that psychoses are very frequent among the Jewish race. I'll not repeat all the obvious racism that turned Jews into the object of his medical observations, but here's one example he presents as proof of Jewish pathology—but that actually emphasizes the strength of Jewish family ties: "Often, when a person in a family is seriously ill, all the parents press together, approach the bed, and communicate aloud a kind of artificial encouragement" (see photo p. 229)." The expression of pain among Jews, Trenga writes, has "a particular physiognomy, dictated by the tradition of the race." Many of them, "still today, respond to the smallest suffering with ... infinite lamentations, they throw themselves on the ground, they hit their throat. Here, the tears, that seem to us a normal response to pain, are insufficient: tears are not noisy enough and mute pain is not suitable."[23] That Trenga understood this as a behavioral pattern tells me, first, that one of the ways to deal with Jews who refused colonial

modernization and de-Algerianization was to send them to Hospital Mustapha and treat them as mentally ill. Second, it tells me that Trenga's pathologization of our family traditions echoed the ethnic caricatures and slurs probably addressed to you daily, far outside the hospital walls. Third, it tells me that the frequent use of those slurs against Jews could in fact be the source of many illnesses and psychoses, as when they were forced to cut their "strong family attachments" and had to act as if it were normal to be left alone, as my father had to.

I'm sure you recognize the slurs I'm talking about: "Like any race who stayed in its childish phase, mystery attracts the Jewish race ... Africa is the classical terrain of magic, and the Jews play their role in the local sorcery. Many old Jewish women are still known as witches, spellcasters (*jeteuses de sort*)."[24] I'm proud of this heritage of ours and I'm starting to feel its power.

Since I could not hear from you what I should have grown up knowing, I have to find you and your world everywhere I can, even in racist portrayals that translate your life into an illness requiring a cure. The illness, I am sure, is racialized citizenship; the only cure for its ravages is abolition.

Let me briefly share with you another anecdote from Trenga:

> One night, we saw a Sudanese using gris-gris exorcising a young Jewess suffering from idiocy. The father had given the gris-gris to the Blacks, fully convinced that the child would be healed as a result of magical practices. The Jewish soul is strongly inclined toward the marvelous; a host of legends, often common to Arabs and Jews, even now entertain deep popularized beliefs in geniuses, apparitions and miracles.[25]

It is the fabric of protection and care between Jews, Muslims, and Blacks, rituals of incantation and objects, legend and magic, apparitions and miracles, that racialized citizenship was meant to destroy.

Until I started to write these letters, I didn't know how the French were able to obtain your loyalty. But once I found language to describe not only how you were made citizens with a piece of paper and how you were subject to de-Algerianization

Letter 14. Fuck you, France, my daughter is Islam

Caption reads, "Napoleon reestablishes the Jewish cult." French print, 1908.

through both soft and hard terror, the answer became crystal clear: your acquiescence was extracted, and it was belied by your resistance.

I want to show you this painting of Napoleon liberating the Jews. I imagine it is impossible for you to recognize yourself in it, though it includes several Jewish symbols like the menorah and the tablets of the Law. In Europe, these kinds of Jewish symbols were crafted mainly by Christian jewelers who fashioned European Jewish symbols differently from the way our ancestors in the Maghreb chiseled, carved, and casted in copper, silver and gold.[26] Napoleon, who appointed himself the liberator of the Jews in Europe, built the infrastructure for what would be a state project of assimilation: whitening those previously racialized through secular Christianization. The creation of a tolerable repertoire of isolated symbols, artifacts, and names for Jews to employ was part of reducing a complex worldliness into the state-administrated domain of religion. It made Jews manageable. When Algeria was colonized, some emancipated Jews in France

The collection of Isaac Strauss displayed at the Palais
du Trocadéro, Exposition Universelle of 1878, Paris.
Photo: Paul Robert, Musée d'art et d'histoire du judaïsme.

were already involved in collecting and displaying Jewish ritual objects from different European communities.

Obviously, you cannot recognize yourself in this Hanukkah lamp either, as ours were totally different in form and function than this one from one of the first collections of "Jewish objects." This collection, which became part of the collection in the Musée de Cluny in Paris, was displayed in the Universal Exhibition in Paris in 1878, where Algerian's resources were again put up for sale. As if being a Jew was ever solely about one's faith and set of objects, an identity category that could be detached from the world in which our ancestors lived!

I'm trying to come closer to you through this letter because I am motivated by a twinned oath to turn my back on the *patrie* and to join our ancestors in their intermittent and often unsuccessful attempts to shield our cults, stories, mysteries, sorcery, miracles, and care for the world from extermination,

Letter 14. Fuck you, France, my daughter is Islam

and renew them as our shared heritage with Muslims, Berbers, and Blacks.

If two colonial projects—by the French and by Zionists—had not separated us, I could have recognized myself as your great-granddaughter, not in the lifeless document I stumbled upon when I was fifty years old, but in the everyday gestures that could have been transmitted to me through your daughter Aïcha and my father, and all the others whose names I'm rehearsing as I get to read them in more colonial documents: Messaouda, Fotunée, Meriem, Nedjma, Sultana, or Semha … I could have recognized myself in the beautifully crafted bracelets you, Julie, or Aïcha wore, some of which I encountered for the first time in books on North African women and their jewelry. I could also have had close to my heart one such bracelet that, according to our tradition, would have been made solely for me on the occasion of my birth. But I was born to be Ariella, in another settler-colonial state.

My father's wish was not to be recognized as Algerian. Can you imagine what it would have meant for him that in the year when I was born, his wish—the death wish that colonizers instill in the colonized—was made a reality? For in 1962, independent Algeria declared that there could no longer be such a thing as Algerian Jews.

I want to tell you one last thing, dear grand-mère—I am an Algerian Jew, and I'm proud to be your great-granddaughter, my dear umm Aïcha.

My visa request to Algeria was rejected, but hopefully next summer I'll come to visit you at the cemetery of Oran and listen to the chant of the trees around your grave.

Aïsha

Letter 15. Why didn't you love me in Ladino?

A letter to my mother, Zahava Azoulay, born Arie

Dear Ima,

I knew that I'd miss you, but I didn't know that your death, just one year before Abba's death, would leave such a void in me. A void that would make me ask "Who am I?," "Who are we?," "Who are our mothers?" and "What are our mother tongues made of?"

I could not answer these questions alone. Perhaps they are not even about me, or me alone.

Ima, I don't have the answers to these questions. This is why I am asking my kin to dwell with me in the abyss these questions open. The things that I write in these open letters seem intimate, but they are not just personal thoughts. I say this at the start of my letter to you since I know how much you cared about how our family was seen by others. You believed strongly in "not airing our dirty laundry in public." Ima, nothing I'm saying is *our* dirty laundry, even though we were charged with washing it. It is this that I'm trying to understand: how our intimacy is not ours but the intimacy of empire. Don't ask me which empire; that's not what matters. I mean that our intimacy is beholden to an imperial force that destroys the worlds we could have inhabited and that compels us to inhabit the world it created.

Ima, it's only now, after I have written letters to others and understood the mechanisms that trap us in the echo chamber of empire, that I can write to you clearly, recognizing your vulnerability. One month after your death, on November 14, 2010, I wrote you a letter that, in retrospect, I think was the beginning of my epistolary engagements. I recently returned to that letter, and I cried. I was clearly afraid that your death would take away our opportunity to one day come closer to each other and reconcile our differences. I wrote there, without being able to fully understand it, that the only way to become attuned to each other was through the bliss we always felt when we spent time together while working with our hands.

Ima, it took me time to understand why these questions that I'm asking ought to also be your questions, since despite our radical differences, we are both imperial mutations, children charged with a cursed mission: to carry out the destruction of our ancestors' world. When I realized that and resigned, I wanted you to do the same.

Ima, I know that you never thought about yourself this way. Our difficulty in coming together as mother and daughter stems from the imperial narrative of the rebellious child who sees her parents as responsible for the chains of backwardness she feels on her wrists. I was trapped in this story for a long time too. And I had good reasons to feel this way. But all these reasons ultimately obscured empire's role in keeping us apart, and they prevented me from seeing that you were barely seventeen when in 1948 you were also kidnapped to be a child of empire. It is through you that I first encountered empire, since part of your duty toward me as a parent was enmeshed in your duty to the state. Imperialism turned our home, all homes, into a separate, imperial sphere of activity. As such, in our family, empire's contradictions on a large scale were experienced as *ours,* as the intimate dynamics of our psyches.

Our interiority exists in empire's echo chambers.

Ima, you know that in the last years of your life, each time I came to visit, we could barely speak without our conversation

Letter 15. Why didn't you love me in Ladino?

exploding. I remember one dramatic moment in 1999, when a Palestinian, Azmi Beshara, decided to run for prime minister in Israel. His campaign challenged the Zionist-based political system and, obviously, his campaign's repercussions were also felt in our family. You knew I was going to vote for him. When I came home after the election and asked who you voted for, you replied, *Yahadut HaTora* (literally "biblical Judaism") and added, "to counter-balance your vote." Ima, I was speechless. It hurt me so much: that as my mother you did something to counter me as if I were your rival. You had nothing to do with this party that had instrumentalized Judaism for colonial purposes. However, perhaps you felt that Biblical Judaism could redress a feeling of loss, that voting for this party could remind you of your father's religiosity, which the state placed in binary relation to secularism. There was no way I could convey what I felt, since I was trapped in the framework of political polemics, which had come to feel normal in our family. So, instead of crying, I laughed, both then and for years afterward. But there is nothing funny about how empire resides in our blood, bodies, and homes, infecting our capacity for care and love.

It took me years to untangle the situation. Within the walls of our home, these moments were experienced as symptoms of *our* relationship, of who you and I were. Now I know why we could not get beyond this doom-loop: it was not made by us, but by the imperial state where we lived and the imperial history from which we both came. Dear Ima, this is what I want to talk to you about. I'm not writing to blame you but to trace how our intimacy as mother and daughter was intercepted by empire, and by the particular cause you were charged with defending. Instead of rebelling against my parents because of a "generation gap" and moving on to an "independent life," I rebelled by fighting empire. As long as empire continued and you aligned yourself with its language and its claims, my struggle was always also against you. The more I rejected empire's footprint, the more I felt I was rejecting you, and vice versa; the more you defended manifestations of empire, the more it felt as if you were abandoning me. We were doomed to feel this imperial psychosis personally, and it seemed almost impossible to untangle our political struggles from

our feelings toward one another. The best we could do, as long as you were alive, was to bypass the explosive topic of Palestine, which buried our losses too.

Ima, Palestine was "our" explosive zone only because it was colonized by Euro-Zionists. "Our land," we were told, was Israel. But Ima, you were not born in Israel but in Palestine. When Palestine was destroyed and made into the enemy, it was taken from you too. It was robbed of its centuries of Jewish imaginaries and prayers, of how Jews had held it like a jewel, close to the heart. It was turned into a land to destroy and grab, and we were made the thieves.

Centuries before Zionism, some of our ancestors went to Palestine to be buried there.

Rabbi Abraham Alkalay[1] left Bulgaria in 1810 to die in Safed, as he considered it the proper place for his last rest. If he could have predicted that Zionism would follow his death, "he would have turned in his grave," as you liked to say.

Here and there, there were always a few Jews who migrated to Palestine, like those Algerian Jews who moved to Palestine in 1830, fearing French colonization and looking for safety among Arabic-speaking communities under the protection of the Ottoman Empire (see painting p. 286). None of these migrations, though, was part of the anti-Jewish organized movement that substitutes the Jewish love for Zion with a settler-colonial death drive implanted in Jews' hearts. This movement has been fabricated as a Jewish trait, innate rather than historically determined, a fiction that destroys both Palestinian and Jewish modes of life.

Ima, if you were to stop disavowing our amputation from our neighbors, there would be nothing explosive about Palestine. On the contrary, it would emerge as a site of mourning and revolutionary love, wherein we would recognize how we were defeated along with our Palestinian neighbors. In Palestine, we could recognize our potential to still defeat empire, at least in our hearts, and to face it together.

In Ladino we will say,

טרס איזייקוס טינגו יי,
איל קי מי לוס דיאמנדה,

Letter 15. Why didn't you love me in Ladino?

נו לוס דו.
נו סון מייוס,
סון דיל דייו!

"Three children I have,
whoever shall ask to have them,
I shall not give.
They aren't mine
but God's!"[2]

We are Palestinian Jews, Ima, not Israelis.
Now, I am a diasporic Palestinian Jew.
The curse that the Zionists put on Palestine will not last forever. One day I shall be able to return to visit your grave and put stones on it, as you taught me that we, Sephardic Jews, do. With the few words in Ladino that my mouth remembers, I will gift your ears the love song of a daughter to her mother, the song that you dreamed of hearing.

Since you've been gone, I've missed you, and I've missed the mother you were when you were not on duty. I'm not sure you can understand this, because your experience as a child was different. Your mother was not on duty, she was simply *your mother*. You were often disappointed that the trusting bond you had with your mother was not recreated in our relationship. You were not ready to ask why; you preferred making me feel guilty. For a long time, I didn't know how to ask these questions without accusing you of causing our estrangement. But now I'm ready to rebel against empire in your name, as well as my own. I am ready to refuse the division between us, which I now realize was essential to the functioning of empire. It is never too late to change the way we yearn for each other.

It feels strange to write to you in English, but maybe it could not be otherwise. While Hebrew was our language, it was also the language that kept you from raising us in your own mother tongue. Your mother, my grandmother Selena, spoke to you in Ladino. She did so despite the fact that in Rishon Lezion, the town where you were born in 1931, the pressure to speak Hebrew was

especially strong. Your mother did not care about the Zionists; they probably seemed to her like all the other nationalist rulers she had known in Turkey and Bulgaria, the ones who forced her parents to keep moving to spare your uncles Moise and Albert from being drafted into the army.[3]

When your father, who was born in Palestine, wanted to get married, he didn't look for a local Hebrew-speaking woman but traveled to Bulgaria looking for a Jewish woman who spoke Bulgarian, the language he used with his parents in Palestine. Thus, despite the pressure imposed by Zionists in Palestine, it is clear why your mother Selena did not, upon her arrival to Palestine in the late 1920s, renounce her own languages for Hebrew, a language that was foreign to her. When Selena arrived in Palestine, she raised you and your brothers as she saw fit, a task she felt had nothing to do with the state, which she saw as foreign and hostile to Jews like her. She knew that raising you in a foreign language could destroy the affection folded into her ways of addressing her children, the forms of affection she inherited from her own mother, with whom she also spoke Ladino.

She did learn Hebrew, but only enough to use terms and phrases here and there, making clear her intention not to abandon the other languages she knew. She spoke Hebrew with a pronounced accent, a stubborn mark of her status as a foreigner. Indeed, her insistence on sounding like a foreigner can be read as an act of resistance against the imperial Zionists who sought to unify the Jews in Palestine by imposing a single form and pronunciation of Hebrew.

That Jewish liturgy was rich and diverse, that Jews didn't want to part from their own vernaculars, didn't bother the engineers who proclaimed that the Hebrew language was dead in order to be able to revive it. Their vision was imperialist: to revolutionize Hebrew from the top down in order to suit "modern times," to dissociate it from its liturgical context in which was preserved the history of thousands of diverse Jewish communities over centuries. They called themselves revivers of the language while actually making language instrumental to a settler-colonial project.

Ima, in the name of nationalism, they elected themselves exterminators of the languages our ancestors spoke, and they sacrificed

Letter 15. Why didn't you love me in Ladino?

the richness of Hebrew. Most of these revivers were products of the European campaign to secularize religion so that it could fit easily into the modern nation-state. As a result, what was left within religion was seen as superfluous for people in "modern times." These language engineers first rejected the speech patterns they had brought with them from Central and Eastern Europe, together with "the 'shtetl' world of their parents."[4] Their determinations invented a binary conception of the Jews as either "Ashkenazi" or "Sephardic."

One scholar describes how, in their aim to reject their ancestral speech pattern, "the Ashkenazi revivers of the language chose what they thought was the 'Sephardi' dialect for the new, spoken Hebrew."[5] One need only look to the case of Algeria, where we could count at least twenty variations of Hebrew pronunciation, to see the falseness of the binary. The unified version of Sephardic diction was also orientalist in the way that it attributed to Sephardi speech an unchanging authenticity, reflecting the undeveloped nature of those societies, whose members were supposedly frozen in time and bereft of the "life of the mind."[6] In Rishon Lezion, however, settlers opposed this Sephardic speech pattern, asking whether Sephardic history had ever possessed great people like Judah Leib Gordon.[7] In the end, not surprisingly, the "revivers" murdered both dictions and invented a new form that we were taught to speak. Forced to speak this "chosen" language, we became incapable of pronouncing Hebrew as our ancestors had.

Ima, why do you think Abba liked Jewish liturgic music, including when sung by Ashkenazi cantors? I think it is because it reminded him of the sounds of his ancestors' Hebrew, not flat like the tongue of those born in the Zionist colony.

The emphatic pronunciation of the guttural letters, for example, has become a marker of a "heavy" pronunciation only since the plain Zionist Hebrew became the commanding norm. Ima, language is much more than a communication instrument, and an accent is not something to hide but to cherish. This is what Grandmother did, for she didn't want to purify its musicality from her mouth. People who kept or could not get rid of the musicality of foreign languages in their voices were

laughed at for their pronunciation, and it was made a sign of their foreignness as well as of their ignorance. I was nine years old when Grandmother Selena died, and I grew up with stories of how proud she was, how she would cast a withering glance on anyone who dared insult her. The majority of Jews in Rishon Lezion were Ashkenazi, and in response to their arrogance, I can imagine how the proud Selena might have answered them in languages they did not know, rather than letting them laugh at her Hebrew.

I still remember the joy of listening to Grandmother singing in all the languages she knew. Abba told me that when you met, you drove him crazy with the question "Are you Sephardi (literally Spanish)?" He told you, "No, I am not Spanish, I didn't come from Spain." "I could not understand it," he told me, "at that time I did not yet know what is Ashkenazi and Sephardi, it took me time to get it."

Ima, until recently, I imagined Abba coming to the Zionist colony and being treated as a Mizrahi; but in fact, when he arrived, the mass migration from the Maghreb hadn't yet begun, so he was initially othered as a Sephardic Jew—only later was his otherness transformed into *mizrachiyut. Elohim yishmor!* How racially inventive was the Zionist project—the racializing machine of those European Zionist Jews was relentless. Jews like you, who moved within the bounds of the Ottoman Empire, were labeled the "old" community (*Yishuv*), as distinct from the Zionist settlers of Europe, who designated themselves the "new" Jews. With this self-nomination, they claimed permission to destroy what was "old," and you were caught in the middle. From 1948, when it was decided for you: you could not be anything but new, modern, a Zionist.

The pressure placed upon speaking (only) in Hebrew in Rishon Lezion coalesced with the founding of the Haviv school in 1866. According to its founders, it was the first school in the world where the entire curriculum was taught in Hebrew. Eliezer Ben Yehuda, a leading figure among the "revivers" of the language, prided himself on the fact that his son, born in 1882, was the "first Hebrew child"—that is, the first child with Hebrew as his true mother tongue. For Ben Yehuda, the Haviv school was a

Letter 15. Why didn't you love me in Ladino?

kind of laboratory where he could experiment on a larger scale with more children.

I don't remember how old I was when I read the biography of Ben Yehuda's child (published as a young adult book in 1967), but I remember loving the story. It was told as an adventure story of "discovering" an old forgotten land-language, camouflaging, as colonial stories do, the violence of "discovering" something in a place where others already live. The story of Ben Yehuda, however, in addition to concealing the colonial violence imbuing Zionist pedagogy, also camouflages the violence that revivers of Hebrew inflicted on children by denying them the plural dialects of Hebrew and Hebrew's sister languages and camouflaging the corpses of multiples languages under the narrative of resurrection that actually fabricated a newly standardized, sterile language. Those revivers taught these children a language severed from the world in which it arose.

When you went to Haviv primary school in the late 1930s, resistance to this revival project had already been sentenced to oblivion. Children like you already spoke Hebrew and could repeat the glorious story about the language's revival without being aware of the violence it entailed. Grandmother, however, was the unruly embodiment of what refused to be forgotten: that Jews have other mother tongues. She raised you in Ladino, which interfered with your formation as a pure Zionist or "sabra," a category invented by the Zionists to designate those who were born in Israel, bereft of diasporic remains. Your history of being a Palestinian Jew was thus snatched from you. I remember how heartbroken you were when Grandmother died. But why did you not then teach me Ladino, to have someone to talk to? You could have mourned Grandmother by refusing to give up her language. Think about it, Ima: Grandmother had already died, and instead of speaking about your shared language, you simply repeated stories of how proud you felt to have been a pupil at the Haviv school. You supplanted the murder of your mother('s) tongue with a story of heroic renaissance. Ima, I still feel every day the pain of how our mouths were colonized.

The Haviv school's "achievement"—that Jewish children learned only Zionized Hebrew—was an anti-Jewish attack that

exiled diverse Jews from the many languages they spoke. It was an attack because it taught Jewish children that these older languages were not theirs and not for them, and that only Israel's single form of Hebrew was authentically "Jewish." In order to invent Zionist Hebrew, the revivers had to kill ancient liturgical Hebrews by declaring them "dead languages," and they had to destroy the livelihoods of those diverse Jews who used them. This denied different Jews access to the memories of their ancestors and to other worlds in which being Jewish meant something different than it did in the Zionist colony. The "revivers" divided language into three forms—spoken, written, and read—and in their nationalist vision, these forms had to be "properly" synchronized into one cohesive language. Thus they condemned existing Hebrew dialects as deficient. The Hebrews of our ancestors were unruly, intermingled with Arabic and other languages that were also theirs; these were living languages. The revivers killed them, expropriated the people of them, sterilized them in order to preserve them for scholars to study.

To our ancestors, old forms of Hebrew felt comfortable on their tongues, sounded like music to their ears, and brought ease to their eyes. They often transliterated different languages into Hebrew characters, a practice deemed improper by the revivers. Moreover, our ancestors read sacred texts in both Hebrew and Aramaic, and were familiar with the meanings of each passage they recited. Theirs was an atmospheric or immersive relationship to Hebrew. The versatility and playfulness they exhibited as they moved through the many different languages alive in their world likely explain why Jews were often portrayed as good language-learners and were recruited as translators, traders, or scribes. You too, Ima, belonged to this tradition.

Your propensity for language acquisition can also explain how, in 1949, despite the fact that you and Abba could not speak Hebrew, you had meaningful enough exchanges over the few days (or was it weeks?) after you met that he decided to stay in Israel rather than return to Algeria. Having grown up in Oran, in addition to French he knew Arabic, basic Spanish, biblical Hebrew, and basic English from watching American films and mingling with American soldiers in Oran in 1943. You

Letter 15. Why didn't you love me in Ladino?

must have been able to use your Ladino to communicate with the little Spanish he knew, and he was probably able to bridge the similarities between words in French and Spanish, grasping their meaning. You also had a solid vocabulary in Arabic from growing up among Palestinians, and you knew some English words as a subject of the British Mandate. As a child, I remember listening to both you and Abba when I was with you in your store, admiring your ability to switch between languages for different costumers. How barren the landscape of languages became under Zionism!

I feel gratitude to Grandmother for not letting you be formed by the Haviv school alone. She raised you with Ladino, your language of affection, the shared language of mother and daughter. It was the language of foreignness in a settler society that aimed at its eradication; it was the language of unruliness in the patriarchal home that your Hebrew-speaking father believed he was running. Ladino should have been my inheritance too.

> Ima, how could you
> not talk to me in Ladino?
> Ima, how could you not love me
> with the very same words
> your mother loved you?
> I'm sure it never occurred to you
> that by not talking to me in Ladino,
> you interrupted
> five centuries of its transmission.
>
> Why am I so sure?
> Because you could not possibly
> have chosen to betray your mother,
> and her mother,
> and her mother,
> and her mother,
> and to disrespect their hard work
> hiding the secret of this language,
> precious luggage they brought with them
> when they were expelled from Spain.

If you could have spoken Ladino
with your mother, not only behind closed doors,
but in community with your children,
it could have helped you
resist national expectations,
and mourn the destruction of beautiful Palestine,
where some of your ancestors came to be buried
—and others to live.

Ima, if you would have spoken to me in Ladino
when the state ordered you to pull me
away from what remained of our ancestral world,
you might have had the power to reply
with confidence, in Ladino,

"she is not mine
she belongs to God."[8]

And I would have understood.

Ima, this wisdom ought not
be lost.

Before the establishment of the Haviv primary school, its founders deliberated over two options: either to establish a secularized *cheder*,[9] where in addition to Hebrew some French would also be taught, or to build a school modeled after the Alliance universelle Israélite (AIU), where Hebrew would replace French as the language of instruction.[10] Both options were related through a shared imperial imaginary. (The *meldar*, the school of Jews under the Ottoman Empire, was discarded without discussion.[11]) The first option, the *cheder*, assumed that Jewish children in Palestine should study a European language rather than Arabic, the local and regional language; the second, influenced by the AIU's imperialist vision of teaching all "Oriental Jews" French (even in countries where they did not live under French colonial rule, as in Turkey or Bulgaria), sought to impose Hebrew as the common language of all Jews. Ima, the French Jews who

Letter 15. Why didn't you love me in Ladino?

founded AIU in 1860 were already poisoned with these imperial notions of civilizing, secularizing, regenerating, and emancipating the Jews of the "East." They believed that they had been "rescued" from the darkness of the religious world and they wanted to forcibly "rescue" others.

A Bulgarian Jew who studied in one of the AIU schools and eventually became the principal of the AIU schools of Constantinople, Sofia, and Smyrna, as well as a member of AIU's Parisian administration, was less adamant about language education in French. He "recommended that the Jews of the Ottoman Empire be encouraged to learn Turkish and to attend government schools." He was also an anti-Zionist, and he argued against the Zionists who later took over AIU schools in Bulgaria. This same man was upset with Bulgarian Jews "for not having become better integrated and for not speaking Bulgarian after thirty-two years of Bulgarian independence."[12]

This man, Ima, is one of your great uncles, Gabriel Arié (1863–1939). I assume you didn't know that you had a great uncle who was a writer, educator, and historian—I wish I knew why this legacy was not shared with you. When your three daughters became writers, we asked several times if there were any writers in the family, and the answer was simply no. I'm sure that if you had known, you would have told us.

Despite his opposition to Zionism, like many who worked with the AIU in the nineteenth century, Gabriel Arié was an advocate of assimilation and emancipation. This also meant he was

Mignot-Boucher powder box, 1943.

supportive of the idea that Judaism "would be reformulated on a strictly denominational basis." He rejected the way the Zionists presented their movement as a response to anti-Semitism. He was "sensitive to Bulgarian antisemitism" but could not "claim the situation in that regard was worse there than elsewhere."[13]

Ima, he was not wrong. Indeed, there was anti-Semitism in Bulgaria. Two members of the Arie family, owners of the Germandrée cosmetics company, were publicly persecuted in 1943 in the heart of Sofia, at the peak of the Nazis' economic destruction of Bulgarian Jews (see photo p. 551).[14] I recently talked with your cousin, Carmela, about that moment in Bulgaria; she remembers the events firsthand. But the existence of anti-Semitism did not mean that there was not solidarity between Jews and their neighbors. Carmela told me that the resistance of the Jewish community, supported by Bulgarians' firm opposition to the Nazi regime, prevented the deportation of the majority of the country's Jews to death camps.[15] Of the stories she told me, one particularly touched my heart: When the Jews of Sofia were ordered to prepare for deportation and they arrived at the train station wearing yellow stars on their clothing, non-Jewish Bulgarians also wearing yellow stars flooded the train station, thus sabotaging the deportation. Soon after, your maternal ancestors in Sofia were encouraged and allowed to flee the city with thousands of other Jews. When they returned after the war, they found their houses intact, just as they had left them. Among your ancestors, Ima, were communists and partisans.

Ima, we grew up as history-less Mizrahim, beggars to whom others gave scraps of history as an act of charity, to avoid seeing us go naked in their public spaces.

Ima, what a shame to believe we didn't have history, to assume that our ancestors had nothing to teach us, to be fed instead with the history of Zionist warriors, who were foreign to who we were.

Ima, I don't think you intentionally deprived us of this history; you were deprived of it yourself.

Ima, Zionism tore us apart, not because you were Zionist but because in 1948 the Zionists baptized all the Jews who lived in Palestine.

Letter 15. Why didn't you love me in Ladino?

If you had been allowed to know your own history, to hand it on to your children, to love them in Ladino and Bulgarian, to encourage Abba to love us in Arabic, French, and in his Maghrebi liturgical Hebrew, you could have known that my anti-Zionism is something for you to be proud of, a continuation and recognition of our family legacy.

Gabriel Arié's opposition to Zionism was of a piece with his opposition to the deracination of Jews from the places they lived. As the descendant of a resilient family, which since its expulsion from Spain had experienced periods of both prosperity and persecution, he didn't idealize the lives of Jews anywhere. Yet he still believed that Jews could lead secure lives and protect their rights wherever they lived. He believed strongly in education, and he studied the expulsion of Jews from Spain in 1492. I assume he knew that when the Jews and Muslims were expelled, it was not the leaders of European states who welcomed the exiled, but primarily Bayezid II, the Ottoman sultan. He opened the doors of his empire and sent his navy to the shores of Spain and Portugal to safely transport a large portion of the Jewish expellees.[16] Bayezid II invited Jews to continue to work their trades within the economies of his empire. The sultan allegedly laughed at the Spanish rulers for getting rid of an entire class of artisans and letting him take advantage of their presence, skills, crafts, knowledge, and visions.[17] All of them, Jews and Muslims, were made citizens, and severe punishments were levied against whoever opposed their inclusion in the Ottoman Empire.

Under the sultan's rule, Jewish printers who had brought tools with them from the Iberian Peninsula established the first printing press in Constantinople in 1493.[18] They printed books in Turkish, Greek, Aramaic, Arabic, and Hebrew, among other languages. Ima, the trauma of the expulsion was alleviated slightly with this warm welcome, for it enabled the weavers, the book illuminators, the bookbinders, the jewelers, the tailors, the embroiderers, the fabric dyers, and others to find refuge and continue their trades. It allowed them to continue transmitting their knowledge to descendants, and so anchor their ancestral practices in a foreign world.

The women of the Arie family were literate and quite unruly. One or two of them ran the services in the synagogue in Bulgaria. And this is only the tip of the iceberg of stories about women of the family; "whatever their fate, their life-mission was to live for the family, to be educated, not to conform, but to fight the habits that impede them."[19] Lately I was lucky to read the unpublished Hebrew translation of a 2,112-page family biography written in Ladino by another Arie ancestor.[20] I asked the translator to share it with me after I learned that its author included in it the command that all descendants of all the three branches of the Arie family have the right to access it. Ima, it is our legacy and we were deprived of it. What a shame that I first learned about this biography of our family from a Stanford professor, who is still waiting to write about it before initiating the translation of this treasure, which transcends our family, to English.

I remember that sometime in your seventies, you decided to go to Samakov and Sofia. You returned impressed by our family's mansion in Samakov, a piece of real estate that had become a national museum, as well as by the desolate family synagogue attached to it. I remember that I was not that interested in what you told us because it lacked context, felt like too little too late. Now I want to apologize: I should have joined you in your effort to reclaim our family's history. Your trip to Bulgaria seemed to me, at the time, like mere participation in the tourist industry that capitalizes on the Zionist state's injunction for Israeli Jews to "find their lost roots." This statist fantasy locates the roots of Israeli Jews in "the past," without acknowledging how the state itself helped make older Jewish communities "past."

Again, Ima, I'm sorry that, at the time, I only knew how to reject this Zionist framework—and not how to provincialize Zionism to access our history from a different angle, how to relate to the Jewish Muslim world outside of the Euro-Zionist perspective. I did not yet know how to approach our ancestors' world as one of potential, not just of loss.

I also think I resisted discovering that our family were the "Rothschilds of the Orient,"[21] which seemed incompatible with the economic precarity I remember from when I was growing up. Discovering this wealth, in your eyes, finally ennobled the

Letter 15. Why didn't you love me in Ladino?

family, but it didn't impress me. The "Rothschilds" remark by scholars, I'm assuming, described the family at a specific moment: when some of our family members became owners of a cosmetics company, or bankers. However, I'm more curious about what happened to them after the expulsion from Spain, as they labored as craftsmen, merchants, interpreters, and moneychangers, among other trades, and passed their artisanal passion on to their descendants.

One day, unexpectedly, I stumbled upon that previously mentioned biography of the Arie family, written between 1900 and 1913 by Çelebi Moshe Abraham Arie, another member of our family who was also a historian and writer. He wrote this book's 2,112 pages in Ladino, on a typewriter. At the time, there were no typewriters with the common characters for writing Hebrew (Rashi or Meruba), so he used a machine with Latin characters.[22] The text is "interrupted" with long, haptic, vivid descriptions of the fabrics and sewing techniques employed by Ottoman Jews, of the clothing they wore and their dress codes, and the family ethics and the community ideals to which Ottoman, and specifically Turkish, Jews subscribed. The descriptions are written with love and care, efforts to transmit a world he perhaps was concerned might not last.

Ima, I thought I'd quote for you a description of the clothing that the three brothers from the Arie family wore, as you always enjoyed looking at clothing with close attention to detail. It reads:

> A large turban with a black silk tassel on their heads, a red belt wrapped around it, like the bonnet worn by the Turks in Thrace. Their heads were shaved, leaving a sideburn on their cheeks, cut in the shape of the fourth letter of the Hebrew alphabet, their beards were neither shaved nor trimmed. On their feet they wore red or black slippers and red or black shoes. Their clothes consisted of fabric breeches, over them a long sleeveless (*anteri*) dimi-cotton cloak, a tight belt around the waist, and over a cloth waistcoat and over it a cloth cloak, and in winter a feathered fur coat. They also had special clothes for Shabbat and holidays. Like the priests in the region who wore *sarik*, they also wore a rabbinical turban (*boneta*) in their homes. The same clothes that the fathers had,

the sons also wore and did not change the fashion. Women also always had a uniform fashion of clothes. The older ones had a scarf on their heads in the shape of a pointed bonnet, at the end of which was a strand of silk or gold and silver embroidery. The veil was decorated all around with gold and glass ornaments, silver and gold embroidery work, and mini ducats (old gold coins) small and large, and pearl and diamond jewelry.[23]

While I don't know our family's experiences in Spain, I do know of the expellees' warm welcome as craftspeople in the Ottoman Empire, and so I read in these descriptions a sense of artistry passed down through the generations. Furthermore, knowing how frequently members of the Arie family traveled between the marvelous markets in the Ottoman Empire to purchase items for their businesses in Bulgaria, I also see in the text how artisanship was cultivated and transmitted. What also strikes me in reading parts of this biography is that the Aries' craftsmanship was constitutive of their being Jews among other Ottoman Muslims and Christians. They continued to learn Torah and Talmud within their communities, yet they also learned Turkish in an effort to establish regular conversations about their learning, including of Jewish texts, with Muslim Turks.[24] They built synagogues and schools. Some of them wrote poetry, producing the still-unpublished collection of one hundred elegies for the ruination of Jewish communities during the Russian-Turkish War.[25] Some of the Aries specialized in herbal medicine and in the preparation of essential oils and hygienic solutions, developing perfume, soap, and cosmetics industries.

When the Jews were forced to leave Spain, they had to leave their homes and precious objects behind: as one historian writes, "Permission was specifically given for the taking of personal belongings, and though there was a ban on taking coins and jewels, we cannot doubt that much made its way across unpoliced sections of the frontier."[26] Even if our ancestors managed to smuggle some jewelry with them, the chances that jewels could be kept safe in the family over five hundred years are almost impossible. And yet, you kept in your clothing drawer Grandmother's gold ring with the twisted (*torsade*), scrolling tendrils

Letter 15. Why didn't you love me in Ladino?

Selena's ring placed on photo of one column in Abū Umar Joseph Ibn Shoshan Synagogue, Toledo, Spain.

and roundels, as if you knew that this ring held more than just precious metal. It is a handmade ring, and its jeweler crafted others like it; at least one more was put up for auction recently. I wish I knew the identity of the jeweler and their clientele. But ever since I saw a picture of the gold-crowned columns of the Abū Umar Joseph Ibn Shoshan Synagogue, built in the early twelfth century in Toledo, I have known that the ring I wear on my finger today is a reflection of the Ottoman Jewish Muslim memory of my ancestors, bearing a design that hearkens back to the craftwork of the Jewish community of Toledo, before expulsion.

I don't know when Grandmother's family—named Semo—arrived in Bulgaria, or where they came from in Spain. I did read, however, that Grandfather's family, the Aries, were expelled from Spain's Léon region. According to this source, Léon was

probably their name prior to the expulsion: "Trying to forget the terror experienced in Spain and the shock of the expulsion, the family decided to translate its name to Hebrew."[27] And so Léon, meaning "lion," became Arie, which is "lion" in Hebrew. According to different pieces of the puzzle that I've assembled, it seems the family may have first reached Portugal, like many of the expellees from Spain, and stayed there until it was no longer possible to do so. (Indeed, it was a Portuguese historian who helped me locate the traces of Arie family in the Inquisition files held there.[28]) Given that there are traces of the Arie family in the Inquisition records, it may be that they spent many years as New Christians, living among hundreds of thousands of other Jews and Muslims. Despite their forced conversion, many New Christians didn't forget who they were, and their shared heritage with Muslims found new forms of expression.[29] Even if the story about changing the name from Leon to Arie is indeed true, it may well be slightly more complicated. It is possible that they were called Arie while in Spain, changed their name to Léon while in Portugal in order to be able to stay (in the hope of returning to Spain sooner or later), and then, when forced to leave Portugal, changed their name back to Arie.

It is known today that only one child, and preferably the youngest, was trusted with the secret that families of *marranos* —the forcibly converted and expelled Jews from Spain and Portugal —were once Jewish. Despite the fact that you didn't talk to us in Ladino, I think that you still succeeded in completing this one mission, for I'm sure that I first heard the term *marranos* from you when I was young. I almost forgot about it. Ima, I am telling you all this not in order to find a definitive answer about our family, but to map how, despite oppression and coercion, our family preserved elements of our Jewish traditions and provided enough clues for descendants to reclaim these traditions. I am trying to keep up the *marrano* tradition.

When we went to the museum of the history of Rishon Lezion for your seventieth birthday to see what records they had of our family, we learned for the first time that the family had stopped in Vienna in the early eighteenth century before moving—or returning—to Bulgaria. We learned it from a gigantic family tree (one

Letter 15. Why didn't you love me in Ladino?

Arie family tree, prepared for the completion of Çelbi Arie II's biography.

of several that exist) prepared by Joseph Arie. Another family tree, prepared for the completion of Çelbi Arie II's biography, was written in Hebrew, Gudezmo (Ladino), and Aramaic (in Rashi script). Jana, Joseph's daughter, told me that this one was prepared by a local painter, whose name we don't know. When we learned about our family's stop in Vienna, we joked about finally knowing the origin of Grandfather's and your blond hair and green eyes.

In 1492, and up until the eighteenth century, most of Europe was closed to Jewish expellees, including Austria. So Austria could not have been the first place that the family went after expulsion. I have already mentioned the possibility that they first went to Portugal. Either way, did they later go to Italy, whose ports were opened? Or to Salonika? Çelbi's biography of the Arie family starts by telling the story of the family's expulsion from Vienna; but why not begin with the story of his ancestors' expulsion from Spain? Is this expulsion from Vienna a parable?

A story about the kidnapping of the youngest, handsomest child in the family precedes the story of the expulsion from Vienna. One day, Çelbi writes, when this handsome boy was on his way to school, he was noticed by the Empress Maria Josepha of Bavaria, who was enchanted by his beauty. She asked her servants to bring him to the palace and to hide him there, where she could see him every day. The child was well treated at the palace, and was even, one day, allowed to go and see his parents. However, when Maria's husband, Joseph II, learned of this affair, he ordered that the entire Arie family be expelled from Austria. They were not allowed to take anything with them. Çelbi tells his readers that he is aware that the story may seem fictional. And yet, he wants his descendants and readers to hear it. Since we may mistake it for fiction, he explains, "I'll write in this chapter, though this is not the right [chronological] place for it, about a second similar episode, that happened to our family in Constantinople in 1878." As in the first story, the kidnapped child should have ended up in the palace. However, this time the child understands that something is wrong in the way the sultan's chief eunuch addresses him in a tramcar, and he runs away. Çelbi invites us to not to look for what is true or not in the story, but to pay attention to the recurrence of the first story in the second: the stories are instructive.

I want to share with you, Ima, how I see both tales and why I feel they address me. The first story is that of being kidnapped into Christianity. That is the major event that preceded and followed the expulsion of Jews from Spain. It is also about the temptation of conversion to Christianity (or later, modernity), which entices one to believe that if they convert, the palace's

Letter 15. Why didn't you love me in Ladino?

doors will open for them, and the shock of being expelled will dissipate after spending time therein: "Both sides were happy and there were no complaints."[30]

The second tale takes place after several centuries in the Ottoman Empire, after the family became well established and prosperous. The scene of the kidnapping occurs in the aftermath of the Russian-Turkish War, which began with violent attacks against the Jewish community in Bulgaria and concluded with the Berlin Conference that accelerated European imperialism. This scene of the boy's almost-kidnapping takes place on the tram, a symbol of speed and modern progress. And though the child runs away from what he senses is a threat, the dangers he faces are not completely averted. In the wake of the incident, his sister prevents him from returning to school, and after a while he is sent to a different school altogether. The tale ends with the boy still in danger.

Ima, there is something prophetic about Çelbi's concern for the effects of conversion upon our ancestors and in his anticipation of its intensified impact on all the *marranos*. After the second kidnapping, which occurred around the same time that Çelbi wrote the Arie family's biography, it became much harder for Jewish children to run away from the allures of converted life. They were drafted into imperial armies, sometimes under the pretext that they would be fighting for their own rights. They worked as industrialists and bankers in structures that betrayed Jewish laws. They were lured into national movements. Zionism was the most damaging system of them all, since those of us born into Zionism's palace lost a sense of where our real homes were. Unlike the boy in the tale, we could not run away; we did not know where to go.

Ima, I can't help but think about this huge gap in our family history—about how, as children, we experienced ourselves in this racist country as naked subjects, as if we came from nowhere. If any of our family history had been present in your life, in our life, you might have prevented the Zionists from kidnapping us from our ancestors, languages, biographies, histories, memories. You might not have sided with teachers in schools, promising them that we'd behave and perform better in class, despite the fact we

were harassed in school for being North Africans, a status almost synonymous with a lack of history and culture.

Ima, some time ago Orly, your firstborn, sent me a draft chapter of a memoir she is writing about her years as a journalist. In it, she returns to an episode in primary school when she was asked by her teacher to read aloud in class a short essay that she was supposed to have written. Despite the fact that she didn't have a written essay in her notebook, she was able to read "it." What she *read* was carefully built like a written text. It sounded like a written text, although it was not written on paper; but Orly knew it was still *writing*. But her writing talent was not recognized by her teacher because no ink or paper had been used to express it.

Here, in her teacher's ignorance, we encounter again the same reasoning of the "revivers" of Hebrew, who discarded those pre-Zionist uses of language that didn't adhere to the codified division and consistency between the read, written, and spoken forms of the one single Hebrew language. I know other people who write their texts in their head without employing writing tools. With speech alone, they can dictate entire books. Orly is one of them, and she was punished for it. You were called to school as part of her shaming ceremony. If you had known the family genealogy of writers, poets, historians, and educators from which we came, Orly's schoolteacher might not have had the power to intimidate you such that you sided with her even before listening to your daughter. These Zionist agents stole your history, Ima, and they tried to steal our inheritance: a kind of writing that we didn't even know we had.

For me this episode is prophetic. Here is how I see it: At this moment of panic in class, Orly had a kind of revelation. She read her "written" text and realized that she had the gift of writing. It surfaced like a life raft during a shipwreck. Ima, this gift didn't come from nowhere. Writing is a practice of resilience, and as such it is transmitted even when it skips a generation or two. It is a craft and it is a disposition, and its power of resistance also emanates from the love of storytelling that we inherited from Abba. At the moment when Orly needed it, this ancestral memory of writing was awakened within her.

Letter 15. Why didn't you love me in Ladino?

Each of us, your three daughters, remembers the moment when this gift presented itself to us. When I was thirteen, I inherited Orly's old typewriter. I tried to use it several times, checking to see if I, too, could write like her. In her memoir, Orly writes:

> There was no chance in the world, even just once, to get my mom into a situation where she would stand by me in the face of the teacher's words. My teachers were the oracles for her. Their word was always sacred, and in any case worth many times more than mine. The teacher knows what she says and does it for your benefit. Even when I told her that they were clipping my wings, she would reply: They know better.[31]

Ima, when it came to school, this was my experience too.

However, reading Orly's description helped me see something else: the smile on your face when you would narrate the event. I'm eight years younger than Orly, and I heard this story several years after it happened. It became a family story, the kind told many times. Orly recalls the situation from her own perspective, since it happened to her, but I only remember the retelling.

Thinking now about the smile that you wore when telling this story, I realize that you felt pride in your firstborn daughter. You were proud of your daughter for being better than what the teacher projected onto her as the daughter of a North African father and a Sephardic mother. In a way, your smile may have also been that of a sweet vengeance, a mark of your pride in our successful recognition that we were no less than "they," that those who always told you that each of your three daughters "have potential but ..." were dead wrong.

I want you to understand that from our point of view, it felt like you had abandoned us. I'm grateful to Orly for the way she expressed this frustration at your seeming betrayal through this particular story. But I also don't blame you; I am trying to understand you. The memory of this smile vividly reminds me that siding with the state was not part of who you were; it was how you thought you should act. You acted for our own good, to help us be accepted in a racist society that considered us inferiors. You spent so much time making us look like "them," thinking that

Zahava Arie, age seventeen.

Letter 15. Why didn't you love me in Ladino?

if we respected the rules and the hierarchies they created that we would gain their recognition and approval. But Ima, you knew that these hierarchies were imposed in 1948, since you were part of a world that was not shaped according to their terms. For a long time, however, you were part of the only Sephardic family in Ashkenazi-dominated Rishon Lezion. The rare times when you dared to doubt the judgments of state rulers were when you had known those rulers as children from before 1948 and were able to see the gap between their public status and who they had been in the community where you both grew up.

When you died, I looked at our family albums and was reminded of the other mother I knew. She was looking at me and smiling even before I was born (see photo p. 564).

She was not always there.

She came to life while using her hands, when we were immersed in craft making, or when we used our legs, when you dragged me with you to those beautiful markets where your eyes began to glow and you became her, asking the sellers to unroll muslins, taffetas, linens, and gabardines, voiles, cottons, viscose, wool, and Lycras, jersey, Scottish checker, jacquard, and pepita.

The sellers always allowed her, you, to touch these fabrics, recognizing her skills in the knowledgeable movement of her fingers, in the way she held these different fabrics against the light, stretched them lightly, and let them fall to see if they poured like champagne, or crisped like dry leaves.

I remember how you looked in the mirror when you began to glow like her, turning those big bolts of fabric at different angles, asking if the eggplant color or the steel blue best suited you, or me. It went on and on and on. We went from the Persian market, to the Bukharan one, and we visited every single store.

But when we were children, you didn't have the money to buy any of those expensive fabrics that we loved, but you could not admit it; so you would half-promise the sellers that we would return to purchase them another day. They knew and we both knew that it wouldn't happen, and that next time we would do the same: enjoy the fabrics we could not afford.

At home, you became her again, cutting up our old clothing and sewing the pieces together in new formations, designing new garments for us inspired by those fabrics we had touched.

Ima, you were born in Palestine. In 1948, when you were seventeen, this beloved place where Jews lived among other peoples could no longer accommodate you as you used to be, unless you converted to Zionism. I don't envy you, becoming a young mother five years after the Zionists destroyed Palestine and proclaimed the establishment of Israel. You had just had your first child, but you felt she was not totally yours, since the state claimed its share of her. To keep custody over your daughter, you were expected to justify a project that was unjustifiable. Children whose families migrated to Israel from Yemen and the Balkans were kidnapped during the first decade after the creation of the state and handed over for adoption to mostly Ashkenazi families in Israel, where they would have better opportunities. Despite decades of efforts of the families to investigate this organized crime, it was only in the early twenty-first century that their allegations began to be acknowledged. And despite the fact that your family was from the Balkans, you assumed that because you were born in Palestine, your children would not be affected. But I'm sure that Yemeni and Balkan children, mysteriously declared dead or disappearing after being admitted to state hospitals, instilled a certain terror in you too.[32]

Your beloved aunt Rachel migrated from Bulgaria in 1949, and after the humiliating ordeal of immigrating as a Sephardic Jew to the Zionist state, she feared to leave her ailing son in the hospital as the medical staff told her to do. When her daughter Carmela, your cousin, told me about this, she told it as a memory burned into the body of the family, using her arms to show me how tight her mother had held her younger brother while saying to the nurse, "No, he will come with me." Your aunt knew from others in the transit facility (where they were forced to live after moving to the colony) that if she left him in the hospital, she might not see him again—and so she took him, still sick, back home. Ima, why did you keep from us the things this state did? You must have heard this story from your aunt or mother.

Letter 15. Why didn't you love me in Ladino?

The state mandated that Jewish mothers provide their children with a "proper" national education. You were not fully qualified for the job, as a Ladino-speaking woman with a religious father and a stubborn mother who walked down the streets like she was still in Sofia. Being a religious man, your father resisted Zionist secularization and continued to read sacred Jewish texts, to go to the synagogue, to wrap *tfilin* and cover himself with a *tallit* every day, not only on Yom Kippur. He also blessed the creator of the fruit of the vine and offered the proper blessing before and after each meal. Grandfather didn't allow you to join the Zionist youth movement that introduced children to the national hagiographies of "great Zionist men"; you also didn't have uncles or older brothers who were members of those Zionist militias. And Abba, your husband, had no respect whatsoever for the new Israelis, whom he perceived as having no culture, since in his eyes they knew nothing about good food, wine, music, radios, or how to connect electric cables.

Yet you tried to be a good Zionist mother. You wanted the best for us, and so you agreed to clip your wings and to respect and submit to the new regime. Grandfather's religious practices still resembled what was included in Israeli schools' primers in the first decades of the state, but the rituals and traditions of your mother were considered too spiritual, too obscure.

The last time I remember covering mirrors and photos with black fabric when someone died was when I was eight years old and Grandfather had passed. We sat on the floor, as we were not allowed to sit on chairs for seven days, and we did not turn on any lights except for lighting candles. The house seemed like a magic cave where these black fabrics vibrated with ghosts. There were all these Bulgarian women I didn't know, who spoke in a mishmash of languages, which, as a child, I could not disentangle from each other but I loved listening to.

This is all gone, Ima. These traditions were discarded as superstitions, no longer part of Jewish life except among orthodox communities. When I gave birth, you didn't prepare sweets or any licorice-scented arak (*raki*) for us. You didn't protect me from Lilith or from evil spirits, though your mother taught you how. However, it is not too late, Ima.

Ima, I remember the pressure I felt as a young teenager to ridicule what the state designated as an outmoded form of Jewish life. I had to perform, along with my peers, my own emancipation from it. My act was going with friends to Jaffa during Passover and buying myself a flatbread with hummus from a Palestinian street food stall. I could eat bread on Passover because I was secularized, but I also learned that this trespass was also a trespass of the apartheid lines of the state. We didn't invent this rite of passage; many others performed it before us. But rather than the act of rebellion we had hoped for, it did no more than force us to align ourselves with the state and its way of drawing lines between colonized and colonizers, between secular modern citizens and religious, described as backward parasites, since they refused to be drafted to the army. These were the confines, we learned, within which we could define our Jewishness, meaning our Israeliness. We learned that our positionality was *against* Muslims, Arabs, and Palestinians in particular—rather than learning that we lived in common with them.

Ima, when your parents died, you felt the loss of the Jewish traditions your father had preserved. But you didn't know how to access and revive them, beyond fasting annually on Yom Kippur or sometimes lighting Shabbat candles and scolding us gently as we laughed at you. Thus we all played our roles in the imperial deal to forget what was taken from us. You tried to rescue something that was hollow, and we rebelled against it.

Ima, if only you had not told us that your history was that of the Israeli state and the "Jewish people"! If only you had not been made to believe that the only thing worthy of note in your biography was that you were sabra, a category invented to erase the fact that you were born in Palestine! You might have told us of the resistance to colonial states and imposed histories on both sides of our family—you might have told us of the resilience of our ancestors, who imagined and rebuilt their worlds. But we didn't know about our ancestors, and so we, their descendants, inadvertently sinned against them. We lived as if they didn't exist, as if we were orphaned.

Ima, we were not orphans. We did have ancestors, some of whom became Zionists, industrialists, modernists, and bankers,

Letter 15. Why didn't you love me in Ladino?

ancestors who welcomed their orphaned status, who accepted the "solution" to the "Jewish problem." But we had other ancestors, and many of them! They were anticolonial, anticapitalist, antimilitarist, antistatist, antinationalist, anti-Zionist, antisecularist, the anarchist, feminist, and communist Jews whose words and deeds resisted the normalization of the "problem." Their approaches were often conflicting and contradictory, and none of them could be imposed on a global scale. Their approaches, which were personal, local, idiosyncratic, incoherent, unruly, unique—just as diverse as Jewish life—unfolded before we were colonized by Euro-Zionism.

Ima, when we were kidnapped into the palace of Zionism, we were lured into sinning against our ancestors. Already a long time ago, I found that it is not too late to repudiate all these Zionist vows, like we are expected to do every year on Yom Kippur. Join me, Ima, please, in rehearsing their cancellation, declaring them null and void, in Hebrew and Aramaic:

> Kol Nidrei (all vows) and prohibitions, and oaths, and
> consecrations, and *konams* and *konasi* and synonymous
> terms,
> that we may vow, or swear, or consecrate,
> or prohibit upon ourselves,
> from one Day of Atonement until the next Day of Atonement
> that will come for our benefit.
> Regarding all of them, we repudiate them.
> All of them are undone, abandoned, cancelled,
> null and void, not in force, and not in effect.
> Our vows are no longer vows,
> and our prohibitions are no longer prohibitions,
> and our oaths are no longer oaths.

Ima, I wanted to go with you to the synagogue this year. I miss the sound of the eucalyptus leaves that announce that the new year is standing at the door. The new year is followed by Yom Kippur; I miss your caring hands, preparing white clothing for us, and the tumultuous children in the synagogue's yard, who laugh and play. More than anything, I miss the music of Kol

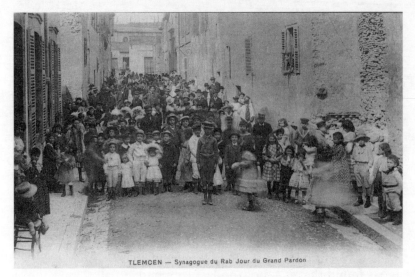

Rabb synagogue, Tlemcen, Algeria, Yom Kippur. Colonial postcard.

Nidrei and the yearly liberation from vows we, or others, should not have made. The music starts quietly, softly, hesitantly, but strengthens with repetition, growing louder as the congregation sings with more confidence, until it becomes a loud and ecstatic plea.

Ima, I looked online for a non-Zionist synagogue and found one in Rhode Island, forty minutes away from where we live. It advertised that its doors were open to queer people, trans people, and mixed couples. It sounded promising. Once inside, however, I noticed two national flags of the Zionist state and of the settler-colonial United States. I felt betrayed since I had checked before going and there was nothing about the congregation's support for nationalist agendas, but I was probably naive to expect otherwise. This has become the norm, and no one feels obliged to mention that this is not a safe space for Jews like me, like us, who were persecuted by Zionists and see in the flag a symbol of our enemy.

There were no children in that synagogue. I don't believe their absence can be explained by other school-day activities. No, it is because for almost two centuries, the pressure to separate being Jews from living-as-a-Jew-in-community has been too much, and scattered "religious" gestures become harder to justify for people who live in Christian states. But I reject the imperial story of progress that invites us to see in their absence proof that the

Letter 15. Why didn't you love me in Ladino?

world of our ancestors is gone. On the contrary: perhaps the children's absence can be seen as a promise that in a couple of years, liberated from Zionism and all imperialisms, these children, now grown, will be able to recite the Kol Nidrei, discard the vows imposed on their ancestors and renew the synagogue as site of healing from Zionist wounds. I see in their absence from this sterile form of being a Jew proof that our world is not gone.

Ima, if you had not been asked to forget our family legacy, you could have recognized, in my refusal to assimilate into a world against us and our neighbors, the image of your ancestors.

Ima, if you had not given me the love of craftwork, I may not have felt confident that our ancestors were different from the people we were made to be.

Because of the love you have gifted me, I believe that they are waiting for us, waiting for us to repudiate and abandon all vows that we, or others, have made under the pressure to convert, to discard oaths made in our name that have barred us from working to repair what was broken.

Ima, you taught me with your hands how to look at the way things are made, how to sense their materiality, how to touch them gently as objects call us to do—to hold them up frontally, diagonally, or against the light—how not to damage them and not to throw them away, how to consult them as to whether their days are over and ask them if they wish to be repaired or have a new life as something else.

Ima, you taught me how to cut, how to fold, flatten, measure, stretch; how to attune myself to the different properties of materials by following the direction of threads in a fabric, or locating possible fractures in their make—how to hand sew or use the machine, how to knit and embroider.

If you had not taught me this, I would not have seen how you were the carrier of this knowledge that came all the way from Spain with our ancestors.

And I would have failed to recognize how essential craftmaking is to the Jewish Muslim world, part of what defined our ancestors as Jews and what can help us to nullify all the vows that condemned us to a codified imperialist world that is the

same everywhere, rather than enabling us to live in the smaller worlds that we can take care of with our own hands. These are worlds in which being a Jew is defined by engaging with others who do not ask us to stop being Jews. These are worlds in which the work of our blessed hands mends the world, daily.

If only you were here to help me with the necklace I prepared from a replica of Abba's fork.

If only I had been able to understand all of this when you were alive...

I miss you, Ima,

your daughter Relly (as you used to call me), now also named Aïsha.

Letter 16. The granddaughters of Sycorax

A letter to Ghassan Kanafani

Dear Ghassan,

Not so long ago, I received an email from a woman named Tama. When she reached her forties, she learned that she was named after her grandmother Safiyya, whose return to Haifa in 1967 you wrote about in 1969. It is a long story, so please bear with me. In her note, she didn't say anything about it; rather, she asked to meet with me to talk about Sycorax, the absent yet ever-present witch in Shakespeare's *The Tempest*.

I was intrigued and wrote back, telling her that I'm not a Shakespeare scholar but indeed interested in the Algerian woman who may have been the model for the witch in the play. This woman was known in the sixteenth century as "the deliverer of Algiers," a witch who in 1541 was said to have destroyed the Spanish king's armada besieging the city.[1]

Her name has not been transmitted to us, though we remember her, those of us who recognize in women like her our ancestors, sages, healers, and prophets.

She survives in the figure of the witch Sycorax, who is vilified by the sorcerer Prospero, one of the play's main characters; his authority over the island rests on her elimination. The characters in the play don't question this, and a brief line of dialogue casts her as a suspicious figure, banished from Algiers for her crimes.

For Shakespeare, as for many other male authors who interpreted the play, she is an old and ugly witch, her powers and knowledge only a stage for colonial actors to appropriate.

What Shakespeare dramatized was the game played by several European colonists, who are accustomed to treating the lands of others as their trophies and playgrounds. Prospero's exile on the island and from his dukedom in Milan, Shakespeare lets us understand, could end if the unacceptable decision of Alonso, King of Naples, to marry his daughter to an Arab man from Tunisia could be changed. With a more "respectable" marriage, the play's plot suggests, the exclusively European right to conquered lands could be restored.

However, a century after this real woman from Algiers, occluded in Shakespeare's character of Sycorax, assisted her people in defeating the conquering army of Charles V in 1541, a Scottish cartographer, John Ogilby, described how another legend replaced hers in order "to palliate the shame and the reproaches that are thrown upon them [the people of Algiers] for making use of a witch in the danger of the siege."[2] Ogilby tells the story of Marabou Cidy Utica, who with his prayers managed to call the storm that destroyed Charles V's fleet. A friend of mine, Nadia Ammour, an Algerian Amazigh woman who collects and sings Kabyle songs, told me about yet another story still told in Algeria today, of the saint Sidi Ouali Dada, who planted his stick in the shore and broke the siege of Algiers.

It was summertime when Tama came to meet me. When she arrived at the doorstep, we skipped the formalities and dove into an intense conversation about Sycorax's name. We hypothesized about its possible origins in Hebrew, which we both thought was meant to denigrate her. Scholars speculate that Sycorax comes from the word *shykoret*, which means "deceiver" or "liar" in Hebrew. We played with further possibilities such as: *shycoret*, a drunken woman; or *shokheret*, a woman who, like an animal, waits for her prey; and *sokheret*, a woman whose mouth is sealed. It mattered to both of us that Sycorax was Arabe or Amazigh, "and possibly *also* a Jew," I added. Neither of us could ignore Shakespeare's silence about the Muslim or Jewish origins of the sorceress from Algiers whom he included in his play.

Letter 16. The granddaughters of Sycorax

It took me some time, I told Tama, to ask why Shakespeare made Sycorax's banishment to the island off the coast of Algiers—where Prospero is then later banished—simply a background detail in the play. The question occurred to me when I learned about the multiple acts in England (1541, 1562, 1563, 1586, 1604, and so on) against witchcraft, as well as about Spanish colonial rule in North Africa's littoral cities during the early sixteenth century. The Spanish regime was obsessed with expelling Jews from the cities they conquered, as testified to by different memoranda, reports, and edicts.[3] Sycorax, I said, was likely banished for her witchcraft, and she was banished for being a Jew. "I didn't know about all this," Tama replied, when I told her what I'd learned, "but I strongly feel the orientalist framework of the play." I could not have agreed more, and we spoke about the repulsive tone of the play toward the natives, be they Muslims or Jews, and especially toward the figure of Caliban, Sycorax's son, who is depicted as monstrous—"not honour'd with a human shape"—and enslaved by Prospero. "Did you know," she asked me, "that Caliban's name likely originated in Arabic and is actually an insult? *Kalib* means dog in Arabic." Before I had time to respond, she started singing the song "Ila Umi," set to Mahmoud Darwish's lyrics. I enjoyed the way she curled her voice as if also singing about Caliban's longing for his mother, Sycorax.

At this point, I understood that Tama hadn't come to see me to talk only about Sycorax, but that she had other sage female characters in mind. I decided not to say anything and to let her decide when she wanted to open her heart to me, and so we kept talking about the play. Tama was not familiar with the anticolonial interpretations of the play, notably Aimé Césaire's rewriting of it, so I described it at length. I have always been unhappy with Césaire's decision to drop the Algerian origins of Caliban and replace him with an enslaved Black man in order to turn the play into a colonial parable.[4] Europeans' centuries-old obsession with the colonization of Algeria is rarely mentioned in canonical texts like Shakespeare's, and it is frustrating that most productions displace the play by setting it in the Caribbean or in South America. It is as if Césaire were saying that in order to make the play's racial politics visible, Algerians had to be replaced with Black characters.

The Tempest takes place in a small island off Algiers, which already in 1510 had been captured by the Spanish and turned into a military garrison named the Peñón of Algiers. This is the historical context of the play. Yet only a few readings of Shakespeare's play address the European anxiety about the "threat of Islam." Barely few mention the 1541 tempest that rescued Algiers from Spanish conquest.[5] But none of the readings discuss the European obsession with conquering North African coastal cities, or the Spanish conquest in particular. By 1541, Spanish conquistadors had already ruined several cities, including Oran, from where 22,000 inhabitants were expelled in order to create a Catholic city. No mention is made of the fact that it was those same Spanish colonists who sought to purify Spain of its Jews, Muslims, and witches, and who sought them out to expel, kill, or convert in North Africa as well. And once they conquered those littoral cities, they obsessively expelled the Jews, after using them for a while as Arabic translators.[6]

Tama was surprised when I told her that Sycorax didn't simply die, as the play leads us to believe. Why should we trust the conqueror's testimony about what happened to Sycorax? For example, the fact that her son was young when Prospero conquered the island raises suspicion about her depiction in the play as old and ugly—she may well have been a young mother, not a crone. Shakespeare omits mention of the colonial violence involved in dominating the island; instead of portraying the Spanish military garrison, he places a single actor, Prospero, in the role of ruler. When Prospero addresses Caliban, Sycorax's son, his words invoke the usual European justification—devil-worship—for why witches like her ought to be executed. *Your mother's sin,* Prospero tells Caliban, *is even worse: she carried you, the devil's baby*: "Thou poisonous slave, got by the devil himself / upon the wicked dam, come forth!" After stealing the power of "this damned witch Sycorax" in order to regain his own, Prospero accuses her of "mischiefs manifold, and sorceries terrible to enter human hearing." Prospero has such contempt for Sycorax that he doesn't use common terms to describe her pregnancy but rather describes her as the one who "with age and envy / was grown into a hoop."[7]

Letter 16. The granddaughters of Sycorax

This is the other historical context of the play, the witch-hunting decades when hundreds of thousands of women were executed across Europe for "going to the Sabbat" or being members of the synagogue of Satan. Many of these women accused of worshipping the devil were regarded as "heretics and propagators of Arabic wisdom."[8] Sycorax, native of Algiers, is not a European witch who propagates a once-existent Arabic wisdom; she herself is an Arab, an inheritor of Arab knowledge, and likely also a Jew. It is this entanglement of Arab, Berber, Muslim, and Jewish culture that took shape under the many moons of coexistence, and that Europeans wanted to decimate, and that they saw as allied with the devil. From the time of the Crusades onward, Europeans had been obsessed with destroying the "orient." In *The Tempest*, we see the colonial desire to obliterate the Muslim Jewish witch—the indigenous sorceress—and to foist upon the land something new, male, Christian.

Tama and I also talked at length about the particular type of disorientation that colonizers inflict upon the colonized, evidenced by the confusion that causes Caliban to think that it was Prospero who taught him "how to name the bigger light and how the less,"[9] despite knowing that his mother understood the moon's secrets better than anyone else. "Caliban," I said to Tama, "is doing his best to resist the effects of Prospero's terror by refusing some of Prospero's commands. But in the new world that Prospero has imposed, Caliban is dominated by the language that Prospero forces him to speak." Prospero coveted Sycorax's powers to provoke storms, but only because he envisioned how such power could assist in keeping the bloodlines of the rulers European and help him regain his power in Europe. Thus he was totally ignorant of and disrespectful to the lunar cosmology known to Sycorax. Caliban, forced by Prospero's regime to discard the lunar calendar common to Jews and Muslims and replace it with imperial temporality, became dependent on Prospero.

Caliban may still remember that his mother would not abuse nature's spirits—as Prospero enslaves the wood nymph Ariel—or conjure a storm for her own selfish interests, as Prospero does. Sycorax used her knowledge of the elements to calculate time properly, so that the tempest she predicted was approaching

would hit the enemy army at a moment of unpreparedness.[10] According to the legend, only briefly alluded to in *The Tempest*, she went to see the emir of the city and "pray'd him to make it good yet nine Days longer, with assurance, that within that time he should infallibly see *Algiers* delivered from that Siege, and the whole Army of the Enemy dispersed."[11]

When Tama called me Aïsha, I saw that she knew quite a few things about me, even though we had just met. Her interest in Sycorax stemmed from her interest in the restoration of ancestral powers, ecologies, genealogies, and names. It felt as if we had always been close.

I prepared us tea with mint leaves and asked Tama to tell me about her name, which is uncommon. Unhesitatingly, she said: "This is why I am here, and these were the last words of my grandmother on her deathbed: 'I am the one who gave you the name Tama. You will thus be named until the day you learn what your real name is.'"

Tama told me that she was actually not surprised when she heard this, and all the more so when her grandmother sat up in bed and recited in one breath a whole sequence from Ecclesiastes:

> One generation goes, another comes,
> but the earth remains the same forever.
> The sun rises, and the sun sets—
> and glides back to where it rises.
> All streams flow into the sea,
> yet the sea is never full;
> To the place from which they flow
> the streams flow back again.
> All such things are wearisome:
> no man can ever state them;
> The eye never has enough of seeing,
> nor the ear enough of hearing.[12]
> ...
> A season is set for everything, a time for every experience under heaven.

A time for being born and a time for dying,
A time for planting and a time for uprooting the planted;
A time for slaying and a time for healing,
A time for tearing down and a time for building up;
A time for weeping and a time for laughing,
A time for wailing and a time for dancing;
A time for throwing stones and a time for gathering stones,
A time for embracing and a time for shunning embraces;
A time for seeking and a time for losing,
A time for keeping and a time for discarding;
A time for ripping and a time for sewing,
A time for silence and a time for speaking;
A time for loving and a time for hating;
A time for war and a time for peace.[13]

Tama could hardly believe that her stubborn father had let his mother decide upon his daughter's name; she described her grandmother as a woman who didn't speak much and who seemed beaten down. Yet Tama recognized that her own political education came from her grandmother, even if it was rarely articulated but instead transmitted through gestures, body movement and idioms. When her grandmother told her about the name, Tama said she also told her that she had promised Tama's father never to tell Tama why she chose this name. She said, "You will have to look for it yourself. The language matters, and once you find out, you will know your way."

When her grandmother started to recite those passages from Ecclesiastes again, Tama joined her, as did I when Tama recited it to me:

A season is set for everything, a time for every experience under heaven.
A time for being born and a time for dying,
A time for planting and a time for uprooting the planted;
A time for slaying and a time for healing,
A time for tearing down and a time for building up;
A time for weeping and a time for laughing,
A time for wailing and a time for dancing;

A time for throwing stones and a time for gathering stones,
A time for embracing and a time for shunning embraces;
A time for seeking and a time for losing,
A time for keeping and a time for discarding;
A time for ripping and a time for sewing,
A time for silence and a time for speaking;
A time for loving and a time for hating;
A time for war and a time for peace.[14]

Tama experimented first with several foreign names in European languages beginning with a T, but none felt right. She asked her father, but he avoided the conversation, as if something were binding his tongue. Tama didn't know, then, that this was a compulsive gesture he had inherited from his father and that expressed itself when he was stressed, though she learned this later, when she read your story. She continued to look for first names that meant "purity," the meaning of her name in Hebrew, but after a while she gave up. A Palestinian friend with whom she shared her quest surprised her when she told her that some Arabic women's names might match. When she mentioned the name Safiyya, Tama felt her heart beat faster. She had heard this name once when her father and grandmother argued. Suddenly, many things became clear, as if the name were the answer to the many questions she had, questions that emerged from silences, from unmatching pieces of information she gathered, and from the pangs in her body. A particular memory surfaced for her then, she told me: when she used to ride a white horse in the Palestinian stable in Galilee, the trainer used to tell her that she was riding like a Palestinian.

Tama waited for the *birth of a new moon* (מולד הירח) to speak with her father, hoping that the moon might soften his heart. When he heard her say, "Now I know everything," his response was sharp like a dagger:

"You will have to make a choice. I will not allow you to go by the name Safiyya; not as long as I am alive." Tama responded without remorse, though she knew she had hurt him: "If Mom

Letter 16. The granddaughters of Sycorax

hadn't died when I was five months old, maybe your heart would not be hard like a stone."

Dear Ghassan, I invented Tama, the daughter of Dov, against his belief that he could deny being born Khaldoun, the son of Safiyya and Said. Ever since I read your 1969 novella, *Returning to Haifa*, I've been living in the world you created. Your character Dov acts as if his decisions can and should determine the lives of others in his family. Growing up in the world the Zionists imposed, you show how Dov could not see himself as Palestinian, since in his world, Palestinians were the enemy. But Dov's world, the Zionist reality, your novella shows, cannot hold, for Dov's family continuously unsettles his certainties.

At the heart of your story is Dov's refusal to recognize Safiyya and Said as his parents. This takes place in 1967, when they are finally allowed to return to Haifa, the city they were forced to leave in 1948. The world is not Dov's, and he cannot stand between Safiyya his mother and Safiyya his daughter forever, nor can he stand between his daughter and the ancestral world she was not even aware was stolen from her. I'm familiar with the human factories in the Zionist colony in Palestine where Dov, born Khaldoun, was adopted and raised as a loyal Zionist. Some of Dov's cleaving to Zionism, his rigidity, stems from anxiety over being read as a credible Jew; for of course he remembers that he is Palestinian. This gives him the arrogant confidence of Israelis in who they are, which he exercises in the story. It is a power that endures into the present. Who better to combat it than his own daughter, who is also the granddaughter of his two mothers?

His adoptive mother, Miriam, did not hide that he was born to Palestinian parents, but he seeks always to deny it. The Zionists who administered the conquered city "gave" Miriam and her husband the apartment that belonged to his biological parents, along with all their belongings and their baby (Khaldoun, whom they named Dov), who was saved—though he could have been murdered, like the other Palestinian child Miriam sees in your novella. Horrified by the sight of how the Zionists treat the child's corpse, Miriam decides to leave Palestine just a few days after

she and her husband migrate from the hell of Europe, for the Palestinian child's death reminds her of the murder of her brother by the Nazis. However, just as she decides to leave Palestine, the baby Khaldoun is offered to her and her husband. She chooses to care for this Palestinian baby. They stay.

Dear Ghassan, I imagine that you were familiar with women like Miriam, women who witnessed Zionist cruelty and were reminded of what they saw done to their family and friends by Nazis in Europe and resented this world Zionists created. They recognized in Zionist violence the genocidal logic of a fascist regime. It is to the credit of this baby, believed to be an orphan, that the Zionist colony in Palestine retains Miriam. You didn't exaggerate her opposition to the Zionists by casting her as a rebellious subject; rather you kept her as an ordinary woman, one who possesses an innate sense of justice that the Zionist enterprise meant to destroy.

In the 1960s, when I grew up in these human factories, the memory of anti-Zionist voices like hers had faded away. Ever since I read your story, I've felt gratitude for your care in inscribing in the Dov biography Miriam's voice, thus also transmitting it to us. We had been deprived of the memory of women like her; the Zionist state needed us bereft of our histories so that we could be raised as the children of colonizers and mature into colonizers ourselves. Miriam cared for Safiyya and Said's son. Miriam trusted Dov's daughter, her granddaughter, to return to Safiyya and Said. She trusted her granddaughter to bring back part of what had been taken from all of them: Miriam's love and recognition of their kinship, and their Palestinian family. Miriam's trust was also entangled with the hope of a possible repair.

In my imagined sequel to *Returning to Haifa*, Tama's mother had to die soon after she was born, since there were no elements in your story that I could have used to portray her. But it was easy for me to imagine Tama being raised by Miriam, her grandmother. I'm not a novelist, only a storyteller, so I had to work with the elements of your story, working with different characters until the knowledge of what Zionism took from all of us could appear within the world of your story. It emerged solid enough to break the colonial curse placed on Said and Safiyya, and on Miriam and

Letter 16. The granddaughters of Sycorax

Khaldoun/Dov and their descendants—the curse placed on all of us when the colonial binary of Palestinian/Israeli was mapped onto diverse communities by the Zionist state with the aim of blurring the differences between Israelis and Jews, and making of them the enemies of Palestinians and Muslims and Arabs, on a global scale.

From her father's house, Tama went directly to her Palestinian friend to thank her. It is there that she stumbled upon my book *Potential History* and read the introduction, where I write about how I discovered that I should have been called Aïcha. She decided to contact me, but was too shy to say why directly. So she used Sycorax as a cover. After a few days together, we understood that Sycorax was not a cover but a metonym. And it was natural that our conversations continued to revolve around names and how they function as incisions, scars, and also panaceas. I told her that in 1948, her grandparents could not have known that the name of the baby they adopted was Khaldoun. Dov is a clumsy name, yet a sensitive choice on your part, dear Ghassan, because despite being pronounced differently, *dov* means "bear" in both Hebrew and Arabic, and bears are known to be empathetic, joyful, playful, social, sharing, and resourceful.

Dear Ghassan, Tama was born in 1982, the year marking both the tenth anniversary of your murder by Zionists and the beginning of the state of Israel's invasion of Lebanon. Her father, Dov, was thirty-two years old when she was born. At the time of Tama's birth, his adoptive mother, Miriam, was slowly fading, no longer able to bear her life in the colony. She was rejuvenated by the birth of her granddaughter.

For the first time in a long time, Miriam raised her voice and told her son:

"Enough! Go now and find Safiyya and Said. They are your parents, and your daughter's grandparents.

"Who we are," she said louder, "is not based on an either/or decision."

Dov refused.

Miriam ignored him and told the baby: "I named you Safiyya. When the time comes, you will understand why."

> *Dov's resistance forced Miriam to find a compromise. "I will translate Safiyya's name to Hebrew: Tama," she said, "and with her knowledge a tempest will come."*

Tama asked me if I knew her father. "Maybe," I replied, and she didn't ask me more. She knew, as I also understood by then, that there was no reason to precipitate things. We would be spending more time together, and it had been a long day. We prepared dinner, and she went to sleep. In the morning before I left for work, I put my copy of your *Returning to Haifa* on the kitchen counter with a note letting Tama know that I'd be back in the early evening. When I returned, she didn't mention the book and instead asked me about Algiers. I told her that I had not yet been able to walk barefoot in Algeria as I dream of doing one day, but that I feel Algeria under my feet every time I talk with Sycorax, from whom I'm learning some of these secrets and *qualities o' th' isle, the fresh springs, brine pits, barren place and fertile.*[15]

Tama was curious to know why I assume that Sycorax has so much knowledge. "Read the play again with the eyes of Safiyya," I tell her, "and you will not miss it."

Prospero's books were useless compared to Sycorax's knowledge of the island, which he extracted from Caliban her son after turning him into an orphan. You will not miss that Prospero and Miranda denigrate Caliban and call him a savage—one who doesn't *know thine own meaning, but wouldst gabble like a thing most brutish*—and also erase his mother tongue, his mother's tongue, Arabic or Amazigh, in their rush to claim that prior to their arrival he had neither language nor meaning.

You will not miss, I tell Tama, Prospero's own recognition that the secrets he extracted from the island could never really be his. They are *of* the place, and he could not retain them once he left:

> Now my charms are all o'erthrown
> And what strength I have's mine own.
> Which is most faint.[16]

Letter 16. The granddaughters of Sycorax

Together, Tama, we will not miss that though Prospero—and all the Prosperos across history—scorched the earth and imprisoned us with their languages, stealing our histories and neutralizing our powers, they can never fully take our collective power from us. They can never truly own what they have stolen.

Much is there for us to reminisce, repeat, retain, re-enchant.

Together we will not miss how our ancestry resides in those women who cherish *the moon, make flows and ebbs, and deal in her command without her power*[17] and whose secrets are our own to reclaim. These are secrets that cannot be learned from books, nor written in books, but are nonetheless out there for us to embrace, believe in, to find in ashes and residues, dreams and poems, things that can only emerge under the light of the moon.

I asked Tama if she wanted me to call her Safiyya. She replied, "*Ana min el yahud*,[18] *Safiyya umm-ul-mu'mineen* (mother of believers), *ana filastinia fi filastin*. I read the story that you left on the table," she said. "If this is my story," she continued, "why did the author Kanafani not mention me?"

I told her about your assassination in 1972 by those who had also stolen Palestine and expelled you.

For a long time she stared at the moon pendant in the window, hanging like an earring, an *alâqa*, and then she asked, "Why were our ancestors distanced from us?" Why were our tales taken from us?

"From now on," she said in a prophetic voice, "my name is Safiyya. I'm the granddaughter of Miriam and Ephrat, and of Safiyya and Said, and a distant descendant of the pre-Islamic Arabian Jewish poet As-Samaw'al bin 'Ādiyā, and of all the female prophets who refused to betray others. My grandparents Miriam and Ephrat were expelled from their homes in Europe and betrayed by Zionists and Europeans, who used their goodwill to advance a violent colonial project. And my grandparents Safiyya and Said were expelled from Palestine by the same Zionists. And they will return.

"The return has already started. Here I am, Tama Safiyya, breaking the Zionist spell over my body, over the land, over our prophetic powers. These are powers that can assist us in

healing, in immersing ourselves in the seven years of repair the Torah calls for, renewing our gratitude to our life among others, respecting the balance and secrets of the world and living under their mantle."

A season is set for everything, a time for every experience under heaven.

With gratitude,

Ariella Aïsha

Acknowledgments

For many years I have been collecting books, postcards, photos, and newspaper scraps related to Algeria, hoping that one day they would help me understand where I came from and why I was raised to know almost nothing about it. I completed my work on my earlier book *Potential History* without knowing how to think with these materials or make them part of the wide arc I drew in that book, as if Jews and Muslims didn't fit within its confines. It was difficult not only because the question of Algeria was the most intimate and disavowed imperial wound I inherited; it was also difficult because the memory of a world where Jews lived with Muslims and Palestinians has been buried under other solid narratives from which it evaporated. In retrospect, I realized that I could not describe such a world without the anti-imperial rehearsals that *Potential History* made possible. Soon after I finished writing that book, I read that Jews had been the jewelers of North Africa and the Middle East. Suddenly my piles of papers and images made sense. I started to look for objects in which this world was encapsulated, to touch them and turn them into my guides. Insightful conversations with many interlocutors, some of them familiar, others newly met in person or online, furthered my understanding. I began to use coins, drill bits, pliers, beads, and thread to interact with the jewelers I encountered in images and documents, working with my hands and learning the worlds entangled in the objects they had made. Those jewelers, whose objects I studied with my hands, are the first among the many people to whom I'm indebted.

My gratitude to the addressees of the sixteen letters of which this book consists is clear, as the letters testify. I'm also grateful

to all my guides who ushered me in this return to Algeria and Morocco, who with love, care, and magic shared their invaluable knowledge, memories, and wisdom with me. Some of these exchanges were brief, similar to stopping someone in a foreign place and asking for directions. Other exchanges were more profound and unfolded over time, and they included assistance in finding places on maps, taking photos of sites inaccessible to me, teaching me prayers and curses, showing me their Algerian jewelry, amulets and red corals, or awakening my muscle memory about everyday rituals: when and where I must throw coarse salt and why, or pour water on the back of departing friends. And indeed, some of these exchanges became friendships. I'm grateful to all these guides and friends: *mu'allim* Abdullah, Chaouki Adjali, Nadège Aïcha Néchadi, Nadia Ammour, Samia Ammour, Sarah Abrevaya Stein, Mustapha Adnane, Lotte Arndt, Maël Assal, Benali Bachir, Yohana Benattar, Ali Benkoula, Meriem Merzouga Ben Bella, Yasmine Ben Bella, Mounir Bencherab, Nadir Benhamed, Sarah Benichou, Aomar Boum, Faycal Dris, Raouf Farrah, Chiara Figone, Olivier Hadouchi, Rachel Koskas, Joyce Kutty, Yosef Uzi Levy, Amina Lina, Jorge Martin, Nassima Mekaoui, Jean-Marc Miretè, Aziz Mouats, Beya Othmani, Foudil Ourabah, Jana Rat, and Michelle Sebag. Older friends joined these conversations at different steps along the way and helped by listening, commenting, sending a reference or an image, or clarifying affinities between Hebrew and Arabic, among them Issmat Atteereh, Kader Attia, Omar Berrada, Simone Bitton, Carmela Dekel, Sarah Frioux-Salgas, Carles Guerra, Saidiya Hartman, Samia Henni, Thomas Keenan, Marc Lenot, Susan Meiselas, Wayne Modest, Jean-Baptiste Naudy, Ishay Rosen-Zvi, Susan Slyomovics, Filipa Vicente, Eyal Vexler, Yonatan Vinitsky, Kathy Wazana, Laura Wexler, and Stanley Wolukau-Wanambwa. The generous support of Brown University, and the department of Modern Culture and Media in particular, was essential for the completion of this manuscript. It is in this intellectual environment, not cut along disciplinary boundaries, that I received intellectual, political, and emotional support from many colleagues, including Amanda Anderson, Tim Bewes, Anthony Bogues, Tamara Chin, Beshara Doumani, Leela Gandhi,

Acknowledgments

Macarena Gomez-Barris, Yannis Hamilakis, Bonnie Honig, Brian Meeks, Laura Odello, Rebecca Schneider, Thangam Ravindranathan, and Peter Szendy. My gratitude to Vazira Zamindar, for our shared weekly walks along the beach or Blackstone Boulevard, exchanging insights about anticolonial practices and theories; and to my graduate students Ahmad Abu-Ahmad, Adel Ben Bella, Kate Elizabeth Creasey and Sherena Razek, my collaborators in the Madrasa/Beit Midrash forum we founded at Brown University, as we struggle to carve a space for rehearsing anticolonial thinking in an academic setting. My gratitude is to all those on campuses engaging in resistance to the genocide in Gaza, by creating a university-within-the-university, a site of refusal to comply with our universities' entanglement with the genocide.

The American Academy in Berlin, where I spent the spring semester of 2022, and the Cogut Institute for the Humanities, where I spent the fall semester, supported me in this research and provided me with the time and the space I needed to write these letters. Earlier and much shorter versions of some of the letters were published in the books *Making the Postcard Women's Imaginarium: Dreaming our Futures out of Our Past* (Peculiarity Press), *Rights of Future Generations: Propositions* (Hatje Cantz), *Europa Oxalá: Children of Empire and European Postmemories* (Afrontamento); and in the journals the *Boston Review*, *The Funambulist*, *Inward Outward*, *NAQD*, *Twala*, *Journal of Visual Culture*, *Errant Journal*, and *QG Decolonial*. I benefitted from the excellent comments, questions, and edits of the editors of these publications, among them Alessandra Benedicty, Andrea Bagnato, Deborah Chasman, Irene de Craen, Salma Ahmad Caller, Daho Djerbal, Raouf Farah, Adrienne Huard, Adrian Lahoud, Léopold Lambert, Hannah Liberman, Rachel Somers Miles and Gabrielle Moser. I'm fortunate to have Verso as my publishing house. I express my gratitude to Leo Hollis, who expressed his commitment to this manuscript from the very beginning, and to Mark Martin, who diligently and thoughtfully helmed the manuscript through its final stages.

I am grateful to Malek Sheikh, whose creativity as a research assistant was invaluable in locating elusive documents and tracking down important threads for the reconstruction of this world

that seemed doomed to disappear. Andie Giraudet-Fort, a second cousin of mine whom, thanks to Malek, I discovered through this research, shared with me her findings concerning the Azoulay/Azoulaï family and assisted me in filling in some holes in these dispersed histories. My deep gratitude to Michael Zalta, who edited earlier versions of many of these letters before I submitted the full manuscript to Verso. I enjoyed his wise and careful edits, his comments and challenging questions, and our rich conversations about the remains of the Jewish Muslim world to which we are both committed, and the traditions and art-making practices among Syrian Jews and Algerian Jews.

I am indebted to the continuous conversations with my nephew, Yarden Katz, where we rehearse potential histories of Jewish communities and liberation projects that preceded or opposed the Zionist project, and for the brilliant insights he offered; to my partner, Adi M. Ophir, for the inspirational conversations on Jewish texts, his willingness to hear my unruly interpretations of many of them, and his insights as reader of some of these letters; and to the never-ending conversations with two of our daughters, Ellie Armon Azoulay and Hagar Ophir, who each in her own way share my intellectual and spiritual quest for a renewal of diasporic forms of Jewish life.

Finally, I owe my deepest gratitude to my incredible editor Jessie Kindig. It has been a special privilege to work with her for the second time on a book of such scale. Jessie generously supported the initial idea of a book of letters and patiently welcomed various stages of my experiments in epistolary writing. She accompanied this book to its completion with her incisive edits and her talent at cutting away blocks of text to show me how the remaining passages reconnected seamlessly with the rest in a more insightful way. Our shared love for sorcery and invocations made her a supportive companion who knew how to foreground the prophecies my ancestors dictated to me. And perhaps most importantly, her intimate understanding of the anti-coloniality of my project yielded invaluable, perceptive, and instructive editorial interventions. Working with Jessie was simply a blessing.

Acknowledgments

This is a book of love for my immediate family, my children, and my grandchildren, dispersed around the world. It is a book of anticolonial and anti-Zionist hope transmitted as a spiritual and artisanal commitment to amplify dreams and further rehearse justice and abolition for the pursuit of liberation from the colonizing and debilitating powers that destroy worlds that were built with caring hands, love, and wisdom. During the months that have passed since the beginning of the genocide, I have listened, along with millions of others all over the world, to the truth-telling voices from Gaza, while working to undo the histories that for decades made them unheard. That has made this book feel even more urgent than it did through the years of writing it. Seeking words and ways to amplify their voices and respond to them from within our academic and cultural institutions, most of which camouflage their own entanglements with genocidal violence, has revealed the book's aim—to make the Jewish Muslim world imaginable and habitable again—to be more necessary than ever. These months of genocide have proven how deeply the West is invested in the perpetuation of the Zionist project, but they have also turned the anti-Zionist struggle into a global anticolonial movement for the liberation of Palestine and for the end of the imperial world that sacrificed Palestine and the Jewish Muslim world to begin with.

This book is also a prayer, a prayer for the rebuilding of worlds with love of the earth, with reclaimed ancestral bodies of knowledge, with justice of repair, with dexterous hand, magic, and bliss.

Notes

Introduction

1 Katherine Jomaa, *Ummah: A New Paradigm for A Global World* (Albany: State University of New York, 2021), 140.
2 On the coordination with Eichmann, see Hannah Arendt, *Eichmann in Jerusalem: A Report on the Banality of Evil* (Harmondsworth, UK: Penguin, 2006).
3 I'm grateful to my dialogue with the artists in the Postcard Woman Imaginarium collective and especially to Salma Ahmad Caller, who edited their book Salma Ahmad Caller, *Making the Postcard Women's Imaginarium – Dreaming Our Futures Out of Our Past*, (London: Peculiarity Press, 2022).
4 Dominique Jarrassé, "Aux origins de la musealisation des objets d'art juif(s), 1890–1920," *Revue germanique internationale* 21, (2015): 21.
5 In the Jewish Muslim world, guilds often created their synagogues and mosques.
6 See Mark Wischnitzer, *A History of Jewish Crafts and Guilds* (New York: Jonathan David Publishers, 1965), 11–12.
7 See Wischnitzer, *A History*, 24.
8 Labelle Prussin, "Judaic Threads in the West African Tapestry: No More Forever?," *The Art Bulletin* 88, no. 2 (2006): 331.
9 Lena Salaymeh and Shai Lavi, "Religion Is Secularised Tradition: Jewish and Muslim Circumcisions in Germany," *Oxford Journal of Legal Studies*, vol. 41, no. 2 (Summer 2021): 437.
10 Valérie Assan, "Les synagogues dans l'Algérie coloniale du XIXe siècle," *Archives juives* 37, no. 1 (2004): 70.
11 Houria Bouteldja explains: "I don't know what meaning she [Chela Sandoval, a Chicana activist who was the first person to my knowledge, to use it] attributed to it but I liked the expression." Houria Bouteldja, *Whites, Jews, and Us: Toward a Politics of Revolutionary Love*, trans. Rachel Valinsky (South Pasadena,

CA: Semioext(e), 2017), frontispiece. If I had to track down the origins of revolutionary love, I may have started with Fanon. I foreground Bouteldja's explanation since it's already soaked of her *judéité*, the Jewishness she reclaims as part of being Algerian.

12 For more on the media workers, see Angela Dimitrakaki and Ariella Aïsha Azoulay, "Gaza, Truth and the Anti-colonial Injunction: An Interview with Ariella Aïsha Azoulay," *Third Text Online*, February 2024.

Letter 1

1 Yohana Benattar, dir. *Bedeau–camp de passage* (forthcoming), film.
2 On colonial aphasia, see Ann Laura Stoler, "Colonial Aphasia: Race and Disabled Histories in France," *Public Culture* 23, no. 1 (2011): 121–56.
3 Paraphrasing Ronny Someck, *Algir* (Or Yehuda: Zemorah-Bitan, 2009).
4 As James McAuley writes about the French Jewish collector Théodore Reinch, "He did not 'die for France,' he died because he was Jewish." James McAuley, *The House of Fragile Things: Jewish Art Collectors and the Fall of France* (New Haven, CT: Yale University Press, 2021), 133.
5 For a cinematic account of shared *ziyara* sites in Morocco, see Simone Bitton's film *Ziyara*. Simone Bitton, dir. *Ziyara* (Brooklyn, NY: Icarus Films, 2021), docuseek2.com.
6 The story is reported in Henri Klein, *Feuillets d'El-Djezair* (Algiers: L. Chaix, 1937).
7 The ministry of war in a letter to Rovigo, quoted in François Dumasy, "Déposséder la ville Alger au début des années 1830," from *Made In Algeria: Généalogie d'un territoire* (Vanves: Editions Hazan / MUCEM, 2016), 101.
8 Klein, *Feuillets*, 32.
9 Abdelwahab Meddeb and Benjamin Stora, General Introduction in *A History of Jewish-Muslim Relations: From the Origins to the Present Day*, eds. Abdelwahab Meddeb and Benjamin Stora, (Princeton, NJ: Princeton University Press, 2013), 14.
10 The quotation is from a Lieutenant-Colonel Lemercier, quoted in Zineb Merzouk, "1 Avril 1831, démolition de la plus belle mosquée d'Alger, Djamaa Es-sayida," *Bab Zman*, April 1, 2015, babzman.com. See also Sidi Hamden-Ben-Othman Khoja, *Le*

 miroir: *Aperçu historique et statistique sur le régence d'Alger* (Paris: Imprimerie de Goetschy Fils et Compagnie, 1833).
11 Paul Eudel, *L'orfèvrerie algérienne et tunisienne*. (Algiers: Adolphe Jourdan, 1902), xx.
12 Quoted in Klein, *Feuillets*, 306.
13 Henry E. Pope, *The Corsair and His Conqueror: A Winter in Algiers*, (London: Richard Bentley, 1860), 88.
14 Eudel, *L'orfèvrerie*, 50.
15 François Dumasy, "Déposséder la ville Alger au début des années 1830," in *Made In Algeria:* 66n3.
16 We were the workers in the "food factory of Europe" that Algeria became, as Zahia Rahmani and Jean-Yves Sarazin argue, and Algeria was the source of many other enterprises, of which knowledge production was one of the most important. Zahia Rahmani and Jean-Yves Sarazin, "Le propos des commissaires," in *Made in Algeria*, 7.
17 Paul Eudel, *L'orfèvrerie*, 85, 96.
18 M. J. Baudel, *Un an à Alger: Excursions et souvenirs*, 7th ed. (Paris: C. Delagrave, 1887), 105.
19 Frédéric Abécassis and Gilbert Meynier, *Pour une histoire franco-algérienne: En finir avec les pressions officielles et les lobbies de mémoire* (Lyon and Paris: La Découverte, 2008), 24.
20 Philip, Brebner, "The Impact of Thomas-Robert Bugeaud and the Decree of 9 June 1844 on the Development of Constantine, Algeria," *Revue des mondes musulmans et de la Méditerranée* 38 (1984): 5–14.
21 Théodore Steeg, *L'Algérie*. (Algiers: Direction de l'agriculture du commerce et de l'industrie, 1922), 78. Translation by author.
22 See also Kalman P. Bland, *The Artless Jew: Medieval and Modern Affirmations and Denials of the Visual*, (Princeton, NJ: Princeton University Press, 2000.)
23 Rood Johnson, "Consuelo Velazquez, 88; Mexican Composer Wrote Pop Ballad 'Besame Mucho,'" *Los Angeles Times*, Jan 26, 2005.
24 Ibid.
25 In the 1930s, the mortality rate among indigenous children from tuberculosis was much higher than among the Europeans. See F. Masselot and E. Bloch, "Tuberculosis among the Mohammedans of Northern Africa," *Tunisie Médicale* 28 (1934): 515–40; see also Jean-Claude Tobelem, *Oran ou la banalité. Essai/Recit d'une famille juive*, (Paris: L'Harmattan, 2017), 52.

Letter 2

1. Quoted in Benjamin Stora, "Benjamin Stora: La mémoire au cœur de l'histoire," interview with Isabelle Safa, *Les cahiers de l'orient* 114, no. 2 (2014): 99.
2. You spoke about it in your opening remarks to a panel discussion you gave with Jessica Hammerman and Pierre-Jean Le Foll-Luciani. Benjamin Stora, Jessica Hammerman, and Pierre-Jean Le Foll-Luciani, "Les juifs anticolonialistes en Algérie," recording of a panel discussion at Musée d'art et d'histoire du judaïsme, Paris, no date, akadem.org.
3. Todd Shepard, *The Invention of Decolonization: The Algerian War and the Remaking of France* (Ithaca, NY: Cornell University Press, 2006), 160.
4. See Jessica Hammerman, "A Jewish-Muslim Battle on the World Stage: Constantine, Algeria, 1956," in *The Jews of Modern France: Images and Identities*, ed. Nadia Malinovich and Zvi Kaplan (Leiden, The Netherlands: Brill, 2016), 228–50.
5. "Déclaration du Comité Juif algerien d'étude sociales on the situation in Algeria," *Oran Républicaine*, November 25–26, 1956, quoted in Hammerman, "A Jewish-Muslim Battle," 38.
6. Quoted in Sung Choi, "Complex Compatriots: Jews in Post-Vichy French Algeria," *The Journal of North African Studies* 17, no. 5 (2012): 872, tandfonline.com.
7. Quoted in Pierre Birnbaum, *L'aigle et la synagogue. Napoléon, les juifs et l'état* (Paris: Fayard, 2007), 8.
8. Benjamin Stora, *Trois exils. Juifs d'Algérie* (Paris: Pluriel, 2011), 92.
9. Abdelmajid Hannoum, *The Invention of the Maghreb: Between Africa and the Middle East* (Cambridge, UK: Cambridge University Press, 2021), 265.
10. Shepard, *Invention of Decolonization*, 245.
11. Sophie B. Roberts, *Citizenship and Antisemitism in French Colonial Algeria, 1870–1962* (Cambridge, UK: Cambridge University Press, 2017), 344.
12. Sarah Abrevaya Stein, *Saharan Jews and the Fate of French Algeria* (Chicago: University of Chicago Press, 2014), 125.
13. Roberts, *Citizenship and Antisemitism*.
14. The mandatory subscription to the UDHR appears in chapter II of the Évian Accords, Accord de cessez-le-feu en Algérie, *Journal Officiel de la République Française*, March 20, 1962, peacemaker.un.org.
15. Évian Accords, chapter II, clause B.
16. On the creation of the Bank of Algeria as one of the first acts

of sovereignty, and on Algeria as "the first Arab and African country to have produced its currency by its own means," see "L'Algérie, premier pays africain et arabe à créer sa monnaie," *InfoSoir*, April 4, 2014, DjaZairess.com.

17 Stora, *Trois exils*, 13.
18 Ibid., 182.
19 Ibid., 182–3.
20 From the Arabic root يكح (HKY), meaning speech. See jewishlanguages.org.
21 Susannah Heschel, "Jewish Studies as Counterhistory," in *Insider/Outsider: American Jews and Multiculturalism*, eds. David Biale, Michael Galchinsky, and Susannah Heschel (Berkeley: University of California Press, 1998), 103.
22 Houria Bouteldja, *Whites, Jews, and Us: Toward a Politics of Revolutionary Love*, trans. Rachel Valinsky (South Pasadena, CA: Semioext(e), 2017), 54.

Letter 3

1 Ariella Aïsha Azoulay and Samira Negrouche, "Correspandance," *Rot-Bo-Krik*, 2023, rot-bo-krik.com. Samira's letter to me was published in Samira Negrouche, *Stations* (Montpellier: Chevre Feuille, 2023)

Letter 4

1 Frantz Fanon, *Toward the African Revolution*, trans. Haakon Chevalier (New York: Grove Press, 1964), 53.
2 See Aomar Boum and Sarah Abrevaya Stein, *The Holocaust and North Africa* (Stanford, CA: Stanford University Press, 2019).
3 Fanon, *African Revolution*, 12.
4 Marc André and Helen Tomlinson, "Algerian Women: What Kind of Citizenship (1930s–1960s)?" *Clio: Women, Gender, History*, no. 43 (2016): 6. As André and Tomlinson argue, many of the several hundreds of thousands of Algerians who were encouraged to migrate to France as workers had either no papers or only very sketchy papers.
5 Fanon, *African Revolution*, 15.
6 Ibid.
7 Alice Nadia Benabid Cherki, *Frantz Fanon: A Portrait* (Ithaca, NY: Cornell University Press, 2006), 43.

8 Max Régis, "instigator of the Algerian pogroms," quoted in Hannah Arendt, *The Origins of Totalitarianism* (New York: HarperCollins Publishers, 1973), 111–12.
9 Olivia Elkaim, *Le tailleur de Relizane: Roman* (Paris: Stock, 2020), 105.
10 Fanon, *African Revolution*, 4.
11 Ibid., 5.
12 All quotations from my father are from the booklet *Life Stories*, which I edited for the occasion of his seventy-fifth birthday. The booklet is based on two or three interview sessions and was printed in 1998 in two copies.
13 Fanon, "Letter to the Resident Minister (1956)," in *African Revoution*, 53.
14 Among the *de jure* segregations that Pierre-Jean Le Foll-Luciani writes about are those pertaining to the age of voting eligibility (French 25, Jews 33), as well as salary for teachers and compensation for mastery of Arab and Berber languages. Pierre-Jean Le Foll-Luciani, "La sortie de guerre des notables juifs et musulmans d'Algérie, stratégies comparées (1918–1923)," *Outre-Mers* 400–1, no. 2 (2018): 213–36.
15 Azoulay, *Life Stories*.
16 Victor Trenga and Royal College of Surgeons of England, *Sur les psychoses chez les juifs d'Algérie: Thèse présentée et publiquement soutenue à la faculté de médecine de Montpellier le 13 Décembre 1902* (Montpellier: Impr. Delord-Boehm et Martial, 1902), wellcomelibrary.org.
17 Frantz Fanon, *The Wretched of the Earth*, trans. Constance Farrington (New York: Penguin Books, 2001), 212.
18 Ibid., 266–7.
19 Cherki, *Fanon: A Portrait*, 38.
20 Cherki remarks that "medical students who aspired to internships in those days used to have a little ditty that went like this: 'if you are male and European, you have 95 percent chance; if you are female and European (meaning Christian), you have a 75 percent chance; if you are male and a Jewish, your chances are 50 percent; if you are female and Jewish 25 percent; and if you are male and Muslim, you have 10 percent chance.'" Muslim women did not enter the equation. Ibid., 46.
21 Ibid., 48.
22 Ibid., 52.
23 Ibid., 49.
24 Ibid., 52.
25 Numa Murard, "Psychothérapie institutionnelle à Blida," *Tumultes* 31, no. 2 (2008): 42, cairn.info.

26 Frantz Fanon, *Black Skin, White Masks*, trans. Richard Philcox, intro. Anthony Appiah (New York: Grove Press, 2008), 119.
27 Fanon, *Wretched*, 219–21.
28 This is confirmed by the numerous testimonies of Algerians in different contexts, including in clinics like yours, as well as in recent scholarship. However, there is more research available in connection to the war. See Todd Sheppard, Catherine Brun, Bibliothèque nationale de France, and Institut du monde arabe (France), *Guerre D'algérie. Le Sexe Outragé* (Paris: CNRS éditions, 2016). See also Sarah Ghabrial, "Illegible Allegations Navigating the Meanings of Rape in Colonial Algeria," *French Politics, Culture, and Society* 39, no. 1 (2021): 59–82.
29 My research is about the mass rape of German women as WWII was ending and the rape of Palestinian women by Zionist soldiers. Ariella Aïsha Azoulay, *Potential History: Unlearning Imperialism* (London: Verso, 2019).
30 Hosni Kitouni, email to author, December 2, 2021. Since I published my open letter to Stora, Kitouni and I have exchanged a series of letters.
31 Ibid.
32 Fanon, *African Revolution*, 205, emphasis original.
33 Ibid., 258.
34 Frantz Fanon, *A Dying Colonialism*, trans. Haakon Chevalier (New York: Grove Press, 1965), 27.
35 As you mention, "The well-being and the progress of Europe have been built up with the sweat and the dead bodies of Negroes, Arabs, Indians and the yellow races." Fanon, *Wretched*, 95.
36 Fanon, *Black Skin, White Masks*, 109.
37 The cleavage of art history into distinct wings of Jewish art and Muslim art perpetuates the omission of Jews from the more universal accounts of the gold and silver trade and the related professions. It is as if the authors of such research did not know what to do with them. On Jews in these professions, see Shai Srougo, "The Social History of Fez Jews in the Gold-Thread Craft between the Middle Ages and the French Colonialist Period (Sixteenth to Twentieth Centuries)," *Middle Eastern Studies* 54, no. 6 (2018): 901; Orit Ouaknine-Yekutieli, 'Rage Against the Machine in the Mellah of Fes', *Hesperis-Tamuda Vol.XLIV* (2009), 89–108.
38 This is from a report produced in 1907 about the use of indigenous labor in the "salvage" of indigenous crafts for the profit of Europeans. Arsène Alexandre, *Réflexions sur les arts et les industries d'art en Algérie* (Algiers: Édition de l'Akhbar, 1907; Hachette Livre-BNF, 2018), 17.

39 You may recognize in my words here an echo of Aimé Césaire, whom you quote to sustain the millennial history of your race. Fanon, *Black Skin, White Masks*, 109.

40 On the transformations the settlers imposed on this world, see Elizabeth D. Friedman, *Colonialism & After: An Algerian Jewish Community* (South Hadley, MA: Bergin & Garvey, 1988), 5.

41 Fanon, in an article co-authored with Jacques Azoulay, "Social Therapy in a Ward of Muslim Men: Methodological Difficulties," in Frantz Fanon, *Alienation and Freedom* (e-book), eds. Jean Khalfa and Robert Young, trans. Steve Corcoran (London: Bloomsbury Academic, 2018), 364.

42 Fanon, *A Dying Colonialism*, 155.

43 Sophie Bessis, *Je vous écris d'une autre rive: Lettre à Hannah Arendt* (Tunis: Elyzad, 2021), 24.

44 Fanon, *A Dying Colonialism*, 153.

45 I assume that the year 1930 is a typo (in the French, and later reproduced in the English), and that actually you meant 1830. Fanon, *A Dying Colonialism*, 27.

46 Fanon, *Wretched*, 28.

47 Fanon, *Black Skin, White Masks*, 92.

48 Fanon, *Wretched*, 28, 33.

49 Ibid., 43.

50 Fanon, *Black Skin, White Masks*, 114.

51 Ferhat Abbas, *Le manifeste du people Algérien* (Orients éditions, 2013), 25.

52 Ann Laura Stoler, "Colonial Aphasia: Race and Disabled Histories in France," *Public Culture* 23, no. 1 (2011): 128.

53 See Geneviève Dermenjian, "Les juifs d'Algérie dans le regard des militaires et des juifs de France à l'époque de la conquête (1830–1855)," *Revue historique* 284, no. 2 (576) (1990): 333.

54 As Genève Dermenjian describes, although French Jews persuaded the French that the process of reformation of Algerian Jews could succeed, after several decades, these French Jews experienced doubt and frustration because such reformation measures failed to completely eradicate "the superstitions and other practices of the old religion." Ibid., 338.

55 Abbas, *Le manifeste*, 26.

56 Similar cases are discussed in Joshua Schreier, *Arabs of Jewish Faith: The Civilizing Mission of Colonial Algeria* (New Brunswick, NJ: Rutgers University Press, 2010).

57 Fanon, *Black Skin, White Masks*, xvi.

58 Ibid., 95.

59 Ibid., 73.

60 Fanon and J. Azoulay, in Fanon, *Alienation and Freedom*, 354.

61 Early in this article, Fanon and Azoulay describe the demographic of the clinic: "On the one hand, there were one hundred and sixty five European women, and, on the other, two hundred and twenty Muslim men." Ibid., 354. The article describes Muslim women only in the context of celebrations, but it is not clear in which ward they are placed.
62 Ibid., 363.
63 Christopher Silver, *Recording History: Jews, Muslims, and Music Across Twentieth-Century North Africa* (Stanford, CA: Stanford University Press, 2022), 124.
64 Fanon, *Black Skin, White Masks*, 89.
65 Azoulay, *Life Stories*.
66 Jacques Attali, *L'année des dupes: Alger, 1943* (Paris: Fayard, 2021), 88–9.
67 See Olivier Le Cour Grandmaison, *Coloniser exterminer. Sur la guerre et l'état colonial* (Paris: Fayard, 2005), 138–45.
68 Alice Cherki notes that most of the "'people from the colonies,' more or less people of color" were not sent to the North as part of this campaign called "whitening of the Free French Forces." Cherki, *Fanon: A Portrait*, 29.
69 Ibid., 26, 30.
70 Abbas, *Le manifeste*. Two years earlier, in 1941, he had submitted a report to Maréchal Petain titled *Algeria of Tomorrow*.
71 Ibid., 35.

Letter 5

1 Hannah Arendt, *The Human Condition* (Chicago: University of Chicago Press, 1998), 180.
2 Joseph Meyouhas, *Bible Tales in Arab Folk-Lore* (London: Aflred A. Knopf, 1928), 7, 8.
3 See Jacques Attali, *L'année des dupes: Alger, 1943* (Paris: Fayard, 2019).
4 Marvin Klemme, *The Inside Story of UNRAA, an Experience in Internationalism: A First Hand Report on the Displaced People of Europe* (New York: Lifetime Editions, 1949), 159.
5 Among them see the NAACP, "An Appeal to the World: A Statement of Denial of Rights to Minorities" (1947), blackpast.org; Messali Hadj's "Le Problem Algérien – Appel aux Nations Unis," 1949, pandor.u-bourgogne.fr; and the American Jewish Committee's (AJC) "Declaration of Human Rights" (1944). On the latter see James Loeffler, "The Particularist Pursuit of American

Universalism: The American Jewish Committee's 1944 'Declaration on Human Rights," *Journal of Contemporary History* 50, no. 2 (April 2015): 274–95.

6 Sealy quoted in Brennavan Sritharan, "The Manchester Town Hall Meeting That Shaped Africa: Remembering the Fifth Pan-African Congress," *The British Journal of Photography*, July 27, 2015.

7 See Loeffler, "The Particularist Pursuit," 281.

8 Rev. W. T. Gidney, *The History of the London Society for Promoting Christianity amongst the Jews from 1809–1908* (London: London Society for Promoting Christianity amongst the Jews, 1908).

9 On these two episodes near Strasbourg, see Gary Kates, "Jews into Frenchmen: Nationality and Representation in Revolutionary France," *Social Research* 56, no. 1 (1989): 213–32.

10 Ariella Aïsha Azoulay and Samira Negrouche, "Correspandance," *Rot-Bo-Krik*, 2023, rot-bo-krik.com.

11 H. Z. J. W. Hirschberg, *Inside Maghreb: The Jews in North Africa* (in Hebrew) (Jerusalem: The Publishing House of the Jewish Agency, 1957), 52.

12 Ibid.

13 Ibid., 27.

14 Ronald Schechter, "A Festival of the Law: Napoleon's Jewish Assemblies," in *Taking Liberties: Problems of a New Order from the French Revolution to Napoleon*, eds. Howard G. Brown and Judith A. Miller (Manchester and New York: Manchester University Press, 2002), 148.

15 Allan Temko, "The Burning of the Talmud in Paris: Date: 1242," *Commentary*, May 1954.

16 Lamentation quoted in ibid.

17 On the mention of the Jews as a nation, see Franz Kobler, *Napoleon and the Jews* (New York: Schocken Books, 1976), 35.

18 Messali Hadj, *Appel aux nations unies: Le problème algérien* (Paris: Imp. du Chateau-d'Eau, not before 1949).

19 Yuval Evri, "Translating the Arab-Jewish Tradition: From al-Andalus to Palestine/Land of Israel," *Rozenberg Quarterly*, 2016, 40, rozenbergquarterly.com.

20 Jessica Hammerman, "A Jewish-Muslim Battle on the World Stage: Constantine, Algeria, 1956," in *The Jews of Modern France: Images and Identities*, eds. Nadia Malinovich and Zvi Kaplan (Leiden, The Netherlands: Brill, 2016), 230.

21 On the work of the Mossad in Iraq, see Yehouda A. Shenhav, *The Arab Jews: A Postcolonial Reading of Nationalism Religion and Ethnicity* (Stanford, CA: Stanford University Press, 2006).

22 Sherene Seikaly, "Productive Discomforts: Sa'da, Blackness, and Palestine" (lecture, Centre for Comparative Muslim Studies Annual Lecture, Simon Fraser University, Burnaby, BC, 2021).
23 Idith Zertal, *From Catastrophe to Power: The Holocaust Survivors and the Emergence of Israel* (Berkeley: University of California Press, 1998). Yosef Grodzinsky, *In the Shadow of the Holocaust: The Struggle Between Jews and Zionists in the Aftermath of World War II* (Monroe, ME: Common Courage Press, 2004).
24 Klemme, *Inside Story of UNRAA*, 148.
25 Ibid., 164.
26 Laura Robson, *The State of Separation: Transfer, Partition, and the Making of Modern Middle East* (Oakland: University of California Press, 2017), 14.
27 Ori Yehudai, "Displaced in the National Home: Jewish Repatriation from Palestine to Europe, 1945–48," *Jewish Social Studies: History, Culture, Society* 20, no. 2 (Winter 2014): 71, 72.
28 Dov Schidorsky, *Burning Scrolls and Flying Letters* (Jerusalem: Magness Press, 2008), 230–1. Schidorsky adds that Arendt, who was involved in the project of rescuing the books, "worked hard to reduce the antagonism between the corporation and the communities, but often did not achieve the level of cooperation required."
29 On Raphael Lemkin's rejection of "We Charge Genocide," see Zoé Samudzi, "Against Genocide – Introduction," *Funambulist*, August 2021, no. 37.
30 This report from Metz is quoted in Robert Anchel, *Napoléon et les juifs* (Paris: Les presses universitaires de France, 1928), 3.
31 Ibid.
32 Sarah Frances Levin, "Narrative Remembrance: Close Encounters between Muslims and Jews in Morocco's Atlas Mountains" (PhD diss., University of California Berkeley, 2017), 22.
33 Marsil Shirizi, "Anti-Zionism for the Sake of Jews and the Sake of Egypt," in *Modern Middle Eastern Jewish Thought: Writings on Identity, Politics and Culture, 1893–1958*, eds. Moshe Behar and Zvi Ben-Dor Benite (Waltham, MA: Brandeis University Press, 2013), 164–73.
34 These lines were written in 2020.
35 The metaphor of the waiting room is from Dipesh Chakrabarty, *Provincializing Europe: Postcolonial Thought and Historical Difference*, new ed. (Princeton, NJ: Princeton University Press, 2007).
36 Zalkind Hourwitz, "Vindication of the Jews," quoted in Lynn

Hunt, *The French Revolution and Human Rights: A Brief Documentary History* (Boston: Bedford Books of St. Martin's Press, 1996), 49–50.

37 Patrick Girard, *La révolution française et les juifs* (Paris: Éditions Robert Lafont, 1989), 22.

38 Joshua Schreier, *The Merchants of Oran: A Jewish Port at the Dawn of Empire* (Stanford, CA: Stanford University Press, 2017), 143.

39 There were earlier attempts to limit Jewish autonomy, sometimes also in response to claims from Jews. In one such example, the widow of Bernard Spire Lévy "refused to accept a Jewish decision that was unfavorable to her" and asked redress in a French court. Instead of redressing this individual case, the French concluded that such injustice cannot be tolerated in their countries, and abolished altogether the authority of the Jews. Arthur Hertzberg, *The French Enlightenment and the Jews: The Origins of Modern Anti-Semitism* (New York: Columbia University Press, 1968), 241–2.

40 On the story of the boat the big rabbi of Seville prepared out of his handkerchief, see Michel Ansky and Abraham Elmaleh, *Yehude Alg'iryah: mi-tsav Kremyeh 'ad ha-shiḥrur* [Jews from Algeria: From the Crémieux Decree to the liberation] (Jerusalem: Kiryat Sefer Publisher, 1963).

41 Ronny Someck, *Algir* (Or Yehuda: Zemorah-Bitan, 2009), 14, author's translation.

42 Jacques Cantier, *L'Algérie sous le régime de Vichy* (Paris: Odile Jacob, 2002), 324, 320.

43 Robert Alter, *The Hebrew Bible, Volume 1: The Five Books of Moses: A Translation with Commentary* (New York: W.W. Norton & Co., 2004), Genesis 11:1–4. All the quotations from the Bible in this chapter are from Alter, 2004.

44 Genesis 11:6.

45 See *Dictionnaire de la législation algérienne, code annoté et manuel raisonné des lois*, 1867–72, 380, gallica.bnf.fr.

46 Trent Dailey-Chwalibog and Brittany Gignac, eds. and trans., "Proclomations [sic], Speeches and Letters of Napoleon Bonaparte During His Campaign of Egypt 1–8," DePaul University, via.library.depaul.edu, 43.

47 Ibid.

48 See 'Abd al-Raḥmān Jabartī, *Napoleon in Egypt: Al-Jabartī's Chronicle of the French Occupation, 1798*, expanded ed., trans. Shmuel Moreh, ed. Robert L. Tignor (Princeton, NJ: Markus Wiener Publishers).

49 See the story of the Corsican-born Maniote in Allen Hertz,

"Neglected Ottoman-Turkish Source Confirms Napoleon Issued a Proclamation to the Jews," researchgate.net.

50 Quoted in Saxe Bannister, *Appel en faveur d'Alger et de l'Afrique du Nord, par un anglais* (Paris: Dondey-Dupré père et fils, etc., 1833; Paris: Hachette Livre BNF, 2013) 833, 5. Citations refer to the Hachette edition.

51 For a long time, European and Jewish historiographies tended to view all ghettos everywhere as one undifferentiated phenomenon. For a critique of the "historiographic ghetto," see Debra Kaplan and Magda Teter, "Out of the (Historiographic) Ghetto: European Jews and Reformation Narratives," *The Sixteenth Century Journal* 40, no. 2 (2009): 365.

52 The resemblance of Italian ghettos to the spatial organization of the Kasbah in the Maghreb, which the French tried to destroy, is striking. See for example the paintings of the Jewish ghetto in Rome by Ettore Roesler Franz.

53 See Anchel, *Napoléon*.

54 Hannah Arendt, *The Jewish Writings* (New York: Schocken Books, 2007), 50.

55 Ibid., 51 (emphasis original).

56 Quoted in Anchel, *Napoléon*, 549.

57 Arendt, *Eichmann in Jerusalem: A Report on the Banality of Evil* (Harmondsworth, UK: Penguin, 2006), 275–6.

58 Ibid., 288.

59 Ibid., 269.

60 Ibid., 268.

61 Ibid., 268.

62 On these camps, see Samia Henni, *Architecture of Counterrevolution: The French Army in Northern Algeria* (Zurich: GTA, 2018).

63 Mendel Grossman, who was the Ghetto Lodge's photographer, took thousands of photos that he hid in the hope they would be found. In 1945, the Nazis assassinated him. His sister brought some of his photos with her to Palestine, where they were lost during the ruination of Palestine. Other photos of Grossman's are in the archives of Yad Vashem and the Ghetto Fighters' House. For an engagement with images of the gas chamber taken by a Jewish inmate, see Georges Didi-Huberman, *Images in Spite of All: Four Photographs from Auschwitz* (Chicago: University of Chicago Press, 2012).

64 Joachim Le Breton, editor of *La décade philosophique*, quoted in Hertz, "Neglected Ottoman-Turkish Source"; Patrice Bret, "Orientales I. Autour de l'expédition d'Égypte," *Annales historiques de la Révolution française*, 2005/2, no. 34, cairn.info.

65 On Napoleon referring to himself as Cyrus the Great, see Hertz, "Neglected Ottoman-Turkish Source." On Adolf Eichmann referring to himself as Pontius Pilate, see Arendt, *Eichmann in Jerusalem*. It seems no Napoleonic proclamation ever publicly called upon Jews to go to Palestine, but the idea was sowed and referred to later. See Jeremy D. Popkin, "Zionism and the Enlightenment: The 'Letter of a Jew to His Brethren,'" *Jewish Social Studies* 43, no. 2 (1981): 113–20.

66 Anchel, *Napoléon*, 129.

67 Berel Wein, *Triumph of Survival: The Story of the Jews in the Modern Era 1650–1996* (Brooklyn: Shaar Press, 2004), 71.

68 "Hostages of the universal" is a term used by Shmuel Trigano in *La république et les juifs après Copernic* (Paris: Les Presses d'aujourd'hui, 1982).

69 Paul Eudel, *L'orfèvrerie algérienne et tunisienne* (Algiers: Adolphe Jourdan, 1902), 62.

70 David Rouach, *Bijoux berbères au Maroc: Dans la tradition Judeo-Arabe* (Courbevoie, Paris: ACR, 1989), 10.

71 Wassyla Tamzali, *Abzim: Parures et bijoux des femmes d'Algérie* (Paris: Dessain et Tolra; Algiers: Entreprise algérienne de Presse, 1984), 80.

72 Eudel, *L'orfèvrerie*, 107.

73 Paul Eudel, *Dictionnaire des bijoux de l'Afrique du Nord: Maroc, Algérie, Tunisie, Tripolitaine* (Paris: Ernest Leroux, 1906), 11.

74 Victor Trenga and Royal College of Surgeons of England, *Sur les psychoses chez les juifs d'Algérie. Thèse présentée et publiquement soutenue à la faculté de médecine de Montpellier le 13 Décembre 1902* (Montpellier: Impr. Delord-Boehm et Martial, 1902), 17.

Letter 6

1 Wassyla Tamzali, *Abzim: Parures et bijoux des femmes d'Algérie* (Paris: Dessain et Tolra; Algiers: Entreprise algérienne de Presse, 1984), 24. Emphasis mine.

2 Susan Slyomovics, "Visual Ethnography, Stereotypes and Photographing Algeria," in *Orientalism Revisited: Art, Land and Voyage,* ed. Ian Richard Netton (Milton Park Abingdon Oxon: Routledge, 2013), 132.

3 Jean Besancenot, *Bijoux arabes et berbères du Maroc* (Casablanca: Editions de la Cigogne, 1953), xiii.

4 Ibid., x–xi.

5 Marc de Ferrière le Vayer, *Christofle deux siècles d'aventure industrielle: 1793–1993* (Paris: Le Monde éditions, 1995), 29.
6 Besancenot, *Bijoux*, xi, ix.
7 Tamzali, *Abzim*, 24, emphasis mine.
8 Ibid.
9 As Abdelmajid Hannoum shows, the dichotomy between Arabs and Berbers could not be as "neat and clear-cut" if other possibilities were not "silenced or, rather, eliminated." These possibilities, he continues, "include the other categories we find in the early phases of colonial historiographic construction, other racial groups: Blacks, Haratin, Moors, Turks, Kouloughlis, and Jews." Abdelmajid Hannoum, *The Invention of the Maghreb: Between Africa and the Middle East* (Cambridge, UK: Cambridge University Press, 2021), 187.
10 Tamzali, *Abzim*, 80.
11 Kader Attia, "Introduction," in *12th Berlin Biennale: Still Present!* (Berlin: Berlin Biennale for Contemporary Art, 2022).
12 Paul Eudel, *Dictionnaire des bijoux de l'Afrique du Nord: Maroc, Algérie, Tunisie, Tripolitaine* (Paris: Ernest Leroux, 1906), 1.
13 Christopher Silver discusses a 1907 review of the work of Edmund Nathan Yafil, Jewish musician and composer/editor of a collection of Andalusian music. Reviewer Joseph Desparmet, a French "Arabist" who lived in Blida, disparaged Yafil and "blamed the volume's error on Yafil's Jewishness, citing his supposed 'ignorance of standard Arabic.'" Christopher Silver, *Recording History: Jews, Muslims, and Music Across Twentieth-Century North Africa* (Stanford, CA: Stanford University Press, 2022), 28.
14 "To produce Arabic language personal and place names accessible to users of Latin alphabet, two French army interpreters attached to France's Ministry of War in Algeria were charged with fashioning transcription protocol. With minor changes, William MacGukin de Slane's and Charles Gabeau's 1866 transcription of Maghrebi names remains in use in North Africa and France to this day." Slyomovics, "Visual Ethnography," 135.
15 Tamzali, *Abzim*, 81.
16 Ibid., 80.
17 Barakat Ahmad, *Muhammad and the Jews: A Re-Examination* (New Delhi: Vikas, 1979), 65.
18 Tamzali, *Abzim*, 81.
19 Omar Berrada and M'barek Bouhchichi, *What Remains (A Popular Fiction)*, installation in a group show titled *Document bilingue*, curated by Erik Bullot and Sabrina Grassi, Catalog, MuCEM, Marseille, July 2017–April 2018, 122.

20 Ibid., 122, 123.
21 Among others see Eudel, *Dictionnaire*; Besancenot, *Bijoux*. Another is by Paul de Cazeneuve, whose title explains its political and commercial purposes: *Catalogue descriptif et illustré des principaux ouvrages d'or et d'argent de fabrication algérienne, avec l'indication des points où doivent être appliqués les poinçons de la Garantie Française, (publié par ordre de M. Laferrière, Gouverneur Général)* (Algiers: Imprimerie Léon, 1900). Plates from these publications were reprinted in different volumes that already framed jewelry-making as a vanishing traditional art in comparison to modern techniques and industries. See Théodore Steeg, *L'Algérie* (Algiers: Direction de l'agriculture du commerce et de l'industrie, 1922).
22 For example Berrada and Bouhchichi, *What Remains*.
23 Ibid., 123.
24 Aomar Boum, *Memories of Absence: How Muslims Remember Jews in Morocco* (Stanford, CA: Stanford University Press, 2013), 2.
25 Labelle Prussin, "Judaic Threads in the West African Tapestry: No More Forever?," *Art Bulletin* 88, no. 2 (2006): 332, 328, 333.
26 Georges Meynié, *Les juifs en Algérie*, 2nd ed. (Paris: Nouvelle Librairie Parisienne, 1888), 19–21.
27 Jewish craftsmen in Morocco are known to have produced the arms of the troops of Abdel-krim el Khattabi (Serfaty, 1977). Among the many Jews who chose to stay with Abd al-Qadir were those who continued to craft his arms. Raphael Danziger, *Abd al-Qadir and the Algerians: Resistance to the French and Internal Consolidation* (New York: Holmes & Meier Publishers, 1977), 202–3.
28 Tamzali, *Abzim*, 80.
29 See Leo Ary Mayer, "Jewish Art in the Moslem World," in *Jewish Art: An Illustrated History*, ed. Cecil Roth (New York: McGraw-Hill, 1961).
30 On healing and magic among Eastern European Jews, see Marek Tuszewicki, *A Frog under the Tongue: Jewish Folk Medicine in Eastern Europe* (London: The Littman Library of Jewish Civilization in association with Liverpool University Press, 2021).
31 One or two among those co-religionists even knew the conjuration words of Rabbi Azulai: "I expel you, all manner of evil eyes: black eye, heavy eye, narrow eye, wide eye, straight eye, crooked eye, eye of man, eye of woman, eye of mother and her daughter, eye of daughter-in-law and her mother-in-law, eye of young bachelor, old man's eye." The story, in Yiddish, was collected by

Avrom Rechtman in *Jewish Ethnography and Folklore*, and is quoted in Tuszewicki, *A Frog under the Tongue*, 282.

32 In 1963, barely one year after they were left with no choice but to leave their homeland, and after more than a century in which different people had tried to disrupt their rituals and change them, Algerian Jews were put on trial publicly in Israel. This trial was initiated by the head of the Jewish Agency and presided over by a professor of law at the Hebrew University in Jerusalem. The Algerian Jews' crime was failing to surrender to "their" national duties and failing to join the colony that was built for the Jews by Zionist Jews. Very little information is provided on the trial in Yossef Charvit, "Le 'Procès public' des juifs d'Algérie à Jérusalem (1963)," *Pardès*, no. 56 (2014): 285–94.

33 The *Sahifah*, as Barakat Ahmad explains, "is actually not the constitution of a state; it lays the guiding principles for building a multi-cultural and multi-religious ummah in which the dominant group will always be Muslim ... It was a multi-religious community." Ahmad, *Muhammad and the Jews*, 46–7. In the 90s, Azmi Bishara offered the conception of the ummah as the framework for the decolonization of the nation-state-constituted-against-the-people. In 2005 I initiated a series of interviews with him around this notion in the context of the colonization of Palestine by Israel. See Ariella Azoulay, *I Also Dwell among Your Own People: Conversations with Azmi Bishara*, 2005, youtube.com.

Letter 7

1 Houria Bouteldja, *Whites, Jews, and Us: Toward a Politics of Revolutionary Love*, trans. Rachel Valinsky (South Pasadena, CA: Semioext(e), 2017), 60.
2 Ibid., 57.
3 Ibid., 53.
4 On the Jewish Fedayeen, see Sabar Shalom, "The Preservation and Continuation of Sephardi Art in Morocco," *European Judaism* 52, no. 2 (2019): 59–81.
5 Bouteldja, *Whites, Jews, and Us*, 60.
6 Ibid., 53.
7 Ibid., 67.
8 Bouteldja, *Whites, Jews, and Us*, 86; this argument is similar to the one presented in the talk.
9 Mathias Dreyfuss, "Ouverture," in *Juifs et musulmans: De la France coloniale à nos jours*, eds. Karima Dirèche, Mathias

Dreyfuss, and Benjamin Stora (Paris: Musée national de l'histoire de l'immigration, Éditions Seuil, 2022), 27.

10 Bouteldja, *Whites, Jews, and Us*, 69.

11 In the late nineteenth century, despite being made citizens and their children being sent to republican schools, they continued to speak and publish multiple journals in *judeo-arabe*.

12 See Simon Schwarzfuchs, *Les juifs d'Algérie et la France 1830–1855* מרכז לחקר יהדות צפון אפריקה (ירושלים) (Jerusalem: Institut Ben-Zvi Centre de recherches sur les juifs d'Afrique du Nord, 1981), 283.

13 "Algerian constitution [1963]," *Middle East Journal* 17, no. 4 (1963): 446–50.

14 Bouteldja, *Whites, Jews, and Us*, 116.

15 Ibid., 53–4.

16 Ibid., 57.

17 Geneviève Dermenjian, "Les juifs d'Algérie entre deux hostilités (1830–1943)," in *Les juifs d'Algérie*, eds. Joëlle Alouche-Benayoun and Geneviève Dermenjian (Aix-en-Provence: Presses universitaires de Provence, 2015), 106.

18 Jean-Pierre Lledo, "La judéophobie musulmane en Algérie avant, pendant, et après la période française," in Allouche-Benayoun and Dermenjian, *Les juifs d'Algérie*, 179–94.

19 Joshua Schreier, "A Jewish Riot against Muslims: The Polemics of History in Late Colonial Algeria," *Comparative Studies in Society and History* 58, no. 3 (2016): 749.

20 Important work has been done on the re-education of North African Jews in Israel, but these interventions are most often contextualized in relation to the Zionist binary of Mizrahim and Ashkenazim, rather than from an anti-Zionist position that accounts for how the existence of the Israeli state, by definition, perpetuates these processes premised on the separation of North African Jews from Muslims and Arabs.

21 Schwarzfuchs, *Les juifs d'Algérie*, 13–20.

22 Ibid., 279.

23 Ibid., 71, 77, 281, 282.

24 Jacques Taïb, *Être juif au Maghreb à la veille de la colonisation* (Paris: Albin Michel, 1994).

25 For Jacques Taïb, who studies Jewish society in the Maghreb prior to colonization (1500–1900), the Crémieux was an authoritarian act, even in the eyes of its author. Taïb, *Sociétés juives du Maghreb moderne (1500–1900)* (Paris: Maisonneuve & Larose, 2000), 52.

26 The source of this narrative is the introduction by Redivide: Schwarz-fuchs in *Les juifs d'Algérie*. See also Patrick Weil, "Le

statut des Musulmans en Algérie coloniale: Une nationalité française dénaturée," *Histoire de la justice* 16, no. 1 (2005): 95.

27 André Nouschi, "Observations sur la démographie historique des Juifs Algériens," in *Les Juifs dans l'histoire de France*, ed. Myriam Yardeni (Leiden, The Netherlands: Brill, 1980), 166.

28 David Nadjari, "L'émancipation à 'marche forcée': Les juifs d'Algérie et le décret Crémieux," *Labyrinthe* 28, no. 3 (2007): 83.

29 David Nadjari, *Juifs en terre coloniale: Le culte Israélite à Oran au début du XXe siècle* (Nice: J. Gandini, 2000), 63–4.

30 See Taïb, *Sociétés juives*, 50, and Michael Brett, "Legislating for Inequality in Algeria: The Senatus-Consulte of 14 July 1865," *Bulletin of the School of Oriental and African Studies, University of London* 51, no. 3 (1988).

31 In 1837 Bugeaud suggested a different solution, their expulsion, a solution that would be raised again at the turn of the century. See Richard Ayoun, "Max Régis: Un antijuif au tournant du XXe siècle," *Revue d'histoire de la Shoah* 173, no. 3 (2001): 137–69, cairn.info.

32 Nadjari, "L'émancipation," 82.

33 See Valérie Assan, "Synagogues d'Algérie, du cliché orientaliste à l'effacement," *Tsafon: Revue d'études juives du nord* 81 (2021), doi.org/10.4000/tsafon.3849, and Schwarzfuchs, *Les juifs d'Algérie*, 350.

34 Taïb, *Sociétés juives*, 52.

35 Bouteldja, *Whites, Jews, and Us*, 69.

36 Assan, "Synagogues," 109–10.

37 Muriam Haleh Davis, *Markets of Civilization: Islam and Racial Capitalism in Algeria* (Durham, NC: Duke University Press, 2022), 3.

38 Taïb, *Sociétés juives*, 53.

39 William Wyld and Émile-Aubert Lessore, *Voyage pittoresque dans la régence d'Alger* (Paris: Charles Motte, 1835), plate XXXIX.

40 On the departure from Algiers, see Rina Cohen, "Les juifs 'moghrabi' en Palestine (1830–1903): Les enjeux de la protection française," *Archives juives* 28, no. 2 (2005): 28–46.

41 Quoted in Jacques Cohen, *Les Israélites de l'Algérie et le Décret Crémieux* (Paris: Arthur Rousseau, 1900), 59.

42 Schwarzfuchs, *Les juifs d'Algérie*, 216–17.

43 Schreier mentions several times these spokespersons during the Algerian war, and he emphasizes that they do not represent the Jews' plurality of visions and ideas. Schreier, "A Jewish Riot."

44 Schwarzfuchs, *Les juifs d'Algérie*, 280.

45 Cohen, *Les Israélites*, 58.

46 On some of them, whose conversion included also becoming collectors and guardians of French art, see James McAuley, *The House of Fragile Things: Jewish Art Collectors and the Fall of France* (New Haven, CT: Yale University Press, 2021).
47 Paul Eudel, *L'orfèvrerie algérienne et tunisienne* (Algiers: Adolphe Jourdan, 1902), 70.
48 René Lespès, "Alger: Étude de géographie et d'histoire urbaines" (PhD diss., F. Alcan. Faculté des lettres de Paris, 1930), 212–14.
49 Alf Andrew Heggoy, *The French Conquest of Algiers 1830: An Algerian Oral Tradition* (Athens: Ohio University Center for International Studies Africa Studies Program, 1986), 5.
50 Ibid., 4.
51 Ibid., 22–3.
52 Ibid., 46–7.
53 Ibid., 47–9.
54 Ibid., 68.
55 Ibid., 54.
56 Ibid., 52.
57 Ibid., 54.
58 Bouteldja, *Whites, Jews, and Us*, 103.
59 Robert Alter, *The Hebrew Bible, Volume 1: The Five Books of Moses: A Translation with Commentary* (New York: W.W. Norton & Co., 2004), Genesis 4:7.
60 Heggoy, *French Conquest*, 53.
61 Exodus 20:3.
62 Exodus 25:9.
63 Exodus 30:5.
64 Noam Sienna, "Invisible Neighbors: Demonology between Jews and Muslims in Morocco," *Jews and Muslims in Morocco* (Lanham: Lexington Books, 2021), 176.
65 Exodus 12:35.
66 Exodus 32: 27.
67 Exodus 12:36.
68 The handling of gold and other precious metals, and keeping them as social currency, partakes in what Ophir describes as the diminution of the "nonmediated presence" presence of God; Adi Ophir, *In The Beginning Was the State: Divine Violence in the Hebrew Bible* (New York: Fordham University Press, 2023), 37.
69 Exodus 35:2, 35:4–5.
70 Exodus 36:6, 35:30–4.
71 Heggoy, *French Conquest*, 53.
72 Exodus 36:1.

Letter 8

1. On the waves of Jewish riots in the Oran province, see Joshua Schreier, *Arabs of Jewish Faith: The Civilizing Mission of Colonial Algeria* (New Brunswick, NJ: Rutgers University Press, 2010), 68–72.
2. Yvonne Turin quotes a letter sent by one French officer to another, describing the hostile response of the local population to French "hospitality." Turin, *Affrontements culturels dans l'Algérie coloniale. Ecoles, médecines, religion, 1830–1880* (Paris: François Maspero, 1971), 67.
3. Frantz Fanon, "Letter to a Frenchman," in *Toward the African Revolution*, trans. Haakon Chevalier (New York: Grove Press, 1967), 50.
4. Recently, I was able to reconnect with the daughter of the elder son who survived, and learned that he was indeed absent when the local police came to kidnap his family, but that he wasn't out buying pasta.
5. Letter quoted in Norman A. Stillman and Claire Drevon, "Les juifs du Maghreb confrontés à la Shoah. Synthèse historique," *Revue d'histoire de la Shoah* (2016), 12.
6. See Geneviève Dermenjian, "La crise antijuive," in *Antijudaïsme et antisémitisme en Algérie coloniale 1830–1964* (Aix-en-Provence: Presses universitaires de Provence, 2018), 48.
7. Gilbert Meynier, "L'algerie revelée: La guerre de 1914 à 1918 et le Premier quart du XXe siecle," (PhD diss., 1979); André Nouschi, "Le travail à Alger dans la première moitié du XIX siècle," *Cahiers de la Méditerranée* 3, no. 1 (1974): 169–84.
8. Annie Stora Lamarre, "Transmission mémorielle au feminine," in *Les juifs d'Algérie: Une histoire de ruptures*, eds. Joëlle Allouche-Benayoun and Geneviève Dermenjian (Aix-en-Provence: Presses universitaires de Provence, 2015), 11.
9. Thus for example, Benjamin Drif, in his account of the Jewish community of Bône, writes: "Among employees, we have distinguished skilled workers (accountants, brokers, insurance agents) from unskilled workers (day laborers, dressmakers, cigarettes makers)." Drif, "Le communauté juive de Bône (1870–1940): Mutations socio-culturelles à l'époque coloniale," (PhD diss., Université Paris 1 Panthéon-Sorbonne, 2015), 62.
10. On the transmission of the profession of the jeweler inside the family, see Tatiana Benfoughal, "De père en fils bijoutiers d'Algérie: Gardiens d'un savoir faire ancestral," *Quintessences*, February 21, 2019, quintessences.unblog.fr.
11. Yvonne Turin distinguishes between Algiers, where French Jews

dominated the Jewish community and imposed and mediated the European education system, and all other places where "hostility was total.'" Turin, *Affrontements*, 56.
12 Ibid., 292.
13 Quoted in ibid., 58.
14 I discuss the first anecdote on the rabbi in my letter to Wassyla Tamzali; the second in the letter to Samira Negrouche; and the third I read in Turin, *Affrontements*, 64.
15 Arsène Alexandre, *Réflexions sur les arts et les industries d'art en Algérie* (Algiers: Édition de l'Akhbar, 1907. Hachette Livre-BNF, 2018), 17.
16 Nassima Mekaoui, "Servir deux familles? Les trois âges de la prédation de sexe envers les travailleuses domestiques," *L'art de supporter. Des travailleurs et des travailleuses domestiques en situation coloniale (Algérie, 1830–1962)*, (PhD diss., 2025).
17 Schreier, for example, quotes a court case where the defendant, a certain Sasportès, mentions that the dates of at least 200 *ketubas* were falsified in Oran only. Schreier, *Arabs of Jewish Faith*, 144.
18 Paul Eudel mentions hundreds of them by name. But, as he writes, "their number is certainly bigger." Eudel, *L'orfèvrerie algérienne et tunisienne* (Algiers: Adolphe Jourdan, 1902), 412.
19 Ibid.
20 Ibid., 431.
21 *Réveil Bônois*, Organe Républicain Indépendant, no. 2137, October 21, 1898.
22 Eudel, *L'orfèvrerie*, 412.
23 Member of the political bureau of the Algerian government Meriem Merzuga (1962–65), in conversation and in a note sent to me, June 2023.
24 Natalya Vince quotes Ahmed Ben Bella's call to women, emphasizing: "The exhibition of jewelry is incompatible with the objectives of our revolution." Vince, *Our Fighting Sisters: Nation, Memory, and Gender in Algeria, 1954–2012* (Manchester, UK: Manchester University Press), 2015, 165.
25 Amy Held, "Holocaust Survivors and Victims' Families Receive Millions in Reparations from France," NPR, February 7, 2019, npr.org.
26 Aurelien Breeden, "'We Are Amplifying the Work': France Starts Task Force on Art Looted Under Nazis," *New York Times*, April 15, 2019, nytimes.com.
27 Annie Store Lamarre tells a similar story about her mother, who ended up working in a Peugeot factory. Annie Stora Lamarre, "Transmission mémorielle au feminine."

28 Of the boycott, Stillman and Drevon write that "it happened to be very effective since the Jews were the principal importers of these products." Norman A. Stillman and Claire Drevon, "Les juifs du Maghreb," 3. On the strikes at Bastos and other cigarettes factories, see Claudine Robert-Guiard, *Des européennes en situation coloniale: Algérie 1830–1939* (Aix-en-Provence: Presses universitaires de Provence, 2017).

29 Robert-Guiard, *Des européennes*, 25.

30 "Projets et propositions de loi relatifs aux questions ouvrières et sociales soumis à l'examen du parlement," *Bulletin de l'office du travail*, January 1, 1904, Tome XI, travail-emploi.gouv.fr.

31 Jules Molle was the anti-Jewish mayor elected in Oran, and he served from 1925 to 1928. In the 1930s, other anti-Jewish men would be elected in other cities. See Geneviève Dermenjian, "Les Juifs d'Algérie entre deux hostilités (1830–1943)," in *Les juifs d'Algérie*, 30.

32 See Richard Ayoun for a series of similar events in Algiers, Constantine, Blida, Boufarik, Sétif and other places. Richard Ayoun, "Les juifs d'Algérie dans la tourmente antisémite du XXème siècle," *Revue européenne des études hébraïques*, no. 1 (1996): 57–99. On plunder of Jewish property and violent protests in the late nineteeth century, see Valérie Assan, "Dans la tourmente anti-juive," in *Les consistoires israélites d'Algérie au XIXe siècle* (Paris: Armand Colin, 2012), 365.

33 This is how Doris Bensimon-Donath describes the choice of the Parisian region between the two world wars. Bensimon-Donath, *L'intégration des Juifs Nord-Africains en France* (Berlin and Boston: Walter de Gruyter GmbH, 2018), 30.

34 On this interdiction, see Benjamin Stora, "Benjamin Stora: La mémoire au cœur de l'histoire," interview with Isabelle Safa, *Les cahiers de l'orient* 114, no. 2 (2014): 73.

35 Secondary schools became free only in 1928, after Camille and Sylvain's departure. Ayoun, "Les juifs d'Algérie," 62.

36 Quoted in Aïssa Chenouf, *Les juifs d'algérie: 2000 ans d'existence* (Algiers: Éditions El Maarifa, 2004), 12.

37 One of Germaine's brothers, quoted in Joëlle Allouche-Benayoun, "Intermittently French: Jews from Algeria during World War II," *Contemporary Jewry* 37, no. 2 (2017): 224.

38 Quoted in Marguerite Duras, *La douleur* (Paris: P.O.L, 2006), 130.

39 I'm grateful for Michelle Sebag, my second cousin, who shared with me her father' memories from this time.

40 Kings 21:19, sefaria.org.

41 Johanna Lehr, "Les morts au camp d'internement de Drancy

(1941–1944)," *Revue d'histoire*, no. 143 (July–September 2019): 99–112.

42 Hosni Kitouni, "Peut-on chiffrer les pertes algériennes durant la période coloniale?," *Twala*, October 14, 2021.

43 On the resistance of Jews to renounce of this family-economic formation see Schreier, *Arabs of Jewish Faith*. On the approach of Muslim to this colonial intervention and the colonial economic interests in it, see Judith Surkis, *Sex, Law and Sovereignty in French Algeria 1830–1930* (Ithaca, NY: Cornell University Press, 2019).

44 On the ambiance in the streets of Algerian cities at the eve of the war, see Meynier, "L'algerie revelée," 265.

45 Mohamed Saïl, "La colonization," *Le Flambeau* (Algiers), July 1926.

46 Schreier, *Arabs of Jewish Faith*, 78.

47 On the history of anarchism in Algeria, see "Anarchisme en Algérie," fr.wikipedia.org; Hassan Remaoun, "Philippe Bouba: L'anarchisme en situation coloniale, le cas de l'Algérie. Organisation militants et presse, (dir.), Michel Cadé et Hassan Remaoun," *Insaniyat* (2016): 65–6, journals.openedition.org; "Liste des périodiques," Bianco Presse Anarchiste, bianco.ficedl.info.

48 Benjamin Stora describes the Crémieux Decree as the first among three exiles. Stora, *Trois exils: Juifs d'Algérie* (Paris: Pluriel, 2011).

49 On the role of French Jews in the Crémieux Decree, see Pierre Birnbaum, *Les fous de la république: Historie politique des juifs d'état, de Gambetta à Vichy* (Paris: Fayard, 1992).

50 On the expulsion of the movement of migration between Morocco and Algeria, see Daniel Schroeter, "Identity and Nation: Jewish Migrations and Inter-Community Relations in the Colonial Maghreb," in *La bienvenue et l'adieu 1: Migrants juifs et musulmans au Maghreb (XVe–XXe siècle)*, eds. Frédéric Abécassis, Rita Aouad, and Karina Slimani-Direche (Casablanca: Centre Jacques-Berque, 2012).

51 This also reflects Daniel Schroeter's observation that "while Jews of the Maghreb were often fiercely loyal to their place or town of origin, a label that was carried when travelling to or settling in new places, a larger identity, rooted in the Arabo-Hispanic world of the Western Mediterranean—the consequence of the relative mobility of traders, pilgrims, and travelers—also developed." Ibid., 125.

52 Benjamin Stora, Raphaële Balu, and Isabelle Safa, "Les juifs du Maghreb d'une guerre mondiale à l'autre," *Les cahiers de l'orient* (2015), 78.

53 Ibid.
54 On the sabotage of telephonic infrastructures, see Turin, Affrontements culturels.
55 On the participation of Jews and Muslims in the opposition to the French under the lead of Bey Ahmed, see Benjamin Stora, "Une famille juive de Constantine," *Le Monde*, July 6, 2004. lemonde.fr.
56 On Turkey, see Meynier, "L'algerie revelée."
57 Schroeter doesn't discuss this in connection to WWI but it is easy to understand why the war would be a threat to this regional and transnational dispersion and connectivity of Jewish communities that he describes. See Schroeter, "Identity and Nation," 6.
58 On the manipulations and deception involved in the recruitment of Jews as soldiers during 1942–43 see Ariella Aïsha Azoulay, "À la recherche du temps volé," *NAQD: Journal of Social Criticism*, no. 43 (Spring 2023); and Norbert Bel Ange, *Quand Vichy internait ses soldats juifs d'Algérie: Bedeau, sud Oranais 1941–1943* (Paris: L'Harmattan, 2006).
59 On the anti-Semitic officers in the camp, see Susan Slyomovics, "'Other places of confinement': Bedeau Internment Camp for Algerian Jewish Soldiers," in *The Holocaust and North Africa*, eds. Aomar Boum and Sarah Abrevaya Stein (Stanford, CA: Stanford University Press, 2018).
60 Sidney Chouraqui uses this term ("le piège du volontariat"). Chouraqui, "Le camp de juifs français de Bedeau ou Vichy après Vichy," *Revue d'histoire de la Shoah* 161, no. 3 (1997): 223, cairn.info.
61 On Bedeau, see Azoulay, "À la recherche du temps volé."
62 On the officers' denial of the existence of Jewish WWI veterans, see Chouraqui, "Le camp de juifs français."
63 Genesis 3:19.

Letter 9

1 While the book indeed indistinctly addresses readers with an attachment to Algeria, Azoulay's postface makes clear that *his* Algeria is the one where you look at the settlers in their Sunday best, and where you are at home with either Jewish Hilloulah or Muslim Ramadan. Paul Azoulay, *La nostalgérie française* (Paris: Eric Baschet, 1980).

2. Mary Vogl writes that Paul Azoulay's book was "apparently written by pieds-noirs and for pieds-noirs." Mary B. Vogl, *Picturing the Maghreb: Literature, Photography, (Re)Presentation* (Lanham, MD: Rowman & Littlefield Publishers, 2003).
3. André Nouschi, "Le travail à Alger dans la première moitié du XIX siècle," *Cahiers de la Méditerranée* 3, no. 1 (1974): 173.
4. Dorota Sniezek, "Costumes des juifs d'Algérie: La collection du muse d'art et d'histoire du judaïsme," in *Juifs d'Algérie*, eds. Anne Hélène Hoog and Musée d'art et d'histoire du Judaïsme (Paris: Skira Flammarion, 2012), 243.
5. Altaras and Cohen, quoted in Simon Schwarzfuchs, *Les juifs d'Algérie et la France 1830–1855* (ירושלים) לחקר יהדות צפון אפריקה מרכז (Jerusalem: Institut Ben-Zvi Centre de recherches sur les juifs d'Afrique du Nord, 1981), 152.
6. Nicole Serfaty, "Chronique d'une émancipation voilée," in *Juifs d'Afrique du Nord: Cartes postales (1885–1930): Collection de Gérard Silvain* (Saint-Pourçain-sur-Sioule: Bleu autour, 2005), 125.
7. Ibid., 126.
8. Ibid., 125.
9. Rebecca Rogers, *A Frenchwoman's Imperial Story: Madame Luce in Nineteenth-Century Algeria* (Stanford: Stanford University Press, 2013), 42.
10. Pirkei Avot [Ethics of the fathers] 1:10, sefaria.org, translation modified.
11. According to Haïm Zafrani and others, this was part of the division of labor between Jews and Muslims that for centuries reserved certain profession to Jews, "especially those in which valuable substances such as gold, silver or precious stones and fine pearls are processed." Haim Zafrani, "Artisanat des métaux précieux et problèmes monétaires dans les décisions des tribunaux rabbiniques de Fès aux XVIIème et XVIIIème siècles," in *Le Judaïsm Maghrébin. Le Maroc, terres des rencontres des cultures et des civilisations*, special issue, *Revue Européenne des Études Hébraïques*, 1997, 76–89. This division of labor also intersects with another, more regional, one that associates specific crafts with certain ethnic groups like Kabyles or M'zab that are composed of Muslim and Jews. On these groupings, see Nouschi, "Le travail à Alger."
12. Nouschi, "Le travail à Alger," 171.
13. Malek Alloula, *The Colonial Harem* (Minneapolis: University of Minnesota Press, 1986), 29.
14. Ibid., 19–20.

15 Joëlle Allouche-Benayoun and Doris Bensimon, *Juifs d'Algérie. Hier et aujourd'hui, mémoires et identités* (Toulouse, France: Bibliothèque historique privat, 1989), 160.
16 Ibid., 162.
17 Nouschi, "Le travail à Alger," 174.
18 Ibid.
19 Ibid.
20 Amélie Marie Goichon, "La broderie au fil d'or à Fès: Ses rapports avec la broderie de soie, ses accessoires de passementerie," *Hespéris* 26 (1939): 49–85.
21 Erik Mattie, *World's Fairs*, trans. Lynn George (New York: Princeton Architectural Press, 1998), 12.
22 On "coolies" in the Algerian context, see Claire Fredj, "Des coolies pour l'Algérie? L'Afrique du Nord et le travail engage 1856–1871," *Revue d'histoire modern et contemporaine* 63, no. 2 (2016): 62–83.
23 Exposition Universelle de Paris 1867.
24 A. Cocuhut contends that his detailed report on the profitability of agriculture resources in Algeria is necessary to justify this sacrifice requested of the French. Cocuhut, "Resources agricoles de l'Algérie," *Revue des deux mondes* 16, no. 1 (1846): 142–69.
25 Marcel Vicaire and Roger Le Tourneau, "La fabrication du fil d'or à Fès," in *Trésors des métiers d'art de Fès*, ed. Isabelle Crouigneau-Vicaire (Originally published in 1937; Paris: Isabelle Crouigneau-Vicaire, 2018), 121.
26 In their study of crafts in Algeria, Fatima Zohra Adel and Abdelkader Guendouz speak about solidarization as the basis of a shared sentiment among craftsmen: "Each trade is united by a common sentiment and the need to unite (solidariser) in order to protect their common interests, to face competition and to improve their socio-professional situation." Fatima Zohra Adel and Abdelkader Guendouz, "La gouvernance des politiques publiques en faveur de l'artisanat en Algérie, essai d'analyse sur la longue période," *Marché et Organisations* 24, no.3 (2015): 103–25, cairn.info.
27 "Pourquoi Alger?" *Ouvrages de Dames*, June 21, 2020, ouvragesdedames.canalblog.com.
28 Gouvernement Géneral de l'Algérie, *L'Algérie à L'Exposition Universelle de Londres 1862* (Algiers: Imprimerie Bouver, 1862), google.com/books.
29 Ibid., 575.
30 Ibid., 601.
31 Ibid., 604.

32 Ibid., 620.
33 Some of these colonial visions for forced labor are discussed in Fredj, "Des coolies."
34 Gouvernement général de l'Algérie, 6–7.
35 Léon Poliakov reconstructs the way the shared cultural deposit was shaped over centuries. Poliakov, "Confluents de Civilisations: Juifs et Musulmans," *Diogène* 8, no. 32 (1960): 98.
36 See Vicaire and Le Tourneau, "La fabrication du fil d'or à Fès."
37 Exposition Universelle de Paris, 1867.
38 Ibid.
39 Louis Forest, *La naturalization des Juifs Algériens et l'insurrection de 1871, étude historique* (Hachette BNF: 1897), 23.
40 Ibid., 7.
41 For an English translation of the Judeo-Arabic petition, see Avner Ofrath, "'We shall become French': Reconsidering Algerian Jews' citizenship, c. 1860–1900," *French History* 35, no. 2 (2021).
42 "The first decades of the French conquest provoked the pauperization of the Jewish population." Allouche-Benayoun and Bensimon, *Juifs d'Algéri*, 52.
43 Shulamit Hava Halevy, "'In a Place Where There Are No Men': The Guidance of Women in the World of *Annusim*" (lecture transcript from the conference A Woman and Her Jewishness, 1999), 2, cs.tau.ac.il.
44 Vicaire and Le Tourneau, "La fabrication du fil d'or à Fès," 127.
45 Haïm Zafrani, *Le Judaïsme Maghrébin – Le Maroc, terres des rencontres des cultures et des civilisations* (Éditions Marsam, 2007), 229, 233. Haïm Zafrani, "Artisanat des métaux précieux et problèmes monétaires dans les décisions des tribunaux rabbiniques de Fès aux XVIIème et XVIIIème siècles," *Revue européenne des études hébraïques*, 1997, 76–89.
46 Vicaire and Le Tourneau, "La fabrication du fil d'or à Fès," 129.
47 Forest, *La naturalization*, 4.
48 Ibid., 13–14.
49 Rodolphe Dareste de la Chavanne, *De la propriété en Algérie: loi du 16 Juin 1851, Sénatus consulte du 22 Avril 1863* (Paris: Hachette, BNF, 1864), 4.
50 Quotation and list of craftsmen both from Nouschi, "Le travail à Alger," 175.
51 Exodus 28:4.
52 Haïm Zafrani retraces the language of this *taqqanah* to the books of Samuel, Ezechiel, and Proverbs. See Zafrani, *Le Judaïsm Maghrébin. Le Maroc, terres des rencontres des cultures et des civilisations* (Rabat: Editions Marsam, 2007), 236.

53 Forest, *La naturalization*, 13.
54 Arsène Alexandre also refers to her as a "precursor." Alexandre, *Réflexions sur les arts et les industries d'art en Algérie* (Hachette, BNF, 1907), 14. On Benaben's gravestone, see Rebecca Rogers, "Relations entre femmes dans l'Alger colonial: Henriette Benaben (1847–1915) et son école de broderies 'indigènes'," *Genre & Colonisation* 1 (Spring 2013): 147.
55 Alexandre, *Réflexions sur les arts*, 8.
56 Rogers, "Relations entre femmes," 153.
57 Pamphlet published anonymously by thread drawers in 1779 in Manchester, England, quoted in François Jarrige, *Technocritiques: Du refus des machines à la contestation des technosciences* (Paris: La Découverte, 2016), 44.
58 Arthur Chandler, "*L'Exposition publique des produits de l'industrie française*, Paris, 1798," arthurchandler.com.
59 Michael P. Fitzsimmons, *From Artisan to Worker: Guilds, the French State and the Organization of Labor, 1776–1821* (Cambridge, UK: Cambridge University Press, 2014), 250.
60 Ibid., 208.
61 Quoted in ibid., 247.
62 Ania A., "'La France a une dette envers l'Algérie de 684 milliards d'euros' estime un spécialiste," *Dzair Daily*, October 10, 2021, dzairdaily.com
63 Jérôme Louis and Jean Tulard, eds., "La question de l'Orient sous Louis-Philippe," special issue of *Kronos* 78 (Paris: SPM, 2015), 52.
64 Due to their "double nature," jewels enter "the composition of the currency in circulation." Valérie Gratsac-Legendre, "L'orfèvrerie et la monnaie au XVIIIe siècle. Quelques observations autour d'une relation étrange," in *Montchrestien et Cantillon. Le commerce et l'émergence d'une pensée économique*, ed. Alain Query (Lyon: ENS Editions, 2017), 305.
65 Baron Pichon, a civil intendant, is quoted in Paul Eudel, *L'orfèvrerie algérienne et tunisienne* (Algiers: Adolphe Jourdan, 1902), 96.
66 Ibid., xiii.
67 Miriam Hoexter, "Taxation des corporations professionnelles d'Alger à l'époque turque," *Revue de l'Occident musulman et de la Méditerranée*, no. 36 (1983): 29. Ibid., 95.
68 On this monumental art, see François Pouillon, "La peinture monumental en Algérie: un art pédagogique," *Cahiers d'Études Africanes* 36, (1996): 141, 142.
69 Arthur Chandler, who describes this inclusion, completely ignores the battle over Zaatcha, and writes, "By 1849, the

French seemed to be in secure possession of Algeria." Chandler, "Exposition of the Second Republic -Exposition Nationale des produits de l'industrie agricole et manufacturière," arthur chandler.com.
70 The story of the petition is reported in Eudel, *L'orfèvrerie*, 96.
71 Ibid., 100.
72 A short history of the practices of *"la fraude et le truquage"* in the collecting of gold and silver in Algeria is given by the newspaper *L'Africain* on June 27, 1930. "Souvenir de l'Alger d'Autrefois – la fraude et le truquage en Algérie avant et après la conquete."
73 On clause no. 74, see "Rapport de M Laborie sur un voeu de M Zévaco, relatif à la garantie des matières d'or et d'argent," 1899, 591, gallica.bnf.fr.
74 Paul de Cazeneuve, *Catalogue descriptif & illustré des principaux ouvrages d'or et d'argent de fabrication algérienne, avec l'indication des points d'application des poinçons de la garantie française (publié par ordre de M. Laferrière, Gouverneur Général)* (Algiers: Imprimerie Léon, 1900).
75 Allouche-Benayoun and Bensimon, *Juifs d'Algéri*, 159.
76 "Rapport de M. Laborie sur un voeu de M Zévaco," 589.
77 Eudel, *L'orfèvrerie*, 122.
78 Sevket Pamuk, "The Ottoman monetary system and frontier territories in Europe, 1500–1700," in Kemal H. Karpat and Robert W. Zens, *Ottoman Borderlands: Issues Personalities and Political Changes* (Madison, WI: Center of Turkish Studies University of Wisconsin, 2003).
79 Alexandre, *Réflexions sur les arts*, 2, 6.
80 Albert Devoulx, *Les Edifices religieux de l'ancien Alger* (BNF, 1870), 3.

Letter 10

1 In my previous book, I elaborated the notion of worldly sovereignty in relation to pre-1948 Palestine to counter the coupling of sovereignty and nationhood. Ariella Aïsha Azoulay, *Potential History: Unlearning Imperialism* (London: Verso, 2019).
2 Ariella Azoulay, *The Civil Contract of Photography*, trans. Rela Mazali and Ruvik Danieli (New York: Zone Books, 2008).
3 *Potential History*'s engagement with the world shares some assumptions and procedures with what Saidiya Hartman calls "critical fabulation," or Ursula LeGuin calls the "carrier bag theory of fiction." Azoulay, *Potential History*; Saidiya Hartman,

"Venus in Two Acts," *Small Axe: A Journal of Criticism* 12, no. 2 (2008): 1–14.
4 Hannah Arendt, *Rahel Varnhagen. The Life of a Jewish Woman*, rev. ed. (New York: Harcourt Brace Jovanovich, 1974), 218.
5 Ibid.
6 Ibid., 218, 220, 222.
7 Ibid., 222.
8 Ibid.
9 Hannah Arendt, *The Jewish Writings* (New York: Schocken Books, 2007).
10 Arendt, *Rahel Varnhagen*, 8.
11 Ibid., 219.
12 This phrase echoes the title of Saidiya Hartman's book on the transatlantic slave trade: *Lose Your Mother: A Journey Along the Atlantic Slave Route* (New York: Farrar, Straus and Giroux, 2007).
13 See Daniel Nordman, *Tempête sur Alger: L'expédition de Charles Quint en 1541* (Condé-sur-Noireau: Éditions Bouchène, 2011), 270–3.
14 Here I am paraphrasing Abdellatif Laâbi's poem "In Front of the Mirror," from his book *Presque Riens* (Montreuil: Le Castor Astral, 2020), 13.
15 Yerri Urban, "L'indigène et le juif comme étrangers dans le droit de la nationalité en Algérie vichyste," *Ultramarines: Revue de l'association des amis des archives d'outre-mer*, no. 23 (2003): 26.
16 Sophie B. Roberts, *Citizenship and Antisemitism in French Colonial Algeria, 1870–1962* (Cambridge, UK: Cambridge University Press, 2017).
17 Azoulay, Potential History, ch. 4.
18 Arendt, *The Jewish Writings*, 251
19 Ibid., 65.
20 Hannah Arendt, *On Violence* (New York: Harvest Books, 1970), 129.
21 Kader Attia, "Introduction," in *12th Berlin Biennale: Still Present!* (Berlin: Berlin Biennale for Contemporary Art, 2022), 24.
22 Arendt, *The Jewish Writings*, 246.
23 *Abrogation of the Crémieux Decree, a Thirty-Four Page Report*, American Jewish Committee Archives, ajcarchives.org, 1943, 34.
24 Hannah Arendt to Karl Jaspers in *Correspondence: Hannah Arendt, Karl Jaspers, 1926–1969*, eds. Lotte Kohler and Hans Saner (New York: Harcourt Brace Jovanovich, 1996), 43.

25 Ella Shohat, "Sephardim in Israel: Zionism from the Standpoint of Its Jewish Victims," *Social Text*, no. 19/20 (Autumn, 1988): 1–35.
26 René Cassin is an exception. See Daniel Schroeter, "Identity and Nation: Jewish Migrations and Inter-Community Relations in the Colonial Maghreb," in *La bienvenue et l'adieu 1: Migrants juifs et musulmans au Maghreb (XVe–XXe siècle)*, eds. Frédéric Abécassis, Rita Aouad, and Karina Slimani-Direche (Casablanca: Centre Jacques-Berque, 2012), 47.
27 The longer brief includes reference to the change in the press's approach to the event, to which I'm assuming your published text contributed. See *Abrogation of the Crémieux Decree*.
28 Ibid., 20.
29 An Algerian informant quoted in Benjamin Stora, *Trois exils: Juifs d'Algérie* (Paris: Pluriel, 2011), 105.
30 Arendt, *The Jewish Writings*, 249.
31 Joëlle Allouche-Benayoun, "Intermittently French: Jews from Algeria during World War II," *Contemporary Jewry* 37, no. 2 (2017): 229. See also Benjamin Stora and the testimony of the great Rabbi Avraham Hazan regarding the preparation of lists of Jews and the completion of the deportation plans. Stora, *Trois exils*, 94.
32 Arendt, *The Jewish Writings*, 247.
33 *Abrogation of the Crémieux Decree*, 18.
34 Norbert Bel Ange mentions with no reference that in the beginning of 1943, "a press campaign denounces to the U.S. the situation of the Jews in the Algerian internment camps." Norbert Bel Ange, *Quand Vichy internait ses soldats juifs d'Algérie: Bedeau, sud Oranais 1941–1943* (Paris: L'Harmattan, 2016), 27.
35 Ibid., 25.
36 *Abrogation of the Crémieux Decree*, 12.
37 Ibid.
38 Arendt, *The Jewish Writings*, 246.
39 Ibid.
40 On the occupations of the Jews before and after the revolution, see Zosa Szajkowski, "Notes on the Occupational Status of French Jews, 1800–1880," *Proceedings of the American Academy for Jewish Research*, 1979–1980 46/47, Jubilee Volume.
41 Hannah Arendt. *The Origins of Totalitarianism* (New York: HarperCollins Publishers, 1973), 125.
42 Arendt, *The Jewish Writings*, 249.
43 Ibid., 247.
44 Arendt, *Rahel Varnhagen*, 216.
45 Ibid., italics mine.

46 See for example Mozart's *The Abduction from the Seraglio* (1782), among other texts.
47 Larry Wolff, *The Singing Turk: Ottoman Power and Operatic Emotions on the European Stage from the Siege of Vienna to the Age of Napoleon* (Stanford, CA: Stanford University Press, 2016), introduction.
48 Arendt, *The Jewish Writings*, 248.
49 Ibid., 248.
50 Ibid.
51 On some of these cases, see Joshua Schreier, *Arabs of Jewish Faith: The Civilizing Mission of Colonial Algeria* (New Brunswick, NJ: Rutgers University Press, 2010).
52 Michel Ansky and Abraham Elmaleh, *Yehude Alg'iryah: mi-tsav Kremyeh 'ad ha-shihrur* [Jews from Algeria: From the Crémieux Decree to the liberation] (Jerusalem: Kiryat Sefer Publisher, 1963), 203.
53 Ibid., 203.
54 Judith Surkis, *Sex, Law and Sovereignty in French Algeria 1830–1930* (Ithaca, NY: Cornell University Press, 2019), and Schreier, *Arabs of Jewish Faith*.
55 Arendt, *The Jewish Writings*, 246.
56 Hannah Arendt, *Eichmann in Jerusalem: A Report on the Banality of Evil* (Harmondsworth, England: Penguin, 2006), 287–8.

Letter 11

1 Hosni Kitouni, *Le désordre colonial. L'Algérie à l'épreuve de la colonisation de peuplement* (Paris: Editions L'Harmattan, 2018).
2 Some stories about individuals can be found in Line Meller and Frédéric Brenner, *"Un marché sans Juifs": Parcelles d'Algérie après 1962* (Cachan: Impr. Polycolor, 1996).

Letter 12

1 Sylvia Wynter, "1492: A New World View," in *Race, Discourse, and the Origin of the Americas: A New World View*, eds. Vera Lawrence Hyatt and Rex Nettleford (Washington, DC: Smithsonian Institution Press, 1995), 5–51; Sylvia Wynter, "Beyond the Word of Man: Glissant and the New Discourse of the Antilles," *World Literature Today* 63, no. 4 (Autumn, 1989): 637–48.
2 Wynter, "Word of Man," 639.

3 Wynter, "1492," 37.
4 Wynter spells the term "Judaeo-Christian" in her writings.
5 Sylvia Wynter, "New Seville and the Conversion Experience of Bartolomé de Las Casas," *Jamaica Journal* 17, no. 2, (1984): 27.
6 Wynter, "1492," 29.
7 Sylvia Wynter, "Africa, the West and the Analogy of Culture The Cinematic Text after Man," *Symbolic Narratives / African Cinema: Audiences, Theory and the Moving Image,* ed. June Givanni (London: BFI publishing, 2000), 29.
8 Wynter, "Word of Man," 639.
9 Susan Slyomovics, "French Restitution, German Compensation: Algerian Jews and Vichy's Financial Legacy," *Journal of North African studies* 17, no. 5 (2012): 881–901.
10 These books came out in the 2010s: Norbert Bel Ange, *Quand Vichy internait ses soldats juifs d'Algérie: Bedeau, sud Oranais 1941–1943* (Paris: L'Harmattan, 2006); Yossi Sucary and Yardene Greenspan, *Benghazi-Bergen-Belsen* (San Bernardino, CA: CreateSpace Independent Publishing Platform, 2016); Aomar Boum and Sarah Abrevaya Stein, *The Holocaust and North Africa* (Stanford, CA: Stanford University Press, 2019).
11 Wynter, "1492," 47.
12 Adi Ophir, *The Order of Evils: Toward an Ontology of Morals* (New York and Cambridge, MA: Zone Books; Distributed by MIT Press, 2005), 519–78.
13 Wynter, "Word of Man," 639.
14 Edward Said, *The Question of Palestine* (New York: Vintage, 1992).
15 Wikipedia, n.d.
16 K. Healan Gaston, *Imagining Judeo-Christian America: Religion, Secularism and the Redefinition of Democracy* (Chicago: University of Chicago Press, 2019), 1, 125.
17 On a coalition of sixteen Muslims organizations petitioning against this offensive depiction, see Tamara Jones and Michael O'Sullivan, "Supreme Court Frieze Brings Objection," *Washington Post*, March 8, 1997, washingtonpost.com. On Islam in early America, see Timothy Marr, *The Cultural Roots of American Islamicism* (Cambridge, UK: Cambridge University Press, 2006).
18 Gaston, *Imagining Judeo-Christian*, 72.
19 Daniel A. Gross, "The U.S. Government Turned Away Thousands of Jewish Refugees, Fearing That They Were Nazi Spies," *The Smithsonian Magazine*, November 18, 2015.
20 See Menahem Friedman, "'נטורי קרתא' והפגנות השבת בירושלים ב–1948–1950 רקע ותהליכים ['Neturei Karta' and Shabbath protests

in Jerusalem 1948–1950: Background and process]," in *Yerushalayim ha-hatsuyah, 1948–1967: mekorot, sikumim* [Divided Jerusalem 1948: sources, summaries and selected polemics] ed. A. Bareli (Jerusalem: Yad Ben Zvi, 1994), lib.cet.ac.il.
21 A copy of the leaflet is in my collection of documents (AAA).
22 Labelle Prussin, "Judaic Threads in the West African Tapestry: No More Forever?" *The Art Bulletin* 88, no. 2 (2006): 329; Alice L. Conklin, *In the Museum of Man: Race, Anthropology, and Empire in France 1850–1950* (Ithaca, NY: Cornell University Press, 2013).
23 Mohamed Amer Meziane, *Des empires sous la terre: Histoire écologique et raciale de la sécularisation* (Paris: La Découverte, 2021), 199.
24 Ibid., 206.
25 See my open letter to Mbembe. Arielle Aïsha Azoulay, "Rewinding Imperial History: A Pre-Bordered World," Stuart Hall Foundation (website), May 17, 2021, stuarthallfoundation.org.
26 Tudor Parfitt, *Black Jews in Africa and the Americas* (Cambridge, MA: Harvard University Press, 2013), 134–5.
27 Parfitt, *Black Jews*, 3.
28 Julien Cohen-Lacassagne, *Berbères juifs: L'émergence du monothéisme en Afrique du Nord* (Paris: La Fabrique, 2020).
29 Prussin, "Judaic Threads," 328.
30 Wynter, *Symbolic Narratives*, 25.
31 Fanon, *Black Skin, White Masks*, 119.
32 Ibid., 8.

Letter 13

1 Katya Gibel Azoulay, *Black, Jewish and Interracial: It's Not the Color of Your Skin, But the Race of Your Kin, and other Myths of Identity* (Durham, NC: Duke University Press, 1997).
2 Ibid., 35.
3 Ibid., 38.
4 Hayoun remarks that his great-grandparents in Egypt did not speak the "mix of Arabic and French that had by then become customary in his family," which meant that "the elders were confined to a shadow society of people who could only interact with other Arabic speakers, a generation that recalled an Arab world before the European incursion." Massoud Hayoun, *When We Were Arabs: A Jewish Family's Forgotten History* (New York: The New Press, 2019), 71.

5 January 15, 2019, X formerly Twitter.
6 Hayoun, *When We*, 52.
7 Ibid., 56.
8 See for example Ella Shohat, "Sephardim in Israel: Zionism from the Standpoint of Its Jewish Victims," *Social Text*, no. 19/20 (Autumn, 1988): 1–35.
9 Gibel Mevorach, email to author, October 6, 2022, edited.
10 Ariella Azoulay, *I Also Dwell Among Your Own People: Conversations with Azmi Bishara*, YouTube, youtube.com, 2005.
11 K. Azoulay, *Black, Jewish, and Interracial*, 9.
12 Katya Gibel Azoulay, "Jewishness after Mount Sinai: Jews, Blacks and the (Multi)racial Category," in "Writing and Art by Jewish Women of Color," special issue, *Bridges* 9, no. 1 (Summer, 2001): 41.
13 Later, following the colonization of North Africa, this "emancipation" was imported to the Maghreb, along with the anti-Semitic culture propagated by the French colonizers. Meynié's book emblematizes this: Georges Meynié, *Les juifs en Algérie*, 2nd ed. (Paris: Nouvelle Librairie Parisienne, 1888).
14 K. Azoulay, *Black, Jewish, and Interracial*, 92.
15 Ibid.
16 Meynié, 44, 71.
17 K. Azoulay, "Jewishness after Mount Sinai," 39.
18 Exodus 31:2–6.
19 Lena Salaymeh, "Colonial Theology: Orthodoxy and Orthopraxy in Discursive Genocide," unpublished text, 3.
20 On the opposition to Zionism in the United States up to WWII, see Yitzhak Galnoor, "The Opponents," in *The Partition of Palestine: Decision Crossroads in the Zionist Movement* (State University of New York Press, 1995).
21 K. Azoulay, *Black, Jewish, and Interracial*, 75.
22 Ibid., 71.
23 Hannah Arendt, *The Human Condition* (Chicago: University of Chicago Press, 1998), 137.

Letter 14

1 A *livret de famille* is a family record in the form of a small booklet.
2 "The word *état* (with a lowercase e) is a synonym for identity, which in law is also called the state [état] of persons. The word 'civil' means 'in society,' just as civil law is the law of relations between individuals living in society." Karim Ould-Ennebia,

"Histoire de l'état civil des Algériens: Patronymie et acculturation," *Revue maghrébine des études historiques et sociales*, no. 1 (2009): 6.
3. Ibid., 7.
4. Radouane Aïnad Tabet and Tayeb Nehari, *Histoire d'algérie: Sidi-Bel-Abbès: De la colonisation à la guerre de libération en Zone 5-Wilaya V 1830–1962* (Algiers: ENAG, 1999), 124.
5. This designation of the city and the numbers are from ibid., 112, 122.
6. Tabet and Nehari describe that this indigenous community of Muslims, Jews and Blacks that preceded the construction of the "new city" was called by the settlers "village nègre" since they were "struck by the number of blacks (13) and the brown or dark complexion of most of its inhabitants." Ibid., 122, 124.
7. On Bugeaud's plans, see Geneviève Dermenjian, "Les juifs d'Algérie dans le regard des militaires et des juifs de France à l'époque de la conquête (1830–1855)," *Revue historique* 284, no. 2 (576) (1990): 333–39. On Sidi-bel-Abbès, see Ammara Bekkouche, "Enjeux coloniaux et projection urbaine en Algérie: Le cas de Sidi-Bel-Abbès," *Insaniyat: Revue algérienne d'anthropologie et de sciences sociales* 13 (2001): 45–59, journals.openedition.org/insaniyat.
8. Dermenjian, "Les juifs d'Algérie dans le regard des militaires," 338.
9. Georges Reutt, quoted in Bekkouche, "Enjeux coloniaux."
10. Ibid.
11. Tocqueville, quoted in ibid.,35.
12. See Xavier Malverti and Aleth Picard, *Les villes coloniales fondées entre 1830–1870 en Algérie (III) - le tracé des villes et le savoir des ingénieurs du génie*. Research report of the Ministère de l'équipement et du logement / Bureau de la recherche architecturale (BRA); Ministère de la recherche; Ecole nationale supérieure d'architecture de Grenoble, Grenoble, 1990. hal.archives-ouvertes.fr, 22.
13. Bekkouche, "Enjeux coloniaux."
14. Léon Bastide, *Bel-Abbès et son arrondissement: Histoire divisions administratives travaux publics services publiques statistique topographie agriculture commerce et industrie depuis leur création jusqu'à nos jours* (Oran, Algeria: Perrier, 1881), 93–4.
15. Tabet and Nehari, *Histoire d'algérie*, 101
16. Bastide, *Bel-Abbès*, 96.
17. Louis de Baudicour, *Des indigènes de l'Algérie* (Paris: Charles Duniol, 1852), 38.

18 Ella Shohat, *Taboo Memories, Diasporic Voices* (Durham, NC: Duke University Press, 2006).
19 Susan Slyomovics, "'Other places of confinement': Bedeau Internment Camp for Algerian Jewish Soldiers," in *The Holocaust and North Africa*, eds. Aomar Boum and Sarah Abrevaya Stein (Stanford, CA: Stanford University Press, 2018), 97.
20 Gerrit Bos, "Jewish Traditions on Strengthening Memory and Leone Modena's Evaluation," *Jewish Studies Quarterly* 12, no. 1, 1995: 44.
21 Yohana Benattar, dir. *Bedeau* (film), forthcoming.
22 Quoted in Norbert Bel Ange, *Quand Vichy internait ses soldats juifs d'Algérie: Bedeau, sud Oranais 1941–1943* (Paris: L'Harmattan, 2016), 39. Among other measures, Bel Ange also mentions that men suspected of being Jews were forced to take off their underpants (45).
23 Victor Trenga and Royal College of Surgeons of England, *Sur les psychoses chez les juifs d'Algérie: Thèse présentée et publiquement soutenue à la faculté de médecine de Montpellier le 13 Décembre 1902* (Montpellier: Impr. Delord-Boehm et Martial, 1902), 17, wellcomelibrary.org.
24 Ibid., 25.
25 Ibid.
26 The collection assembled by Isaac Strauss includes only five items from North Africa. Victor Klagsbald, *Catalogue raisonné de la collection juive du Musée de Cluny* (Paris: Ministère de la culture: Éditions de la réunion des musées nationaux, 1981).

Letter 15

1 I'm grateful to Jana Rat, another descendant of Arie family, who shared with me this information on Rabbi Alkalay.
2 Poem printed in Niza Dory, "A Selection of Recitations and Poems for Children in Spoken Ladino and Their Thematic and Folkloristic Meanings," *Between the Lines* 4 (2019): 67.
3 I'm grateful to Carmela Dekel, your cousin, for this info.
4 Benjamin Harshav, *Language in Time of Revolution* (Stanford, CA: Stanford University Press, 1993), 153.
5 Ibid.
6 I prefer this Arendtian term to the term "intellectual life." Hannah Arendt, *The Life of the Mind,* one-volume ed. (New York: Harcourt Brace Jovanovich, 1981).
7 D. R., "לקראת חגיגת היובל של ראשון לציון" ["Toward the fiftieth-year

jubilee of Rishon Lezion."], *Doar Hayom*, August 14, 1932, National Library of Israel, Jerusalem, nli.org.il. On the Zionist leadership's opposition to model the "revival" of the Hebrew on Arabic, see Lital Levy, *Poetic Trespass: Writing Between Hebrew and Arabic in Israel/Palestine* (Princeton, NJ: Princeton University Press: 2014).

8 Poem printed in Dory, "A Selection," 67.
9 *Cheder* literally means a room. These schools were common in Central and Eastern Europe in the eighteenth century. In them a *melamed*, the Hebrew word for teacher, taught a few children the basics of Judaism and Hebrew.
10 On the deliberations between the options, see R. D.
11 The term *meldar* sounds closer to the Arabic *el-mahdar*, which means the same.
12 Gabriel Arié, Esther Benbassa, and Aron Rodrigue, *A Sephardi Life in Southeastern Europe: The Autobiography and Journal of Gabriel Arié 1863–1939* (Seattle: University of Washington Press, 1998), 22.
13 Ibid., 18, 20.
14 Minsooky, "The Tragic Story of Mignot-Boucher," *Minsooky*, June 19, 2022, minsooky.com.
15 See also Bernard Dichek, "What Made an Anti-Semitic Spanish Diplomat Rescue 150 Macedonian Jews? His Wife," *The Times of Israel*, April 21, 2020, timesofisrael.com.
16 The numbers vary between 80,000 and 400,000. Henry Kamen, "The Mediterranean and the Expulsion of Spanish Jews in 1492," *Past and Present* 119, no. 1 (1988): 30–55.
17 Gilles Veinstein, "Jews and Muslims in the Ottoman Empire." In *A History of Jewish-Muslim Relations: From the Origins to the Present Day*, eds. Abdelwahab Meddeb and Benjamin Stora (Princeton, NJ: Princeton University Press, 2013), 177. On migrations to Provence and some Italian states that were more receptive to *marranos*, see Kamen, "The Mediterranean."
18 Shalom Sabar, "The Preservation and Continuation of Sephardi Art in Morocco," *European Judaism* 52, no. 2 (2019): 59–81.
19 Mira Mayer, "Women and Jew: Traditions in the Arie Family from 1768 till Nowadays," paper presented at *Tikkun Olam: Jewish Women's Contributions to a Better World*, 6th International Bet Debora Conference of European Jewish Women Activists, Academics, Rabbis, and Cantors, Vienna, February 2013.
20 My gratitude to the translator, Yosef Uzi Levy. Here are a few published excerpts: Arie II, Çelbi Moshe Abraham, *Biografia Arie, Para la Familia Arie de Samokov*, excerpted and translated

by Yosef Uzi Levi, the Bulgarian Jews, August 4, 2019, the bulgarianjews.org.il.
21. Mathilde Tagger, "'Les Rothschild d'Orient.' Histoire familiale des Arié et analyse onomastique," *Généalo-J*, no. 120 (2014).
22. Six chapters of this biography were published in Hebrew by Yosef Uzi Levy, a descendant of Arie family, who in the meantime has completed the translation, but it has not yet been published (Arie, unpublished). The entire manuscript has also been translated into Bulgarian.
23. Çelbi Moshe Abraham Arie II, unpublished.
24. Arie II, unpublished.
25. Michael Studemund-Halévy, "'Sintid esta endetcha que quema el corasson': A Judeo-Spanish Epic Poem in Rhyme and Meter, Lamenting the Brutality of Invading Russians toward the Jews in Bulgaria," *Miscelánea de estudios árabes y hebraicos* 63 (2014): 111–31.
26. Kamen, "The Mediterranean," 38.
27. Tagger, "Les Rothschild," 34.
28. I'm grateful to Jorge Martins for his efforts to locate the family. While there are several traces of Arie and Léon families in the files of the Inquisitions in Spain and Portugal, we could neither refute nor confirm that they led to our branch of the family. We used the methods recommended in Danielle Levy, "How to Find Out If Your Ancestors Were Conversos," My Heritage, education. myheritage.com.
29. On *mudejar* art, see Sarit Shalev-Eyni, "Tradition in Transition: Mudejar Art and the Emergence of the Illuminated Sephardic Bible in Christian Toledo," *Medieval Encounters: Jewish, Christian, and Muslim Culture in Confluence and Dialogue* 23, no. 6 (2017): 531–559.
30. Arie II, unpublished, chapter 1.
31. Orly Azoulay, unpublished.
32. "The Yemenite, Mizrahi and Balkan Children Affair," Amram Association, edut-amram.org.

Letter 16

1. John Ogilby, *Accurate Description of Africa*, folio, 1670, 230–1, quod.lib.umich.edu.
2. Ibid., 230.
3. On the Spanish rule in Oran and Mers el-Kebir between 1509 to 1708 and again from 1732 to 1792 and in other North African port cities, and the use of the Jews by the Spanish and their

expulsion, see Jean-Fréderic Schaub, *Les juifs du roi d'Espagne* (Paris: Hachette, 1999).

4 Aimé Césaire, *A Tempest, Based on Shakespeare's The Tempest, Adaptation for a Black Theatre*, trans. Richard Miller (New York: TCG Translations, 2002).

5 The dominions of Charles Quint, emperor of the Holy Roman Empire, included Germany, Northern Italy, Austrian lands, Burgundian low countries, Spain, Naples, Sicily and Sardinia. On the failed conquest of Algiers, see Charles and Mary Lamb, "On a Passage in *The Tempest*," *Miscellaneous Prose (1794–1834)*, gutenberg.org. On the Ottoman empire and Islam, see Barbara Fuchs, "Conquering Islands: Contextualizing *The Tempest*," *Shakespeare Quarterly* 48, no. 1 (Spring 1997): 45–62.

6 Already in the beginning of the sixteenth century the Spanish made their first attempts to conquer Algiers, by seizing the island facing it and building a fortress from which they bombarded the city.

7 William Shakespeare, *The Tempest*, in *The Norton Shakespeare*, eds. Stephen Greenblatt, Walter Cohen, Jean E Howard, Katharine Eisaman Maus, and Andrew Gurr, 2nd ed. (New York: W.W. Norton, 2008), i.ii.322, 266, and 259–60.

8 On the obsession in Europe regarding "the Sabbat or synagogue, as the mythical witches' gathering," see Silvia Federici, *Caliban and the Witch: Women, the Body and Primitive Accumulation* (Brooklyn: Autonomedia, 2004); see also Carlo Ginzburg, *Ecstasies: Deciphering the Witches' Sabbath* (Chicago: Chicago University Press, 1991).

9 Shakespeare, *The Tempest*, i.ii.338.

10 The etymological origins of tempest in *tempus* combine time and weather.

11 Ogilby, *Accurate*, 230–1.

12 Ecclesiastes 1, sefaria.org.

13 Ecclesiastes 3, sefaria.org.

14 Ecclesiastes 3, sefaria.org.

15 Shakespeare, *The Tempest*, i.ii.340–1.

16 Ibid., v. Epilogue, 1–2.

17 Ibid., v.i.273–4.

18 Almog Behar, "Ana min el yahud" (in Arabic: I am one of the Jews), 2005. An English translation (by Vivian Eden) of the story can be found on the author's website: almogbehar.wordpress.com/english/.

Index

Abbas, Ferhat, 91, 143–5, 156; *Manifesto of the Algerian People,* 156
Abdulla Ibn Salam Mosque, 23
abolition, 187, 193, 441, 534
Acre (Palestine), 32
Africa, 2, 5, 20, 31, 95, 127, 142, 148, 185–6, 198–201, 210, 249–59, 424, 439, 461–6, 475–82
Agadi-Tissint, 229
Ahmad, Barakat, 244
Aïcha, Aïsha, 7, 31, 79, 109, 178, 197–8, 265, 340, 367, 393, 421, 426, 444–6, 481, 505–9, 513, 526–8, 537, 578, 583
Akoune, Aron, 413
Alfa, 134–5, 532
Alger, 316, 521
Algerian Revolution, 28, 92, 127, 138, 151, 322, 431, 609n; Algerian independence (1962), 1, 20, 81–6, 89, 92–4, 100, 117, 130, 156–8, 239, 279, 431, 441; decolonization of Algeria, 123–4, 245, 340, 431; nationality Law (1963), 276, 279; "New Algeria," 128–31 *See also* FLN
Algerian Jew(s), 1–8, 17–19, 24, 38, 41–2, 46–9, 52, 55, 73, 82–8, 91–102, 105–8, 115–25, 130–48, 155–60, 165–73 passim, 176–9, 188, 199–205, 213, 228, 231, 265–6, 273–82, 290–2, 311–2, 316–19, 326, 340–2, 349–50, 369–70, 382–3, 390–3, 422, 426, 432–3, 437–42, 447–56, 489–90, 498, 514–22, 529–37, 542; amputation of, 66, 89, 91, 121; de-Algerianization of, de-Arabization of, deracination of, 2, 16, 106, 287, 424–6, 437, 448, 513–19, 525, 533–4; Europeanization of, Frenchification of, 338, 369–72, 390–2, 457, 514; exile(s) of, expulsion of, forced departure of (1962), 5, 20, 24, 30, 37–40, 72, 79–88, 95–103, 117, 123–4, 158, 176, 244–7, 251, 256–62, 276–7, 333, 402, 430, 441, 46–70, 520, 614n; modernization of, 52–4, 533–4; regeneration of, 96, 139, 209, 326, 519, 551
Algiers, 19, 22, 28–9, 46–61, 66–7, 72, 79, 82, 95, 105, 117, 157, 271–3, 283–303 passim, 409–17, 477, 533, 573–8, 584, 611n, 613n, 631n; Central Square, Royal Square, Martyrs' Square (Place du Gouvernement, Place des Martyrs), 52, 62–8, 72, 79, 95–6, 105, 283–4, 290, 295, 415–6; Dar-es-Sultan-el-Quedima Djenina, 48, 58, 64, 67–8; Djamaa el-Djedid, 54–5, 63, 290, 299; El Ghideur (Algiers), 54; Hospital Mustapha, 533–4; Kasbah, 53, 56–7, 303, 406, 409–10; Lower Kasbah, 284, 295–7, 308–9; Mosqué Es-Sayida, 415; Peñón of Algiers, 576; Palace of the Dey, 57; "Old Algiers," 49, 54, 417; Port of Algiers, 53; al-Qaisariya, 297; sculpture of the Duc d'Orléans, 284, 416
Alkalay, Rabbi Abraham, 542, 628n
Alliance Israélite Universelle (AIU), 393, 439, 449, 550–2
Alloula, Malek, 374
Alsace, 155, 188
Altaras and Cohen, 326, 370, 616n
Amar, Sylvain, 315, 327, 338–9, 613n
Amazigh, 28, 52, 100, 108, 292, 476, 574
America, Americans. *See* United States
American Jewish Committee (AJC), 427
Ammour, Nadia, 574
anarchism, 348–9, 353, 614n
ancestors, 159, 329–36, 349–360 passim, 367–433 passim, 441–4, 450–65, 475–7, 482–7, 493–518, 525–85 passim; ancestral craft, 58–60, 132, 162, 377, 399–400, 415, 424, 555–6; ancestral home, ancestral land, 16, 35, 43, 108, 159, 266–7 487; ancestral memory, 285, 503, 562; ancestral professions, ancestral trade, 17–18,

ancestors *(continued)* 66, 69, 110, 313, 320, 335–6, 399, 553, 555; ancestral refusal, 132, 148, 186, 190–1, 195–8, 211, 219, 234, 250, 257, 274, 279–80, 287, 348–9, 358, 414–17, 423, 450, 482, 486; ancestral transmission, 13, 43, 50–4, 100, 110, 144–7, 160, 175–7, 223–30, 234, 292, 298, 313, 318–21, 328, 349, 382, 390–3, 486, 549, 553–5, 611n; ancestral world, 1, 4–5, 89, 100, 322, 334, 349, 485, 404, 493 540, 550, 554, 581

Andalusia, 127, 165, 176, 328, 605n

Ankawa, Rabbi Ephraim Ainqaoua, 285–6

Annaba (Algeria), 286

Ansky, Michel, 447

anticolonialism, 1–5, 13, 19–20, 28–31, 78, 100, 118, 123, 127, 138–9, 151, 158, 168–70, 250–1, 280, 287, 312, 322, 346–53, 358, 417, 419, 431, 460, 472, 480, 503–5, 532, 569, 575

anti-Jewish, anti-Judaism, 43, 83, 87, 115, 142–3, 149, 168, 202, 279, 316–18, 331, 337–8, 490, 542, 548, 613n

antipatriotism, 348, 353, 357

anti-Semitism, 45, 103, 133, 147–53, 167, 172, 195, 208–14, 291, 329, 338, 356, 448–9, 498, 500–3, 552, 615n, 626n

anti-Zionism, 158, 208, 231, 266, 273–5, 501–2, 551–3, 569, 582, 608n

apartheid, 162, 500, 518, 568

Arab(s), 3, 7, 11, 18, 39, 45–7, 52, 73, 76, 85–7, 92–4, 100–3, 116–19, 124–33, 149–51, 156, 163–72, 176, 207, 220–6, 236–43, 247, 292, 314, 330, 339, 377, 383, 390, 412, 430–4, 440–3, 450–1, 466–7, 472–9, 486–9, 494, 498, 501, 510, 518, 568, 574, 577, 583, 605n, 608n

Arab Jew(s), 11–13, 21, 47, 100–3, 125, 150–1, 163–4, 167, 177, 190, 239, 242–4, 433, 477–9, 487

Arabic, 22, 28, 69, 96–9, 125, 163, 175, 178, 189, 194, 201, 205, 242–3, 297, 314, 339, 341, 358, 383, 427, 509, 525, 528, 532, 542, 548–9, 550–3, 575–84, 595n, 605n, 625n, 629n

Arabness, 85–6, 89, 108, 125, 198, 433, 478, 487, 518

Aramaic, 275, 548, 553, 559, 569

Arendt, Hannah, 5, 18, 30, 161, 208–215, 419–52 passim, 503, 601n, 628n; on assimilationist and nationalist narrative, 208–15, 448; on "attack upon human diversity," 213, 441; *Eichmann in Jerusalem*, 212, 429, 432, 441, 591n, 604n; on Frantz Fanon, 428–30; *The Human Condition*, 161, 419–20, 503; on "oriental Jews," 426, 428, 432–3, 449; *The Origins of Totalitarianism*, 427, 430, 440, 449; *Rahel Varnhagen*, 423, 431, 442–3; on "vita activa," 419–20; "Why the Crémieux Decree Was Abrogated" (essay), 424–7, 432–40, 449; on Zionism and anti-Semitism, 208–10

Arie family, 552–61, 628–30n; Arie, Çelebi Moshe Abraham, 555; Arie II, Çelbi, 559–60; Arié, Gabriel, 551–3; Arie, Joseph, 559. *See also* Zahava Arie Azoulay

art history, art historians, 12, 248–51, 294, 416, 597n

Arzew, 205, 445

assimilation, 2, 19, 30, 52, 96, 102, 118, 134–7, 145–7, 156–8, 162, 167, 188, 193–4, 203, 208–9, 213–16, 275–8, 282, 291, 351, 372–5, 391–3, 399, 421–8, 432, 439, 442–4, 448–9, 460, 465–9, 488–93, 498–503, 517–20, 535, 552. *See also,* Algerian Jews; diverse Jews; Hannah Arendt

Atlas Mountains, 109, 189

Attali, Jacques, 153

Attia, Kader, 242

Auschwitz, 18, 29, 38, 44–6, 118, 120, 315, 341, 344

Austria, 175, 351, 483, 560, 631n

Azoulaï (Azoulay) Aron, 304, 326–8, 336–7, 345–50, 447

Azoulay, Ariella Aïsha, *The Civil Contract of Photography*, 420; *Golden Threads*, 109; *Potential History*, 165, 187, 280, 420, 583; *Weaving in the Inner Bark of Trees* (exhibit), 408

Azoulay, Jacques, 122–6, 133, 137, 150–1

Azoulay, Joseph, 287, 311–15, 321–8, 336–53, 446

Azoulay, Paul, 366

Azoulay, Roger Lucien, 5, 27, 32–79 passim, 90, 202, 342, 436, 445, 495, 505; *Star Wars* (painting), 497

Azoulay, Zahava Arie, 5, 32, 219, 539–72 passim

Bab Azzoun, 49, 66

Bafour, Sebe, 477

Baker, Josephine, 200–1

Baldwin, James, 479

Balfour Declaration, 179

the Balkans, 176, 566

Bastille, 75, 341

Bastos cigarette factory (Oran), 336–7, 613n

Bardo, 72

Index

Bataillon des pionniers israélites (BPI, Jewish Pioneer battalion), 356, 437
The Battle of Algiers (film), 271
Bavaria, 560
Bayezid II, 553
Bedeau forced labor camp, 19, 27, 37–8, 44, 74, 116, 135, 154, 198, 354–6, 434–5, 513, 530–1, 622n
Beirut, 32, 472
Béjaïa (Algeria), 29
Ben Bella, Adel, 71, 199
Ben Caïd Ahmed, Hassen, 383–4
Ben Yehuda, Eliezer, 546–7
Benaben, Luce, 400–3, 619n
Benattar, Yohana, 506, 515
Benhamou, Stéphane, 530; *Algeria sous Vichy* (film), 530
Benjamin, Walter, 351
Berber(s), 7, 47, 100–1, 126, 150, 189, 201, 205, 221, 238, 252, 265, 390, 537, 577, 584, 596n, 605n; Arabization of, 390; Berber Jews, 11, 21, 103, 125, 150–1, 176, 222, 239, 242, 428, 251, 477; Berber type, 390
Berlin, 28, 186, 442; Berlin Conference, 561
Berrada, Omar, 245–6
Besancenot, Jean, 109–10, 229, 234–8; *Arab and Berber Jewelry from Morocco*, 234
Beshara, Azmi, 487, 541
Bessis, Sophie, 137
Black people, Blacks, 11, 31, 134, 147–51, 201, 425, 476–7, 483–503 passim, 517, 534–7, 575, 605n, 627n; Black Americans, 200–1, 502–3
Blida-Joinville Psychiatric Hospital, 19, 28 119–23, 131, 150, 605n
Boston Review, 30
Bou-Saada, 228
Bouanani, Ahmed, 245
Bouhchichi, M'barek, 245–6
Boum, Aomar, 247
Boumendil, Camille, 29, 314–15, 326–7, 338–45
Boumendil, Julie, 5, 18, 29–30, 58, 311–60 passim, 446–7, 532, 537
Boumendil, Nathan, 366
Bourdieu, Pierre, 408
Bouteldja, Houria, 5, 19–20, 29, 102, 265–310 passim, 591n; Partie des indigènes de la république, 29, 273; on "revolutionary love," 19, 265
Bouzian, Sheikh, 410–11
Breslau, 442
Brouillet, André, 506
Bulgaria, 32, 175, 351, 542–4, 551–61, 566–7
the Bund, 274–80, 287

Camps-Farber, Henriette, 245
Canada, 119, 131, 276
Cantier, Jacques, 203
Casablanca, 342–3
Center of the National Archives of Algeria, 405
Certificat de nationalité, 77, 90–2, 436
Césaire, Aimé, 136, 155, 575, 597n
Charter of the Medina, 15
Cherki, Alice, 117, 122–6, 155, 596n, 599n
Christian(s), Christianity, 2, 10–12, 24, 83, 91, 119, 147, 167, 171, 193–5, 216, 266, 292, 300, 381, 390–3, 422, 428, 439, 457–60, 466–78, 488–504, 523, 535, 560, 577; Christian world, 2, 10, 167, 216, 500; "New Christians," neo-Christians, 119–23, 148, 442, 558; secular Christianization, 533–5
citizens, Citizenship, 2, 7, 13, 17–18, 36–9, 73, 91–3, 100–3, 115–24, 128–32, 137–51, 155–6, 160–73, 179, 182–215 passim, 273–4, 279–82, 287, 291, 313, 316–19, 326, 347–51, 356, 390–95, 419–52 passim, 455–6, 478, 485–93, 498–503, 515, 525–9, 534, 553, 568; colonial citizenship, 100, 138, 155, 313, 317, 426, 439; differential body politic, 427–31; the "gift" of citizenship, 100–2, 144, 205, 438–9; imperial citizens, imperial citizenship, 16, 38, 149, 160–2, 167, 171–3, 179, 191, 195–6, 203, 432, 440, 456, 478, 500; imposition of French citizenship upon Algerian Jews, 20, 46, 77–8, 82, 87, 124, 131–3, 149, 167, 194–5, 203, 209, 282, 313, 356, 395, 421, 502; violence of, 203–4. *See also* colonial bargain; Crémieux Decree; French citizenship
co-religionists, 254, 258–62, 291–2, 606n
Madame Cohen, 17, 30, 361–418 passim
Cohen, Abraham, 40
Cohen, Marianne, 5, 31, 58, 198, 505–37 passim.
Cohen, Salomon, 367, 514, 521–3
Cohen, Sliman, 178, 198
Cohen-Lacassagne, Julien, 477
colonial amnesia, 54, 92, 95, 144, 416, 482
colonial aphasia, 39, 85, 122, 592n
colonial bargain, imperial bargain (of citizenship), 36, 73, 82, 87, 92, 102, 148, 166, 194, 203, 214, 274, 316, 353, 372, 423, 478, 502
colonial curse, colonial spell, 165–6, 239–40, 252–62, 311, 476, 582–3

colonial disorder, 30, 115, 121-2, 127-34, 141, 155-6
colonial postcards, 6-7, 21-2, 30, 49-55, 59-73, 157, 220-2, 233, 236-7, 247, 299, 317, 324-6, 335, 361-77, 399-402, 409-10, 415-17, 450-1, 570, 591n
colonial syndrome, 82, 126, 158. *See also* colonial disorder; North African syndrome
colonial taxonomy, colonial inventory, colonial types, 7, 52, 56, 67, 120, 125, 223, 234, 242, 246, 415, 478
colonial technology, 3, 12, 259, 272, 282, 320, 340, 374-6, 380, 390-5, 411, 439, 460, 465, 514-19. *See also* imperial technology
colonization of Algeria, conquest of Algeria (1830), 3, 18 -19, 37-40, 46-8, 51-2, 81, 93, 117, 120, 189, 194, 318, 404, 421, 522, 575
concentration camps, 19, 37, 115, 152-4, 213, 333, 353-6, 464-5, 491, 529
Confédération Générale du Travail Unitaire, 287, 348-9
Constantine (Algeria), 27-30, 68, 72, 179, 233, 316, 337, 352, 403, 457; Division of Constantine (1844), 72
Constantinople, 551-3, 560
the Conquest of the Desert (exhibit), 211
converts, conversion, 1, 12, 16-23, 41, 47, 52, 63, 69, 91-3, 118-20, 125-33, 137-8, 144-9, 155-8, 163, 171-4, 193-8, 207-9, 216, 243-7, 262-3, 267, 276-84, 292, 301, 326, 333, 372, 382, 391-7, 402-3, 411-12, 422-6, 431, 443-9, 455-60, 518-20, 533, 558-61, 566, 571; forced conversion of Algerian Jews, 1, 12, 16-20, 91, 118-20, 127, 133, 144-7, 188, 195-8, 207, 292, 392, 396, 411, 422-6 , 442-6, 457, 558; conversos, 119-20; crypto-Jews (*anusim*), 17-18, 391-3, 400-2; London Society for Promoting Christianity amongst the Jews in Jerusalem, 466. *See also* Cremieux Decree; French citizenship; Marranos
craft, craft-making, 4, 7-8, 12-18, 24, 54- 62, 68, 72, 82, 110, 125, 135-6, 159-62, 180, 211, 215, 222-7, 234-7, 242-52, 256-8, 275-6, 280-3, 298, 319-34, 341-4, 372-89, 394-410, 415-27, 493-6, 517-19, 535-7, 553-7, 562-5, 571, 616-17n; craftspeople, craftsmen, 12, 15, 17, 54, 57-8, 62, 68, 72, 160, 235-7, 242-6, 280, 319-22, 328, 333, 351, 373-84, 389-90, 396-7, 400-3, 407-9, 438, 517, 555-6, 606n, 617-18n; crafto-cide, 372-3, 396, 400. *See also* guilds
Crémieux, Adolf, 20, 349, 439
Crémieux Decree (1870), 2, 77, 82-8, 92-6, 102, 115, 143, 156, 160, 282, 328, 339, 356, 421, 424-7, 432-40, 446, 449, 455-7, 490, 514, 514, 518 614n
crimes against humanity, 81,101-3, 212-3, 440-1, 475
Crusades, 2-3, 25, 178, 466, 475, 577
Cuba, 31
culture-cide, 284, 528
Cyprus, 181

Dada, Sidi Ouali, 574
Dah deg el-hommès, 223
Damane Demartrais, Michel François, 217
Dar as-sikka (Moroccan mint), 395
Dārja, 341
Darmon butchery, 338, 377
Darwish, Mahmoud, 318, 575
Daumas, Melchior Joseph Eugène, 295-6
David, Jacques Louis, 527; *Oath of the Horatii*, 527
dhimmi, dhimma, 15, 94, 131, 144, 160, 273, 281, 303. *See also* Algerian Jews; Ottoman Empire
De Gaulle, Charles, 93, 152, 343-4
Declaration of Rights of Man and Citizen, 446
decolonial, decolonization, 24, 118, 130, 141-2, 145-9, 158, 263, 267, 469, 501-2, 607n. *See also* of Palestine; of Algeria
Delacroix, Eugène, 409, 410, 449-50; *Women in Algiers in Their Apartment* (painting), 409-10
democratic aphasia, 128, 144-5, 151, 155-6
Derb Lihoud, 321, 367, 400, 525-6
Displaced Person Camps, 168, 180-3
Djellaba, 377
djinn, djenoun, 187, 226, 346, 506-7
Drancy, 29, 341-4

Earth mother, 108-9, 174
Ecclesiastes, 578-9
Egypt, Egyptians, 8, 12, 178, 190, 206-7, 215, 236, 242, 288, 303-6, 404, 426, 463, 471, 625n
Elkaim, Olivia, 117
embodied knowledge, 10, 318, 358
embroidery, 32, 58-61, 136, 323-7, 368-85 passim, 397-403, 416, 556; Ben Aben embroidery workshop,

Index

embroidery school for girls, 59, 136, 324, 327; embroidery rooms, *ouvroirs*, 400. *See also* pre-capitalist professions
Les enfumades, 154
England, 403–4, 575
English, 28, 200, 271–2, 295, 314, 543, 549, 554
epistolary exchange, epistolary engagement, 3–5, 16, 31, 106, 127, 134, 424, 428, 444, 540
Essaouira, Mogador, 328–9
état civil, 446–7, 508
Ethiopia, 476–8
Étienne Dinet, Alphonse, 228; *Arab children playing* (painting), 228
Eudel, Paul, 64, 223–8, 243, 294, 328–30, 409, 612n; *Dictionnaire des bijoux de l'Afrique du Nord, Dictionary of Jewelry from North Africa*, 223, 243
European Enlightenment, 193, 422–5, 448
European Jews, 11, 18, 92, 96, 125, 131, 164–7, 174, 184, 214–5, 274, 419, 425, 433, 442–3, 449, 464–70, 488, 510–11, 535
Évian Accords (1962), 84, 87, 89, 92–5, 131, 156, 276, 279–80, 446, 456, 594n
evil eye, 8, 190, 229, 234, 413
Evri, Yuval, 178
Exodus, 304

Fanon, Casimir, 341
Fanon, Frantz, 5, 19–20, 28, 115–58 passim, 188, 341, 428–30, 475–6, 479, 501, 533, 598n; on "Algeria's European Minority," 132, 137; "Algeria Unveiled" (essay), 188; *Black Skin, White Masks*, 124, 141, 146–7, 151; on "man among men," 141–3, 147–52 passim,; on "New Man," "New Humanity," 131, 141; "The 'North African Syndrome'" (1952) (article), 116, 126, 155; on "ontological resistance," 145, 149, 304; *The Wretched of the Earth*, 121, 133, 141–2
fascism, fascist, 116, 168, 170, 582
Feraoun, Mouloud, 105
Fez, 110, 112, 322, 366, 388, 393
First World War. *See* World War I
Fitzgerald, Ella, 200–1
FLN, 85, 93, 127–9, 140, 279, 431
forced labor camps, 27, 44–5, 121, 153–4, 168, 258, 277, 341, 354–6, 437, 464, 617n; Groupment des travailleurs israélites (GTI), 356. *See also* Bedeau

France, 1, 7, 19–22, 27–9, 37–8, 46–7, 56–8, 74, 78, 81, 86–95, 100–5, 115–19, 131, 139, 148–55, 168, 172, 187–222 passim, 239, 265–77, 291–2, 315–19, 327–50 passim, 359–60, 377–415, 436–56, 489, 516–22, 529–35, 605n; Franco-German War, 438; Free French Forces, 155, 168; French (language), 45–6, 265, 548, 550–1, 553; French Army of Africa, *French Armée d'Afrique*, 19, 27–8, 37, 152, 154, 341, 352, 513; French citizenship, 19, 37, 45–7, 77–8, 82–4, 87–8, 91–3, 96, 100–2, 115–16, 119–23, 128–33, 137, 144–5, 151, 155–6, 160, 188, 194–7, 201–3, 287, 317, 347, 391, 421, 427, 438–43, 450–1; French colonial education, Republican education, 89, 120, 320–1, 326, 339, 383–4, 392–4, 486; French colonialism, 1, 3, 7–8, 18–19, 28, 37–45, 51, 63, 71, 79–81, 85–9, 93, 97, 102–3, 110, 119–25, 144, 148, 154, 198, 206, 219–22, 235, 267, 271–9, 300, 308, 315–19, 337–40, 348, 356, 367, 378, 392, 400, 412, 416, 427–30, 439, 443–6, 455–6, 490, 507–10, 516–20, 542, 551; French consistory system, 22, 89, 139, 188 194, 218, 337, 348, 391–2, 431–2, 448–9, 518; French Foreign Legion, 31, 522–3; French language code, 83–96; French naming system, 243, 525–6; French Office of Control for gold and silver, 411–13; French republicanism, 120, 152, 202, 316; French Revolution, 41, 83, 141, 167, 187–8, 192–3, 205, 215, 281, 322, 333, 403–4, 425, 486, 527; Frenchness, 10, 39, 73, 78, 84, 88, 117–18, 123, 145, 277, 291, 399, 489, 498, 532
French Jews, Metropolitan Jews, 20, 47, 96, 177, 188, 213, 275–6, 290–2, 298, 326, 340, 349, 391, 431–2, 447–8, 474, 516–20, 551, 598n, 611n

Galilee, 580
Garanger, Marc, 227
Gaston, K. Healan, 468
Gaza, 24–5, 191, 500
Geiser, Jean, 299, 324
genocide, 19, 24–5, 185–6, 212, 258–60, 344, 455–6, 489–91; cultural genocide, 178, 282, 454–6; genocidal violence, 19, 25, 119, 140, 166–8, 171, 185, 195, 213, 258–9, 277, 467, 498, 582

639

Germany, 19, 27, 30, 149–52, 168, 212–3, 336, 351, 467, 480, 631n
Al Ghariba, 285–6
Gibel Mevorach, Katya (Katya Gibel Azoulay), 11, 31, 483–504 passim; *Black, Jewish, and Interracial*, 483; on "collective amnesia" of American Jews, 483–4, 503; on the intersections of identity, 484, 487–9
Girard, Patrick, 193
Giraud, General Henri, 427, 434–7
Giraudet-Fort, Andie, 315, 336
Gold threads, "*fileur d'or*," 17, 30, 62, 110–11, 136, 237, 322, 368–9, 374–81, 385, 388–9, 393–400, 411, 415; *ma'allemin sqalli*, 393
Golden Calf, 301–7
Goldsmiths, 110, 134, 228
Goodman, Benny, 200
Gordon, Judah Leib, 545
Greek, 206, 553
Grudzinski, Yosef, 180
Guadeloupe, 406
Guelma, 344, 377
El Guerch, 246
Guèye, Massamba, 242
guild(s), 8, 13, 17, 23, 54, 58, 82, 136, 283, 318–20, 335–7, 373–4, 379–89, 395–9, 403–5, 415, 519, 524–5

habous system, 288, 415
Hadj, Messali, 178; *Appel aux nations unies: Le problème algérien*, 178
Haifa, 32, 511, 573, 581–4
Haiti, 8
Hakétia, 97
Haleh Davis, Miraim, 287
Hammerman, Jessica, 179
Hannoum, Abdelmajid, 92, 605n
harkis, 1, 138, 277
Hayoun, Massoud, 486–7, 625n; *When We Were Arabs*, 486
Hebrew, 17, 22, 27, 32, 76, 108, 125, 163–4, 179, 193, 283, 306, 358, 425–7, 447, 508, 533, 543–62, 569, 574, 580–4, 629–30n; revival of, revivers of, 544–8, 562
Heggoy, Alf Andrew, 295–6, 299
Henni, Samia, 270; *Architecture of Counterrevolution*, 270
Herero and Nama peoples, 186
Heschel, Susannah, 100
Hirschberg, H. Z. J. W., 176–7, 179
history; European history of the Jews, 102, 209, 421, 441; historical fiction, 420; history that should not have been ours, 160, 421 505, 510; imperial history, 173, 222, 482, 541; surrogate history, 127; "waiting room of history," 191–5. *See also* imperial temporality

Hitler, Adolf, 168, 342, 470
Hobbes, Thomas, 304
Holiday, Billie, 200
the Holocaust, 18, 44–6, 166, 171–2, 213–4, 326, 465, 467, 500, 503, 529; exceptionalization of, 170–1, 185, 212–15, 467, 502
human rights, 204, 467
human factories, 1, 22, 37–9, 45, 91, 139–42, 165, 268, 312, 335, 397, 419–20, 505, 510–6, 581–2; manufacture of modern subjects, 38; manufacture of "Jews," production of the "Jewish people," 166, 177–9. *See also* the category "Jew," the invention of "the Jewish people"

Iberian Peninsula, 68, 119, 176, 352, 391, 469–70, 553
ibn Ezra, Abraham, 531; *Sefer Hanisyonot* (*The Book of Experiments*), 531
ibn al-Haytem al-Qurtubı, Abd al-Rahmān, 531
Ibn Khaldun, 518
imperial temporality, 96, 136–9, 298–9, 372, 417, 526, 577; *fait accompli*, 139, 147, 428–9, 444; the future, 393–4; generational gap, 486, 541; imperial progress, 5, 101–2, 137–40, 146, 211, 219, 329, 338, 370–1, 399, 417, 421–2, 444, 571; the past, 12, 49, 96, 101–3, 299, 372, 376, 420, 428, 442, 482, 487, 528, 554
imperial technology, imperial tools, 2, 24, 84, 103, 166, 443, 464, 474, 486, 519; the new, 130–1, 146, 519. *See also* museum
indigenous Algerians, 31, 63, 71, 115, 197, 288, 295, 434; Arabité, 7. *See also* Algerian Jews
"indigenous Jews," 91, 131, 148, 160, 344, 392 443, 478, 523; indigenous Jewish autonomy, 287–8, 298
indigenous labor, 58, 323
industrialization,17, 226, 319, 328, 377–84 passim, 403–5, 472
interpreters, 122–4, 149, 383, 475, 555; indigenous interpreters, 138, 383–5
Iraq, 471
Islam, 15, 23, 72, 82–6, 94–7, 160–3, 172, 178, 198, 244, 251, 267–9, 278, 287–8, 302–5, 457, 468–9; Islamic art, 60–3, 72, 494; Islamic identity, 265–9, 274, 280; Islamic law, 94, 131, 493; Islamicness, 108, 478
Islamophobia, 97, 103, 263, 277, 475
Israel, Israeli, 24, 27, 32, 38–41, 58, 84–5, 99–100, 119, 131, 156, 161–6, 174–98 passim, 209–14, 219–22,

Index

247–52, 266–70, 276–7, 321, 357–8, 420–5, 445, 464–69, 474–9, 484–91, 498–501, 541–8, 554, 566–83, 607–8n; Israel studies, 425; Israeli identity, 10, 41, 99–100, 113, 149, 161–5, 177–9, 239, 266–70, 321, 420–2, 454, 485–491, 515–6, 528–9; Mossad, 85, 179. *See also* Zionism, Zionist

Italy, 19, 27, 160, 176, 214, 533, 560

Jaffa, 568
Jamaica, 31, 483–4
Jaspers, Karl, 432
Jerusalem, 32, 211, 286, 432, 466; National Library, 183–5
Jewelry, jewelry-making (Algerian, Maghrebi), 7–10, 13–15, 23–4, 56–8, 62, 67–9, 109–11,134–6, 173, 199, 222–38, 242–63, 275, 283, 293–4, 302–9, 327–35, 345, 350, 358, 370–3, 367, 389, 396, 405–17, 420, 477–9, 495–6, 513, 517, 537, 541, 555–7, 606n; *alâqa*, 14–15, 228; amulets, 8, 298, 302–6, 341, 426, 512–13, 588; cloisonné, 237; fabrication of authenticity, 226, 234–8, 382–4; fibules, 69; metalworking, 223–7, 236, 244–51, 492–4, 513; *mu'allimūn*, 328–9, 588; necklace, 8, 224–7, 241, 252–3, 305–9, 410, 531, 572; ring, 252, 556–7; *sarma*, 50, 289; semainier, 334; *souk es-seyyâghin* (the jewelers' market), 146, 294, 414; taqlid, 305
Jewelers (Algerian, Magrhebi) 7, 14, 23–4, 56–7, 67–9, 79, 89, 94–5, 108-11, 134–6, 199, 224–7, 235–8, 242–62, 293–4, 303, 327–35, 350, 358, 372, 389, 397, 411–14, 496, 513, 535, 553
the Jewish Agency, 85, 607n
Jewish art, 12–13, 248–51, 493–4, 597n
Jewish Cultural Reconstruction, Inc., 183–4
Jewish jewelers, 15, 23, 68–9, 134, 230, 236, 244, 248, 293–4, 302–3, 328–333, 412–14, 556–7; absent presence of, 224. *See also* Tamzali, Wassyla
Jewish Muslim World, 3–7 passim, 12–13, 18–25, 29–31, 38, 45–7, 81–6, 109–10, 119, 126–7, 138, 148, 173, 230–3, 251, 267, 275–6, 278–9, 288, 309, 311, 337, 344, 349, 395, 410, 424–6, 439, 454, 469, 472–5, 489, 493–4, 511, 526, 532, 554, 571, 589, 591n; artisans of the, 18, 50–2, 58, 110, 285, 302, 335, 405, 494; descendent of, 18, 186, 311; destruction of, 4, 12, 18–25, 31, 72, 81, 85, 266, 278, 315, 344, 349, 494; detachment of Jews from, exile of Jews from, 52, 82, 89, 126, 175, 178, 244, 276, 341, 536; disappearance of the disappearance of, 475–6, 482; Jewish Muslim conviviality, 5, 119, 146, 176, 337, 373; recovery of, resuscitation of, 51, 146–7, 167, 267, 279, 309
the Jewish Question, the Jewish Problem, 11, 18–19, 167–73, 276, 422, 466, 499, 501–3, 569; solution(s) to the, 3, 11, 167–73, 214, 279, 465–70, 498–503, 569, 609n; Final Solution to the (1942), 18–19, 139, 315, 435–6, 569
Joseph II (of Bavaria), 560
Josepha, Empress Maria, 560
Judaism, 86, 178, 216–18, 266–7, 279–82, 361, 392, 422–5, 468, 474, 487, 536, 541, 552; Andalusian Jew, 113, 165, 176; American Jews, 170, 185, 274, 427, 434, 468, 484, 502; Ashkenazi Jew, 11, 46, 175, 432, 529; Black Jews, 476; the category of "Jew," the invention of the "Jewish people," 2, 7, 10, 46–7, 84–8, 96–102, 119, 134–7, 144, 151, 156, 160–2, 178–9, 193, 218, 233, 249, 266, 275–8, 291, 339, 390–5, 422–8, 439–41, 446, 456, 469–75, 483, 488, 490–4, 529, 568; diverse Jews, diverse modes of being Jews, 4, 11–13, 29–32, 87, 99–101, 124–5, 148, 160, 165–7, 171, 193–4, 206–10, 215–18, 247, 274–9, 298, 422, 468–9, 483, 488–93, 498–504, 544–8, 569; emancipation of Jews, 2, 12–3, 17, 38–41, 83, 101–2, 145–9, 172–3, 180, 207–14, 291, 322, 370–5, 403, 447, 489–91, 510, 535, 551–2; Iraqi Jews, 99, 108; Jewish exceptionalism, 170–1, 185, 212–5, 467; Jewish ghettos, 207–8, 603n; Jewish law, 8, 373, 397, 561; Jewish liturgy, 27, 544–5; Jewish type, 7, 220–1, 365, 390; Moroccan Jews, 189, 349; new Jew, 21, 211, 219, 439, 546; North African Jews, 110, 148–9, 195, 451, 608n; Orthodox Jews, 208, 472–4, 567; Polish Jew, 192–3; Saharan Jews, 93, 160, 477; secular Jews, 4, 18, 159, 165, 448, 470–4, 485, 533
Judeo-Arabic, 112–3, 125, 205, 391, 426, 441, 525
Judeo-Christian tradition, 2, 86, 100, 174, 249, 278, 428, 460–77, 491, 503

Kabyle(s), 129, 221, 226, 247, 574
Kader, Emir Abdel, 10, 63, 296, 313, 521

Index

Kanafani, Ghassan, 5, 32, 573–86 passim; *Returning to Haifa* (novella), 32, 581–4; Dov, Khaldoun, 580–4; Ephrat, 585; Miriam, 581–4; Safiyya and Said, 25, 581, 583, 585
Kattan, Naïm, 107–8
Kherrata, 344
kidnapping, 45, 341–2, 540, 560–1, 566; of babies from the Jewish Muslim world, 127, 277; of children from their ancestors, 313; of Jews by Zionism, 250, 566, 569
kin, kinship, 20, 127, 187, 215, 248, 260, 341, 366, 445–6, 479, 507, 526–7, 539, 582; chosen kin, elected kin, 3–5, 19, 230, 280, 351, 428
King Charles V, 426, 547
King Louis-Philippe I, 410–1
Kitouni, Hosni, 10–11, 30, 129, 453–7; *Colonial Disorder*, 30
Kol Nidrei, 569–71
Koran, 300–1, 468–9

Ladino, 32, 175, 205, 358, 426, 441, 486, 542–59, 567
Langlois, Colonel Jean Charles, 414; *Grand Place d'Alger* (painting), 414
Lazarus, Jacques, 85–6
Le Tourneau, Roger, 388, 394
Lebanon, 471, 583
Lespès, René, 295
Levi-Strauss, Claude, 493
Levin, Sarah Frances, 189
Leviticus, 132
Levy, Esther, 345–6
liberal feminism, 271–2
Library of Congress, 183–5, 429; Exhibition of Nazi atrocities (1945), 185
Libya, 463
Lilith, 58, 567–8
Livret de famille, 79, 436, 507, 626n
Locke, John, 304
looting, plunder, 62, 94, 106, 133, 143, 161, 168, 185, 246, 259, 277, 284, 309, 329–38, 376–82, 396–7 404–12, 428–9, 472, 490, 495–9, 519; of Jewish objects, 171, 183, 186, 329–34, 613n; of Palestine, 161
Lord Palmerston, 465
Lyon, 116

Maghreb, 13, 17, 27, 57–8, 62, 68, 81, 100, 115, 188, 210, 235–44, 251, 276, 282–5, 298–302, 316, 326, 333–6, 349, 373, 387–91, 397–402, 463–5, 478, 493–6, 513, 529, 535, 546, 603n, 608n, 614n, 626n. *See also* North Africa
Mansour, Sidi, 48–9, 62

Marabouts, 48, 530
Marrano, 293, 457, 558, 561, 629n
"La Marseillaise," 347
Martinique, 28, 151–2, 341, 406
Mauritania, 477
Mbembe, Achille, 476, 481, 625n
Mecca, 286
Meddeb, Abdelwahab, 86
Mediterranean, 29, 312–14, 338, 352, 386, 439
Mekaoui, Nassima, 326, 612n
Meknes, 366
Mellah, 111, 395
Meyouhas, Yosef, 178
Mezianne, Mohamed Amer, 476
Mezuzah, mezuzot, 106, 252, 255, 259–61
Miami, 471
Middle East, 172, 181, 209, 424, 433, 469, 499–501
Midrash, Midrashim, 163
Milan, 574
Miró, Joan, 497
Mizrahi, Mizrahim, 36, 164–5, 174–5, 270, 510, 546, 552, 608n. *See also* Arab Jews, North African Jews
Le Mobacher (journal), 383
mode of being in the world, 136, 173, 242, 319
modernization, 41, 54, 63, 208, 319, 472, 533–4; command to be modern, 370, 379; premodern, 37–39, 287. *See also* imperial temporality
Mokta el Hadid, 381
Mollet, Guy, 93
Montréal, 118
Morocco, 8, 109–11, 160, 165, 189, 200–1, 233–5, 246–7, 328, 349–54, 366, 378–9, 388, 394–6, 400, 450, 463, 529, 606n. *See also* Moroccan Jews
Mosaic Law, 301, 345, 432, 447
Moses, 123, 206, 301–7, 493
Mosque du Pacha, 69–70, 354
mother tongue, 3–4, 32, 38–9, 46, 98, 108, 163, 189, 266, 297, 371, 425–7, 506, 543, 547, 584
El Moudjahid (newspaper), 28
Moulin, Félix-Jean, 374; *L'Algérie Photographiée (1857)*, 374
muezzin, 69, 108, 158
Mugniery, Léon, 116–7, 121
Murard, Numa, 126
muscle memory, 8, 112, 134, 246, 250, 305–8, 323
museum(s), 10–15, 45, 50, 62–3, 67, 72, 87–9, 103, 110, 171, 182–5, 246–52, 261–3, 333–4 357, 366–76, 396–7, 402–11, 416, 424, 456, 467, 493–4, 504, 554–8; archivists, 103, 139,

642

367–8, 465; captives of, 263; Central Museum for the Extinct Jewish Race, 499; colonial framework of, 371, 409; workers, 368–9, 409. *See also* imperial technology
museums (French), 50, 72 ,140, 308, 333, 397, 406–8, 456; *Musée d'art et d'histoire du judaïsme* (Paris), the Jewish Museum in Paris, 17, 30, 361, 402, 536; *Musée de Cluny*, 492–3, 536; *Musée de l'homme* (Museum of Man), 476; *Musée national des Arts d'Afrique et d'Océanie*, 397; *Musée Quai Branly* (Paris), 14, 140, 308
Muslim(s), 7, 12–15, 20, 28, 51–2, 67–73, 83–6, 93–5, 100–3, 119, 125, 131–8, 143–60, 176–82, 224–5, 251, 267, 276–90, 295–305, 321, 329–30, 339–40, 347, 352, 360, 373, 377, 383, 389–90, 431–4, 440–3, 456–7, 472–9, 510, 517–18, 556, 574–7
Muslim Jew, 10–11, 15–16, 20, 29, 47, 101–3, 108, 125, 130, 136, 145, 163–7, 171–4, 178, 221, 233, 240, 251, 266, 273–5, 280–2, 287–8, 329, 424–5, 455–7, 466–70, 474–79, 486, 493–4, 498, 514–17, 525, 577; Muslim Jewish memory, 282, 469. *See also* Jewish Muslim world
Muslim Jewish world. *See* Jewish Muslim world.
mutual aid, 136, 146, 162, 192, 203, 126, 278, 444
Mz'ab, 456–7

Nadjari, David, 282
Napoleon, 86, 99, 177, 206–8, 215–18, 275, 290, 392, 404, 468, 535; expedition to the Orient, 206, 215; General Divan of 189 notables, 178; invasion of Egypt, 177, 236. *See also* Sanhedrin; emancipation of Jews
nation-state, 5, 16–18, 166–7, 187, 230, 267, 279, 322, 340–1, 350, 422–4, 430–1, 474–7, 482–5, 490, 500, 510, 545, 607n. *See also* imperial technology
Native Americans, 162, 186, 213
Nazi, Nazism, 3, 18–19, 37, 43, 46, 119, 126, 133, 149, 153–5, 168–70, 183–5, 198, 207, 212–3, 315, 333, 344, 356, 434–6, 466–9, 483, 491, 499–502, 529–33, 552, 582. *See also* Auschwitz; the Holocaust; Vichy; World War II
Negrouche, Samira, 8–9, 11, 28, 105–13 passim, 174
New York Times, 434
North Africa, 2, 5, 8, 19, 44, 74–6, 97, 110, 116–18, 126–7, 148–9, 164–5, 176, 179, 195, 200–22, 238, 245–7, 252, 265–7, 273–4, 291, 344, 397, 407, 433, 439, 451, 464, 469, 475–9, 482, 503, 508–11, 528–9, 537, 562–3, 575–6, 628n, 631n
Nouschi, André, 455; *Le désordre colonial*, 456
Nuremberg Trials, 185

OAS (*Organisation armée secrète*), 85, 279
Ogilby, John, 574
onto-epistemological violence, 89, 276
Ophir, Hagar, 28, 109, 186; *Recalling History*, 186
oral history, 295, 299, 302
Oran (Algeria), 10, 17–23, 27–31, 38–44, 57–8, 69–79, 106–7, 113–19, 127, 148–53 176, 194, 199–202, 223–6, 274, 287–93, 312–17, 327–8, 332–41, 346–55, 363–7, 402, 417, 424, 435–6, 445–7, 479–80, 495–6, 505–6, 515–32, 537, 546–8, 562, 575–7, 611–13n, 631n
orientalism, orientalist, 72, 176–9, 215, 289, 323, 408, 428, 442–3, 450, 545, 575
Ottoman Empire, 32, 56, 176, 275, 281, 284, 289, 293, 298, 351–2, 400, 415, 442, 542–6, 550–7, 561, 631n; Ottoman Jews, 555–7
Ouhaddou, Sara, 246

Palestine, Palestinians, 2–4, 8–12, 24–8, 32, 44, 76–9, 85–6, 99–100, 106–8, 113, 119, 149, 156–67, 174–82, 190–1, 211, 215, 251, 266–70, 276, 289, 309, 344, 357, 420–6, 433, 454, 460–80 passim, 486–91, 498–502, 505–11, 516–22, 541–4, 547–53, 566–8, 580–3, 585, 597–609n, 620n; colonization of, 3, 32, 179, 421, 433, 472, 607n; decolonization of, 24, 501–2; destruction of; 79, 100, 106, 161, 357, 421–2, 460, 465, 470, 542, 550, 566; expulsion of Palestinians, 158; *Nakba* (1948), 24, 485; Palestine Liberation Organization, 32; question of, 422, 465–7, 501
Palestinian Jew(s), 4, 165–7, 174, 266, 426, 543, 547; erasure of, 174
Pan-Africanism, 476; Fifth Pan African Congress, 169–70, 600n
Paris, 14, 17, 28–9, 38, 44–5, 66, 73–5, 86, 116–7, 120, 140, 158, 177, 201, 218, 230–1, 263, 273–4, 288, 292, 341–4, 361, 367, 380–4, 389, 400, 405–6, 410–12, 439, 445–9, 476, 493, 508, 528, 536, 551
Perkei Avot, 373

Index

Pétain, Maréchal Philippe, 92, 202, 316
photography, photograph, 33, 36, 58–60, 68, 73, 110–11, 158, 161, 170, 238–42, 247, 325, 343, 361–76, 390, 417–20, 471–2; being-there-ness of photographed people, 158; colonial photography, colonial photographer, 110, 374–5; event of photography, 374, 420; invention of, 158; photographs of types, 220–4, 361–3, 375; rights of photographed persons, 375, 420
Plunder. *See* looting
Pieds-noirs, 82–3, 91–3, 131, 277, 366, 457, 616n
Piyyut, Piyyutim, 27, 40
Poland, 274
polygamy, polygamous family formations, 146, 327, 345, 442–52
Portugal, 97, 133, 349, 391, 460, 482, 553, 558, 560, 630n
postwar Europe, 166, 172, 185, 429, 450, 467, 491, 503; new world order, 3, 278, 467–9, 477, 481, 499. *See also* Judeo-Christian tradition; restitution
potential history, 30, 95, 207–10, 252, 621n
pre-capitalist professions, 1, 15–17, 69, 148, 236, 244, 302, 313, 319–20, 329–37, 368, 376–8, 387–90, 395–404, 410–11, 597n, 611n, 616n; butcher, butchery, 136, 148, 287–8, 313–14, 321, 336–8, 348–50, 377; coin minting, 95, 218, 244, 302, 395, 409–10; shoemaking, shoemakers, 136, 335–7, 397, 517, 524–5. *See also* embroidery; gold threads; jewelry
Prophet Mohamed, 468
Prussia, 423
Prussin, Labelle, 248, 478
psychiatry, 19, 28, 115–23, 133–4, 150, 229, 293

Rachbatz (Rabbi Shimeon Ben Tzemach), 48
race, racializing technologies 84, 116, 120, 126, 134–6, 142, 147–54, 160, 165, 170, 174–5, 180, 191–5, 201–2, 228–9, 234–8, 252, 277–9, 291, 361, 375, 380, 437, 449, 465–9, 475–7, 488–94, 500–4, 510, 528, 533–5, 546, 575. *See also* deracination of Jews
racial capitalism, 12, 17, 103, 172, 283, 288, 303, 309, 319, 344, 373, 380–1, 392, 395, 422, 441, 470, 473, 501
rape, 128–30
Ras-el-Ma, 530
refugee, 162, 164, 483
religion, 18–19, 84–7, 137, 167, 173, 178–9, 192–4, 206, 262, 278, 284–91, 339, 360, 373, 392, 429, 456–60, 532–5, 545; French construction of, 84, 167, 173, 178–9, 192–3, 284–6, 373
Renoir, Pierre-August, 449–51; *Jewish Wedding* (painting), 449
restitution, 91–2, 170, 199, 333, 357, 429, 440; restitution of Jewish property, 184–6, 333, 429
Rhode Island, 28, 162, 570; Pawtucket, 162
Ribach (Rabbi Isaac Bar Sheshet), 48
rights, 15, 29, 67, 83–4, 92–4, 137, 155, 167, 170, 183, 282–3, 316–17, 375, 420–3, 433–44, 448, 468–71, 489–90; belonging rights, 67; corporate rights, 183–4; group rights, 160; imperial rights, 162, 490, 498, 553, 561; right to be *with* others, 162; universalized language of rights, 192–3
Rishon Lezion, 32, 529, 543–6, 558, 565; Haviv school, 546–550
Roberts, Sophie B., 93
Robespierre, Maximilien, 403
Rome, 527
Roth, Cecil, 251; *Jewish Art*, 251
Rouach, David, 224–7
Roumain, Jacques, 142
Rousseau, Jean-Jacques, 304
Russian–Turkish War, 556, 561

sabra, 547, 568
sacrifice of Isaac, 306
Safed, 542
Said, Edward, 479
Saïl, Mohamed, 348
Salaymeh, Lena, 500
Salonika, 560
Samakov, 554
As-Samaw'al bin 'Ādiyā', 585
As-Samiri, 301
Sandok Tadamoun (National Solidarity Fund), 331
Sanhedrin, 86, 177, 216–18
Sartre, Jean-Paul, 122–4, 147–8; *Anti-Semite and Jew*, 147–8
Schidorsky, Dov, 184
Schreier, Joshua, 194, 280, 609n, 612n
Schwarzfuchs, Simon, 281
Sealy, Mark, 169–70
secularism, 4–5, 16–18, 83, 89, 94, 106, 132, 147, 167, 179, 274, 284–7, 292, 302, 306, 392, 439, 470–4, 485–8, 541, 567–8; French secularism, *Laïcité*, 83, 86, 94, 167, 266–7, 292, 391, 412, 439, 475, 490; secular colonial regime, colonial secularism, 4, 106, 162; secular Jews, secularization of Jews, 66, 159, 165,

286–7, 448, 470–4, 533–5, 567. *See also* Christianity
Seikaly, Sherene, 179
Seine, 45
Senatus Consulte (1865), 286–7, 349, 438
Senegal, 8, 475
Sephardi, Sephardim, 174–6, 529, 543–6, 563–6. *See also* expulsion of Jews and Muslims from Spain
Sétif, 344, 613n
settler-colonial, 3, 25, 78–9, 100, 117, 139 304, 542
Seville, 197
Shakespeare, William, 426, 573–6; Alonso, 574; Ariel, 577–8; Caliban, 575, 577–8, 584; Miranda, 584; Prospero, 573–7, 584–5; *The Tempest*, 426, 573–8. *See also* Sycorax
Shabbat, Sabbath, 161, 225, 307, 382, 473–4, 519, 555, 568
Shaw, Artie, 200
shedim. See djinn, djenoun
Sheikh Badr (Jerusalem), 211
Sheikh, Malek, 347
Shepard, Todd, 84, 92
Shire, Warsan, 276
Shirizi, Marsil, 190–1
shiva, 35, 41
Shmita, 161, 278, 509
Shohat, Ella, 433
Sidi-bel-Abbès, 31, 366, 445, 457, 516–25, 529–31; European city/Arab city binary, 516–23, 529
silkworms, 23, 385–6
single language, 203–4, 210
Slyomovics, Susan, 234, 464
Sofia (Bulgaria), 551–4, 567
Someck, Ronny, 198
South America, 330, 575
sovereign, sovereignty, 93–5, 99, 260–1, 303–4, 340, 422, 473, 484, 491, 500, 595n; worldly sovereignty, 246, 420
Spain, 32, 48, 97, 119, 133, 148–50, 160, 174–6, 328–9, 349–50, 379, 391, 412, 457–60, 482, 486, 522, 546–60, 571–6, 630–1n; expulsion of Jews and Muslims from (1492), 32, 48, 68, 133, 148–50, 160, 174–6, 328–30, 349–50, 379, 391, 469–470, 550, 553, 555–7, 560, 575; *Megorsahim* (expellees), 97; Spanish (language), 97, 205, 548–9; Spanish Inquisition, 119, 391, 558
Stein, Sarah Abrevaya, 93
stolen identity, 453–5
Stoler, Ann, 144; on colonial aphasia, 144
Stora, Benjamin, 27, 29–30, 81–103 passim, 231, 453–4; on exile, 82–5, 87–8, 95–6, 100–3; *A History of Jewish–Muslim Relations*, 86; *Juifs d'orient*, 86; *Juifs et musulmans de la France colonial à nos jours*, 86; on "profound trauma," 81–3; *Three Exiles*, 83, 87, 95
Strauss, Isaac, 492–3, 536, 628n
Strasbourg, 188, 209, 218, 600n
strike, 23, 111–12, 336–7, 348, 386–7, 470–1
Sycorax, 426, 573–8, 583–4
synagogues, 13, 21–3, 51–5, 72, 171, 193–4, 206, 282–7, 293, 373, 468, 493, 556, 569; Abū Umar Joseph Ibn Shoshan Synagogue (Toledo), 557; Great Synagogue (Algiers), 157; Great Synagogue (Oran), 21–23, 194; Rabb synagogue (Tlemcen), 570
Syria, 215, 289, 471

Taïb, Jacques, 282, 287
talisman, 189, 230, 252, 345, 452
Talmud, 177, 556; French burning of Talmudic literature (1242), 177
Tama, 573–85
Tamzali, Wassyla, 29, 225–7, 231–63 passim; *Abzim*, 231–2, 241; *Éducation algerienne*, 231
taqqanah, taqqanhot, 395, 399, 618n
Tel Aviv, 107, 161, 231
Tétouan, 349
A Thousand and One Nights, 299
Tlemcen, 30, 285, 366, 388, 398, 402, 517–19, 570
Torah, 25, 252, 286, 300–4, 392, 419–20, 447, 491–3, 499, 503, 556, 586
Toubul, Semha, 198, 521
Tower of Babel, 202–4, 215. *See also* single language
Trenga, Victor, 120–1, 533–4; *On the Psychosis of Algerian Jews*, 121
Tunisia, 8, 12, 137, 230, 294, 354, 407, 412, 463, 529, 574
Tunis, 19, 28, 201, 378
Turkey, Turks, Turkish, 206, 352, 377–8, 397, 412, 520–, 544, 551–6, 561
Tutankhamun, 241

Umar Pact, 15, 93
ummah, 2–3, 7–11, 15, 23–4, 79, 89, 94, 111, 134–6, 244, 249–63, 303, 330, 350, 358, 513, 607n; jewelers of, 111,134–6, 252–6, 260–2, 393, 350, 358, 513. *See also* Jewish jewelers
United Kingdom, 28
United Nations, 123, 170, 178, 204, 467; Resolution for Partition of Palestine, 467, 471, 475; UNESCO, 467, 471; Relief and Rehabilitation Administration (UNRRA), 168, 181; Universal Declaration of Human Rights (UDHR), 94, 471, 599n

Index

United States, 3, 11–13, 25–7, 31, 41, 74, 154–8, 162–70, 181–6, 198–201, 213, 222, 249–52, 266, 272–4, 300, 314–16, 330, 354, 407, 427–35, 467–70, 477, 482–91, 498–503, 513, 549, 570
universal exhibitions, 379–4, 387, 390; 1851 (Great) Exhibition of the World of Industry of All Nations, 380; 1862 Universal Exhibition in London, 383–4; 1867 Universal Exhibition in Paris, 389; 1878 Universal Exhibition in Paris, 536
unlearning, 3, 38, 112, 137, 146, 163, 168, 215, 269, 322, 419–20, 440, 457, 478, 484–5; unlearning imperialism, 3, 103; unlearning Zionism, 266
unruliness, unruly, 23, 172, 234, 280, 485, 457, 548, 554, 569
USSR, 185
Utica, Marabou Cidy, 574

Val d'Hiv, 341
Velázquez, Consuelo, 74; "Besame Mucho" (song), 74
Vernet, Horace, 410
Versailles, 410
Vicaire, Marcel, 388, 394
Vichy regime, 19, 27, 37, 76–8, 87, 91–2, 102, 115–21, 149–55, 168–70, 199–203, 213, 316, 332–3, 353–6, 424–7, 432–5, 440, 528–30; confiscation of Jewish property, 37, 115, 168; deportation of Jews, 45, 86–91, 102, 115–20, 213, 315, 435
Vienna, 558–60
Vinitsky, Yonatan, 362, 364, 401; *Are You Relatives?* (montage), 362, 364, 401

Wahbi, Ahmed, 40
Wannsee Conference, Lake (Berlin), 18, 315, 435
Washington, DC, 183, 468
West Africa, 57, 248
whiteness, 2, 12, 24, 83, 102, 134, 147–51, 166–7, 170–2, 192–5, 215, 277, 381, 461, 469–78, 483–4, 488–91, 500–4, 535; Jewish whiteness, white Jewishness, 477, 483, 488, 500–2
Wischnitzer, Mark, 13
witchcraft, 573–5
world-building, world-maintaining, 319, 333, 494

World War I, 79, 145–8, 287, 318, 336, 347–52, 356, 615n
World War II, 3, 37, 45, 74, 86, 92, 94, 102, 115–21, 149, 166–7, 184–5, 214, 315–16, 353, 356–7, 429, 450, 464–7, 472, 477, 489, 491, 502, 529; Allies, 91, 155, 168, 185–6, 316, 344, 429, 434–7, 467; Axis powers, 116; Operation Torch (1942), 168, 198, 316
worldliness, 66, 196, 284, 329, 351, 444
Wyld, William, 288–90; *Departure of the Israelites for the Holy Land* (Algerian scene), 289
Wynter, Sylvia, 5, 31, 428, 459–82 passim, 488; "1492: A New World View" (essay), 459–60, 481–2; "Beyond the Word of Man" (essay), 459–60; "The Cinematic Text and Africa" 479; on "Judeao-Christian," 31, 460–1, 470, 474; on Man, 459–61, 465–9, 475–9

Yahadut HaTora, 541
Yehudai, Ori, 182
Yemen, 566; Yemeni Jews, 12, 566
Yiddish, 175, 193
Yishuv, 175, 546
Yom Kippur, 188, 567–70

Zertal, Idith, 180
Zionism, Zionist, 2–5, 10–13, 18, 22–35, 40–6, 76–8, 100, 106, 119, 127, 131, 136, 149, 156–9, 161–6, 170–90, 208–19, 239, 247–52, 266–80, 314, 321, 344, 391–2, 421–4, 429, 433, 441, 454–77, 485–92, 500–10, 522, 528–32, 537, 541–8, 551–4, 561–2, 566–71, 581–5, 597n, 608n, 626n, 629n; El Arish Plan (1902), 181; Zionist colony in Palestine, 2, 5, 10–13, 18, 27–9, 35, 41–6, 78, 86, 127, 156, 159, 163, 214, 266–70, 312–14, 421, 433, 454, 457, 460–5, 472–3, 477, 486–7, 491, 505–10, 526–9, 545–8, 581–2; Zionist project, 22, 85, 127, 131, 165–6, 176, 180, 250, 392, 489, 500, 510, 546, 590; Zionist state, 2, 29, 35, 175–6, 267–8, 423, 465–7, 470–4, 477, 500–1, 510, 554, 566, 570, 582–3. *See also* Anti-Zionism; Israel, Israeli
ziyara (pilgrimage), 48
Zochrot Gallery (Tel Aviv), 161